Tina Modotti

Tina Modotti

Between Art and Revolution

Letizia Argenteri

Yale University Press
New Haven and London

Designed by Gillian Malpass

Printed and bound in Great Britain

Library of Congress Cataloging-in-Publication Data

Argenteri, Letizia.
 Tina Modotti : between art and revolution / by Letizia Argenteri.
 p. cm.
Includes bibliographical references and index.
 ISBN 0-300-09853-7
 1. Modotti, Tina, 1896–1942. 2. Women photographers – Mexico – Biography.
3. Women photographers – Italy – Biography. 4. Mexico – Social conditions.
I. Title.
TR140.M58 A74 2003
770'.92 – dc21

 2002014916

A catalogue record for this book is available from
The British Library

To Fabrizio

Contents

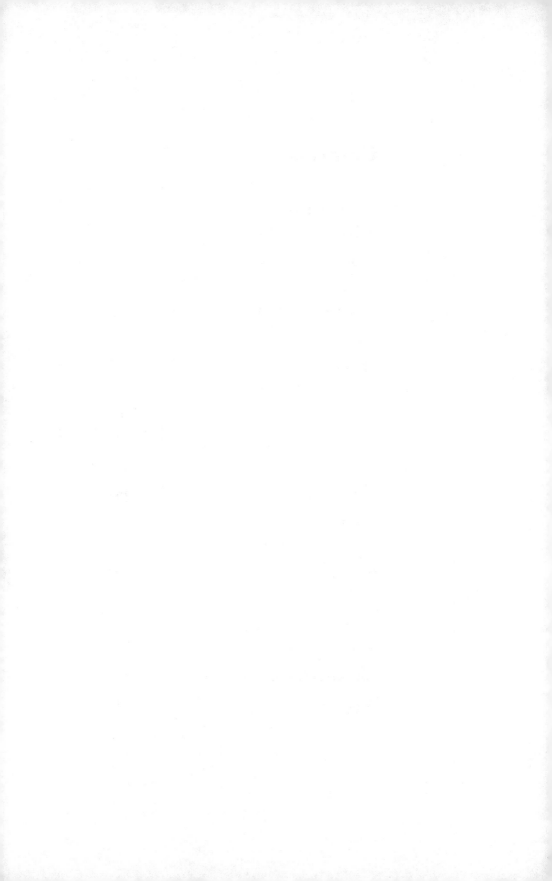

Acknowledgments

My name alone appears as author and I alone am responsible for the content of this book, but it has been a cooperative enterprise, since many people shared with me their findings and information, with a selflessness and disinterest unprecedented in academics, even when they knew that we were not going to agree in politics and world view. Naming all of the people that helped me would be impossible. However, some must be mentioned for their special efforts to bring my project to fruition.

I am particularly indebted to the staff of the Abraham Lincoln Brigade Archives, Brandeis University Libraries, Waltham; AIHA (American Italian Historical Association), Staten Island; Bancroft Library, at the University of California at Berkeley; CEMOS (Centro de Estudios del Movimiento Obrero Socialista), Mexico City; Center for Creative Photography, Tucson; Comitato Tina Modotti, Udine; J. Paul Getty Museum (Department of Photographs); J. Paul Getty Research Institute, Los Angeles; Michele Filomeno Agency, Paris; The Museum of Modern Art, New York; San Francisco Museum of Modern Art; Istituto Nazionale per la Storia del Movimento di Liberazione in Italia, Milan; San Francisco Public Library (Special Collection); Libreria Sormani, Milan; Fototeca I.N.A.H., Pachuca; Geisel Library, University of California at San Diego (particularly the Interlibrary Loan, Special Collection, and Art and Architecture Sections); Mills College Art Museum, Oakland; Biblioteca Nacional, Mexico City; Archivo de La Palabra, Mexico City; Archivo General de la Nación, Fondo Presidentes, Mexico City; Green Library, Stanford; DNA Model Management LLC, New York; Immigration History Research Center at the University of Minnesota, Minneapolis; Jan Kesner Gallery, Los Angeles; Fondazione Istituto Gramsci, Rome; *La Repubblica*, Milan; California Historical Society, San Francisco; University Research Library of the University of California at Los Angeles (UCLA); Fondazione Giangiacomo Feltrinelli, Milan; Centro Friulano Arti Plastiche, Udine; Southern California Library for Social Studies and Research, Los Angeles; Hoover Institution on War, Revolution, and Peace, Stanford; and the UCLA Center for the Study of Women, Los Angeles.

The academic year 1995–96 when I taught at UCLA was a refreshing period in my life, not only because I returned to my writing and research

(specifically to this project, which I had neglected for a while), but also because I again came into contact with a true academic institution where research was appreciated, encouraged, and rewarded. This book greatly benefited from my UCLA teaching year. As a graduate student there in the 1980s I enjoyed conversations and chats (mainly on opera) with the former chairperson of the history department. I have never forgotten what he told me: "Write while you research, otherwise you lose so much of your research." This suggestion has proved invaluable.

I would like first of all to thank my Readers. I am also very grateful to the San Diego Mesa College for graciously allowing me (actually, encouraging me) to continue my research while teaching there. I am indebted, besides to the people who wish to remain anonymous, to these individuals: Valentina Agostinis, Rafael Alberti (in memory), Robert J. Alexander, Stéphane Allart, Manuel Alvarez Bravo (in memory), Barbara Argenteri, Cristina Argenteri, Alessandro Baccari, Riva Bacon, Christiane Barckhausen-Canale, Victor A. Berch, Carlos Blanco Aguinaga, Giorgio Bocca, Janet L. Boone, Edoardo Bossi, Janice Braun, John Britton, Argentina Ferrau Brunetti, Jackie Burns, Enzo Cainero, Andrew Canepa, Barry Carr, Louie Chaban, John Charlot, Lynda Corey Claassen, Leslie Ann Coles, Maria Grazia Collini, Enzo Collotti, Jaime Concha, Amy Conger, Mildred Constantine, Dante Cosolo, Maria Grazia Cutuli (in memory), Robert D'Attilio, Edward and Janet Deland, Mari Domini, Wilfred Dubois, Gianfranco Ellero, George Esenwein, Gisèle Freund (in memory), Fred Gardaphe, Paolo Giovannitti, Susannah Joel Glusker, César A. Gonzáles-T., Deanna Paoli Gumina, Mary Habeck, Sandra Harding, Christine Hatzky, Ron Hill, Margaret Hooks, Vincenzo and Paola Invernizzi, Gabriel Jackson, Stephan Jost, Nilde Jotti (in memory), Dainis Karepov, Norma Karram, Robert Kern, Jan Kesner, Richard Koprowski, Mary Kovach, Christophe Kutner, Carol Leadenham, Luis Leal, Sarah M. Lowe, Adele Maiello, Gail Malmgreen, Nancy Morris, John Mraz, Weston Naef, Aldo and Claudio Natoli, Dianne Nilsen, Marisa Nuccio, Mario Passi, Stanley Payne, Manuel Plana, Margarita Ponce, Elena Poniatowska, Arturo Porras, Paul Preston, Missy Rayder, Giuseppina Re, Nancy Relaford, Ramon Eduardo Ruiz, Rita Sanchez, Tracey Schuster, Rosalie Schwartz, Joseph Sciorra, Miriam Silverberg, Susan Snyder, Helen Solanum, Libera Sorini, Amy Stark Rule, Lung-Kee Sun, Gary Tennant, John Thompson, Riccardo Toffoletti, Reiner Tosstorff, Eric J. Van Young, Rudolph Vecoli, Pasquale Verdicchio, Bianca Vidali, Carlos Vidali, Kim Weston, Linda Wheeler, and Ella Wolfe (in memory).

A special thanks to Gillian Malpass, at Yale University Press, for her constant encouragement and wise suggestions, to Fermin Catacutan, for his

unfailing help, and to Michael James Kelly for his priceless, first-class expertise. To my little summer guest, Benedetta Marcella Grasso, my warmest thanks for being such a fun and patient girl and especially for allowing me to see the world through her eyes. To my *mamma*, who once again acted as my research assistant and consultant, a big GRAZIE is long due. To my governess, my deep gratitude for "just being always there" for me.

A few years ago, a person who became very close to me (even though sometimes the ocean divides us) suggested that I had to think seriously of the possibility of writing a book on Tina Modotti since I was the right person. His reasons were: that I was trained as a cultural historian; that I can "read" Modotti's photography; that, because of my interests, I possess a solid understanding of political party struggle; that I read and speak all the major foreign languages required for the project (except Russian); that I am Italian (as Modotti originally was), and that I have been living in California for a number of years, so I have a feeling for the place where Modotti spent perhaps the happiest period of her life. Moreover, I had expressed a strong interest in a project about a female political activist.

I admit that I was intrigued. I also recognized that I had some advantages over other historians and biographers but, perhaps precisely because of that, I was afraid that it would become a monumental project (as it did). Moreover, I wanted to write a book that, although heavily footnoted and fully documented, was also accessible to as wide an audience as possible, as my first book had been. It is the historian's duty and my profound desire to find all the data and facts – insofar as they are attainable – but it is also the historian's duty to reach an audience outside the strictly academic circle. Without those goals and views, it would have been very difficult for me to produce this book.

Now I am glad that I chose to embark and stay on the project, and I am grateful to that person who first inspired me. He was always at my side through the entire process and, most of all, he showed me that there are other joys (especially culinary!) in life than ascetic researching and writing. Without his encouragement and his tolerance I could never have brought this project to fruition. Thus, the book is dedicated to him.

* * *

A few points to bear in mind:

(1) In the notes, when quoting from journals and newspapers I have been as specific and as detailed as possible, but in the case of *El Machete* and

other newspapers, especially the ones published in the 1920s and 1930s, it has not always been possible to give the page numbers.

(2) Most of the biographies published in American English for an American audience constantly stress their subject. If a biographer deviates for a while from that path, he or she is accused of "biographical heresy." I have deliberately avoided constantly bombarding the reader with every detail about Tina Modotti for two principle reasons: first, because at times I must explain the background or an event (for example, the Cristeros movement or the formation of the Mexican Communist Party), and second, because my protagonist was often at the mercy of events and simply "vanished" from the main scene, which the narration must indicate.

(3) Unless otherwise specified all translations from Spanish, Italian, French, and German are mine (I even struggled through a text in Portuguese).

Preface

"The gist of writing biography, today more than ever before, is
to render the cold and dead warm and alive."[1]

In 1896, while the world was experiencing the frenzy of the *fin de siècle*,
in Udine, a town in Friuli in north-eastern Italy, a child named Assunta
Adelaide Luigia Modotti Mondini was born. Tina – as she called herself all
her life – might have slipped into oblivion had she not plunged herself into
a series of tortuously political, artistic, and emotional events. Her life at
times reads like a fiction created by a witty sorcerer. But everything she
experienced did happen and has been documented and verified.

When reviewing a book on Tina Modotti, the Italian journalist Corrado
Augias compared her with Misia Sert, Lou Salomé, and Dolores Ibárruri,
the famed Pasionaria. He also asked himself why an extraordinary woman
like Tina did not become a myth.[2] Obviously he cannot have been
familiar with the bibliography, since Modotti did indeed become a myth.
In fact one of the problems encountered while researching her life is the
difficulty of separating myth from reality.

Augias continued his article by stating that, had Modotti been born in
the United States instead of Italy, she would have been the subject of at
least a couple of Hollywood films. Granted, Hollywood is chauvinistic as
regards its film subjects, but in this case nationalities do not matter much.
Ideologies do. It was Tina's social beliefs that made her unacceptable as a
possible popular icon.

Modotti became so integrated into American society (first north
American, then central American) that she transformed herself into a root-
less person. One is even inclined to question her desire to preserve her
Italian identity, despite her distinctive Latin looks and despite the pride that
Friuli people take in their language.[3]

While emigrés to America can point to plentiful examples of ethnic and
racial discrimination and persecution, it is clear that fear of new or dif-
ferent ideas – particularly political and social ideas – accounts for many of
the pogroms directed at "un-americans" throughout U.S. history. Sacco
and Vanzetti did not lose their lives in 1927 just because they were poor

immigrants or because they were accused of committing a capital crime. If the accused have economic power and social status, they may escape justice but in the xenophobic atmosphere of the time, Sacco and Vanzetti, a shoe factory worker and a fish peddler, were condemned in advance of their trial and penalized mainly for their anarchist ideology. The crime of which they were accused and convicted was only an excuse to strike at the core of their political beliefs. In fact, for many years the Sacco–Vanzetti subject has been treated with caution by historians, who feel defensive and puzzled about the legal flaws in the trial: crucial documents were altered, aborted, or even deleted in the name of a patriotic credo. Yet numerous books continue to show the judges' self-righteousness. Thus the case became "the case that will not die."[4]

The Modotti phenomenon is more complex than the Sacco–Vanzetti one, and thus harder to decipher. It presents a myriad elements that must be analyzed in their totality, partly in order to avoid stale statements or readymade clichés. Thus explanations of political and art movements and events are required, involving several countries and secret identities. Moreover, the phenomenon brings into focus the four issues of immigration, art, gender, and politics, thus making it a "multicultural project" (to use a phrase still in vogue in academia).

Everything related to Modotti's life seems to have been controversial, right to the end. It is as though she were in need of conflicts of all kinds: she lived intensely and dramatically, as if following a script, and she covered the traces of her real person behind her. Was this a conscious act on her part? It is difficult to say, so a veil of mystery will never be fully lifted from her persona. We know what is available in terms of documents. Mallarmé used to say that to reorganize the life of others in small, tangible fragments is somewhat impertinent. This I very much feel when I read the letters from Tina to Edward Weston. I feel I am committing an act of transgression and intrusion and that I am violating something sacred – the privacy of a human being who, I believe, never suspected she would become the center of such interest.

The Modotti phenomenon has produced interesting effects. Certain political groups have tried to appropriate, indeed almost monopolize, her persona in the name of communism – an ideology that Modotti embraced with conviction, while her free spirit perhaps prevented her from becoming a dogmatic communist. Or so most biographers usually present her. Nor was she ever an anarchist, even though some members of the anarchist movement aspire to make her a posthumous anarchist comrade. They have tried to demystify her "proletarian" origin, arguing that her background was more middle class. Therefore, they claim that her profession of faith,

although vocally leftist, cannot be understood in simple, politically orthodox terms.

Both groups have made a cult out of Modotti – something I understood only quite late in my research. They talk as if she were still alive; they hide situations of her life regarded as embarrassing, as if to protect her against some evil forces; they are never critical of any aspects of her life, and they live with the expectation of never finding any more information about her, because that would spoil the air of mystery that pervades her myth. It is ironic: on one hand, they want to know more about Modotti, so that they can have complete information on her brief life; on the other, they do not want to know, so that they can continue searching, that is, so that they can continue being in her company but on their own terms.

The Modotti case has generated two curious phenomena, one for each gender. The first I call the "soul-searching process," related to women "Tinologists" who identify with Modotti to such a point that they even believe they are her reincarnation. The second is more subtle, arising from the ego of men who have appointed themselves custodians and paladins of female aesthetics and beauty. The fascination Modotti exerted over some men is representative of the many responses that a sensational woman can inspire. Even the cover illustration chosen for a book about her perhaps unconsciously indicates an attitude to which gender and sex appeal are not alien.[5]

Modotti herself was perhaps never fully aware of the phenomenon. Despite the fact that she was an actress for a while, and "had a flair for for the dramatic,"[6] she did not look for fame. She would not have welcomed it, and hated to see her name associated with banalities and triviality. Although she never or used the term "feminism" or talked in clear terms of feminism in the ways now familiar to us, she manifested a certain unconventional feminism (despite establishing friendships with men much more easily than with women). In fact, Modotti has been associated with Isadora Duncan, who died in 1927, 15 years before her. Neither woman could see beyond the constraints and context of the 1920s feminism they typified.[7]

In more than a quarter of a century, between 1973 and 2002, Tina Modotti has inspired a good number of authors. Several exhibitions around the world have also been dedicated to Modotti the photographer. Some of these books and catalogues are remarkable from the artistic point of view. However, those that do not stress the artistic aspect tend to start Tina's saga with the year 1913, that is, her departure from Italy, or – even more – with the year 1923, her departure from the U.S.A. for Mexico, as if she had been born only then. These books usually de-emphasize her northern American

cultural background and emphasize the first Mexican period (there was more than one), which is well documented. The teenage Tina was not yet the beautiful woman we are used to seeing in some pictures, or the glamorous femme fatale as some have tried to depict her, or the revolutionary heroine, associated for a while with the Diego Rivera and Frida Kahlo group. It is true that Modotti's Mexican years, including her role in the Mexican Communist Party, were crucial to her political development, which led to her conversion to communism in Mexico (as all the records seem to suggest). But her California years are equally important in comprehending her later choices, such as her (de facto) marriage to an artist and her (much more stable) marriage to a political cause. One also wonders why the role of the Italian-American theater in San Francisco, and the role of immigrants in general in California, are never fully developed.

The various approaches used in researching the Modotti phenomenon are a clear indication of the authors' different ideologies. One can even witness a conscious form of historical revisionism, performed at a high level and with the best of intentions. This selective reconstruction of her life, which at times is a true "memory deletion," pays high dividends but has its historical disadvantages. It makes Modotti the well-known politically untouchable priestess vis-à-vis her last companion, Vittorio Vidali, who is always presented as the villain. But it also makes her a prisoner of her own revolutionary golden cage and, especially, of her own myth.

Finally, it appears that Modotti's real commitment to the Spanish Civil War has never been fully analyzed, partly because the historiography of the period seems to be affected by bouts of amnesia with regards to women (of both political sides) involved in the war, with perhaps one exception. Shortcomings of this type can be fatal; they may lead down dangerous paths, creating different and incomplete versions and interpretations of the subject in question. Ultimately, a complete and thorough analysis may even shed some light on Modotti's sudden and rather mysterious death.

We now have the chief ingredients of Tina Modotti's life, and a full repertoire of stories about the highlights of her existence has been developed. But are all dates correctly established and all stories accurately placed? Mere accumulation of knowledge can become a problem, because unguided it can create dangerous myths and produce senseless generalizations. And ultimately it creates what we want Modotti to be, not who Modotti was. I myself need and choose to stop here, not only to acquire the distance necessary to continue with other projects, but also to avoid a common mistake of cultural historians – to over-interpret the meaning of the artifacts and rituals related to a subject.

It is to be hoped that this book will also stop the obsessive quest of those who keep asking me whether I have discovered something new or original concerning Tina Modotti, or what contribution I have made to the historical discipline. The point is that when I was working on my book on the merger of the Italian monarchy with fascism (presented as a biography of the last Italian king), nobody asked me anything, as if I were perfectly suited to the task and the subject suited to me. It seems that, for this particular subject, one needs a special license to belong to a cult membership, a special political color, a special attitude, a special devotion, and something sensational to feed to the public. I find that both odd and ahistorical.

If by sensational one means shocking then I shall disappoint my readers, since my concept of sensational is different. The act of rechecking all the original records, down to the smallest detail (even the material published in three languages, such as Modotti's correspondence to Weston) was for me the truly sensational task. Approached seriously, some of the wording of the political documents, for example, was sensational in this sense, requiring much careful interpretation. Primary sources, read if possible in their original language, and textual analysis should take pride of place in historical writing – both becoming rare, it appears.

These components, together with a real sympathy for the leftist cause, are in my opinion missing in previous works on Modotti, who in the U.S.A. is venerated by anarchists and by feminists but is virtually neglected by what I consider the true left. The irony is that, although Modotti was a communist, her American biographers are anything but Marxist and their work often constitutes a subtle attack on the very ideology in which Modotti believed, disguised by the patina of an attack on Stalinism. Anyone with a sense of justice obviously condemns Stalinism, as I do, particularly the Stalinist government of the U.S.S.R. in the 1930s and 1940s. Even the staunchest of Marxists today would concur. However, as I say more than once in this book, there are distinctions among the various forms of communism, and I do not attach any evil connotation to the militancy of certain "comrades," with whom I may well disagree.

As an historian, I try to be as exhaustive as possible in explaining the contexts and circumstances, which will probably be criticized as deviating from the main subject. But without explaining, for example, the formation of the party that played a crucial role in Modotti's life the biography would be neither complete nor satisfactory.

The historian Simon Schama has emphasized "the importance of storytelling as the elementary condition of historical explanation,"[8] which I acknowledge I have to some degree abandoned. This work, I hope, redresses the balance, but not at the expense of a satisfactory negotiation between "familiarity and strangeness."[9]

It is also my intention to narrate not the story of a myth or character in a play but rather a real woman's life – that of Tina Modotti, whose commitment to a cause seemed to be more important than life itself. In doing so, I have to reproduce, recreate, and vivify the objective world my subject lived in, was shaped by, and which she shaped through her artistic, social, and political commitments.

1 Udine

"Romai essi lontans a val, Friuli, essi scunussus. A par il timp
dal nustri amour un mar lustri e muart."[1]

The period 1896–1913 – the years spent by Tina Modotti in Italy (and
briefly in Austria) – can be divided into two distinct political phases: the
crisis of the *fin de siècle* and the era of the prime minister Giovanni Giolitti.
The first was characterized by the repressions and attempts at authoritarian rule of the ministers Antonio Starabba Rudinì and Luigi Pelloux. The
second was marked by a government that within certain limits could be
regarded as liberal, even progressive.

Italy was a newly unified country, with all the problems and tensions that
the 1861 unification had brought with it. In an apposite reference to
Dante's *Divine Comedy*, a later historian stated that "Italy had struggled up
that purgatorial mountain with all its set backs and sufferings, buoyed up
by the belief that on the summit stood the Earthly Paradise, and when at
long last they reached it, they found, not an Earthy Paradise – but a building site."[2]

A new spirit was also to be observed in the country in the last decade of
the century: socialism, which produced a perhaps unstable but politically
united alliance, arose in opposition in the Chamber. Thus from the socio-economic point of view, the years 1896–1913 were fairly uniform and
homogeneous. Economic development made possible the turning point
of 1900–01, to which the liberal center-left wing also contributed. That
wing indeed became the de facto representative of the more politically
progressive sectors of the bourgeoisie, which were opposed to political
repression.

The outcome of all this was a unique form of government, known as
Giolittianism, much loved and admired by Anglo-Saxon historians, perhaps
for its strong liberal component and its ability to compromise. If Giolitti's
political system did not succeed in forming a stable and compact bloc of
social forces, mainly by levelling the social classes, at least it succeeded in
mitigating class conflicts, achieved by Giolitti's constant and persistent
flexibility and willingness to compromise.

In 1896–1913 Italy was transformed from an agrarian country to an industrialized one. Giolitti understood that such a mutation required political change and, consequently, a new political system. Nevertheless, his desire to change, although genuine, did not in the end modify the existing political order. This deep contradiction is one of the striking features of Giolittianism, and in the long run it opened the door to the totalitarian system that evolved in the 1920s.

During 1909–13, Italian emigrants abroad numbered about 679,000. The majority, 404,000 of them, mainly from the South and from Sicily, chose the American continent as their destination. The north-eastern region of the Veneto contributed to the numbers, although far less than the South. The emigration, besides producing a profound psychological and ultimately dysfunctional dislocation, contributed to slowing down the economic crises of the most backward parts of the country. The departure of the labor force was the catalyst for widespread savings to be invested, which, thanks to the banking system, nourished the industrial development of the north-eastern areas. Emigration to the new world nevertheless only postponed the so-called Southern question. It produced a series of reforms and gave the ruling class the illusion that the Southern question could be solved mainly by constant aid (*politica di soccorso*), not by a radical change in political structures.

It was in this social and political milieu that Tina Modotti was born and raised, in an Italy that, on the very day of her birth, had announced the engagement of the Savoy crown prince of Naples, Victor Emmanuel, to the Montenegro princess, Helen. At that time, Udine was the capital of the center-west Friuli region, with 36,899 inhabitants, while Gorizia was the capital of the eastern part, included in the Habsburg Empire. In 1896 Friuli, which had been annexed to the Italian kingdom in 1866 – that is, after the third war of independence – had 592,000 people.[3]

Four years earlier, on May 25, 1892, the Milanese newspaper *Il secolo* (The Century) had published a supplement devoted to Udine, which contained some basic general information. Its inhabitants were praised for their work ethic, their sober mood, and for their understatement, which made them somewhat unknown in the rest of Italy. Life in Udine was described as simple but rewarding. The main attraction was dancing, considered – according to the journalist A. Purasanta – a real passion of the Udinese. In the section devoted to industry in general, the silk industry was foremost, followed by metal, wood, textile, paper, and food industries or occupations.[4]

Modotti's date of birth, which in the town hall registry appears as August 17, 1896, at 11 a.m., was reported as August 16 in her certificate of baptism, dated January 27, 1897. The correct day is the 16th, as Modotti

herself reported in her 1932 Russian documents.[5] The mistake was proba-
bly due to the fact that the family neglected to report her birth within the
five days prescribed by law. So, postponing the birth date by one day gave
them one more day to report it.[6] Her godfather is indicated as Antonio
Bianchi, hairdresser by trade. Tina's full name was Assunta (after her
mother) Adelaide (after her maternal grandmother) Luigia (after her
maternal aunt). All her life she was called Tina, not only to distinguish
her from her mother, but also because in Friuli it was customary to call
children by a name different from the ones given at baptism in order to
confuse evil spirits and keep them at bay.[7]

The span of five months from Tina's birth to her baptism was unusually
long, considering the high infant mortality rate of the time. At first sight,
this could indicate the ambiguous attitude of her family toward a religious
ceremony or the doubtful attitude of don Antonio Ciccutti, the priest
performing the baptism, or both. These assumptions might be valid if
people were coherent in their ideas. But in Italy then, and now, everyone
is baptized, unless a member of another religion. Such compromises
(whether political, religious, or otherwise) are always achieved smoothly and
with the best results in Italy.

So, the fact that Tina's father considered himself a socialist did not
prevent him from having his children baptized. Nor did it prevent the chil-
dren from receiving the sacrament of confirmation, which in the case of
Tina occurred a month before her departure for America, when she was
already a teenager.[8] It appears that Giuseppe Modotti had affiliations with
the Udine socialist circle, indicated by the fact that one of the "assistants"
chosen for the baptism, held in the Basilica delle Grazie, was a prominent
socialist (although the word *assistenti* is ambiguous in Italian, and could
mean simply that the people named were present).

His name was Demetrio Canal, shoemaker by profession, who in 1892
had written a piece calling for the curtailment of the long hours of the silk
workers, who he claimed went to work half asleep and left the factory in
much the same state.[9] (The other assistant at Tina's baptism was Lucia
Mondini, a governess.) From August 15 to September 20, 1896, Canal was
director of the second socialist newspaper in Udine, *L'operaio* (The Worker).
In 1897, with Arturo Zambianchi and the photographer Luigi Pignat,[10] he
founded a socialist circle in Cicogna Street, where meetings and lectures
were held every Thursday. The circle was soon suppressed by the police
forces.[11]

After all, it was only a year later that the Italian working class, especially
in Milan, experienced the brutal repressions ordered by General Fiorenzo
Bava Beccaris, called by the socialists "the butcher of Milan" and by certain

American presses "the country's saviour." The general used cannon against unarmed civilians, and cavalry charges cleared the downtown area of Milan. That year, 1898, Bava Beccaris was complimented by King Humbert I and rewarded with the Grand Cross of the Military Order of the Savoy House for his services to "monarchy and civilization," producing a profound conflict between crown and people.[12] A popular song immortalized the event, "Il feroce monarchico Bava," whose first verse went: "Alle grida strazianti e dolenti / di una folla che pan domandava / il feroce monarchico Bava / gli affamati col piombo sfamò".[13]

Another event, from summer 1903, is relevant. When Victor Emmanuel III visited Udine to attend its regional exhibition, Canal personally handed him a letter. In it he defined himself as a "socialist, anarchist worker, who is fond of his majesty." He exhorted the king to proceed along the same political path, and to listen to the voice of the working-class people.[14]

What was the state of the immediate world that surrounded Tina Modotti at her birth? First of all, her family, although usually presented as proletarian, is actually hard to categorize class-wise. It is probably accurate to state that it was lower-middle class, composed of her mother, Assunta Mondini, her father, Giuseppe Saltarini Modotti, and two other children, Mercedes Margherita and Ernesto, born respectively in 1892 and in 1894. The family name had originally been Modotto, transformed into Modotti by a registration error in the eighteenth century. Their nickname was Saltarin.[15]

The year in which Tina was born, 1896, was full of events both at home and abroad. The most striking was the Italian defeat, more moral than territorial, at Adwa on March 1 at the hands of the Abyssinians.[16] Of the 15,875 Italian soldiers present at the battle, 6,634 (of whom two were generals) were killed, while 1,500 were wounded and 1,800 were taken prisoner. The Abyssinians lost over 9,000 men, with 10,000 wounded. It was the first time that an African army had defeated a European colonial power.[17] This shattered the Italian nationalists' imperial vision until the 1930s, and marked the end of the career of Prime Minister Francesco Crispi, who "tried to make Italy run before she could walk, and she stumbled."[18]

On April 3 in Milan, the *Gazzetta dello sport* (whose pages were then colored green, not yet pink) was founded, taking the place of *Tripletta*, and became available twice a week, since sports events were held on Thursdays and Sundays. On April 8, the International Feminist Conference was held in Paris. On April 10, the Red Cross presented the Eritrean colony with a mobile hospital, fully equipped with staff and fifty beds, transported by ship from Naples. Nevertheless, the African adventure was not welcomed by the majority of the Italian population. The cry of the deputy Andrea

Costa, "Not a single man, not a single penny must be spent for the African venture," became famous. In May, the minister Matteo Renato Imbriani placed before Parliament a petition initiated by the International Society for Peace, a Milan-based organization, in which one hundred citizens requested the end of the African adventure. Imbriani blamed two factors for the ills of Italy: the African campaign and the Triple Alliance of Italy, Austria, and Germany, which on May 6, 1896 was tacitly renewed for another six years.

In the same year Italy was confronted by the deaths of a significant number of political, academic, and cultural figures: in January, the senator Agostino Farina, the composer Riccardo Alborella, the law professor Carlo Negroni, and the archeologist Giuseppe Fiorelli; in February, the senator Matteo Ricci and the actress Carolina Ropoli Favi; in April, Antonio Cagnoni, composer of comic operas; in May, Luigi Cossa, professor of economics at the university of Pavia, the patriot Enrico Cernuschi, and Luigi Federico Menabrea, prime minister from 1867 to 1869; in June, the actor Ernesto Rossi and the senator Luigi Orlando; in July, the law professor Narciso Feliciano Pelosini; in August, the historian and patriot Giuseppe Silingardi and the writer Enrico Nencioni; in September, the linguist Pietro Dazzi, the geologist Luigi Palmieri, the patriot and explorer Tarsillo Barberis, the senator Giovanni Barbavara, and the poet Alessandro Arnaboldi; in October, the magistrate and senator Gregorio Caccia, General Agostino Ricci, and the mathematician and minister of labor, Costantino Perazzi; in November, General Ignazio De Genova di Pettinengo, the legislator Edoardo Deodati, the conductor Giuseppe Menozzi, and the writer Evelina Cattermolle Mancini, known by her pen name Countess Lara;[19] and in December, the lawyer Augusto Barazzuoli, the deputy and lawyer Achille Fagiuoli, the publisher Innocenzo Vigliardi-Paravia, and the literary figure Angelo Dalmedico. On December 6 the Swedish chemist Alfred Nobel died in San Remo, leaving a patrimony which was later converted into the world-renowned prizes.

On Christmas Day of the year 1896, Italians could buy the first issue of the socialist daily newspaper *Avanti!*, run by Leonida Bissolati. The contributors were, among others, Corrado Corradini, Enrico Ferri, Cesare Lombroso, and Edmondo De Amicis, the creator of the famous novel *Cuore*. In 1912, Benito Mussolini, then an ardent socialist from the region of Romagna, became one of its most brilliant writers.

The paper was the logical outcome of the fourth National Congress of the Socialist Party, held in Florence from July 11 to July 13, 1896 with the aim of restructuring the party, which by then had developed all the features of a "modern" party – individual membership card, internal electoral

procedures, regular congresses, a network of local sections – modeled on the German Socialist Party.[20] Even the title of the paper was taken from the German *Vorwärts*. And, like the German paper, *Avanti!* in no time became a successful party organ, with 50,000 copies printed for each edition.[21]

How much all this affected Tina's father is hard to say, considering that Udine already had a revolutionary tradition. In April 1883, for example, it was Udine that held the trial of two young men with a "revolutionary past". Rigosa and Giordani were tried for providing political aid to the *irredentista* Guglielmo Oberdank, who had been condemned to death in 1882 by the Vienna War Council for attempting to take the life of the Austrian emperor on his visit to Trieste.[22] Rigosa and Giordani were acquitted for lack of evidence.

Giuseppe Modotti searched all his life for new places, new people, new worlds, new types of work, and new meanings in life. This searching indicates not just the economic conditions of the time, but also his need to move around and to change. He was a mechanic by trade, although it has been wrongly suggested that he had received some training as an engineer, and he was even identified as a "mechanical engineer" by the Immigration Office in 1904–05. The confusion probably arose from the Italian for "engineer." An engineer, in Anglo-American English, for example, could be merely what in Italy was (and still is) considered a specialized machinist or a mechanic. In fact, Tina's birth certificate identifies her father as a mechanic, and he is listed as such in the certificates of baptism of two of her sisters. When the family emigrated to Austria, Giuseppe was identified again as an *Eisendreher* (turner). However, in San Francisco in 1918 he called himself "engineer and machinist" on a business card,[23] probably using the word "engineer" in the more general, American sense.

In 1887, when he was barely 24 years old, Giuseppe left Udine for Genoa, a city frequently called "the door of hope" because of its fortunate location. It was mainly from this port that emigrants would wait for a ship to the new world. However, delays were frequent, so they would often waste all their savings on room and board in cheap hotels recommended by immigration agents.[24]

It is uncertain what Giuseppe Modotti did in Genoa; he may have worked as a bicycle mechanic. What is certain is that two years later he returned to Udine and became engaged to Assunta Mondini, a tailor by profession, whom he married on October 5, 1892, in the Basilica delle Grazie in Udine. The marriage occurred only a month before the birth of their first child, which made them an unconventional and non-traditional couple at that time.

Their home, located at what was then 113 Pracchiuso Street (currently 89, the site of a dormant photo shop),[25] had been the Mondini home until the death of Assunta's father. Pracchiuso, in dialect *praclûs*, derives from *pratum clausum*, which suggests that at the end of the nineteenth century there was a meadow, used for the animals belonging to a patriarch's residence, closed (*clausum*) to outsiders. The Modottis lived there until they emigrated to Austria in the summer of 1897, almost certainly for economic not political reasons.

In Austria the Modottis lived for two years in Ferlach, a small town south of Klagenfurt, the capital of Carinthia, described in a tourist guide as a "quiet and elegant eighteenth-century city and a meeting point between the Germanic and the Slavic world."[26] Giuseppe was employed as a mechanic in the Grundner Franz und Otto Lemmisch factory in Oberferlach, which produced a peculiar item: bicycles made of bamboo.[27] The moment was ripe for bicycles; in 1896 the Austrian empire granted them the dignity of being "a transportation vehicle," and thirteen rules were established for them. Regulation number 9, for example, stated that bicycles had to give way to horse carriages and move quickly, in order not to upset the horses.[28]

From Ferlach, the Modottis moved to St. Ruprecht, while Giuseppe continued working as a mechanic. We have no information on his political activity. However, according to one source,[29] he used to take Tina with him to the May Day celebrations in Austria. (This echoes the life of La Pasionaria, who in spring 1903 as a little girl witnessed a miners' strike in her home town.) The story of the May Day parades never fails to be mentioned in the Modotti literature yet, with one exception,[30] nobody has questioned its veracity. Considering the source – the oral account of a strong Stalinist who added (or erased) whatever did (or did not) conform to the image of a good communist – one is inclined to doubt it, especially in view of the fact that Tina was the only Modotti child to go with her father.

Moreover, in Tina's childhood recollections, there is no mention of churches of any sort. Was Tina's memory so selective as not to remember, even slightly, the St. Ruprecht church, or any Italian church? Granted that Giuseppe was not a practising Catholic, still churches abound in Italy and Austria, and they are points of reference for anybody, even for non-believers. Childhood memories would not fail to include passing by a church at least once or twice a week.[31]

Three more children were born in Austria: Gioconda in 1899, Jolanda Luisa in 1901, and Pasquale Benvenuto in 1903. Ernesto died at four years old on March 3, 1898 from meningitis or tuberculosis and was buried in the St. Ruprecht cemetery.[32] The seventh and last child, Giuseppe Pietro Maria, was born in 1905 in Udine, where the Modottis had returned to

live, but in Villalta Street.[33] (A street has now been dedicated to Tina Modotti in Udine, in the northern section, the first time that Italy has devoted a street to a photographer.)

Nine mouths to be fed were plenty for a worker who had been trained as a simple machinist and who had already sought his fortune. Thus, the golden American dream was undoubtedly an attraction. Emigration by then had become "a popular destiny,"[34] regarded with a certain pride as a sign of emancipation by those who were looking for a way out of misery. For Friulanos in particular emigration was regarded as logical, a wish to explore the unknown and to see the world with its wonders.[35]

In August 1905, in a new peripatetic mood and phase, Giuseppe Modotti, then 43 years old, left Italy for the United States of America, via Le Havre, with the idea of sending for the family later on. His last son, also called Giuseppe, was not yet born when he left the country. A poem, written in dialect, articulates the conditions of Friulanos:

Da Nô La Int Nas Lostès

Da nô
no 'nd'è ce fâ
ma la int
nas lostès
cussì si crès
come i gjòcui
in libertât
tra las còtulas
das mâris
e las risclas
dai pez
e quant
ch'a si capìss
bisugna lâ.[36]

Tina's father arrived in New York on August 27 and went on to Turtle Creek, Pennsylvania, where his brother Francesco lived. There is another tradition which holds that he did not leave Italy until April 1906, after the San Francisco earthquake. While the date in itself does not greatly affect the larger picture, it is important in the light of future references, especially because, if Giuseppe had reached San Francisco in 1905, it would have made him a witness to one of the most tragic natural events experienced in the United States. His family would have remembered that event but

there is no family record of it.[37] In fact, Giuseppe did not move from the east coast to California until 1907, thus missing the earthquake. He lived in California until his death in 1922. According to immigration historians, the decision to choose the west coast for his final destination not only put him in a higher social category vis-à-vis the east coast immigrants, but also displayed a more adventurous and daring spirit than his compatriots, who settled in New York.

The San Francisco that Giuseppe saw was a city in the process of being rebuilt, after the earthquake. In North Beach, an Italian area, Giuseppe, who had by then Americanized his name to Joseph, opened a photographic studio, together with a certain A. Zante, at 1865 Powell Street, advertised as Modotti Joseph & Co. in *Crocker-Langley's San Francisco* 1908 and 1909 City Directory.[38] The two partners, who called themselves "artistic photographers and all kinds of view work," were not successful, so the business closed down within a year. Giuseppe did not despair and soon he opened a machine workshop at 1051 Montgomery Avenue. Meanwhile, his family, left in Udine, was trying to make ends meet. Later Tina declared that, sometimes for many months, they had no news of their father, nor did he send money home, for lack of work, so they had "to live practically on charity."[39]

The years spent by Tina in Udine as a silk-spinning worker in the Domenico Raiser factory, from 1909 to 1912, were romanticized by her sister Jolanda's stories, and thus reported by all the books on Modotti. One of these stories is a constant, considered relevant to her later commitment to the communist cause.[40] Tina was 14 years old in 1910, and was apparently considered the "adult" of the children since in 1911 her sister Mercedes joined her father in America. One cold winter night, the story goes, Tina returned home with a package of food – bread, cheese, and salami – which she had obtained with money made from selling a blue shawl given to her by her aunt Maria. In order to justify her action, she stated that she never really liked the shawl and decided to raffle it off at the silk factory in order to provide some food for her family.[41]

If this story was partly constructed *ad hoc* by members of her family or political comrades to show Tina's selflessness and dedication, it served its purpose. Not only did she emerge as a heroine, but also as an enterprising young woman, who could put into practice the Italian motto *il bisogno aguzza l'ingegno* (need sharpens one's wit). Some have complained that it is difficult to reconcile these "stories of impoverishment and debilitating factory labor"[42] with the later image of actress, photographer, and femme fatale. Actually, these roles are not incompatible with one another and, in

a way, they follow a logical pattern, which culminates in the elevation to the role of political goddess. Edward Weston himself, who came to be probably Tina's closest friend, had no problem in reconciling the image of a poor, deprived girl with that of a sensual woman.[43]

Whether Tina's past has been retouched or not, the labor of the textile workers, the majority of whom were women, was indeed hard and tiring. In Italy, an entire oral tradition was formed around textile workers, especially those in the spinning mills. One song in particular, of which these are two verses, powerfully describes the exhausting process:

> Mamma mia, mi sono stufa
> o de fà la filerina,
> ol cal e el poc a la matina
> ol provin do voeult al dì.
>
> El mestee de la filanda
> l'è el mestee degli assassini,
> poverette quelle figlie
> che son dentro a lavorar.[44]

The identification of the Modotti family by a particular element of the left as "proletarian and socialist"[45] is not entirely accurate. A better classification, although a bit vague, would be "skilled craftsmen with a radical orientation,"[46] judging by the type of work of the Modotti father and by Tina's recollections of May Day parades in Austria (if the information on this point is reliable). But at least four of the Modotti children were subsidized in school, in the form of food and books, due to the precarious financial condition of the family. In 1932, while answering a biographical questionnaire for the Soviet Communist Party, Tina defined the social position of her parents as "proletarian," underlining that both of them also came "from proletarian families and [were] very poor."[47]

As far as Tina's education is concerned, the only records of formal education are for the years 1905–07 in Udine, although in 1913, when Tina left Europe for the U.S.A., she classified herself as "a student" for immigration purposes.[48] In 1993, a group of elementary school teachers from Udine researched Tina's childhood and education, with the intent of pasting together a few fragments that would, if not clearly define everything, at least give some precision to their subject.[49] The research showed that during the school year 1904–05 Tina had to repeat some examinations since she did not know the Italian language well – as the official documents show – which is not surprising for a young girl who had lived in Austria from the age of 2 to the age of 9 and who spoke the Friulano dialect at home. But

at the end of the school year 1905–06 Tina's results were outstanding: a total of 59 out of 60, with the exception of home economics (then titled as *lavori donneschi*).

It is unclear from the documents whether Tina learned photography at an early age. What is certain is that she was acquainted with photography early in her life, since her paternal uncle, Pietro Modotti – listed in a military draft certificate as a *pizzicagnolo* (delicatessen dealer), in an inexplicable change of profession – by 1900 had become a first-class photographer in Udine, with a photography atelier at 10 Carducci Street.[50] He also wrote extensively about his photographic experiments, such as stethoscopic execution or candlelight photography, using here and there his knowledge of English (in 1909 he had visited the U.S. for one year).[51]

In 1903 Pietro Modotti exhibited an oil portrait and three enlargements, one of which was retouched with a brush.[52] His photography also became known overseas. The 1926 edition of *American Photography* published his portrait of a little girl, entitled "Bubi Orio" (1926), whose expression is described as "enchanting." Thanks to this photograph, he won second prize in a photographic contest. According to Rosamaria Zampi, the daughter of Spartaco Zampi, one of Pietro's pupils, Tina Modotti visited her uncle's studio regularly in order to learn the techniques of and to experiment with the medium.[53]

At Pietro's death, his photographic studio was inherited by his daughter Cora, who ran the business with a partner, Luciano De Giorgio. Cora was not particularly interested in her father's business and later sold it to her partner at a good price. She spent the last years of her life as governess of a certain Miss Von Hoffman.[54] It is thanks to De Giorgio that we have any material to testify to the fertile productivity of Tina's uncle and, ultimately, perhaps to the first germ of Tina's creativity.[55]

This then is a partial view of the world into which Tina Modotti entered and to which she responded, and which she in profound ways came to shape and influence, even if paradoxically in obscurity on the one hand and celebrity on the other.

2 America! America!

"Mamma mia, dammi cento lire, chè in America voglio andar.
Cento lire io te le do, ma in America, no, no, no!"[1]

It was Tuesday, June 24, 1913, when a young woman aged 16 sailed from Genoa on the German ship SS *Moltke* to Ellis Island, New York, where she arrived on July 8. In her pocket she had 100 dollars and a train ticket for San Francisco, where her father and her sister Mercedes resided.[2] Her trip had started from Udine, where she took a train for Genoa, via Mestre and Milan, with a ticket that cost 22.5 liras.[3] She traveled alone – an indication of the independence that characterized her life, despite her various associations. To the immigration authorities, the passenger gave her name as Assunta (called Tina) Saltarini Modotti, although in the records her name became distorted as Madotti.[4] She declared herself to be single, five feet one inch tall, in good mental and physical health, and a student. This last statement was probably a smart way to allay any suspicions of the immigration authority, who stated her ethnicity as "Italian North."

Besides this basic information, not much is known of her first trip to the new world. Like all other immigrants, once in Ellis Island, Tina was probably first required to take a shower and then undergo a medical examination to check against eye infections.[5] Possibly, Modotti expected to have what is regarded as a normal life, to have a decent job, and make new friends, perhaps to see Italy again. Since neither journals nor diaries are left, it is not known whether she had some rudimentary English but, considering her talent for languages, she may have picked up some during her trip.

Some immigrants came to the U.S. with preconceived attitudes, which formed the basis for their reactions to American life. One of them related that just before the trip an immigrant would read every printed word he or she could find on the new world, and read all the letters that reached the village from those who had already emigrated.[6] It is possible that Italians living in urban areas had more information than rural people about employment and life overseas.[7] It is likely, therefore, that Tina relied on the information provided by her sister and her father, although, besides a few letters from one of her brothers, no family letters survive.

In the same year that Tina left Italy (and the year of the actor Rodolfo Valentino's departure),[8] a pamphlet was published in San Francisco in Italian to help immigrants adapt themselves to the new world.[9] And more articles, dealing with legal aid for Italian immigrants and how to obtain American citizenship, were published in *L'Italia*, the major Italian newspaper of the west coast.[10]

That the Italian immigrants helped each other was noticed even by President Woodrow Wilson, who stated:

> The Italians in the US have excited a particular degree of admiration. They are the only people of a given nationality who have been careful to organize themselves, to see that their compatriots coming to America were guided to the place of the industries most suitable to their previous habits. No other nationality has taken such pain as that; and in serving their fellow countrymen, they have served the US. They have thereby added to the prosperity of the country itself.[11]

The success of Amedeo Peter Giannini (the founder of the Bank of Italy in 1904, later transformed into the Bank of America) in California, for example, was possible thanks to his network of contacts among Italian immigrant farmers, whose trust he had won as a commission merchant.[12] The most important activity of the Committee of Relief, created inside the Italian Colony, was the "taking care of the incoming immigrants." Members of the committee would meet the arrivals at the Oakland pier and would take them to San Francisco, where they were introduced to the Italian community.[13]

Italian emigration to the U.S. reached its peak in 1913.[14] Another Italian, Luigi Sogliuzzo, one year younger than Tina, arrived that year. He settled in San Pedro, California, where he became a fishing industry pioneer. He lived until he was 88 years old and was honored just before he died in 1985 by an article written by his granddaughter, Rosemary Spinoso. "A Man and His Dream" captures the essence of the Italian immigrants' experience in a foreign land.[15]

Contrary to what has been claimed, the Italians who emigrated to the U.S.A. in 1913, did not all have a politically red affiliation. In fact, very few did, even though their emigration document was indeed red.[16] It has also been said that Modotti was typical in her migrational patterns but this is contradicted by all that she had experienced by 1913 and by what was to follow. However, it is to a certain extent right to say that Tina Modotti's immigration history follows certain patterns shared by other women from her region. The history of Friuli emigration in general and Modotti's in particular are also somewhat parallel.[17]

Friuli (together with the Veneto, Campania, Sicily, Lombardy, and Calabria), has been one of the Italian regions with the highest number of emigrants. In the century from 1876 to 1976 two million Friuli people emigrated to America.[18] In 1913 specifically, more than 40,000 people emigrated from the city and suburbs of Udine.[19] Some Friulanos were first directed to Canada, such as Antonio De Piero, from Cordenons, who on April 19, 1913 left Trieste by ship, in the company of a good number of lice.[20] Modotti, like 95 percent of the Italians who emigrated to the west coast, went directly from Italy to San Francisco, whereas only 40 percent of the Irish, 30 percent of Germans, and 20 percent of Russians did so.

In 1913, Giuseppe Modotti was living at 1952 Taylor Street, right at the center of the Italian Colony in San Francisco. Telegraph Hill was the first area of Italian settlement. Originally an Irish and German neighborhood, it had become more Italian by the end of the nineteenth century. From here the Italians spread to North Beach, between the Hill and the Bay, the section with the lowest rents in town, and the Mission and Potrero districts. Unlike most Italian colonies in the United States, that of San Francisco around 1913 did not show a high concentration in one area. Even North Beach could hardly be called an Italian enclave.

After the First World War, the Modotti family moved to 901 Union Street, in an apartment looking out on the port, a fact that has been commonly regarded as a sign of upward mobility, although the need for more living space was certainly the main reason. By 1919, indeed, the family was almost reunited: Tina's mother, along with two sons and another daughter, had joined her husband. In general, many Italian immigrants to California "learned how to put aside their earnings to the eventual purchase of a home or business"[21] (the same was true for the Italians who returned to Italy from America), and a popular refrain ran: "He who crosses the ocean can buy a house."

Judging from the documents available, the ten years spent by Tina in California (first in San Francisco and later in Los Angeles), appear to have been overall a happy time, in which there were few of the anxieties usually associated with the early stages of migration.[22] The more common mixture of feelings was well articulated by the Sicilian poet Vincenzo Ancona, who wrote: "In this great land you can find every blessing. Even if thorns at times will prick your hands."[23] In Modotti there are also no traces of the nostalgia for Italy expressed in the writings of other immigrants, such as these words, written in June 1913: "Dear sister-in-law, by now the cherries must be ripe there. Please eat them for me too, since here there are none."[24] Or these lines written in 1914: "E la turba, così degli emigranti /

salpa e dispare nelle nebbie d'oro / Lunghe lasciando scìe di desideri e di speranze . . ."[25] Or even much more recent words: "Il sole picchia giù. È gialla la fotografia, quel giovane sei tu. / Amico mio sono con te/amico mio perchè / Ad essere straniero sai . . . non ci si abitua . . . Mai!"[26]

In contrast, Tina was with her family, she had a job (as a seamstress), and she was a young woman who, apparently, regretted nothing left behind. Also, there was no demand for loyalty to the old world or a moral obligation to preserve the old traditions. Perhaps, in the United States she could reconstruct her persona, shape it to fit the direction and appeals of the new world. And she could exorcise that part of herself left in Udine.[27] Moreover, it appears that the Italian community on the west coast was culturally vivacious and more affluent than that on the east coast.[28] These lines written by an immigrant from Italy reflect the enthusiasm felt by many of his compatriots:

> La California la tengo in core
> E tutte l'ore mi va al cervel.
> Giorni lietissimi colà passai
> E mai, giammai, la scorderò.[29]

One key to understanding Tina's later commitments (personal or political) is found in these California years. After all, Modotti always considered San Francisco her city of adoption, as she wrote to Edward Weston in January 1926.[30] And, instead of shaping a compensatory universe or recreating the way of life she had known in Italy – as many Italian immigrants had done on the west coast, thus "italianizing" their surroundings – Tina assimilated herself to the California milieu, developing an enterprising spirit. This is not to suggest that she completely erased her Italian identity, only that California, besides being the beginning of a new world, represented for Modotti the departure point for a long cultural and political process of growth. In this frontier land par excellence there was no real burden of history, such as Tina had previously known.

By 1860 there were 2,900 Italians living in California. Ten years later, 4,660 Italians were recorded, of which 1,600 lived in San Francisco.[31] In 1920, the numbers in California had grown to 23,311 first-generation Italians and 21,635 second-generation Italians, totaling almost 45,000.[32] By 1924, San Francisco had the sixth largest Italian community in the country. The number of Italian immigrants continued to increase into the 1930s.[33]

One striking fact to be aware of at all times is that the Italians who had settled in other regions of America were reticent about their nationality, but in California, the land where gold was abundant, they were open about it.

This shows that California was more receptive to immigration in general than east-coast states, even though the east coast was traditionally where the majority of European immigrants settled. The Italians in California, for example, achieved the reputation of being desirable citizens.[34] As early as 1867, the newspaper *La voce del popolo* reported that Italian immigrants in San Francisco enjoyed a better reputation among Americans than Italian immigrants in other American cities, and that they regarded themselves as "the model colony of the United States."[35] Later on, some of them became wealthy: by 1913, the California Fruit Canners' Association (CFCA), mostly owned by a Genoese, Marco Fontana, the son of a marble cutter, operated the world's largest cannery, Del Monte, with a yearly capacity of 24 million cans.[36] One of the pioneers of the moving picture business on the Pacific coast was an Italian-American, Peter Bacigalupi, whose involvement dated back to 1894. His eponymous firm was located at 908 Market Street, San Francisco.[37]

The life of the vivacious Italian–Americans living in San Francisco has been analyzed from various angles, drawing on a plentiful supply of material. And much of that life gravitated around their churches, since they have always been both community centers for believer and non-believer alike and places of worship. Sts. Peter and Paul Church, called the Italian cathedral of the West, was founded in San Francisco on June 29, 1884, as the church of the first national Italian parish of California. It was located at Filbert and Dupont Streets (now Grant Avenue); by 1913, a second church had been built on Filbert Street (opposite Washington Square) and the parish used the old church for organizational and recreational activities. Since the "cathedral" was located in North Beach, in the heart of the Italian Colony, it became a landmark of the area and a symbol of the dedication of the immigrant priests and lay people. For the Italians, it evoked the beautiful cathedrals of Italy and became a place to commemorate special regional feasts, an opportunity to gather to talk, and a continuing contact with Italian national and cultural events.[38]

Photographers and other artists immortalized the Italians living in San Francisco and in the surrounding communities. J. B. Monaco (1856–1938) was a photographer whose work is now exquisitely displayed in the North Beach Museum.[39] Another photographer, Gino Sbrana (1879–1947), a native from Pisa, Tuscany, emigrated to San Francisco in 1900 with his parents and two brothers. There Sbrana and his brother Carlo became professional photographers. They opened a portrait studio on Broadway, called the Pisa Studio, which after the 1906 earthquake had to be relocated in Oakland.[40] Whether dressed in their Sunday best or in their work clothes, the Italians in Sbrana's lovingly detailed photographs indicate a community

that was trying to amalgamate with its new country while also trying to retain some Italian features.[41]

San Francisco Italians could count on Italian banks, shops, and professions, who all placed advertisements in the newspaper *L'Italia*.[42] The proprietors' names were often a mixture of the old and the new world: Camillo Barsotti (doctor), Devoto (lawyer), Joseph Tognotti (vet), and Gemma Zolezzi Passera (midwife). Mario Isnardi, a medical doctor who took a short holiday for a "deserved rest in Lake Tahoe," from the pages of *L'Italia* reassured his clientele that, "loyal to the promise made to his patients," he was coming back to work.[43] The Italian pharmacy was located at 512 Montgomery, near the French pharmacy at 748 Broadway. The Firenze bakery, also in Broadway Street, specialized in *panettoni, grissini*, and *gallette*. And by 1917 many more bakeries and shops had opened.[44] Little grocery stores abounded. Prices, at least in today's terms, were quite reasonable. A pound of bananas sold for 5 cents in 1917, while a dozen pineapples sold for $3.50. Salmon cost 20 cents per pound, and halibut and codfish cost 12 cents per pound.[45] A few years later, turkeys were sold at Thanksgiving between 35 and 50 cents a pound.[46]

Italians were then (and still are) rather conservative and traditional in their culinary habits. One brief article in the Italian press informed the public that in Vallejo, California, a group of Italian miners, working at St. John mine, went on strike to protest against the Japanese cook, who had taken the place of the Italian cook in the kitchen. Apparently, the new cook kept serving steamed rice. The article stressed that no race issue was involved, only a culinary one.[47]

Gaetano Giurlani, from Lucca, sold his "genuine" olive oil at 453 Jackson Street. And the patisserie La camelia, owned by Messrs. Marino and Salvatore, produced cakes for all occasions. The hotel La giovane Italia (whose name perhaps evoked the patriot Giuseppe Mazzini's political group), located at 70 Jackson Street was managed by E. D. Bacigalupi, V. Stefani, and N. Castiglioni. An advertisement reassured the Italian community that there one would eat exceptionally well and *veramente all'italiana* (truly Italian style).[48]

Sacred and profane merged. Anyone who wished to learn English could buy a grammar book published by *L'Italia*, located at 118 Columbus Avenue.[49] Anyone who wished to buy Italian cigars or Italian wine could easily do so. Anyone who needed the car washed and repaired, could go day and night to J. B. De Maria, at 528 Jackson Street. And anyone who wished to be enlightened on the "hygiene of sex" could attend a lecture by Dr. Romilda Paroni, from the University of California at Berkeley.[50]

Besides such advertisements, *L'Italia* provided all sorts of information. In October 1913, Ruggiero Leoncavallo, the composer of *I Pagliacci*, visited San Francisco and, to the delight of its readers, *L'Italia* printed a photograph of him with the newspaper's editor, Ettore Patrizi.[51] One of the most tragic articles covered a series of workplace accidents and disasters, many of which were suffered by immigrants. An affecting drawing by Bayard accompanied the article.[52] One of the most amusing articles dealt with a female immigrant, Elena Parazzi, who as soon as she landed in San Francisco compared the photograph of the man whom she had promised to marry with the reality. Since she found a large discrepancy between the picture and the man himself, she decided to renege on her promise, but first told the unfortunate man that the reality did not honor the print that he had sent her.[53] It was indeed imperative to subscribe to *L'Italia* to link the old and new worlds. An advance subscription was "rewarded" with a gift described as a twenty-inch square tapestry depicting Milan Cathedral, St. Mark's in Venice, St. Peter's in Rome, the Colosseum, or Mt. Vesuvius in Naples.[54]

Two points need to be mentioned since they will shed some light on Modotti's later life. One is the California immigrant movement, which by 1913 had become thoroughly established. The second, and more important of the two, is cultural radicalism, into which Modotti plunged from 1916. It displayed a free spirit typical of a certain bohemian urban intelligentsia in San Francisco as well as in Los Angeles.

The year 1913 also represented a turning point in the history of the American west-coast working-class movement for two reasons, centering on John Nolan and on the Wheatland incident. The reverberations of the 1912 strikes on the east coast, especially in Massachusetts, reached the west coast mainly through the collaboration of Italian immigrants and American labor unions.

John Ignatius Nolan, from the Molders' Union, was elected to serve in Washington, D.C., as the first congressional member from a California working-class background. Of Irish origin and raised in California, Nolan embodied the San Francisco working-class movement, which was Caucasian (despite a large Asian population), from old stock, and racist.

Strong resentment against the immigrants from the east was vocalized by the trade union leader Paul Scharrenberg, of German origin, who would speak in terms of maintaining "California for us and our kind of people,"[55] and envisioned that each race be confined to its continent of origin.[56] The Japanese question reached a critical state in 1913 also because of the Webb Alien Land Law, which prevented Japanese from holding real estate, despite the vigorous protests of the Japanese government.[57] (And still today racism

and xenophobia re-appear in California, perhaps the expression of a similar insecurity and paranoia).

Wheatland was the town where a workers' riot occurred in August 1913. Advertisements for hop pickers at the Durst ranch at Wheatland near Marysville, north of Sacramento, drew 2,800 people, including women and children, many of whom were native-born migrant workers. No provision had been made for sanitation or garbage disposal; only eight "revolving filthy toilets," frequently infested by insects, were provided for nearly 3,000 people of both genders. Disease abounded, also because drinking and cooking water was scarce and far away. Proper dormitories were not available so the workers had to camp in tents (which Durst rented to them at $2.75 per week)[58] or sleep on piles of straw under the open sky or use so-called "California blankets," that is, newspapers used for bedding.[59] The advertised bonus turned out to be, instead, a 10 percent "hold-back" from the pickers' earnings, which was paid only if the picker worked for the entire season.[60]

Among the pickers were a hundred union members of the Industrial Workers of the World (I.W.W.), an idealistic and romantic industrial union. The "Wobblies" (as they were called) were committed to organizing the entire working class into one big union with a revolutionary program. Their militancy terrified the conservatives, and even the Socialist Party felt obliged to distance itself from them.[61] Two I.W.W. members, Richard "Blackie" Ford and Herman D. Suhr, were prominent protest organizers, despite the fact that Suhr was declared partly mentally retarded.

According to the report of the investigation conducted by Carleton Parker, executive secretary for state immigration,[62] a request for improved conditions was submitted to the ranch owner through a workers' committee. Along with demands for higher wages and other improvements, the I.W.W. insisted that men be assigned to help women with heavy sacks and that separate toilets be installed for women.[63] The requests were rejected, provoking a strike. While Blackie Ford was talking to the crowd, on August 3, a sheriff's special posse drove up and tried to disperse the crowd and arrest Ford. The situation deteriorated. The National Guard was brought in. Many protesters, among them Ford and Suhr, were arrested and sent to prison, some only because they happened to be present at the time of the protest.

The Durst ranch, described by the I.W.W. attorney Austin Lewis as "an open air factory,"[64] was also the workplace for an average of over 1,500 immigrants of different nationalities, religions, and races (Japanese, Mexican, Hindu, Italian), who united with the other pickers to protest against the inhuman working conditions. Italians were one of the major

ethnic groups involved in the riot.[65] Wheatland represented an early spontaneous attempt by the west-coast working class to create a collective, democratic voice. For the first time, the California newspapers paid some attention to the conditions of migratory workers. This resulted in the creation of the state Commission of Immigration and Housing, active from 1913 to 1914, with the aim of improving living conditions for itinerant laborers. However, the Commission also began secret investigations into I.W.W. activities, using agents who were paid to find any kind of potentially incriminating evidence. Their reports should thus be treated with a good dose of skepticism, especially since the press blamed I.W.W. members for sabotage, instigation of violence, arson, antipatriotism, and even murder.

When Austin Lewis took on the case of the I.W.W. members in September 1913, he found the course of justice totally obstructed – which made him state that itinerant laborers in the state of California were treated "with a calloused indifference both to the law and to ordinary elemental justice."[66] It is thus not surprising that Ford and Suhr were sentenced to life imprisonment in Folsom State Penitentiary, despite Suhr's mental disabilities.

Despite the tragic conclusion – two pickers (one Puerto Rican and the other English), a deputy sheriff, and the district attorney Manwell were killed during the insurrection – and despite the bloody repression by the National Guard, Wheatland marked the beginning of a dialogue among the revolutionary trade unions, the I.W.W., and the so-called seasonal workers. Talks intensified during the First World War, when there was demand even for this type of worker, who found in Wheatland something that would give them proper recognition in society. The riot occurred at the beginning of August 1913, when Tina Modotti had just arrived in San Francisco. It was a part of the milieu in which she began a new phase of her life.

The San Francisco found by Modotti was an unusual city in that its predominantly Catholic population of 505,652 was 70 percent immigrant, of which 94 percent were from Western Europe.[67] In spite, or because, of their numbers (almost 100,000), the Italians were shunned by the non-Italian European immigrants. The Irish felt that in the job market the Italians were generally a threat. However, one union leader, Patrick Henry McCarthy, who had come to the United States in 1880 from Ireland, and was head of the State Building Trades Council, befriended the Italians. By 1909, he had become mayor of San Francisco as the Union Labor Party's candidate, but was defeated in 1911.[68]

Many of the Italian immigrants came from Friuli, for whom the new continent – *Merica*, as they called it – represented a huge and unknown

country. In a popular motto, America was "long and large, and surrounded by rivers and mountains" – *E la Merica l'è lunga l'è larga l'è circondata di fiumi e muntagne* [*sic*].[69] One feature of the Friulano immigrants was that most came with their families.[70]

In 1911 a monograph on the Italians living in California was published to honor the memory of the first Italians who arrived in California at the turn of the century. Among them figured a baker named Barbero from Turin. His "sweet miracles," sold in his shop at 1362 Stockton Street, gained him the nickname of "prince of the patissiers." The monograph was prepared by Ettore Patrizi, the publisher of *Il giornale d'Italia* (Italy's News-paper), as well as editor of *L'Italia*. With a sense of pride in the achieve-ments of Italian immigrants, Patrizi stated that the Italian community in San Francisco took shape hand-in-hand with the formation and develop-ment of the city. It was this combination that gave direction to the economic structure of both. For that, Californians regarded themselves as fortunate in having acquired a group of such active and productive immigrants.[71]

To Tina, San Francisco must have appeared as an exotic and almost magical city, where everything was possible, like Voltaire's El Dorado in *Candide.* Change seemed to be sacred in a city that, in many immigrants' eyes, represented the new world. This was partly because of its climate and partly because of its new, booming industries, following the 1906 earth-quake. The Mexican painter José Clemente Orozco spoke of San Francisco Bay as of "one of the most beautiful landscapes in the world, which only the pen of writers like Balzac or Maupassant can describe."[72] Another Mexican wrote that it seemed that San Francisco had preserved the perfume of myrrh and the voluptuousness of sandalwood.[73] Robo de Richey immor-talized the city in a poem, "San Francisco": "O city of Sea and Ships: / you shall always be / the memory of deep midnights . . ."[74] Even a New Yorker could appreciate the beautiful city:

> built like Rome, on hills, though in place of Rome's seven hills there were nine, and yet other rising ground that would be counted as hills if they were in New York City or environs. One cannot imagine without seeing it how golden the Golden Gate can be as the sun sets behind it, and how jewel-like the nearer flank of Mount Tamalpais can become in sunset colors made translucent by the haze that surrounds it.[75]

Not every one, though, had found the city attractive. Some literary sketches written by a Milanese in the nineteenth century in the form of letters are not so complimentary in describing either the Italians settled there or the climate, which the visitor found *abominevole* (abominable):

I found a mass of Italians here, coming from all parts. I will mention some of them. Invernizzi from Como starts putting up a lot of air. Tazzoni from Carate Lago has a store.

. . .

San Francisco climate is thoroughly unpleasant: until 10 a.m. it was very hot; at 10 a terrible wind started blowing and the bora did not stop until evening. The night was cold and humid.[76]

The author, Pier Giuseppe Bertarelli, born in 1819, visited California in 1850 out of "cultural and political curiosity" (as he put it) and to avoid the Austrian military draft. Disappointed by just about everything there, he returned to his native Milan in 1853.

San Francisco was and still is atypical as an American city, mainly for two reasons: its geography and its lack of Anglo-Saxon influence. These have contributed to its tolerance and a certain resistance to the puritanical matrix present in many other American cities, but have also kept San Francisco somewhat isolated from the rest of the country, despite its cosmopolitanism. That was only confirmed by the city's decision to hold a Panama–Pacific Exposition in 1915 to coincide with the opening of the Panama Canal. It was also atypical in being the city of the west coast where people spent most on enjoying themselves – a record that continued for many years.[77]

Looking back at one of his visits to the city, the writer Kenneth Rexroth had this to say about the San Francisco of 1927:

It was a truly Mediterranean city, and yet it had none of the horrors of poverty that still make Marseille, let alone Genoa, Barcelona, or Naples, impossible for a sensitive person to work in very long. It was like an untouched Mediterranean village – like St. Tropez or the Cinque Terre in those days – and yet it was a great city, and in its own way not a provincial one but the capital of its own somewhat dated culture.[78]

In fact, small-town ideology – provincial and moralistic – was absent from San Francisco. Consequently, it was accused by other Americans of being the fertile soil for vices (drunkenness and prostitution), and of hosting two kinds of dangerous people, the immigrants and the intellectuals, who were considered un-American in the extreme.[79] As has been noted, "indifference toward conventional mores and openness to cultural innovation made San Francisco a mecca for persons in search of new life styles."[80]

The vitality of the city was reflected in its press, some of which was produced by and for the Italian immigrants, as I said before. Publications in

Italian abounded; the first newspaper published in Italian in San Francisco was *L'eco della patria* (The Motherland's Echo), founded in 1855 by Federico Biesta. The paper, which consisted of four pages, was published twice a week on Wednesdays and Saturdays. In 1872, it merged with *La voce del popolo* (The People's Voice), founded in 1870, an antimonarchist paper that followed the line of the republican Mazzini.[81]

The first daily published in Italian on the west coast dates back to 1889, also called *La voce del popolo*. Its office was at the corner of today's Columbus Avenue and Kearney Street. The paper kept a progressive orientation until 1943, when it had to merge with *L'Italia*, which had been founded in 1906.[82] *L'Italia* had begun as a weekly in 1887, funded by La Lega dei Mille (The One Thousand League), and only later became a major daily.

Before the First World War its political orientation was liberal, and it was not uncommon for *L'Italia* to side with the workers "against the crudest capitalistic tyranny."[83] In 1913, the paper defined itself as "the most progressive Italian daily with the largest circulation of any foreign paper west of Chicago."[84] But conflicts and tensions between *L'Italia* and *La voce del popolo* were not rare, especially during the two world wars.[85]

L'Italia's publisher Ettore Patrizi promoted strong links with Italy, which in practice meant devoting at least two pages to Italy and Italian politics and an entire page on the Italian community in San Francisco. Patrizi personally supported the cause of the Fiume affair in 1919–20, when the poet and patriot Gabriele D'Annunzio occupied the city of Fiume and established his own government.[86] During the fascist period, Patrizi became a sympathizer of the regime. His admiration for the Italian leader was expressed in a pamphlet, *Come considero Mussolini: pensieri di un italiano all'estero* (How I consider Mussolini: Thoughts of an Italian abroad), published in 1924, in which he stated that the sons of Italy, scattered around the world, found in Mussolini the symbol of their feelings of love for Italy.[87] Patrizi even met Mussolini several times in Italy in the 1930s.[88] In contrast, the antifascist voice of the Italian press in California during fascism was represented by the weekly *Il corriere del popolo* (The People's Courier), openly oriented toward the working class. The newspaper was founded in 1911 by Carlo Pedretti, republican and anticlerical. When the Second World War broke out in 1939, *Il corriere* became fortnightly.

Other publications for the Italian community include *L'Italo-Americano*, whose publisher was Cleto Baroni; *Gagliardia* (Courage), which stressed Italian sports activities and whose publisher was Italo Scaladrin; *L'unione* (The Union), a Catholic-oriented weekly publication, whose publishers were James Bacigalupi and Sylvester Andriano; *Rassegna commerciale*

(Commercial Review), published by the Italian Chamber of Commerce; *La parola* (The Word), founded in Los Angeles by Bontempi, Colantoni, and De Caro and directed by Falasca, an attorney; *La capitale* (The Capital), a weekly published in Sacramento by Luigi Rolla; *Sole* (Sun), published in Stockton, whose publisher was Flavio Flavius; *Il carroccio* (The Chariot), which defined itself as a "monthly cultural magazine"; *Il leone* (The Lion), founded and published by Luigi Menchini. Menchini, who had worked on the east coast for *Il grido della stirpe* (The Cry of the Race), was the author of the words of a military hymn whose music was written by another Italian, G. Pezzolo.[89]

By 1913, some newspapers for immigrants were bilingual, reaching a vast number of people. One publication that Modotti may well have encountered was the radical weekly magazine *The Blast*, published in early 1916 in San Francisco by Alexander Berkman, one of the anarchist Emma Goldman's friends and colleagues.[90] *The Blast*, however, lasted only until 1917 when its founder was jailed for evading the draft.[91]

The job chosen by Tina in San Francisco was typical for a female immigrant of her class,[92] and it was also her mother's profession. It is known from her own account that Tina worked as a seamstress at home and in a San Francisco major department store, or a "man's shirt factory," as she put it.[93] Like many other immigrant women, she had craft skills.[94] In the years preceding the First World War, a man's hat could cost as little as $1, while a good suit usually sold for $20 (in the sales for around $14.75).[95] I. Magnin, centrally located in Union Square, and regarded as an exclusive fashion center, in 1913 defined itself as a retail shop for ladies, children, and infants. Since no I. Magnin records are left of that period, we have to rely on the information related by Jolanda, Tina's sister, who worked with her and who in later years acquired the function and role of Tina's living memory.

According to Jolanda, life was hard for Modotti, due to the precarious situation of the immigrants;[96] her work was tiring and unrewarding,[97] and probably called upon little of her imagination and creativity. She then became a home modiste and then an actress. Tina probably used her department store connections to reach the stage. Economically, however, the Modotti family was not considered poor by immigrant standards, as indicated – some biographers argue – by the fact that Tina's father had by then acquired a telephone.[98] This piece of information with other more important data make up the socio-economic mosaic of the Modottis.

First of all, something needs to be said about the psychology of certain immigrants. Gadgets not only represent the new world but also act as

symbols of a status otherwise unavailable, no matter what the economic conditions are. I recall my own early experience in the U.S.A. I noticed that an air conditioner was de rigueur even for those regarded by American standards as not wealthy, such as first-generation immigrants, and even in places where the climate did not require an air conditioner.

Objective information should be sought: what was the net earning of the Modotti family in 1913? How much tax did the family pay? To how many tax deductions was Giuseppe Modotti, as the head of the family, entitled? How difficult was it to obtain and maintain a telephone in San Francisco in 1913? What was the number of immigrants who could afford a telephone in the city then? If historians knew this information, which is next to impossible to obtain mainly because Giuseppe Modotti did not have a steady income, they could then make significant statements and draw comparisons. What can be said is that by 1913 a conspicuous number of people had a telephone in San Francisco, but that is still only a vague statement. The mere fact that Tina's father appears in the telephone directory does not say very much about his social status. But it does indicate that he could pay the monthly rate, that he had a business that required the use of a telephone, and that he was an enterprising man – fairly typical of the immigrants of the west coast, therefore.

No less enterprising was Tina, who immediately detected the message that novelty was highly valued in San Francisco. But how to articulate that in practical and meaningful terms? How concretely to translate that need to transcend her limited world? Theater, apparently, could lead her forward. Tina had grown into an attractive woman. According to Lolo de la Torriente, she was rather petite and nicely proportioned. Her natural Latin look, with her deep chestnut hair, sensual mouth, and large, deep, melancholy eyes, was in demand at the time.[99] It helped her to model clothes at I. Magnin and later to play Mexican characters on stage. An undated photograph of this period, taken by a professional San Francisco studio (Terkelson and Henry at Market Street), presents a beautiful young lady wearing an evening dress made even more elegant by a chiffon shawl. The pose is evidently chosen to stress her beautiful shoulders, and her hair is gathered in the back in a mischievously disordered chignon. The caption says "Miss Tina Modotti, who will dance at the Bal Masque of the Italian Public Society Saturday night."

It was at this point that the cultural life of the section of San Francisco called Little Italy, became crucial to Tina's future, thanks to the inauguration in 1918 of the Stockton Street tunnel, which linked North Beach to the downtown area.[100] (North Beach is still one of those places "where history and culture form a distinctive blend that sets it apart

from other neighborhoods and gives it a strength and vitality all its own."[101]) That tunnel provided a new opportunity for the Italian immigrants of Little Italy, who were described as "an entity that can no longer be neglected."[102]

3 Enter Robo and an Acting Career

Softly,
over your Pan-like forehead
blossom-pale
the purple shadows of your dim hair
fall . . .

<div align="right">Roubaix de L'Abrie Richey</div>

From 1906 to 1915, the world watched the redevelopment of a city that gradually resurrected itself after two tragic natural calamities. As Orozco put it, it was like a city's proud resurrection from its ashes.[1] Filmmakers rushed into production with graphic depictions of the disasters, earthquake and fire, whose devastation was immortalized by Arnold Genthe's photography.[2] The film *San Francisco*, made by the Pacific Coast branch of Biograph, was produced using a model of the city constructed entirely from photographs, "tinted red to represent the glare of the fire."[3]

San Francisco showed outstanding recuperative vitality, and in 1915 retained its position of gateway to the Orient by hosting the Panama–Pacific International Exposition. The exhibition, which opened on February 20 and lasted until December, became the city's opportunity to invite the world to see the results of its reconstruction. It was visited by 19 million people.[4] Located at Harbor View (now the Marina District), it stretched for three miles along the slope of Pacific Heights.[5] The Palace of Fine Arts was especially beautiful – with a romantic lagoon – and included in its display modern paintings, sculptures, and photographs, some of them exhibited for the first time, such as works by the Italian futurists and paintings by Edvard Munch.

The press particularly noted the Italian contribution because of the role Italian bankers and businessmen had played in rebuilding the city.[6] And the parishioners of Sts. Peter and Paul Church took pride in their involvement.[7] The so-called Italian pavilion was considered one of the best and was universally praised. In the 1987 film *Good Morning, Babylon* (directed by Paolo and Vittorio Taviani), the motion-picture director David Griffith (the author of the film *The Birth of a Nation*), while being driven

through San Francisco in 1915, wants to stop to enjoy the view of the Italian pavilion.[8]

Before the publication of the most recent biography of Modotti,[9] it was often claimed that the 1915 Panama–Pacific International Exposition changed the course of Modotti's life, because it was at the Palace of Fine Arts that she met the person who introduced her to an aesthetic life, Roubaix de l'Abrie Richey, nicknamed Robo. Now it seems probable that Tina met Robo in 1917 through his sister, Marionne Richey,[10] though even that is not certain. However, to make the story more palatable and more romantic, the couple created their own version of their first meeting,[11] which became the accepted account, reported even by the Modotti family.[12]

A native of Oregon, Robo preferred to stress his distant (and more impressive) origins. His grandmother was from Quebec, while his mother, Rose Salina LaBrie, from Roseburg, Oregon, had married James Akin Richey, a farmer. In 1914, at her husband's death, Rose had moved from Pleasant Valley, a town near Portland, to California. Robo, six years older than Tina, was "tall and slender, with fine classic features, a piquant little moustache and large eyes that knew many moods."[13] In another verbal portrait, he is depicted by a Mexican, Rafael Heliodoro Valle, as having "a look full of illusions," and as being "a quiet person, who spoke little and gently, and smiled softly."[14] Robo played the role of the artist to its fullest, as if he were living a film script. At times he wore a black four-in-hand tie, which was interpreted as a "clear badge of anarchism;" it is in this garb in 1921 that he posed for a photograph by Edward Weston.[15] In Tina's words, "with Life he was never friendly. He faced it with hostility, and was forever endeavoring to escape its realities, and to live from the heart regardless of the common conception of things."[16]

In 1911, Robo had moved from Oregon to San Francisco in order to attend the Mark Hopkins Art School, currently the San Francisco Art Institute.[17] In October 1915, he married Viola McClain (who called herself Vola Dorée), a model, dancer, and actress, from whom he filed for divorce in August 1918.[18] A self-declared poet and painter – even the 1913 San Francisco telephone directory identified him as an "artist" – Robo passed from writing to painting and back, "unable to decide which of the two was his best medium of expression."[19]

Beauty in its most abstract sense was Robo's obsession. It was also his favorite subject of conversation – Beauty in life, Beauty in the visual arts, and Beauty in language. Indeed, at the age of 12, he had invented a vocabulary which he called *ziziquiyana*, in which sounds were attuned to colors, to replace the old vocabulary that he regarded as stiff and colorless. What he tried to build up was "not the word itself, but the idea of the word –

the synthesis of the meaning of the word.[20] So, the words *Proster-mozarumtarencmo* (kitchen) and *xevaci* (tobacco) were supposed to convey the flavor, spirit, and smells of the place and associated objects. Feelings also had colors. Since there are different kinds of love, each one had a color: love for a mother was pink, while love for God and the Holy Virgin was white.[21] Tina absorbed so much from Robo that she tried, perhaps unconsciously, to convey his linguistic vision in photography.

The few years that Tina spent as Robo's companion represent her cultural radicalization and bohemian period; Robo proved to be her "ambassador into the literary and artistic milieu of bohemian San Francisco."[22] It seems that they never officially married, although to please Robo's family they stated that they had married in Santa Barbara, and from 1918 Tina started signing her name as Modotti de Richey. They established a home in Los Angeles with other members of the Richey family: Robo's widowed mother, his grandmother, and Robo's sister Marionne, who was Tina's age.[23] The southern California city had half a million people, passing from "a modest community of 50,000" in 1888 to a metropolis in 1920.[24] At first, the de Richeys all lived at number 1407 11th Street.[25] By 1918, it appears that Modotti had become an American citizen, according to the Los Angeles Township 1920 census record.[26]

A photograph of Robo and Tina, taken in 1921 in Los Angeles by the Canadian photographer Walter Frederick Seely (although the picture is sometimes attributed to Weston), captures the bohemian atmosphere of their life. They are both intently engaged in creativity: Robo sits on the right, painting perhaps a batik piece (which Tina later used for acting), while Tina on the left kneels on a stool, modeling or sewing a dress. He wears a loose painter's smock, while she wears a possibly handmade cotton dress. In the background one can see batik curtains created by him beside a small table. What appears to be a portrait of Tina hangs on the wall.[27] Not much is known about the circumstances in which this photograph was taken, but it is probably representative of the type of life they led in Los Angeles. Not only does the picture evoke a sense of calm and concentration, but the two subjects are so much in harmony with their surroundings that one can agree with the statements that "there was a resilient grace about him that matched her own"[28] and that "Robo and Tina made an irresistible pair."[29]

Their home became the meeting place for misfit and displaced souls, who while drinking sake[30] created in their minds a world larger and less banal than their real lives. It also became an intellectual and artistic workshop, a true thinking laboratory, where everything was perceived through the lens of their eccentricity and utopian ideals. Among the guests were

Ramiel McGehee, a homosexual writer and former dancer of the Ruth St. Denis Group, who had spent five years in the Far East and had developed a keen interest in Buddhism; Edward Weston (a picturesque figure with his big stick)[31] and Margrethe Mather, both photographers; Ricardo Gómez Robelo, a Mexican poet and archeologist; and Sadakichi Hartmann, a film critic, half-Japanese half-German, who frequently contributed to Emma Goldman's anarchist journal *Mother Earth*.[32] Years later, Weston characterized the group as "parlor radicals," who "drank, smoked, had affairs."[33] According to another contemporary source, "Everyone knew everyone, and the permutations of the love affairs – like an electric current – attracted one person to another."[34]

Robelo was probably the most glamorous figure of the group. He was nicknamed Rodión after an exemplary bohemian story.[35] Dostoyevsky was Robelo's favorite writer. As a young law student, in a night of "smoke and music," like Rodión Romanovitch Raskolnikov in *Crime and Punishment*, Robelo knelt down to kiss the foot of a prostitute and told her: "It is not you that I am kissing, but the suffering of all humanity!"[36] In a poem titled "Navidad" (Nativity), written in December 1919, he toasts his friends in the beauty and mystery of midnight, conveying his inebriation with life:

> Hay siempre algo de divino
> en esta hora, en bien o en mal.
> Alzo mi vaso a Robo, Tina, Rosina . . .
>
> (There is always something divine [magic]
> at this hour, for good or bad.
> I raise my glass to Robo, Tina, Rosina . . .)[37]

He also took a practical interest in bringing foreign literature to Mexico, translating into Spanish the poetry of Edgar Allan Poe, whom he regarded as the greatest American poet, and that of Carl Sandburg and Conrad Aiken.[38]

Robo, Tina, and their bohemian friends conducted their lives in the context of troubled national and international events and changes. Revolution was in the air. The Russian Revolution had just turned the world upside down. On the east coast, Emma Goldman and Alexander Berkman were arrested for obstructing the military draft and sentenced to two years in prison, before being expelled from the country. In Mexico, Emiliano Zapata, who headed an Indian peasant rebellion aimed at land reform, was murdered in 1918. In the same year, about one hundred "Wobblies" were sentenced to prison in a Chicago mass trial.

In summer 1917 hundreds of Italian workers from the Bay Area canneries went on strike in protest against low wages and long hours. The

majority of the strikers were women, who had to work up to 14 hours a day to receive a wage of $1.25.[39] But the strike also exposed the tensions between radical and conservative forces in the San Francisco labor movement.

To the patriotic American public, nothing was considered more dishonorable than striking during war time, particularly in an industry that played an important role.[40] Ralph P. Merritt, federal commissioner and strike mediator, whom *L'Italia* referred to as "the dictator of food supply," exploited the theme of patriotism successfully: "if the fruit is not packed, we are going to lose the war and if you do not want it said that the Italians of California lost the war, you must listen to us and not ask what is not right."[41] Women and students proved most receptive to such a call. One hundred housewives from the Oakland area went to work in the canneries, and an undetermined number of middle-class women "took some steps to save the fruit crop."[42] Students from the University of California also took time off from their studies to work in the canneries. In the majority view, there was the loyal, law-abiding, middle-class American public on the one hand, and on the other hand, there were the Italian immigrants, disloyal, egotistic, and, worst of all, traitors to a just cause. In reality, the Italian cannery workers were torn by conflicting needs. They needed to be assertive as a class, but they also needed the recognition and the respect of the public in order to be accepted as Americans. By the end of the summer the mediation team had finally reached an agreement with eleven canning companies. Both parties had to compromise: all strikers were to be reemployed and the hourly rate was raised, but the employers did not recognize the cannery workers' union, the Toilers of the World.[43]

Bohemian circles considered the old social values rigid and static, and at times totally rejected them as middle-class products. The development of a new order, in which irreverence for institutions and conventions would be essential, became imperative for this particular group, prominent in whose intellectual and artistic vocabulary stood phrases such as "free love" and "mystical life". "Change" became the motto for their life. What needed to be changed? The status quo, society, even a couple's relationship.

It is not clear whether it was at this juncture that Modotti started an affair with Weston. It is not improbable, since one of her early love letters to him that still exists is dated January 27, 1922, in which she remarks how much he has added to her life.[44] And one of the best photographs of Modotti by Weston, entitled *The White Iris*, is dated 1921; it shows Tina nude with her eyes semi-closed, smelling an iris. In the light of their scorn for traditional morality and the dissatisfaction that both supposedly found in married life, an affair would have been the logical step. As Mildred

Constantine, the first biographer of Modotti, commented, "That this affair was adulterous for both did not lessen the beauty; indeed it contributed to the madness."[45] At the same time, Tina still mythicized the ethereal Robo, as *The Book of Robo*, published in 1923, shows.[46] In fact the records demonstrate that Tina never legally married anybody, although she became attached to several men. In March 1924, while in Mexico with Modotti, Weston commented on her approach to love: "There is a certain inevitable sadness in the life of a much-sought-for, beautiful woman, one like Tina especially, who, not caring sufficiently for associates among her own sex, craves camaraderie and friendship from men as well as sex love."[47]

The eternal issues of artistic independence and freedom of expression in art became once more current. Exoticism was rediscovered, and the line, "Have drown'd my Glory in a shallow Cup" (from Edward FitzGerald's 1859 translation of Omar Khayyám's *Rubáiyát*), became a much quoted source of bohemian inspiration.[48] A photograph of Modotti, taken in 1919 in Los Angeles by Jane Reece, clearly shows the mood of the time. Tina is dressed in an exotic costume, suggesting either a moment of meditation or simply a dramatic and intense pose. And the photograph is titled "Have Drowned My Glory in a Shallow Cup."

It is interesting to notice that Tina referred to these bohemian years as frivolous, adding that her cultural milieu developed in her a certain "superficiality, a bohemian concept of life, and a bit of arrogance."[49] But she was being quoted much later and by a dogmatic Stalinist through the filter of his doctrinaire views. In fact, for Tina those years were everything but frivolous – perhaps decadent but certainly not empty, since they were part of a soul-searching process. The life she shared with Robo encouraged avid reading, experimenting, and learning. The magazine *The Little Review*, though later dismissed by some political activists as lacking in political seriousness[50] (and identified by Michael Gold as "an art-poseur, but the best literary magazine after *New Masses*)[51] provided a good start for Tina. But a spiritual and vocational vacuum needed to be filled by something that would help her to define herself and to create a new identity. The stage provided that identity.

In a 1917 announcement of the San Francisco Liberty Theater (the former California Theater on Broadway Street), the name of Tina Modotti appears for the first time, associated with the Compagnia Comica Città di Firenze, directed by Alfredo Aratoli, a former actor whose most famous role had been Iago in *Othello*. In July 1917 *L'Italia* mentioned Tina as a professional actress in the play *Stenterello ai bagni di Livorno* (Stenterello at Leghorn Beach); he is a character who represents the city of Florence and was created when Italy was under French rule; therefore he is anti-French,

witty but simple-minded, and always on the side of justice.[52] In September of the same year, the Compagnia announced that it was presenting in its last week of performances a "special evening performance" in honor of Miss Tina Modotti, who was playing Lisetta in *Dall'ombra al sole* (From the Shade into the Sun) by Libero Pilotto. *L'Italia* reported that Modotti was "an intelligent young actress" who had "won the affection of the public and who had gathered around her a string of admirers."[53] The lines were accompanied by a picture of a smiling Tina in rather English attire (unusual for her): a long-sleeved blouse with a dark jabot.

San Francisco had always been considered a good theater town, by west-coast standards. The French theater gave "rather stiff and amateurish performances of Racine, Corneille, Beaumarchais, and Marivaux – still, it was the French classic theater. There were three Chinese theaters which played every night in the week."[54] Vaudeville theaters found that supplementing performances with films increased attendance. Thanks to the Majestic Theater, a moving-picture house popularly known as the House of Universal Pictures, San Franciscans could enjoy the first films.[55] The Orpheum Theater was reported as doing good business with various vaudeville-type acts especially when in 1909 a motion picture showing the inauguration of President Taft was added. Pantages' Empire Theater, another vaudeville house, had a variety of live acts, spiced with two motion picture features. And the Silver Palace Theater, on Market Street, was extremely popular with its moving pictures and a few vaudeville acts.[56]

The Italian theater of the 1900s in particular had its roots in the popular amateur drama groups of the Italian Colony, the so-called *compagnie filodrammatiche*. They were able to mix the sacred and profane, offering a potpourri of comedies, tragedies, sketches, folk songs, operas, and operettas, whose main purpose, besides entertaining their audiences, was to keep the Italian language alive among the immigrants, who often communicated with each other in dialect, which tended to encourage regionalism.

Italian theater in San Francisco had officially been born in spring 1905,[57] when a famous Neapolitan opera singer, Antonietta Pisanelli, not only presented a series of successful opera and play pieces but also acted as her own impresario. In order to do so, she organized local artists into a company and rented the Apollo Theater on Pacific Street.[58] Her first program included several songs, two plays, and a farce, *Prestami tua moglie per dieci minuti* (Let me borrow your wife for ten minutes). (That same year Enrico Caruso made his first San Francisco appearance at the Tivoli Opera House, following Pietro Mascagni's appearance as conductor in 1903.) The highlight of Pisanelli's first show, on April 5, 1905, was her role as Santuzza in *Cavalleria rusticana* by Antonio Mascagni.

Pisanelli, whom the Neapolitans affectionately called *canzonettista* (songs singer), had emigrated as a child to New York from Naples, where she had been born in 1869. She was known to be "beautiful, extremely talented, and a shrewd business woman."[59] Moreover, she had "a magnificent stage presence."[60] In 1904 she had gone from the east to the west coast to escape a series of tragedies, among which was the death of her youngest child. As frequently happens, Pisanelli found solace in concentrated work, in which San Francisco did not seem to be lacking. So she decided to settle in the city with her remaining child and "little else but her talent."[61]

Intermittently, from 1905 to 1924, with the interruption of a year spent in Saint Louis, Pisanelli managed to reorganize the life of San Franciscan Italian theater. The Apollo was already a favorite meeting place for the Italian clubs of North Beach,[62] but later Pisanelli moved her show to the larger Bersaglieri Theater, at the corner of Stockton and Union Streets. She converted the theater into a combination of café-chantant, club, and opera house, naming it Circolo Familiare Pisanelli. Under her direction the theater experimented with substituting admission tickets by the sale of refreshments. Memorizing the lines of a play was not indispensable for the success of a show; spontaneity and improvisation were the real requisites.[63] And Signora Pisanelli never failed in those. Her club inspired similar shows, the *Chauve-souris* in Moscow being the most famous. It opened in 1908 with parodies and farce and illusion numbers. Although the revolution forced its closure in Moscow, it continued in other cities round the world.[64]

The Circolo Familiare Pisanelli was an instant success because it met the needs of the expanding immigrant community, for which it soon became the dominant social institution. There, in a familiar part of the city, the Italians could feel at home. To the single males, the Circolo provided warmth and companionship. To the families, it offered respectable entertainment, which could be shared by women and even children.[65] The Circolo also helped the non-Italian audience – many of whom were sponsors – to learn more about the habits and customs of the immigrants.

The character of Stenterello was a great attraction, and appeared on stage out of nowhere, even during Shakespeare plays. He would interrupt a scene, ridicule the actors, make grimaces, and disappear as quickly as he had come. In his wit and irreverence he was comparable to *King Lear*'s Fool. Arturo Godi of the De Cesare company was a great Stenterello, and made the character a fixture. His make-up included purple circles around his eyes and red-and-white blotches all over his face. His hair was fixed in a pony tail. His clothes were colorful: flashy vests, floral jackets, and tight trousers.[66] There are still people in San Francisco who recall their parents and

grandparents telling them that it was thanks to the ubiquitous and unpredictable Stenterello that they as children could digest a play by Shakespeare.

Italian theater overcame many adversities, including an Irish priest who tried to prevent it flourishing.[67] The most tragic was of course the 1906 earthquake. By a stroke of luck, three days before the earthquake Pisanelli had sold the Circolo for $20,000. She then split the company into small groups and sent them on tour. The publicity they garnered was immense, mainly because of the dramatic name chosen by Pisanelli to identify them: the Survivors of the San Francisco Earthquake.

After the earthquake, three nickelodeon-type theaters were created thanks to Pisanelli and her new partner, the actor–singer Mario Scarpa: the Iris Theater on Broadway Street, the Bijou Theater on Montgomery (later Columbus) Avenue at Stockton, and the Beach Theater, on the corner of Vallejo and Montgomery, across from the church of St. Francis of Assisi. A show cost a nickel or a dime, so even the working class could afford it.[68] Those were years of tremendous growth for the nickelodeons; motion pictures were still a novelty, and the public flocked in record numbers to nickel theaters as they opened.[69]

In 1909, the Italian theater moved to Powell Street between Union and Filbert, the site of a former Russian Orthodox church, which Pisanelli had succeeded in buying. On April 10, 1909, the new Washington Square Theater opened with the Compagnia Comica Drammatica Italiana from New York. The theater's seating capacity was almost one thousand, and its prices ranged from a nickel to a dime. From 1910 to 1912 the Compagnia, under the actor-director Antonio Maori, dominated the scene. Maori introduced Shakespeare to the Italian public, which was also exposed to works by D'Annunzio, Sardou, Beaumarchais, Dumas, Busnelli, and Goethe. Less known were the plays by Mario Scarpa, *Caino e Abele* being one of them. The Washington Square Theater was the only legitimate theater in San Francisco to change its program every day and twice on weekends.[70] And it was not uncommon to watch a Beaumarchais play followed by a wrestling match. In that case, the press would usually devote more space to the sports event.

From 1912 to 1917, the Italian theater was virtually silent, with the exception of a special engagement in summer 1914 of the actress Mimì Aguglia, first at the Cort (later Curran) Theater on Ellis Street and then at the Washington Square Theater.[71] Aguglia, who has been called "the best actress ever to live in America,"[72] acted in *Madame X* and *La figlia di Jorio* (Jorio's Daughter) by D'Annunzio.[73] Pisanelli attempted to resurrect the moribund Italian theater by inserting a modern look. Stenterello, by 1917 regarded as too provincial and passé, was replaced by the burlesque figure

of Farfariello, a sort of mixture of a modernized Harlequin and an unlucky but generous character *à la* Charlie Chaplin.[74] His make-up was exaggerated and his clothes were deliberately out of fashion. His use and abuse of language, whether playing Mr. Colonno, the fruit dealer, the fisherman, the *teppista romano* (Roman rascal), the Parisian lady, or the merchant, were notorious, and his humor encompassed social satire. Despite his constant efforts to become Americanized, Farfariello, played almost exclusively by Edoardo Migliaccio, always remained an Italian immigrant, who spoke a mixture of uneducated Italian and uncultured English. So he ended up representing the conflicts and the contradictions, even linguistic, of a group of people who, despite being "in between everything," was nevertheless geared toward a real Americanization, but not without paying a high price for it.[75]

A correspondent from a Milan newspaper described Farfariello as "the most delightful colonial sketch that one can imagine."[76] In fact, he treated the process of immigration with irony, humor, and tragedy. And, since the Italian community could identify with him, Farfariello helped the immigrants to assimilate the new social reality.[77] The public knew that Farfariello actually represented his creator Migliaccio, who had been a garment sweatshop worker in New York until he was fired for burning a hole in a pair of pants.[78] Like Farfariello on stage, Migliaccio became a hero for those immigrants who could buy a collective dream for a few pennies.

If one takes a look at the war years 1915–18 through *L'Italia*, one sees a striking patriotism in many articles, which is not surprising given that Italy was fighting the Austrians to regain its lost provinces. The press provided the link between the old and new countries. When the patriot Cesare Battisti was executed by the Austrian government in April 1918, *L'Italia* declared that "Austria will never change!"[79] Such comments were not isolated incidents; they were all part of the same campaign, and they responded to the same quest for justice. A drawing in *L'Italia* of July 31, 1918 showed a young lady, whose features and gestures resemble Modotti's, cursing "the damned Huns" for the atrocities they had committed.[80] A few weeks later, an article informed its readers that a campaign had been launched against German street names in American cities. All the Teutonic names – Bismarck, Hamburg, Vienna, Hannover, Moltke, Munich – were going to be substituted with "more civilized names," with justifiable exceptions: Guttemberg (*sic*) could not be replaced.[81] For the Italians as for other immigrants, "identification with the best interests of the homeland seemed not only compatible, but intimately connected with a fervent American nationalism."[82]

In 1917, the Americans entered the war, doubling the loyalty of the Italian community both to their country of origin and to their country of

adoption. The year opened with a speech by Patrizi on the world conflict, which he called "our war."[83] In February, James Rolph, the San Francisco mayor, participated in a ball sponsored by the Italian Aid Committee.[84] In April a new committee – the Italian Board of Relief – was formed to aid war victims,[85] and in May *L'Italia* offered its subscribers a color picture representing the soldiers of the Italian army.[86] Several balls were organized in the summer as fundraising events.[87] Starting from May 1917, *L'Italia* launched a campaign to make people consume more bread and less meat, underlining that eating bread was "an instinct of the human race, not only because it is tasty, but especially because it is the least expensive of the food products."[88]

Then in the fall *L'Italia* offered its subscribers a map of Italy showing the war zones and a portrait of General Raffaele Cadorna, called "the supreme *duce*."[89] In November, the club Progresso gave a ball at Liberty Hall in Stockton Street for the families of Italian soldiers.[90] And the San Francisco Civic Auditorium showed a series of war films about the Italian front, whose profits were destined for the war victims.[91] Advertisements for war speeches by the Italian king and his ministers appeared along with some advertisements for the sale of records of American hymns, available in the original tongue with an Italian translation.[92]

Flags, those powerful patriotic symbols, could be purchased by mail from Sadler Co., which specialized in decorations for parade floats. The offer was for both Italian and American flags, available in many sizes, and shipped all over the country.[93] It is evident from this "flagmania" that the Italian community adapted itself to the American mentality, recreating American values with an Italian flavor.[94] A poetic note was struck at Christmas 1917 when *L'Italia* published one of the worst poems by Ada Negri, *Vigilia in corsia* (Christmas Eve in the Hospital Ward), accompanied by a sentimental drawing of a Red Cross nurse.[95]

After the war, the Testa Cigar Co. of San Francisco created a cigar named after General Armando Diaz, the soldier who had brought Italy to victory.[96] The Italian communities of New York, San Francisco, and Kansas City welcomed the general when in fall 1921 he made a tour of the U.S.[97] In Fresno he received a huge box of California's famous raisins.[98] The previous year, San Francisco had been "blessed" with the visit of another part of Italian history, no less a person than Anita Garibaldi, granddaughter of "the man most dear to all Italians," Giuseppe Garibaldi. The public was informed that during the war Anita had been an Italian Red Cross nurse.[99]

The name of Modotti comes up several times in conjunction with the war. In December 1917 Tina had *L'Italia* publish a letter she had received from Italy. Her brother Benvenuto had written that her family, left in

Udine, had had to be evacuated to a small village in the Abruzzi in central Italy, where they had to live among strangers, albeit friendly strangers.[100] In the family was a pregnant sister, Valentina Gioconda, who on January 15, 1918 in Chieti (Abruzzo) gave birth to a boy named Tullio, whose father was a soldier.[101] This was one of the few times that Friuli and Udine were mentioned in *L'Italia*.[102] Nevertheless, the Friuli region was among the war arenas and played a major role in the conflict, as Mussolini himself declared in Udine in September 1922, just before the March on Rome.[103] The cover page of *L'Italia* for December 17, 1917 showed a picture of a group of women and children refugees from Friuli with the caption "The sad pilgrimage."[104] Another affecting image was printed a few weeks later depicting a pathetic wartime Christmas.[105]

Modotti, with her typical enthusiasm and never failing energy, helped in any way she could to instill in the Italian community a sense of *madre patria*. Causes and commitments were what she needed all her life. Since she was then intent on an acting career, she used the stage to become involved in matters she then regarded as political. In February 1918 she took the part of Amelia in *La gerla di papà Martin* (Papa's Martin Wicker Basket), by Cormons and Grange, and was photographed by *L'Italia*, who described her as "intelligent and competent, although not a professional."[106] The three-act play, also called *Il facchino del porto* (The Port's Porter), was represented at the Washington Theater as a fundraising event for war victims, with tickets at 25, 50, and 75 cents.[107] The play featured the famous Oreste Seragnoli from Bologna in the double role of protagonist and director. He was presented with a gold medal designed expressly for him by the renowned San Francisco jeweler, Frank Fontana, whose shop was located at 252 Columbus Avenue. One side of the coin represented Seragnoli as Papà Martin, carrying some luggage in his famous basket, the other was inscribed with the dedication.[108]

The play, which the Italian paper defined as "a serious, yet not heavy, nor tedious work,"[109] focused on the story of a young man, Armando (played by Mario Franco), who instead of studying law spent a debauched time in Paris squandering the money that his father, Martin, had accumulated with his hard work. Modotti, whose Amelia was identified as "the kind and passionate daughter of the heroic Friuli" and a "lovely, local acquaintance," was noticed for her promising "uncommon qualities" and "gracious" acting. At the end of the second act, she received a bouquet of flowers.[110]

There are conflicting ideas about Tina's involvement in the war. Vidali represented Tina's father and uncle Francesco as anything but interventionists and hinted that Tina herself was opposed to the war. But the evi-

dence shows that not only was she not opposed to it but that she helped the cause of the war in any way she could, including raising funds for the men at the front and for war orphans. She was also active as a member of the Italian Aid Committee, which in February 1918 organized a masked ball as a fundraising event for the needy of the colony. Tina Modotti's name appears among the organizers.[111] And I mentioned earlier an anti-German caricature depicting a young Italian woman cursing the enemy, who bears a strong resemblance to Modotti.[112]

In 1918 Modotti became entangled in a lawsuit. An aspiring painter, Stefania Pezza, had come from Rome with her companion, the sculptor G. P. Portanova, for the San Francisco Panama–Pacific Exposition in 1915. Pezza claimed that Portanova failed to reimburse her for the fare of the ticket from Italy to San Francisco and that she had supported him since 1915. She was suing him for $25,000 in material damages, without being able to claim any "moral" damages for Portanova's constant promises of marriage.[113] Since Modotti knew both parties she was called to testify as a witness, but was mistaken for one of Portanova's models who had posed for the nude statue *Rigenerazione* (Regeneration), commissioned by the Fairmont Hotel. The press reported that "Miss Tina Modotti, 1952 Taylor Street, will be called by attorney H. K. McKevitt acting for Portanova."[114] It also reported that "Portanova was inspired by the classic countenance of this pretty signorina in the execution of the statue *Rigenerazione* and the beautiful outline of the lady that Portanova had sculpted is none other than that of the features of *signorina* Tina."[115] The following day a statement signed by Tina Modotti appeared in *L'Italia*: "I had not served as a model for the sculptor Portanova, but I had consented a few times out of pure courtesy to permit the said artist to sketch the outline of my head while he was giving the final touches to his statue *Rigenerazione*."[116] (The real model for that statue appeared later in court: "White slave charges [were] made by Kathryn Cope," another of Portanova's models.[117])

It is not clear why Modotti rushed to make the correction, since nobody had yet accused her of immoral acts and since modeling was something she later did gladly for more than one photographer. Perhaps it was her growing reputation as an actress in a community that was rather traditional that made her rectify the statement. At any rate, Pezza won the lawsuit[118] and Tina went on with her acting career.

The Washington Square Theater, which in 1914 had been sold to an American theater group, was bought in 1917 by a group of Italian investors. Modotti performed there as well as at the Liberty Theater, where in March 1918 she played with the Alfredo Aratoli Company.[119] She had the part of Balilla in *I figli di nessuno* (Nobody's Children).[120] In April, she

acted in the sketch *Don Francesco*, by E. Zolla, together with Oreste Seragnoli, Mario Scarpa, and Gigi Mattioli. The sketch was part of the much larger program of a fund-raising event organized by the Compagnia Città di Firenze for the Italian Red Cross.[121] Modotti's acting in *Acqua cheta* (Still Water) by Augusto Novelli was particularly praised for its "great spontaneity."[122] In May, she performed in *La morte civile* (The Civil Death) by Paolo Giacometti, in the role of the prisoner's daughter. On the Fourth of July, 1918 a new company created by Amelia Bruno and Oreste Seragnoli (called Bruno-Seragnoli) made its debut at the Washington Square Theater with Romolotti's *Amor nel tempo di guerra* (Love in a Time of War), in which Modotti had a part. She also acted in *La lettera smarrita* (The Lost Letter) by Dario Niccodemi;[123] *Il segreto* (The Secret) by S. Lopez; and as the sole protagonist in *Il Biricchino* [sic] *di Parigi* (The Urchin of Paris) by Bayard.[124] A preview of the play remarked that "the intelligence and the decisive artistic inclination of this young actress make us expect an excellent performance."[125] On August 1, 1918 Modotti played in *I disonesti* (The Dishonest Ones) by Gerola Rovetta with Oreste Seragnoli, Arturo Godi, Mario Scarpa, Matilde Galazzi, Amelia Bruno, Gigi Mattioli, and Giuseppina Rondero.[126] Her persona on stage was characterized as "extremely gracious, exquisite."[127] In the one-act drama *Papà Stefano*, written and played by Mario Scarpa, her performance led *L'Italia* to state that "Miss Tina Modotti received applause in abundance."[128] As noted before, she also acted the part of Lisetta in *Dall'ombra al sole* in an evening to honor Gigi Mattioli, who played Don Gaetano, a priest and follower of Garibaldi.[129]

Her major roles, though, were in *Ghosts* by Ibsen, in which she played Regina Engstrand, the illegitimate daughter,[130] and *La nemica* (The Enemy Woman) by Dario Niccodemi. The latter was particularly significant for her not only because its first showing was in America but also because it was set in the war.[131] In the part of Marta Regnault, Tina was admired for the "dramatic intensity of her acting," especially in the final scene of the first act. She was praised for her perseverance and discipline but also for her goodness of heart.[132] The play was so successful that one performance was devoted to fundraising for war victims and more than $800 was collected.[133]

Another major role taken by Tina was that of Scampolo in the eponymous play by Niccodemi. As the care-free protagonist she used to make her stage entrance with a laundry basket in one hand and an apple in the other. The character of Scampolo was loved by the audience because although touched by tragedy she was able to retain a sense of purity.

By 1918 the Bruno-Seragnoli Company had disbanded and Bruno established La Moderna (the Compagnia Moderna di Opera Comica), which

also performed at the Washington Square Theater. In the upper right-hand corner of a 1918 playbill for La Moderna, among the pictures of other actors and actresses can be seen a young woman in the latest hairstyle: it is the 22-year-old Tina, who had succeeded in appearing with actors such as Oreste Seragnoli, Frank Puglia (who became a Hollywood star), and Carlo Tricoli, later an assistant district attorney in San Francisco.[134] During the war, La Moderna staged a few works (not all plays) of strong patriotic flavor, primarily anti-Austrian, for which the company was much praised by the Italian press.[135] They included *L'unico figlio* (The Only Son); *Silvio Pellico e le sue prigioni* (Silvio Pellico and his prisons) and *La forza della coscienza* (The Force of Conscience) by Luigi Gualtieri; and *Le ultime ore di Oberdan* (Oberdan's Last Hours).[136]

In tune with being a minor celebrity, Tina's private life ceased to be private. On October 16, 1918, on the page devoted to San Francisco and its Italian community *L'Italia* published a short article under the heading "Tina Modotti sposa" (Tina Modotti the bride), accompanied by what appears to be a commercial photograph of Tina. The pose is so artificial and so contrived that it does not even resemble her: the low-cut dress, the earrings, and the posture seem to suggest the stereotype of a sensual Latin woman, which the American cinema helped to create. The article was announcing Modotti's marriage to "Mr. R. De L'Abrie Richey, an excellent and distinguished young Canadian-American, very much interested in painting, and belonging to a wealthy family," and informed the public that the event, which took place in Santa Barbara, explained Tina's several weeks' absence from the stage. Yet, as shown earlier, not only was the young man not Canadian but also a legal marriage never took place, or at least there is no official documentation.[137]

It was in 1917 that Tina, by then a veteran stage performer, decided to plunge into the glittering and mysterious Hollywood world, which meant moving to Los Angeles, where Robo's mother and sister lived. Since 1876, Los Angeles had had a railroad connection with San Francisco, which by 1915 made communications easy for the state's horticultural enterprises, as well as for the immigrants. The land boom of California, which began in 1917, also created thousands of customers for southern California. A harbor connecting Los Angeles to San Pedro had been completed by 1914, and the city greatly benefited from the world trade route of the Panama Canal.[138]

In the first 20 years of the century, Hollywood was the center of a demographic explosion. At the end of the nineteenth century Hollywood had been merely a small town with 50,000 souls, whereas in 1910, when it was annexed to Los Angeles, it contained 319,000 people.[139] In 1917,

when Modotti arrived in Hollywood, just the people involved in the movie business numbered around 20,000.[140] At that time, the city was still taking shape and forging its identity, although its basic patterns and milieux had already been formed. This, in practice, meant incorporating different components, many of which were alien to Los Angeles itself.

The pioneers of the motion-picture industry found the southern part of California compatible with their needs: the temperature was mild, the labor market accessible, and the city was tolerant of a mercurial and risky business. One successful deal that had long-lasting consequences was the 1916 merger of Famous Players, owned by Adolph Zukor, with Lasky Company, owned by Jesse Lasky and Samuel Goldfish. The new Famous Players-Lasky Corporation (which later became Metro-Goldwyn-Mayer) boasted capital of 12 million dollars.[141] With so much money, the company set the tone for a new way of life, which resulted in a rise in the cost of living.

Nevertheless, the lavish lifestyle that became a hallmark of Hollywood, was limited to a small circle of people, among whom a cosmopolitan view of the world was not common. The average Hollywood resident still perceived life through provincial lenses, from a narrow-minded and moralistic point of view. A culture that was largely puritanical could not possibly either like or understand a movie industry with all its supposed terrible sins. So Hollywood grew out of a unique and unconventional culture put side by side with small-town culture. Neither culture was congenial to the other, but they learned how to adapt to each other.

It was in this melting pot of values and ideas that Modotti found herself when she was offered a part in the silent movie *The Tiger's Coat*, filmed in summer 1920 and released in November the same year.[142] The film, directed by Roy Clements and produced by E. W. W. Hodkinson, featured Myrtle Stedman and Lawson Butt.[143] It is possible that either Clements, who until then had been an actor, or Hodkinson, who owned a chain of movie theaters in San Francisco, noticed Modotti there.[144] Moreover, Tina had become a friend of Myrtle Stedman, whom she had met in 1919 and whose companion was the photographer Walter Frederick Seely.[145] Besides the experience of the San Francisco Italian theater, the prelude to Modotti's film acting was some modeling she had done for the photographer Jane Reece, who in 1919 had come to Los Angeles from Dayton, Ohio, presumably to coordinate one of her exhibitions, held at the Los Angeles Public Library. Tina and Robo proved to be good models, which in Tina's case probably led to her being cast in John Stevens McGroarty's *Mission Play*. This had been performed annually since 1911 at the Mission San Gabriel to celebrate its founding by a Franciscan priest.[146]

The Tiger's Coat, set in La Classe, California, was Jack Cunnigham's adaptation of the 1917 novel by Elizabeth Dejeans, which had been published under the same name in *The Pictorial Review* between November 1916 and February 1917.[147] In *Moving Picture World* of October 1920 an entire page was devoted to the film, whose heroine was associated with a painting that compared her to a "tawny tiger skin." Modotti was described as "sleek and sinuous and softly sweet, and as dangerous as the tiger whose tints and tones were in her eyes, her skin, her hair."[148] Again, the November issues of *Moving Picture World* advertised the "exotic allure of Tina Modotti"[149] and claimed that the movie would "charm the women and delight the men."[150] The shifts in accent of the publicity probably reflect an escalation of Modotti's role since the early stages of the film: perhaps her acting had convinced the director that she was the main attraction.[151] In November 1921 the film was shown at the Washington Theater in San Francisco, and the Italian community had the opportunity to see the little Italian emigrant, who "was raised in North Beach" and who had "shown an extraordinary artistic vein and a true call for acting."[152]

Modotti played a Mexican servant girl, Maria De la Guarda, who in order to escape poverty and reach the United States takes the identity of her mistress, Jean Ogilvie, a Scottish woman who has died. When her true identity is discovered, Maria is sent away and has to work as a dancer to make a living. But love conquers all: in the end, she is accepted and loved for what she is. The plot appears simple and romantic, and the acting was overtly dramatic according to the style of the time, but a puritanical moral was inflicted once more upon the audience: lying is bad and only gets you into trouble, and one should not try to be what one is not.

The film contains several issues that recur in the story of Modotti's life. First of all, the race and class problem: Maria is banished from the house because she is Mexican and because she comes from a lower class. There are references to her ethnic identity – "She's got the darkest skin I ever saw on a Scotch girl" – and she is said to have "skin like a tiger's coat." Then there are the strong Mexican and exotic components, which were also present in her California years as Robo's companion, and finally her posing as a model for an artist – in the film a painter – which Modotti did for Weston and others. In the film Modotti wears a mysterious and rather sad expression, but this was characteristic of her in life too. According to Livio Jacob, the film also raises the subject of the destruction of art, for in one scene Modotti destroys a portrait for which she has posed – which Jacob sees as foreshadowing her abandonment of photography.[153]

Modotti acted in only two other films, *Riding with Death* (1921) and *I Can Explain* (1922). In the former (originally called *Pony Tracks*) she again

played a Mexican woman, Rosa Carilla, and appeared with Betty Francisco, Jack Mower, and J. Farrel McDonald under the direction of Jacques Jaccard.[154] The film, tailored for Charles "Buck" Jones, an expert horse rider, appears to have been a western with a Mexican flavor. However, since it is lost in film form – only the script still exists[155] – little can be said about it. (The review in *Variety* criticized it for the great length of its story.[156])

In the last film, *I Can Explain* (also called *Stay Home*), directed by George D. Baker and featuring Gareth Hughes and Grace Darmond, Tina once more played a Mexican woman, Carmencita Gardez.[157] All that appears to survive of it are some stills, one of which shows Modotti at Balboa Park in San Diego, where the film was made. *I Can Explain* closed Tina's Hollywood adventure, although there were rumors of a fourth picture, *Greed*, filmed in 1924 in San Francisco. The news was incorrect; somebody mistook another actress for Tina Modotti, who by then was already living in Mexico.[158]

What was Hollywood's place in Modotti's life? Perhaps just a footnote. If Weston's report is faithful, Tina was not particularly proud of her brief Hollywood career and she had "no wish to return to the stage."[159] She regarded it as something to joke about: while in Mexico in March 1924 Weston and Modotti watched an unidentified film in which she had "a small part." With his usual mockery, Weston remarked that "We had a good laugh over the villainous character she portrayed. The brains and imaginations of our movie directors cannot picture an Italian girl except with a knife in her teeth and blood in her eye."[160] However, it was thanks to this parenthesis in her life that Modotti discovered that she could see and "reinvent the world" through a "camera which could produce magic: that is, give a shape to creativity;"[161] she longed to be behind that camera.

It is hard to look at the California period with absolute clarity, partly because in retrospect it can seem to be the mere prelude to the overwhelmingly political years in Mexico. Evidently, her bohemian life – her intellectual involvement in Robo's circle and the acting experiences – did nourish a deeper engagement. Perhaps it can be regarded as the chrysalis stage from which she developed into a committed revolutionary. The two California milieux – political and cultural – although pointing in different directions nevertheless set the tone of her future choices. By 1923, Modotti was prepared to receive the political message that changed her life and, especially, to embrace the discipline of a political party, although she did not officially join a political group until later. She was ready to move from individualism to something larger and more engaging: a party line.

4 Mexico!

"México vive en mi vida como una pequeña águila equivocada
que circula en mis venas. Sólo la muerte le doblegará las alas
sobre mi corazón de soldado dormido."

Pablo Neruda[1]

In spring 1920 Robo de Richey's cartoons started to appear on the cover
of *Gale's*, an English-language magazine published in Mexico City. Founded
in 1918 by Linn A. E. Gale, a red-bearded American leftist, member of the
I.W.W., and draft evader, the magazine called itself the "Journal of Revo-
lutionary Communism." It ran until March 1921, after changing its name
to *Gale's International Monthly of Revolutionary Communism*. The choice of
subjects was deliberately eclectic in order to reach as wide an audience as
possible, and its cost made it accessible to all: in 1919 a copy cost 40
Mexican cents (20 US cents) and an annual subscription cost 4 Mexican
dollars (US$2). Gale's ideas also varied – he collaborated with the Carranza
government as a publicity agent and later with the labor leader Luis
Morones.[2]

An article entitled "How is Mexico Now?" dealt with the transforma-
tions of the country, while a feature noted "the Mexican racial tendency of
overlooking more practical and prosaic things while delighting in gorgeous
flowers, beautiful parks . . . and magnificent monuments."[3] Another article
was devoted to the constitution of a Mexican communist party, as envis-
aged by Gale himself and Adolfo Santibáñez, a radical lawyer.[4] A 1919
article was aimed at "defending" the Mexican people. The author, Gale
again, compared the features of Anglo-Saxons with those of Mexicans and
showered the Mexicans with laudatory words and praise, stating that their
politeness was "born and bred in the race."[5]

The journal appears to have been most prolific in 1920. Of many notable
articles (such as "The Reason for Intervention in Mexico"[6] and "Commu-
nism Explained in Simple Language"[7]) perhaps the best-known was that by
the Russian revolutionary Alexandra Kollontai, "Communism and the
Family," published in September. It began with the arresting questions
"Will the family continue to exist under communism? Will the family

remain in the same form?"[8] (Five years earlier, Kollontai had visited Los Angeles and San Francisco on a lecture tour of the United States.) Political issues round the world were covered by *Gale's*, including the situation of the working class in Italy,[9] the social revolution in Germany,[10] the Turkish question,[11] the comparison of Mexico with Australia.[12] Among the contributors to *Gale's* these names stand out: John Reed,[13] Sylvia Pankhurst, Yone Basada,[14] Andrew Miller, George D. Coleman,[15] Henry E. Brote, George N. Falconer,[16] W. T. Goode, and Sen Katayama, who wrote on Japanese women.[17] Advertisers in *Gale's* matched its political tone, such as the suitably named Radical restaurant in López Street, Mexico City; it also published poems by Bertuccio Dantino, Adeline Champey, Berton Braley, and Covington Ami.

The palpable sense of renewal and diversity in *Gale's* ensured it a large readership among California radicals – Robo being one of them. He began contributing cartoons, in one of which a cowboy with a sombrero and a gun wears a scarf that says "Wall Street," while a cactus tree appears in the background.[18] Another cartoon shows a fat, sweating, cigar-smoking, pig-like American capitalist who is watching proletarians in a demonstration who carry a banner and hail bolshevism.[19] It conveys cultural and economic imperialism: Mexico, the country that according to the left had been raped by the "gringos," had responded with a revolution.

In the 1920s Mexico was a country still in search of institutional and political stability and, consequently, of social and economic reform. The November 1910 revolution continued to reverberate,[20] but whatever its political failures, it was a cultural success, not only because it inspired populist movements but also "because it revealed a nation to itself," and it made clear the cultural continuity of Mexico, which had survived the political fractures.[21] It was discovered that, despite poverty and lack of education, the Indian population had managed to preserve its artistic and ethical cultures and that these could be developed.[22]

Mexico's cosmopolitan and revolutionary atmosphere attracted a large number of American radical intellectuals, who detected a bond with the Mexican leftists, partly through the journalist John Kenneth Turner, who had brought the spirit of the Mexican revolution alive in his book, *Barbarous Mexico*, published in 1911. "Intellectually and artistically Mexico was at the height of the wave" wrote Kenneth Rexroth of 1920s Mexico: "it was all very free and open, even riotous."[23]

John Reed visited Mexico between 1913 and 1914, during Francisco "Pancho" Villa's time, and breathed in the revolutionary air. The spell of Mexico enveloped him. The result was a vibrant book, a tribute to a country that ultimately helped Reed to know himself more. In *Insurgent Mexico*

(1914), we learn not only about the motives of the Mexican revolution but also about American radical reaction to the revolution. Although the book "did not achieve the apocalyptic appeal"[24] of Reed's account of his later Russian adventure, it was rightly praised as "a vast panorama like one of the great murals of the Mexican painters, full of color, motion and the life-and-death struggle of a people."[25] Indeed, it contains passages of brooding love for the peon – the illiterate, gentle, oppressed, poetic, heroic Mexican peon.[26] As John Dos Passos commented, "it was Mexico that really taught Reed to write."[27]

Americans who wanted a lively dialogue with Mexico read the weekly *La Prensa*, one of at least ten papers published in Spanish in Los Angeles alone. From its founding in 1912 its coverage was heavily political, and news of the Mexican revolution was regularly and faithfully reported. The journal *Regeneración*, edited by the Mexican anarchists Ricardo and Enrique Flores Magón, was also attuned to historical revolutions; in 1917–18 for example publishing articles on the achievements of the Russian revolution. And in 1913 readers could buy a series of essays titled after Ricardo Flores Magón's slogan *Tierra y Libertad* (Land and Freedom).

Robo de Richey was not immune to this fever, although his affinity to Mexico was more sentimental and perhaps mystical than ideological (others too were inspired by Mexican mysticism[28]). His friend Ricardo Gómez Robelo (who had returned to Mexico City and had become director of the education ministry's Department of Fine Arts) persuaded Robo to go to Mexico in December 1921, where he would paint while waiting for Tina, who at that time was acting in California in *I Can Explain*. Gómez Robelo, whose ambitions for his country had been raised by José Vasconcelos (then rector of the National University), predicted an intense cultural and artistic renaissance. He and Robo had already collaborated, on his collection of poems *Satiros y Amores*, published in 1920 in Los Angeles. Robo's contribution consisted of 19 illustrations in a distinct, black-and-white Art Nouveau style much in vogue at the time. The author Antonio Saborit has described the female figures as "implacabiles y lánguidas, inertes y fatídicas, esculturales y depravadas" (implacable and languid, idle and fatalistic, sculptural and depraved).[29] It is possible that their poses and features were inspired by Tina, as has been suggested.[30] (We will see that, in 1929, when Tina was accused of murder, the Mexican press presented her as a loose, promiscuous woman, "much like those figures she has posed for." However, one should not try to go further and interpret Tina and Robo's relationship on the basis of these drawings. For the poem "Tentación" (Temptation), for example, Robo chose to draw a female nude covered only by a black lace mantilla, a fan, and a rose, but that should not be seen merely

as a portrait of Tina. Gómez Robelo also invited Edward Weston to exhibit his photographs in Mexico, so all three – Robo, Weston, and Tina – were to live there to find inspiration, each for his or her own work. It was also decided that Robo and Weston were going to share a studio. Again, we now should be wary of judging such arrangements as a *ménage à trois*, since it is not possible to enter their frame of mind or know the details of the case.

By 1921, José Vasconcelos had also become the Mexican minister of education under the presidency of Alvaro Obregón, who had won the respect of the army and the Mexican people after his defeat of Pancho Villa on April 16, 1915. In a three-day fight in Celaya, followed by the battle of Santa Rosa, Obregón lost his right arm, an injury made worse by crude battlefield surgery.[31] Thereafter his name was forever linked to Villa's legendary defeat, which also consolidated his alliance with Carranza.[32] Obregón, who himself had emerged as the hero of a left-wing faction called the Jacobins,[33] brought his populist style of politics to government in December 1920. It was this populism that made him the unifier and peacemaker of Mexico.[34] Even among non-Mexicans Obregón was respected and admired. The front cover of the first two issues of *The Magazine of Mexico*, edited by Katherine Anne Porter, carries the picture of the new president, accompanied by an essay on him.[35]

Vasconcelos (who had once been a soldier with Pancho Villa and a friend of the "Attila of the South," Emiliano Zapata) had returned to Mexico in May 1920, after a period of five years abroad. On June 9, 1920, while rector of the university, he presented himself as an "emissary of the revolution," inviting students to share the same responsibilities and efforts in the struggle (his favorite line was *Por mi raza hablará mi espiritu* (My spirit will speak for my race[36]). He emphasized that he had not become the rector to work for the university but to ensure that the university would work for the people.[37] Vasconcelos was committed to fighting illiteracy through a vast cultural reform movement, modelled on that of Anatoly Lunacharsky, the Commissar of Education and the Fine Arts in the Soviet Union, and of Maxim Gorky, who encouraged the study of the classics by all social classes.[38] In one of Vasconcelos's campaigns, addressed in particular to women, he invited the literate to think of teaching the illiterate as "a moral duty."[39] One of Diego Rivera's murals, at the Ministry of Education is devoted to precisely this theme, *Alfabetización* (Literacy). The main figure is a woman distributing books to the children around her, while the upper part of the panel is occupied by three men – a peasant, a worker, and a soldier – all intent on reading. Thanks to Vasconcelos, government-supported schools were established all over Mexico, and public libraries in the Federal District, to arouse interest in reading.[40]

Viewing art and politics as a continuum, Vasconcelos was able to embrace many "isms" – Buddhism, socialism, constitutionalism, liberalism, neoplatonism, to mention only some – which gave caricaturists the chance to mock him in all kinds of poses and situations.[41] He stressed the cultural aspects of the revolution, proclaiming that artists should be allowed to express themselves fully, "without ideological censorship" (as Constantine says[42]) and calling for an art free of academic posturing that would be liberated from the conventional imitation of European models.[43] Regarding himself as a progressive Catholic, he could reconcile the Spanish Christian faith to the Indian heritage with its cult of human sacrifice and its adoration of death.[44]

In 1921 Vasconcelos founded his best publication, *El Maestro* (The Teacher), a magazine with an unfortunately brief life. He planned to make it "a small manual of general culture," though in practice it was anything but a manual, publishing pieces by new Mexican writers such as Salomón de la Selva, Carlos Pellicer, López Velarde, Julio Torri, Agustín Loera, Carlos Pereyra, and Teja Zabre. But it was far from parochial in scope; it also published Miguel de Unamuno, José Martí, Giovanni Papini, Romain Rolland, Rousseau, Tolstoy, Rubén Darío, Anatole France, Pestalozzi, Walt Whitman, Ada Negri, Gorky, and, naturally, the Chilean poet Lucila Godoy Alcayaga, known as Gabriela Mistral. She was Vasconcelos's favorite writer and spent two years in Mexico from 1922 to 1924.[45] The transformation of the cultural realm extended well beyond the 1920s, for André Breton, who visited Mexico in 1938, found a magic "point of intersection between the political and the artistic lines," united in a single revolutionary consciousness, "while still preserving intact the identities of the separate motivating forces."[46]

Vasconcelos believed that artists also had a duty to be involved in politics at all levels. After all, in Mexico the painters were intellectuals whose role was analogous to that of writers in other countries.[47] At the core of Vasconcelos's dream to *forjar la patria* (forge the motherland) was his unconditional belief and trust in culture. In the visual arts this meant in practice the creation of new schools and new art workshops in urban and rural areas, and a solid improvement of the university system and the *escuela preparatoria* (something between a senior high school and junior college). Mexico had gone from Indian empire to Spanish viceroyalty to independent republic.[48] Declaring that Mexican education should be founded on its blood, its language, and its people, Vasconcelos proposed a revival of Indian culture, which during the revolution had re-entered the mainstream of Mexican history. The aim was to educate Mexicans in their heritage using didactic art (and not to repeat the mistakes of the past: in 1910, under

Porfirio Díaz the government had ordered the construction of the Teatro Nacional or Palace of Fine Arts in various European styles; ironically the project was carried out by North Americans[49]).

Painters such as Diego Rivera, José Clemente Orozco, Alfredo Ramos Martínez, and David Alfaro Siqueiros were recalled from their voluntary exiles – mainly France and Italy[50] – and hired at one peso an hour[51] to decorate public spaces in schools, churches, market places, universities, and local bars (the famous *pulquerías*, the name deriving from *pulque*, the potent spirit of the *maguey* plant) with murals that glorified Mexican history and culture.[52] As the French artist Jean Charlot stated, "the true art exhibit is on the street."[53] The first contracts for murals were signed at the end of 1922.[54] Originally the subjects were religious but later the muralists turned their attention to social problems and Mexican Indians.[55] Although the style of the murals was traditional, their political content was radical. They captured the indigenous culture and drew inspiration from popular culture, which before had been totally absent from Mexican art.[56] The goal was the integration of social concerns with visual art, or the cultivation of a visual interest in social conditions.

The Mexican revolution showed artists that a new approach to creation was not only possible but necessary. In a way, it was the recurrent theme of the ancient Mexican culture: humanity has to destroy itself in order to be reborn. Instead of the exotic or the primitive feeding into European art, the reverse would happen: the training artists had received in European art would feed into the native Mexican tradition.[57] In so doing, the artists were completing a cycle: "they used native techniques and forms to enhance their own creative powers in order to explain the meaning of the revolution to the people who started it."[58] The use of popular forms was encouraged both to ease communication and to construct a mythic past linked to the present.[59]

Diego Rivera far exceeded the government's original intention, which was mainly to paint Mexican history. He elevated the suffering of peasants and workers and made his murals into a song of liberation. The misery, struggle, and triumph of the exploited became the focus of his 123 depictions in the Ministry of Education and in the National School of Agriculture in Chapingo (called the Sistine Chapel of Mexico), challenging the notion that art should be detached from its social content. The numerous murals at the Ministry of Education in particular testify to his strong political commitment,[60] and they conveyed his message so powerfully that the American radical magazine *New Masses* reproduced one as a front cover in March 1927.

For Siqueiros too it was the duty of painters to *socializar el arte* (make art a social issue) – a favorite saying of his. In practice, this meant that artists

could not remain in the privacy of their studios but should be face to face with their people. Siqueiros had been Mexican military attaché to Spain until he was expelled for the subversive eulogy he gave at the funeral of a Mexican anarchist, Del Toro, killed by police forces in Barcelona. From Spain he went to Argenteuil in France before returning to Mexico, recalled by Vasconcelos.[61] Siqueiros's idea of *socializar el arte* was part of an ambitious overall aim that he had been developing for a long time, which was to merge art and politics into one single body. For Siqueiros, artistic creation later became subordinate to politics, which developed into party activities, when he joined the communist party.[62] The whole point of the mural was that it fuse with whatever architectural elements were present, and become a public art piece. The artist would become so much part of the process that he would no longer be a simple decorator but would be a prophet, a seer, a declarer of monumental visions. The public, on the other hand, would be the voice, the speaker, the mind – in Indian terms a *Tlatoani.*[63]

Mexican mural painting began under excellent auspices, and even its mistakes were beneficial,[64] but the response of the general public to the new art was not always positive. Conservative students failed to understand the purpose of the murals and claimed that they were "immoral, subversive and grotesque – inappropriate for an academic institution."[65] The public criticized the minister of education for wasting funds on what they regarded as a meaningless project, and the press sensationalized it.[66] Some murals were even vandalized and mutilated,[67] and the eloquent work of Orozco was singled out for attack.[68]

Since he could no longer work on his murals, Orozco returned to caricatures, praised even by Weston as "splendid drawings, in which he spared no one."[69] His drawings appeared in *El Machete*, which as its title suggests was oriented toward peasants and workers. In 1925 it became the official organ of the Mexican Communist Party and would play a major role in Modotti's life. As a peasant tool, the machete could be taken as a symbol of Mexico and thus became a subject of art – including a drawing by Rufino Tamayo,[70] and a mural, entitled *Campesino con machete* (Peasant with Machete), at the Ministry of Education.

Rivera's response to the attacks on the murals was yet another mural, also at the Ministry of Education, entitled *El que quiera comer que trabaje* (He who wants to eat ought to work) – a different version of this slogan appeared as the caption to a drawing by Xavier Guerrero on the cover of *New Masses*, in September 1926.[71] In Rivera's mural, a figure on the far left, who is believed to be the Mexican poet Salvador Novo, is kicked by a soldier holding a gun, and thus falls over his lyre and his easel. The poet represents

the elitist artist, elegant and formal but totally detached from the people, so he is equipped with ridiculous mule ears.[72]

The criticism of the new art forms prompted a group of artists (among them Rivera, Charlot, Orozco, Xavier Guerrero, Roberto Montenegro, and Siqueiros), to sign a *Protesta* in June 1923 in which they accused their detractors of being a *masa incolora y mediocre* (shallow and mediocre petty crowd), incapable of deciphering an historical statement.[73] The new painting movement, they stressed, was intended to express Mexico's new identity,[74] and was an experiment to bring Mexico into the modern world on its own terms, without passing through any cultural imperialism.

This also became one of the aims of the *Manifiesto* drawn up by the new Sindicato de Obreros Técnicos, Pintores y Escultores Mexicanos (Syndicate of Technical Workers, Painters, and Sculptors of Mexico), which, besides Rivera as president and Siqueiros as secretary general, included Orozco, Guerrero, Ramón Alva Guadarrama, Germán Cueto, Fermín Revueltas, and Carlos Mérida.[75] Neither the union nor the mural movement had Mexican women artists as members or participants. (It was not until 1936 that Aurora Reyes received a commission, although non-Mexicans – Ione Robinson, for example – had been engaged in mural painting in the 1920s.[76])

The *Manifiesto*, published in June 1924 in *El Machete*, was addressed to the "indigenous race humiliated for centuries." It became a call to reclaim Mexico for its people, to elevate people's art, repudiate bourgeois individualism, and encourage the new form of socially responsible murals. Art, which until then had been "a manifestation of individualistic masturbation," had to become a tool of education, beauty, and struggle.[77] Orozco later explained the difference from the old, pedantic art:

> Los profesores de estética creen quel el arte sólo puede existir en París, heredero de Roma, interpretando torcidamente lo de que París es el "cerebro el mundo," mirándolo todo con la "lupa" o lente de su erudición de biblioteca anticuada.

> (The professors of aesthetics believe that art can only exist in Paris, heir of Rome, in a warped interpretation of the idea that Paris is "the brain of the world;" they view art through the magnifying glass or the lens of their outdated bookish knowledge).[78]

However, Orozco became skeptical of the aims of the *Manifiesto* and argued that it had the paradoxical effect of actually helping the bourgeoisie since it allowed them to buy the so-called proletarian art below cost. Moreover,

according to Orozco, the Mexican Indians, for whom this art was supposedly produced, were never part of the process and had not even heard about it. And in the United States, it was believed that the Mexican painters were tremendously popular among Indians, as Zapata had been, but this belief Orozco declared mistaken.[79]

The effects of the Mexican revolution on other Latin American nations were profound. Víctor Raúl Haya de la Torre (1895–1979), the leader of the Peruvian federation of students, took the Mexican revolution as the model for antifeudal and anti-imperialist struggles in no less than twenty countries.[80] In 1923, Haya de la Torre had been banished from Peru by the Leguía administration for so-called subversive activities and had taken refuge in Mexico. Perceiving Mexico as "a synthesis of all the problems" that could be seen amplified throughout the rest of the nation, he hailed the Mexican revolution as the first contemporary social movement that could offer an invaluable lesson to peoples around the world.

Inspired by the Soviet Communist International, in May 1924 Haya de la Torre founded the Alianza Popular Revolucionaria Americana (American Popular Revolutionary Alliance or A.P.R.A.), popularly known as the Aprista movement, to spread Mexican revolutionary principles throughout Latin America.[81] But its markedly abstract and "spiritual" visions (acquired mainly by Haya del la Torre's contact with the pacifist writer Romain Rolland in Switzerland) drew violent criticism from some communists. The Cuban Julio Antonio Mella, in particular, when living in Mexico attacked A.P.R.A. (which he called ARPA, that is harp, to stress its romanticism) for its vague programs and its opportunism.[82] The mainly indigenous A.P.R.A. became a party in 1945 under the name Partido Popular (Popular Party) – a model later followed by the Chinese communists, who, in an entirely different context, presented their 1949 revolution as the leading revolutionary force in Asia and among the third world countries.

The revolution brought a surge of vitality to Mexico and spiritual growth to its artists.[83] In the words of Andrés Iduarte, director of the National Institute of Fine Arts: "That was a time of truth, of faith, of passion, of nobility, of progress, of celestial air and of very terrestrial steel."[84] An entire generation was formed by the values of revolutionary Mexico. The painter Frida Kahlo, for example, was born in 1907 but chose to declare 1910 her birth date in tribute to the year of the outbreak of the revolution. That made her the "personification of all national glory"[85] and the "Mexican mood concentrated in an epoch."[86] And, in order to assert her nationalism and *mexicanidad*, to prove her solidarity with the common people of Mexico, and to dignify the country that holds the record in the Americas for suffering foreign invasions and exploitation, she wore the colorfully

embroidered ethnic dress and jewelry typical of the women of Tehuantepec, as opposed to the colonial garb of the exploiters.[87] One of her many self-portraits, *Self-Portrait: Time Flies* (1929), became an expression of national consciousness, dominated by the green, white, and red of the Mexican flag.[88] When merged with her political credo, her cultural choices produced painting that often combined ancient Indian symbols with those of communism. As recently as June 2001, the United States Postal Service singled out Kahlo with a 34-cent stamp bearing her 1933 self-portrait.

The 1920s Mexican renaissance has been compared with that of Russian art of the same period. In both countries an old regime was overthrown – tsarism and Porfiriato[89] – and society reconstructed, a task in which the artists' role was to produce a new art for the new society. Diego Rivera exemplifies the link between the Russian and Mexican avant-gardes.[90] According to Bertram Wolfe, his early biographer, it was the Russian revolution that clarified his artistic vision and enabled him to set his course.[91] While in Paris Rivera lived in the Russian colony, La Ruche, and was invited to the Soviet Union after the October revolution. He went again in the 1920s, after Mexico had established diplomatic relations with the Soviets. There Rivera participated in the debates on the relation between avant-garde art and revolutionary politics – how they related to each other and how they clashed. His visit was compared with Eisenstein's visit to Mexico.[92] Eisenstein had intended to film an epic about the Mexican revolution, but he never completed the movie, though it was released in 1934 as ¡*Que Viva México!*[93]

The similarities between the two post-revolution countries did not, however, produce similar outcomes. While in one country a debatable form of socialism was achieved, in the other a new type of state developed. In Mexico the vestiges of feudalism were crushed and even though an indigenous capitalism emerged among a new bourgeoisie, workers' and peasants' demands were met to a certain extent.

The Mexican revolutionary message as conveyed through its art, had a strong impact on writers and artists of all kinds in the United States, especially from the late 1920s. In March 1930, for instance, the editor and writer Michael Gold used Rivera's murals as examples of "good art that also spoke to the people"[94] during a debate with the painter Georgia O'Keeffe on the functionality of art. Gold was one of the editors of *New Masses*, an American magazine founded in 1926, which became a primary organ of writers and artists who were sympathetic to communism, but retained a certain independence from any political party. The magazine's contributors and readers were very receptive to the Mexican artistic and political call. Robo de Richey too had high expectations of Mexico, which were not disappointed. He became the spectator of that renaissance predicted by Gómez Robelo. In a glowing ten-page (800 words!) letter to Weston, dated

December 23, 1921, Robo wrote with great enthusiasm of a country which he extolled as "the land of extremes" and "a paradise for creativity."[95] Everything in Mexico touched his senses – the people, the colors, the cultural ferment – making his letter far more gay, far less ethereal, and more forceful than his letter of about the same time to Sadakichi Hartmann: "Too long have I dreamed and hesitated – too long my soul shrank from those cold heights where nothing is concealed."[96] To Weston Robo spoke of a "volcano pouring forth clouds of smoke," child artists producing "the finest things I have ever seen," and "heavy-lidded señoritas." As an artist, he declared that he felt "drunk with subject matter," and probably not only with "subject matter" since he included the prices of liquors: "5 cents for the gold old cognac (100 years old), and 35 cents for gold Tequila."[97] His vocabulary, too, becomes vibrant and powerful, and the word "beauty," being a leit-motif in his life, could not be absent from his letter: "There is little that is devoid of beauty."

Robo had finally found a place not just conducive to his art but where he could fully express himself. In Mexico, art and life became synonymous for him. But his fascination with life was aborted by smallpox, which he contracted only a few months after his arrival. Modotti had planned to go to Mexico and on February 3 was on the train to San Francisco to say goodbye to her family when she was handed two telegrams sent by Robo, announcing his own illness and asking her to return to California.[98] Instead, fearing the worst, she rushed to Mexico City where Robelo told her what had happened: a few days before, Robo had been admitted to the British Cowdray Hospital where he now lay moribund, but Tina was not allowed to see him for fear of contagion. Robo died on February 9, 1922 after five days of terrible agony.[99] He was 31 years old.

On February 11, Tina wrote to Robo's mother and sister, Rose and Marionne de Richey, lamenting his sudden death and wishing they had had the baby that both had wanted.[100] Tina and Rose Richey seem always to have been close to each other, and after Robo's death Tina continued to write to Rose and to send her new photographs, almost until Rose's own death in 1937.[101] For her part, she helped pay for Tina's trip to San Francisco from Mexico.[102] In her letters, Tina consistently addressed Rose by the Italian nickname *Vocio*, meaning "murmur" or "whisper," perhaps indicating either rapid speech or a busy-body nature. Given that *vocio* is a neutral noun and not an adjective, it is an odd way to address someone in Italian, which suggests that the nickname is unlikely to have been chosen by an Italian speaker – perhaps it was chosen by Robo.[103]

Robo was buried at the American Cemetery, his tomb a simple headstone engraved with name, dates of birth and death, and the words "his wife," as a later photograph by Modotti shows.[104] The chapter on the first

of her companions was closed; as she later wrote of Robo, "with Life he was never friendly."[105] After Robo's burial, Tina stayed in Mexico for about one month, during which time she wrote to a friend about the pain of Robo's loss: "Oh! How bitter I feel against life & nature!" The guilt of not being at his side may have increased her sorrow in "recalling his beloved figure." "I torture myself imagining him at my side . . . unseen . . ."[106] Despite or perhaps because of her mourning, Modotti managed to realize one of Robo's projects (may be to honor his memory?), a colorful exhibition of his typical batik-dyed fabrics. The exhibition also showed photographs by Weston (including portraits of Tina), Jane Reece, Margrethe Mather, and Arnold Schröder.[107] Organized through Gómez Robelo at the Academia de Bellas Artes, the show was a critical success and had the unexpected side effect of a sale of Weston's photographs. (It was Tina herself who communicated the good news to Weston – in a letter now considered lost – and Weston passed it along in April 1922 by letter to his friend Johan Hagemeyer, a flamboyant Dutch photographer whom he had met in Los Angeles in 1917.[108]) Robo was also commemorated by an obituary in *El Universal Ilustrado*, published with his illustration of the famous naked woman for "*Tentación*" from Robelo's *Satiros y Amores*.[109]

In the same period Tina had to confront a second death: at 59 years old, her father Giuseppe Modotti died from stomach cancer on March 14, 1922 in San Francisco.[110] Tina returned to California to be with her family and stayed there a month. By 1922, the year of Mussolini's March on Rome, all of the Modotti family had emigrated from Italy except Valentina. Jolanda was then married to an emigrant from Trieste, Guido Gabrielli, a decorator and craftsman (from whom she was divorced in 1930),[111] and she still worked at I Magnin, as did her sister Mercedes. Beppo and Benvenuto had ventured into other business than their father's.[112] After their father's death, the two brothers moved to 890 Union Street where in 1927 the rest of the family joined them.[113]

Assunta and Tina Modotti had become widows practically at the same time, and for Assunta the tragedy was intensified because she had not long been reunited with her husband. San Francisco, a city that Tina always adored, at this point was of no comfort to her; she found herself almost a stranger there and could no longer relate to its society, which appeared to her anemic and aseptic. (Weston too, after returning from Mexico, felt like a stranger, even a foreigner, in Los Angeles, a city that he once called "the plague spot of America."[114]) What we bring with us can be reflected anywhere we go, even in the places that were once a source of joy. Tina, who had gladly and consciously become *la fanciulla del west* (the girl of the west),[115] could no longer identify with that west. Death has a strange way

of neutralizing everything, even the most joyful moments. While in San Francisco, though, Tina saw Johan Hagemeyer, who had moved there from Los Angeles sometime in late 1918 or early 1919. Two letters she wrote to Hagemeyer in 1921 and 1922 may indicate a romantic involvement, which Constantine read as a substitute for Weston's presence.[116] Certainly, Tina's tone appears uninhibited:

> I have written you a dozen letters in my mind but never have I been able to put them into written form. Not for lack of thoughts – instead – the impressions left to me of the afternoon spent with you were so many and so deep they overwhelmed my mind. But here I am making a brave effort to express all I feel – well knowing it is futile – for not even to myself can I clearly answer why I suppressed the great desire I had to call on you once more. Was it will of power or was it cowardice? Maybe the same spirit moved me then, that moved Oscar Wilde to write this paradox. "There are only two tragedies in this world: one consists in not obtaining that which you desire; the other consists in obtaining it. The last one is the worst – the last is a real tragedy." And so I left without satisfying my desire of listening once more to Pergolesi's *Nina* in your company.[117]

And again:

> I hesitated long whether to get in touch with you or not for I had made it my programme before coming here not to see anyone outside of my family. But the other day – finding myself alone – an uncontrollable desire came upon me to hear *Nina* again. And so I did – and as I listened to it the agitated life of these past few months became dimmer and dimmer while the memory of a certain afternoon came back to me with all the illusion of reality . . .[118]

It is unclear whether Tina was referring to the song *Tre giorni son che Nina* (commonly known as *Nina*), attributed either to Giovanni Battista Pergolesi (1710–36) or to the conductor Legrenzio Vincenzo Ciampi (1719–62). The song (which was available by 1919 in a recording sung by Enrico Caruso[119]) is a call to all the players to rouse Nina, who has been lying on her bed for three days. It is said to have been introduced into the opera *I tre cicisbei ridicoli* (alias *Bertoldo*) by Ciampi, who is often listed as the opera's composer.[120] Another possibility is that Modotti may have confused Pergolesi for Giovanni Paisiello (1740–1816), who in 1789 wrote the musical comedy *Nina, o La pazza per amore* (Nina, or Mad for Love), the story of a woman who lives in a state of delirium, waiting for her lover to come back.[121]

Modotti may have become infatuated with what Hagemeyer represented and what he had to offer. He was, in fact, a very interesting (and neurotic) man. He always wore a cape and carried a walking stick. He proclaimed himself a vegetarian. He was well-versed in music and philosophy, and provided intellectual stimulus for Tina;[122] he also adored nature and had received some training in horticulture.[123] Photography was of course a common interest, politics equally so. Throughout his life, Hagemeyer maintained a radical political affiliation. In Europe he had met Kropotkin and in the U.S. he knew Emma Goldman, Bill Haywood, and Max Eastman.[124] He kept company with members of the I.W.W., which Weston did not particularly enjoy, but which probably attracted Tina. Moreover, both Hagemeyer and Modotti were European immigrants (he had emigrated to America in 1911), although Tina became much more assimilated into American culture than "the melancholic Dutchman," as Weston used to call him.[125] One can see that in fact everything about Hagemeyer would have attracted Tina. In the early 1920s he discovered the picturesque Carmel-by-the-Sea, then a village of a few hundred people south of San Francisco, which had already drawn artists, musicians, and bohemians in general. Enchanted with the area, Hagemeyer bought some land and hired Dene Denny and Hazel Watrous to build his house (now the Garden House). Later he had a cottage with a photographic studio (now the Garret and Manor House respectively) added to the grounds. There Hagemeyer photographed some of Carmel's notable visitors such as Salvador Dalì, Albert Einstein, Nikita Balieff, and Henry Miller.[126]

In spite of all this glamor, it seems that California, which in Tina's eyes once represented the future, had become the past. As she wrote to Hagemeyer: "Here I live constantly in the past, and 'Life,' said George Moore, 'is beautiful at the moment, but sad when we look back.'"[127] At 25 and within two months, Tina had become the orphan of two people and two worlds. The two deaths seemed to signal to her that two chapters in her life were closing – the Italian chapter represented by her father and the Californian chapter represented by her companion. (She returned to California only once, in 1925.) The future rested in Mexico.

5 Edward Weston

"The photographer is a like a cod, which lays a million eggs in order that one may be hatched."

George Bernard Shaw

The period between spring 1922 and July 1923, when Modotti left California for Mexico, was a time for reflection and meditation. Tina returned to Los Angeles where in mid-May 1922 she exhibited and put on sale Robo's batiks and paintings at the MacDowell Club of Allied Arts.[1] It was the first step toward coming to terms with being a widow, besides being a source of income. She also selected poems, short novels, and drawings for The Book of Robo, a work she published privately the following year; it represents his artistic legacy and shows the style and direction of his art. Tina, referring to herself as "Robo's wife," wrote the biographical sketch and the Welsh, socialist writer John Cowper Powys (the author of The Meaning of Culture), then living in California, wrote the introduction: "The little book is evocative of many curious meditations. The struggle of youth is in it, the wistful impatience of youth, to find its method, to find itself in its method, to break the opaque crust of traditional response to life which covers like an awkward alien skin the personal response of the wakening living creature."[2] The words Robo himself used in his poetry are often a world in themselves, such as these from "Fragments":

> You are the sea.
> You wash the shores of all the world,
> The storied coasts of India and Spain,
> And the glimmering coral strands
> Of the outermost Islands of Dream.[3]

Now Modotti was completely free to pursue her relationship with Weston. Their love is confirmed by a letter written even before Robo's death. It opens with: "Edward: with tenderness I repeat your name over and over to myself – in a way that brings you nearer to me tonight as I sit here alone remembering." And closes with: "It is very late now and I am exhausted from the intensity of my feelings. My eyelids are heavy with sleep

but in my heart there is a hidden joy for the hours that will still be ours."[4] The whole letter, as Amy Stark has noted, is "filled with the concrete smells, tastes, and sounds of an encounter, written using memory and imagination to create a heightened sense of what passed between herself and Weston."[5]

Who was Edward Weston? If his self-representation, written with a good dose of irony and contempt for middle-class mentality, is to be believed, Weston neglected school to make snow scenes in Chicago parks (he was born at Highland Park, Illinois, on March 24, 1886). But his father, a physician, decided he "had better go to work,"[6] so he worked for two years in a dry-goods house. When he was 16, his father gave him his first camera, a Bulls-Eye.[7] When he was 19, he went to California on a vacation, never to return. In 1910 he opened a portrait studio in Tropico. The 1915 showing of Pictorial Photography at the Panama-Pacific Exposition included some photographs by him and gradually he acquired an international reputation and recognition in the form of medals, awards, and favorable press comments. He became a member of various salons which he said were "all discarded and forgotten."[8] In 1908, Weston had married Flora May Chandler, described by Weston biographers as a domestic, homely, rigid puritan, and an utterly conventional woman, with whom he had little in common, since he abhorred conventions – he believed they threatened his art. They had four sons, Chandler, Brett, Cole, and Neil.[9] From the beginning he had affairs, that with Modotti being probably the most publicized, and the marriage ended in divorce in 1938.

Since several people have tried to dissect the Modotti–Weston affair and to define its content and form, I shall not do so, but obviously Modotti felt the need for a completely different relationship, once more with an eccentric man. It also gave her another way of expressing herself: photography provided that and much more. Through photography Tina was able to read and interpret the world around her. After all, as Weston wrote in 1932, through photography one presents the significance of facts, so "they are transformed from things *seen* to things *known*."[10] Where Robo's legacy had been largely a linguistic vision, Weston's was to place such a vision into the photographic realm, which meant inventing (or reinventing) a visual grammar.

In identifying the sources or inspirations that propelled Tina into new activities or interests, I do not intend to suggest that Modotti depended on men to express herself and that her achievements were merely a reflection of men's glory. Rather, I suggest that she forged ideas and found inspiration to fit her own state of mind and needs. Of course it is possible and reasonable that such stimulation should originate with two people who were her companions. There was one thing, however, that Modotti did not need

to learn from anybody and that was the poverty she saw in the streets of Mexico, which led her to redefine herself and ultimately to become a committed political activist. Perhaps these verbal and visual educations made her alert, sensitive, and responsive to the realities, not just the facts, of the world around her.

Another factor was Tina's friendship with Xavier Guerrero, a Mexican Indian painter of her age. In November 1922 Guerrero and the artists Adolfo Best Maugard, Emilio Amero, and Julio Castellanos organized a major exhibition, the "Traveling Mexican Popular Arts Exposition," which visited Los Angeles.[11] Best Maugard was the first pedagogical artistic experimenter,[12] whose aim was to show the social function of art and the meaning of *arte popular*. He articulated his theory in a treatise published in 1923 (and in 1926 in English) on the tradition, revival, and development of Mexican art, in which he emphasized the Indian root of Mexican art in, for example, the stylized, non-perspective method of representation.[13]

Modotti contributed to the exhibition catalogue, which was edited by Katherine Anne Porter, one of the first Americans to be interested in Indian art.[14] Porter's theory rested on the purity of such art, which she claimed European influence inhibited. The photographs were by the cinematographer Roberto Turnbull, who also filmed the exhibition – not without problems. Since the U.S. government refused to recognize the Obregón regime, the show was perceived as political propaganda rather than as art, with the result that it "languished in a railroad siding for two months until duty was paid on it as a commercial enterprise and it was sold to a private dealer in Los Angeles."[15] More than 5,000 pieces (some reported 80,000) including watercolors and drawings were exhibited and beautifully described by Porter, whose "interest ranged from the individual objet d'art to the larger quest for universality of expression."[16] It was after this overwhelming show that Tina developed a taste for Mexican art and *lo mexicano* in general.

By the end of 1922, Modotti had decided to move to Mexico in the following spring (according to Weston's diary) although more than one biographer has written that she planned to open her own photographic studio in San Francisco.[17] While there is no evidence to sustain that, it is known that she became interested in photography at this time and asked Weston to teach her. So she could both enjoy her work and be economically independent. Weston, by then 37 years old, decided to do what he had intended to do earlier: go to Mexico with his muse to continue his photography there. The terms of the professional agreement between Weston and Modotti were clear, as he spelled out in a letter of February 1924 to his family;[18] the terms of the sentimental agreement were less clear.

He was going to teach her photography, taking her as his apprentice. She was going to be his agent, or business assistant, which meant several things: she would act as a cushion against cultural shock;[19] as a link to a different social code; as his darkroom assistant; and as an interpreter (her Italian helped her when speaking with Mexicans, even though her Spanish was not yet fluent). In short, she was going to run their household and make all the necessary professional contacts. As far as emotions were concerned, things were rather vague, especially because Weston had decided to take with them to Mexico "a hostage to his past,"[20] his 13-year-old son Chandler. Love and photography were obviously "a combination that was natural to him all his life."[21]

In Mexico Tina became his spokesperson but she also often translated his statements loosely or distorted reality a little in order to present Weston as a public figure who cared about justice. In September 1923, for example, during an interview with a Mexican journalist, Modotti made Weston appear far more radical that he actually was, saying that he had left the United States because he found it impossible for an artist to cope with the restrictive laws, Prohibition, and the rising Ku Klux Klan.[22] Nevertheless, in a letter to his wife dated two weeks after the interview, Weston wrote: "You see this is an enlightened and free country. There may have bullfights but we don't have the Ku Klux Klan nor lynching bees"[23] – it was only on January 1, 1923 that an unknown number of blacks had been massacred by an angry white mob in Rosewood, a nearly all-black town in Florida.[24]

It is true that Weston often spoke in terms of freedom, and that he found restrictions of any sort unbearable, but the freedom for which he longed was more that of an artistic nature. Weston was mainly an individualist. Radicalism per se never interested him; in fact, he resented Hagemeyer's closeness with the anarchist movement or the Wobblies. And while in Mexico Weston kept his distance from the communists (although it has been said that he was tempted to join them[25]), justifying his stance on the basis that he could not afford any more complications in his life.[26] Moreover, the empathy that Tina felt for the poor and the Indians and her approach to *indigenismo* were unknown to Weston, as his photographs show and a comment he made clearly indicates: "too much sentimentality over the proletariat. Too much deification of the Indian."[27] Whenever Weston did become interested in politics, it was always on purely intellectual terms or out of cultural curiosity. After all, he never took himself seriously and regarded life as an unending adventure. The best description of his philosophy comes from a passage in his diary: "Life is not so difficult for me, I slip a new disc into my musicbox of emotions, grind the crank and out squeaks another tune. To be sure it may be a more or less familiar melody, but one can always change the tempo and use imagination!"[28]

By January 1923 Weston had moved out of the family home to a studio. He had become close to the Modotti family in San Francisco (whom he continued to visit after Tina was no longer in California).[29] The moving photographs he took of Tina's mother, affectionately entitled "Mamacita," and of Tina and her mother, called "Mother and Daughter," date from this time. In his diary, Weston mentioned that he showed these photographs to Alfred Stieglitz, when the two met in New York in November 1922, after Weston had received a letter from Tina.[30] Stieglitz was the leader of the photo-secessionists and a father figure for many photographers, whose comments Weston gladly recorded and valued: "I like the way you attack each picture as a fresh problem" and "This print has a fine dignity. Treat anything your undertake with dignity, a portrait or a box of matches. . . . My last message to you is work, seek, experiment."[31]

Tina, meanwhile, had a poem published by the literary journal *The Dial* in May 1923.[32] The same issue also contained an article by Francis Birrell on Marcel Proust[33] and a drawing of Roger Fry by Boardman Robinson. Other issues published an article by Benedetto Croce,[34] a short play by Luigi Pirandello,[35] three poems by William Carlos Williams,[36] an article by Bertrand Russell,[37] and work by Picasso, Archipenko, Matisse, William Zorach, and Adolph Dehn. Amy Conger suggests that Modotti was probably introduced to the journal through John Cowper Powys (whom Weston had photographed in 1918). Cowper Powys's sister-in-law, Alyse Gregory, became *The Dial's* managing director around that time.[38]

The poem by Modotti is worth prolonged attention (it is also her only known poem):

> *Plenipotentiary*
>
> I like to swing from the sky
> And drop down on Europe,
> Bounce up again like a rubber ball,
> Reach a hand down on the roof of the Kremlin,
> Steal a tile
> And throw it to the kaiser.
> Be good;
> I will divide the moon in three parts,
> The biggest will be yours.
> Don't eat it too fast.

If the ideas and feelings expressed by the speaker can legitimately be ascribed to Tina, she must have felt positive about herself and fully in charge of her life when writing this – as is evident immediately in the title "Plenipotentiary." She was about to cast off the ties that had bound her to

California and somewhat restricted her to conventional, bourgeois, American mores and values. She was about to embark on the adventure with Edward Weston and his son Chandler in Mexico. She was filled with a sense of power, freedom, liberation, generosity, possibilities of transformation, and exhilaration.

The word "plenipotentiary" means one who is fully invested with power – for instance, an ambassador or representative of one government to another. However, in this instance, there is no specific reigning power of which the speaker is a representative. Her domain and arena of action is universal, encompassing not some petty court but "the sky," "Europe," the "Kremlin," the "kaiser" (Germany), and "the moon" (the heavens). The reference to eating the moon suggests the realm of the fanciful and unknown, insofar as this can be understood to allude to the old legend that the moon is a large wheel of cheese. This is written by a woman who feels as expansive and utterly unlimited as space itself.

In the first line, we are playfully presented with feelings of power and freedom: "I like to swing from the sky." At once, the speaker establishes her parameters: the heavens and earth, "sky" and "Europe," and her home is already the sky, she has been liberated, that is her basic condition. But she has not achieved some sort of divinity that leads her to turn her back on this world. Rather, she "swings from the sky" in order to "drop down on Europe," to maintain her fundamental relationship with this world. Freedom is not selfish and neglectful or indifferent to one's fellows. In fact, she will "bounce up again" (according to the properties of her nature "like a rubber ball,") so that she can "reach a hand down" to touch "the roof of the Kremlin;" that is, in one bound, she will encompass two similar yet dissimilar entities or orders. The reference to the Kremlin is typical of contemporary radicals' discourse on communist Russia. As for the kaiser, why is the German emperor the target of her tile, instead of Mussolini, considering the date of the poem? Perhaps because during the war the kaiser had been the enemy of her adopted country.

On the one hand, there is the old Europe – hierarchical, imperialistic, class-structured, aggrandizing, individualistic (for the wealthy and powerful), and economically capitalist and essentially *laissez faire* (for the wealthy and powerful again). On the other hand, there is the new order, represented by the Kremlin, the center of the worldwide new revolution – promising the overthrow and transformation of the old order and the ringing in of the continuing advancement of the proletariat. So sure is the speaker of the healing properties of the Bolshevik revolution that she seeks to unite the old and new by snatching a tile from the Kremlin's roof and throwing it to the symbol of corrupted power, chastened and destroyed by historical

processes, Germany. Note the use of "to": the kaiser is not a target, as would be suggested by "at;" rather, he is a recipient. Out of the largesse which is within the speaker's power to distribute, she donates a roof tile. This perhaps indicates that the remedy for the world's social, economic, and political ills is so potent that a simple tile can cure them. In any case, the preposition "to" creates an image of sharing and generosity, not forced conversion.

This tone is even clearer in the last four lines of the poem: she offers her apparently singular auditor the largest portion of the moon, which she will divide in three parts, perhaps for herself and two companions. The speaker takes into her hands the power of this partition of the moon, a distant object that belongs to everybody and nobody. Why three? For the three people shortly leaving for Mexico? Or for the people of a *ménage à trois*, as the arrangement for Mexico the year before suggested? Since she has the power of deciding the size of the shares of the moon, she will cut a piece to be the biggest for an undefined "you." Then, in the last verse, we hear Modotti saying (as if she were talking to a child): "don't eat it too fast." So, because of the playful Tina, the universe is temporarily deprived of the moon – the inspiration for many poets. There is delightful tone of playful motherliness when she urges the auditor first to "Be good" and then not to "eat it too fast." Again, she is nurturing, generous, and rewarding in her relationship and in the exercise of her power, which extends to the moon. Among the points of interest in these four lines is the continuing insistence on her empowerment, her generosity, and the object of her power – the moon, which has numerous associations and metaphorical uses.

Probably the most common association of the moon is with love and lovers. The allusion here may simply declare Modotti's desire to share her love with her lover (who at that time was Weston). By invoking the traditional love image, she enlarges and elevates her love for her auditor to a grander sphere than the merely earthly and temporal; it might represent her great capacity for love, and (despite less generous interpretations by cynical and moralizing critics), it might reflect and explain taking a number of lovers over the years. Certainly, nothing in the poem suggests a wanton woman with a voracious sexual capacity; instead, as pointed out, the imagery is playful, nurturing, almost motherly. When the reader combines that with the poem's tone of freedom, expansiveness, universality, and potency, it does not require much imagination or argumentation to begin to understand the writer from a poor girl in Udine to modiste and stage actress in San Francisco, film actress and bohemian in Los Angeles, to photographer's assistant and apprentice, and photographer and documentator of the oppressed in Mexico, and finally to member of the Communist Party

in Mexico, then in Moscow and Spain during the Civil War. That is to say, Tina constantly sought to find somebody or something to match her infinite capacity to give.

This love was not a religious, spiritual love, whose ultimate satisfaction is to be found in the hereafter, with an eternal being as its object. On the contrary, the choice of the moon as her metaphor strongly suggests that hers is a sublimary love: she aspires to nothing higher on the Great Chain of Being than that which lies beneath the moon. She and her lover (or lovers) will devour the moon (that great round of cheese) and rise no further; there is nothing beyond but the darkness of death. Furthermore, to move from the personal to the universal, the historical process of evolution must be assisted by revolution, to transform the world and its populations into a paradise here, not in the beyond.

All of this is important only if it helps us to understand Tina's character, her choices, and her life itself. If my reading has some validity, then the poem performs a sort of balancing act in which we can view both the large and little movements of her life. And it may offer some insight into the dark aura that descended over her life in her latter years, commencing with her exile from her beloved second adopted country, Mexico. Readers can readily find the counterpart to the optimism that marks the poem in the despair and pessimism that descended when her hopes, dreams, dedication, and efforts to transform the society of humans worldwide were frustrated by the realities of the Comintern in the Kremlin and its application in the world, especially as she experienced it during the Spanish Civil War.

On Sunday July 29, 1923 Tina, Edward, and Chandler Weston sailed from the port of San Pedro for Mexico on the S.S. *Colima*, a United Fruit Company cargo boat. It was a critical time in Mexico: on July 20, Pancho Villa had been ambushed on the way to his ranch by a hired killer.

Modotti and Weston took with them their large-format cameras, Tina's a 4 × 5 Corona and tripod. Flora Weston and the 4-year-old Cole were there to see them off. Cole later reported that the departure was "more than he could handle."[39] Among other Weston friends were Peter Krasnow, a painter and sculptor, his wife Rose, and Ramiel McGehee, who would send Weston many touching letters.[40] Modotti was seen off by Rose and Marionne Richey, as well as by Marionne's friend Emile Scolari, an Italian-Swiss contractor.[41]

If for Tina the decision to leave the U.S.A. became a true commitment to Mexico, for Weston it never did. His choice of Mexico was led by a sense of malaise that he had developed toward certain parts of California. Glendale in particular was frequently the target of his scorn. Being almost

exclusively a place of "self-respecting people," more devoted to others' busi-
ness than their own, the town came to signify in Weston's mind everything
that was wrong, backward, and provincial in America. Such disgust for petty
morality was "part of the intellectual equipment of the time," according to
Maddow,[42] so Mexico represented a "psychic voyage, a circuit of escape from
himself."[43] At first, Weston did not seem to be anguished by deserting his
family, his work, his friends, and his business partner and lover Margrethe
Mather, but guilt visited him later, as his letters to his wife show.[44]

The voyage was uneventful, though Tina had to endure seasickness, faith-
fully reported by Weston in his diary: "The sea was rough, the *Colima*
pitched and rolled – Tina sick, *pobrecita!*[45] At times, even in entries written
later during his stay in Mexico, Weston used poetic words to describe the
natural phenomena: "our ship cut through silent glassy water domed by
stars." "A half-moon half hidden by heavy clouds – sculptured rocks, black,
rising from silvered waters." "A quite marvellous cloud form tempted me,"
and "Mexican nights are bewitching."[46] His photographer's eyes were always
alert to capture even nearly imperceptible effects in nature.

The three passengers arrived in Mexico on August 4. Mazatlán (in Aztec,
the place of the deer) was the first port of call: Weston identified life there
as "both gay and sad . . . vital, intense, black and white, never gray."[47] And
he again compared the vibrancy of Mexico with the anemic, spiritless,
and uniform gray Glendale, "peopled by exploiters who have raped a fair
land."[48] The first impact of Mexico was experienced as rich colors and
tactile, visual extremes: "cool patios glimpsed from sun-baked streets which
sheltered coconut palms, strange lilies, banana trees."[49] The first impres-
sions were also of an imposing culture, in which history predominated:
"The cathedral, with its crude Christ, horribly real,"[50] and "old churches
stand like impregnable fortresses."[51]

From Mazatlán the ship continued to Manzanillo, where the three pas-
sengers arrived early in the morning of August 8. After clearing customs,
they wandered through the streets, escorted by the ship's captain, until their
train left for Mexico City via Guadalajara. They reached the capital on
August 11 and leased "an old and beautiful hacienda of brick with high
ceilings and tall arched windows" in Tacubaya, a forty-minute trolley ride
from the center. They called the house El Buen Retiro (The Lovely Retreat).
Weston liked it so much that later he called it "the most charming spot"
he had ever lived in.[52] Then in September they moved into a place within
walking distance of the heart of Mexico City, at Lucerna 12, Colonia Juárez,
for 260 pesos a month. Its central location made the move a good business
choice. In May 1924, they moved again, to the cheaper Avenida Veracruz
42, Esquina Durango. The triangular house was called El Barco (The Boat)

and had an *azotea* for sunbathing, where some of Weston's nudes of Tina were taken.[53]

Mexico proved to be a new testing place for both Modotti and Weston, and it was able to provide a liberating effect in their personal life. Weston's journal gives an invaluable insight not only into his and Modotti's life in Mexico but also into his photography. Although at times he falls into clichés and stereotypical romanticizations of Mexico such as "I expected shawls and mantillas,"[54] nevertheless a genuine appreciation of the natural beauty of the country shines through his words. He wrote as if he were photographing it, intent on the details: "acres of water lilies along the tracks, pale lavender hyacinthine stalks;" "the Mexican sky, always dramatic, presented a surpassing spectacle. Gathering rain clouds, gold rimmed, massed against intense blue;"[55] "I saw a sky as magnificent as any I have seen in Mexico. Twilight came on and a superb sunset, long streaks of scarlet clouds over black hills."[56] Weston had a deep feeling for Mexicans and their culture, and he was pleased when Mexicans paid him compliments in return.[57] He revered the country's past, referring to the present as "an imposed artificiality,"[58] and was impressed by the tremendous wealth of Mexico's natural resources – his journal typically quotes an ironic comment from an Italian newspaper: "Poor Mexico, she is so rich!"[59]

Amy Conger, the author of an exhaustive book on Weston in Mexico, mentions that of the people who had met the photographer in Mexico many "remembered him fondly and clearly."[60] Weston's words convey a sincere admiration and respect for the artistic achievements of a country which was mythicized by many Americans of the period, even though his comments on the Mexican bourgeoisie are as ironic, witty, and full of contempt as those on his compatriots. He calls the Mexican upper-class taste "execrable, tawdry," and "rubbish," and their new architecture "Hollywood burlesqued."[61] When faced with some American tourists, he imagines them equipped with a bottle of Lysol in each of their pockets,[62] and with his usual arrogance he states that "after all, middle class minds and aspirations are the same everywhere."[63] However, he also records that nobody in Mexico – middle-class or otherwise – ever questions his relationship to Tina,[64] which suggests that there was a more permissive attitude toward unmarried couples than in North America. The only disapproval he ever encountered came from an American woman living in Mexico, who thought that the arrangement was "disgraceful" and refused to send her daughter to Weston's home to be photographed (his main income came from portraits). Weston responded to puritan mores with customary wit, attack, and a certain logic: "I accept the loss of a sitting. I can use one sheet less of toilet paper per day, eat one less tortilla . . . Do you ask your butcher his moral attitude

before buying a slice of ham? Do you come to me for a portrait by a craftsman, or to see a marriage certificate garnished with angels?"[65]

In fall 1923 Modotti arranged an exhibition of photographs by Weston at the Aztec Land House, whose owner was a certain Rubicek (spelled Roubicek by Weston).[66] The exhibition, which lasted from October 17 to November 4, proved a success and Weston sold eight photographs,[67] although he felt unsatisfied with his work.[68] The show was visited by between 800 and 1,000 people, mostly men, which Weston noted was the opposite of what happened in the U.S.A.[69] He himself created a sensation in Mexico: it was said that he was a lens wizard,[70] that he *pinta con la lente* (paints with the lens), and that "Photography begins to be Photography for until now it has only been art."[71] Not only that, but his style of photography was called *la supremacia en exquisito arte fotografico* (the ultimate in the outstanding art of photography). He was also praised for having immediately understood the beauty of Mexico.

Modotti became a skillful coordinator. As Weston wrote to his wife on September 1, 1923, "Tina has arranged for my exhibit. She is invaluable. I could do nothing alone."[72] However, this was the first time that Modotti and Weston lived in close contact with each other and the story continues with ups and downs in their relationship. Faithfulness was not one of Weston's virtues and he had a brief affair with Xavier Guerrero's sister Elisa at this time. He photographed her in Mexican folk dress and sold the print at the exhibition. While Weston tended to advertise his affairs, Modotti was a little more discreet, which makes it harder to follow her love life. But it seems that she also consoled herself with other men, who "visited her room overnight," and that "her affairs troubled Weston very deeply."[73] It has been suggested that one of these men was José (Pepe) Quintanilla y del Valle, the brother of Luis Quintanilla (1900–80), poet, playwright, diplomat (in 1940 acting ambassador to the U.S.A.[74] and in 1943 ambassador to the Soviet Union[75]), and a member of the *estridentismo*, the "strident" movement that is often associated with Italian futurism.[76] The relationship between Tina and Pepe, who vaguely resembled Robo, may have started while Weston was still in Mexico and continued when he returned for a few months to California. One of Tina's letters to Weston of December 1924, mentions Pepe as "lovely in his desire to help without being intrusive in my present mood . . . he succeeds in being just a gentle abstract presence – impersonal."[77] A photograph of 1924, attributed until recently to Weston but now thought to have been taken by Modotti herself,[78] captures a sensual Tina and Pepe embraced in ecstasy.

Within a month of their arrival in Mexico Weston noted that "something has gone from between us. The excitement of conquest and

adventure is missing."[79] On another occasion he added that "The mercury rise and fall [sic] when two people live in too close contact."[80] And by November 1924 he had decided that he and Tina should "separate forever."[81] However, when away from Tina he missed her. It seemed as if their relationship was better when the two were apart; as he wrote in his diary, parting "has brought us together."[82] Again, he wrote, "I am alone in the great room – no, you are with me, but only your counterpart on the wall."[83]

It was in this period that Weston took his most evocative nude photographs of Tina.[84] Rivera used one of them to paint *Life and Earth* at the National School of Agriculture in Chapingo. When Weston saw the mural in November 1925 he noted in his diary that it was "majestic."[85] According to one of Rivera's biographers, it was as if Modotti "broke open some old Catholic shell that had encased one part of Rivera's talent."[86] One photograph in particular, taken on the *azotea* in 1924, stands out not only because of the texture and physical quality of the photograph itself but also because it does not have the detachment of his other nudes. The rapport between photographer and subject was clearly intense, as is suggested by other prints that show Modotti in a kimono but focus on her face, especially her sad eyes. The series called "Tina reciting" and "Tina with a Tear" are also extraordinary. All these portraits signified various phases of Modotti's life and she kept them with her until she died.[87]

Tina, then 27 years old, had grown into a sensual woman, a real enchantress or *mujer encantadora* as a Mexican would say,[88] with whom every man seemed to be in love, and none cared to disguise it. Weston was certainly aware of this and in September 1923 promised himself next time to "pick a mistress as homely as hell!"[89] According to people who met her in that period, Modotti was "a fragile person, not very tall, whose strength rested in her interior."[90] Pablo Neruda wrote that he had to make an effort, as if he were holding a handful of fog, to remember Tina since she was a fragile, almost invisible creature, and yet her pale oval face with her large, velvet eyes were printed on his mind.[91] Others said she had "a distinctive Italian look" with "large and expressive eyes,"[92] "a great sense of humor,"[93] and the appearance "of a young and Virginal Madonna."[94] She was not trying to be beautiful, "she was born beautiful."[95] She was particularly graceful in her movements,[96] and she spoke Spanish with a harmony that she brought to her own photography and "with an Italian lilt that added to its charm."[97] She dressed in a simple almost austere style,[98] preferably in dark colors, especially black, often wearing a Mexican *rebozo* (shawl) and a skirt or a pair of jeans, which was very unusual for women at that time.[99] The painter José Luis Cuevas placed Modotti with the artist Rosa Covar-

rubias and with Lupe Marín (Rivera's wife) as the "immense feminine presences who enriched Mexican culture in the twenties and thirties.[100]

The secretary of the Mexican Communist Party in 1924, Rafael Carrillo, later commented on Modotti's avid quest for knowledge, while Miguel Angel Velazco remembered Tina's humility and especially her compassion for people.[101] Vittorio Vidali, her companion for ten years, stressed her personality, strong yet calm, which awakened in him a feeling never experienced before.[102] Fernando Gamboa commented on her tragic sense of life but added that she also "knew how to laugh and be happy."[103] Federico Marín's recollection of Tina is of "a mysterious beauty, without any vulgarity, very polite and introverted."[104] Ione Robinson, who met her in 1929, when Tina was 34, was struck by her eyes and "the manner in which she held her mouth, half open when she was not speaking."[105] Angélica Arenal de Siqueiros, the painter's wife, who met Modotti during the Spanish Civil War, found her "very thin, still very beautiful, and very feminine" and that there was a "romantic aura" about her.[106] Flor Cernuda, who also met Tina in Spain, said that she was "soft and calm, but incredibly active."[107] And Mildred Constantine, who met Tina just before her death, described her as "quite tiny, very pale, very beautiful."[108] The best description of Modotti, though, came from Baltazar Dromundo: "era como mi país: triste, dolorosa y resplandeciente" (she was like my country: sad, suffering, and resplendent).[109]

In this Mexican sojourn, old acquaintances reappeared (the dandy artist Best Maugard, for example, who attended Weston's show), and new ones were added. The intelligentsia (the "political Montparnasse"[110]) included Xavier Guerrero and his sister Elisa; Jean Charlot, a French painter, who coined the term "Mexican renaissance"; Rafael Sala, a Spanish painter, and his Catalan wife, Monserrat (Monna) Alfau; Manuel Hernández Galván, a radical lawyer and senator; and Manuel Martínez Pintao, a Spanish woodcarver. It also included a couple of extravagant artists, who lived in a baroque-style former convent: Gerardo Murillo (a vulcanologist, poet, and painter) and Carmen Mondragón (a painter and poet), who gave themselves the Indian names of Atl (water)[111] and Nahui Olín (renewing movement of the heavens in the cosmos).[112] Others were Carleton Beals, an American journalist, correspondent of *The Nation*; Anita Brenner, an art critic, born in Mexico and raised in the U.S.; Alfons Goldschmidt, German professor of economics in Mexico, and Frau Goldschmidt; Guadalupe (Lupe) Marín, "barbarically splendid";[113] and obviously the star of all, the monumental Diego Rivera, who had met Modotti while she was organizing the March 1922 show after Robo's death.[114] The encounter between the two primadonnas, Weston and Rivera, must have had its comic side: one

was short and thin, the other was six foot and weighed in at 300 pounds – "rotund, brilliant, and intractable[115] – and always carried a pistol with him. They met through Tina, who took Weston to see Rivera's murals "the work of a great artist," Weston stated.[116] And Rivera himself immediately reciprocated with appreciation of Weston's work.

Intellectual and artistic ferment rose high in Mexico City. Those cosmopolitan Americans who had escaped what they considered petty and provincial America were fascinated by the prospect of the creation of a new world by processes that operated outside the realm of bourgeois values, and believed that somehow they could remake their own nation.[117]

During Holy Week in April 1924 Weston and Modotti together with friends took a trip to Tepotzotlán, a town northwest of Mexico City. There they both found fascinating material to photograph, including a sixteenth-century church (which Weston wrongly dates as seventeenth-century) in high baroque Churrigueresque style, with an adjacent convent, where they were given permission to stay. In contrast, an interior composition by Tina of Weston smoking his pipe while writing a letter uses a window in the background as a frame. It was a time to discover nature and landscape: both artists' eyes were captivated by organ cacti, maguey, and luminous shadows – "a vivid week to remember," as Weston put it.[118]

The church of San Agustín Acolman, in the direction of San Juan Teotihuacán, which they visited on May 5, 1924, was built by the Franciscans in the sixteenth century and appeared to them as a simple massive structure "with none of the pompous show and glitter of Tepotzotlán."[119] They attended a Sunday service, noticing the "kneeling Indians," and were moved by an Indian playing the organ and singing Tosti, while birds "joined him from the vaulted ceiling above."[120] They saw the church of La Santísima in Chapingo too, at the end of May, where they paused "in mute contemplation" before finding themselves in front of Nuestra Señora de la Soledad. Weston elevated this church to the top of his list of favorites.[121]

Apart from touring, Tina briefly returned to acting: in September she participated in a production of the *Chauve-Souris, el Teatro Mexicano del Murciélago*, staged as a musical review by Luis Quintanilla.[122] Her performance, according to Weston, showed "restraint and understanding."[123] And from October 15 to 30 Weston held another exhibition at the Aztec Land House, whose viewers included Vasconcelos. The former minister of education showed a particular interest in photographs of clouds and requested seven prints for publication in his magazine, *La antorcha* (The Torch).[124] Francisco Monterde García Icazbalceta wrote a favorable review of the show in the magazine *Antena*, commenting particularly on the photograph *Pirámide de Cuernavaca*. Then on November 1, 1924 the first joint public

exhibition for Modotti and Weston opened at the Palacio de Minería in Mexico City, and was inaugurated by President Obregón. It also showed the work of other artists, among then Rafael Sala, Jean Charlot, and Felipe Teixidor. Ten prints were exhibited by Tina, who signed the guest book with a humble note, "Tina your apprentice of the past, present and may she be of the future. Mexico, 1924." Others thanked Weston, addressing him as a poet: *muchas gracias, poeta Weston!* The names of Rivera and Orozco Muñoz also appear in the book. Modotti had now acquired her own style of photography. On this occasion, Weston won the first prize for photography, consisting of 150 *pesos*, probably thanks to Diego Rivera who was one of the jury.[125]

The year 1924 closed with Modotti, then 28, writing her will – for no known reason. The major beneficiary of her personal property – furniture, books, photographs, and all of her photographic equipment – was Weston, who could retain for himself what he wished and distribute the rest among family and friends. The will closed with the request to be cremated.[126] It has been suggested that she wrote it at that early age because she was about to undertake a decisive step in her life, perhaps to enroll in a course at the Lenin School in Moscow,[127] and wanted to leave her possessions, mainly her photographic equipment, with a person who deserved and would cherish them. If that was the case, though, her decision was never realized.

From Weston's diary we get glimpses of their daily life, which was carefree but largely ruled by the demands of their photography, at least in public. A few descriptions by Weston may represent the mosaic of their time in Mexico. We can visualize the street market ("kaleidoscope of life") that Weston could see from his room.[128] We encounter the public toilet constructed out of wooden stalls, with its shrine to the Virgin resplendent with flowers and candles,[129] and we may enjoy the comedy of the taxi ride in which one of Tina's legs went through a hole in the cab floor.[130] We smile at the comment of some Indians encountered in the street market who, believing Weston was Italian as well, felt free to open their mouths and comment about Americans: "The gringos? we kill them and eat them!"[131] And we cannot help finding the Indian sense of time curious: when Tina asked an Indian for the time, he answered that it was three o'clock, but when Tina noticed that it must have been much later and told him so, the man answered "So, then, it is four!"[132] Weston spared nothing and nobody in his diary. On his fortieth birthday, he had an assignment with a family and their status symbol, their dogs: "Members of a wealthy Mexican family, mother, child and dog: the mother alone, the daughter alone, the dogs alone, the mother and daughter together, the dogs and daughter together, until my brain was a muddle of mother, daughter, and dogs, wriggling and

posturing, barking and smirking."[133] The power of the description springs from the gerund form of the verbs he chooses: "wriggling and posturing, barking and smirking," without ever using the most logical verb, posing; we get "posturing" but not "posing." We can just see Weston rolling up his eyes and sighing, being inexorably pulled into this uncomfortable business (far removed from the type of photography he wanted to produce), as if a vortex were about to suck him in. Then we discover his profound need for withdrawal from the world: "Last night I literally ran away from the house to be alone."[134]

When making the famous picture of his own toilet (which he calls "that glossy enameled receptacle of extraordinary beauty"), Weston writes that he prepared for it under great stress, fearing every moment that someone would wish to use the toilet for other purposes than his, while the household made sarcastic remarks about his efforts (his son even offered to sit on it during the session).[135] We are also exposed to Weston's art theory and his obsession with forms. He tells us that "photography is a most intellectual pursuit. In painting or sculpture or what not, the sensitive human hand aids the brain in affirming beauty. The camera has no such assistance."[136]

There were also sad notes. Robelo's death in August 1924 was long expected but still left its mark on his friends.[137] Vasconcelos even blamed Modotti for his death, commenting in his memoirs on Robelo's consuming passion for the "depraved" Tina (whom he disguised under the name of "la Perloti"), who did not reciprocate it. His vitriolic litany described Modotti as "insensitive and seductive" and a true "vampire woman," who used Robelo to introduce her into artistic and political circles. Vasconcelos's words make one question his own motives and feelings toward Tina, especially in view of his description of their last meeting: "her silhouette was a powerful magnet in the sunny afternoon."[138] This reversal of friendship was only one of several changes Vasconcelos went through over time. Other changes, of a political nature, were much deeper, making him a truly conflicting and enigmatic figure.[139]

Weston's diary also shows us that he and Modotti enjoyed social meetings, debates, and for his part Sunday bullfights (although he seldom photographed them).[140] The Saturday dinner parties given by Oscar and Beatrice Braniff, American millionaires, seem from Weston's account to have been interesting melanges of money, intellect, and radicalism all garnished with a good sprinkling of posing. However, the soirées were soon cancelled because of political turmoil.[141] Food figures relatively frequently in Weston's diary: he records their own and their acquaintances' culinary habits. As a good Northern Italian, Tina frequently cooked spaghetti with butter, which she taught to Orozco,[142] and the Goldschmidts served "poor food." Of life's trivia we learn that Brett Weston "adored butterflies," that

"Tina bargained for everything (except for a rare old sarape)," and that with Puebla church bells not even a deaf person needed an alarm clock. We discover that Rivera was a strict vegetarian, and that around him and Lupe Marín there was always an overflowing energy – they had frequent and violent fights, and she did not mind throwing dishes at him.[143] And we smile at Modotti and Weston's habit of exchanging written messages within the house, especially given that the messages were delivered by the house-keeper, as if the house were a palace.

Money seems to have been a constant preoccupation for both Weston and Modotti; one day he jots down a philosophical maxim: "A broken heart is more easily cured than a shrivelled stomach."[144] There was never a steady rhythm in their household, and their living as portrait photo-graphers could be unpredictable. They charged from 50 cents to 8 dollars per sitting, which, considering the cost of living,[145] would have made them fairly well off had the sittings been regular. Further more, Weston had little patience with sitters unless they were people he knew well, whereas Modotti in general had a good rapport with sitters. Despite their financial difficulties, though, they did not deprive themselves of certain luxuries, such as the help of a *criada* (housekeeper). From November 1923 she was Elisa Ortíz, who in 1924 sat for at least two photographs by Modotti. Her aid cost them 15 *pesos* a month, plus room and board.[146] They frequently invited groups of people for dinner and parties; perhaps Tina was trying to recreate the atmosphere of her early California days with Robo, when friends were always welcome in their home. Since expatriates and travelers in Mexico formed the center of this group, they have been compared with the bohemians of New York's Greenwich Village in the 1912–17 period.[147] At a costume party on Mardi Gras of 1924, Tina and Weston exchanged clothes and imitated each other's gestures. She smoked his pipe and bound down her breasts, while Weston wore a pair of cotton falsies.[148] When writing of another masquerade party, he comments that their make-up and acting were excellent, judging from the effect they had upon their hosts.[149]

In August 1924, to commemorate their first anniversary in Mexico, Tina insisted on having a portrait photographer take a photograph of her and Weston as a couple. They are shown in a rather affected pose, holding hands, with a cheap vase of flowers standing between them on a small column. Weston, as might be expected, reports the story humorously.[150] It reveals a romantic side to Tina that contrasts with her later image as a harsh revolutionary.

From Weston's diary, we also gain a sense of the differences in concep-tions of artistic and intellectual work between him and Mexicans: in Mexico they were indivisible from political action. Weston is a fair example of a

certain type of American artist – individualistic, self-centered, inconstant, obsessed with privacy, often torn between "heart and brain,"[151] and skeptical about politics in general (a female counterpart would be Georgia O'Keeffe). It is strange that a later author could call him "a notorious communist."[152] For the most part, Mexican artists could not afford much individualism. The revolution had taught them to work in groups, to share, not even to sign their own work, and to perceive art as an ideological tool (not at all Weston's view). However, there were similarities between Weston and the politically committed Diego Rivera. The latter stated that

> to be an artist, one must first be a man, vitally concerned with all problems of social struggle. The artist must interpret the unexpressed hopes, fears, and desires of his people and of his time; he must be the conscience of his culture. His work must contain the whole substance of morality, not in content, but rather by the sheer force of its esthetic facts.[153]

Rivera joined the Mexican Communist Party in December 1922[154] but it was no secret that the party never knew how to handle him.[155] As early as 1924 his friend Bertram Wolfe, at that time a member of the Central Committee of the Mexican Communist Party (while still an American citizen), tried to convince Rivera to resign from the party on the grounds that the leftist cause would be better served by him as an artist than as a political member.[156] According to Wolfe and others, Rivera was so absorbed in his art that he forgot the dates and times of political meetings. But he made frequent donations to party funds from his meager wages – which caused constant fights with Lupe Marín, who could never understand his attachment to the party.[157] Wolfe for his part, while praising Rivera as "a revolutionary artist," expressed his doubts about the repercussions of the Mexican government's support for him.[158] Modotti too was skeptical about Rivera's commitment to politics, believing that it would "spoil a great artist."[159] As for Rivera himself, in 1925 he wrote a letter of resignation from the party, openly declaring himself to be much more useful to the communist cause as an artist and sympathizer of the party than as a full-time militant. But he was readmitted in 1926 though tensions and disagreements continued: he could never become a totally committed, let alone orthodox, communist, despite his nickname of the Lenin of Mexico.

6 The Party Calls

Scholars, throw away your brushes!
Secluded women, take up arms!
Together we can hold back
The flooding waves.

Ch'iu Chin[1]

The official entry of Tina Modotti into the Mexican Communist Party took place in 1927, a crucial year. The two Italian anarchists, Sacco and Vanzetti, were executed on August 22, in the United States, while Calvin Coolidge, former governor of Massachusetts, was president, after what had been a lengthy and in many ways a mock trial. It appeared that they were arrested, tried, and convicted more for their ideology and status as immigrants than for the actual crime, as Jim Seymour's ballad "Sacco and Vanzetti" had demonstrated as far back as 1921: "No, s'r, I ain't sheddin' no tears / Over them two guys. / It serves 'em right. / It ain't so much because they're reds – / That's bad enough, God knows, / But bein' a damn ignorant foreigner is the limit."[2] The verdict generated a series of protests to suspend the execution. Rexroth for one described it as "a great cleaver cut through all the intellectual life in America."[3] Pictures of Sacco and Vanzetti appeared on many magazine covers, including *New Masses*,[4] and Upton Sinclair wrote a documentary novel entitled *Boston*. Even Mussolini tried to save the two men, perhaps remembering his own anarchist past.[5] One of the protests was held in Mexico City just before the execution. It was organized by the Creación del Frente único pro Sacco e Vanzetti (Creation of the pro-Sacco and Vanzetti United Front), an offshoot of the Mexican Communist Party, founded on July 2, 1927 and headed by Luis G. Monzón.[6] It was at this demonstration that Modotti met Vittorio Vidali, an Italian communist activist from Muggia (Trieste) who had lived in the United States under the name of Enea Sormenti,[7] and had corresponded with Vanzetti.

In February 1927 Vidali had been deported from the U.S. to the Soviet Union, because of his involvement in the Sacco–Vanzetti protests.[8] "Leaving America," Vidali wrote to a friend, "had become for me not just a necessity but also a deep pleasure."[9] Since Moscow did not have

diplomatic relations with Washington at the time, it could not provide Vidali with a passport but received him as a guest of honor.[10] It also made him a Comintern representative and sent him to Mexico, where he arrived at the end of summer 1927 on the *El España*.[11] There, "boasting a string of aliases,"[12] Vidali worked mainly under the name of Carlos Contreras, of Spanish nationality.

Several murders of Stalinist imprint were attributed to him by the *vox populi* but nothing was ever proved. In keeping with such dramatic stories, it was claimed (with a good dose of fantasy) as late as 1974 that in his youth Vidali and another man organized the assassination attempt on the Italian heir to the throne, Prince Humbert of Savoy on October 25, 1929 in Brussels.[13] The attempt was in fact carried out by a lone antifascist, Fernando De Rosa, who had fled to Belgium from Mussolini's government.[14] Vidali's enemies would certainly have capitalized on any involvement by him in a monarchical assassination attempt, but not even the worst of his detractors claimed that he was in Europe in 1929, though crediting him with the gift of ubiquity. I shall return to Vidali, often described as a "mysterious character,"[15] for he provides a key to understanding Modotti after 1930, when their political lives became entwined. Modotti joined the Communist Party in 1927 but her interest in communism dated from much earlier.

As her circumstances changed, the space for politics was enlarged. In December 1924 Weston had gone back to California, "leaving his studio in charge of Miss Tina Modotti," as *El Universal* put it.[16] He sailed back to Mexico, this time with his son Brett, to his "unfinished period of work and life,"[17] arriving at the end of August 1925 in Guadalajara. There they were met by Modotti who with Carlos Orozco Romero had arranged for an exhibition of both of their work at the State Museum.[18] The show was highly praised by the press, which rebaptized Weston "the Emperor of Photography, who, notwithstanding his birth in North America, has a Latin Soul" (this naturally provoked Weston's laughter). The papers also declared that "in his camera lens, Weston has the depth of a cyclopean eye"[19] and that "Tina and Weston speak separately their own emotional languages."[20] The usually austere Siqueiros wrote a glowing review that said "the work of Weston-Modotti is the best proof of what can and must be accomplished in the dark room" and "Weston and Modotti possess a true photographic beauty. The texture, the physical quality of things could not be rendered with more exactness: the rough is rough, the smooth is smooth, flesh is alive, stone is hard."[21]

Just before the show Tina was interviewed by José M. Peña for *El Sol* to whom she seemed at first a *bella y amable sufragista* (a beautiful and agreeable suffragist), perhaps because of what he called her "totally masculine

attire" – a shirt and tie. He noted that her accent in Spanish was more English than Italian, and that she hated photographic retouching. Modotti, while accepting a cigarette, praised the efficiency of big cities, stating that life in the United States was agreeable because it was "perfectly organized" – which did not mean to imply that she did not admire or like the Mexican style, quite the opposite. Peña was so impressed by Tina that he fantasized that at her birth she had received three gifts from the Three Wise Men: her goodness of heart for gold, her illusions for incense, and her inspiration for myrrh. The interview closed with a kiss that the journalist could not help delivering on Tina's "refined and delicate hand."[22]

After the show, Modotti, Edward, and Brett Weston returned to Mexico City by train. Tina insisted on riding second class "in the dim light among the Indians," while the other two had first-class tickets.[23] Weston's second Mexican sojourn, which lasted until November 1926, turned out to be prolific as far as work was concerned, although his diary reveals tiredness and intolerance toward urban life – Mexico City already numbered 625,000 people. Nevertheless Mexico proved so stimulating that Weston produced several experimental pictures, thanks to the visual baggage he had accumulated. He was even offered a teaching job, which he declined. Meanwhile, in October 1925 Tina's sister Mercedes came to stay for about two months. With Weston and Carleton Beals, the Modotti sisters spent a brief time in a Cuernavaca home belonging to their friend Fred Davis, the owner of the Sonora News Company gallery in Mexico City. Beals was apparently bewitched by Mercedes, whom he described as "a strikingly beautiful and romantic girl," and the place as "an enchanting spot."[24] (They also went to see Rivera's murals in Chapingo.[25]) Mercedes and Beals even exchanged love poems and amorous letters – which did not prevent her becoming friends, years later, with Beals's wife.[26]

Weston's relationship with Modotti had definitely moved to another sphere, of friendship and business only; they had both grown distant from the other. For pages and pages in Weston's 1926 diary, Modotti is hardly mentioned, partly simply because she had to leave for San Francisco when her mother had become ill. But with Tina absent from the end of 1925 to March 1926, the Mexican household suffered to such an extent that the electricity was cut off for non-payment of the bills.[27] The major reason, though, for the distance between them was that Tina had become more and more absorbed in politics. From 1926 on, all the men she loved were associated with political militancy. This, however, does not mean that she was incapable of original political thinking, as Octavio Paz has claimed: "Modotti's figure belongs more to the history of passions than to the history of ideologies."[28] Rather the reverse: precisely because of her political credo

her emotional associations paralleled her ideological line. Weston, by contrast, had turned to "flying" affairs that, while being safe emotionally, were by his own admission tiring and time-consuming. His love/hate relationship with Mexico continued. Although the restless artist adored Mexico and was glad to return there, he was never quite satisfied there or elsewhere.

Tina, however, embraced Mexico and Mexican culture thoroughly and "was able to enter more quickly into the essence of Mexico."[29] When interviewed by a Mexican journalist in 1923 she had stated that while living in Mexico she felt like a Mexican, but while in the United States she felt that she was in a foreign country.[30] Yet for ten years she had made California her home and had felt at ease with Californian culture. But when she returned to San Francisco in December 1925 she found herself alienated from the city and its people. In a handwritten letter to Weston of January 1926 she complained that her old friends and acquaintances in San Francisco did not take her "seriously as a photographer" and that nobody asked her to show her work.[31] But the photographer Consuelo Kanaga must have provided an antidote to such impressions when she made Tina go through the complete collection of the journal *Camera Work* in her studio at 1371 Post Street. Most of Modotti's friends, after all, could not possibly have followed her photographic career in another country, or they might indeed have thought that she was not serious about photography. Officially she remained "Weston's assistant"[32] or "Weston's *discipula*" (pupil),[33] and during this trip to California she articulated to herself, and to Weston as a kind of sounding board, her need to embrace photography, and her motivations and expectations.

While in California she also took the opportunity to sort out her belongings in Los Angeles and decided to destroy a great part of them. In "a rite de passage from a materialist's existence in capitalist America, to an idealist's future in revolutionary Mexico,"[34] she kept only the possessions that were "in relation to photography," as she explained by letter to Weston: "The rest – even things I love, concrete things – I shall lead through a metamorphosis, from the concrete turn them into abstract things – as far as I am concerned – and thus I can go on owning them in my heart forever."[35]

Guided by Kanaga, Modotti traded in her old Korona 4 × 5 for a new smaller camera, a Graflex, so that she could "loosen up," as she wrote in the same letter. It was with this camera that from June to August 1926 Tina photographed Mexico for a famous project, although the extent of her contribution is still unclear.[36] Weston had been hired to travel around Mexico to make a series of prints for a book on Mexican folklore, *Idols behind Altars*, by Anita Brenner.[37] The writer's commission from Alfonso Pruneda, the former rector of the Universidad Autónoma (National University), was

to make Mexican culture known to the American public. Weston must have welcomed the prospect of visiting and photographing new parts of the country, and being paid 1,000 *pesos*. Negotiations between Weston and Brenner began in April,[38] but the project did not materialize until summer. Together with Tina and Brett, Weston visited Puebla and Oaxaca first, then Michoacán, Jalisco, Guanajuato, and Querétaro. In his ubiquitous diary he recorded the well-known "mixture of coarseness and sublimity, that is characteristic of most poverty cultures."[39]

Brenner was born in Aguacalientes in 1905 to Jewish American parents whose family was part of an extensive community of Jews in the South.[40] Anita was raised speaking Spanish and English in Texas, where she experienced both antisemitism and anti-Mexican attitudes. As a child in Mexico she witnessed a pro-Villa campaign, something that later emerged in her writing. She studied anthropology at Columbia University in New York and worked for two years as a research assistant to Ernest Gruening, the former editor of *The Nation* and the author of *Mexico and Its Heritage* (1928), who went to Mexico in 1922, from New York. Weston reports meeting him in October 1925 at a Saturday night party.[41]

The first mention of Modotti in Brenner's journal (edited by her daughter Susannah Joel Glusker) occurs in November 1925, shortly after Weston and Brenner had signed the contract for *Idols behind Altars*. As Glusker suggests, one can discern a certain animosity between Brenner and Tina, who apparently snubbed Anita, calling her "a vulgar scheming adventuress" and her work "perfect publicity."[42] The relationship eventually improved, especially after Weston's departure left Tina as the only professional photographer available in their circle. She even photographed Anita, dressed mannishly in a black velvet jacket, a black bow tie, and soft felt hat. But Brenner always detected the "undercurrents of hostility"[43] in Modotti, whom she characterized as "actively friend," "actively enemy," and "actively both."[44] Although the two women never became friends, they were civil to each other, and many years later, Brenner even stated that she liked Tina very much since she was a romantic, gentle person.[45] The two women would sit together and gossip, mainly about Rivera – the prime subject of many stories. At times, Brenner would ponder whether "a life like Tina's diffusing much joy by numerous cohabitations, and also by fine prints, weigh [*sic*] with [Francisco] Goitia's chastity, and Michael Angelo's."[46]

In one incident, however, Brenner was double-crossed by Modotti. Brenner possessed a better knowledge of copyrights than Modotti so was furious when she discovered that in 1927 Modotti had given some of the photographs of Orozco and Goitia that she had taken for Anita to Ernestine Evans, a freelancer who contributed to various magazines and was

preparing a book on Mexican murals. The original photographs, which later appeared in Brenner's book, were published in London without Brenner's permission and, worse, without her knowledge. Since Evans (who was married to Kenneth Durant, the head of the Soviet news agency's New York bureau), was also a communist like Tina, Brenner vented her anger against "unethical comrades."[47] But once *Idols behind Altars* had been published, in October 1929, the issue seems to have been forgotten. In fact, Brenner acknowledged both Weston and Modotti as the two photographers ("masters of their craft") who shared the commission.[48] Tina returned the compliment by comparing Anita's work to the "birth of the first brainchild."[49]

The book was reviewed by the same Ernestine Evans in *Creative Art*.[50] As a multidisciplinary approach to Mexican culture,[51] it combines acute observations on Mexico and its art with a strong empathy and sensitivity for Indian culture. Brenner was attacked on exactly this issue in 1931,[52] and a great patron of the arts, Antonieta Rivas Mercado, labelled the book "Jewish propaganda, pro-Diego and pro-Charlot,"[53] to which she added *un mamarracho de mala fe* ("a worthless thing done in bad faith"), "poorly organized, and useless as a reference book."[54] Generous praise came from Carleton Beals, who wrote that "this book is a glorious record of a glorious decade."[55]

Brenner had grasped the essential points of Mexican culture: religion, in her view, had always been the dynamic power in Mexican art and the pillar of civilization; but some idols were on altars while others were behind altars or crosses.[56] The author also detected before anybody else that Mexican art had a strong "collective" aspect, using that word long before it became current in academia. Her profound understanding of Mexico may have been the result of what John Britton has called "a blending of Mexican, Jewish, and bohemian values with a growing sense of populistic radicalism."[57] Photographs and reproductions of architectural buildings, murals, illustrations for ballads by Guadalupe Posada, drawings by Paul Higgins, woodcuts by Xavier Guerrero, oils by Carlos Merida, Jean Charlot, Carmen Fonserrada, Abraham Angel, and Manuel Rodríguez Lozano, watercolors by Rufino Tamayo, and pastels from Francisco Goitia make up the illustrative material of the book. Between 250 and 400 photographs were taken, but only 70 were used.[58] Eisenstein was so inspired by the book that in 1930 he traveled to the United States and Mexico to see if he could make a film. Its provisional title was *¡Que viva México!* and it was financed by the American producer, Upton Sinclair. The Mexican photographer Manuel Alvarez Bravo was hired to be the cameraman.[59] But the project never fully materialized because of conflicts with Sinclair's family: the film

was made, but without a script. The Mexican government later published a book of drawings by Eisenstein.[60]

If Weston was the contracted photographer of the project, Tina once again was his link to reality and to the human world, a sort of cultural filter through which Weston could cope with unrest and tension. As he himself admitted, with her tact and sympathy for the Indians, Tina proved to be indispensable.[61] While travelling to Michoacán, Tina and Weston learned that a friend of theirs, the senator Manuel Hernández Galván, had been murdered by political opponents.[62] Their journey also coincided with the Cristeros' religious revolt, in the western states: President Calles had ordered compliance with various anticlerical clauses in the constitution, which the clergy had refused to obey. Beginning in July 1926, masses and church services were banned for almost three years. This made it difficult for Modotti and Weston to carry on that part of the project related to churches and religious objects. Some of the artifacts had simply been sealed and locked up. Moreover, people had become skeptical of foreigners who visited sacred places; sometimes the photographers were accused of being government spies. This attitude, on a much smaller scale, could be compared with that which prevailed during the Chinese Cultural Revolution, when visitors arrived at museums from far away, only to find them closed!

Tensions between government and the ecclesiastical authorities were not new in Mexico. They arose out of conflicting views on territorial and spiritual influence and control. The republic's constitution had never been accepted by the Catholic church, whose clergy had never before been subjected to government control, or had their traditional wealth regarded as excessive.[63] Mexico's modern history abounds with church protests and government bans. On January 13, 1923, for example, the government, led by Obregón, had expelled Monseñor Ernesto Filippi, an apostolic delegate, on the grounds of constitutional violations. Filippi had been in charge of the construction of a monument devoted to *Cristo rey* (Christ the king) in Cerro del Cubilete. A church protest followed his expulsion. Three days later, Mussolini as head of the new-born fascist regime received a petition from the ecclesiastical authorities to intervene with the Mexican government, so that in Mexico "Christian ideas be respected and freely professed."[64]

In February 1925 Luis Morones, the secretary of the Confederación Regional Obrera Mexicana (Regional Confederation of Mexican Workers) demanded that a parish priest hand over his church building. Conflict had escalated to such a point in 1926 that in July the government, led now by Calles, issued an order to promote secular education in schools, to make only civil marriages valid, and, as noted earlier, to suspend religious services. In other words, the president was reinforcing the 1917 Constitution.

Calles, a fervent anti-Catholic, was determined to strip the church of its land and wealth. The most powerful cleric in the ensuing battles was Archbishop Pascual Diaz of Mexico City, under whom the Iglesia Católica Apostólica Mexicana was created by Father Joaquín Pérez and the Cristeros movement was formed with Pedro Quintanar as its leader.[65] Religious masses were secretly performed at risk of a government raid, and priests sheltered in the homes of wealthy participants in the fight, or if coming from poor villages they were hidden in caves.[66] Rural schools were attacked by Cristeros fanatics who, while proclaiming abhorrence of violence, murdered teachers and left their bodies labelled with banners that said "Christ is king." Government army units acted with comparable violence. At the core of the Cristeros movement was the belief that the government, formed by "imperfect" men, should be neglected because only "Christ is king." Thus the Cristeros's total allegiance to the church and their hatred for government laws, considered by them to be "work of the devil." Meanwhile, in the U.S.A. the Knights of Columbus raised no less than a million dollars to help the Christ-the-king guerrillas.[67]

In fall 1927 the conflict appeared to have been solved, through the intervention of Walter Lippman from the U.S. Council of Foreign Relations and Dwight Morrow, ambassador to Mexico, both sent by President Coolidge.[68] However, peace was only temporary. When Calles's term ran out in 1928, Obregón was re-elected by emergency decree to bypass the law that forbade the re-election of a president. Nevertheless, Obregón had played the role of mediator between church and government and was therefore the logical successor. In July 1928 Modotti photographed the pro-Obregón demonstration that accompanied the new president's entry into the capital.[69] But the most fanatical Catholics had not forgiven the government and its emissaries. An attempt on Obregón's life on November 13, 1927 carried out by a group of Cristeros members (one of whom, a Jesuit priest, Miguel Agustín Pro Juárez, was captured by the police and shot),[70] was followed in less than ten months by a second. On July 17, 1928, about ten days before Obregón's inauguration, José León Toral, a young Catholic teacher and disciple of Concepción Acevedo de la Llata (known as Mother Conchita), fired five shots at Obregón in the restaurant La Bombilla and killed him.

The church distanced itself from the assassination, blaming the killer as a "fanatic and abnormal." The answer of the communists to the church's behavior was an article by Julio Antonio Mella who indirectly blamed the church and the clergy for preparing the ground for such fanaticism.[71] After a lengthy trial, in which the assassin explained that Christ the king required the sacrifice of someone's life, in February 1929 Toral was executed. He had

been horribly tortured, even hung up by his testicles, but Beals reported that the police never broke his spirit,[72] despite the brutality of an officer, Valente Quintana (who later played a major role in Modotti's trial). At Toral's execution, believers waited for miracles to be performed by scraps of his personal belongings.[73] His diabolic mentor, Mother Conchita, who used to brand her followers with a cross,[74] was sentenced to more than twenty years for conspiracy.[75] Obregón's support never believed the official version of the assassination, and pointed their fingers at Luis Morones, who was known to have presidential ambitions of his own: they were so persuasive that Calles requested Morones's withdrawal from his ministerial post.[76] The church–state conflict, which caused the death of many citizens,[77] was not resolved until summer 1929, when the well-known lawyer and governor of Tamaulipas became president – Emilio Portes Gil, from the Partido Nacional Revolucionario (PNR).[78]

The summer 1926 trip was the last major project Modotti and Weston undertook together. Weston credited Mexico with influencing his thought and life, with revealing to him both its "soil" and the freshness of its elemental culture. In an article in *Mexican Life* of June 1926 he compares photography and painting: far from photography affecting painting, it had been moving away from a school of painters who were in fact trying to imitate photography – to prove his point, Weston lists Diego Rivera, Jean Charlot, and Carlos Mérida. His conclusion claims that "only the photographer can register what lies between himself and the object before his lens."[79]

According to Calles's granddaughter, Adriana Williams, during that summer Weston and Tina became the artists Miguel and Rosa Covarrubias's frequent companions, touring Mexico together and "chronicling their visits to Indian villages and recording the craggy landscapes they traversed, and one another, in hundreds of photographs."[80] Rosa Covarrubias, a dancer and painter, learned photography from both Weston and Tina, and described it as the "newest and long-lasting form of artistic expression."[81] One of the very rare (if not the only) pictures of Tina holding her camera shows her with Miguel Covarrubias, hands in his pockets. The photograph, taken by Weston on the roof of their house in Mexico City, appears to have been taken earlier – probably in 1924 – as the camera she holds is not the Graflex she acquired in early 1926.

In November 1926 Weston left Mexico City for good. Since he associated Mexico with Tina, the leaving of the country, he wrote in his diary, "will be remembered for the leaving of Tina."[82] Weston's words are full of tenderness, despite the composure (and sense of humor) he was trying to keep:

The barrier between us was for the moment broken. Not till we were on the Paseo in a taxi rushing for the train did I allow myself to see her eyes. But when I did and saw what they had to say, I took her to me, – our lips met in an endless kiss, only stopped by a gerdarme's whistle. Our driver tactfully hinted that public demonstrations were taboo, – for shame! Mexico is surely becoming United Statesized.[83]

That was the last time that Weston and a tear-filled Tina saw each other, though they corresponded for a few years with great affection. As she wrote to him: "Whenever the mozo of the building appears at my door with one of those long envelopes I feel a thrill run through me – to keep in contact with you means so much to me Edward."[84] And: "My heart is always with you dear even when my mind is not."[85] Weston had lost not just a lover but also a friend, peer, nurse, model, muse, apprentice, translator, agent, studio manager, and occasional porter, cook, and maid.[86]

After the first painful moments, Modotti must have felt liberated from him, especially from his conflicts and contradictions, for she changed radically. The problem of reconciling her artistic calling with her political calling emerged. By her own admission, before 1926 she had felt "too restrained" in her work.[87] Her domain enlarged, her life and political visions changed, so too did her photography. She became distant from the people she knew with Weston. By his rejection of political ideology, Weston had created a protective barrier between them and the world, which now fell away.[88] In sum, she gradually passed from an early cultural radicalism to a committed militancy, and her choice was "convinced and passionate, although not without conflicts."[89]

Changes were imperative. As shown on her business card, where she identified herself in English as "photographer,"[90] Modotti moved into a small apartment on the fifth floor of the Zamora building at 31 Abraham González Street, only a few minutes away from Zocalo Square. The place was simple, tidy, functional – it included Tina's studio and dark room.[91] From 1927 many political meetings were held in that three-room wooden-floor apartment, equipped with a telephone. Tina the comrade had learned the central importance of a team for successful political work. A constant stream of people came to see her – writers, musicians, and painters, who all wore "overalls with a red star pinned on the front."[92] She frequently gave parties, especially if there were something to celebrate – the release of a comrade from prison, for example,[93] or if funds were needed for a political cause.[94] In that case, while collecting the money she would pass around somebody's hat, stating in Italian: *A buon intenditor poche parole* (To he who understands, few words are necessary).[95] But she never acted as the pro-

tagonist of these parties, although "her presence was much noticed."[96] Sometimes she was accompanied by men who are mentioned only once and then disappear from the scene, for example a German doctor named Hutz.[97]

Modotti began her serious contribution to the communist party, probably inspired partly by another female activist, Alexandra Kollontai, who in fall 1926 visited Mexico as emissary from the Moscow Communist Central Committee.[98] A few months later, in January 1927, Kollontai became the official Soviet representative to Mexico and a member of the Soviet delegation to the League of Nations.[99] Within a year she had to leave her post (she was replaced by Alexander Makar). The heat and high altitude of Central America were affecting her health, although according to another theory she was asked to leave by the Mexican government because of her "extra diplomatic activities of subversion." The health reasons were merely the official version agreed by the Mexican government and the Soviet Union.[100] Kollontai returned to Moscow in October 1927.[101] While in Mexico she had met Modotti, who spoke of her with great affection.[102] During the farewell for Kollontai at the Russian embassy, the Mexican police raided the party, claiming that they suspected an illegal religious service was in progress.[103] The police arrested several people, among them Modotti, but little is known about this incident.[104]

The period of Tina as nude model was gone, but the fact of having posed nude created the myth of her as a femme fatale. All of the men who knew her admit to having fallen in love with her, mainly because of her grace. Rivera, being a notorious womanizer, "biologically unfit for fidelity" as he liked to say to justify his pecadillos,[105] could not possibly have acted differently; it does not follow that Tina reciprocated. However, perhaps out of "docu-drama addiction" most people (except Sarah Lowe)[106] like to think that she did, supposing that their affair occurred as follows.

In spring 1927 Modotti and Rivera spent a considerable amount of time together. For at least two of his murals of this period, titled *Song of the Earth*, Modotti served as his nude model, depicted with beauty and sensuality.[107] In one nude, Tina is painted like a mermaid, with arms above her head, breasts facing the viewer. In another, titled *La tierra dormida*, she is holding an orange flower, like an offering, like a vulva.[108] As Tina wrote to Weston, she was also commissioned to photograph Rivera's murals, as a way of supporting herself.[109] Brenner suggested that Tina was Rivera's "megaphone."[110] But according to Lupe Marín, then still Rivera's wife, they were not only photography or innocent modeling sessions: "he carried on so flagrantly" with the model Tina Modotti.[111] Marín was then occupied with the birth of her second child but once the baby had arrived she turned into a sleuth and discovered the affair. The story ends like a soap opera. Lupe,

the untamed creature who "had a genius for insulting everybody,"[112] sent one of her insulting notes to Tina.[113] Modotti, who was clever enough not to have a person like Marín as an enemy, ended the affair abruptly. In the years to come, Modotti and Rivera met without amorous entanglements.

After this little parenthetical tragi-comedy (and here ends the melange of fiction and reality), Diego Rivera left Mexico in fall 1927 for the Soviet Union for the second time, accompanied by Siqueiros.[114] Edo Fimmen, president of the International Transport Workers' Federation, had arranged for Rivera to attend the celebrations of the Tenth Anniversary of the October Revolution. Among Rivera's party was José Guadalupe Rodríguez, founder and leader of the Peasants League and of the Labor Party of the State of Durango.[115] In Moscow, Rivera was caught up in the pageantry of the celebrations, recording as much as he could in sketches.[116] The Russian press discovered the Rivera phenomenon and passed it along to the public; *Krasnaya Niva* for example, had him paint a picture for the cover of their Paris Commune anniversary number.[117] He was also commissioned to paint a mural on the Red Army building in Moscow but the project never materialized: a series of conflicts and misunderstandings arose with Rivera's Russian assistants, whom he judged "incompetent," and from a sudden illness caused by sketching winter scenes outside in the snow of a rigid Moscow winter. Then in spring 1928 came the campaign for the personality cult of Joseph Stalin. Images of the face of the Soviet ruler appeared everywhere. Rivera was commissioned to make a sketch of Stalin but, according to Wolfe, the painter was not favorably impressed by his subject.[118] (Picasso too encountered difficulties over his portrait of Stalin in honor of his 70th birthday in 1949, although the poet Rafael Alberti had no trouble "exercising the proletarian rhetoric" in a terrible poem on Stalin's death[119].)

At this point, to avoid further embarrassments and problems on both sides, Rivera was recalled to Mexico by the Communist Party and the Latin-American Secretariat of the Comintern, to perform as president of the Workers and Peasant Bloc.[120] He returned to his household in May to find that Lupe had moved in with a pseudo-poet, Jorge Cuesta, whom she later married (and divorced). In fact, this was not a shock for Rivera since he had been told the news in Moscow in a letter from Lupe. Moreover, Rivera was not new to scandals and controversies, even taking pride in them.[121] Besides attacking him personally (she called him *canalla*, vile), Lupe inserted some slanders on his communist affiliation with the Soviets.[122] Since Rivera and Lupe had not been married by the state (only in church, in June 1922), no legal divorce was necessary.

Other Mexican party members proved to be less individualistic than Rivera and more loyal to "Mother Soviet Union," among them Xavier Guerrero, whom Modotti had met in 1922 in Los Angeles. There was a brief but intense affair of some kind between them which had probably started when Weston was still in Mexico. It was either a strong friendship based on loyalty to a common political cause, which was mistaken for love, or truly a love affair. The playwright Víctor Hugo Rascón turned it into a play entitled "Tina Modotti," with an intransigent Guerrero and a Modotti almost allergic to theories.[123] The real Guerrero exemplified the revolutionary artist. He had been directly associated with the muralist movement, at first as an assistant, painting his own murals in 1925 in Guadalajara. A portrait photograph of 1923 by Weston (in some books attributed to Modotti) shows his "beautifully carved face"[124] that suggested respect and pride. Guerrero was a Tarahumara Indian from Coahuila, with straight black hair, high cheekbones, and impassive countenance. Among his friends he was known as el perico (the little parrot), because he could be silent for long periods[125] and then suddenly speak, as little parrots do. According to Vidali, it was precisely because of his reserved character that Modotti fell in love with him, as a reaction to her previous association with a "neurotic man."[126] She too made a picture of Guerrero, with Francisca Moreno, the 8-year-old daughter of Francisco Moreno, a communist worker and deputy in the Veracruz legislature who had been assassinated by General Lindoro Hernández on September 14, 1925 inside the Jalapa municipal palace.[127] Like other portraits, this one of 1927 has the quality of "old Venetian lace," to use Carleton Beals's words.[128] Tina took a second photograph of the little girl, wearing a Soviet Young Communist Pioneers badge. After Francisca lost her father, Tina, Guerrero, and his sister Elisa often looked after her; she is one source for our knowledge of for instance Modotti's visits to the Soviet embassy in Mexico City to meet with Kollontai.[129] Modotti photographed Francisca again with Rose Richey, who came to visit her Tina in July 1927.[130]

Guerrero was reputedly a compassionate man (which shows in his affectionate pose in the picture with Francisca), with a visionary's belief in the power of revolution.[131] He embraced communism and joined the party, becoming a devoted member. Perhaps Guerrero became Tina's link to political commitment, as in Los Angeles he had been her link to Mexican culture.

As an activist he was involved in several artistic and revolutionary organizations, among which was the Friends of China.[132] While they were together in 1927, Modotti translated one of his articles for publication in New Masses. Titled "A Mexican Painter," the essay gives Guerrero's

rationale of art as a revolutionary tool, expressing his hope for an "art that can lead to a classless culture of the future."[133] Over the years *New Masses* continued its interest in Guerrero and published his drawings.[134] When Dos Passos went to Mexico to look for inspiration for a new novel, it was Guerrero who accompanied him to Indian villages.[135] The American writer was so overwhelmed by their visual impact that he wrote an enthusiastic article, published in *New Masses* in March 1927,[136] in which he explains the inevitability of the revolution and its link to art, as the muralists had perceived it. Modotti reported Dos Passos's visit to Weston, adding that the writer appreciated photography "as it should be."[137] She photographed Dos Passos wearing a poncho among the Indians.

At the end of 1927, Guerrero was chosen by the party to go to the Lenin School in Moscow for a three-year course. He was not expected to question the decision of the party and he did not. In December he left with no hesitation. Just before his departure, Tina joined the Communist Party – a decision that had gradually taken shape in her mind – but according to Vidali she was not yet active in party life.[138] Her membership number was 2018142.

The purpose of Tina joining may also have been to cement their love, which was largely founded on their political beliefs. For a while, they continued their relationship by letter. Guerrero did not always agree with Tina's gestures of camaraderie at parties and meetings, which he believed could be misunderstood or misinterpreted and might give their enemies the opportunity to criticize. His protective attitude was the result of both guilt (for not being there with her) and jealousy (toward other men). He also promised to send Tina some cloth, although nothing fancy, he said, and "nothing comparable to what one can find in Los Angeles."[139]

Deprived of affection once more, Tina immersed herself in several freelance projects and political work. Since 1923 a steady job had held no interest for her, perhaps from lack of discipline or of motivation. An attempt in spring 1925 resulted in aborted failure: she was employed for five hours in a shop called Casa Guastaroba (of unidentified nature). In her explanation to Weston she wrote: "I just had to quit – I have no other reasons in my defense only that during the first morning of work I felt *a protest of my whole being* – it was something instinctive – not reasoned. . . . during the five hours which constituted the morning work I suffered tortures. It was good to have this trial, for now I appreciate so much more my freedom – my time – my life – everything." The letter was signed "A happy and *free* Tina, happy because she is free."[140]

Around the time that Tina Modotti joined the Communist Party, she became involved in the Mexican branch of International Red Aid (Socorro

Rojo Internacional), a leftist version of the Red Cross (she later continued the work in the Spanish branch of the organization, during the Civil War). Created at the end of 1922 in Moscow, following the Fourth Congress of the Communist International, International Red Aid (in Russian, MOPR) was conceived "as a mass, nonparty organization with the purpose of giving aid to all those who suffered imprisonment or exile for having supported the proletarian movement against capitalist reaction."[141] The organization provided help to political refugees and the victims of political persecutions.[142] In practice, this meant protecting and supporting them and their families, adopting and educating their children, and providing legal and medical assistance, as a letter from the Italian Communist Party to one of its members shows.[143] As a publication of the Spanish Civil War written by the Marxist group POUM stated, "the work of Red Aid is the complete opposite of bourgeois charity."[144] The work of the *patronati* (those organizations that took refugees under their wings) became inseparable from Red Aid's work.[145] In fact, the activities of International Red Aid belong in a much broader context with other, no less important, auxiliary organizations such as International Workers' Aid, headed by Willi Münzenberg, a German communist[146] who perished in 1940 in mysterious circumstances.[147] The *patronati* also played a crucial role on behalf of Italian refugees in France during the fascist period.[148] Modotti herself became the secretary of the Italian Patronato Messico-California in a joint effort with the Defense Committee for the Victims of Fascism, directed by Henry Barbusse.

In Europe and in the Soviet Union, International Red Aid attracted several well-known people who were not necessarily leftists – among its followers were Albert Einstein, Thomas Mann, Romain Rolland, and Maxim Gorky. The communists believed that the socialists, despite their international outlook, were sectarian and opposed Red Aid almost as vehemently as right-wing groups. One communist has claimed that, for example, the Foundation Matteotti was created in Italy in April 1926 by the social democrats with the specific aim of fragmenting the unity of Red Aid; in fact, it was a condition of joining the Matteotti Foundation that one had to leave Red Aid first if one were a member.[149] The first local International Red Aid conference was held in Moscow in April 1927 with delegates from 44 countries. Its president was Elena Stasova (better known under the name of Absoljut), a Bolshevik from Lenin's entourage. On November 7, 1932, on the fifteenth anniversary of the Bolshevik revolution, Red Aid held its first world conference, with 67 delegations. By then its members numbered more than 11 million[150] and it issued various publications of which the most well-known was the Soviet *Puti Mopra*; it

published several photographs by Modotti. But in spite of such numbers, government repression in some countries forced the organization to work illegaly, as in Italy from 1925.

In Mexico, the Red Aid section was fairly new. Working along side the Anti-Imperialist League, Vidali as one of its leaders in 1927 tried to transform Red Aid into an umbrella organization for various revolutionary movements.[151] A fellow communist recorded that Vidali's work was limited to "ordering around other people," speaking first in Italian then in "atrocious" Spanish.[152] Although Vidali remained the titular head of the Mexican branch and in 1928 took much of the credit, as he himself wrote to a "dear comrade,"[153] in reality Modotti was its indefatigable chief coordinator and director, which Vidali later admitted.[154] An historically charged photograph of hers shows Rivera participating in a Red Aid meeting. The organization's banner makes an odd background, resembling a large flying flag, as if Rivera were greeting the crowd from a hot-air balloon. But the photograph by Modotti that gives the idea of community in the organization is that of a Red Aid rally in spring 1929.

As had happened in Europe, in Mexico Socorro Rojo Internacional attracted people from various political backgrounds. This is not surprising since the cultural and political worlds were (and still are) closely related.[155] The Sacco and Vanzetti issue, which Tina pursued passionately and unconditionally, was one of Red Aid's most prominent battles.[156] By 1929, several members of the Mexican Red Aid were working side by side with the Communist Party. El Machete itself regularly published a section devoted to "Ayuda" Roja, with which several communist members collaborated, among them Macario Flores and Horacio Muñoz.[157] Therefore, especially in the eyes of the Mexican government, Red Aid and the Communist Party were synonymous – which accounts for the police raid against Red Aid's headquarters in Mexico City at the end of summer 1930.

Modotti's activism in this period was noted by Jean Charlot when writing to Weston: "Tina goes hard on social work."[158] But she was socialable too, in particular with Robo's mother who, as noted before, came to stay with her for a month in summer 1927.[159] Modotti also worked with Manos Fuera de Nicaragua (Hands Off Nicaragua), an association created in May 1927 in response to the American occupation of Nicaragua.[160] A photograph from 1928 presents the Sandinista group posing with a captured American flag. El Machete reproduced a photograph of the Sandinista flag on which it was said that Sandino himself had written a commemoration of the battle of El Zapote in May 1928.[161] And New Masses celebrated the victory of the Sandinistas with an article by Sandino's brother.[162] The

struggle of the Nicaraguan people became a beacon for the left because it showed that a small but zealous army could face a colossus.[163]

It was on the bilingual magazine *Mexican Folkways* that Tina collaborated with her best woman friend in Mexico, Frances Toor, its founder. Paca (as she was nicknamed) was an American Jewish anthropologist, an expert on folklore, who had arrived in Mexico in 1922 with her husband, Dr. Weinberger, to take a course at the National University and decided not to return to the United States. She was fascinated by Indian culture and customs, as her work on Mexicana shows;[164] as she explained in the first issue of the magazine, she was funded by a grant from the Ministry of Education.[165]

From the correspondence and documents of the time, Toor comes across as truly opinionated and a busybody, always ready to make unsolicited suggestions and always keen on reporting gossip. In other words, a person whom, although good-hearted, one must take in small doses. Not for nothing did Brenner call her "a competitive colleague."[166] From New York, Orozco wrote to Charlot that Frances was there looking at everything so she could go and tell it to Mexico.[167] In another letter, he said that Paca was in the neighborhood, "snooping around."[168] Toor was aware of people's dislike of her, as she wrote to a friend.[169] Part of the problem was that the intelligentsia in Mexico formed a fairly small group, so the gossip traveled fast. Moreover, the office of *Mexican Folkways* was conveniently located on the first floor of the building where both Modotti and Toor lived. Thus Toor was always, willingly or unwillingly, kept posted on all the news.

Publication of *Mexican Folkways* continued sporadically until 1933. Its first art editor was Jean Charlot and other contributors, as writers or translators, included Carleton Beals, Monna Alfau, Diego Rivera (who later became art editor), Anita Brenner, and Robert Redfield, a young anthropologist from the University of Chicago. In spring 1926 *Mexican Folkways* published a laudatory article by Rivera on Modotti and Weston's photography, which greatly pleased Weston.[170] The format of the magazine changed in 1927: it became larger, more impressive, but still reproduced Modotti's photographs. Her subject matter was people and murals, prints of which she sold for 50 U.S. cents each, as advertised in the magazine.[171] A California-based philanthropist, Albert Bender, ordered a set of fifty prints of Rivera's murals directly from Modotti at a cost of $25.[172] And Orozco, who was in New York in 1927, commissioned Tina to photograph sections of his murals. As she wrote to Weston: "As time goes by, I find myself liking Orozco's [painting] more and more. I feel the genius."[173] The commission was fulfilled through his "twin"[174] Jean Charlot, who reported

that Modotti's photographic "pharaphernalia was old-fashioned, even for that day, and it took much ingenuity to fit her bulky box camera and tripod along the staircases."[175] The two Covarrubias also played a part in Modotti's social and artistic world, particularly in summer 1928,[176] but otherwise spent long periods in New York. Bruno Traven, writer and revolutionary, commissioned Tina to produce a set of prints of murals for a film, which however was made only much later and without Modotti's images.[177]

Tina also worked for *El Machete* as translator, freelancer, and photographer, and in this last capacity she provided a new direction and an element the paper had lacked until then, as explained in an article.[178] *El Machete* was founded by Siqueiros, Guerrero, and Rivera in March 1924[179] and Orozco contributed illustrations from the early numbers. It continued legal publication until August 1929 when it was suppressed by the government after Obregón's assassination.[180] The weekly defined itself as the "workers' and peasants' newspaper." For its first three years the official director and editor was Rosendo Gómez Lorenzo.[181] Graciela Amador (then Siqueiros's wife) became the writer of the mottos and *corridos* (popular ballads created spontaneously)[182] besides being one of the editors. The red and black oversize front page, $16^{1}/_{2} \times 5$ inches, carried a large scythe across the top[183] and Amador's first fiery masthead proclaiming:

El Machete sirve para cortar la caña, para abrir las veredas en los bosques umbríos, decapitar culebras, tronchar toda cizaña y humillar la soberbia de los ricos impíos.

(The machete serves to cut the sugar cane to open paths through the darkest forests, behead vipers, chop down all weeds, and shame the arrogance of the godless rich.)[184]

The paper's orientation was evident also from the drawing of a closed fist, by Siqueiros,[185] and from the publication on its cover of the musical score and words of the *International* hymn.[186] On April 12, 1925 it became the official organ of the central committee of the Mexican Communist Party,[187] to merge information, theory, and practice, although Siqueiros stated that the paper represented "a very embrional experience of the various revolutionary forms of graphics."[188] Its targets were American imperialism, the Mexican bourgeoisie, and "bureaucratized" and static intellectuals. Its purposes were to raise people's political consciousness and to expose the condition of peasants and miners.[189] At the end of 1928, *El Machete* had reached 11,000 copies. The paper sold for ten *centavos*, so, according to a critic, it was inaccessible in price to the majority of the workers and peasants, who earned an average of thirty cents a day. Moreover,

despite its popular ballads, it was inaccessible by virtue of its ideas and language.[190]

An overview of *El Machete* from its birth helps us to reconstruct Tina's political life, which in a way went hand in hand with the development of the paper. Although the topics of its articles are eclectic, there is an evident major interest in the local politics of Mexico, and a strong identity with the Soviet Union, at that time the country of revolution *par excellence*. One example is the salute of the Mexican comrades given to the Soviet ambassador, which could not be missed since it was placed on the cover page.[191]

Many articles in *El Machete* are unsigned but there are some references to Italian fascism made by Modotti – although Carleton Beals argued that there were many, they are not so numerous as one might expect.[192] My calculations are based on the fact that Italy was Modotti's country of origin; that the Italian political situation in the 1920s certainly needed criticism; and that in Italy two worlds co-existed – the official world, which sponsored military ceremonies, and the unofficial world, made up of emigrants and the unemployed.[193] *El Machete* reported, for instance, the death of an Italian worker, Gastone Sozzi, who was tortured and killed by the fascist police in a Perugia prison in May 1928.[194] (One of the Italian voluntary antifascist groups fighting in the Spanish Civil War was called after him the *centuria* Gastone Sozzi, mainly formed by the Unified Socialist Party of Catalonia[195]). Then in September *El Machete* carried stories of the tortures inflicted by the fascist government on its dissidents, including Antonio Gramsci.[196] And in October an antifascist protest in Italy was reported.[197]

Writing as a member of the Antifascist International League, Modotti invited the public to a political meeting presided over by Enea Sormenti (Vidali), in a brief article of May 1928, *Contra el terror fascista!* (Against the Fascist Terror!).[198] She mentioned that the writer Henri Barbusse was demanding an investigation of the supposed Sozzi "suicide," and she reported an attempt in April 1928 against the life of the Italian king, Victor Emmanuel III, for which a group of innocent Italian workers were arrested in lieu of the true plotters, presumed to be the fascist officials.[199] The report of the meeting, which appeared in *El Machete* a week later, was positive: the event had been "a true statement of the antifascist feeling that Mussolini's crimes have produced all over the world."[200] The Italian Ministry of Foreign Affairs was briefed about the meeting and wrote Modotti down as a sort of suffragette who screamed that "Italy had become a huge prison and huge cemetery."[201]

Two letters from Tina's brother Benvenuto, written from Pasadena to his sister in fall 1928, show that Modotti was trying to obtain from him some material for a meeting scheduled for October 27, 1928.[202] Her aim was to

prove the involvement of Italian fascism with the Vatican in its opposition of the Calles government, since the Vatican identified its interests with those of fascism. Benvenuto suggested that his sister address the issue by asking the audience by what right the Vatican as a supporter of fascism in Italy could at the same time play the champion of freedom of religion in Mexico.

Another article in *El Machete* of winter 1928, advocated breaking off relations with Mussolini's government. It was proposed by the International Antifascist League during a meeting chaired by Modotti.[203] Among the speakers (Mella, Rivera, Muro Méndez, from the Association of Proletarian Students), a well-known radical intellectual, Tristán Marof, was especially noticed for tracing back Mussolini's regime to the Italian poet D'Annunzio – an idea which was later elaborated by other historians.[204] Marof's theory was that D'Annunzianism paved the way for fascism, especially in its use of ritual and symbols, and that D'Annunzio acted as the Duce's precursor. At the same meeting Rafael Ramos Pedrueza, representing the International Workers for Education, traced the struggle against tyranny back to that of Spartacus and the Gracchus brothers in Roman times. Pedrueza ended his speech by reminding the audience of the crimes and cowardly attacks by Italian fascists against academics. To jump forward for a moment, *El Machete* printed a cartoon by Covarrubias in May 1936 when the Italian empire was proclaimed following the conquest of Ethiopia. Mussolini makes the Roman salute on top of a mountain of skulls, while the caption ironically notes his "civilizing mission" in Abyssinia.[205]

Back in 1924, *El Machete* was violently attacking the fascist Italian government for sending "vain people" to Veracruz on the ship *Italia.* Mussolini's government was portrayed in the paper as the "assassin of the Italian proletariat."[206] Orozco drew a caricature of the six pompous Italian guests accompanied by a flying lady who personified Fame, adorned with laurels and trumpets. The Obregón government, which proclaimed itself as revolutionary, was attacked in another drawing in *El Machete* for receiving the Italians with official honors – thus according to the left wasting funds that could have been channeled to needy causes. The cartoon, which chose the moment of the departure of the ship from Mexico, shows four Mexican public officers (ironically referred to as "revolutionaries," followed by a question mark) intent on venerating and licking the boots of a sinister figure placed at the center, who is dressed in fascist black.[207] An earlier cartoon showed a group of black shirts, some of whom were presented with skull-heads, all gathered in a circle to give the Roman salute, while a flame burns in the background.[208] The ship, formerly owned by the German mercantile fleet under the name *König Albert,* after a visit from Victor Emmanuel III,[209] sailed from Italy on February 18, 1924 loaded with Italian artifacts,

from the enormous such as bulldozers, to the small and delicate such as Murano glass and Venetian lace.[210] Giovanni Giuriati, a fascist militant, was the political head of the expedition, or as he was named, "plenipotentiary in the Latin American countries," while the painter Aristide Sartorio had the role of artistic curator on board. Sartorio became deeply attracted by the Antarctic world and sketched a vast number of views, which he completed after his return to Rome.[211]

The timing of the journey in 1924 was critical for Mussolini, who needed to consolidate his power. In the middle of the ship's long journey (it lasted until October 20), in June 1924, the socialist deputy Giacomo Matteotti was kidnapped, wounded, and then killed by a fascist gang in Rome. His body was not found until August, when a retired officer, while strolling with his dog in the Roman countryside, came across a body which had been hastily buried. The socialist deputy had caused offense by publicly exposing the fascists' corruption in elections, and paid for it with his life. Mussolini's government was held responsible for Matteotti's murder and lost numerous followers and sympathizers, although it did succeed in staying in power, partly because the monarchy chose not to intervene and partly through Mussolini's ability to sway the masses.[212] A dose of propaganda abroad became indispensable to clear the good name of Italy. That task was given to the *regia nave* (royal ship), whose patriotic name, *Italia*, created no ambiguities.[213]

From Veracruz, where the ship stayed from August 24 to August 30, it continued to Havana, Port au Prince, Cartagena, Porto Colombia, La Guayra, Port of Spain, Las Palmas, and Gibilterra, everywhere provoking protests against the arrogance and bombastic ostentation of Mussolini's government. In Havana, where the *Italia* arrived on September 3, the Círculo Nacional Fascista Cubano had just been formed under Emilio Cassi. Its periodical, *Diario de la Marina* (Marine's Diary), urged its readers to repress any protests against the Italian government.[214] Meanwhile the Confederación de Estudiantes de Cuba (Confederation of Cuban Students), whose president was Julio Antonio Mella, called on students and workers to join the protest against the presence of a fascist ship. The Italian dignitaries took in a visit to a Cuban tobacco factory, Partagás, whose workers left in protest as soon as the Italians entered. The same occurred at a beer factory, La Tropical.[215] This event symbolically united the revolutionaries of Mexico and Cuba.

If it is not hard to know when Modotti became a party member, it is not easy to pinpoint the path of her ideological conversion to communism. Her political maturity was slow and gradual, although a few exterior factors, such as the Sacco–Vanzetti affair, or her connection with many

communists may have accelerated the process. But her choice of friends might have been dictated by her political views, or the other way around. In her letters to Weston, she rarely spoke of her political beliefs, or of her reasons for embracing a cause that appeared alien to Weston. She did mention some events related to her activism but her letters are not very enlightening in this respect. (At times she would write to him as though she were writing to herself, mainly about the function of art.) I have already mentioned that in Mexico it was impossible to participate as an artist and intellectual without becoming part of the political milieu as well. And in 1920s Mexico political meant revolutionary, and communism drove the revolution. This is the key to understanding the role of the Party inside Mexican society.[216]

Cultural radicalism as experienced with Robo in California had prepared Tina to receive the leftist message. This radicalism showed itself in a malaise with a contempt for convention, the status quo, and the bourgeois approach to life in general (to which Weston was also receptive). But Modotti developed beyond malaise: she came to reject individualism in any form, to become a selfless comrade. The poverty she had seen in Udine, in California, and especially in the streets of Mexico – where ten million Mexican peasants and workers were sleeping on straws mats on the ground[217] – was real and tangible. She possessed a great sense of justice and treated the oppressed with the dignity they deserved.

The description of certain areas of Mexico by Wolfe (then a communist) confronts us with images of "homeless boys, orphaned by all the rebellions, begging and picking pockets by day, and tearing down billboards after nine o'clock at night when the second night show has begun, sleeping on the sidewalks with nothing but the billboards to lie on, and perhaps a flea-covered little dog to wrap in their torn shirts to keep them warm."[218]

Those biographers interested in stressing Tina's Italian roots see a strong family leftist tradition in her politics. If the Modottis were not strictly of proletarian origin, at least they appear to have been radically oriented. Most of all, in Tina's heart and mind there was a vacuum that the Communist Party filled as no man could ever fill. The party gave her a sense of belonging and a sense of identity. It became her religion and her family, absorbing her and protecting her. In the party she found her motherhood *manqué*, which expressed itself in terms of caring for the poor. After all, communists have often been compared with the first Christians.[219] It seems that Modotti had a greater capacity for giving than for receiving. In Latin cultures, besides family, church and political parties constitute strong social pillars. Tina made her choice and until her death was consistent in it, although "she never aspired to become a political leader."[220]

Moreover, she was no theoretician, but she never professed to be one.[221] She never spoke of Marx's doctrine, nor did she ever speak in consciously dialectical terms. However, her best political vehicle, photography, shows a strong and instinctual dialectical approach, independent from the subject chosen. Their power was acknowledged at the time by fellow communists and published in, for example, *New Masses*. In 1928, her photographs were selected to be on October and December cover pages: "Mexican *Sombrero* with Hammer and Sickle," and "Hands resting on Tool," which the magazine titled "Hands to Build." Modotti proudly sent copies of the journal to her brother Benvenuto.[222] Other photographs, totaling nearly one hundred, appeared in international, political, literary, and art journals, such as *AIZ* (*Arbeiter Illustrierte Zeitung* or Workers' Illustrated Newspaper), *CROM* and *30-30* (both Mexico City), *BIFUR* (Paris) and *L'Art Vivant* (both Paris), and *International Literature* (Moscow).[223] Although it would be hard to attribute to Tina all the prints that appear from 1926 to 1929 in *El Machete* since they are not credited, nevertheless her approach and angle are visible in many.[224] They speak eloquently, they chart a progression that reflects the changes in her life, which reached a peak when she became a selfless comrade of the Communist Party.

Before the formation of the Mexican Communist Party we see in the years 1910–17 the disappearance of the army, as the pillar of the old order, the loss of political power by the landowner class, and the new phenomenon of the populist army of the peasant constituency, whose leaders rarely worked with the communists, although the communists had great respect for them (many of Rivera's murals present Zapata as a symbol of revolution and progress).[225]

The history of the Mexican Communist Party possesses unique characteristics that arose from its odd merger of Marxism and a populist form of libertarianism. First of all, since the Mexican predated the Bolshevik revolution, even the leftists looked to the indigenous revolution, which represented an attempt to deal pragmatically with the problems faced by the nation. Then there is the component of the foreigners who helped to organize the party – which Anglo-Saxon historiography tends to emphasize – the Russian Mikhail Borodin (born Mikhail Grusenberg), the Bengali Manabendra Nath Roy, and the Japanese Sen Katayama are the three key figures of the initial period (to a lesser extent the Philippino Fulgencio C. Luna also played a part). In the first phase of the party, all these foreigners shared a sense of the importance of the anti-imperialist struggle, which does not seem to have been an issue for the union leaders of the time.[226]

The Mexican Communist Party was formed in November 1919 after an assembly of the Mexican Socialist Party, a continuation of the POS (Partido

Obrero Socialista de la Républica Mexicana or Worker's Socialist Party of the Mexican Republic), created in August 1911 – not to be confused with the PSO (Partido Socialista Obrero or Worker's Socialist Party), founded in 1904.[227] In chapter four, I mentioned the importance of Linn A. E. Gale, who organized a periodical that became the organ of the party. Gale ran into some serious opposition in the person of José Allen, a Mexican engineer, and M. N. Roy, a nationalist converted to communist who worked closely with Borodin. Roy had arrived in Mexico in 1917 with his American wife Evelyn Trent, who in 1919 helped the Mexican feminist groups to form the Consejo Feminista Mexicano (Mexican Feminist Council).[228] It is commonly believed that a deal was struck between Roy and Borodin whereby if the Indian helped in converting the socialist party into a communist one, the Russian in exchange would help India to fight against British imperialism.[229] The historian Barry Carr doubts this theory on the grounds that the time involved was too short for the task, but he agrees that Borodin may have represented for Roy and the party a link to the outside world, that is, a detailed source of information on the developments of the communist movement in Europe.[230]

The power struggle between Roy and Gale resulted in Gale's expulsion from the party in November 1919, but Gale had already formed another organization, which he called Partido Comunista de México (Communist Party of Mexico); this, according to Carr, was never more than "a paper organization," and "existed completely on the margins of the Mexican working class."[231] Roy (called "fakir" by Gale)[232] was the one who was eventually expelled from the party but not without first forming his own communist party, called Partido Comunista Mexicano, in 1919. For some time the two parties claimed to be the "real" communist party of Mexico. Gale's had the blessing of President Venustiano Carranza but Roy's had the blessing of Borodin and other Soviet leaders including Lenin, and was created by those further left than Gale's. Roy's party therefore formed the official delegation to the 1920 Congress of the Communist International.[233]

At this point Katayama entered the Mexican political scene. He was a member of the executive committee of the Communist International and came from a religious background in Japan and in the U.S.[234] Katayama and other members of the committee, such as Louis Fraina from the American Communist Party, were sent to Mexico by the Comintern to investigate and report on the Mexican situation with the idea of expanding communism to other Latin American countries. But the mission failed because of frictions with the Mexican communists and because Gale's com-

munist party dominated the situation. In April 1921 Katayama proposed merging and unifying the two parties with the Socialist Party of Mexico.[235] By the time of its first national conference in December 1921, Gale had already left Mexico.

In April 1923 at the second national conference, the party became officially the Partido Comunista de México, section of the Communist International, and its first general secretary was José Allen. In January 1939 at the seventh national conference, the party's name was changed into Partido Comunista Mexicano with 30,125 members.[236] Its first headquarters was in Arteaga Street, in the Colonia Guerrero, the former base of the 1922 Sindicato Revolucionario de Inquilinos (Revolutionary Tenants' Union), a movement originally created in Veracruz by Héron Proal to encourage 35,000 tenants to refuse to pay rent until the landlords accepted 2% over the value of the properties.[237] The Sindicato had been defeated by the Obrégon government in June 1922, mainly because of its poor discipline and organization. However, its legacy remained and this vague and unidentified sense of community transformed itself into a much vaster organization, a proper party. It was at this point that thanks to Diego Rivera the communists came into contact with a sector of the population until then generally unknown, the intelligentsia. Rivera presented the richness of Marxism to the artists and intellectuals, showing them the necessity of forming a link with the working and peasant classes, while speaking the same artistic language as the proletarians through his murals. The first result of this liaison was the creation of the Grupo Solidario del Movimiento Obrero (Solidarity Group of the Workers' Movement), joined by among others the writers Pedro Henríquez Ureña and Julio Torri; the actress Lupe Rivas Cacho; the painters Orozco, Guerrero, and Best Maugard; the poet Carlos Pellicer; and the architect Alberto Vázquez del Mercado. After Rivera's official entry into the party, other artists and intellectuals followed him: Guerrero, Orozco, Siqueiros, Máximo Pacheco, Fermín Revueltas, Amado de la Cueva, and Jorge Juan Crespo de la Serna – to mention just a few.[238]

The Mexican anarchist Ricardo Flores Magón, the man who coined the slogan "land and freedom," was found dead on November 21, 1922 in his prison cell in Kansas. The official cause of his death was reported as a heart attack.[239] The "Kropotkin of Mexico" had been forced into exile by the Porfirio Díaz government in 1904. From 1907 he had been living in Los Angeles, where he was arrested several times for his political activities, and in August 1918 Flores Magón was tried for the last time and condemned to twenty years, on the grounds of instigating "sedition" according to the 1917 Espionage Act.[240] When his remains reached Mexico City on January

15, 1923 they were honored by leftists of all colors. It was in this political climate that in April 1923 the second national congress of the Communist Party met. Although the information on this period is scanty, we know that new tactics were implemented as far as the 1924 presidential elections were concerned, and that Rivera was elected director of the journal *La Plebe* (The Plebeian Class). Another innovation was a women's section, incorporated into the party by Concha Michel, Sara López, Luz Garcia, and Laura Mendoza.[241]

The first years of the party were characterized by a certain independence from Moscow; the so-called Bolshevization, which expressed itself after the Sixth Congress of the Communist International, had not yet spread. At this point, the party's intention was to adopt a much more international approach, which was made possible also by the foreigners who had joined its ranks. Bertram Wolfe was one of them. Born in Brooklyn in the same year as Modotti, 1896, Wolfe arrived in Mexico clandestinely with his wife Ella in 1923.[242] As a product of the 1917 antiwar movement and the American Communist Party, in the New York section, Wolfe was interested in Latin America and regarded Mexico as the logical first step along his political route. On his arrival in Mexico as an English teacher, he found a party in need of expansion after the departure of Gale and Borodin.[243] In July 1923 Rosendo Gómez Lorenzo became national secretary of the Mexican Communist Party, Rivera became its political secretary, and Manuel Díaz Ramírez its international secretary.[244] Díaz Ramírez, *el tabaquero veracruzano* (the tobacco worker from Veracruz) and a former secretary of the Federación Comunista del Proletariado Mexicano, reached this post after a long involvement with the North American I.W.W.[245]

Wolfe advocated support for the Obregón government, in power since December 1920. His choice was motivated not by loyalty but by historical necessity. Following the line of the party central committee, Wolfe intended to fight the reaction, which he considered much worse. In reality, he was hoping to obtain military help from the government for the party and the unions to fight the army units that had defected to the factions of Adolfo de la Huerta, the minister of the treasury. Díaz Ramírez opposed Wolfe and Rafael Carrillo on this issue. After a power struggle inside the party, in April 1924 Díaz Ramírez was ousted and Carrillo became the party secretary.[246] At the Fifth Congress of the Communist International, held in Moscow in June 1924, Wolfe represented Mexico and found himself among 504 delegates from 49 communist parties.[247] His task was to bring Mexico and Latin America to the attention of the congress, which he believed was accomplished, as he wrote to his wife.[248] Both Bert and Ella Wolfe worked so efficiently for the party that, as Carrillo (whose nickname was Frijolillo)

wrote to Ella, he wished that "the Mexicans be injected with American glands, as far as organization was concerned."[249]

In March 1925 Wolfe became the first editor of *El Libertador: Organo de la Liga Anti-Imperialista Panamericana*, a monthly journal located in Mexico City, set up to promote the expansion of the party in Mexico. Wolfe was not new to the job of writing and editing in Spanish, as his contributions to *El Machete* had proved.[250] The first issue of *El Libertador*, run by Ursulo Galván, stressed the importance of the sovereignty of the Latin American countries, deprived of their rights by the Monroe Doctrine. Its first four covers were drawn by Xavier Guerrero (who was the journal's administrator), employing the same technique he used for *El Machete*: he carved his own linoleum, or etched his work directly on the zinc or copper. Each number cost 10 *centavos*, while a yearly subscription cost $1. Among others, its contributors were the Argentine writer Manuel Ugarte, José Vasconcelos, and even Ernest Gruening and Scott Nearing (these last two sending articles from the U.S.).[251] But in June 1925 Wolfe was expelled from Mexico because of his communist activities, although the Mexican press presented him as either a narcotics dealer or a fomenter of railroad strikes.[252] He returned to Mexico only in 1936, when the country was under the Cárdenas government.[253]

The Communist Party had obviously become Tina Modotti's life and had given her a new image. She had made her own the lines by the Cuban revolutionary José Martí, *Con los pobres de la tierra quiero yo mi suerte echar* (I wish to share my destiny with the poor of the earth everywhere).[254] In November 1928 Rivera immortalized Modotti in a mural panel, *En el arsenal* (Inside the Arsenal), part of a project started in 1923. The painting, also called *Insurrection*, decorates one of the walls of the Ministry of Education and is part of nine adjoining sections of *Del Corrido de la Revolución* (Ballad of the Revolution) on the third floor of the building. The mural was reproduced on the front page of *El Machete* in February 1929.[255] Tina is shown at the far right corner, wearing an austere black skirt, communist-nun style,[256] and a red sweater with a black collar, while distributing ammunitions for weapons (something she actually did later in Spain), together with other people, ideological symbols of the revolution: Siqueiros on the far left side, Vidali wearing his usual French beret and gazing at Tina from the back, and, at the very center of the mural, Frida Kahlo, a 21-year-old Young Communist League member, who met Rivera through Modotti, although the two women were never photographed together.[257] Kahlo too is dressed in a black skirt and red shirt, with a red star and is distributing arms to the revolutionaries. Besides Tina and Frida, there are many female figures: Graciela Amador, Belem de Sárraga, Luz

Ardizana, Concha Michel, María Vendrell, María Velázquez, Olivia Saldívar, and Susana González (the last two had been imprisoned on June 20, 1926).[258]

There is somebody else in the panel, standing close to Modotti – a man who changed the course of her life – Julio Antonio Mella.

7 *Persona Indesiderata*

Amor, ch'a nullo amato amar perdona,
mi prese del costui piacer sì forte,
che, come vedi, ancor non m'abbandona.[1]

Dante, *Inferno*, Canto v, 103

Julio Antonio Mella was a brave, handsome, and adventurous young Cuban law student who cut his political teeth during the persecutions in 1925 of the Cuban dictator Gerardo Machado, whom he nicknamed an "operetta general" and *el Mussolini tropical*.[2] Machado, a former cattle thief who had climbed the political ladder with shrewdness,[3] was at the apogee of his "pharaonic delirium," supported by the United States and by the remains of a once enormous sugar empire,[4] on which Cuba's economy mainly depended. In 1923, Mella had participated in student demonstrations against the then Cuban president, Alfredo Zayas, and became secretary general of the Federación Estudiantil Universitaria in 1924.[5] In that position, he had voiced his anti-American feelings against the North American envoy, Enoch Crowder, who had been granted an honorary doctorate by the Cuban authorities.[6] Mella was then made president of the newly formed First Congress of Cuban Students in the same year.[7] Perceiving the university as a workshop for the Marxist struggle, he led a successful student strike against the university authorities.[8] He also formed the Anticlerical League to fight against the influence of the church in schools,[9] and was one of the founders of the populist university, José Martí, playing a role that overall resembles Rudi Dutschke's.[10] Then in August 1925 Mella became the first secretary general of the Cuban Communist Party, founded in Havana by seventeen people, six of whom were non-Cubans.[11] The moment was crucial; the Machado administration, elected by popular suffrage in 1924, was becoming a dictatorship.[12] For these activities, Mella was first temporarily expelled from the school in October; then in November, under the false accusation of having placed a bomb in the Payret Theater in Havana, he was imprisoned by Machado, then president-elect,[13] along with around forty communists.[14] The response of the young revolutionary was a 19-day hunger strike begun on December 6. The

Committee for Persecuted People (an organization inside the Mexican Communist Party), the Anti-Imperialist League, International Red Aid,[15] and the Student Federation all demanded that Machado release Mella.[16] Release came on December 28, 1925 and, a few weeks later, expulsion from Cuba. It seems that his own new-born party was critical of his behavior[17] and went as far as purging him from the party over his hunger strike.[18] Mella entered Mexico through Guatemala in February 1926 and continued his political work, joining the Communist Party, which he represented at several conferences,[19] and planning a coup against Machado.[20] On June 30, 1928 Mella became the Interim National Secretary of the party.[21]

When Mella left for Mexico, his wife Olivia (or Olivín) Zaldívar Freyre, at that time pregnant, refused to join him. The couple had already separated, mainly from incompatibility and Zaldívar's inability to cope with her husband's frequent absences from home on political duty. Mella does not seem to have been a "family man," never felt the responsibility of being a father – as he himself admitted.[22] Mella's daughter, Natalia (or Natacha), born in Cuba on January 1, 1927, never met her father.[23] (Olivín Zaldívar pursued a diplomatic career and years later defected from Castro's regime while consul general to Denmark.[24])

As far as the love story between Mella and Modotti is concerned, it is believed that the two met at *El Machete*, through Rosendo Gómez Lorenzo, around September 1928.[25] Mella fell in love almost immediately with Tina, eight years his senior, and went to live with her in her apartment, with or without the party's blessing, creating some problems for her. For this *coup de foudre*, Modotti was later labelled "a vulgar adventuress, old and ugly" by Claraval, one of Mella's friends.[26] Modotti felt obliged to inform Guerrero, to whom she was still officially tied, of this new development: on September 15, 1928 she received a passionate letter from Mella and then wrote to Guerrero in Moscow. The original document no longer exists so we have to rely on testimony given later at Modotti's court hearings,[27] from which it seems that Tina told Guerrero that the time had come to open her heart; it was not easy and she had postponed it for a long time because she could not find the necessary peace of mind. She said that she had struggled to resist that love, even contemplating suicide; she could not believe that it could ever happen – stop loving him for another man – but it had; most of all she was concerned about him as a person and the consequences of such a decision on the revolution. The next part of the letter was a self-absolution. After all, she wrote, "my cause, our cause will not suffer, since my work for the cause is neither the result nor the reflection of loving a revolutionary. It is a very deep conviction, rooted in me. In this

respect, I owe you a great deal." Finally she thanked him for opening her eyes politically and for strengthening her convictions.[28]

The basis of Modotti's decision lay in a sense of honesty, responsibility, and no doubt guilt. She wanted to free Guerrero and herself from a bond that had become meaningless to her. She also wanted to avoid any misunderstanding that might arise from comments of comrades in the party. Guerrero could have responded in several ways: he could have ignored her letter and pretended that nothing had happened; he could have written a bitter answer, cursing Tina for her betrayal; or he could simply have acknowledged her letter and then chosen silence. With his usual composure he replied by telegram: "I received your letter. Goodbye, Xavier Guerrero." This time he did not sign with a *nom de guerre*.[29] This telegraphic mode turned out to be much more effective than a long, angry letter, which, if the information is reliable, Guerrero later wrote and gave to Rafael Carrillo to deliver to Modotti.[30] In October 1930, when Tina went to Moscow, she visited Guerrero at the Hotel Lux,[31] described by Carrillo as "a prison called a hotel."[32] Modotti was received very coldly[33] by Guerrero who categorically refused to discuss the matter with her. He limited himself to listening to her and stating that there was nothing else to add, except that for him she had "never existed."[34]

According to Haya de la Torre, Mella was of "unquestioned revolutionary faith" and "genuinely believe[d] in the anti-imperialist struggle."[35] His interest in Mexico and its revolution had been sparked by his mentor in Cuba, Salvador Díaz Mirón, an exiled Mexican poet (whom Mella had the chance to see again in Mexico).[36] In his three years in Mexico, Mella developed an intense political agenda:[37] he organized the Asociación de Nuevos Emigrados Revolucionarios de Cuba (Association of New Immigrant Revolutionaries from Cuba) in April 1928, and as interim general secretary of the party he traveled extensively inside Mexico under the name of Juan José Martinez.

From Veracruz he wrote to Modotti on September 11, 1928, typing in red and addressing her as "Tiníssima," the name Modotti's mother often called her. Mella's words of love are powerful – especially in comparison with the stereotypical image of a revolutionary totally committed to the communist cause and thus incapable of uttering words of love:[38]

I could not erase your face for the whole trip. I can still see you in mourning, in cloth and in spirit, saying goodbye for the last time, as if you wanted to come toward me. Your words, too, are impressed on my mind, as if they were caressing me. . . . The wounds caused by this separation – the most painful of all my life – are still open. . . . I am convinced that our life [together] is going to be productive and grand.[39]

He goes on to tell her that he sees her shape in the tropical landscape. Later, his anguish is reflected in his words: "As far as I am concerned, Tina, I have taken my life in my own hands and thrown it at your balcony, the accomplice of our moments of love." Here is a poetic image of the balcony as an accomplice in their love making, but the letter's ending reveals political priorities: "Greetings comrade."

Mella's indefatigable and passionate work for the revolution[40] is exemplified in his excellent and versatile writing; he was also a skillful editor. The political tale *El asno con garras* (The Donkey with Claws), written during his first months in Mexico but never published, is addressed to children.[41] His famous *El grito de los mártires* (Cry of the Martyrs), a strong protest against any kind of dictatorship, published in August 1926, sums up his struggle. That is why Modotti's photograph of 1928, *Mella's Typewriter* (also called *La Técnica*), is iconic. Since the typewriter for Mella was an essential revolutionary tool, the picture became "the synthesis of Tina's photography and politics."[42] It can also be regarded as a symbolic "abstract portrait"[43] of Mella, through which Modotti paid tribute to a machine that played a crucial role in the history of the left. Two versions of this picture exist: one with a text held in the typewriter (possibly a montage by Modotti), the other without. I shall return to the subject shortly.

The aliases under which Mella published articles in *El Machete* include Kim, Juan José Martinez, Cuauhtémoc Zapata (the fusion of two Mexican heroes), or Nicanor (Meier) MacPartland, the name under which he was registered at his birth in 1903.[44] His mother, Cecilia MacPartland, was Irish,[45] while his father, Nicanor Mella, a tailor by trade (in other versions, a fabric merchant), had Dominican ancestry.[46] The couple were never legally married and separated when the boy was still young. After Mella's mother moved to New Orleans, he was raised in Havana by his father, who later sold his business to a Mexican who counted the future president Cárdenas among his customers.[47] Nicanor tried in vain to direct his son toward a military career but the young man chose to study law.

It was only when he entered Mexico that the young revolutionary took the name Julio Antonio Mella, perhaps to evoke his paternal grandfather's actions in the Dominican republic's independence movement.[48] While living in Mexico (if Claraval's information is accurate), Mella received from his father 80 dollars a month,[49] with which he funded his numerous political activities, such as the publication *El tren blindado* (The Armored Train). Claraval, who made no secret of his disapproval of Modotti, claimed that Mella "supported Tina Modotti,"[50] but this is at least inaccurate, since it is known that Tina was working and contributing to the house expenses.

However, those who came into contact with them as a couple reported that they were generous and always ready to help others so never had any money.

A collection of Mella's articles for *El Machete*, edited by Raquel Tibol,[51] provides a complete picture of his political views and his variety of interests – among other subjects, Russian peasant art,[52] the Sacco–Vanzetti case,[53] an assessment of Mexico,[54] and the Olympic Games.[55] Mella was also a man of action, as his own words indicate: "Now that politics is synonymous with revolution, it is the right moment for the masses to understand what politics is for us communists."[56] As noted before, he was involved in several groups and committees: the Mexican section of the Liga Antiimperialista de las Américas (Anti-Imperialist League of Americas); the Liga Nacional Campesina (National Peasants' League); the Confederación Unitaria de México (Unitary Confederation of Mexico), and Manos Fuera de Nicaragua (Hands Off Nicaragua),[57] in which Modotti was also active.

In summer 1928 Mella began collecting arms and men in preparation for a coup d'état against Machado, taking as his model José Martí during the struggle for independence from Spain. (By coincidence, the concurrent Sixth Congress of the Communist International in Moscow had chosen an eclectic program.[58]) Unfortunately for Mella, the Cuban government had been following his steps closely, as a letter by the head of the National Police proves.[59] To add to their case against him, Mella was blamed for an incident that occurred on December 15, 1928. A group of political refugees from various Latin American countries had rented a room at the Centro de Obreros Israelitas (Jewish Workers Center) in Mexico City to organize a Cuban night, a fundraising event for ANERC (the Association of New Revolutionary Emigrants from Cuba), and for the magazine *Cuba libre* (Free Cuba), directed by two Cubans, Manuel Cotoño and Rogelio Teurbe Tolón. At the request of the club, no flag was to be displayed but a Cuban man, Raúl Amarall Agramonte, known as an *agent provocateur* despite his professed status of political refugee, raised a paper-made Cuban flag. When asked to lower it he refused. So Tolón intervened and did it for him. Amarall, who had been sent by Machado, distorted the truth and blamed Mella.[60] (Years later, Conchita Barreiro, the daughter of Alejandro Barreiro, admitted that her father was the only person responsible.[61]) In the following days, the Havana newspapers, fueled by the Cuban ambassador to Mexico, Guillermo Fernández Mascaró, did not hesitate to portray Mella instead of Tolón as an "irreverent desecrator" of his country's flag. The communists were accused of having made this saying the ideology of their life: "No tengo, ni quiero patria, / ni rey, ni Dios, ni bandera, / soy ciudadano del mundo / y rechazo las fronteras."[62]

To such accusations (which "only idiots can believe"[63]) Mella replied on January 8, 1929 in a letter to the editor of the newspaper *Excelsior*, explaining the circumstances, denying any involvement in the alleged desecration, and requesting a public correction.[64] Other versions also mention a telegram to Sergio Carbó, editor of the newspaper *La Semana* in Havana, requesting the same corrections. Mella drafted the note with Modotti on the evening of Thursday, January 10 after a meeting at Red Aid's headquarters on 89 Isabel la Católica Street. They had left the building and walked north. Mella asked Modotti to drop the telegram at the telegraph office and to wait for him there after his 9 p.m. meeting with Pepe Magriñat, a Cuban living in Mexico, in a nearby bar called *La India*. Magriñat, the son of a banker, was a notorious *tahur* (gambler), and had been a corrupt policeman in Cuba; he was therefore regarded with suspicion by Mella.[65] However, Mella had agreed to meet him since Magriñat had said it was urgent and imperative. The meeting supposedly took place on time and lasted about twenty minutes, during which Magriñat told Mella that Machado had sent his assassins to Mexico to kill him. That was not new for the young revolutionary: the month before he had received a letter dated December 14 from New York from his friend Leonardo Férnandez Fuentes warning him that his life was in danger.[66] When Mella met with Tina again a little before 9.30 p.m. at the telegraph office, he told her of the warning and they decided to rush home immediately. It was imprudent of them to walk home thus so exposed, but it would have been even more imprudent to stand waiting for a tram, an easy target. As they were approaching the Zamora Building, two sharp shots were heard; Mella fell. He had been holding a copy of *El Machete* that carried one of his articles – the paper that had played an important role in his life was with him at his end.

Mella died a few hours later in San Jerónimo Hospital while in surgery. His death represented a turning point in Tina's personal life and in her political career. The assassination is so important that at least three biographies on her open with it. The ballistic report from General Gabriel Terrés and Colonel Alejandro de la Peña, determined that he had been shot twice from behind, with a .38 pistol. One bullet hit his left shoulder and the other perforated his right lung and severed an artery before exiting through the stomach; in falling on the sidewalk, he also broke his arm. While waiting for surgery, Mella slipped in and out of consciousness – conscious enough to release a statement to the police chief Fernando Rodríguez implicating Machado as the prime instigator of the murder,[67] and enough to inform two Red Cross attendants, Manuel Flores and David Malpica, that Machado had acted with the complicity of the Cuban embassy in Mexico.[68]

Mella and Modotti's friends were promptly informed. Carleton Beals upon his return home that day found pushed under his door a note scribbled on the back of an envelope. He dashed to the hospital and managed to be admitted to the operating room, only in time "to see the last of life ebb from Julio's body."[69] Meanwhile, two of Mella's comrades, Sandalio Junco and Tolón, went as representatives of ANERC to the office of *Excelsior* to inform the press of the crime and to protest against the Cuban government.[70]

On Friday January 11 at noon Mella's corpse was taken to party headquarters in Mesones 54, where Tina was able to take one last photograph of her companion, lying dead; it was published on *El Machete's* front page on January 19.[71] A death mask was also made of Mella.[72] Jean Charlot reports that his funeral became an occasion for violent street demonstrations. A news photograph shows a gigantic red banner being carried over a sea of closed fists, with Diego Rivera heading the parade as "its self-appointed grand marshal."[73] Tina was at the front, dressed in a black coat and a hat. Besides Rivera, several people spoke before and during the funeral: Rafael Carrillo, Luis G. Monzón, Alfonso Díaz Figueroa, Hernán Laborde, and three Cuban comrades of Mella, José Muñoz Cota, Sandalio Junco, and Montalván, who named Machado "an apocalyptic beast which feeds itself with the blood of workers and students."[74]

Mella's murder had been planned in October 1928[75] and carried out through Magriñat (an "adventurer" as the Mexican press called him[76]), who clearly acted as a double agent and contracted the two killers, Arturo Sarabia (sometimes called Zanabria or "the man of Cunagua") and José Augustín López Valiñas, a Cuban who had been living in Mexico for a few years. Both had criminal records.[77] The meeting with Mella, which Magriñat always denied despite a paper found on Mella's body with Magriñat's telephone number, was a setup to control the victim's movements.

It was originally decided that Sarabia was going to open fire on Mella on in the first week of January but then the date of the assassination was moved to January 10, close to the scheduled departure time of the steamer *Alfonso XIII* from Veracruz, to make it easier for the assassins to escape.[78] However, the plan did not go quite as expected; Sarabia delayed shooting, so his accomplice had to pull the trigger on Mella, who nevertheless survived until 1.40 in the morning.

The outcome of the murder was extraordinary. It caused an unexpected solidarity on the left in general, except among the Trotskyist groups who were engrossed by Trotsky's expulsion from the Soviet Union. In Cuba, Mella's death caused indignation toward Machado, as an angry manifesto showed,[79] and thereafter Mella was always mentioned in political speeches.[80]

New Masses blamed "some Wall Street Mussolini," and called the affair "a Matteoti [*sic*] case."[81] Mella's death also generated sympathy for him, even among liberals. For the communists, the young man, who in a photograph by Tina appears as a fearless athletically built Homeric hero, became an immortal icon, a martyr, and the symbol of justice, especially since his last words were "I am dying for the revolution." A *corrido* in his honor begins:

> Cuando cayó Julio Mella
> la mano en el corazón,
> dijo: Mi muerte es muy bella
> es por la Revolución.[82]

In the years to come the communists continued to honor Mella's memory. He became "like a symbol around which everyone revolved," as an American who visited Mexico that same year noted.[83] The communists continued their quest for justice, pressing the Mexican government to investigate further, in spite of their belief that the government itself was an accomplice.[84] Magriñat, considered the organizer of the assassination, was apprehended while still in Mexico[85] but soon released, for insufficient evidence. He always denied any part in it, and with the complicity of the Mexican police disappeared from Mexico to reappear shortly in Cuba. He was killed in August 1933 during the coup against Machado.[86] Sarabia was never imprisoned or tried *in absentia*.[87] He died, hanged in Matanzas, Cuba. In October 1931 Lopez Valiñas was turned in by his Mexican wife, María Guadalupe Gil Oceguera.[88] Fearing for her life, she claimed that her husband had boasted about Mella's killing, for which he had supposedly received $50 a month for six months from the Cuban government.[89] Valiñas was tried and acquitted, despite numerous requests and the pressure that the left put on the Mexican legal system.

An investigation was also requested into the involvement of Mascaró, the Cuban ambassador to Mexico in 1929, based on Mella's statement on his deathbed.[90] (Immediately after Mella's murder, Mascaró became conveniently ill for some days, thus avoiding the questions of the press.[91]) In spite of Portes Gil's declaration that a complete investigation was under way,[92] the communists always believed that the Portes Gil and Machado governments organized the murder jointly, aided by the police forces under the anticommunist Valente Quintana, the head of the Central Police Department and, according to Carleton Beals's report, the owner of brothels in Mexico, at which several Cuban assassins arrived shortly before Mella's murder and fled right after the crime.[93] Quintana was nevertheless removed from the case three days after the murder for excessive zeal in dealing with Modotti, who by then was herself suspected of having murdered her lover.[94]

It appears that on the evening of the crime Quintana telephoned his "friend" Magriñat.[95] Quintana's place was taken by Colonel Talamante, an improvement on his predecessor only in words: the police continued their practice of concealing important information to obstruct the investigation.[96] But the Cuban ambassador to Mexico was recalled to Cuba and although diplomatic relations between Mexico and Cuba were never severed, the Cuban government was without any diplomatic representation in Mexico for more than a year.[97]

The former secretary of the Interior and the Navy in Cuba, Rafael Iturriaga later testified that Machado had sent his killers to slay Mella – it seems that Machado too even boasted about it.[98] An American newspaper reported that Iturriaga's testimony "caused a sensation."[99] In the minds of many who had been close to Tina during the ordeal, including Beals, there was never any doubt that Machado, with the complicity of a corrupt police, was Mella's killer. Beals's perception of Machado's Cuba, which he visited in 1932, was colored by this tragic case.[100] Apparently, it was not the first time that Machado had tried to eliminate Mella through a killer. The first time occurred when the young man was still in Cuba, but by coincidence the killer informed Mella's wife.[101]

In 1932 the Mexican Communist Party organized a campaign to have Mella's ashes sent to his native Cuba, with the approval of one of Mella's comrades, Antonio Guiteras. The task was accomplished in September 1933 under the short-lived government of Ramón Grau San Martín, through a committee of Mexicans and Cubans chaired by the president of the Partido Unión Revolucionaria de Cuba (Revolutionary Union Party of Cuba), Juan Marinello,[102] who later met Modotti in Spain.[103] The ceremony was not without disturbances: shots were fired by unknown individuals (probably under orders from the dictator Fulgencio Batista), and many were wounded.[104] Some even spoke of "the second death of Mella."[105] Later, a memorial was erected in Mella's honor in front of Havana University,[106] where it is still customary for wedding couples to deposit the bridal bouquet, as a Cuban folk saying explains[107] – for good reason: a man who wrote passionate words of love deserves a flower from people who are about to start their life together. On the ninth anniversary of Mella's murder, a commemorative plaque and portrait, offered by the Unión de Emigrados Revolucionarios cubanos, were placed at the precise spot where he had been shot.[108] On the 50th anniversary, in January 1979, the Cuban government issued a stamp in memory of Mella and indirectly Modotti: it is a reproduction of one of Modotti's portraits of Mella.[109] Finally, on January 10, 1996, the 67th anniversary of Mella's death (and one hundred years since Modotti's birth), 67 young Cubans from the FEU

(Federación de Estudiantes Universitarios de Cuba) brought to Mexico a bronze bust of Mella that was placed in San Carlos park in the Tabacalera colony.[110]

* * *

In 1929 (and during the following years) some Mexican newspapers wrote a great deal about Mella's murder, turning it into a sensational lurid affair (the dirtiest and most ridiculous ever encountered, according to Lola Alvarez Bravo[111]) and presenting Modotti as an undignified and loose woman who "despite her apparent naiveté" was extremely shrewd.[112] Vittorio Vidali decided to confront the matter: he went to the police in Mexico City to protest against such behavior and to inquire about the limits allowed the press, but the police were vague and nothing was achieved, since the press claimed freedom of expression. However, Vidali, who chose to be accompanied by an army officer, Adalberto Tejeda, stressed that this was not *libertad* (freedom) but *libertinaje* (libertinage), conducted in the most outrageous way and with the connivance of the government.[113]

Tina, whom *Excelsior* described as "the attractive Venetian, impenetrable and mysterious, with dark eyes and a deep expression,"[114] did not receive much more respect from the non-Mexican press. She was identified by the *Los Angeles Times* correspondent in Mexico as a "Pasadena art student," leading a "Bohemian life," and having "an impulsive Italian temperament."[115] The same article twice called Modotti (then 32) "the girl," while men were identified by their proper names. In another unidentified article, she was again twice referred to as simply "the girl."[116] Weston noted in his diary: "Startling news has come from Mexico," and "Her life is a stormy one."[117] It was at this time that Modotti probably became fully aware not only of her beauty but also of the problems that came with her beauty, as her comments to Weston indicate.[118]

The Italian–American newspaper *L'Italia*, which had played such a crucial role in Tina's earlier life, chose to be silent about the whole affair even in the days following the murder, turning public attention to completely different matters – such as the theft on January 14, 1929 of a Leonardo sketch from the Mexico City Museum. By 1929 *L'Italia* had in fact become openly supportive of the fascist government in Italy, and in January proudly informed its public that an American statesman and attorney, Richard Washburn Child, who was a friend of Mussolini, was going to deliver a series of talks in California on the *condottiero*.[119]

Some Mexican journalists persisted in identifying Modotti as the accomplice of the killer, basing their accusation on discrepancies in her testimony

given on the night of the murder.[120] When questioned by a police officer at the hospital, Tina had given her name as Rose Smith Saltarini, a native of San Francisco, California. She promptly corrected her statement, explaining that she had given the wrong information to protect her true identity. One of the judges in charge of the investigation even suggested since she was Italian she could be a Mussolini spy. This enraged Vidali, who under the name of Enea Sormenti rebutted the accusation in a public letter published in *El Machete*.[121]

On January 12, Modotti was arrested and detained at the police station.[122] Meanwhile, her house was thoroughly searched – twice – and everyday items were taken as potential evidence against her. However, no proof connecting her to the crime was found. The police did discover some of Weston's nude photographs of her, love letters from and copies of letters she had written to other men, and seven letters from her brother Benvenuto – all private. The police also found a nude photograph of Mella, taken to fulfill the entrance requirements of a rowing club in Cuba, when Mella did not even know Modotti; she was nevertheless blamed. Among the confiscated photographs, there was alleged to be one of an erect (but unidentified) penis.[123]

From other papers it became evident that Modotti had owned a .45 Colt pistol, a gift from Guerrero, which she had given (or sold) to a German journalist, Fritz Bach.[124] To the police it made no difference that the Colt was a .45 and not a .38 (the murderer's weapon). Nor that Bach and Carleton Beals, who had been present during the deal, testified for her,[125] let alone the fact that everybody in Mexico owned a gun – Neruda called the phenomenon *un fetichismo de la cuarenta y cinco* (a fetishism of the .45).[126] The idea was to make the evidence fit their scheme, whose aim was publicly to humiliate a leftist woman.

The murder was reenacted on January 14 with Modotti, Rivera, Toor, Luz Ardizana, Beals, and Gómez Lorenzo taking part. According to the police, the case, and especially the rumors created by the case, were sufficient to justify applying article 33 of the 1917 constitution, which allowed the president to expel or deport "pernicious foreigners" without trial. Furthermore, a precedent for the expulsion had been set in April 1921 when Gale had been "unceremoniously dumped over the border to Guatemala"[127] and in June 1925 when the Wolfes had been deported. Tina escaped this fate only because Rivera came to her rescue, but expulsion was merely temporarily postponed. From January onward the government looked for an excuse to deport her.

Slanders against Modotti continued intermittently. In 1934, when Tina was already out of Mexico and the truth had finally emerged (at least as far

as Tina's involvement was concerned), *El Universal Ilustrado* maintained that a number of charges still existed against her since she was suspected of complicity "in the sensational crime."[128] Again, the communists responded vigorously, underlining the point that, despite the "disgusting campaign" against Modotti, her "revolutionary prestige was still very high."[129] *El Universal Ilustrado* had obviously changed sides since 1929: a few days after the murder, Cube Bonifants, a young woman journalist, had published a poem to show her solidarity with Tina.[130] The poem, which begins with the words *Asesinaron al hombre a quien amaba* (They killed the man she loved), suggests that Tina had been misunderstood by some sections of the press because of her lack of expression of grief and labelled as a "heartless" woman. This notion of her was repeated in *Excelsior*, which portrayed her as "a woman who seems to be made of steel wrapped in skin."[131]

It was not enough that Modotti was grieving for her companion and had to relive his murder in a re-creation by the police. She had to be stripped of her dignity. She had to be accused of complicity. Her private life had to become the daily nourishment for an avid and voyeuristic public, whose hungry interest was dressed in moralistic garb. Her ethics had to be questioned, and her past dissected. Degrading words had to be used to condemn her unconventional choice of life, to make her look like a vampire adventuress. She was indeed paying a high price for her beauty, intelligence, and political creed. Most of all, she was paying for her gender, her values, and her way of living.[132] Anita Brenner commented from New York that the next logical step in the whole affair would be psychoanalysis, then spiritualism, concluding with "Church penance and absolution."[133]

As late as 1983, during an exhibition on Kahlo and Modotti at the National Art Museum in Mexico City, the issue of Modotti's implication in Mella's crime surfaced once more, and with it a defamatory campaign against communism in general. Through an article published in *Vuelta* (edited by Octavio Paz), a former communist, Philippe Cheron (promptly called a renegade by Mexican communists[134]), pointed his finger first at Vidali, referring to him as "a sinister individual."[135] Basing his accusations on information from Julián Gorkin (alias Juan Gomez),[136] by then a strong anticommunist, Cheron accused Vidali of involvement in not only Mella's assassination but also others', incited by internal party conflict. Cheron then turned to Modotti, proclaiming her complicity in Mella's murder, for reasons he failed to explain. Along the same lines, in a note he called Mildred Constantine's book on Modotti "a biography that does not depart from the Stalinist version." The comments by Paz himself, which follow Cheron's article,[137] do not do much to dispel the dark ambiguity surrounding Modotti's figure. With regard to Tina's "silence" concerning

various political murders Paz wrote that nobody can say whether or not it derived from "connivance, complicity, or terror."

The idea that Mella was eliminated by his own comrades because of conflict inside the party found several believers, mainly among the conservatives. But even some leftists admitted that the Cuban revolutionary caused friction in the party with his independent thinking. It was common knowledge that Mella had become critical of Stalinist tactics – a fact also suggested by his decision to publish the anti-Stalinist Krassin's letter in *El Machete* (Krassin later committed suicide).[138] It was also common knowledge that Mella admired Trotsky greatly, describing him as "a human dynamo"[139] and associating him with Lenin.[140] (In 1926, Michael Gold had claimed that Trotsky was "almost as universal as Leonardo da Vinci."[141]) Furthermore it was suggested that Mella's conflicts inside the party were dictated by his desire to create a new workers' trade union, this time under the party's leadership, since the existing union seemed inadequate. For this and other ideas, Mella had been several times on the verge of expulsion from the party, and his ideas were labelled as Trotskyite,[142] a degeneration of the term Trotskyist.

When Mella decided to strike against Machado, preparing a coup without the party's approval, he was harshly reprimanded by his comrades. In a letter of December 4, 1928 to the Wolfes, Rafael Carrillo wrote that Mella's reaction to the party's rigidity was equally harsh and ended in his resignation, which he later withdrew.[143] Although the left in general (with some exceptions)[144] never doubted that Mella's murder was ordered by Machado, Vidali himself admitted that inside the party there had been disagreements with Mella.[145] But he denied any purges or expulsions.[146] Mella's frictions with the party have been reported by others. One of them, Victor Alba, quotes Claraval to claim that during the party central committee meeting in September 1928 Stirner, a Swiss, unsuccessfully proposed Mella's expulsion for differences in tactics and strategies.[147] Of this issue, Russell Blackwell (called by the Mexicans *Negrete*), an American Trotskyist and former communist party member, gave a slightly different version. In an article published on the second anniversary of Mella's death Blackwell stated that "the relations between Mella and the party leadership became exceedingly tense at the end of 1928."[148] Barely two weeks before his assassination Mella was expelled from the Mexican Communist Party – according to Blackwell – because of his inability to collaborate with the party leadership. On January 3, 1929 (a week before his death) Mella requested a reconsideration of the party's decision, fully acknowledging "his error."[149] It was decided to reinstate him, with the stipulation that he was to hold "no posts of responsibility for a period of three years."[150]

This version of Mella's expulsion from the party was repeated by the economist Robert Alexander, who even added that "Carlos Contreras [that is, Vidali], an Italian Communist, who has served as a Communist agent in half a dozen countries in Europe and America, has been implicated in his death."[151] Alexander revisited the story many years later in another book,[152] this time making his allegations more specific: "Mella had a serious quarrel at a meeting of the Political Bureau of the Mexican Communist Party with the Italian Comintern agent Vittorio Vidali, who under the name of Carlos Contreras was then one of the leaders of the Mexican party."[153] Alexander quotes Gorkin's report, according to which Vidali attacked Mella with the words "oppositionists like you deserve only death."[154] In a slightly different version, the day before Mella was murdered Vidali is supposed to have told him: "Remember, comrade: nobody leaves the International, except expelled or dead."[155] Another source also blames Vidali, identifying him as a "sinister agent of the GPU [secret security]."[156] If the information *per se* is inaccurate, the psychosis of betrayal is not, and it explains many atrocities, especially during the Spanish Civil War.

In yet another, more elaborate version Mella was killed by a double agent working for both the communists and Machado.[157] In 1981 a former Fidel Castro secret agent, Juan Vivès, published *Les Maîtres de Cuba* in which he accused Vidali of mobilizing a campaign to provoke Mella's expulsion from Cuba.[158] According to Vivès, Vidali acted under orders from Fabio Grobart, a Soviet agent of Polish nationality, who arrived in Cuba in 1928 as a businessman and later served as a liaison between Cuba and Moscow. (In another version, Grobart, also known as Abraham Simcowiz or Otto Modley, was of Lithuanian origins and arrived in Cuba in 1925[159]). Vivès stated that there was no doubt that Machado ordered Mella's death in Mexico. Thus, it is not surprising that a secret police agent, paid by Machado to control Mella's movements in Mexico, received 5,000 *pesos* (around $6,000) from an unknown man to kill Mella. What it is surprising, though, is that the supposedly unknown man was Aurelio Randulfo Garcia, also a member of the Cuban Communist Party (whose card number was 3008) and one of Vidali's collaborators.

Mella's widow herself, Olivín Zaldívar, as late as April 1967 insisted on the version that assassins were hired by Machado's agent Magriñat, who she claimed worked with Vidali, alias Luigi Sormenti, alias Carlos Contreras, "a known Comintern agent."[160] Even if this version corresponds to the truth, years later Vidali praised his supposed victim in public: when in spring 1976 Vidali visited Cuba for the third time, he released an interview that focussed on Mella's merits.[161] And on his 80th birthday, held in Trieste in 1980, Vidali remembered with affection the words by "comrade

Julio Antonio Mella," written the day before he died: "Even after death, we are useful."[162] In 1961 Mella's daughter Natacha had written an open letter to Carleton Beals, stating that she had a moral duty as a daughter to clarify a few aspects of her father's death. One of these was that Modotti was not the "romantic soul" people thought she was: instead, she was an adventuress and an international communist spy, whose function was to watch Mella's movements, since at the end of his life he was in conflict with the communist party. Natacha ended by accusing Portes Gil of complicity in closing the murder investigation and Lázaro Cárdenas of setting Valiñas free in 1932.[163]

Was Mella truly in conflict with the party? Was he the Trotsky follower that some would like him to be? In Modotti's photograph of Mella's typewriter the text on the sheet of paper in the typewriter has unanimously been attributed to Trotsky, although the source has never been identified until now, as far as I know. The text reads *inspiración, artística, en una síntesis, existe entre la* (inspiration, artistic, in a synthesis, exists between the). According to information provided by Vidali in the 1970s, the photograph was dated January 1929, not 1928, and the quote was the last piece typed by Mella before his assassination. Thus both message and photograph acquire a special meaning.

If Vidali's intention in changing the date to 1929 was to prove that a quotation from Trotsky made Mella a suspect communist, he failed in his aim. The same words, in fact, were quoted by Modotti herself in a brochure for her December 1929 photographic exhibition. The complete paragraph, as she used it, reads:

> La técnica se convertiera en una inspiración mucho más poderosa de la producción artística: más tarde encontraba su solución en una síntesis más elevada el contraste que existe entre la técnica y la naturaleza.

> (Technique will become a more powerful inspiration for artistic work, and, later on, the contradiction itself between technique and nature will be solved in a higher synthesis.)

The piece comes from "Revolutionary and Socialist Art," a chapter in Trotsky's *Literature and Revolution,* which appeared in a Spanish edition in 1924.[164] When Modotti quoted Trotsky, nobody raised any doubts about her commitment to the party and nobody accused her of Trotskyism. Vidali noted that outside Mexico it was "murmured" that she might once have been a Trotsky sympathizer, but he contradicted the story as totally inaccurate.[165] If quoting a sentence from an article by Trotsky makes a person a Trotskyist (or, worse, a Trotskyite), one wonders what would have been said if in the photographed typewriter, instead of a Trotsky quotation, there

had been one by Mussolini. Would that have been enough to qualify Mella as a fascist?

After establishing that the quote is indeed by Trotsky, not by Mella or Modotti (as has even been suggested), I must stress that the accusation of being a Trotskyite, made by communist (meaning Stalinist) members in those years and in the 1930s was nothing but a "polemical blanket,"[166] a symbolic word to identify heresy and to denigrate a communist of the opposition.[167] As Borkenau said during the Spanish Civil War, "it derives from the fact that the communists have got into the habit of denouncing as a Troskyist everybody who disagrees with them about anything."[168] Vidali himself always had a sort of obsession with Trotskyism – here he is in February 1928 to a comrade: "Knowing the 'Latin weakness' of our comrades, as soon as I arrived here, I started writing a series of articles against Trotksyism."[169] The Stalinists were never able to shake off this obsession, which arose in the 1920s and expanded in the second open Stalin trial, begun in Moscow on January 23, 1937, whose target was the so-called Parallel Trotsky Center.[170] In the 1930s, Elena Dimitrievna, Molotov's wife, was sent to jail accused of being a Trotskyite, while her husband continued to serve the party. And when the writer Isaac Babel was arrested by Soviet authorities on May 15, 1939 and held in a Moscow prison, the case built against him developed around "a Trotskyite conspiracy."[171]

For the party members who regarded themselves as the sole heirs of the Bolshevik revolution, the term Trotskyite was elastic and covered a traitor of any kind. During the Spanish Civil War La Pasionaria used to state that Trotskyism and duplicity were synonymous. Whoever expressed or professed opposition of some sort was commonly labelled a Trotskyite by the Stalinists, even though the person in question might never have read Trotsky – which, however, was not the case with Mella. After all, Trotsky's name had a strong appeal to the intellectuals not just of Latin America but also of North America. Trotsky's "intellectual and literary predilections blended harmoniously with his extraordinary career of revolutionary activism,"[172] and he became the image that many leftist intellectuals – Mella included – wished to live up to, no matter what their true ideology.

The fuel for this controversy and the wish to identify Mella as a Trotsky follower (with no shred of evidence) derives from eagerness to capture Mella and his legacy in order to retrieve him from the Stalinist camp. So we are told that Mella was not a "dogmatic Stalinist" (well-known by now) and that the Stalinists eliminated their opponents (also nothing new). Hence the rush to attribute the quote in Mella's typewriter to Trotsky, without identifying the exact source for years. However, now it has been established that Mella was not eliminated by Stalinists but by right-wing forces.

Nevertheless, for the sake of truth, one can state that in his writings[173] he was opposed to Stalinist sectarianism, and was much more sophisticated and cosmopolitan than the average Stalinist. At times Mella was perhaps close to a Trotskyist vision of life, but he was certainly not close to Trotsky's political theories. The idea of preserving the bourgeoisie in a communist system, for example, which is anathema to an orthodox Trotskyist, is typical of Mella's writings. His political theories, if one has to label them, are actually much closer to what was later called a Maoist doctrine. A Trotskyist vision of life may be discerned specifically in Mella's Jacobinism, his belief in the permanent revolution, and his readiness to serve fanatically the Idea. His writings are revealing in this respect; they retain a certain degree of individual criticism and individual initiative inside the party – Mella always felt uncomfortable with the so-called mystique of the collective. Most of all, he was thoroughly aware of the fate in store for dissidents. As he wrote to Carrillo around 1927: "I believe that I can be useful to the party and to the revolution. He who has accepted and suffered the 'discipline of the worst inquisitor' of the parties of the International does not go to Mexico to become a rebel."[174] And again: "And if at the end I will no longer be useful, do to me what is now being done to Trotsky."[175]

In May 1928 when Mella began the publication of *Cuba libre*, his fame as an oppositionist would be difficult to exaggerate. Although he still used Marxism as a point of reference, he did not support his arguments with any Leninist jargon, nor did he mention his own militancy in the party.[176] This unorthodoxy may have been taken as a betrayal by the inflexible hardline communists, who, although they never openly stated that Mella was a Trotskyist, nevertheless accused him of always having had "Trotskyist weaknesses"[177] – again, this must not be read literally but as evidence that Mella was an independent communist thinker. Or it could have been misunderstood by conservatives and liberals, who often fail to comprehend the subtlety of leftist politics. Stated perceptions of such matters may indicate more the ideology of the authors of these comments than their subject. In 1927, for example, when Mella returned from the Soviet Union he was labelled as possessed "by an intransigent Bolshevik fanaticism."[178] And yet, during this visit to Moscow, it seems that Mella had met with members of the opposition and with Andrés (or Andreu) Nin Pérez, a Catalan communist, who had been one of the founders of the Spanish Communist Party, although he was later expelled from it.[179] Nín (as he is usually called)[180] translated several Trotsky works into Spanish and Catalan.

After Mella's death, the Mexican Communist Party became more intransigent and its discipline far more rigid, with the consequent expulsion from

the party of some valuable members.[181] Accusations against the party were many, particularly over the attitude toward women, who according to the insider Concha Michel were treated by party members just as the bourgeoisie treated them.[182] Slanders against Trotsky and his followers doubled, as a post-1929 review in *El Machete* shows.[183] Indeed, Trotskyists were always given much worse treatment by Stalinists than were anarchists.[184] A 1932 article in *El Machete*, informing its readers of the death of an old Italian anarchist, Enrico Malatesta, ended with the words: "The international proletariat salutes the old struggler, who has died."[185] Words of this kind were never uttered or written by Stalinists of a Trotskyist comrade. However, the Trotskyists themselves gladly retaliated.[186]

About two weeks after his death, Mella was made honorary general secretary of the newly formed communist syndicate, CSUM (Confederación Sindical Unitaria de México or Unitary Syndicate Confederation of Mexico), joined by 116,000 workers and 300,000 peasants.[187] His legacy continued. To commemorate the first month since his death, on February 10, 1929 at Theater Hidalgo International Red Aid organized a *velada* (wake), with music from the (unidentified) Russian Funeral March. Modotti chaired the evening.[188] In her speech, she stated that Mella represented the opposition to all right-wing dictatorships, not just the Cuban. She warned the audience against the way the assassination was being presented in parts of the press as to distract people's attention from the real killer. Modotti repeated that Mella's murder was political and she spelled out the instigator's name, Gerardo Machado. She demanded to know why the investigation was so slow: a full month had elapsed, with no light shed on the crime by official circles – perhaps to give the assassins time to escape from Mexico City or even from the country altogether. Mella in death, she claimed, would become more perilous to Machado than in life. Finally, she demanded that the Mexican government break off relations with Cuba.[189] Other speakers were Jacobo Hurwitz, from the Caribbean Secretariat of International Red Aid; Sandalio Junco, from the Association of New Immigrant Revolutionaries from Cuba; Rafael Ramos Pedrueza, from the Committee for Persecuted People; and Rivera, from the pro-Mella committee. This engagement and Modotti's defense in general were the last official acts that the painter rendered a party comrade.

Rivera's relations with party members had become strained, which caused discomfort for Tina, a devoted party neophyte, especially when in September 1929 Rivera was excommunicated from the Mexican Communist Party and his membership card, number 992, was not renewed. Joseph Freeman presided over the expulsion meeting.[190] The party had once more

devoured one of its own children. A few years later Vidali wrote to Freeman expressing his pride in having played a part in the purge of "those agent provocateurs acting in the revolutionary movement of Mexico."[191]

As far as Rivera's commitment to the communist faith is concerned, here are the perceptions of Ione Robinson (at that time Freeman's fiancée), who went to Mexico in June 1929 to work as Rivera's art assistant:

> For my part, in spite of Diego's talk, I am convinced that he is a "pure" Communist, especially since I have learned from Joe and his friends what that really means. Diego is too busy being shrewd in every phase of living: in the way he eats, and dresses, and wears his hat, and divides the land, and makes love (in French) and divorces his wife, and rears his children, and mixes sand and lime and revolution all together, and belongs to the Central Committee of such a hard-driving political party as the Communists – all of these things at the same time, with, I think, his tongue in his cheek.[192]

The reasons given for Rivera's purge were vague, in the category of "ideological deviation." The painter was accused of becoming much too close to bourgeois thinking – which according to his former comrades made him alter the subject of some of his paintings.[193] Apparently, Rivera chose to paint grapes near a sickle instead of a hammer.[194] But these were merely pretexts, since nobody was specific about his "crimes" or could accuse him of fully embracing bourgeois values. Nevertheless, as explained by Freeman in 1932 in an article in *New Masses*, "it was on the question of middle-class leadership of the Mexican revolution that he was expelled from the Communist Party in which he occupied a unique and anomalous position."[195]

Apparently, as head of the Workers' and Peasants' Bloc, and member of the Central Committee of the Communist Party, Rivera failed to clarify his attitude toward a government that in 1929 was persecuting, arresting, and murdering his comrades. (The request for a clarification came from a Comintern official, Dimitri Manuilsky (or Mannilski), who as "comrade Pedro" had tried to bring about a peasant insurrection against the government.[196]) Rivera also refused to decline the post of head of the National School of Fine Arts, offered to him by the Portes Gil government. Modotti was particularly sensitive on this point, since after Mella's murder she herself had declined a tempting offer of a post as official photographer of the National Museum, on the grounds that she could not work for a government that in her eyes was an accomplice in her lover's death and did nothing to bring justice to the case. She expressed her views on Rivera's expulsion to Weston:

> Diego is out of the party. Only last night the decision was taken. Reasons:
> That his many jobs he has lately accepted from the government – deco-
> rating the Nat. Palace, Head of Fine Arts, decorating the Health Depart-
> ment are incompatible with a militant member of the party. Still the p.
> did not ask him to leave his posts, all they asked him was to make a
> public statement declaring that the holding of these jobs did not prevent
> him from fighting the present reactionary government. His whole atti-
> tude lately has been a very passive one in regard to the p. and he would
> not sign the statement, so out he went. There was no alternative. . . . He
> will be considered, and he is, a traitor. I need not add that I shall look
> upon him as one too, and from now on all my contact with him will be
> limited to our photographic transactions.[197]

Judging from this evidence, Modotti was endorsing the official party line,
even in (wrongly) predicting that Rivera's expulsion would do "more harm
to him than to the party."[198] She was known for never taking sides in inter-
nal party struggles and for "accepting the party decisions, even the unfair
ones."[199] Rivera himself – who had caught the "virus of Stalinophobia"[200]
– perhaps to identify a clear target, interpreted his expulsion in terms of
the contradictions seething around Stalin, to whom he never professed
loyalty;[201] nor did he want to be in the official Stalinist party.[202] His expul-
sion (only one among the many to come[203]) appears to have been part of a
worldwide purge directed by Moscow, which called the offense "right-wing
opportunism." And it made a great noise because Rivera was famous.

According to the strongly Stalinist Siqueiros, who also had many per-
sonal conflicts with Rivera, he orchestrated the whole affair himself, in order
to be expelled from the party.[204] While Siqueiros's accusations are full of
acrimony and bitterness, it is a fact that Rivera preferred to be expelled from
the party rather than sign a protest against the government. (And ten years
later, in 1939 in one of his inexplicable political moods Rivera bitterly
attacked Cárdenas and backed his rival, Andrew Almazán, a right-wing
general.[205]) Rivera was also accused by his comrades of becoming a Trotsky
sympathizer but it appears that neither he nor the party leaders were able
"to give a coherent account of the causes of the break."[206] It is true that
Rivera admired Trotsky deeply (his bedroom walls were covered with pho-
tographs of Trotsky[207]) and that his friendship with Trotsky inevitably
brought him into contact with the Mexican Trotsky movement.[208] That,
however, was not until 1930, that is, after his expulsion from the commu-
nist party, when he developed a close association with Manuel Rodríguez,
who himself had been expelled from several communist front groups for
other reasons than his adherence to Trotskyism.[209]

It was not until the end of 1936 that Rivera formally appeared in the leadership of Mexican Trotskyism,[210] and was instrumental in gaining political asylum for Trotsky in Mexico (the change of government in Norway might have meant death for the Russian revolutionary). George Novack, a socialist member of the Jewish group Menorah, alerted Anita Brenner who in turn contacted Rivera, who went to see Cárdenas and asked him to give Trotsky asylum.[211] But Rivera had grown critical of Stalinism (mistakenly viewed by many as the only form of communism) by 1929, when he issued a public statement: "Stalin was making a bourgeois government out of Russia and therefore issued the order that all the great, real leaders in the Communistic cause were to be ousted."[212]

According to Siqueiros, it was in 1927 while in Moscow that Rivera started favoring Trotsky's line, mainly after a two-hour speech by the communist Nín, whom Rivera greatly admired.[213] The feeling was mutual. In 1928 Nín even sent Trotsky a volume of reproductions of Rivera's paintings and sculptures, which Trotsky deeply appreciated mainly because he identified with the painter's restless search for a new artistic expression.[214] Not only that: Trotsky found in Rivera's paintings, charged with pathos and passion, the exaltation of the humble and poor.[215] While in exile in Turkey in June 1933 he sent an appreciative letter to Rivera, addressing him as *estimado camarada* (distinguished comrade).[216]

In 1934, Rivera joined the newly established Asociación de Estudios y Divulgación Marxista-Leninista (Association for Marxist-Leninist Studies and Propaganda), a front organization of the Liga Comunista Internacionalista (Communist Internationalist League, the former Oposición Comunista de Izquierda or Communist Left Opposition), mainly formed by those expelled from the Communist Party. He became the association's secretary-general.[217] But he always had the highest respect for the party that he believed was the only one that could defend the interests of the Mexican working class[218] (he called himself "an honest ally of the proletariat"[219]). At the same time he had the highest respect for Trotsky as well, despite their personal and political differences.[220]

A few articles, published in 1934 in *El Machete*, show the harshness and unfairness of Rivera's former comrades in dealing with him. In a cartoon about the school system, Rivera at left is drawn as a reactionary, holding a banner that says "ultra-radical (Trotskyite)," while the church at right advocates *libre catedra*. The proletarians, with their fists raised, reject "the socialist farce" as well as "free teaching," and request "scientific materialistic teaching" and free schooling.[221] Insults range from "political garbage," "a liar," "the painter of the billionaire yanquis," to "a traitor,"[222] when only

ten months before his expulsion from the party, Rivera had been addressed by his comrades as "the great revolutionary painter."[223]

In *Idols behind Altars*, published in the same year as Rivera's expulsion, Brenner stated in the chapter devoted to him that "the word masses is associated with Rivera in many minds,"[224] thus crediting the artist with a strong populist following and with unquestionable service to the proletariat. Granted that the Mexican press had the habit of prefacing Rivera's name with the word *discutido* (disputed), as if it were a title,[225] there is a large gap between "disputed" and "political garbage."

This constant, almost comical, anti-Rivera campaign failed to make him either an anticommunist or a symbol of counterrevolution. In fact, in the year of his expulsion he stated that the only intelligent thing a person could do was "to become a Communist," which meant "to forget his individual self and work only for the collective advancement of the masses."[226] For Rivera, art as a vocation was always indivisible from its social role. And art through him regained its role of portraying human, social, and political unrest (as had happened in the catacombs of the early Christians or during the Renaissance period).[227] Rivera continued until his death to serve the cause in which he believed and never fought his comrades – who even while denouncing him were "begging for donations," according to Wolfe.[228]

By 1936 Carrillo at least admitted that Rivera should never have been purged,[229] but in public it was still claimed at the time that he was an active informant for the FBI in the American Embassy in Mexico City, in order to "preserve his ability to get a visa and flee to the United States from any personal threat to him in Mexico."[230] In September 1954, that is, after Frida Kahlo had died and three years before his own death, Rivera was allowed to rejoin the party, after three unsuccessful attempts,[231] and after he had openly criticized his link to Trotsky.[232] But for hardline communists he remained a "mystical *zapatista*"[233] and, as recently as 1980, a Trotskyite.[234]

* * *

On January 17, 1929, after a second reconstruction of Mella's murder, Tina Modotti was acquitted. She had been represented by José María Lozano, a progressive lawyer, and helped by various friends and comrades, among them Rivera, who characteristically enlarged his contribution to the case: "My evidence, presented in court, ripped apart the net of speculations in which the prosecution had hoped to entrap Tina."[235] The day after the acquittal *Excelsior* called her "the comrade of the student Julio Antonio Mella," and Rivera "the communist painter, her strongest defender."[236] On January 16, Miguel Covarrubias and others had written a letter of protest

to *Excelsior* on Modotti's behalf, stressing the fact that the photographs found in Tina's home were "not immoral pornographic nudes but artistic nudes."[237] The Mexican government took some measures to assure a certain façade of legality: the Cuban ambassador to Mexico was withdrawn and the chief of police was removed. But the damage to Modotti's life had been done, and she remained a controversial figure.

Immediately after the trial, Modotti withdrew into herself, and by the fall was considering the possibility of leaving Mexico.[238] But Italy was out of question. The fascist police had been working incessantly to watch her movements. The police prefect of Udine wrote to the Italian minister of the interior in Rome that Modotti, a communist, had emigrated to the U.S. in 1920 (she emigrated in 1913) and that, while still in Udine, she had practiced "clandestine prostitution."[239]

Tina needed some time to distance herself from the noise and turbulence of the city and from the insults of the press. She had been so humiliated that she needed to be reconnected with her soul. She had loved Mella, and he was no longer with her. Since it was a love aborted at its blooming, their short story has tended to be romanticized, and their youth and beauty increased the myth. Moreover, Mella had died tragically so he was bound to become a martyr. And it was this martyrdom, not Mella himself, that made him the symbol of the party.[240]

In a letter to Weston, a convalescent Tina conveyed her self-elected distance from everything and her totally new outlook on the world: "At times I wonder if I have really changed so much myself or if it is just a kind of superstructure laid over me."[241] The trial had made a different woman of her. The press had depicted her in such derogatory terms that Ione Robinson, who met her for the first time that summer, had difficulty reconciling the simple and generous human being with the image of a "femme fatale, or an accomplice in a sensational crime."[242] When she was staying in Modotti's home, Modotti insisted on helping her, sending her to bed, and even unpacking her clothes for her: "I saw her look at each dress like a nun who has renounced all worldly possessions."[243] Mella's presence was everywhere; Tina even kept a deathmask of him, which made Robinson feel uncomfortable, "lying on the hard cot looking at him."[244]

In spring 1929 Tina's brother Benvenuto came to stay for a few months, working in a cement factory,[245] and in April participating in a meeting and demonstration led by International Red Aid.[246] He had been thinking of visiting his sister in a long time and had studied Spanish for a while.[247] From Benvenuto himself it is known that Vidali was involved in his decision to visit Tina: the terms of the visit appear to have been Vidali's.[248] Benvenuto's U.S. passport for traveling to Mexico was released in January

1920, as a telegram by the Italian Ministry of Foreign Affairs to the Ministry of the Interior proves. The telegram describes him as a "very active antifascist, secretary of the extremist club, *Rivendicazione*, and undoubtely a relative of the notorious Tina Modotti."[249]

Having a member of her family was consoling and therapeutic for Tina, as she briefly commented in a letter to Weston[250] and as Monna Sala wrote just before Ben's arrival.[251] As noted, Benvenuto was sympathetic to his sister's political ideas: "The communist cause is the cause that mostly addresses and solves my emotional and intellectual needs. In it, I find the reason and joy of life and I devote my whole life to it."[252] When Benvenuto left Mexico in August, Modotti decided to leave the capital herself for a brief period. The party may also have suggested that she keep a low profile until public interest died down. After the cause célèbre of Mella's death everything had happened so quickly that she had had time neither to mourn him nor to heal from her loss.

The Mexican countryside was able to provide the human and soothing touch she needed. In late summer 1929 Tina left Mexico City with her best friend, her camera. She traveled south to the Isthmus of Tehuantepec, and Juchitán, in order to see and record little fragments of life. The photographs of Tehuanas (Zapotec Indian women) and children that she took in this period are remarkably beautiful. They are bursting with life – the best way to honor Mella.

8 The Camera as Comrade and Ally

"A photograph is a frozen moment from a river that never
stops. There is still complete belief that a photograph is a
reflection of reality, something that really happened. It is like a
mirror. But it has a message because there is a consciousness
behind it."

<div align="right">Steven Kasher[1]</div>

Photographers tend to establish a certain stylistic language. Tina Modotti's
photographs evince no one stylistic language, which makes analysis par-
ticularly challenging. Moreover, she frequently used her Graflex camera as
if it were a small camera, moving toward the street photography that in the
1920s was still in its infancy. That is why orthodox historians of photog-
raphy often claim that she was not a street photographer like Lola Alvarez
Bravo (from 1935),[2] but in any case the concept as perceived by Henri
Cartier Bresson had not yet been developed. However, at least one of her
photographs, taken in Mexico and titled *Misery*, has been considered a street
photograph.[3]

Since they work through a medium that is both silent and still, photog-
raphers recognize the expressive power of gestures: the way people move
and stand can offer eloquent testimony to their lives. If one looks at
Modotti's portraits – taken mainly in the period of her chief production
from 1926 to 1930 – one realizes that her overriding goal was to capture
the soul of the photographed subject through details, and to translate emo-
tions into limpid images. Since Modotti was a woman full of compassion,
"she was able to make visible the humility, simplicity, solitude, and forti-
tude of the Mexican people."[4] The photographer Gisèle Freund always
stressed the importance of this rapport among camera, photographer, and
object, in which the camera acted "merely as a mediator."[5]

As early as 1913 the Mexican writer Marius De Zayas stirred up the
debate as to whether or not photography should be considered an art.[6]
Modotti and Weston liked the articulation of his pronouncement "Pho-
tography begins to be Photography for until now it has only been art" so
much that they used it in the announcement of their 1923 exhibition at

Aztec Land in Mexico City.[7] De Zayas's answer was that if photography was not art, photographs could be made into art. He departed from the commonly used parallel between nineteenth-century painting and photography in order to give photography its own dignity, based "on its own terms of reference and its own potential as a means of representation."[8]

Art photography and ideology in Modotti merged in one body, which prompted Martí Casanovas to write that she "placed this marvelous instrument in her hands at the service of the revolution."[9] That is why we do not feel that her photography was an act of aggression against her subjects. Rather, it was "a way to mark the historical presence of subjects to whom it had been denied or made inaccessible."[10] Through the camera lens, Modotti communicates a character's entire history in an evanescent moment, and through her images, we are able to see and "read" the poverty of a country. Her photographs contain an obsession with humanity;[11] her subjects become concepts,[12] and the images she was able to obtain were not neutral on social reality.[13] Thus the photographer became an artisan who denounced the ills of society,[14] because she carefully chose her subjects from the bottom of society, not the top, and her photography became "a medium for didacticism, to teach, exhort, and proselytize ideals."[15] Her full production may appear rather low in numbers – between 160 and 225[16] – but this is not a meager oeuvre given that she was fully active as a photographer for only a brief period of her life.

Margaret Hooks considers that the photograph *Workers' Parade*, published in the August–September 1926 issue of *Mexican Folkways*, was the first of Modotti's ideological attempts to unite politics and art.[17] The politics of the photograph, taken with a Graflex camera, immediately strike the viewer: the peasant oceanic masses with their large straw *sombreros* march united in the struggle reflected in the May Day parade. The composition too is impressive in conveying movement and vastness. The marching peasants practically invade the whole image, leaving us no alternative but to concentrate on their dignified posture. Moreover, we have the distinct feeling that Modotti refused to stand back, in spite of the high viewpoint of the photograph; she mingles with the crowd in spirit. The photograph was so powerful that it was published at least four more times during Modotti's photographic career, with four different titles.[18]

Tina was able to expose social inequalities also through the faces of the children she photographed, without sugary romanticism, sentimentality, or picturesqueness and without ever intellectualizing poverty.[19] Among the best of these is her 1928 photograph of a little girl in *Railway Worker's Daughter*, which exposes children's labor.[20] Because of the empathy she felt for children in general, she was able to reveal to the world a magical and

mighty Mexico, as opposed to the superficial and clichéd Mexico.[21] The people in Modotti's works, in fact, never lost their dignity, nor do they appear remote. More than 70 years later, her photographs are still intensely moving, and grounded in the fluid movements of everyday day life. Her whole production in fact contradicts what she herself once stated: "one cannot express one's own social feelings with photographic art."[22]

In the famous *Woman with Flag* (or *Woman with a Banner*), printed on the cover of *New Masses* in June 1929 and reprinted in practically every publication on Modotti, a uniquely feminine combination of three elements of Modotti's life emerges – art, politics, and feminism (although Tina herself would probably have hesitated to articulate and identify the feminism in her photography). Judging from the date of the photograph, 1928, its subject has been accepted as Benita Galeana, a Mexican activist who used to wear folk-style white dresses.[23] However, recent studies on Modotti have suggested an alternative, perhaps Luz Jiménez.[24] But the woman's identity is irrelevant, since the photograph is not a portrait; it is an ideologically charged image. (As Eli Bartra states, the fact that "doubts exist about the model's identity indicates that it is not a portrait."[25]) Thus, as in other photographs by Modotti, what it represents in terms of social class is far more important than who or what it is.

While Weston, in another part of the world, with his usual "sharp exactness"[26] was photographing shells, trees, and rocks, demanding and exercising total control over his subjects, animate or inanimate,[27] and creating a distance between photographer and photographed, Modotti was concentrating her attention on the oppressed, the marginal, the exploited, the poor, carefully choosing her subjects, her rich compositions, and her structures, as if she were establishing a political dialogue with the poor of the world, a dialogue that remained uninterrupted until her death, even when she abandoned photography. After all, to take a photograph is to create a bond with the photographed.[28] The photographer "must try to give him something in return."[29] Thus we never see Tina lecturing in her pictures, but only sharing. We see that she identified with the silence of the people,[30] and that she "transmuted matter into ideology."[31] That is why the painter Paul O'Higgins stated that "when her hand raised her camera to work, she was able to reach the deepest photographic expression that Mexico has ever had."[32] And that is why, in comparing Weston and Modotti's photography, Anita Brenner stated that Tina's way was much softer and more emotional, since Weston was working toward sharpness and an architectural feeling and texture, without much feeling for people.[33] Thus Patricia Albers's comment that Tina "conjugated communism with compassion"[34] applies equally to her photography.

As Riccardo Toffoletti noticed, both Weston and Modotti took advantage of the luminosity of Mexico. But while Weston captured the same formal tension in a face that he could draw from a shell or an artichoke, Modotti tended to avoid a frontal exposure, instead showing careful attention to the subject as a whole. In so doing, and by modulating tone with light, Tina the photographer merged with Tina the comrade and was able to convey a sense of psychological depth.[35] For the terse accuracy and human intensity of her photographs, all without blatant populism, Modotti ranks alongside the Sicilian writer Giovanni Verga (1840–1922), part of whose work was translated into English by D. H. Lawrence; or the Sardinian writer Grazia Deledda (1875–1936), who received the Nobel Prize for Literature in 1926. Both writers, considered the greatest representatives of *verismo*, acted as a classical chorus in their works, which are distinctive on account of the authors' closeness to the poor of the earth.

Like a Greek tragedian, Modotti played the chorus to her visual work, "conjugating her esthetic component with her political engagement."[36] And she represented in her photography the hope of the oppressed. If art is, among other things, a form of knowledge, like all such forms, art (in this case photography) contains ideological elements, addressing itself not only to reason but to feelings, sensations.[37] Her *Worker Reading* "El Machete," dated 1927 (the year she entered the party) is a call to action and to literacy, which echoes one of Rivera's murals, *Literacy*.[38] This is not to suggest that Modotti was dependent or unoriginal in her artistic production, as has been widely claimed – for example, by Octavio Paz, who called the photograph *una obra derivada* (a derivative work).[39] Of course, Weston's influence is obvious in Modotti's technique, but Paz detects Weston's mark everywhere in her photography, as if Modotti as a woman were incapable of producing original work. Yet as early as 1924, on more than one occasion Weston praised Modotti's work and wished he had done it himself.[40]

The most moving picture of this repertoire – scholars of photography may find it technically inferior – which delivers an almost palpable charge, is that taken by Modotti in Mexico City in 1927 when she visited the working-class colony called de la Bolsa with some American friends of the Wolfes. Two children (perhaps brothers) look into the camera. They appear scared, vulnerable, and one seems to protect the other, holding him back. As noted in chapter six, the photograph, a montage, originally appeared uncropped in 1928 in *El Machete*[41] and the following year was reproduced in *Puch Mopra*, the Russian publication of International Red Aid.[42] Tina

was much moved by the colony, as is visible in this photograph and others taken of similar subjects.[43] She wrote about her visit to the colony school to Weston: "when we left the place we all had tears in our eyes."[44]

Children's nudity, which among the elite classes was a sign of elegance, here means only one tragic thing. Nobody could fail to be moved by such an image: there is nothing artificial or rhetorical about it, everything is there in front of you, with no border or margins to defuse or dilute its meaning. And poverty hits you, since it is there in front of you. This scene indeed "becomes elevated to something Dantesque."[45] However, it is precisely its immediacy that makes it unusual for Modotti, who generally avoided presenting a situation where nothing was left to the viewer's imagination.[46]

The portrait *Elisa* (1926) exemplifies her allusive style: the hands of a woman all wrapped in black are the focus of the picture; they signify manual work and constitute "a statement of the hardship of labor."[47] Its simplicity renders it as powerful as Modotti's hammer and sickle photograph and its concentration on only one element – the tools of work – increases the impact.[48] Modotti's compositions were admired by Lola Alvarez Bravo who perceived the discipline in Modotti.[49] When Tina moved into a strictly ideological photographic mode her camera became her eye and her soul in order to denounce misery and to exalt the political system that she embraced to fight such misery. Modotti was by no means the first to engage in social photography. Contrary to Stieglitz, "who believed true artists should live rarefied lives, devoted to art"[50] and should avoid depictions of labor, Lewis Hine (an American trained as a sociologist) had used this medium in 1905 to highlight the plight of poor European immigrants. Later his involvement in the National Child Labor Committee as a staff photographer and investigator exposed the shocking working conditions of children.[51]

The women whom Modotti photographed in Tehuantepec were never asked to pose – they were simply attending to their usual chores, washing clothes, transporting food in their baskets, holding and feeding children. The resulting images could almost have influenced the paintings of women by Rufino Tamayo such as *Tehuanas* (1938) and *The Fruit Sellers* (1938), in which quotidian life is perceived without any trace of sentimentality. But Modotti's images of women taken after Mella's death are not just images, they are minuscule particles of life grouped behind a lens, with no trace of paternalism, the synthesis of Tina's commitment to communism, and the visual statement of her suffering. They are important because they read like an open book, as articulate as if they were words: they plead and cry for attention and justice. They "convey a sense of her personal commitment to

human concerns."[52] And the period in which they were taken is crucial: Tina's lover had been murdered at her side for his revolutionary cause. She needed to recreate and redefine her role in life, and those women came to represent life in various forms, including child bearing: in simple terms, they represent the exaltation and continuation of life itself. These women functioned in a way as Modotti's spiritual mediators.[53] Photographing women and children soothed her. Tina adored children, although she never had any – Vidali stated that she was unable to conceive because of her immature uterus,[54] and Brenner recorded that having children was a non-issue for Tina.[55]

It should not be forgotten that Tehuantepec is traditionally and histori-cally a matriarchal society whose customs and folklore reflect that fact. In 1937, for example, the image of a Tehuana was chosen for the 10 *peso* bill.[56] Carleton Beals described a dynamic female-oriented society in 1958: "The women boss Tehuantepec with energy, vivacity, and passion. They do most of the work, all the buying and selling, hold the family purse-strings while pretending that their lazy hammock-lolling husbands are the masters. Daring, full of fire and fun, their tongues are spicy, and they have few inhibitions."[57] The Isthmus of Tehuantepec seduced (and continues to seduce) many people, including a French abbot, Charles Étienne Brasseur de Bourbourg in the middle of the nineteenth century.[58] Miguel Covarru-bias too succumbed to the place's charm, which for him lay in its violent contrasts:

> its arid brush, its jungles that seemed lifted from a Rousseau canvas; the Oriental color of its markets, where chattering Indian women, dressed like tropical birds, speak tonal languages reminiscent of China; the majestic bearing and classic elegance of the Tehuantepec women walking to market in stately grace with enormous loads of fruit and flowers on their heads . . .[59]

Whether Modotti's choice was accidental or not is unknown, but what is certain is that she returned to Mexico City at peace with herself and ready to continue pursuing Mella's and her struggle. Her trip to Tehuantepec represented a turning point in her life, in terms of art and politics, for it had added a particularly warm humanity to her political world.

What makes these photographs humanly and artistically effective? The subjects themselves? No. Why do we not feel the same empathy in looking, for example, at *Unemployed Man* (1928) by August Sander? Is it because we sense a certain distance between subject and photographer? Or is it because the resigned figure does not face the camera and has been margin-alized? As Clarke observed, "to be unemployed here is to be without status

and, more problematic, identity."[60] Is empathy perceptible in Modotti's photographs because of her political commitment and our tendency to see it in everything? Although that is a risk, it is not the case. Modotti's photographic work is covered with the patina of ideology, which changes one's outlook on life. Her empathy is spelled out in capital letters. Her ideology, present both in the smiles and in the sadness of children, dictated the terms of her artistic approach. (For Weston it was the opposite, although his best work, mainly portraits, occurred when he had "some intense sympathetic or erotic relation with his subjects."[61] But however erotic Weston's relation may have been, it was still detached.)

Among Modotti's other works the series of puppeteers and puppets stands out. Contemporary society was receptive to a "renaissance of the marionettes,"[62] but Tina was apparently enchanted by puppets in general: during her first year in Mexico, 1923, she had taken a photograph of a cowboy puppet whose shadow is thrown onto the background. On the back of the print she wrote, "My latest Lover!" Six years later, after Mella's murder, Tina found herself photographing puppets again, but this time with their puppeteers and, perhaps, with a definite ideological meaning. The hands of a puppeteer are the focus of another 1929 photograph. Louis Buñin, a naturalized American of Russian origins, was invited by Rivera to visit Mexico with his wife, Alice, to paint the country's colors but once in Mexico the Bunins were asked to teach the art of marionettes to the Indians. This they found to be an effective vehicle of criticism of the government. *Louis Bunin with Dancing Puppet* has always reminded me of Thomas Mann's short story *Mario and the Magician*, written in 1930 to expose a powerful magician, Benito Mussolini.[63]

Was Modotti's photograph of the puppeteer's hands a conscious ideological statement, as the puppeteer had intended in making his puppet? A few seem to believe so – Toffoletti has called this "a metaphor for power"[64] – since the puppet is a subject controlled from above by others. So the photograph might signify the power of the oppressors and the impotence of the oppressed. Or does the image indicate that we are in the hands of destiny, like marionettes at the mercy of some unknown power? Even though the idea of a supreme being was not entertained by communists, it was not incompatible with the idea of destiny. In composing this picture Modotti would not have been disloyal to her materialism but could have been thinking about the role of destiny in one's life.

In her seven years in Mexico Modotti made portraits of at least fifty subjects. The actress María Dolores Asúnsolo (better known as Dolores del Rio) was probably the most famous of her sitters, who included Jean Charlot, Carleton Beals, María Marín de Orozco, Federico Marín, Anita Brenner,

Ramon de Negri, María Orozco Romero, Antonieta Rivas Mercado, Ione Robinson, and Concha Michel (with her beloved guitar). However, they do not, by and large, constitute her best work, even when a relationship between photographer and sitter was established. And it was not lucrative: Tina did not always charge for her work or people would not pay her in full but in instalments or whenever they could. Several letters mention debts to Modotti for her work, as does Brenner in her diary.[65] Some of these prints were used independently: Joseph Freeman's portrait, for example, taken by Tina in 1929, was reproduced on the cover of one of his books, and in 1931 he asked his former wife, Ione Robinson, to untie the rope of a trunk and "fish those pictures out," the only thing he had left of his "Mexican adventure."[66] Robinson herself wrote to him that she had been proud to show Tina's prints to her teacher and art director in Los Angeles.[67]

Modotti's photographs of flowers, then, stand apart, especially the voluptuous roses of 1924 (whose print sold in 1991 at Sotheby's for $165,000[68]). The roses (probably President Maccia or cabbage rose type, commonly regarded as ambassadors of love) lie as if they are gently forming a pillow. They are human, vivid, and almost morbid in their simplicity; they have a tangible feeling, almost inviting one to touch them or to breathe life into them. Compared with other photographs of flowers, which are often cold, detached, almost perfect, and practically sterilized, Modotti's roses are not carefully arranged in a vase but rather entirely monopolize their space. The borders are cropped to focus only on the image, in which we as viewers are immersed. Sarah Lowe interprets them both as objects that have "outlived their usefulness as things of living beauty" and as a universal reminder and symbol of love and death,[69] while Andrea Noble sees the photograph as "a symbol of lack."[70] The novelist Bárbara Mujica, writing on Frida Kahlo, suggests that Tina's crushed roses symbolize "the souls of workers detroyed by the capitalist system."[71]

Among various cultural, political, and artistic changes, the formal innovations of the *estridentista* movemement influenced the content of such photographs by Modotti as *Glasses* (1924) and *Telegraph Wires* (1925), which John Mraz, for example, reads as the precursors of the various photographic montages.[72] (On June 30, 1978, in recognition of the scientific discipline of *informatica fotografica* and to mark an exhibition of Modotti's and Weston's work at the Galleria dell'Obelisco in Rome, the Italian government, at the suggestion of Francesco Carlo Crispolti, issued a 120-lire stamp showing *Telegraph Wires*, in honor of Modotti.[73])

Her technical masterpiece has long been acknowledged to be *La Técnica*, better known as *Mella's Typewriter*. As remarked before, it has been rightly interpreted as an allusion to the role played by the intellectuals during the

Latin American revolution,[74] and a symbolic and abstract portrait of the Cuban revolutionary.[75] Here we have the major tool of Mella's political activism, his powerful typewriter, far mightier and far more aggressive than a gun. The machine is silent, ready to be used, that is, ready to shoot Mella's words of reproach against American imperialist policy, the wealthy Cuban bourgeoisie, and the petty Mexican élite. Despite the fact that the print could have been made before September 1928 (that, is before Modotti became Mella's lover), we still think of him when we look at the picture, and the machine becomes him *de facto.* In Mella's passionate letter to Tina from Veracruz he mentions that a tear fell on the typewriter's keyboard – "the typewriter," he wrote, "that you have socialized with your art."

Looking at the critiques of Modotti's photography published while she was alive, I notice that in February 1929 *Creative Art* published an eight-page article by Carleton Beals on her work, with seven reproductions.[76] Beals found Modotti "more abstract, more intellectual, more ethereal than Weston." Her depth came from her socially minded approach, influenced by Rivera's painting, and from her superb "still compositions, portraits and architectural details, in the arrangement of something as artificial as a cartridge belt, a guitar, and a dried ear of corn."[77] If he needed to photograph a hammer, that is, a worker's tool, Weston would have photographed a clean, immaculate tool, never used by a worker. Modotti, instead, chose to immortalize the used tools – dirty, sweat-stained, consumed by work, but authentic. Beals found an enigmatic and puzzling analogy between Modotti's Italian culture and her photographic sense. This is especially evident in her images of flowers – such as that of two calla lilies – which are reminiscent of the angel trumpets of the painter Fra Angelico, while in other photographs Beals saw Piero della Francesca's structure. In her compositions of massed crowds Beals found an analogy with the verbal descriptions of Gabriele D'Annunzio's *Trionfo della morte* (*Triumph of Death*, 1894).

* * *

After analyzing Modotti's photography, can I honestly say that George Bernard Shaw was wrong when he stated that some day the camera would do the work of Velázquez and Pieter de Hoogh, color and all, and that ninety-nine percent of our annual output of art would belong henceforth to photography? When I was a graduate student working at the J. Paul Getty Center for the History of Art and the Humanities (as it was then called), I met a Dutch art historian who told me something that at the time surprised me. He said that he did not think in terms of words but merely of images. So immersed was I in my thesis, which for me was words, words,

and again words, that I could not perceive a world that was merely visual – only verbal. But, although at that time I did not quite understand the statement, still it stayed with me and surfaced at random here and there. After working on my book on Modotti, I can say that this approach is not just valid but essential for understanding her photography, provided it is placed in the context of her politics.

9 Expulsion

She stands in the quiet darkness
This troubled woman
Bowed by
Weariness and pain
Like an Autumn flower
in the frozen rain.
 Langston Hughes, "Troubled Woman"

The year 1929 was decisive not only for Modotti but also for the entire workers' movement. It started with Mella's assassination, which set the tone for subsequent years.[1] Manuel Alvarez Bravo's 1933 photograph, *Obrero en huelga asesinado* (The Striking Worker Killed), summarizes the political atmosphere of the 1930s. On one hand, misery and unemployment were tangible, especially in certain rural areas. On the other hand, corruption was rife among government officials who according to the communists enriched themselves at the expense of the poor. In 1929, the unemployed numbered 89,690, starting an "uninterrupted chain" of unfair dismissals, mass suspensions, and reduced working weeks.[2]

Thus the exhibition of Modotti's photographs organized under the auspices of the National University, which had just become autonomous as the Universidad Nacional Autónoma de México, acquired the air of protest against the government, and it represented the last revolutionary act performed by Modotti in Mexico. It also gave a strong voice to her artistic and ideological stand. To Weston, Tina indicated that she felt almost an obligation to Mexico to show not so much what she had done there "but especially *what can be done*, without recurring to colonial churches and charros, and chinas poblanas, and the similar trash."[3] The solo exhibition (the only one entirely devoted to her art) was held from Tuesday to Saturday, December 3–14, 1929 in the university library hall on Uruguay and Isabel the Catholic Avenue. Modotti was becoming known as a photographer: she had received a few requests for her work from Europe and from the U.S.A.,[4] and in October an exhibition of her photographs was held at the Berkeley Museum of Art in California. But the Mexican show

was the most important. It was arranged by Carlos Orozco Romero and Carlos Mérida who in November had invited Tina to exhibit her photographs,[5] and other organizers were artists such as Gabriel Fernández Ledesma (the brother of the National Library's director, Enrique Fernández Ledesma), Best Maugard, Roberto Montenegro, Miguel Covarrubias, Carlos Chávez, and Guillermo Ruiz. It was advertised in *El Universal* as "the first revolutionary photographic exhibition held in Mexico."[6]

No formal catalogue was issued, but it is known that about forty photographs were shown, divided by genre: nature, portraits, architecture, and documentary photographs, among them *Scythe, Ear of Corn* (1928), *Bandolier* (1927), and *Woman with Flag* (1928), which had been published that summer as a cover for *New Masses*.[7] The following list gives an idea of the variety on show: *Portrait of Mella*, 1928; *Stadium*, 1925; *Loading Bananas, Veracruz*, 1927; *Mella's Typewriter*, 1928; *Elegance and Poverty*, 1927–28; *Hands Resting on Tool*, 1926–27; *Mother and Son*, 1926; *Napales*, 1925; *Meeting*, 1926–27; *Tank No. 1*, 1927; *Circus Tent*, 1924 (Rivera's favorite); *Roses*, 1924; *Convent of Tepotzotlán*, 1924; *Construction Workers*, 1927; *Hammer and Sickle*, 1927; *Campesinos Reading El Machete*, 1927–28 (published in *New Masses*); *Glasses*, 1924; and *Man with Beam*, 1928, which was also printed on the cover of the same issue of *New Masses*, there called *Unskilled Labor*, right above the title of an article by the anarchist Carlo Tresca.[8] A photograph of Tina at the exhibition shows a different woman from the femme fatale of the previous years. As said earlier, this period could be characterized as post-Mella, an interpretation supported by her posture, which is that of retreat from the world: she crosses her arms as if in self-protection. Directly above Modotti her *Hammer and Sickle* sets the tone and the direction of her new life.[9]

The show was inaugurated at 7 p.m. by the rector of the university, Ignacio García Téllez. Other speakers were Enrique Fernández Ledesma and Romano Muñoz, and Concha Michel sang.[10] Entry was free and the exhibition turned out to be popular with various social classes – students, workers, and peasants, especially young people and women. The president, Emilio Portes Gil, was also invited but did not attend.[11] The response of the critics was also excellent. Gustavo Ortiz Hernán declared himself enthusiastic, while *New Masses* described Modotti as somebody who "simply and beautifully, has made a documentary record of working class life in Mexico – at work, at play, their poverty, the hovels they live in."[12] Carleton Beals had already joined the chorus of excellent reviews of Modotti's work a few months before.[13] The exhibition was reviewed in glowing terms by Paca Toor who underlined the new direction in Modotti's art, from the purely

aesthetic to "expressing the meaningful phenomenon of daily life with an explicit social content."[14]

Tina was enthusiastic about the outcome of the exhibition but also pre-occupied with the political situation.[15] Publication of what is considered her only written public statement on art coincided with the show. In order to avoid misunderstandings and ambiguities, Trotsky's words were deleted from the article. Modotti enunciated the meaning of her work, stressing that the photographer needs the approval only of those who accept pho-tography as the most eloquent and most direct medium to record their times. She spoke in terms of "registering objective life in all its manifesta-tions," which "is the source of its documentary value." She used words such as *sensibilidad* (sensitivity) and *comprension de asunto* (understanding of the matter), and, above all, "a clear orientation as to the place photography should have in the field of historical development." Such words now seem ominous in the light of her later political commitments. After the show had closed, Tina wrote to Baltasar (or Baltazar) Dromundo Cherne, who had given a closing speech, as had Siqueiros.[16] In the letter, which Dromundo kept until his death,[17] Tina expressed her sadness at not being able to develop all the wonderful possibilities that existed only in seed form, end-ing with the words "Spiritual brotherhood today and for ever!" This was perhaps an astute and diplomatic way to gain some distance from Dromundo, on whom Modotti exercised a great appeal. Dromundo's wife, Rosa Rodríguez, interviewed by Margaret Hooks, reports that she re-members how enamored of Tina her husband was, showering her with flowers and poems. She also remembers how insensitive were both Dromundo and Modotti toward her, then only 18 years old but already the mother of an infant girl.[18]

On November 17, 1929 an engineer, Pascual Ortiz Rubio, had been elected as president of the republic (by then of 17 million people) with a majority of nearly 2 million votes, representing 94 percent of the total, of which 117,149 were won in the capital.[19] His presidency, corruptly gained in an atmosphere of intimidation, did not become effective until February 1930.[20] Vasconcelos had returned in 1928 from a period in Europe and the U.S.A. to register his candidacy for president. Although he appeared to be accepted by the Mexican community living in North America and well balanced in his campaign, he won only 110,979 votes (5.2%), of which 21,517 came from the capital.[21] During the presidential campaign in spring 1929 an unsigned article in *El Machete* presented him as the "ladies' candidate," also informing its readers that, although Vasconcelos was a strong Catholic, he did not support the

cristeros movement.[22] The communists' candidate was Pedro Rodríguez Triana, who received 23,279 votes (a modest percentage), of which 2,124 were obtained in Mexico City.[23]

Vasconcelos returned to the United States on December 12, hoping to be able to regain the presidency through a populist movement. But that did not happen, since the new government was keeping tight control of the situation. Then on Saturday December 14, a former friend of Mella, the Cuban Tolón, informed the police that a certain Saturnino Ortega Flores (alias Cecilio Flores), a member of the local chapter of Juventud Comunista (Communist Youth) intended to kill the president-elect. Not only that, Tolón under pressure also pledged in writing that he would no longer be involved in politics.[24] Flores's arrest and subsequent disappearance alerted the communists that the situation was indeed critical. On December 28, the American president Herbert Hoover met with Ortiz Rubio (accompanied by Puig Casauranc), and bestowed upon him an honorary doctorate from George Washington University.[25] Two days later Vasconcelos announced that he would leave politics for academic life, teaching at the University of California.[26] From the very beginning Ortiz Rubio ran an aggressive antileft campaign, which according to the communists had been prepared by Portes Gil, who pardoned the *cristeros* with an amnesty.[27] Ortiz Rubio's administration was also marked by nepotism: many of the president's relatives and intimate friends from Michoacán, his native state, were speedily advanced. "Colossal robbery" went on in several departments.[28]

The year 1929 marks the beginning of a crisis-ridden period for the communist party and the left in general, which culminated in underground activities during the 1930s. Many Mexican leftists thought of leaving their country[29] since reaction was "in full swing."[30] Leftists in the U.S.A. fared no better, judging from the numerous arrests in Chicago.[31] We had to wait a long time before the words uttered by Mella when he was still a student in Cuba, *Todo tiempo futuro tiene que ser mejor* (All the future must be better),[32] were realized.

The Mexican government had closed down *El Machete* in June 1929, followed by other communist publications: *Defensa proletaria* (Proletarian Defense), the organ of the communist trade unions; *Bandera roja* (Red flag), the organ of the Workers' and Peasants' Bloc; and *Spartak*, the organ of the Young Communist League, in which Flores participated. The aim was to isolate the communists and render them more vulnerable to persecution.[33] In its last 1929 legal issue, *El Machete* published a melodramatic closing *corrido: El machete irá a las masas con su voz recia y triunfal preparando en sus proclamas la revolución social* (El Machete will go to the masses with its

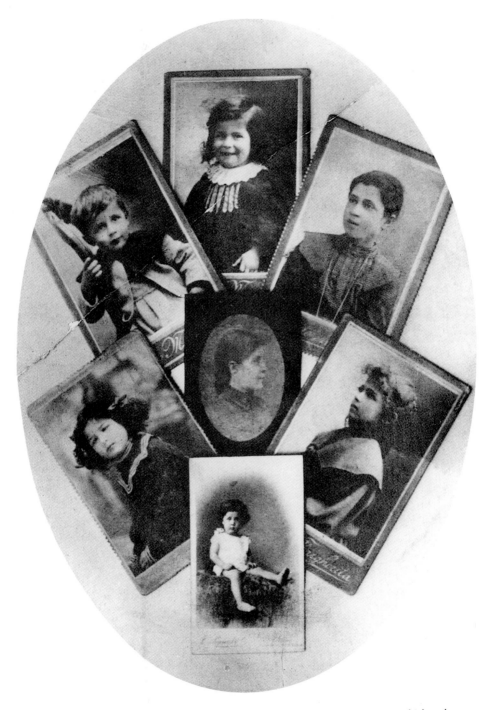

Montage of Modotti family photographs, all undated and taken at various times, which makes identification of the girls difficult. Tina's mother, Assunta Mondini, is in the center, with her children around her, clockwise from top: Tina (although it has recently been suggested that this is Jolanda); Mercedes; Valentina, called Gioconda (now believed to be Tina); Giuseppe, called Beppo; Jolanda (also believed to be Valentina Gioconda); and Benvenuto. Courtesy of the Cosolo family, Trieste

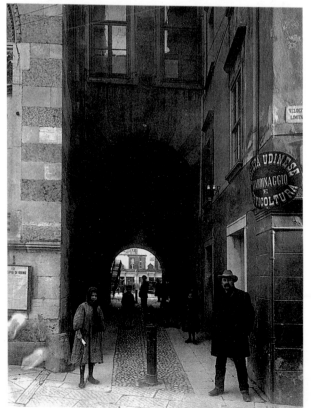

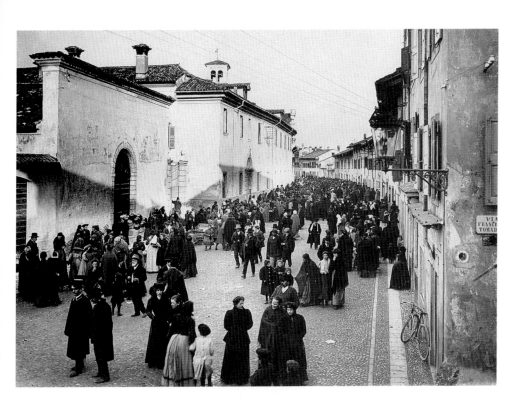

above
Via Manin, Udine, 1910. Pignat
Photographers, Udine

left
Tina's house in via Pracchiuso,
formerly no. 113, now no. 89 and
a photography store

facing page top left
Tina's parents, n.d. Courtesy of the
Cosolo family, Trieste

facing page top right
Tina's mother, Assunta Mondini
Modotti, n.d. Courtesy of the Cosolo
family, Trieste

facing page bottom
Tina with her mother in San
Francisco, photographed in 1922 by
Edward Weston. Courtesy of the
Cosolo family, Trieste

left
Tina's father, Giuseppe Modotti, in San Francisco, n.d. Courtesy of the Cosolo family, Trieste

facing page top left
Tina's sister Jolanda in San Francisco, n.d. Note the strong resemblance to Tina. Courtesy Comitato Tina Modotti, Udine

facing page top right
Tina's sister Valentina in the Giardino Umberto I, Udine, n.d.. Courtesy of the Cosolo family, Trieste

facing page bottom
The Modotti family photographed on the roof of its San Francisco apartment by Tina, c. 1926. Clockwise from top: Beppo, Benvenuto, Mercedes, Assunta, Jolanda, and Jolanda's first husband, Guido Gabrielli. Courtesy of the Cosolo family, Trieste

below
Tina's mother and sister, Jolanda, in San Francisco, n.d. Courtesy of the Cosolo family, Trieste

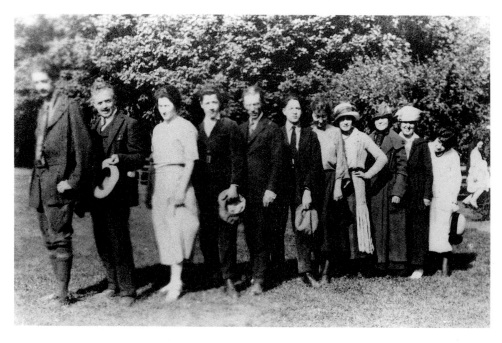

Modotti family group in San Francisco, c. 1920. From left to right: Robo de Richey; Tina's father, Giuseppe; Mercedes; Giuseppe jr.; Uncle Francesco; Benvenuto; Marionne Richey; Tina; Tina's mother, Assunta; Rose Richey; Jolanda. Courtesy of the Cosolo family, Trieste

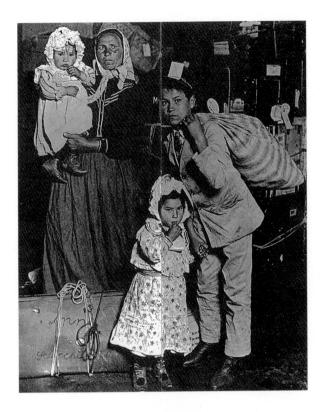

Italian immigrants arriving at Ellis Island, New York, 1905. Photograph by Lewis Hine. The woman has been identified as Anna Scicchilona by Hine, and she is shown with her three children

facing page bottom
The Modotti family returning to Italy from California in 1930. Courtesy of the Cosolo family, Trieste

left
Advertisement of 1915 for the Fugazi bank, one of the most important sources of credit for Italian immigrants arriving in San Francisco

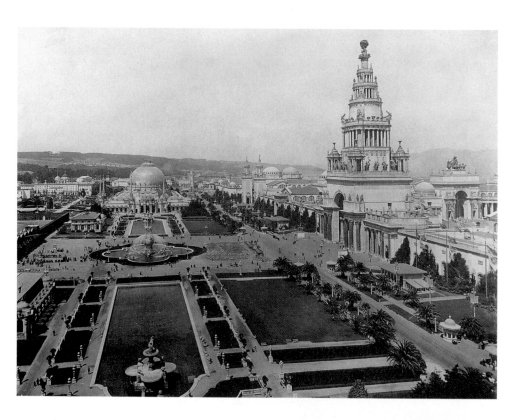

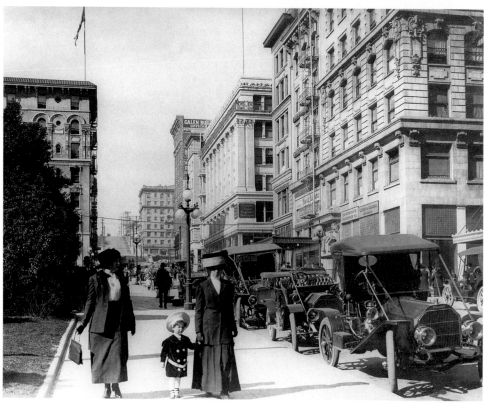

Tina as a young woman, c. 1919. The photograph is dedicated to her mother. Courtesy Comitato Tina Modotti, Udine

facing page top
View over the South Gardens at the Panama Pacific International Exposition, San Francisco, 1915. San Francisco Public Library

facing page bottom
Shopping on Union Square. View from Geary Boulevard on the east side of Union Square, looking down Stockton Street, San Francisco, 1915. San Francisco Public Library

Tina as a young woman photographed by Terkelson and Henry before a ball in San Francisco, c. 1915. The caption to the photograph reads: "Miss Tina Modotti who will dance at the Bal Masqué of Italian Public Society Saturday night." San Francisco Public Library

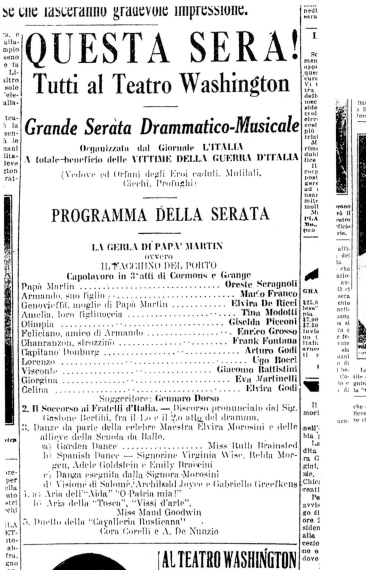

Cuttings from L'Italia newspaper, February 13, 1918, showing an announcement for the play *La Gerla di Papà Martin*, being performed that evening, in which Tina appears in the role of Amelia Martin, and an accompanying photograph of Tina

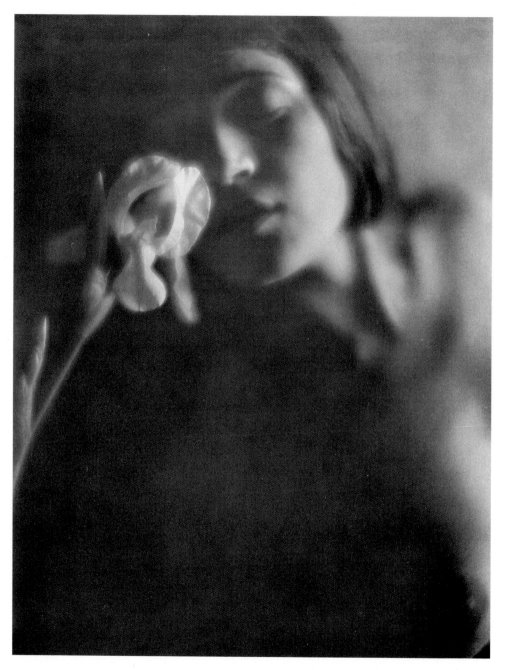

The White Iris, 1921. Photograph by Edward Weston, palladium print. Collection Center for Creative Photography, The University of Arizona, Tucson. © 1981 Center for Creative Photography, Arizona Board of Regents

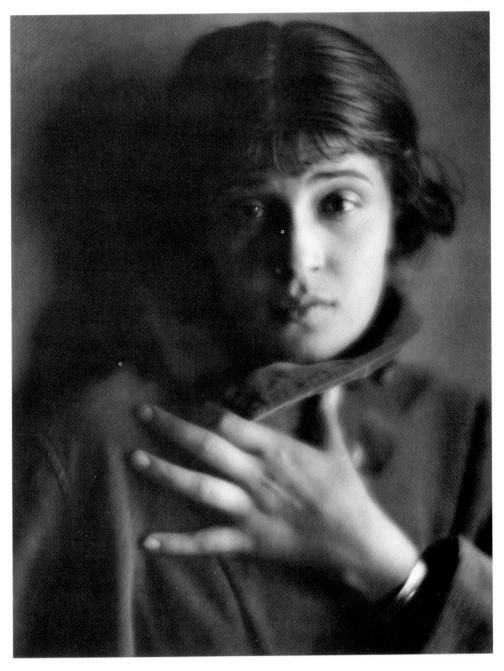

Tina, Glendale, 1921. Photograph by Edward Weston, gelatin silver print. The J. Paul Getty Museum
© 1981 Center for Creative Photography, Arizona Board of Regents

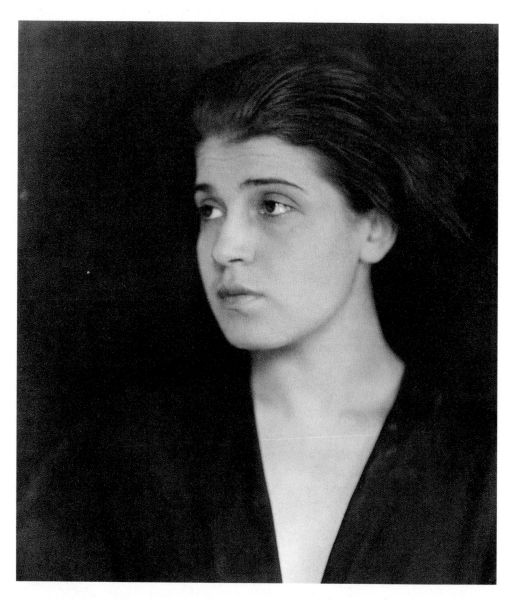

Tina, photograph attributed to Edward Weston, c. 1924–25. Courtesy of Riccardo Toffoletti/Comitato Tina Modotti, Udine

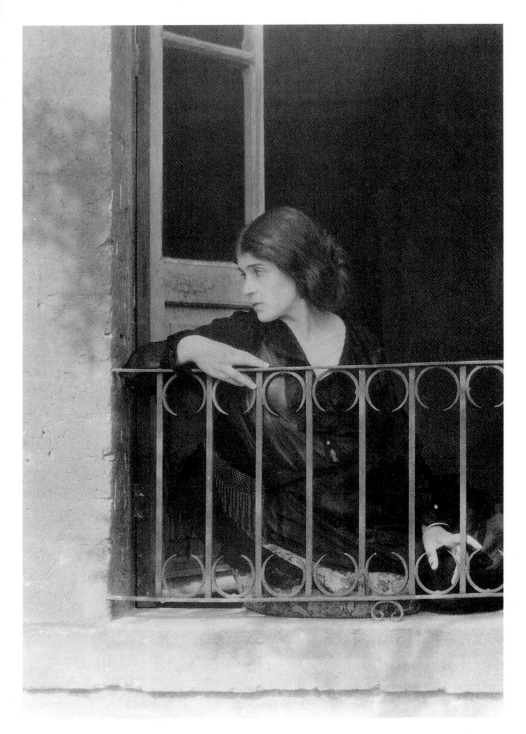

Tina in Tacubaya, Mexico, 1923. Photograph by Edward Weston. The Bancroft Library, University of California, Berkeley

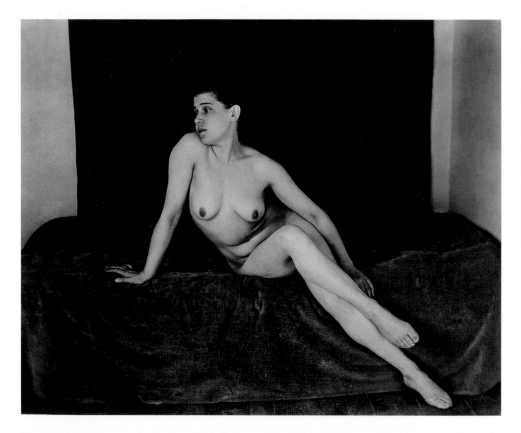

Tina, nude, seated on a sofa, Mexico, 1924. Photograph by Edward Weston, gelatin silver print. Center for Creative Photography, The University of Arizona, Tucson. © 1981 Center for Creative Photography, Arizona Board of Regents

facing page
Half-nude in Kimono (Tina Modotti), 1924. Photograph by Edward Weston, posthumous reproduction print from original negative. Edward Weston Archive, Center for Creative Photography, The University of Arizona, Tucson. © 1981 Center for Creative Photography, Arizona Board of Regents

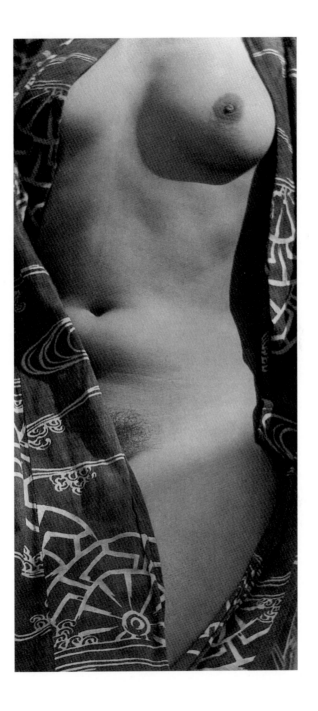

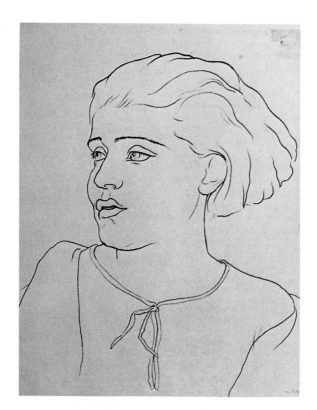

Jean Charlot, *Tina Modotti*, 1924. Charlot Collection, University of Haiwaii at Manoa

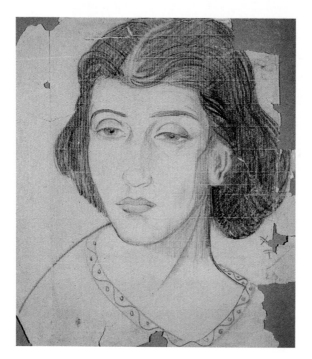

Anonymous drawing of Tina with her hair down, Mexico, 1923. Courtesy Comitato Tina Modotti, Udine

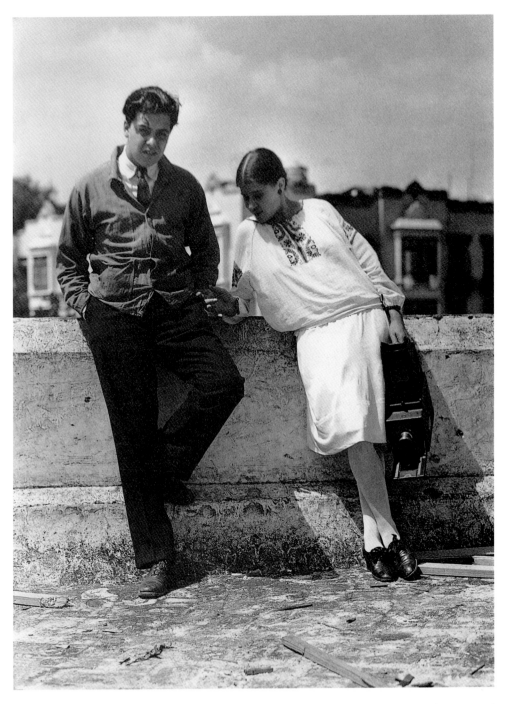

Tina and Miguel Covarrubias, c. 1924. Photograph by Edward Weston, modern print from original negative. Edward Weston Archive, Center for Creative Photography, The University of Arizona, Tucson. © 1981 Center for Creative Photography, Arizona Board of Regents

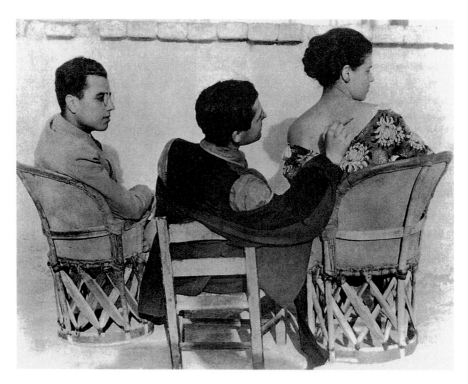

Federico Marín, Jean Charlot, and Tina on the Azotea, 1924. Photograph by Edward Weston. Courtesy Comitato Tina Modotti, Udine

Fiesta de amigos, c. 1925, by an unknown photographer. Tina is standing, second from the right, dressed as a man and holding a pipe. Courtesy Comitato Tina Modotti, Udine

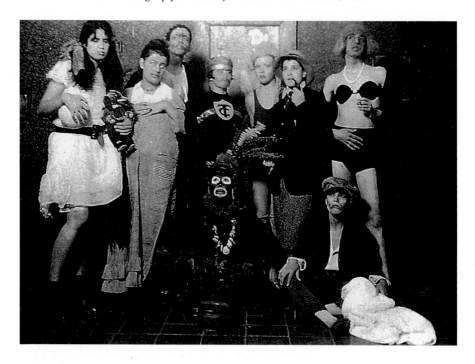

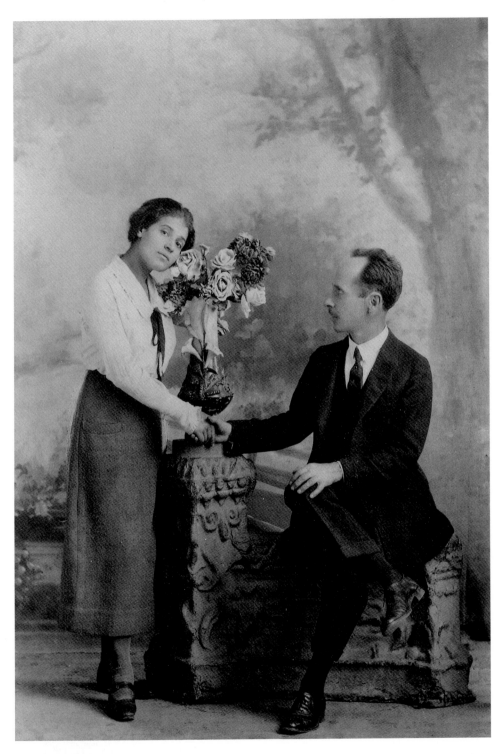

Staged marriage portrait of Tina and Edward Weston, 1925, by an unknown Mexican photographer. Gelatin silver print. The J. Paul Getty Museum, Los Angeles

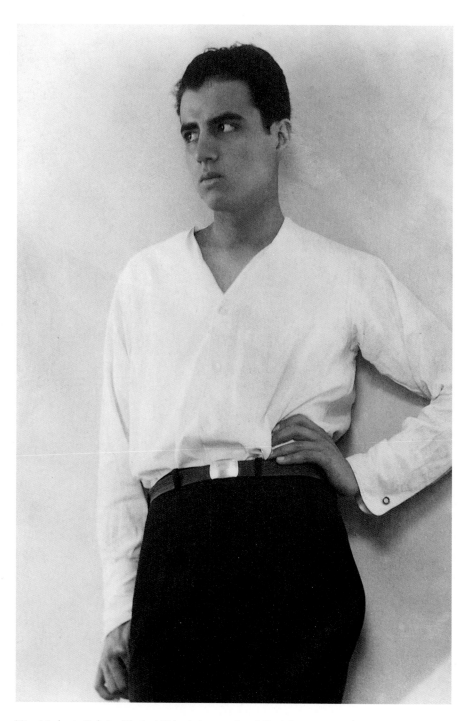

Tina Modotti, *Federico Marín*, 1924, platinum print. J. Paul Getty Museum, Los Angeles

Tina Modotti, *Convent in Tepotzotlán*, 1924, platinum print. (Courtesy of Riccardo Toffoletti)

Tina Modotti, *Tree with Dog*, 1924, platinum print. The J. Paul Getty Museum, Los Angeles

Tina Modotti, *Experiment in Related Form* (or *Glasses*), 1924, platinum print. © Collection of the Mills College Art Museum, Oakland

Tina Modotti, *Workers' Parade*, 1926. Private collection

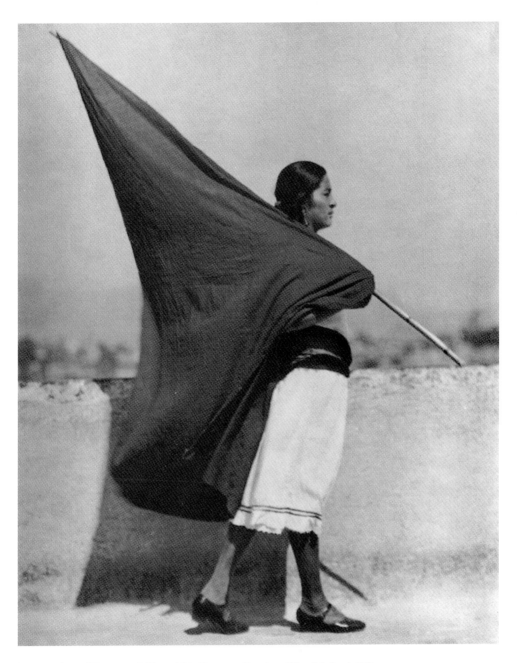

Tina Modotti, *Woman with Flag*, 1928. Courtesy Comitato Tina Modotti, Udine

facing page top
Tina Modotti, *Hands Resting on Tool*, 1927, platinum print. The J. Paul Getty Museum, Los Angeles

facing page bottom
Tina Modotti, *Mexican Sombrero with Hammer and Sickle*, 1927 (from the cover of *New Masses*, October 1928)

(?)Tina Modotti, *Donde no ha llegado la Revolución*, 1927, reproduced in *El Machete*, June 30, 1928. Interior of a house in the Bolsa Colony, Mexico City. Courtesy of the Hoover Institution on War, Revolution, and Peace, Stanford

facing page
Tina Modotti, *Los contrastes del regimen*, 1927, reproduced in *El Machete*, June 23, 1928. Courtesy of the Hoover Institution on War, Revolution, and Peace, Stanford

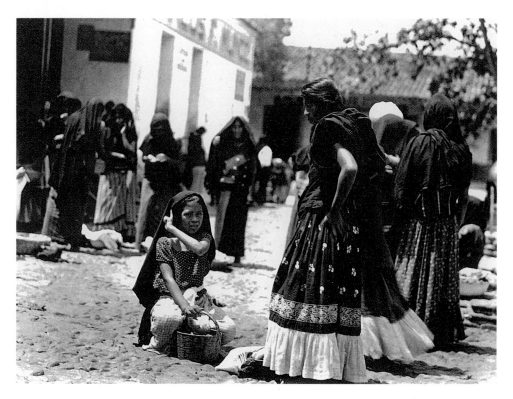

Tina Modotti, *Market in Tehuantepec*, 1929. Private collection.

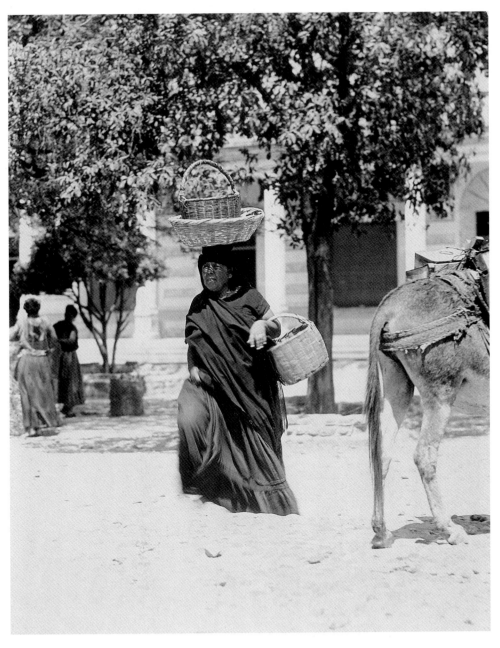

Tina Modotti, *Untitled [Street Scene–Woman Carrying Baskets, Tehuantepec]*, 1929, gelatin silver print. Collection Center for Creative Photography, The University of Arizona, Tucson

Tina Modotti, *Sugar Cane*, 1929. Courtesy Comitato Tina Modotti, Udine

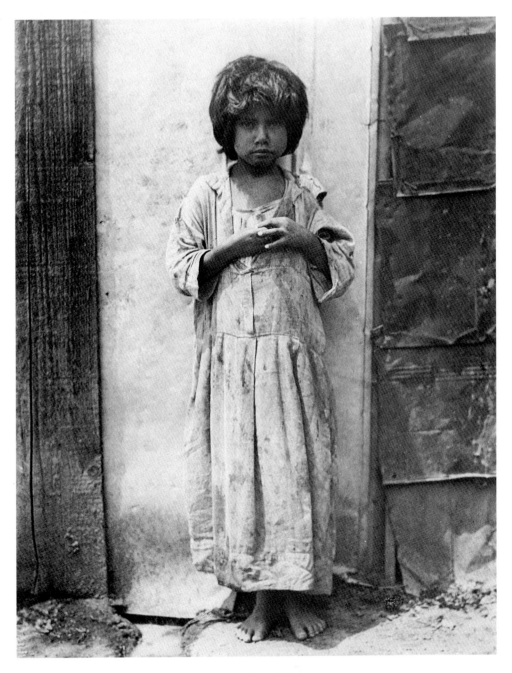

Tina Modotti, *Mexican Girl*, 1929. Courtesy Riccardo Toffoletti

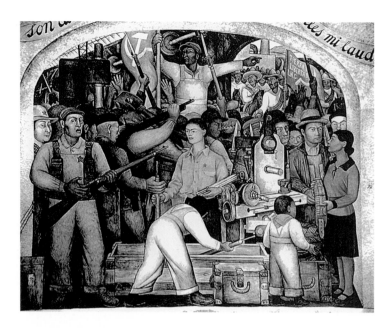

Diego Rivera, *In the Arsenal* (detail), 1928. Mural in the Ministry of Education, Mexico City. Tina is at the right edge, with Vidali (in a beret) just visible above her head and Mella facing her. Frida Kahlo is at the center of the composition and Siqueiros at the left edge

above left
Italian stamp (larger than actual size) issued in 1978 in honor of Tina Modotti, after her photograph *Telephone Wires* of 1925

above right
Cuban stamp (larger than actual size) issued in 1979 in honor of Julio Antonio Mella, after a photograph of Mella by Tina Modotti of 1928. Courtesy Comitato Tina Modotti, Udine

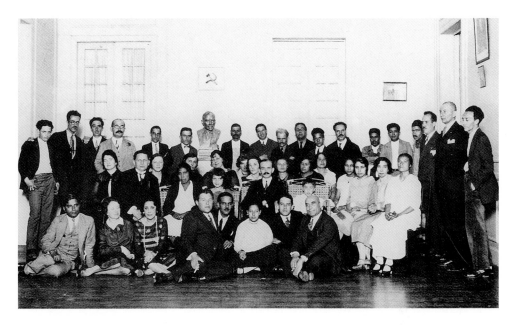

Tina Modotti, *Reception at the Soviet Embassy, Mexico City,* 1927. Tina's photograph of a hammer and sickle is just visible on the wall above the bust of Lenin. Paca Toor is among the guests. Courtesy Comitato Tina Modotti, Udine

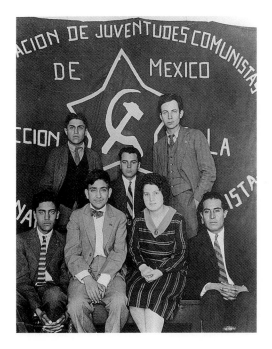

The Youth Communist League, Mexico City, 1927–28. Russell Blackwell is standing on the right and Jorge Fernández Anaya is seated second from left. Courtesy Riccardo Toffoletti

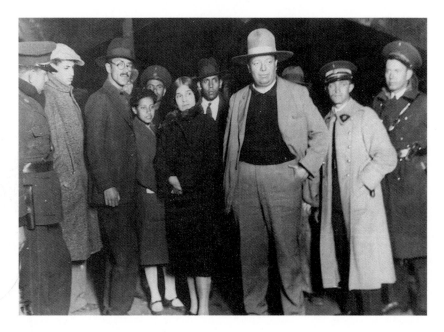

Tina is accompanied to police headquarters in Mexico City by Diego Rivera after the assassination of Mella, January 1929. Courtesy Comitato Tina Modotti, Udine

Tina at police headquarters in Mexico City after the assassination of Mella, January 1929. Courtesy Comitato Tina Modotti, Udine

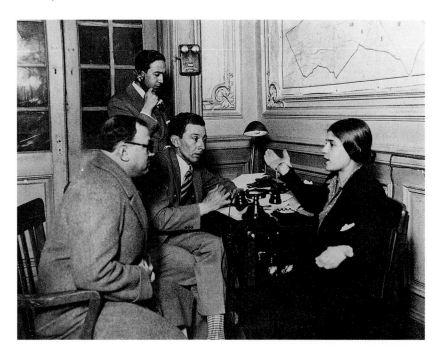

Photograph from the *Excelsior* newspaper showing Tina reviewing documents from the trial following the assassination of Mella, January 1929

En Memoria de

JULIO A. MELLA

Asesinado por los esbirros del Gral. Gerardo Machado,
en la noche del 10 de enero de 1929 en la capital
de la República Mexicana.

VELADA organizada por el

SOCORRO ROJO INTERNAC.

=== PROGRAMA ===

MARCHA FUNEBRE RUSA

JACOBO HURWITZ a nombre del Secretariado del Caribe
del SOCORRO ROJO INTERNACIONAL.

DIEGO RIVERA a nombre del Comité Pro Mella.

SANDALIO JUNCO a nombre de la Asociación de los Nue-
vos Emigrados Revolucionarios de Cuba.

PROF. RAFAEL RAMOS PEDRUEZA a nombre de la
Liga Pro Luchadores Perseguidos.

HARAN USO DE LA PALABRA BREVEMENTE PARA ADHERIRSE A LA CONME-
MORACION: VENEZUELA: DON CARLOS LEON. CUBA: ALEJANDRO BARRIS-
RO: BOLIVIA: TRISTAN MAROF: ARGENTINA: JORGE PAZ: NICARA-
GUA: SOCRATES SANDINO. ESPAÑA: ENRIQUE R. LUMEN.

El Socorro Rojo Internacional,
La Liga Antiimperialista de las Américas y la Asociación de los Nuevos Emigrados
Revolucionarios de Cuba invitan, a todos los que repudian el imperialismo y las ti-
ranías que oprimen a los pueblos latinoamericanos, a esta grandiosa demostración
de protesta contra el Gobierno Fascista de Cuba que ordenó el asesinato de JULIO
ANTONIO MELLA en territorio mexicano, ultrajando la dignidad y el decoro de este
pueblo.

La Conmemoración tendrá lugar en el

TEATRO HIDALGO

2a. DE REGINA

DOMINGO 10 DE FEBRERO DE 1929, A LAS 19.30 HORAS - 7.30 P. M.

PRESIDIRA: TINA MODOTTI

Notice for an evening gathering organized by the International Red Aid in memory of Mella, to be held on February 10, 1929 at the Hildalgo Theater, Mexico City. Courtesy Comitato Tina Modotti, Udine

ESTRATTO

del

BOLLETTINO delle RICERCHE

Supplemento dei sovversivi

N. 144 *in data* ... 25 Giugno 1931 - IX.

Schedina N.

5097

SALTARINI MODOTTI Assunta detta " Tina ,, fu
Giuseppe, nata 17. 6. 96 ad Udine, residente all'este-
ro, fotografa.

Comunista da fermare.
Questore Udine, 28. 5. 931.

Bulletin of Research, from Tina's Italian police record, dated June 25, 1931 (Fascist year IX). Tina, filed as no. 5097, is listed as a subversive and a "Communist to be detained."

R. AMBASCIATA D'ITALIA

TELESPRESSO N. 3308

AL REGIO MINISTERO DELL'INTERNO - Gas.Pol.Centr.-
e per conoscenza
AL REGIO. MINISTERO DEGLI AFFARI ESTERI R O M A

COPIATO 13 OTT.1931

BERLINO, LI 1.ottobre 1931/IX

OGGETTO· SALTARINI MEDOTTI Assunta (detta Tina) - fotografa - comunista.

Dispaccio di cotesto R.Ministero Nr.59731/18853 del 27.7.1931.

Ho l'onore di comunicare all'E.V. che il Ministero degli Affari
Esteri del Reich mi ha testé partecipato che dalle ulteriori indagini
esperite dai competemti organi di Polizia é risultato che la comunista
in oggetto indicata ha alloggiato dal 7 maggio 1930 fino alla fine del
successivo ottobre in una pensione di questa città nella Tauentzienstr.
Nr.5. Nello stesso tempo ha lavorato presso lo studio fotografico di
certo Jacobi nella Joachimsthalerstr.5 e qualche volta anche per conto
prpprio.

Verso la fine del mese di ottobre us., la Medotti, per le difficol-
tà di lavoro, ha lasciato la Germania, dirigendosi probabilmente in
Russia.

Nulla é stato accertato sulla attività politica della Medotti che
non era denunciata alla polizia locale.

81714

Document no. 3308, from Tina's Italian police record, dated October 1, 1931 (Fascist year IX): a letter written from the Italian embassy in Berlin to the Italian Ministry of the Interior, with information concerning Tina's whereabouts

Tina Modotti, *Couple at the Zoo,
Berlin*, 1930, gelatin silver print.
The J. Paul Getty Museum,
Los Angeles

Tina Modotti, *Street Scene,
Berlin*, 1930, gelatin silver print.
The J. Paul Getty Museum,
Los Angeles

Tina at the Soyuznaya Hotel, Moscow, June 1932. Photograph by Angelo Masutti. Courtesy of the Cosolo family, Trieste

CARTONES DE "EL MACHETE"

Un Aspecto de la Obra Civilizadora de Mussolini en Abisinia

Cartoon by Miguel Covarrubias in *El Machete*, May 17, 1936, mocking the "civilizing mission" of Mussolini in Abyssinia. The Italian dictator had just proclaimed an Italian empire

Tina's false Spanish passport giving her name as Carmen Ruíz Sánchez. Courtesy Comitato Tina Modotti, Udine

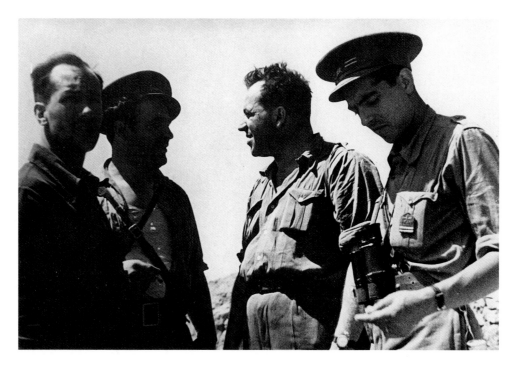

Vittorio Vidali as "comandante Carlos," c. 1937. Pina Re Archive

Logo of the Fifth Regiment. Courtesy Riccardo Toffoletti

Jensen in The Chicago Daily News

THE SPANISH CAVALIER

Cartoon by Jensen of
Francisco Franco,
1938. Fondazione
Feltrinelli, Milan

Children in Barcelona during the Spanish Civil War, April 1937. Istituto Nazionale per la Storia del Movimento di Liberazione in Italia, Milan

Tina's dog, Suzi, on the terrace of her house,
41 Dr. Balmis Street, Mexico City, c. 1940.
Courtesy Comitato Tina Modotti, Udine

below
Tina in Mexico with a group of friends, among
whom is Vidali, c. 1941, a year before her
death. Courtesy of the Cosolo family, Trieste

I – Tina Modotti – do hereby will –
upon my death – to Edward Weston –
all my personal property = furniture.
books – photographs – etc.? all and
all photographic equipment =
lenses – cameras etc.

He can retain for himself what
he wishes + distribute the rest
among my family + friends –
I hereby express also my
desire to be cremated

Tina Modotti
December – 1924
Mexico – D.F.

Tina's will, dated 1924. Courtesy Comitato Tina Modotti, Udine

Room set up ready for a memorial meeting for Tina, Mexico City, January 1942. Courtesy Comitato Tina Modotti, Udine

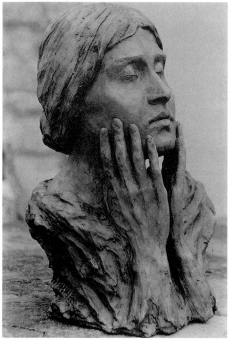

facing page
Tina's tombstone at the Pantheon de Dolores in Mexico City. The bas-relief profile of Tina's head is by the Mexican sculptor Leopoldo Méndez. The engraved text is from a poem by Pablo Neruda

left
Terracotta bust of Tina by Maria Grazia Collini, 1993, inspired by a photograph by Edward Weston. Photo: Riccardo Toffoletti/Courtesy Enzo Cainero, Udine

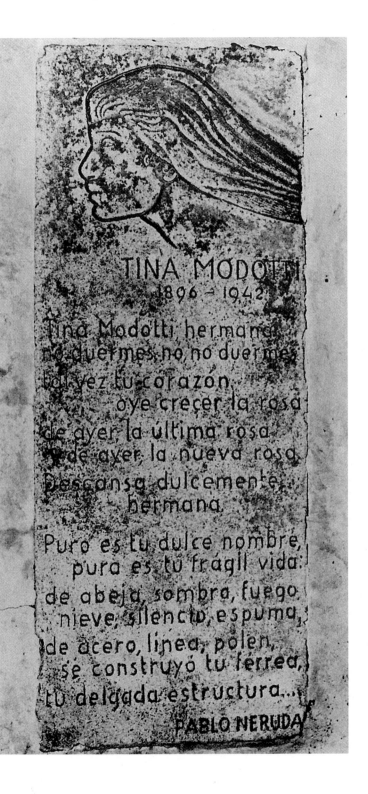

TINA MODOTTI
1896 – 1942

Tina Modotti, hermana,
no duermes, no, no duermes:
tal vez tu corazón
 oye crecer la rosa
de ayer, la última rosa
de ayer, la nueva rosa.
Descansa dulcemente,
 hermana.

Puro es tu dulce nombre,
 pura es tu frágil vida:
de abeja, sombra, fuego,
 nieve, silencio, espuma,
de acero, línea, polen,
 se construyó tu férrea,
tu delgada estructura...

PABLO NERUDA

Wire composition by Maria Grazia Collini, 1993, inspired by Tina's photograph *Woman with Flag*. Photo: Riccardo Toffoletti/Courtesy of the artist

Photograph by Christophe Kutner, inspired by Tina's photograph *Woman with Flag*. The model, Missy Rayder, is wearing an outfit designed by Yohji Yamamoto. Courtesy Michele Filomeno Agency, Paris

Fashion label by Susie Tompkins for Esprit, repoducing Tina's photograph *Roses*

Jacket of the first book published about Tina, in March 1973, with a drawing by Renato Guttuso

below
Telegram dated March 20, 1973, sent from Mexico to Vittorio Vidali by some of Tina's former comrades on the occasion of the publication of the first book about Tina (see jacket, left). The text of the telegram acknowledges her as a great artist and a great revolutionary who dedicated her life to the struggle of the Mexican people, to the service of the politically persecuted, and to the aid of the Spanish republic. Fondo Vidali, Fondazione Istituto Gramsci, Rome

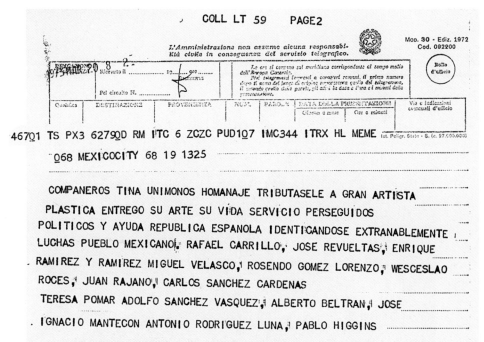

Vittorio Vidali as an Italian senator in Rome, in the company of the Spanish poet Rafael Alberti and an unidentified woman (possibly a journalist), c. 1974.
Pina Re Archive

below
Vidali photographed by Franco Pinna in Italy, reading the women's publication *Noi donne*, issued by the U.D.I. (Unione Donne Italiane), n.d. Pina Re Archive

robust triumphant voice preparing the social revolution with its proclamations).[34] Communists were sent to the penal colony of Islas Marías, where Catholic rebels were released to make room for leftists.[35]

From November 1929 to 1934, *El Machete* was published illegally from a small printing house known as La Aurora (The Dawn), a gift to the Mexican communists by German workers. Numbers 178 to 302 were the illegal 124 editions published biweekly, sometimes with great difficulty. The paper asked its readers to donate money[36] or buy revolutionary literature directly from them.[37] In one of the most difficult periods, the party told its members in December 1933 that they did not have the right to be called revolutionaries, still less communists, if they did not support their press.[38] During this clandestine period, Hernán Laborde, secretary of the Communist Party in 1929, was also editor of the paper. As part of the intimidation of the left, on May 14, 1929 government agents assassinated the communist Durango peasant leader, José Guadalupe Rodríguez, and 14 of his men, including Salvador Gómez. Rodríguez had just been released from prison.[39] As a Red Aid co-worker, he had gone to see Tina a few days before May 14.[40] Vidali recalled Rodríguez with affection and admiration but also underlined his sectarianism, which ultimately brought him to his death.[41]

On January 23, 1930 the Portes Gil government under pressure from the U.S.A. broke off diplomatic relations with the Soviet Union, established in August 1924 by the Obregón government. The Soviet ambassador, Alexander de Makar, was requested to leave Mexico[42] and was placed under temporary arrest in Veracruz by the Mexican authorities. After various humiliations, de Makar was allowed to proceed with only his personal effects, while the official archives were sent back to Mexico City to be examined by the police.[43] This break with the country of the Bolshevik revolution provoked a number of demonstrations in several countries. And the Mexican Communist Party was declared illegal.

On Sunday February 5, 1930, on his first day as president, Ortiz Rubio was shot at six times in his Cadillac. His jaw was shattered and his wife and niece were also wounded by broken glass. For weeks he was on the verge of death, but finally he was "resurrected" with a jaw partly of platinum[44] (and with a new, bullet-proof Cadillac). Although the attempt possessed no leftist mark and was symptomatic only of "the differences between individuals and groups"[45] – the gunman was Daniel Luis Flores, a 23-year-old religious fanatic – the communists were immediately blamed and presecuted. Flores, who was apprehended and condemned to about 20 years in prison,[46] always insisted on having acted independently, although the Italian embassy in Mexico associated him with followers of Vasconcelos.[47] He was

even believed to be Ortiz Rubio's son and to have acted on the personal grounds of being neglected by his father.

The government then had its pretext. Its targets, besides communists, were Vasconcelistas, Catholics, and labor leaders. The poet Salvador Novo, together with José Emilio Pacheco, articulated the general opinion of the middle class in a comic epigram in which the bullet was supposedly sent "to prevent Ortiz Rubio's jawbone from biting."[48] While the new president was recovering, Mexico was terrorized by the "ferocious"[49] general Eulogio Ortiz, the son of a Spanish father and an American border woman, who "was obsessed by a keen desire to eliminate people,"[50] and who arrested whomever "his heated imagination conjured up as an enemy of the regime."[51] More than 60 people were unconstitutionally arrested and taken to Topilejo, halfway between Mexico City and Cuernavaca, where they were killed without a trial, after being ordered to dig their own graves.[52]

On February 7, 1930 Tina Modotti was arrested by three agents, accused of an attempt on the life of the new president. (The Italian police called her "a dangerous agitator" seven weeks later.)[53] She was taken to police headquarters on Revillagigedo Street and six days later moved to the Lecumberri penitentiary, where she wrote for help to two American friends: Mary Louis Doherty, who was living in Mexico, and Beatrice Siskind, a friend of her brother Benvenuto, in New York. Paca Toor, her best friend, was away in California – she said later that she resented being unable to help at such a time.[54] The letter to Siskind, dated February 17, never reached her but still exists in the Mexican state archives: Tina wrote about the arrest and expressed the loneliness of an isolated comrade whose ties with the outside world had been severed. She mentioned "an iron cot without mattress, an ill smelling toilet, no electric light," and described the "mental anguish of not knowing anything from the comrades, especially the foreign ones."[55] It is not clear whether Doherty received Tina's undated note (after the police had copied it),[56] in which she asked Mary to contact José María Lozano, the attorney who had represented her in the Mella case. However, Doherty was able to visit Modotti before she was transferred to Lecumberri, thanks to the head of the federal district, the former medical doctor and former minister of education, José Manuel Puig Casauranc, whose children Tina had once photographed. Knowing the aggressive (even brutal) habits of the police inspector, Valente Quintana (already encountered during Modotti's trial), Puig Casauranc issued an order to replace Quintana with General Mijares Palencia.[57] (The change did not, alas, prevent the torture of Flores, who died in his prison cell in April 1932.[58]) Modotti was also allowed to be visited by another friend, Luz Ardizana, but was detained in Lecumberri for 13 days; after that, she was

given the choice of either abandoning her communist activities if she stayed in Mexico, or being deported. She chose to leave. A U.S. passport had been denied, but she held an Italian passport, no. 3300, issued in Mexico City on January 7, 1930 (valid for one year), in which she was identified as a photographer, "age 34; height m.1.64; hair brunette; eyes brown; nose regular; mouth regular; complexion healthy; special marks none visible."

So, on February 24, 1930, after two days' notice, Modotti was deported from Mexico – although she had already thought about leaving because of the increased government pressure on leftists.[59] She was escorted to Veracruz and embarked on the S.S. *Edam* (which Vidali calls *Emden*)[60] for Europe. But Tina's bonds to Mexico were still very strong, as she had written in October 1929 to Anita Brenner: "I almost dare say snake like attraction that pulls one back."[61] Thinking of her departure, a sad Paca Toor wrote that she "could not imagine anyone who would be missed by so many people."[62] In the last few hours before she left, Tina gave a photograph to Fernando Gamboa,[63] sold her negatives to Rivera, and her cameras (one of which belonged to Weston) to Manuel and Lola Alvarez Bravo.[64] The novelist Elena Poniatowska has recreated the scene of them trying to console Tina while she was preparing for the unknown, but in the end, it was Tina who consoled them.[65] A beautiful image comes from the Mexican playwright Víctor Rascón:

> Salió de Veracruz al mar y por la fuerza,
> barco sin pasajero, gaviota presa . . .
> Y ella se aleja, deja la terra
> la bruma se la traga, sin una queja.[66]

On the day of Modotti's deportation Weston wrote in his diary: "Dear, lovely Tina! You seem so much more remote [*sic*] in Germany – for now I cannot picture your surroundings."[67] In 1991 Mario Passi, another Italian and the biographer of Vidali, wrote of Vidali's voluntary departure from Mexico: "I am leaving this city, which now appears to me even more beautiful than ever: the blue and fiery horizon surrounds everything in a tender embrace."[68]

Among the foreigners expelled that year were Johann Windisch (born on January 7, 1899), a waiter with permanent residence in Vienna; Isaac or Icek Abramovick Rosenblum (born in Odessa on March 13, 1908), a shoemaker; and a Mexican of Russian origin, Julio Ramírez Gómez (or Rosovski), who died in Moscow in 1985.[69] Windisch and Rosenblum were deported on the same ship as Tina. In Tampico, a man carrying the passport of a Peruvian journalist, Jacobo Hurwitz Zender, boarded the ship – it was Vidali in disguise. He had been unable to contact Tina while still in

Mexico City and forced himself onto the ship. His final destination was Moscow. Nothing else is known about Vidali's real motives for joining the ship, since he never explained them, only mentioning that they were friends and that a month and a half (the duration of the trip) gave Modotti the opportunity to pause in her life, which had become turbulent. When the ship arrived in New Orleans – the Carnival was in full swing – Tina had to be detained onshore by the authorities, which meant being locked in a room, "a strange mixture between a jail and a hospital,"[70] with much empty time on her hands. Ironically, in looking out from her window, she could not help concentrating on a common and frequent sight, an American flag whose stars and stripes would "wave with the wind," a sight, the irreverent Tina commented to Weston, "which should – were I not such a hopeless rebel – remind me constantly of the empire 'of law and order.' "[71]

It is not known whether Modotti was able to inform her family of her deportation. We also do not know the family's reaction to Tina's political activities, although Benvenuto, as noted earlier, was a communist and had declared himself "the only communist in the whole city of Pasadena."[72] In summer 1929, while Tina was recovering from Mella's murder, her brother Beppo, then 24 years old, ran into political problems: he was arrested during a riot in Chinatown, San Francisco, together with other foreigners, Greeks, Japanese, and Hungarians.[73]

By 1930, Modotti had a crystal clear understanding of the political situation and of the tactics of the Mexican government, which – in her words – had been very clever in grasping the right moment to act, waiting until the public was most upset and distracted by the shooting of Ortiz Rubio. Perhaps because she valued Weston's opinion, she wrote from the ship: "I am sure that no matter how hard you try, you will not be able to picture me as a 'terrorist.' "[74] This letter is her most moving in its loneliness and desperation; despite adversity and "thanks to an enormous amount of will power,"[75] she kept herself from going insane. The description of the small prison cell is frightening: the light is scarce, the iron cot does not even have a mattress, and the toilet is evil-smelling. In reading Tina's words, we can even hear the slamming of the iron door and the turning of the lock behind her. And, in the middle of the tiny room, stands a lonely Tina, the great survivor, who wonders if it is "all a bad dream." But, with her usual courage, she finds a strength in herself, remembering something that Weston once quoted to her: "What does not kill you, strengthens you."[76] From 1930 on, this sentence seemed to become her motto, accompanying her in all her peregrinations.

After Modotti's expulsion, the Italian police kept a tight surveillance on her. Two days after her expulsion from Mexico, the Italian Ministry of

Foreign Affairs sent a telegram to the Ministry of the Interior, informing it that "the well-known Italian communist Tina Modotti, leading element in the recent communist demonstrations in Mexico, was arrested immediately after the assassination attempt which occurred on the 5th, against the new President of the Republic."[77] From the police reports and correspondence, we know that Modotti had 420 dollars on her.[78] We also know that on April 1, 1930 Modotti was arrested by Dutch harbor police, and was denied entry to Holland, thus risking deportation to Italy by an agent of OVRA (the Italian secret police). But Red Aid lawyers helped her obtain a transit permit for Holland, which allowed her to continue her trip to Berlin, while Vidali went to Moscow.[79]

Modotti's deportation from Mexico – "shame and sorrow in our history," a poet has written[80] – must be seen as part of a much larger picture than that of simply clearing Mexico of communists. It reflects the weakening of Mexican communism and was a means to consolidate the right-wing government in power. Communists, communist sympathizers, and liberals continued to experience extreme difficulties: they could be detained under the smallest suspicion. Paca Toor expressed her fear that her magazine, *Mexican Folkways* (her "beloved child," she called it), could be closed down.[81] On February 14, 1930 Carleton Beals was arrested by the police, who appeared at his door in plain clothes and took him away by force, despite Beals's request to inform the American embassy. Because of some correspondence with friends in which he had criticized the Ortiz Rubio government, he was accused of being involved in antigovernment activities, and was left incommunicado for six hours. He was later released through embassy channels.[82] Then on August 26, 1930 a group of police agents broke into Red Aid's office in Mexico City and arrested Gastón Lafarga, Angel Aráutz, Samuel S. Alvarez, Antonio Rodriguez, and Jesús Flores. The police confiscated all the available material, including lists of measures for assisting political prisoners, and financial papers. It was reported that the police aimed at "striking dead communist propaganda."[83] Ultimately the Mexican Communist Party was declared illegal, in a place that had always been regarded as the only democratic "island" of Latin America.[84]

By 1930 its revolutionary epoch had ended and Mexico was entering a new historical phase. Tina, too, was entering a new phase, that of the fugitive, which started with her new name (taken on the ship), Carmen Ruíz Sánchez. The *Edam* was taking Tina away from a country where, for the most part, she had been happy, and where she had lived seven years as if it were a lifetime. A crucial chapter of her life was ending. How to describe her departure from Mexico? As the song *La Lupe*, by Juan Almeida, suggests, she was leaving behind a piece of herself.[85]

In November 1929 she had written to Freeman: "life makes you pay dearly for the little joy it bestows on you. . . . when I think that in a little while we will be scattered in different continents each one of us busy in facing the problem of life . . . how all this hurts!"[86] By 1930, Tina Modotti had become deracinated and notorious, but what is fame, after all? As Rainer Maria Rilke said, "nothing but the sum of all misunderstandings that gather around a new name."

10 Vittorio Vidali

Trieste ha una scontrosa grazia.
Se piace
è come un ragazzaccio aspro e vorace,
con gli occhi azzurri e mani troppo grandi
per regalare un fiore.

Umberto Saba[1]

It has never been clear from the existing documents about Modotti's German period – a few letters to friends and a few photographs – whether she intended to settle in Berlin or whether she perceived Germany as merely a prelude to the Soviet Union. In view of the precarious political situation, probably she herself did not know and was playing it by ear. Whatever she may have originally intended, the six-month period spent in Germany from April 14 to October 1930 came to represent a time of reflection for her. After the intensity of Mexico, with all its political vicissitudes, Modotti needed to reconstruct her life and to establish her priorities, meaning "be useful to the movement,"[2] while she also had to think of surviving economically.

Berlin gave her the chance to "sort out" her life, but at the expense of her morale. In Berlin she fell into a deep depression that in the fall culminated in the decision to leave for the Soviet Union. She thought Berlin beautiful but angular and almost hostile, a city from which she felt alienated. She complained to Weston that people never laughed, that they walked the streets very gravely, always in a hurry.[3] For somebody who was used to passionate Mexico, Germany could at first appear unpassionate. And yet 1930 Berlin was an intense cosmos whose cultural repercussions and intellectual ferment were felt all over Europe. The city was in the middle of the transformation associated with the new social phenomena. An entire bibliography developed around the culture of the Weimar Republic, which started showing its fragility, and intellectuals of many nationalities gravitated to Berlin's intellectual groups. Elias Canetti's *Die Fackel im Ohr Lebensgeschichte 1921–1931* marvelously conveys the intensity of the intellectual atmosphere at that time in Berlin, compared with

the static and almost sterile Viennese world.[4] Canetti paints vivid portraits of some artists – Bertold Brecht with his attraction to cars;[5] Isaac Babel, with his curiosity about Berlin and his people;[6] and Ibolya Feldmesser (alias Ibby Gordon), a Hungarian woman poet, who exchanged a porcelain donkey figurine from an antique shop for a poem devoted to the donkey.[7] Canetti describes the impact that Upton Sinclair had on Europeans,[8] and perceives Berlin as the most cosmopolitan city of its era, where everything was available. No matter where one came from, even from such an old capital as Vienna, "in Berlin you would inevitably feel like a provincial."[9]

How much Modotti was touched by this ferment, however, is not known. In this period, she wrote abundantly to Paca Toor, who boasted that she was the only one to answer Tina, who "clings to me like Death."[10] These letters reveal that Modotti was "terribly lonely for Mexico," since "the gloom of the German climate and seriousness" was depressing her. (Toor, who had returned to Mexico from California and moved into Modotti's apartment, considered sending Tina some money but hesitated out of uncertainty about her friend's reaction.) In pasting together Tina's life in Berlin, one is confronted with a series of questions, two of which are basic. Where did she live and what did she do in Berlin? Despite intense surveillance by the Italian police, which continued even when she moved to Moscow,[11] she managed to keep her movements and her address fairly secret. The police records show that from May 7 to October 1930 she lived in a pension owned by the Schulz family, at 5 Tauentizienstrasse.[12] But she had actually found a place downtown, "a room, very convenient and private,"[13] near Charlottenburg; and she tried to integrate herself culturally and socially into the intense capital, which in 1930 had four million people, 350,000 of whom were unemployed.

She visited a couple she had met in Mexico, the German economist Alfons Goldschmidt and his wife Lina, despite Tina's dislike of her – to Tina she seemed shallow and affected, "posing as a grand lady and as an intellectual."[14] In contrast, the Witte couple was much closer to Modotti's heart. Frau Witte "emanates such a spiritual beauty that the best of one is stimulated in her presence."[15] Despite their past clashes and differences in approach to life and politics, Modotti met also with Anita Brenner, who was there on her honeymoon.[16] The fact that they met outside Mexico, a different territory from their original meeting place, contributed to the cordiality of the meeting. Other Berlin contacts were Walter Dittbander, the administrative secretary of Red Aid,[17] and the Australian-born writer Ella Winter, the wife of the American journalist Lincoln Steffens, who met Tina in August 1930 on her way to Moscow.[18]

As far as photography was concerned, Tina complained that the light in Germany was not the same as in luminous Mexico ("I have not yet seen the sun once during my ten days here"[19]). As Weston's good disciple, she gave tremendous importance to light in relation to texture. But at first she decided to stay in Berlin for a while, to prepare an exhibition,[20] and she gave an informal exhibition of her work in the studio of Lotte Jacobi (the two women were to meet again in Moscow in 1932).[21] She even joined the press agency Unionfoto and produced some interesting photographs *Couple at the Zoo, Ventriloquist, Woman with Child,* and the beautiful *Young Pioneers.* However, she soon realized that the working environment was quite different from what she was used to; that the competition was high; that she was not assertive enough for reportage work; and that her photographic style was appreciated and valid only in Mexico, since the growing interest in the exotic was mainly confined to the American continent. At times, Tina thought that there had to be "something" for her but she had not found it yet. Thus, in the process of discovering that "something," she would spend sleepless nights "wondering which way to turn and where to begin."[22]

Her letters to Weston from Germany reflect this constant soul-searching. Modotti explained to herself more than to him the photographic process and its meaning. That clarification was needed in order to decide in which direction to move. To advance with new concepts? Or to retreat into the type of photography she had worked in until then? Or what else? And how was she to tie that to her political calling? It seems that at this moment of her life, the conflict between art and politics became manifest, and her desire to engage in political militancy matured to such a point that it led to her decision to abandon photography altogether, in order to follow politics solely. When that became clear to Tina, the Soviet Union became her next choice and the logical next step in her political career. And that step reflected a change in her emotional life as well.

* * *

In Isaac Deutscher's 1949 biography of Stalin he writes of a "grim page in the annals of Russian literature," since Stalin's personal style became Russia's national style.[23] One wonders whether Modotti (who even as a party member had been free in Mexico) was aware of that grim change of direction, or suffered because of it. Deutscher also spoke of the "dull uniformity" of the Russian press, and of the Stalinization of the spoken language, as if the "whole nation had succumbed to a ventriloquial obsession."[24]

Again, one wonders whether Modotti, who was attentive to language (judging from her letters to Weston), could have failed to notice that chilling climate. And yet, in one of her letters to Robo's mother and sister, she said that there was so much to tell that she did not have the heart to start mentioning the immense quantity of publications devoted to Soviet Russia.[25]

Sheila Fitzpatrick has recently conveyed the oppressive atmosphere imposed by Stalin in the 1930s.[26] She reports on the social and cultural mood of the population – impossible to describe before 1991, because historians until then were deprived of important details of everyday life (including the lives of party members); thus they turned to other matters. Fitzpatrick defines "everyday" in terms of daily interactions that in some way involved the state,[27] such as shopping, celebrating, telling jokes, including mocking the Soviet bureaucracy.[28]

How did Modotti, a foreigner and yet a party member, fit into the mosaic of Stalinist life? I think everybody would agree that her Soviet experience was undoubtedly linked to Vidali, a complex figure who can only be understood in his political context and in terms of revolution. Whatever is known about Tina, especially after 1927, comes in great part from his recollections. And whatever is known of the revolutionary man from Trieste comes partly from Passi's laudatory biography,[29] partly from the police records,[30] but mainly from his own books, which deal extensively with his background and ideology – the best by far is *Orizzonti di libertà*, a sort of spiritual testimonial.[31] An article by the American radical Max Schachtman, published in the U.S. in 1927, gives a brief account of Vidali's North American period. Despite the epic tone of the piece, there Sormenti/Vidali is depicted as a man with a "sharp and merciless tongue" and "fearless personal conduct."[32]

The photograph of Vidali taken by Modotti in Mexico in 1927 might be an excellent mirror of his soul were it not so artificially constructed. The young Vidali, then aged 27, stands against a sunlit wall, in a rather threatening posture, somewhere between the serious and the ironic. He wears a black suit, a black shirt, and a mafia-style dark hat (an attire that in his youth his sister used to mock[33]). His pencil-thin moustache gives him an even more sardonic look, underlined by the fact that he has his right hand in his pocket, as if he were about to withdraw a gun. What else to make of this picture? Perhaps it conveys a sense of contempt for the (capitalist) world? In another of her photographs, taken in 1930 on the *Edam*, Tina presents a Vidali who is more accessible, more palatable, and far more natural. The revolutionary stands on the dock of the ship, holding a cigarette. He is calmly looking far away, as if he were hoping for a better future. On the right side of the image, the ship railings form a sort of prison bars,

an image that conveys a sense of enclosure, without limiting the sense of space.

Tina Modotti arrived in the U.S.S.R. through Leningrad in October 1930, bringing with her two cameras.[34] Her sentimental relationship with Vidali probably started at the end of that year, more or less coinciding with her last letter to Weston, dated January 12, 1931. Tina wrote that she was living "a completely new life," so much so that she felt almost "like a different person, but very interesting." (She also took the opportunity to ask Weston if he knew anybody who could buy her Graflex camera so she could buy herself a Leica.[35]) The date of 1930 agrees with Vidali's unpublished diary, in which he notes that she was 34 and he was 30 when they started their long story. To that, Vidali adds that, more than lovers, they were true friends, "deeply bonded to each other."[36] In another account, Vidali stated that they came together "almost without realizing it,"[37] certainly without any calculated planning. In a vivid explanation worthy of a soap opera, a former C.I.A. officer spoke of Modotti's calming effect on Vidali – "her siren like seductive beauty and vivacious personality."[38] An Italian writer, Giorgio Pressburger, who met Vidali, has found a parallel between the Modotti–Vidali couple and his own family members: an aunt of Pressburger's mother was born in 1896, as Tina was, while his father was born in 1901, and Vidali in 1900.[39]

Tina's relationship with Vidali was firmly linked to the Moscow years, and that period, for good or bad, became a point of reference in their lives, as Vidali himself stated.[40] However, in November 1930 in Moscow, Vidali had a daughter, called Bianca (after Vidali's mother), whose mother was a Russian woman, Paulina Hafkina. Contrary to what has been believed, he was legally married to her, although rumors say he was in love with Paulina's sister. The marriage license, dated August 19, 1930, was signed Jorge Contreras.[41] In one of his interviews, Vidali claimed that he divorced "the day after he got married,"[42] relegating Paulina more or less to the peripheral position of a footnote in his life. Perhaps in order to leave some distance between Bianca's birth and the *de facto* marriage with Modotti, Vidali's biographer skilfully moved the beginning of his relationship with Tina to 1932.[43]

Vidali and Modotti never married, although in a 1932 party questionnaire she wrote: "the name of my husband is Vittorio Vidali."[44] In Moscow, she even signed her name as "Tina Contreras." Vidali (whose only true marriage was with *Madame la révolution*), claimed that the two never thought of marriage, neither in the Soviet Union, nor in Spain or Mexico, since it appeared to be "a superfluous ritual."[45] But apparently the Soviet party thought that they were married, since in 1930 it accused Vidali of being a

polygamist. He was questioned on this matter by Elena Stasova, then Stalin's secretary, the rigid custodian of Bolshevik morality.[46] According to his report, Vidali promptly clarified everything.[47] In regards to her falling in love with Vidali, Modotti wrote to Toor at the end of 1931 that life was again good to her in matters of love and that there was a new man in her life, whom she loved and who loved her. Paca, according to her spirit and habit, told Freeman in the U.S.,[48] adding that Tina had given up photography for the present.

It is impossible to know whether the joyful and playful Moscow life with Tina that Vidali describes in his book corresponds to the truth or to an image that he preferred to portray. One has the impression that there is a fusion of reality and legend in his Moscow accounts, in order to create a cheerful and harmonious atmosphere – that of a good communal and communist family whose members were all happy with each other. Three years before, in different circumstances, Vidali wrote to a friend that he regretted leaving Moscow because he had grown fond of the city, which he described as a "big, almost Oriental village that calms down the nerves with its patriarchal calm, and which rests one's brain almost to the point of making it idle."[49] Of 1930 Moscow Vidali mentions soirées of art exhibitions, concerts, ballets, plays, and drinking parties that Modotti frequently attended, together with people such as the Regents from Trieste, the Marabinis, the Prestes, or Russian comrades.[50] Unfortunately, the memories of the few survivors are now faded or filtered through the anti-Stalinist campaigns that followed, while Vidali is careful not to mention any comrades whom he undoubtedly met there and who disappeared, such as Luciano Visentin from Trieste, Virgilio Verdaro from Florence (who was accused of anarchism), or Riccardo Papa from Comerio (Varese).

An exceptional case is that of Giuseppe Rimola, known as Micca, from Novara, who, from 1932 to 1935 was the representative of the Italian Communist International and the director of the Italian section of the foreign languages publishing house in Moscow, a post that would have brought him into contact with Modotti. Rimola was married to Ornella Labriola, Arturo Labriola's daughter, and worked as a professor of Italian literature at the university of Moscow. He was arrested in 1938 in the dingy corridors of the Lux Hotel with the usual accusation, "Trotskyite tendencies." Torture broke him, and he committed suicide. His wife, who managed to return to Italy after the war, as late as 1961 wrote to the then secretary of the Italian Communist Party, Palmiro Togliatti, to request at least the political "rehabilitation" of her husband. Togliatti's reply was vague, assuring her that much was being done for her and other similar cases.[51]

It seems that in Moscow Modotti probably interacted only with party members, although she may have met the Spanish poet Rafael Alberti, who was studying theater in Moscow (he joined the party in 1934).[52] A former Italian communist party member, Felicita Ferrero, who was then in Moscow, reports that in 1932 Modotti and Vidali, both employed as MOPR (International Red Aid) officials, lived as a couple at the Majak hotel, located around Miasnizkaia Street (later called Kirov), on a cross street of Trubnoy Boulevard.[53] The hotel was a huge, square, and gray building with large corridors, and was distinct from all the other hotels, since it had once been a place where prostitutes took their customers. That gave the rooms a rather seedy and decadent air, worsened by the fact that the hotel was frequently infested by petty thieves. It was even the scene of a political crime. The victim was Alfredo Bonciani known as Grandi, an Italian from Tuscany, who had completed a course in the International Leninist School and was working as an electrician in the Kaganovich factory. Grandi, who had originally tried in vain to get his family sent to Moscow, had merely expressed to his embassy his wish to return to Italy. He was "summoned" in a room at the Majak, where he was later found dead, stabbed by three compatriots, Luigi Capanni, Giovanni Bertoni (who worked for Red Aid), and a third man from Genova known simply as Pera, who had come to Moscow via the U.S.A.[54]

Vidali at that time used the name Contreras (later with a Russian first name, Georgii Ivanovic),[55] and although he did not conceal his true identity to party members when asked, he did not volunteer the information. From Ferrero's account, it appears that Modotti was cordial with other comrades and, perhaps out of boredom, did not pass up a chance to make new friends. At the beginning of the 17th Soviet Communist Party Congress (which went down in Soviet history as "the conference of the winners"), held in 1934, Tina peeped into Ferrero's room and invited her to go and watch the communist delegates arriving from all over the world.[56] Apparently, Vidali's fame as a womanizer was known to everybody, comrades included. However, it was believed "he never lost his mind."[57] Tina, who was described as "sweet and good-hearted," was extremely tolerant of his *pecadillos*. Anytime Vidali's sentimental escapades became evident, she would say, "As long as I know that he loves me"[58] (a phrase that today would be anathema in the feminist canon).

While Vidali was undoubtedly a man of great charm and a great political vision, almost none of the descriptions left of him are complimentary, mainly for political reasons. The sources are frequently drawn from his enemies or detractors, anarchists and Trotkyists, who certainly suffered from

Stalinism. Or, much worse, the slanders come from anticommunists (even subtle ones) or betrayers of communism, who are more "papist than the pope" (as one says in Italian). A much "healthier" category of Vidali's enemies in Europe is constituted by former genuine communists, who became disillusioned with Stalinism and all forms of dogmatism. Among them, Guelfo Zaccaria in his book on Italians who never returned from Moscow mentions that Vidali went as far as reporting one of his former friends from Trieste, Luigi Calligaris, whose fate is still unknown to his family.[59] Years later, in 1974, Vidali, when confronted with Calligaris's name, said that he did not recall it, nor was he even in Moscow at that time.[60]

Stereotypes and recollections of Vidali as a vulgar, gross, and loud man, who would bark at people, are religiously repeated in every book on Modotti. The more that caricatures of him are repeated, the more they become facts, rather than merely speculations. Broué and Témime, for example, report Simone Téry's less than kind description of Vidali as a small man "with the look of a comedian, a pink face with a tuft of blond hair."[61] Feminists shudder with abhorrence when it comes to the subject of Tina's love of Vidali, and they tend to justify their repulsion with some strange cultural theories. The fact that both Modotti and Vidali were from Italy – they say – is the key to understanding their love and contributed to cementing their relationship. This is unconvincing. First of all, the two cities of Trieste and Udine share little in terms of history and culture. Moreover, in the 1920s, Tina had gradually lost her Italianness, becoming a deracinated citizen of the world. The accounts of her never refer to this aspect of her persona. By 1930 Modotti had been romantically involved only with men from north and south America. She had lived in the U.S. and in Mexico. The Italian community of San Francisco (which was itself diluted) was far from her mind and heart. Often, she even communicated with her brother and sisters in English. Vidali himself was not what could be considered a typical Italian, nor did he ever aspire to be since for him class struggle was above and beyond nationalism. His regional accent had been softened by living abroad for a long time. Thus, at least until the 1950s, it was hard to detect his regional origin from his accent. So, if one needs to intellectualize or explain their relationship, one can say that the two met in the name of a credo they shared, and that Vidali always considered himself as Modotti's mentor – a role that is evident in his books.

In Moscow, Modotti originally worked directly under Elena Stasova, who since 1928 had been the head of MOPR on a voluntary basis.[62] In 1930 Tina was put in charge of the Latin American (of which Vidali was also a committee referee),[63] Italian, Portuguese, and Spanish Departments, and

became a translator for the MOPR Moscow office. She chose that over pho-
tography, an option that was offered to her by the Soviet Communist Party
but which she refused, partly from lack of confidence in herself, partly to
continue her work with Red Aid, which totally absorbed her energies.[64] In
1932, during the World Congress of International Red Aid, Modotti was
awarded 500 rubles and a little award of merit for among other things her
skills as a translator.[65] Later, as her faith in the system increased and as she
became more trusted by Soviet authorities, she was given more perilous
assignments, or "special work," as it was called. This in practice meant that
Modotti became a sort of Soviet agent – or that her personal life became
buried beneath the domain of her party life. And, effectively, she chose an
alternative form of suicide: "entombment in the airless world of clandes-
tine operations."[66] It also meant that Modotti acquired other identities (as
did Vidali, who at one point in 1933 traveled with an Australian passport,
identifying himself as a fur dealer).[67]

Tina's "Soviet years" are only now beginning to be reconstructed, as doc-
uments from the Soviet archives begin to come to light.[68] It is entering dan-
gerous territory to analyze Modotti's tasks as a possible agent and to deal
in general with her "missions." It appears that she was assigned some, but
is that enough to label her an agent? If Vidali is truthful in his memoir,
both he and Modotti once received an offer by a Soviet army officer, Berzin,
to join the Soviet espionage and counter-espionage service, to go and work
in China. They accepted, with a certain hesitation, but the assignment never
materialized, for reasons Vidali chose not to explain.[69] One biographer pre-
sents Modotti and Vidali as victims of the Soviet system, which had diluted
its original ideology and in which they were going to be drowned.[70] Poni-
atowska continues the same tone in *Tinísima*, presenting Modotti as a
comrade/victim, with the beautiful image of "a red star in lieu of a heart."[71]
Some have solved the problem as to whether she was agent or victim by
simply relegating Modotti to one among other women in espionage.
Alphabetical order has played a trick on Tina: in a biographical dictionary
of women spies, she appears between Eustacia Maria Caridad Mercader, the
mother of Trotsky's assassin, and Margaret Mowbray, the famous English
spy "Peggy Dantin."[72] But Modotti must have had some redeeming quali-
ties for the author since we are also told that she is most often remembered
as the model for the caring María in Ernest Hemingway's *For Whom The
Bell Tolls*.

Contacts with the outside world were infrequent but not impossible.
While in Moscow, Tina received the news of José Quintanilla y del Valle's
death, via a telegram from his family.[73] The young Mexican, affected by
tuberculosis, had committed suicide on February 15, 1931 in Switzerland.[74]

Five days earlier, a 31-year-old woman had also committed suicide inside Notre Dame in Paris, inspiring a film years later. She was Antonieta Rivas Mercado, at that time Vasconcelos's mistress.[75] Tina had photographed her in 1929, alone and with Manuel Rodríguez Lozano, a supposedly homosexual artist (the former husband of Nahui Olín), to whom Rivas Mercado wrote a series of love letters, expressing the impossibility of their relationship. It was in one of these letters that Antonieta compared a series of photographs owned by the painter Emilio Amero with Modotti's photographs, simply referring to her as "Tina."[76]

At the end of 1933, Modotti and Vidali received from Stasova the order to move to Paris. This time the task was to reorganize the western section of Red Aid, which gave them the opportunity to maintain crucial links with the intellectuals involved in the campaign for the Reichstag's fire.[77] Modotti traveled with a Costa Rican passport and Vidali was given a Spanish passport. From this moment on, their lives became an intricate puzzle that is often hard to decipher because of difficulties related to their movements, although scanty documentation allows us to piece together their life, for example the report by Modotti in which she recounts her trip to Spain in 1933. She arrived in Madrid in April 1933 on a Red Aid assignment, went to Barcelona from May 1 to 9, then returned to Madrid via the town of Reus. In Madrid, Tina was detained by the police, questioned about her whereabouts in Spain, and finally expelled, or – as she put it – "accompanied by an agent to the French border."[78]

According to Vidali's account, it was after their first Paris assignment that Tina became even more reserved and certainly more militant, with an unquestioning and total devotion to the party, which – she supposedly said – "is always right."[79] Was that a way to come to terms finally with her choices and to reconcile politics and life? Or was it a way to sever ties with the past? Or both? Probably we shall never know. But by 1934 that "extraordinary harmony between life, art and revolution, the harmony that had brightened Tina's Mexican experience, had dissolved."[80] In Paris Vidali was arrested under suspicion of being a Soviet agent and expelled to Belgium, where he met Tina again. He received from Moscow the order to return, while Modotti was still in Brussels.[81] By August, Tina was back in Paris to organize a conference, the World Congress of Women against War and Fascism, held in the Left Bank. What remains of that conference is a 30-page publication, *Women under fascist terror! Women on the Front of Solidarity and Combat!* prepared by Ella Winter and Modotti. Even the austere Stasova participated in the conference as a speaker, lecturing a vast audience on the Soviet liberated woman.

In reality, by 1934 life in the Soviet Union had become unbearable even to the staunchest Stalinist, and especially for the opinionated Vidali, who was used to expressing his disapproval of all sorts of injustices. More than once he was cautioned not to criticize the party. The situation became critical following the murder of Sergei M. Kirov, a promising young Bolshevik competing with Stalin, who was assassinated on December 1, 1934 in Smolny, near Leningrad. The assassin was a young party member, psychologically disturbed, named Leonid Nokolaev.[82] The murder has been explained and interpreted in various ways, and it "provoked endless popular speculation and discussion,"[83] but its matrix remains Stalinist, although the Trotskyists were again blamed.[84]

At the end of 1934 Modotti and Vidali were "invited" as Red Aid members to leave for Spain, to help the victims of the repressions in the region of Asturias. Their mission included reorganizing Red Aid, which had collected five million French francs for the victims.[85] Vidali found himself compelled to accept the new offer, encouraged by Togliatti. This time Vidali's identity was French Canadian – Charles Duval – and his profession, businessman.[86] Given the difficulties that even the most sincere communists started to encounter, leaving the Soviet Union could almost be considered a liberation, despite the proclamation of love for Russia and its people made by Vidali a few years before.[87] It was irrelevant that he was going to join a country torn apart by war. It appears that on the last evening in Moscow Tina expressed to Vidali her happiness at leaving.[88]

The Chilean poet Pablo Neruda, who in 1936 was living in Spain, had created the literary journal, *Caballo verde para la poesia* (Green Horse for Poetry). Its pages hosted the poems of Miguel Hernández, Federico García Lorca, Juan Ramón Jiménez, and Rafael Alberti. The sixth number of the journal was to appear on July 19, 1936 but that day the "green horse" could not gallop. The streets of Spain were filled with gunpowder.[89] A still unknown young general, Francisco Franco, was about to change the course of Spanish history.

11 María

Había soñado con vos,
Entre mis manos,
Una rosa, un lirio
Y un pájaro preso.
Entre pastos
Conejos, búhos
Gaviotas y golondrinas.
Caminé
Miré en vos
Ese verde olivo y la chaqueta
Con que te conocí miliciana.[1]

On July 18, 1936 a military, nationalist-oriented movement headed by General Franco took up arms against the fledgling Spanish republican government created in the February elections, thus beginning the Spanish Civil War. The Popular Front, a coalition composed of antifascist forces – republicans, socialists, communists, syndicalists, and anarchists – united in resistance against the nationalists.[2]

In a few weeks, Franco succeeded in occupying the southern and western parts of Spain, while the republicans, or loyalists, controlled Madrid and the eastern part including Catalonia. The invasion of Spain by fascist and nazi forces from 1936 to 1939 became the opportunity to fight fascism (labeled as "the bloody child of the Inquisition[3]") for many champions of liberty from 53 countries, totalling an estimated 40,000 people. Many Soviet workers became so enthusiastic about this fight that they were willing to sacrifice up to one percent of their pay for the Spanish cause.[4] The Spanish conflict also offered the reactionaries an opportunity to side with the right in a less compromising way than siding with nazi Germany or fascist Italy.[5] In the first six months of 1937, nonmilitary aid from the Soviet Union amounted in total to 51,442,000 rubles, in the form of exports.[6] Stalin himself, in a telegram addressed to the secretary of the Spanish Communist Party, José Díaz Ramos, stated that in helping the Spanish cause the Soviet people were "merely doing their duty."[7] In

Hollywood, fundraising took place during a film by Lubitch starring Marlene Dietrich.[8]

Several intellectuals of various nationalities became concerned with the threat to democracy, publishing a myriad articles on it – for example, John Cowper Powys, who had written the introduction to Robo's book,[9] and Anita Brenner produced no less than 45 manuscripts and many articles. She even planned to write a book on the war.[10] One of these articles was published in a self-styled "independent journal of radical opinion" based in New York, which in 1937 sold for 15 cents a copy.[11] The Spanish Civil War had profound repercussions everywhere. In Mexico, school children were required to wear blue overalls, to evoke the uniform worn by Spanish republican militants.[12]

The literature on the war is extensive, making it difficult to select representative passages. In English, besides the world-known classics on the war in the field of history,[13] we have Langston Hughes's poems with their carefully crafted words, such as "Moonlight in Valencia: / The moon meant planes. / The planes meant death."[14] We also have the beautiful words of the British poet and writer Stephen Spender, who spent some time at the front, from where he reported his experience.[15] And the testimony of a painter, whose words powerfully convey the images she creates: "I will never forget the way a frail little girl with long, dusty hair grabbed a piece of bread from my hand . . . it was done so fiercely, like a dog and not a child."[16] And last but not the least, we have the passionate account of a member of the International Brigades.[17]

What is most interesting about this war is its transformation from a local, proportionately micro conflict to a disproportionately mega conflict. In this transformation the war became vitiated and lost its primordial, genuine essence, becoming not just an ideological, bloody arena (which it always was) but also an excuse to punish one's political and ideological counterparts brutally, in the name of an Ideological Sanctimonious Truth. In the case of civil wars "a surplus of horror and an excess of violence" are implicit, totally dissociated from the immediate aim of the war. It is not enough to declare themselves enemies; it is necessary to deny in the other first the brother then the man. And it is exactly this excess of violence that causes almost a collective removal of civil wars from history.[18]

Capturing the circumstances in which Tina Modotti lived during the Spanish war becomes an ordeal for various reasons. First of all, the majority of the people who participated in the war and knew her are now dead. The best-known case is the poet Rafael Alberti, who died in October 1999 aged 97. Second, in search of anonymity and security, Modotti lived in various places, in a friend's house or in a hospital or even in hotels.

Also, she acted under the common name of María, often without a last name. The choice, suggested by the Asturian revolutionary Isidoro Acevedo (whom Tina helped to save at the end of the war)[19] was meant to signify a simple common name, frequently used by women who were lonely and marginalized.[20] (In her official capacity of Red Aid representative in international conferences, Modotti used the name Carmen Ruiz[21].) Third, the official Spanish war archive, located in Salamanca, is currently undergoing an extensive catalogue reorganization, while the Moscow archives on the war, after a brief interlude, have been muted again, perhaps to protect Russia's image and to hide the relationship of instrumentalization between the Soviet and the other European communists.[22] But I was fortunate to consult the Bolloten collection at the Hoover Institution (where nevertheless Modotti is hardly ever mentioned), several private archives in Europe, rich in periodicals and pamphlets, and especially the Southworth collection.

Where information still exists, besides being strongly filtered through ideological channels, it is for the most part strictly gendered. There are, of course, exceptions, which become valuable precisely because they are exceptions.[23] But, generally speaking, the Spanish Civil War historiography seems to suffer from a selective gender-amnesia. Yet it is common knowledge that numerous and brave women of various nationalities played key roles, and thus a special place should be reserved for them. Women "have learned the most difficult thing of all: how to be hard on themselves and gentle to the wounded."[24] They fought alongside the men,[25] and from the mouth of a male fighter come these words: "if that was a glorious struggle, much is due to the women's participation."[26]

And last, but certainly not least, if archival materials are important – indispensable to historians (who are virtually trained to rely almost solely on them) – in the specific case of a civil war, the archival materials are not sufficient to recreate the so-called "collective feelings of the people."[27] Moreover, according to one of the leading historians on the war, Paul Preston (who has been involved for a considerable time in a research project on the Italian intervention in Spain), there is not a single reference to Modotti, or to other names under which she could be found, perhaps because in the context of the Spanish war she was not considered Italian.[28] Therefore, we are left with bits and pieces that we have to reconstruct with the patience of a Carthusian monk (as we say in Italy), in order to recreate the mosaic of Tina's life in those three crucial years. Almost the opposite applies to Vidali, who lived a long life and thus had time to produce an abundance of books, three of which are devoted exclusively to his participation in the Civil War – his moment of glory in every respect.[29] At times it seems that

the Trieste communist had firmly positioned himself as the sole repository of the Revolution.

Vidali's stigmatized contribution to the republican cause was more demarcated and less elusive than Modotti's; and I stress "less elusive" – his was not necessarily more important. In forming the Fifth Regiment in a Salesian convent in Madrid, using the Russian Red Army as a model, Vittorio Vidali under the name of Carlos Contreras had a highly visible post of command, and thus is inevitably mentioned in various books, although not always in a good light. (Strangely enough, while the official history of the Italian Communist Party gives ample space to Vidali's Fifth Regiment,[30] the memoirs of Dolores Ibárruri, La Pasionaria, do not even mention him in reference to the Fifth Regiment but mention him later on a couple of occasions[31].)

What we know about Tina Modotti in this period is that she first participated in the war as a Spanish Red Aid nurse and an International Red Aid officer. (In the previous chapter, I mentioned that some even believe that she was the inspiration for the character María depicted in Hemingway's masterpiece *For Whom The Bell Tolls*, published in October 1940.[32] Others, in quest of an ubiquitous Modotti, even believe that the 50-year-old "barbarous"[33] and passionate Pilar, from the same novel, was loosely based on the 40-year-old Modotti – which is unlikely because, years after Tina had died, Hemingway told a Spanish friend that the person who inspired the character of Pilar was still alive in 1953 in Galicia.[34]) Tina arrived in Madrid on July 19, 1936, having left Granada just in time to escape Franco's troops. In the evening, she joined Vidali at the home of a Spanish couple, the recently recruited communists Matilde Landa and Paco Ganivet, with their daughter Carmen. That evening, the destination of each member of the group was decided: Paco would go to Somosierra with the Galán column; little Carmen would be sent to an uncle who was teaching at El Escorial; and Vidali would return to his barracks, to form the Fifth Regiment, a disciplined people's army, "formed by men of all shades of political opinion who wanted to defend their country."[35]

Vidali accomplished his task after gathering 10,000 fighters, becoming the first political commissar of the Spanish republican army.[36] In his task, he was aided by two Italians, Ettore Quaglierini (alias Pablo Bono) from Livorno, and Pietro Ravetto from Biella. The regiment demanded discipline, hierarchy, and organization, and that every act, that every rifle responded to a necessity of the war.[37] In an internal communist report, Vidali (there called Carlos) was called a "good organizer."[38] The Fifth Regiment, which soon became a complete army in microcosm,[39] was vital in the creation of the myth of the invincible left, and was often mentioned

in communist publications, although not only the left participated in it.[40] The front page of the November 8, 1936 issue of *Milicia popular*, the diary of the Fifth Regiment, is entirely devoted to Carlos Contreras. In other issues he is inevitably mentioned on the cover page. José Herrera Petere dedicated a poem to the *forjador* (creator) *del 5o regimiento*.[41] And one cover page shows a drawing representing Comandante Carlos.[42] On January 27, 1937 the Fifth Regiment – "the soul of the Spanish Civil War," as the poet Antonio Machado described it – was dissolved and merged into a regular army. So the 139,000 Fifth Regiment men could be sent to the various fronts: Madrid, Extremadura, Andalucía, and Aragón.[43]

Landa and Modotti were assigned, respectively, to direct and assist in reorganizing a tuberculosis sanatorium in a working-class area of Madrid, Cuatro Caminos. The place, formerly run by a group of nuns, was renamed Hospital Obrero (Workers' Hospital) by the republicans. Besides Landa, it was directed by Juan Planelles, a Catalan doctor.[44] It seems that the nurses (who were nuns) refused to admit any wounded people, and that the nationalists tried to sabotage the work of the republicans, poisoning the food.[45] So Tina chose to work in the kitchen. In the hospital, she also met an English nurse, married to a Mexican diplomat, Mary Bingham Urquidi; a certain María Valero; and a young Cuban communist, María Luisa Lafita, who in 2002 is still alive in her native country, almost totally blind.[46] (Lafita was particularly close to Modotti because her husband, Pedro Vizcaino, in 1933 in Cuba had executed Magriñat, one of Mella's assassins[47].)

Once the organization of the hospital was on the way, Modotti went back to her work with Red Aid, which then counted thousands of members. The few documents we have of Tina, signed "María," pertain to Red Aid.[48] In that capacity, she participated on July 4, 1937 in the Second International Congress for the Defense of Culture against Fascism, held first in Valencia, then in Madrid (a concert by Pablo Casals was held in Barcelona),[49] with a final section held in Paris, due to the precarious Spanish situation.[50] International Red Aid was an active organization: in September of the same year it also sponsored a congress for refugees in Valencia. Among the speakers and organizers mentioned are Matilde Landa, Moral, Regina Lago, Carlos Contreras, and the "Catalan comrade Bargallo."[51] The general purpose of the Congress for the Defense of Culture was to discuss the role of the intellectuals of the world with regards to the Spanish Civil War – more specifically, the connection between politics and literature.[52] Among the participants, were Pablo Neruda, André Malraux, Silvestre Revueltas, Karin Michaelis, Heinrich Mann, Juan de la Cabada, Bertold Brecht, Julien Benda, J. R. Bloch, Martin Andersen-Nexö, Kol'cov, Rafael Alberti, Antonio Machado, Maria Teresa León, Nicholás Guillen,

Anna Seghers, Alexei Tolstoy, Herbert Hemingway,[53] a young Mexican poet, Octavio Paz,[54] and Ilya Ehrenburg, who praised the heroic soldiers of the Fifth Regiment for saving the paintings by Velázquez and the treasures of the Prado Museum.[55] Stephen Spender participated as a Spanish delegate under the name of Ramos Ramos, using a forged passport obtained for him by Malraux.[56]

Thanks to this occasion, Tina acquired a keen sense of belonging to a group *engagé* of intellectuals of democratic and leftist orientation, with whom she kept in contact whenever possible, at least until 1939. It was also through her Red Aid work that she met the famous Canadian doctor Norman Bethune, for whom "thought and action were virtually synonymous."[57] His blood transfusions at the front became a landmark in the medical history of the Spanish Civil War.[58] Upon arrival in Madrid in November 1936, Bethune went to the headquarters of the Fifth Regiment to confer with Vidali, who – Bethune was told by American and British correspondents – was the man "who gets things done."[59] Bethune had high praise for International Red Aid, which he regarded as "the best organized and powerful health organization in Spain and much superior to the International Red Cross," which was "very suspiciously fascist."[60] By the end of 1936 Red Aid had 275 hospitals and places of aid, and 150,000 members.[61] And Bethune reported that his organization, the Canadian Service of Transfusion, obtained blood through daily broadcast appeals for blood donors, to which thousands of volunteers responded.[62] On December 23, 1936 the first transfusions were given in University City, delivered by the mobile Spanish–Canadian blood unit.[63] The blood was stored at suitable temperatures in vacuum bottles and transmitted to any hospital needing it.[64] For the first time since humans learned how to kill their brothers, a man had appeared on the battlefield to reverse history – to give blood, not to shed it.[65]

Many were dying. Although people had "trained themselves"[66] not to mourn for their dead, death still had a shocking effect. The Hungarian journalist and photographer Gerda Borohylle (commonly known as Gerda Taro) died in Albacete, crushed by a military truck. She was the special war correspondent for the magazines *Ce Soir* and *Life* and was married to the photographer Robert Capa, who had immortalized the major battles.[67]

At Brunete, a village located 30 kilometers west of Madrid, in summer 1937 the republicans launched an unfortunate surprise attack on the nationalists.[68] The battle cost both sides thousands of men, but morally it was more costly for the republicans, who soon became demoralized. Moreover, because of the date of the counter-attack, July 25 (the day of the patron saint of Spain, St. James), the nationalists saw in their victory the

hand of God, a sure sign of fate. The strength of Franco indeed lay in his astute use of religious symbols and his association and ties of the holy cross to western civilization. This religious aspect is evident in all of the nationalist publications.[69] They regarded the Bolsheviks as barbarous people, and depicted, for instance, a statue of a lamenting Christ with his hands "severed by the reds."[70] A biographer of Hemingway has said that the writer's scorn for the Franchists stemmed from the fact that they were convinced that they were waging a holy crusade and therefore "drank and fucked and killed with a sort of sacred fury."[71] But, if most nationalists were religion-oriented people, the other way around is not true, because there were Catholic laymen, such as the lawyer Angel Ossorio y Gallardo, who declared that a "Christian cannot be a Fascist because Catholicism means liberty of spirit and respect for human thought, whereas Fascism means the rule of force to protect a privileged class."[72]

In their zealous, self-righteous campaign to attach religious significance to the war, the Franchists did not mind presenting the communists as monsters and priest-eaters. In the collective memory of the people, Vidali became the rapist of 347 nuns in a single night,[73] while La Pasionaria was believed to have lacerated priests' throats with her teeth. Juan de Cordoba referred to her soul as *su alma negra acostumbrada a las perversidades* (her black soul used to perversities),[74] while for somebody else she was a "medieval ascetic."[75] In the elementary school textbooks published in Italy in 1942, it was stated that "in 1936, a tyrannical government, the negation of God and civilization, tried to extend its dominion of disorder all over the world, and promoted a subversive government in Spain;"[76] and from 1941: "Russia spread its hatred among those wretched people who belonged to the lowest classes in France, England, and Spain, and sent them to fight so the red flag would be victorious."[77]

Contemporaneously to the work in Red Aid, both Modotti and Landa were drafted into the women's section of the Fifth Regiment, where they learned how to shoot with a rifle and a pistol and how to launch a grenade.[78] To learn how to shoot was imperative even for women who had no knowledge of guns, and it became part of the so-called "rise of consciousness," as Vidali reports.[79] Modotti also worked as a reporter for *Ayuda* (Aid), a weekly journal edited by the Spanish Red Aid, an organization that was active during the war, having placed a luxurious 200-bed hotel at the disposal of the wounded.[80] The line between life and death became so fragile that Tina must have known that her death was a daily possibility too. She certainly faced it more than once. And yet, when she was told that a comrade had died, she would suffer intensely, as if it were the first time that she had encountered death. Her first contact with wounded (or moribund)

milicianos had been indeed tragic, and she never forgot it.[81] Death in all its forms always shocked her, even the death of animals. Gabriel Fernández Ledesma, director of the magazine *Forma*, reported to Poniatowska that when in Mexico Modotti became very attached to an art school pet, a spider monkey called Panchita, used by the art students in life drawing. One Sunday, when the attendant was off duty, a coyote escaped from its cage and butchered all the animals, Panchita included. On Monday morning, when Modotti arrived at the school, she found the little monkey in agony under a pile of stones, with its intestines exposed. Tina was overwhelmed by the horrible scene, and could not keep her usual calm composure.[82]

During the extraordinary circumstances of this Spanish period Tina and Vidali valued life together immensely – although Camus taught that "those who truly love justice have no right to love"[83] – fiercely capitalizing on every moment of love and intimacy that their work could grant, when "even an embrace was a luxury."[84] They spent the first new year's eve of war together, dancing or, rather, pretending to dance since Modotti could not dance very well. With them were La Pasionaria, Pepe Díaz, Lister, Nenni, and Luigi Longo.[85] Some self-images by Vidali – as the fiery *comandante* Carlos, who shouted to his men through a megaphone (*altavoz del frente*) – are probably exaggerated to keep the pathos alive, but they are no less beautiful. One feels almost disarmed when reading of Vidali leaving for Paris, saying goodbye to a sad Tina in Barcelona. And what to say of the tender image of a Vidali seriously wounded who wakes up in a Madrid hospital to find a sleeping Tina, her head leaning on his bed? Those brief sketches too are part of the war.

To increase Tina's sadness, at the end of 1936 she was informed of her mother's death in a letter from her sister Mercedes, but the news did not reach her until two months after the event, which had occurred on September 30, and meanwhile Tina had continued writing to her mother. One letter, simply dated November 1936 (whose postal stamp indicates November 30) is particularly moving, because it ends with the word *addio*, which in Italian means goodbye forever.[86] Assunta Modotti had moved back to Italy, so mother and daughter had been geographically much closer than before but without any possibility of seeing each other. It appears that Assunta (the "golden mummy"[87]) had always been much closer to Jolanda and Tina than to Mercedes, with whom she had frequent fights. When Tina was still in Mexico, Assunta voiced her wish to "escape to Mexico to Tina."[88] (Apparently Mercedes, who is portrayed by her brother Benvenuto as a petty bourgeois obsessed by luxury, had different values from her sisters', with whom she did not share any leftist ideas.) At the news of her mother's death, Tina must have suddenly realized that she was deprived of much

more than the hope of seeing her again: she had been denied the protective rite of a farewell from her, and the fact of not knowing of the death at the time it occurred must have greatly increased her sadness. (By coincidence, Vidali's father also died in November 1936, aged 71[89].)

Upon receiving the news, Tina wrote to her sister Mercedes but to the wrong address, 210 Guardiella Scoglietto, in Trieste; Mercedes had already moved to 8 delle Linfe Street. The letter, which begins with the words "dearest sister," was dated December 1936 and arrived in Italy through France on January 13, 1937, where it was intercepted by the Italian authorities. It is a sad letter, of a composed sadness, and it reveals Tina's wish to be near her family in order to help them to bear the *immenso dolore* (immense sorrow), asking forgiveness for not being able to write sooner. At the end of the letter, Tina asks Mercedes to convey her grief to the other members of the family, to whom she could not write personally, since she was involved in an activity that absorbed her completely. But the memory of her mother was like a bond that kept them united, despite the distance. Modotti also thanked her sister for the great care she had for their mother. The letter is signed "Mercedes," to confuse the Italian fascist police, to whom Tina and her family were known as subversives.[90] Ben Modotti wrote to his sister Mercedes on November 23, 1936 from New York to suggest a simple grave for their mother, perhaps with a pine tree, an everlasting green plant – Ben said – since Assunta Modotti was always hoping for better days, which the color green suggests.[91] A pine tree was indeed planted and grew beautifully, as Mercedes wrote to Tina in 1939.[92]

With whom did Tina interact in Spain and by whom was she mentioned? It appears that she met La Pasionaria when the "communist Virgin"[93] was a resident of the hospital, recovering from hepatitis.[94] Under doctor's orders, only Modotti and Lafita were allowed to enter the patient's room, kept under strict surveillance for fear that the nationalists might dispose of La Pasionaria. Tina also correspondend with Teresa Andreetti, wife of Pietro Guerzoni, both communists and Red Aid members, who had a seedy *osteria* (at least according to the Italian fascist police) in Paris, in Passage de l'Avenir.[95] Tina also came in contact with Francesco Leone, a Red Aid Italian delegate who arrived in Spain in August 1936. In a pamphlet issued in 1938 by *Secours Rouge*, the French section of the Red Aid, Modotti is mentioned as María Ruiz in a positive light, as a "representative of internationalism."[96] Because she worked primarily as a nurse, one expects to find her mentioned in several medical records and yet that is not the case. Fredericka (Freddie) Martin, the head nurse of the International Brigades' American contingent in Spain, who had some material on Tina, was

attempting to write a history of the medical services, but she died in 1992 before she could bring her project to fruition.[97]

Modotti was mentioned in October 1936 by Andreu Castells, a Catalan republican, as María Ruiz the assistant to Pauline Marty, in the International Brigades counter-espionage organization. The *adjuntos* (adjuncts) were identified as Karanov, Firtos, Maxine Rieger, Arnold Fajin (alias Roman Filipcev), Vladimir Stefanovic (alias Vlajko Begovic), José Moreno (alias Karel Hatc), and, on a sporadic basis, Theodor Balk (alias Dragutin Gustincic). Until September 1937, Pauline Marty also supervised the administrative sector of the sanitary international area. Evidently Modotti's past was known, and Mella's ghost followed her to Spain, too. Castells refers to Modotti as the "wife" of *comandante* Carlos and adds that it was with Carlos' complicity (rumors said) that she organized the murder of her own lover, the Cuban leader Julio A. Mella, who wanted to break away from communism.[98] In a letter of May 1938 to Vidali, addressed to Comandante Carlos, Antonio Machado says of Vidali's wife "we have so much to be grateful for."[99] And in another account she has become "Maria Modetti," an old Comintern functionary and the wife of the Comintern agent Vittorio Vidali, who used the *nom de guerre* Carlos Contreras, "untouchable even by members of the politburo of the Spanish party."[100]

On less personal ground, the information available indicates that the first International Brigades nurses comprised around thirty young women (of unidentified nationalities), sent by the Fifth Regiment to Albacete. After that, all the other international nurses came to the scene.[101] In the middle of 1937, the medical situation of the International Brigades was as follows: 23 hospitals with 5,000 beds; more than 220 general doctors; 13 specialized surgeons' groups, fully staffed and equipped; 580 nurses and assistants; 130 ambulances; 7 surgical wagons; and 3 evacuation groups.[102] From December 1936 convalescent centers were set up in the regions of Murcia, Denia, and Benicassim. The last was directed by Dr. Yvonne Robert. Later, in Madrid, the Casa de Reposo Luckács was founded.[103]

At the end of 1937 the Red Aid headquarters was transferred to Barcelona. In March 1938 the Catalan capital suffered one of the worst bombings ever inflicted on a city. More than one thousand people died, three thousand were wounded, and a Red Aid building succumbed to fascist brutality. However, according to one report, Barcelona did not look like a city in wartime since "it was almost too gay, the people almost too happy. They seemed unconscious of the dangers."[104] The constant bombing prompted the move of several Red Aid members, Tina included, to Valencia. When asked where the front was, a doctor pointed in all

directions of the horizon: "Everywhere – heaven and earth!"[105] Red Aid was still playing a crucial role: by 1938 the various antifascist committees were united under Red Aid with 700,000 members.[106] In November 1938 Modotti helped organize the Red Aid National Congress in a Madrid under siege by the enemy. One wonders whether Modotti knew then that there was a strong possibility of losing the war. But even mentioning the possibility of defeat of the republicans was a sort of taboo.[107] In fact it appears that throughout the war Tina refused to think in terms of defeat and she shared the destiny of the republicans until the very end. Even later, she was in a state of denial.

From Catalonia Modotti went to France. In Paris she lived at first with the family of a lawyer, Marcel Willard (whom she had met years before over the Dimitrov trial[108]), and then, when it became dangerous to stay there, she was hosted by the Joliot-Curie family – all her movements still carefully watched by the Italian police. But where to go next? There were a few possibilities, all precarious. One option was to return to Moscow, after a six-month rest in the Crimea. But news of Stalin's fraudulent trials (which created the term "enemy of the people"[109]) had reached Modotti, who had been given the hint that because of her association with Vidali she would probably wind up in a labor camp in Siberia, which in Stalinist terms was the Crimea's "logical" culmination. It appears that nobody was able to escape the accusation of Trotskyism,[110] not even the loyal Elena Stasova, who after being investigated more than once, in 1938 left the decimated MOPR to accept an editorial job at the magazine *Internatsionalnaia literatur (International Literature)*.[111] In Italy a fascist government was in power, so Modotti could not return without facing a sure death penalty. Another option was the United States, where she (and Vidali) could help to organize the work of 500,000 or so refugees.[112] But to enter the U.S. with a false passport (as would have been Modotti's case) could mean deportation to Italy. At the end, she and Vidali chose to go to the country that had played a vital role in Tina's political growth. She would still enter Mexico illegally but such illegality would not be immediately dangerous.

* * *

With regard to Vidali's violence and cold-blooded executions – which all Modotti's biographers never fail to mention as though they were the nemeses of justice – there is no doubt that Vidali felt more comfortable on a battlefield than in a senator's armchair. His own words to Capraro in 1927, that "it is not enough to read *Das Kapital* and to learn the history of the revolutionary movement, but it is necessary to become iron revolutionaries, and creative minds,"[113] are almost a profession of faith. And in

Comandante Carlos he stated that "terrorism could be a means of struggle to be adopted against class enemies."[114] To Capraro he said that "a Marxist must reason coldly" and "a Leninist must look at the goal to be reached without worrying too much about the obstacles created by others."[115] However, violence for Vidali was neither positive (as in fascism) nor negative in itself; it was intrinsic in the nature of class struggle, especially in the case of a war. Thus, as an instrument violence had to be employed (whereas for nazism it was integral to its doctrine).[116] This does not justify violence. It merely explains it.

According to an American correspondent, Herbert L. Matthews, the order for the massacre of Madrid, on November 7 and 8, 1936, came from the Comintern agents: "I know that the sinister Vittorio Vidali spent the night in a prison briefly interrogating prisoners brought before him and, when he decided, as he almost always did, that they were fifth columnists, he would shoot them in the back of their heads, with his revolver."[117] The term "fifth columnist" was coined by General Mola, who in reply to a journalist who asked him which of the four columns would capture Madrid, answered "None," for a fifth column of hidden insurgent supporters would arise.[118] The term then alluded to Franco's undercover partisans, ready to become active if needed in Madrid, and was later applied by communists indiscriminately to all non-Stalinists.[119] Machado, who never considered himself a communist, states that the left and right parties in the war were simply divided in to either "Fifth Regiment" or "Fifth Column."[120] Hemingway even entitled a three-act play *The Fifth Column* in 1937 which he later strongly disliked.[121] He also reported to Matthews that he heard that "Vidali fired so often that the skin between the thumb and index finger of his right hand was badly burned,"[122] while Matthews himself wrote that "Carlos was even tougher than Lister for he was a real killer, but he was also an inspired organizer as well as a ruthless disciplinarian."[123] By one historian Vidali is described as "ruthless" as well as "efficient and imaginative," with a "reputation for shooting cowards," and for making the Fifth Regiment march in step by hiring the Madrid municipal band to keep time.[124]

Another account, by Norberto Fuentes reporting Hemingway, toward the end of the war, when Franco's troops were getting closer and closer to Madrid, suggests that Vittorio Vidaldi (*sic*) shot indiscriminately at an undetermined number of prisoners detained in the Modelo Prison in Madrid. He also shot civilians suspected of being fascist, who were picked up at random in the streets of the capital during the so-called punitive actions. Fuentes asserts that is why people would say that "with comandante Carlos around, the militia men are fearless."[125] According to Fuentes, in a letter from Hemingway there is a reference to the role played by Vivaldi (*sic*) in

the Madrid action, identified by the writer as occurring in San José de las Latas – a parody of the Cuban town San José de las Lajas.[126] The letter was addressed to Joris Ivens, the director of the documentary film *The Spanish Earth*, the best visual tribute to republican Spain, made in 1937 under the auspices of Contemporary Historians Inc. with a script by Hemingway.

At this point the information becomes extremely puzzling and confusing, because in the same paragraph Fuentes lumps together Vidali with Hemingway's own experience during the Second World War, which the latter used to recount to his intimate friends. Fuentes says that Hemingway admitted to having participated in punitive actions and admitted to having stabbed some German soldiers, without thinking that they too could have been the sons of poor Germans.[127] Elsewhere in his book Fuentes reports a request that he says was the "secret key between Ivens and Hemingway,"[128] referring again to the punitive actions conducted by *comandante* Carlos. Ivens demanded to know the nature of and the reason for the actions against the unarmed fascists. Hemingway reported Ivens's request in the words of the character Robert Jordan in *For Whom the Bell Tolls*, after Pilar had finished recounting the lynching of fascists in a small village, a passage in which the reader can sense the smell of death.[129]

Such crimes were actually committed no less by the nationalists; in fact, if one considers all the years that followed, the nationalists committed many more crimes.[130] According to the Spanish historian Javier Tusell, after the war the nationalists shot no less than 50,000 people and 250,000 were illegally detained.[131] The assassination of García Lorca, the most loved Spanish poet, was the most inexplicable and senseless death, a *monstruoso crimen político, en esta tierra de envidiosos Caínes* (monstrous political crime in this land of jealous Cains).[132] News of Lorca's death reached the art studio of Renato Guttuso, who painted from memory *Fucilazione in campagna* (Execution in the Countryside). The poet was killed in Granada, his home town, by irresponsible nationalist fanatics for reasons still unknown, on August 19, 1937 – unanimously regarded as the most difficult year for both democratic and leftist people.[133] Did Lorca pay with his death for his (mild) opposition to fascism, or for his sexual tendency? It is still uncertain. What it is certain is that the nationalists had the same attitude of the Stalinists toward those sexual orientations considered perverted. The case of Russell Blackwell, a former communist party member, speaks clearly. During the Spanish Civil War, Blackwell was arrested and detained in Valencia by the secret police. The Stalinists accused him of being a Franco agent, of being a Trotskyist (which he was), and, worst in their eyes, of being a homosexual. It took a defense committee, in which Anita Brenner among others participated, to free him.[134]

The Spanish Civil War was doubly tragic and doubly a civil war. Not only do we see right against left, fascists against antifascists, but we also see Stalinists against anarchists, and – most tragic – Stalinists against other communists, who were equally sincere and equally engaged in the anti-Franco struggle. The refusal of the idea that the fight against Franco's troops should take precedence over factionalism proved fatal. The terrestrial paradise promised by Marx's dialectical materialism gradually turned into hell. In other words, the revolution had brought no evolution.

From the anarchist point of view, therefore, it was if not impossible, then at least extremely difficult to accept the military and collective discipline of the communists, who were not used to combat in "romantic barricades," as the socialist Pietro Nenni noted.[135] The anarchists became prisoners of their own anti-authoritarian bias, which prevented them from understanding that a revolution is (or can be) the quintessential form of authoritarianism. But most of the anarchists could never be persuaded that war and revolution were not in conflict, and that fighting in a war, according to their ideology, could be equated with fighting for a revolution.[136]

When looking at the factions in the war, we do not have only right against left but also left against reason.[137] The Stalinists claimed that they could not avoid assuming certain distinct, ideological positions, which created a rationale all its own. A Spanish socialist and feminist, Margarita Nelken, who after a 1934 trip to the Soviet Union turned to communism in 1937,[138] admitted to Anita Brenner that "the anarchists are the scum of the earth" and "should be exterminated."[139] They were indeed exterminated. The famous case of the Italian anarchists Camillo Berneri and Francesco Barbieri, who died on May 5, 1937, is the best example, as the anarchist-oriented publication *Spain and the World* shows.[140] Such extermination led to the building and guarding of a secret crematorium that enabled the Stalinists to dispose of their victims without leaving a trace of their remains.[141] To orthodox communists, behind extermination lay a fundamental, ideologically rational justification. In that rationale lies the source of the intransigence and brutality that, unfortunately, scar all sides of the Spanish Civil War. This is not to diminish the responsibility of the left faction linked to Moscow, or to tone down the barbarous incidents that occurred. And certainly it is not an effort to romanticize the war – that has already been abundantly undertaken, especially by people living outside Spain during the conflict. Rather, it is an attempt to state that the fault lies in the war itself, which as in all wars unleashed the worst instincts of human beings, who acted accordingly. War seems to make it permissible to alter truth, and to rewrite history retrospectively.

It is not for nothing that Brecht wrote *Mother Courage*, charged with denunciations and accusations against war in general, and that Aristophanes in *Lysistrata* and *The Acharnians* condemned war. Even Hemingway, who enjoyed fighting, wrote that war was evil and whoever denied this was a liar, but that sometimes fighting could not be avoided.[142] Vidali himself, a great part of whose life was devoted to fighting, wrote to his son in 1945 that he hated war, and that his wish was that future generations would no longer talk in terms of militarism.[143]

One can argue that not all men during a war have the same instincts, since some retain their best aspect. However, Vidali, who perceived life exclusively in terms of class struggle and courage (which he never lacked), could not have acted differently. Regarding himself as the last Stalinist messianic prophet, and believing that he owned the sacred truth on communism, he made himself the bearer of such truth, and violence came with that. As I noted earlier, all of his biographers and eulogists are unanimous that the Spanish war was the peak of his existence.[144] One could go further and state that therefore it was not the communists who promoted the civil war but the war that promoted the communists.[145] And this brings me to the crucial question: was Tina Modotti aware of the atrocities committed by her own comrades against other comrades? Did she too become the "petulant guardian of republican justice"?[146]

There is no doubt, despite what has been said or written, that she did know at least part of them, and that she accepted them to a certain extent, although that cannot be proved. (Obviously, this does not erase or undermine the work she performed in the antifascist struggle: the two are not incompatible.) In order to present a rosy image of Modotti, most of the existing biographies do not even entertain the idea that she could have been involved in anything that was not ideologically "pure." In fact, Modotti is always presented as the sensible and sensitive person who warns Vidali about various matters, as if she were the champion of truth and justice. The term Stalinist, which is constantly used of Vidali (always with negative connotations), is practically never used to identify Modotti, despite her Stalinism. Her premature death "freed" her from the taint of Stalinism. Vidali's death did not; thus his name has been burdened with it even after death.

On the other hand, Modotti's most recent biographer (who uses the negative term Trotskyite throughout her book) goes out of her way to show that Modotti was responsible for reporting those who were considered renegades by her comrades, thus making her an accomplice to the crimes committed against those reported. The proof is supposedly evident in a typed letter sent from Paris, addressed to the Central Committee of the Spanish

Communist Party, dated January 24, 1937, and signed María. Here is the text in the original:

Valencia, 24/1/1937
CC del PCE
Departamiento de Cuadros

Estimados camaradas:
La comunicación que más abajo citamos ha sido enviada por el Partido Comunista de Brasil a nuestros camaradas de Paris los cuales han encargado de transmitirla a Uds. a fin de que tomeis las medidas necesarias.

"El teniente Alberto Bezouchet se encuentra actualmente en España. Despues de su salida de Brasil se ha descubierto que Bezouchet ha pasado al trotzkismo. El ha dejado una puebra que es una verdadera provocación contra la revolución nacional y tambien urje notificar todos los camaradas a fin de que no le permitan utilizar el nombre del Partido Comunista de Brasil."

Esta comunicación me ha sido entregada en Paris el día 20 de enero fecha de mi regreso a esta. Me permito indicaros la conveniencia de enviar copia de esta comunicación a la Comisaria Politica de las Brigadas Internacionales.

Con saludos comunistas

María
(del S.R.I. – calle Montornes 1).[147]

The document was pointed out to me in spring 1998 by a German historian, Reiner Tosstorff, who was in contact with a group of Brazilian Trotkyists. One of them, Dainis Karepovs, presented a paper on a Trotskyist militant, Alberto Bomilcar Bezouchet (or Besouchet), during a conference held in July 1997 in Brazil. Like many other idealists, Besouchet perished in 1938, after fighting on various fronts and being interned in a Stalinist prison for his "Trotskyite tendencies." This much is known, but I am not completely convinced about the author of the document – the name María was widely used during the war – nor am I convinced of the audacity of the supposed Modotti's gesture. As outrageous as it sounds, reporting those who were considered defectors or possible dissidents in time of war was a duty of party's members. It may be something we abhor today (especially if taken out of context), yet that was the common practice. Denunciation was encouraged by the Soviet regime in the 1920s and 1930s,[148] and consequently was carried out by all communist party members, Modotti

included, during the Spanish Civil War. Denunciation was, in fact, a frequent and widespread practice in Russia long before the Soviet period.[149]

By way of corroboration, Karepovs presents a second letter, dated September 24, 1937, written from Paris by a certain "Castro" to a certain "Jack." Since this Castro's title was "member of the Politburo and delegate of the Brazilian Communist Party," Karepovs identifies him as Honório de Freitas Guimaraes, a Brazilian Stalinist, while in Jack he sees the usual suspect, Vidali, although Jack could also have been Jack Tolschen.[150] This letter too warns against Besouchet's Trotkyite deviations, saying he had been influenced by his brothers and a correspondence with Elsie Houston, a Brazilian singer.[151]

It is well known that Stalinists disposed of those whom they regarded as their enemies, even an innocent gypsy of the *kalos* tribe, Zeffirino Jimenez Malla, whose only "crime" was to carry a rosary and a little knife, used by horse traders to perform bloodlettings. Arrested on July 25, 1936 by militiamen, the gypsy was thrown into prison in Aragon and two weeks later executed along with other prisoners, mainly priests. (Zeffirino, nicknamed *El Pelé*, is the only gypsy in the world to have been canonized by the Vatican.[152]) As in the case of Zeffirino, some disappeared without trace: Kurt Landon (Landau), an Austrian militant, editor of the central European *Der Funke*; Marc Rhein, a Polish Trotkyist known as Moulin; Erwin Wolf, a Czech; José Robles, a professor from Johns Hopkins University; and General Gopru, to mention a few.[153] The favorite sentence of the Stalinist André Marty was *la vie d'un homme vaut soixante-quinze centimes, le prix d'un cartouche* (a man's life is worth seventy-five cents, the price of a bullet).[154] On the eve of the war, in 1936, communist party members (that is, Stalinists) were only 30,000 while by June 1937 they had become one million.[155] And they had access to substantial funds, which enabled them to establish a large apparatus for action and propaganda.[156] It is ironic that Stalinists, while they were disposing of Trotskyists, recruited into their ranks members of the Estat Catala, a separatist, nationalist, and ultra-right group from Catalonia, which disarmed and murdered workers, dispersed strikers, and was in direct contact with Mussolini.[157] In order to "erase" some key leaders from the people's collective memory, evidence needed to be fabricated. The most famous case was that of a Catalan revolutionary who had rejected the Stalinist sectarianism.[158] A vicious campaign was launched against him in 1937 – a year that began with the second Stalinist trial, held in Moscow in January (as previously mentioned), intended to crush the Trotskyists.[159]

At noon on June 16, 1937 Andrés Nín, one of the founders of the Spanish Communist Party in 1921,[160] was arrested by the official police in

Valencia, headed by David Vazquez, acting together with a Russian military leader, Leonid Navitsch (later found dead in Barcelona).[161] Nín's first prison guards were identified as Juan Bautista, Carmona Delgado, and Santiago Gonzalez Fernandez. With the entrance of Sergei Mihail Shpiegelglas on the political scene, Nín was removed from police control by eight officers of Russian and Polish nationality who claimed they had received an order to transfer the prisoner elsewhere. Thus, Nín was subjected to endless interrogation and atrocious torture, which he endured in the private prison of Alcalá de Henares, near Madrid (Cervantes's birthplace, later bombed), and at El Pardo, where he was brutally murdered.[162]

Nín had succeeded Joaquín Maurin as the national secretary of a group of Catalonian communists, P.O.U.M., the Partido Obrero de Unificación Marxista (Workers' Party of Marxist Unification), created in March 1935. P.O.U.M. is not easy to place politically: until 1934 the group, not yet a party, was mainly focused on theoretical work, as reflected in their publication *Comunismo*.[163] What is certain is that P.O.U.M. was loyal to Marxist-Leninist ideas; it was international – (their publications frequently also appeared in foreign languages[164]); it was historically oriented (Nín himself used to draw analogies with the past), and it was supportive of women, as its literature shows.[165] It is also clear that P.O.U.M. was anti-Stalinist, as Nín wrote in April 1937, while identifying the beliefs of the republicans: "These people think that the revolution is like a train which arrives on time at the station, and then the station-master says: 'gentlemen, we have reached the social revolution.' Revolution is not, cannot be, like that . . ."[166]

P.O.U.M. is often but not accurately labelled a Trotskyist group, although its members themselves at times professed "to have become Trotskyists"[167] and although they were always treated as such by Stalinists.[168] P.O.U.M. sympathized with Trotskyism but also had its differences with it, and it always retained its independence, which is probably why it represented a real danger for both sides in a revolutionary era.[169] Trotsky himself criticized the group, despite his respect for it, on the basis that P.O.U.M. members were more attuned to the Popular Front than to Bolshevism.[170] Bertram Wolfe wrote in his notes for a talk delivered in 1937, "Why call POUM Trotskyist?"[171]

The background of Nín's arrest up to his "bloody repression"[172] helps in understanding the escalation of events. Under the order of Antonov-Ovsëenko, the Russian consul general (and a renegade Trotskyist), and Vicente Uribe, a communist party representative, in May 1937 P.O.U.M. was declared illegal, its broadcasting stations were expropriated, its daily *El combatiente rojo* (The Red Fighter) was banned, and its headquarters at the Hotel Falcón was closed.[173] But the socialists and the prime minister,

Francisco Largo Caballero, refused to support the suppression of P. O.U.M., thus precipitating a cabinet crisis.[174] Caballero wanted to form a new government from which the Stalinists would be excluded – an action that would have alienated Moscow (and thus Russian aid) from the republican side. But the help of the Soviet Union was crucial for the republicans and strengthened the Spanish Communist Party, whose members would grow from 30,000 to 300,000.[175] On May 15, 1937 Caballero resigned. At the request of President Manuel Azaña Díaz, considered a center-left republican (or, better, a bourgeois republican),[176] Juan Negrín formed a new government on May 17. The new government included no anarchists or any of Caballero's socialist followers. It then began a witch-hunt against P.O.U.M., with the arrest of Nín and other members in June 1937.[177] The anarchists, whose dislike of P.O.U.M. was not a mystery, at this point began to protect P.O.U.M. members in order to protect themselves, since they interpreted the P.O.U.M. massacre as a final attack against themselves.[178]

A few days of torture had transformed Nín into an unrecognizable piece of human flesh. As it was said in Catalan: *tenía la carn masegada* (his flesh was all bruised).[179] The G.P.U., which had become an international instrument of persecution, then proceeded to execute the 45-year-old revolutionary (as Khrushchev later admitted), under the false charge of espionage. This action was given "a veneer of legality by the retroactive decree on June 23, creating Tribunals of Espionage and High Treason."[180] (Stalinist paranoia saw Trotskyists everywhere: as early as October 1936, the official organ of the Soviet government, *Pravda*, had declared that the Spanish Trotskyists were trying to break the Popular Front.[181]) Nín's body was never found, although that too seems to be disputed.[182] According to one theory, he was secretly buried in Spain; according to another, his body was put in a crate and shipped to the Soviet Union.[183] The news of his death shocked many people. Hemingway mentions him in *For Whom the Bell Tolls*.[184] George Orwell wrote respectfully of him in *Homage to Catalonia*.[185] Decades later, the film director Ken Loach offered an idealized version of Nín's death in his film *Land and Freedom* (1995). A well-known Catalan poet and chief of the Catalan press bureau, Jaime Miravitlles, declared the accusations against Nín absolutely false. The Italian writer Ignazio Silone offered his help and in July 1937 Federica Montseny, the former minister of health in the Largo Caballero cabinet, publicly asked the government for information on Nín's whereabouts.[186]

Graffiti started appearing on the walls of Barcelona, questioning the government about Nín.[187] Juan Negrín, the new Spanish premier, and Indalecio Prieto, minister of national defense, were held responsible for Nín's disappearance by P.O.U.M. members, who demanded these minis-

ters' heads in exchange for his. Negrín first threatened to resign, but later decided to stay in office. But Nín's murder became a *cause célèbre*. The execution order and a false nazi kidnapping (planned to the smallest detail) were attributed to the operation leader, Vidali, according to information provided by Enrique Castro and by the Spanish minister of education, Jesús Hernández, then a member of the Comintern executive.[188]

In 1938 the Stalinist Max Rieger wrote a devastating book whose aim was to prove, through the use of some photographs, the links between P.O.U.M. and fascists. Rieger, who simplistically associated the P.O.U.M. movement solely with Trotskyism, claimed that some messages, sent directly to Nín by the falangists and vice-versa, were found in the headquarters of the P.O.U.M. Executive Committee in Barcelona.[189] Nothing of the kind was true; but Rieger's book has to be seen in the light of the witch-hunting atmosphere created by Stalinists – an atmosphere that caused a painful fracture between the various leftist factions in general.[190] The comments of one of Siqueiros' biographers are along much the same lines: P.O.U.M. is labeled as "notoriously unreliable" since it "conspired with anarchists" in May 1937; it "attempted a counterrevolutionary coup against the government of Spain;" and – obviously – P.O.U.M. members even collaborated "with fascist agents operating within Barcelona."[191]

The person who represented the link with the Comintern was Togliatti (alias Alfredo) as far as purges were concerned, but the section against Trotskyism was left in the hands of Contreras.[192] A former Stalinist, Julián Gorkin (already a communist at 17 years old), repeated the accusations, adding to the list of executioners the names of Nikolsky Alexander Orlov (alias Sehwed or Schwed, alias Lyowa), the chief in Spain of the People's Commissariat of Internal Affairs (or NKVD, later renamed MVD, Ministry of Internal Affairs).[193] Gorkin also accused Bielov, who he claims spoke Russian to Nín while Vidali shouted "in Mexicanized Spanish merged with Italian insults."[194] The P.O.U.M. members openly accused Fernando Valentín Fernandez, Carlos Ramallo y Garci Nuño, Jacinto Rossell Colmo, and Jacinto Ucedo Mariño.[195]

These accusations were strongly rejected by Vidali himself, on the grounds that he was in Madrid at the time.[196] Recently, a certain Iosif Grigulevich (or Grigolewitsch), a former G.P.U. agent (befriended during the war by the Spanish communist leader Santiago Carrillo, who even made him his son's "secular godfather"[197]), has been identified as Nín's executioner, although we are still left with too many questions and too few answers in our quest for accurate, honest, impartial, and reliable records.[198] If, like all the products of the earth, truth is subject to the rhythm of the seasons, then it must wait for its proper moment of germination. But it is

impossible to predict when the truth will surface.[199] In September 1937 Nín was remembered by his comrades as a "writer, POUM General Secretary, killed by Stalinists."[200]

<div align="center">* * *</div>

After almost 30 months of fighting, the Spanish Civil War officially came to an end on Tuesday, March 28, 1939, when an exhausted Madrid fell into Franco's hands. Britain and France had recognized his government since February; the Vatican had recognized it since 1937.[201] The propaganda of the Italian fascist government explained the victory of the nationalists to elementary school children in these terms: "200,000 men victoriously entered Madrid, after fighting against the communists supported by Moscow. Russia had tried to export Bolshevism, that is, the negation of Faith and of any healthy human energy, to Spain."[202] On April Fools' Day, Franco signed the last war bulletin, in which he stated that the war had ended and that the nationalist army had achieved "final military objectives."[203] I leave the description of the last moments of war to the mighty pen of a woman who spent 18 years in one of Franco's jails – Juana Doña:

> De forma febril todos buscaban "algo": ?cómo? ?por dónde salir de allí?, pero también los había con tal desesperanza que su única huida, su auténtica evasión era la murte.[204]

The long fascist nightmare had begun.[205] As has been written, "it made Spain a prison and a graveyard."[206]

The republicans had lost the war, but not the cause. However, 36 years passed before one of them, at Franco's death, wrote:

> It is all over Franco
> your government
> the ugly garrota
> torture, tyranny.
> Today people prepare their celebration
> their bull fight
> and, as Rafael says, all Spain
> is a *Plaza de Toros.*[207]

The total number of human losses caused by the Spanish Civil War was one million according to the first nationalist press release, issued in 1940.[208] But historians have always doubted the authenticity of this report, which presented a round number, since it was unclear whether exiles were

or were not counted. A post-Franco report speaks of a much lower figure, 640,000, calculated as follows: approximately 320,000 people killed while fighting; 220,000 dead of disease or malnutrition, and 100,000 murdered or executed.[209] Even those figures, however, seemed inaccurate.[210]

Tina Modotti was not among the dead but, in a way, she began to die that spring of 1939.

12 The Return of the Mexican *hija*

"The first morning I opened my eyes in our new home I did
not see the bare floors and walls nor the empty rooms. I saw
only the Mexican sky lit up by the rising sun and being turned
into a gem of many colors – colors of rubies and emeralds and
opals and topaz. I have had this same sensation every day since.
It has never failed me nor have I grown weary of it. I expect I
never shall."[1]

Evacuations from Spain for the republicans and their sympathizers had
become a necessity, even before the declaration of fascist victory. On
February 9, 1939 Modotti had left Spain for France, as said before. She
came with nothing but the dress she wore.[2] One of the last images we have
of her in Spain comes from the Mexican Fernando Gamboa, who spotted
her at sunset in a village near Figueras, sitting all alone in a café in "con-
templative mood."[3] She was actually waiting for Vidali on his way to that
village.

At the end of March Tina sailed for the United States on the *Queen Mary*.
She arrived in New York on April 6, and was immediately detained by the
U.S. immigration authorities for one week, unable even to meet her sister
Jolanda, who was then living in New York. While in transfer in the port of
New York, Tina heard of Franco's victory.[4] Although expected, the news hit
her while she was still "processing" and "interpreting" the role of the repub-
licans in the struggle. Spain was sold to the fascists, as Machado had written
back in 1937: Pienso en España vendida toda / de río a río, de monte a
monte, de mar a mar.[5] From New York Modotti sailed to Veracruz on the
Siboney and reached Mexico City by train at the end of April. An exhausted
Tina (and yet younger, according to her passport) returned to the country
that nine years before had expelled her. She traveled with a Spanish pass-
port, no. 239222, released on December 21, 1937 under the name of
Carmen Ruíz Sánchez, a Spanish citizen, widow, born in Seville on August
16, 1903, professor by occupation.[6] Vidali, who had traveled to Mexico
under the name of Carlos Contreras, professor of history, with a visa
obtained through David and Angelica Siqueiros,[7] was already in Mexico

when Tina arrived. He was equally exhausted – wounded, ill, and spiritually old, despite the fact that he was not yet 40.

Spanish exiles sought refuge in Cuba, the Dominican Republic, Argentina, Venezuela, and Chile (the family of Machado, who had died of pneumonia, went to Chile as exiles). But Mexico was the most hospitable country to those dislocated Spaniards, declaring that it would accept an unlimited number of refugees.[8] Between 1939 and 1942, 12,125 refugees were admitted, although the figures are not accurate because the government was not systematic in its census methods.[9] By 1949 the number of refugees reached around 18,000,[10] again a figure still in dispute among historians. Apart from the regional differences and inflexions, there was no language barrier for them in Mexico, which allowed many Spaniards to revive and reconstruct their professional, cultural, and artistic lives, especially in the capital.[11] Some of them even found positions in Mexican academia.

The same could not be said for the Spanish refugees who went to France or the Soviet Union, where their treatment was quite different unless they had the political stature of La Pasionaria.[12] Hierarchy was apparently an issue in the Soviet Union. The Soviets stated that they would grant the Military Star to the foreigners who had gone to Spain to fight from the Soviet Union but in fact granted it only to certain people.[13] It appears that France, although culturally much closer to Spain than the Soviet Union, did not make the exiles feel welcome, even refusing them the legal status of political refugees.[14] One account states that the French camps were "implacably harsh;"[15] another that "the French officials simply threw the food (one loaf of bread for four people a day) into the compound, as if it was corn for chickens."[16] Apparently, even the French leftists did not help the refugees. During a meeting organized by Red Aid in France in 1939, a French communist openly stated that the Spanish refugees should not ask for much since, after all, they had "lost the war."[17] To this insensitive statement, Modotti firmly replied that the defeat of the Spanish people was much more than a mere military defeat: it represented the defeat of all of the democratic and leftist forces against fascism. This interpretation is a leit-motif in the recollections of several Spanish refugees.[18]

Mexico received and absorbed the greatest number of refugees, giving them the opportunity "to live with dignity," and making them feel at home.[19] Thus they always felt "a deep gratitude toward Mexico,"[20] even though they thought that it was going to be a temporary displacement and one day they would return to Spain.[21] Even before the end of the Spanish Civil War, in July 1938, the Mexican president Lázaro Cárdenas had founded La Casa de España in Mexico City, which in 1940 became

El Colegio de México. The institution, described as "the meeting of the best of Mexico with the best of Spain," was directed by Alfonso Reyes (until his death in 1959), aided for ten years by Daniel Cosío Villegas.[22] At that time Cárdenas's wife, Amalia Solórzano, was leading the Aid Committee for Spanish Children and the school "Mexico-Spain" in the city of Morelia.[23] Cárdenas, a native of the state of Michoacán, was, *toute propor-tione gardée*, a multifaceted liberal with broad visions: he was known, for example, for having conducted his own presidential campaigns, traveling mostly on horseback to see the abject conditions under which the Indians lived.[24] A popular phrase created to perpetuate the Cárdenas myth claimed that when he was president, "it seemed as if Jesus Christ walked on earth."[25]

Moved by a genuine sense of justice, and feeling a certain similarity of ideals between the Spanish republicans and the self-inspired Mexican revolutionists, Cárdenas displayed a great sympathy for the Spanish exiles.[26] Known to be more dedicated to work than to words[27] and identified by Vidali as a "pure revolutionary" (*rivoluzionario integro*),[28] he went as far as offering the exiles the right of Mexican citizenship in January 1940.[29] In the eyes of many, the Cárdenas government and the social block created around the government party came to represent the popular front in Mexico,[30] ironically called by some "the government popular front."[31] For many people, the president himself embodied justice and the fight against dogmatism.[32] However, the most conservative and the ultra-Catholic sectors of the Mexican population, who already viewed Cárdenas as a radical traitor who had imported "exotic" ideologies aimed at destroying religion, did not support his decision, on the grounds that the Spanish refugees were anticlerical; that they would pose an economic problem and competition at work, and that they would interfere in local politics, even if requested not to. Moreover, since colonial times Spaniards had not been regarded in a friendly light by Mexicans, who referred to them as *gachupines*.[33]

But the exiles did not seem to be fully aware of this. Reading the account of a refugee, Carmen Romero, who also arrived in Mexico City via Veracruz, we become acquainted with the humane side of Mexico. On arrival in Veracruz by ship (the first was called *Sinaia*), each refugee was received by an official city commission and given 60 *pesos* to catch the train for the capital. Romero expresses her relief at hearing Spanish spoken again (although with a graceful Veracruz drawl), and her surprise at being told that on landing they did not have to pay for a meal, since they were "refugees who had just arrived."[34] Another account tells us of Milagros Latorre Piquer, who came from the Soviet Union via Dallas. When the refugees arrived in Dallas, the young girls of the group were placed in a Mexican convent where Milagros, in talking to other young ladies

there, had the chance to "defend the theory of Darwin as far as the creation of the world" was concerned – something of which her mother disapproved. But Milagros knew the art of compromise: the day after, she went to mass.[35]

Modotti's situation was evidently different, although she had also entered Mexico as a Spanish refugee. While Vidali was "recharging himself," walking around the main streets of the capital, elegantly dressed in English style with a briefcase in his hand,[36] Modotti did everything she could to pass unnoticed, given her precarious illegal status. Most of the people who met her in that period say that she seemed to live in a dissociated state, a passive observer of things around her. They found her rather opaque and different from the previously glamorous Tina – understandably so; events such as a fratricidal war can alter a character. For three years Modotti had witnessed people dying in front of her eyes, and death must have become a constant in her life. She herself said that she had seen "so many horrible things in Spain."[37] But apart from this reference to the war, she left no writings from that period, so I can only speculate about her feelings or rely on the impression of acquaintances. Another Spanish refugee reports a recurrent nightmare, "a large meadow with, at the center, a gravestone, which opened up showing a bloody hand."[38] In a different context, the Italian poet Salvatore Quasimodo left a lucid and vivid description of war:

> Scende la sera: ancora ci lasciate,
> o immagini care della terra, alberi,
> animali, povera gente chiusa
> dentro i mantelli dei soldati, madri
> dal ventre inaridito dalle lacrime.[39]

The Chilean Luis Enrique Délano wrote in 1979 that it was hard to fit the image of the revolutionary Tina with the person he met in Mexico in 1940, since she appeared pale, silent, distant, and almost absent.[40] Somebody else described her as "an old, poorly dressed woman, physically exhausted."[41] Apparently, in 1940 she still trembled while crossing Morelos Street, where Mella had fallen 11 years before.[42] Because of her Soviet years, she had also acquired a paranoid mentality, increased by her hiding and fighting in Spain. It must have been difficult to erase that from her mind and heart. Thus, finding some sort of equilibrium must have been an ordeal. However, Leni Kroul, who met Tina on May 1, 1939, speaks of her as a balanced person, capable of opening her heart to trustworthy people, and supportive in a time of a friend's grief – Kroul's husband, Alfons Goldschmidt, died suddenly in Mexico City in January 1940, and Tina was at her side for days to console her.[43]

By contrast, Vidali's photograph appeared in the newspaper *El Popular* on the occasion of a political meeting to commemorate the defense of Madrid. The meeting, held on Saturday, November 11, 1939 in the Hidalgo Theater, was sponsored by the Federation of former fighters of the Spanish republic, a so-called "ghost" organization, which included Siqueiros. Vidali was among the speakers.[44] In one of his sarcastic moods, Bertram Wolfe, who by 1940 had become the leader of the democratic anti-Stalinist party called Lovestonite, based in New York, wrote to a friend: "As to the dry cleaning establishment, Sormenti and Tina are known to us."[45] In another account, Modotti was described as somebody who had come back "very discreetly," like so many other refugees who "were capable of still acting as Stalinist agents."[46] And according to Gorkin in 1974, it was Margarita Nelken who provided Gorkin with a list of secret agents working in Mexico for the Soviets.[47] In 1941 he had written that Stalin had various "specialists" in each country; "in U.S. they are, among others, Jack Tolschen and Sultán; in Mexico the Italian Sormenti (Carlos C. Contreras) and Tina Modotti (María Ruiz); in Argentina Codovila (Medina)."[48] Some of these Soviet agents had various passports. Juan Andreu, for example, had a dozen professional identities – such as lawyer, businessman, medical doctor, writer – and at least five nationalities.[49] Anita Brenner described "a complex web of activities," and remarked on the role of Nelken and Modotti as "liaisons between Germany and Russia."[50]

If these people were known in Mexico in 1939 despite keeping a low profile, their activities as Comintern agents were not. Vidali's name has been insistently mentioned, as early as the 1950s, in association with Tresca's murder in 1943 in New York,[51] but nothing concrete has ever been proven.[52] Now it appears that Tresca was actually shot by the then unknown gangster Carmine "Lilo" Galante.[53] Modotti, who was also keeping a low profile, could not help being known to Mexicans, due to her story with Mella and her subsequent expulsion. Rivera himself, in an unsigned article, addressed the problem of the *agents provocateurs* in Stalin's service, who in 1939 entered Mexico among the real refugees, helped by "Mexican traitors." The painter identified by name Vidali, Ross, and Rosenberg, a "bunch of international outlaws, protected by their right of political asylum, ready to murder this country."[54] Probably because of their old friendship and camaraderie, Rivera left Modotti's name out of his list, although the contrary has been asserted.[55]

This comment by Rivera is revealing of the feeling felt by many Mexicans, even leftists, toward the refugees who still were or had been agents, whose situation was far from simple. First of all, there was the problem of their political status to be solved. Second was their financial

situation. After being the guest of a family in a small house in San Angel outside Mexico City[56] (whose "lady of the house" later became Vidali's wife), Tina and Vidali moved for a few months to a Morelos apartment, as guests of Adelina Zendejas. In winter 1940 Tina moved to a small apartment in Pedro Barranda Street, and by spring 1941 she had moved again into a tiny apartment, located on the fifth floor at 137 Calle Doctor Balmis, near the civil hospital[57] (which cost her 50 *pesos* a month). From it she could enjoy the panoramic view of the vulcanoes, the starry sky with purple dawns, and the Ciudad de los Palacios.[58] There she lived, on and off alone, until her death.

The place was so small that Vidali had the impression of entering the house of "Snow White and the seven dwarfs."[59] To make it even more crowded, Tina rescued a little white dog called Suzi (immortalized in a photograph), and, soon after, a cat invited herself as a guest. She was named Kitty.[60] If the fauna was complete (even in excess for such a small space), the flora was represented by a red carnation plant left by the previous tenant and by more carnations, white and red, planted later. The place was "so small indeed that it can barely contain her great spirit,"[61] but certainly did not lack character, since one account speaks of entering "a different world after walking through a run-down apartment building in a workers' section."[62]

For Modotti the financial problem became very difficult to solve, even though one would think that being part of a political community was already a guarantee of financial support. But Vidali states that they chose not to take advantage of the financial subsidies granted to those who had fought in Spain on the side of the republicans.[63] It was not for nothing that Modotti was described in this period as "aged and overwhelmed by poverty."[64] as if the war had left the María in her.[65] Also, she had become obsessed with her illegal immigrant status, threatened by the possibility of being recognized, although in 1941 Cárdenas annulled Tina's expulsion of 1930, thus defining her juridical status.[66] This was the outcome of several requests by Modotti's friends – Adelina Zendejas being one – who were determined to regulate her position in Mexico. In an official letter addressed to the minister of the Gobernación, Ignacio García Téllez, Tina indicated that, since her 1930 expulsion from Mexico had not been by presidential decree but by an administrative act, the case could speedily be settled, so she could move around freely and look for a job.[67] Zendejas recounted to Poniatowska that for the first visit to Téllez she loaned Tina a hat and a pair of gloves, which gave her the appearance of a grand dame and made her feel radiant.[68]

Yet, practical problems aside, something had profoundly changed in Modotti. In the years 1939–42 she remained loyal to communism, perhaps

even trying to recreate the revolutionary world she had encountered and loved before in Mexico. She even quarrelled with Paca Toor over her involvement in the Spanish Civil War, of which Toor disapproved.[69] But the original 1920s pre-Stalinist concept of communism, as Modotti had experienced it in her first years in Mexico, could not be recreated. By 1939 it had been altered, enlarged, and vitiated by Stalinism, whose sinister and brutal nature was not known to the world until 1956, three years after Stalin's death, when in a moment of rare historical significance Khrushchev denounced Stalin.[70] Ella Wolfe, in a 1991 interview, made a sharp distinction between the communists of the 1920s and the people who joined communism in the 1930s; the first group were innocent and the second were complicit in Stalin's purges.[71]

Perhaps Modotti felt compelled to choose between her former free and unconventional life and a disciplined, party-imposed life in a system that was anything but free. And that choice included a monogamous (although not mutually so) relationship. As quoted earlier, in 1931 she wrote to Weston from Moscow, in what appears to be her last letter to him, "I am living a completely new life, so much that I almost feel like a different person, but very interesting."[72] The price paid for that new life was the removal from her mind of a part of her past, and the acceptance of the inevitability of the crimes she encountered or heard about, and that she should not question the party's directions.[73] To all this we must add the fact that the communist movement had to cope with the non-aggression treaty (the Molotov-Ribbentrop Pact) that Stalin had signed with Hitler on August 23, 1939. Tina heard of this upon her return from New York, where she had gone under a false passport to explore the possibility of Vidali moving there permanently. According to Vidali's report, it was hard for her to understand such a pact, since on September 1 Germany invaded Poland.[74]

If Vidali was a revolutionary of wartime, Modotti was a revolutionary of peacetime. Vidali, as he himself admitted, could only fight[75] and clash with his enemies head on. For many Italian communists, he still represents the model of the old militant, like Teresa Noce, Arturo Colombo, and Velio Spano, just to mention three.[76] Above all, wrote Orwell, during the Spanish Civil War "there was a belief in the revolution and the future, a feeling of having suddenly emerged into an era of equality and freedom."[77] That feeling of being invincible had dissipated with the victory of the right-wing faction in Spain, despite the illusions of some of the revolutionaries, who always refused to believe that the Spanish left had been defeated, as La Pasionaria declared in one of her speeches.[78] The Cuban poet Nicolás Guillén, in a beautiful poem dedicated to her, brings up this point:

Que al pie del árbol caído,
paloma dile,
otro árbol crece y su tronco
de verde viste.[79]

Disillusion took the place of illusion. And many people "had every reason to have lost their faith in the virtue of civilization and progress."[80] Moreover, as was emphasized in an exile's memoir, one of the characteristics of exiles is the feeling that their identity has been lost, which is why memories become vital. If, for the exile in general, cultivating memory means much more than simple nostalgia, and if it is a true search to free one's interior world – where the person lives alone since there is virtually nobody who could reflect his past[81] – one wonders what pains and torments Tina experienced, for by 1939 her memories were fragmented, aborted, and mutilated.

What we know of Modotti's working life in that second Mexican period is that she occupied herself mainly with translations.[82] At the time of her death, she left two translations incomplete, an essay on Diderot by the philosopher Luppol, and an article by the Italian communist Mario Montagnana.[83] But something strange was happening to Tina. In contrast to many refugees from Spain, whose feelings of indifference and numbness experienced throughout the war were disappearing as they gradually settled down in Mexico,[84] Tina was becoming more and more anguished and unsettled. To many, she appeared resigned and hopeless. Was it because of her deteriorating health? Or because of her declining morale? Or because of her beliefs that were now questionable? Ironically, it seems that Stalinism succeeded in infusing a certain assurance in troubled souls who looked for a global and exhaustive explanation in a society in which they felt ill at ease.[85] This reassurance seems to have vanished in Tina. Not even a project dealing with photography could resurrect her spirit or, especially, initiate her own return to photography.[86]

In summer 1940 Tina was chosen by Constancia de la Mora, a Spaniard who was then living in Mexico as an exile, to assist two American photographers, John Condax and his wife Laura, in the creation of a series of prints for a book. The word "assist" echoes what Tina did for (and with) Weston in summer 1926 for Brenner's book, *Idols behind Altars*, except that then she was a photographer.

De la Mora's first book, *In Place of Splendor* (from which I quoted more than once in chapter eleven),[87] is a wonderful account of the rise of political awareness of a Spanish aristocrat who was raised in a very sheltered Catholic milieu. Gradually de la Mora learned about "the other" social classes and their wish for a political voice. Ultimately her quest transformed

itself into a solid anti-Franco ideology, and she gloriously embraced the republican cause.

Her second book, *Mexico is Ours* (whose publication, however, never materialized) was intended as a homage to Cárdenas's Mexico. Because of her linguistic expertise and her familiarity with Mexico in general, Modotti, who had met de la Mora during the Spanish Civil War, was indeed the appropriate choice for the project. But, although still fascinated by the beauty of the Mexican countryside, Tina could no longer bring herself to photograph, not even when she confessed to the Condaxes that once she had been a professional photographer and he offered to lend her his Graflex. Two years before publishing her biography on Modotti, Margaret Hooks was able to interview John Condax, who assured her that Tina had refused to return to photography.[88] It seems that an impasse was created between her and photography.

* * *

On May 24, 1940 the world was stunned by the first attempt on Trotsky's life, made in Mexico by a tragicomic human being, always in need of an audience, David Alfaro Siqueiros (codenamed Kone), who perceived communism as a garish melodrama and who "was animated by an exuberant ideological mix of art, revolution, Stalinism and exhibitionism."[89] The attempt was made with a truck, which supposedly belonged to Diego Rivera,[90] using a floor plan of Trotsky's villa on Calle Viena smuggled out by a Stalinist agent, Maria de la Sierra (code name Africa), who had been Trotsky's secretary in Norway.[91] Accomplices numbered about 20 communists (more or less of Stalinist faith), among whom were Luis and Leopoldo Arenal (Siqueiros's brothers-in-law), Antonio Pujol, Narciso Padilla, and Nestor Sanchez Hernández, a former captain of the International Brigade during the Spanish Civil War.[92]

According to some, Vidali, "whose record as a master of the art of assassination was well known among Spanish civil war veterans,"[93] and who was "another of the most formidable of the killers from Spain,"[94] was also involved in the attack. The information about Vidali's complicity is insistently repeated by various people, who unanimously claim that when Togliatti was informed of Vidali's involvement he shouted that "Vidali was ordered to have nothing to do with it."[95] The report, though, is always given at second or third hand through Jesús Hernández, who was supposedly with Togliatti in the Soviet Union when the details of the attempt reached Moscow. However, Hernández, in his major book (the original, thus not vitiated by translation) never mentions Vidali in relation to the first attempt on Trotsky's life or to Trotsky's actual murder, although the author does mention Togliatti several times in other contexts.[96] The

comment in question, attributed to Togliatti in 1940, is also not mentioned in one of the major biographies of Togliatti, written by an Italian journalist and historian, Giorgio Bocca, whose intellectual integrity has never been questioned among European intelligentsia and whose ideology has certainly always been far from Stalinism.[97]

Moreover, there is always the problem of the veracity of sources. An article on Modotti referring to Vidali asks: "How far can the words of an unrepentant Stalinist be trusted as historical evidence?"[98] The very same could be said about the "repentant" Stalinists. How reliable was Hernández, who broke with the Ibárruri leadership because of personal intrigues and only a few years later rewrote history, giving political justifications?[99] Perhaps what a Soviet Marxist historian wrote was not wrong: "it is communists who should be the strictest judges of their own history."[100] Years later Vidali not only dissociated himself completely from Trotsky's murder, blaming a "Trotskyite" Rivera for the allegation, but he also exposed Siqueiros's naiveté in the first attempt.[101] If his account of the event is reliable (although it was written in the 1980s), Vidali said that he had the distinct impression that in 1940s Mexico something inexplicably evil was going to happen, something that was premeditated and calculated long before he (and Tina) had returned in 1939.[102]

More recent research has produced other suspects. As reported in a Russian article, the same Iosif (Joseph) Romualdovich Grigulevich (then codenamed Maks and Felipe) who in 1937 was involved in Nín's murder, before dying confessed his crimes in an interview.[103] It also seems that the mastermind of Trotsky's murder was the secret police officer Leonid Alexandrovich Eitingon (one of the most celebrated Soviet womanizers), who was given "unlimited funds for the purpose"[104] and was later adorned with the prestigious Order of Lenin.[105] The most recent account points its finger at General Pavel Anatolievich Sudoplatov, who lives in Moscow on his government pension.[106]

In his autobiography, published in 1977, Siqueiros adopts a defensive mode when dealing with the Trotsky affair (which is inexplicably put between quotation marks, identifying it merely as an "*atentado*" (attempt). He devotes a whole chapter to the matter with the purpose of setting the stage for an ideological justification, despite his statement that "violent acts do not belong in Marxist doctrine."[107] In describing the event, Siqueiros builds up a drama that culminated in what he believes was the "logical" outcome, that is, the absolute elimination of a counterrevolutionary, only after – as he claimed – "having exhausted all other non-violent possibilities."

He uses an incident at the national congress of the Spanish Communist Party, during the Spanish Civil War, as motivation for his action. While delivering a speech in Valencia, which had become the headquarters of the

republican government, La Pasionaria mentioned the Soviet Union as the first revolutionary country to have aided Spain most in its bloody struggle against the nationalist forces. But, instead of honoring Mexico right after the Soviet Union, she praised Czechoslovakia. (However, in other sources she praised Mexico and its president for their "symbolic aid."[108]) This failure to mention Mexico, noted even by Margarita Nelken, hurt Siqueiros's pride and was interpreted by him and his peers as a tacit reproach of the Mexican government, headed by Cárdenas, for having allowed Trotsky political asylum in Mexico in 1937.[109] There is no doubt that Siqueiros was always keen to show (and boast about) Mexican participation in the Spanish Civil War. In a letter of 1938 sent from Spain to Cárdenas, Siqueiros informed the president with pride of the participation of various Mexicans in the war.[110] Cárdenas himself had already noted in January 1937 that in four months his government had sold almost $1,500,000 in armaments to the loyalists.[111] Since Mexico had not signed the Non-Intervention Pact it was able to send material legitimately to the Spanish government forces.[112] But it appears that Siqueiros's true motivation in the Trotsky affair was not especially ideological in origin. If Hooks is correct, immediately before May 1940 he had been reprimanded by the party for mishandling some funds. Thus he was eager to regain the party's respect with an impressive (and bombastic) gesture.

In the Trotsky circle a life attempt had not only been feared for a long time but also expected by everybody, including Trotsky himself. In the summer of 1938 the defector Alexandr Orlov, then living in the U.S.A., sent Trotsky anonymous letters warning him that his life was in danger because of an NKVD agent in Paris named Mark.[113] From the beginning, Trotsky's presence in Mexico had been regarded as an aggravation and a burden for the communist party,[114] which explains part of the estrangement felt by the communists toward Cárdenas. Attacks on Trotsky had become frequent in the press, which according to the Russian revolutionary was often the prelude to a gun attack. Only five days before the first attempt, on May 19, 1940 Trotsky had been identified by Stalinists as "the old traitor of the revolution" in an unsigned article, in which he was called *el puerco anciano de Coyoacán* (the old pig of Coyoacán). The words used in the article, always erroneously attributed to Lombardo Toledano, are vitriolic: Trotsky's behavior was antiworking-class, comparable to that of a buffoon, and even anti-Mexican. The article ends with the verdict that the workers had decided that Trotsky had to be expelled from the country.[115]

Despite recognizing that the attempt was a crime, Siqueiros basically explained it as merely an expression of discontent and "as virtually a spontaneous outburst of internationalists who had fought in Spain,"[116] relegating Trotsky to the category of traitors.[117] In so doing, willingly or

unwillingly, Siqueiros weakened the investigations. Even now, decades later, it is difficult to establish whether his statement on the attack was motivated by naiveté (as some thought),[118] real ignorance of Moscow's role in it (as Vidali suggested),[119] or by calculated act to distract the investigators and to gain wide popular support.

A month after the attack, the Mexican Communist Party issued a categorical statement in which it dissociated itself completely from the act, stressing that none of the participants in the attack were party members.[120] Seven years later, the same statement was made by Dionisio Encina, secretary of the Mexican Communist Party, reacting to an open letter published in Mexico by Trotsky's widow, Natalia Sedova.[121] In the same year, 1947, Siqueiros stressed his participation in the May 1940 attempt as an independent action and considered it "one of the most honorable acts" of his life.[122] (In 1972, two years before his death, he took a softer approach and confessed that when it came to the point he had been paralyzed by emotion, since before he had never faced the need to kill in cold blood.[123])

One thing is sure: Siqueiros and his men, all dressed in police uniforms (provided by Mateo Martinez at David Serrano Andonegui's request[124]), and with false moustaches, were more suited to shoot a low-budget mafia film than to kill a political enemy. Since "in Siqueiros art, revolution and gangsterism were inseparable,"[125] these theatrical moods and dramatic postures were to be expected. Real actions require serious behavior and a clear sense of combat. And apparently, despite his fighting experience in the Spanish war (especially in the battle of Jarama in February 1937[126]), and his posturing with guns and pistols, Siqueiros had no idea of how to organize and handle an attack. Not only did he and his *compañeros* badly miss the target, despite the three hundred shots fired and the seventy-three bullet holes counted in walls and doors, but he fled in fear to the countryside to elude the police investigations.[127] From that moment on, Siqueiros's name became inevitably linked to the attack, obscuring much of his artistic accomplishments and diminishing his otherwise uncontested painting and writing talent.[128]

There is no report as regards Modotti of specific repercussions of this attempt, but Siqueiros's involvement resulted in his alienation from people who had once been friends or on friendly terms with him, such as Anita Brenner, who found the affair "intolerable,"[129] especially in view of the fact that Trotsky's grandson, Seva, was wounded during the attack. Obviously, Siqueiros and his men had none of the hesitations of one of Camus's characters, the romantic Ivan Kaliayev, who in the play *Les Justes* (*The Just Assassins*) refuses to throw a bomb at the grand duke's carriage because there are children in it.

The second and tragically successful attempt on Trotsky's life (called in Soviet code "Operation Utka,"[130]) occurred on August 20, 1940 at the hands of the sinister Jaime Ramon Mercader del Rio Hernandez (codenamed Raymond), the son of Eustasia Maria Caridad Mercader (codenamed Mother), a Stalinist, Cuban by birth, Catalan by adoption, with close connections to the GPU. On August 22, *Pravda*, through its agency TASS, reported that "an attempt was made on the life of Trotsky, who has been living in Mexico." On August 24, *Pravda* casually reported that Trotsky had been buried.[131] The facts surrounding Trotsky's murder are by now well known and widely published, although a few details still remain obscure. The assassin – also known as Salvador Torkoff, Jacques Mornard, Frank Jackson, and Vandendreschd – skillfully managed to penetrate Trotsky's household through the French Trotkyist Alfred and Marguerite Rosmer and through Sylvia Ageloff, a Trotskyist from New York, who was present at the founding conference of the Fourth International in 1938.[132] Joseph Losey's 1972 film *The Assassination of Trotsky* focuses on the conflict of the assassin (played by a young Alain Delon).[133]

Again, nothing was revealed regarding Modotti's involvement or behavior in this tragic matter, in keeping with the official party line. However, a photograph taken of Trotsky's funeral procession in Mexico City on August 22 shows Modotti's style and technique,[134] although for part of that summer she was supposed to be away from the capital for de la Mora's project. (Also, curiously enough, after Vidali's death in 1983, the folder dealing with Trotsky's murder – numbered iii and called Trotsky's case – disappeared from his documents. This folder and others were destined by Vidali for the Gramsci Institute in Rome, as Laura Weiss, his last companion and editor, mentioned in a letter of January 25, 1986 to Fabrizio Zitelli of the Gramsci Institute.[135])

The world was stunned but not unprepared for Trotsky's death, which inspired a Mexican *corrido*, typically spontaneous and full of populist soul:

> Murió Trostky asesinado
> de la noche a la mañana
> porque habian premeditado
> venganza tarde o temprana.
> Fué un día mártes por la tarde
> esta tragedia fatal,
> que ha conmovído al país
> y a toda la capital.[136]

13 The End

At midnight
the finger of death touches my lip,
and stops my dying wish,
And I sleep forever
Never to awake
In the lake of oblivion.

Hsiung Hung[1]

Tina Modotti died alone in a taxi on Tuesday, January 6, 1942, in the same month in which Mella had died. When, 17 years before, the journalist José M. Peña had stated that, at her birth, Tina received gifts from the three Wise Men,[2] little did he know how tragic the day dedicated to the Feast of the Three Kings was going to be for her.

The reconstruction of her last hours reveals that in the evening of Monday, January 5, dressed in a black suit, Tina, although claiming she was not feeling well, had gone to a party given by the architect Hannes Mayer and his wife Lena. Around midnight Tina left the party in a state of distress, escorted outside by the painter Ignacio Aguirre. Then she took a taxi, requesting to be dropped off at home. As a point of reference, she gave the taxi driver, Federigo Trejo, the address of a hospital near her home. But she never reached her destination. She died around 1 a.m; Trejo, realizing that his passenger was gasping, had tried to take her to a nearby hospital, the Cruz Verte, where she arrived already dead, after being turned away from the General Hospital, which did not deal with emergency cases. Vidali, who had left the party before her to attend to some business at *El Popular*, was home reading by 1 a.m. when a police officer rang his bell to inform him of Tina's death. In another of his accounts, though, he said that while Tina was dying he was with Az Cárate.[3]

The official autopsy, performed by Dr. Armando Zárate, reports the cause of her death as cardiac arrest.[4] But it is common knowledge that in many cases autopsies prove to be inaccurate, sloppy, even directly or indirectly manipulated. Constantine reports Manuel Alvarez Bravo's suggestion that Modotti's death was caused by congestive failure, aggravated by

indigestion "after a heavy meal" and lack of prompt medical care.[5] Vidali reacted with surprise to this statement, since Tina ate practically nothing at the party (confirmed by the autopsy). According to Vidali, Tina ate her last real meal the day before the party.[6]

Modotti's sudden death, like her life, created a myriad hypotheses, which the press helped to perpetuate. In announcing her death, *Excelsior*, besides calling her Tina Modotti "Mundoni" (and Vidali, Carlos Jiménez Contreras, of Spanish nationality), continued along the same line as in 1929, this time presenting her as the mysterious Kremlin spy who gained some party merit through Mella's death.[7] To those accusations came the prompt response of some of her comrades and friends.[8] What appears evident from Modotti's second Mexican period is that she was frequently tired, haggard; her legs were frequently swollen, and she was in a state of perpetual exhaustion – a condition that the high altitude of Mexico worsened. Moreover, the campaign against Vidali that followed Trotsky's death in 1940 had been a severe blow, and the first seed of her failing health.[9] Constantine says that when she met Tina in 1941 she did not feel that "her silence was born either out of serenity or timidity, but that she seemed tragically tired."[10]

As far as her personal life was concerned, the information on her state of mind is conflicting. Some describe Tina as extremely sad. It is no secret that Vidali was gradually becoming emotionally involved with Isabel Carbajal, a Mexican woman (whose *nom de guerre* was Antonia Rosas),[11] who had been previously married to a Spaniard, Martín Díaz de Cossío, by whom she had two sons. Despite Vidali's statement that he felt "terribly Tina's death,"[12] he married Isabel only two months afterward, and in 1943 they had a son, Carlos. But events like that seem to have disturbed other people more than the two women in question, who, according to Carlos Vidali, were quite friendly with each other. (In fact it was Isabel Carbajal who at Vidali's request went to fetch Tina's body, since Vidali himself went into hiding for fear of being accused of murder.[13] And in 1975 Carbajal was asked to help organize an exhibition on Modotti.[14]) There is no doubt that all his life Vidali adored surrounding himself with women, for whom he became a lover, a mentor, a companion, and a comrade. This concept of a communal/communistic harem never left him. His macho pride must have been intrigued at seeing the two women quietly attending to chores for him, under the guise of antibourgeois camaraderie.[15] But what we should not do is judge Vidali's relationship with Modotti through the eyes of a restrictive modern feminism, which is often not only pretty bourgeois in spirit but also limited to a non-political vision, and thus tends to distort matters.

Also, the great physical love affair between Tina and Vidali that he professes in his books, usually identifying it as "generous, creative, and complete,"[16] could be (and I stress "could be") more fantasy than reality, or more a wishful thinking and a macho boasting than an actual fact. On one hand, claims of this sort, written when years and years have gone by and the person in question is no longer alive, must be read with great caution, but we cannot dismiss them altogether, as one biographer chooses to do, calling the statement categorically false. (The puritanical climate in which people live in the U.S. may have something to do with that choice; or, more likely, the strong antipathy that Modotti's biographers in general feel for Vidali as a person and particularly for his ideology – even though it was also Modotti's ideology.) On the other hand, sometimes the distance in time clarifies things and explains feelings. Moreover, it is thanks to Vidali that we have most of Modotti's photographs and some fragmentary sketches of her life. Thus, we must allow a certain historical (and human) revisionism, dictated more by emotions such as guilt and by a need to construct a self-image than by actual malice. And we have to accept at face value words such as "her beauty, her strong and mild personality raised in me a feeling which I had never experienced before," which Vidali wrote just before his death.[17] If others who knew Modotti had written a biography on her, they would probably have fallen into the same pattern.[18]

As far as Vidali's statements in general are concerned, I would use much greater caution when reading his praises of Togliatti,[19] and especially when reading his 1974 book on the Twentieth Congress of the Communist Party, held in Moscow in February 1956. There Vidali gives the impression at first of being more a spectator than a participant, and then of being much more critical of the Stalin leadership than he actually was during the congress.[20] It is difficult to determine when an account represents the party's voice and when it expresses a personal, authentic feeling.

As far as Tina is concerned, Vidali's book, *Ritratto di donna* (written at Piana, Piedmont, in the company of friends and comrades[21]), brought Modotti onto the Italian scene, and perhaps helped to ease his guilty conscience. The book was launched on April 26, 1982 at the Bookstore Rinascita in Udine and was well received by internationally known figures, as the correspondence to Vidali shows – the scientist Margherita Hack, who wrote from the *Osservatorio astronomico* in Trieste;[22] a militant from the Spanish Civil War, Manolo y Flores;[23] Tina's sister Jolanda;[24] the politician Giulio Andreotti;[25] the communist Angelo Emiliani;[26] the deputies Laura Diaz and Sergio Scarpa;[27] the composer Luigi Nono;[28] and the art historian and Modotti's first biographer, Mildred Constantine.[29] None of these

raised the issue of veracity, because they understood the background and the circumstances in which the book was written. Obviously, it is a "revised" account, probably even more than other historical accounts. But it achieved its purpose. It presents the Tina that Vidali wanted us to know, keeping another Tina for himself. If the information is correct, when Poniatowska interviewed Vidali, he presented Tina in another light, that is, a woman permanently available to anybody sexually and an intransigent and inflexible Stalinist comrade, which is not reflected in Vidali's writing on her.[30]

Nine years earlier, in 1973, Vidali had published *Tina Modotti garibaldina e artista* and received the congratulations of personalities such as the politician Giorgio Napolitano[31] and the conductor Gianfranco Gavazzeni, who addressed Vidali as *Illustre senatore.* In his letter Gavazzeni spoke of an "obscure and tormented period" in his life, adding that reading the book on Tina had given rise to many reflections.[32]

Having said all this about Vidali and Modotti, it seems true that in her last years their relationship became almost intolerable. The two lived in a constant state of tension: fights were frequent and intense, and words of reproach were uttered by both sides, although Vidali claims that they "never had a fight, only misunderstandings, which were promptly cleared."[33] It appears that at one point he reminded Tina that in Mexico she had the reputation of being a little whore.[34] (An anonymous source told me that Modotti had, in fact, acquired the reputation of a "loose" woman and that "she physically infected the whole Red Aid organization.") Anita Brenner years later stated that although Modotti was not a conventional woman she was not "loose" either.[35] And Germán List Arzubide has remembered that Tina always maintained her relationships discreetly as a free and cosmopolitan woman.[36]

As far as Vidali's sexist statement is concerned, nobody can say whether or not he really made it, but it indicates an incredible double standard for a man who had lived all his life outside any conventional parameters even to think of such a comment. However, anger (and machismo) can produce such effects and Vidali was known "to act macho" and to have a short temper[37] and a quick tongue. In his last book, which can be considered his spiritual testament and indeed his swansong, he melancholically stated of his last years with Tina: "We could have been happy, if in our lives the problems, the dramas, but also the small miseries of our political situation had not weighed so much."[38]

The statement has the ring of tragic fate. For both Tina and Vidali, as for many leftists, there was also the Spanish defeat to confront. After 1939, a self-defeating left was prostrated by a long and exhausting conflict, whose psychological implications were enormous. Those who spoke to Tina in her

last years remember that she frequently pondered the defeat and insistently asked where they were at fault or in which assessment they had been wrong.[39] Stalin himself was said to have been preoccupied with the tragic end of the Spanish war.[40] Moreover, the leftists who had participated in the war, and were now scattered around the world, were going through intense soul-searching. They could no longer look at the Soviet Union as their point of reference; news of manhunts and hasty trials (and consequently hasty executions) were coming from Moscow, and it was no longer possible to hide the Stalinist paranoia beneath an ideology.

At least for Tina, that must have meant the fragmentation of an entire world, for which more than once she had risked her life.[41] How could she – who had held her freedom dear in her early Mexican years – accept that her own comrades had become the victims of one of their own, the pre-varicator, who labelled them "enemies of the people"?[42] Perhaps Modotti came to realize after 1939 that it would have been far more productive for the left to struggle for a Spanish democratic republic with ample social content, instead of advocating the type of dictatorship of the proletariat that was embodied in Stalinism as the only feasible solution to political and social problems. That lack of unity in the left was counterproductive and resulted in political suicide.

Modotti's death as well as her life has, inevitably, a strong taste of tragedy. As a journalist wrote once, "making up Modotti rumors was a favorite pastime for some unidentified people, which seems like a little crime-wave in itself."[43] In 1929, during the Mella ordeal, the journalist Rafael Cardona wrote that drama was inevitable in her life, since she was born and would die bearing that mark.[44] Imogen Cunningham even thought that Tina had gone from the Soviet Union to Romania and been murdered there.[45] Doubts and questions remain unanswered, especially since the end was quick, unexpected, and controversial. But in order to make allegations we must have the facts. The main question remains: was Tina Modotti killed? Some people, more zealous to attack an ideology than perceive the truth, seem to have no doubts about that.[46] If this is the case – if she was indeed "eliminated" – who did it and why?

In Gorkin's book on Trotsky's murder he states that before dying Modotti confessed to some intimate women friends that Contreras was "a danger-ous assassin."[47] The French edition of the book, published nine years later, reduces the intimate women friends to one single "intimate [male] friend."[48] The statement in itself, though, does not prove much since it could refer to the role that Contreras/Vidali played in the Spanish Civil War. Gorkin also reports that "the delicate and romantic figure" of Tina, remembering a fight between Vidali and General Valentín Gonzáles (called

El Campesino), told Gonzáles: "You should have killed him then. It would have been a good deed. He is an assassin. He dragged me into an atrocious murder. I detest him with all my soul. Nevertheless I must follow him until death."[49] Again, in the French edition, the sentence, "He dragged me into an atrocious murder," is missing.[50] Something crucial must have happened between 1961 and 1970 to convince Gorkin that Modotti did not after all utter those words, or that Vidali did not after all drag Tina into any crime. When reading these statements, it is important to remember that Gorkin and Vidali were enemies, and became more so after Tresca's murder in January 1943.[51] In an article written a few days after Modotti's death, a Mexican journalist stated that "she carried a secret with her to her grave," without being specific about it.[52] Most biographers have interpreted this as referring to Mella's murder, but it is difficult to believe that now, given the plethora of information on Mella's murder.

Neruda, who was the Chilean consul general in Mexico when Tina died, reports that he saw Vidali suffering like a lion bleeding in front of her little corpse, while parts of the press filled its pages with filthy stories. For them Tina had become "the mysterious Moscow woman," and she had died "because she knew too much."[53] Of what terrible secrets had Tina become the bearer? After all, her loyalty to the party had never been questioned, despite the fact that after 1939 she did not renew her membership – she noted a possible conflict with her political refugee status in Mexico.[54] She may at times have disagreed with the party and Stalinists in general were capable of "quickly disposing of people," yet we still cannot state unequivocally that Modotti's death was a murder, as even the Trotskyists claim, unless there is concrete proof.

It is too simple to accuse the Stalinists of her death, but it is also too convenient just to blame it on her health or suggest the possibility of suicide.[55] In 1976 or 1977, shortly before his own death, Bertram Wolfe wrote a couple of paragraphs about Modotti's death, which he attributes to "poisoning by the agents of the G.P.U., led by Sormenti (Vidali-Carlos), the finger-man for Stalin in Spain."[56] Apart from the fact that by then Wolfe's memory was no longer efficient or accurate, as far as dates are concerned he dated Tina's death to 1943, and his own statement as being made in October 1977, when he himself was no longer alive. Nor is his claim that "Tina Modotti broke with Stalinism" supported by any evidence. This statement sounds, rather, like an interpretation or an expression of Wolfe's own political path, projected into Modotti's life.[57]

Nobody has attempted to suggest that Tina could have been assassinated under a pact between the American and Mexican secret services. After all, the extreme right wing was active in Mexico in that period,[58] when other

mysterious deaths occurred – W. J. Cash's being one.[59] Thus, we should not totally discard this hypothesis, even though a real motive escapes us. It would not be the first time that the F.B.I. and the Soviet secret service were involved in an operation together. Alan Gelfand, a Trotskyist and member of the Socialist Workers Party, stated that in the case of Trotsky's assassination the NKVD was, in some indirect way, linked to the F.B.I., or at least some of the Soviet operatives were double agents. Sylvia Franklin (alias Callen, alias Caldwell, alias Doxsee), an American communist and Soviet agent, also worked for the F.B.I. in the 1940s. In fact, she was protected by Joseph Hansen, once a secretary of Trotsky.[60] Thus, determining, or even attempting to determine, the truth is extremely difficult.

All of his life, Vidali was fully aware of the allegations and suspicions made against him regarding Tina's death.[61] But as soon as she died he went into hibernation for a short period. Then in October 1948 (when he had permanently returned to Italy), he felt he had to respond openly to a vitriolic article that had appeared in *Time* magazine in September 1948, accusing him of all sorts of crimes.[62] Vidali's response, published in *L'unità del popolo*, a self-described Italian-American Progressive Bilingual Weekly, was called "Il record delle bugie" (The Record of Lies).[63] He clarified a few erroneous points, among which was the accusation that in a fight against the Yugoslav leader, Tito, Italians from Trieste (communist and non-communist) "went on an anti-Slav rampage, removing Slav names from streets, trams, crossroad signs." (He was referring to his conflict with Tito, which produced a fracture in the party, identified as the famous *colpo di bora* (the icy blast of the Trieste wind). Vidali also touched upon Modotti's death, which he said occurred in a car and was caused "by a heart attack, following a visit to the family of the former Spanish ambassador, Azcarate's brother." (This obviously does not concur with the information released earlier.) And he stated that "Tina Modotti was not my mistress, but my wife."

Two weeks after Vidali's article, another very short (10-line) article appeared on the front page of the same paper, signed by Tina's brother Benvenuto.[64] He stated that his sister had been seriously ill from a heart condition, discrediting any further speculations about murder. He reported his last meeting with Tina, when she told him, "Goodbye, forever. I am practically already dead. It will be impossible for me to survive in Mexico." She was probably referring to Mexico's high altitude, which would be detrimental to her heart. Benvenuto ended this telegraphic article with the statement that, although this was the truth about his sister's death, he nevertheless did not share Vidali's political views.

People who had close contacts with Vidali until his death told me that he used to tease himself about Tina's sudden death with Tina's sister

Mercedes, who in the 1950s worked in the Vidali household as a governess.[65] It is unlikely that one who is guilty of a crime would joke about it, especially with members of the family of the supposed victim. But this still does not clear any political group (right or left) of the accusations. It only in part clears Vittorio Vidali. In her will, written on January 9, 1965, Mercedes (or Margherita) Modotti requested that, among other things, a sealed leather briefcase be given to "senator" Vidali.[66] Four years after Tina's death Mercedes wrote to Weston expressing surprise about Tina's heart trouble and anguish at her sister's unexpected demise. However, she added, referring to the Spanish Civil War, it was "like a miracle to have gone through this infernal war and have come out of it alive."[67] In the letter, there is no suggestion at all that foul play was suspected by any members of the Modotti household. Was this because they trusted Vidali totally? Or was it because Tina herself never mentioned any health problem to her family, from whom she lived apart for the majority of her adult life?

* * *

Finally, on January 7 the corpse of an emotionally charged Tina, wrapped in a white shroud, was put to rest in a large coffin,[68] almost too big for her small body. The expression of her face appeared serene, as if she were sleeping. A memorial event was held on February 23, 1942 at the Teatro del Pueblo. People from all over the world who had met her and respected her work as a social photographer and political activist dedicated eulogies and poems to her, later gathered in a memorial book.[69] Among them were Juan Marinello, the Cuban writer, who met Modotti in Spain; the Italian communist Mario Montagnana; Luz Ardizana; Hilde Rosenfeld; Margarita Nelken, who wrote that people should be inspired by her example;[70] Adelina Zendejas; Salvador de la Plaza, from Venezuela; Paul (or Pablo) O'Higgins; Anna Seghers, a German writer; María Luisa Carnelli; Simone Téry; Cruz Díaz and Luis Zapirain, respectively leader and former secretary of Spanish Red Aid; and, naturally, Edward Weston, who wrote, "Any superlative employed to refer to Tina's character and beauty, would not be adequate. Thus I will limit myself to salute her memory."[71] Vidali published a eulogy that began "She died without seeing the splendid dawn."[72] Neruda composed a poem, "Tina Modotti ha muerto" (Tina Modotti has died), part of which was engraved as an epitaph on her tombstone. His lines inspired the titles of four books on Modotti.[73] The poem begins: "hermana, no duermes, no, no duermes" ("sister, you are not sleeping, no, you are not sleeping"), and ends: "Porque el fuego no muere" ("Because the fire will not be extinguished").

Considered by Mexicans as part of their country,[74] Tina is buried in Mexico City, where she truly belongs, at the Panteón de Dolores. Her tomb is located at lot no. 5, *linéa* no. 28, *sepultura* no. 26. The bas-relief on her grave is from a drawing by Leopoldo Méndez, leader of the Veracruz section of the Anti-Imperialist League.[75] With time it has aged and deteriorated, a concern for people who were devoted to her. Vidali was aware of this fact, reported to him also by a Mexican, Paco Bolea, as late as 1979.[76]

The left mourned a comrade. The nondenominational press preferred to be silent. Even *L'Italia*, where Tina had been mentioned several times as an actress, chose to ignore her departure from the world. The only reference to Mexico in *L'Italia* during that period is the news that Mexico had broken off diplomatic relations with the Balkan states.[77] The Udine police head-quarters apparently did not even know about her death, for in a report dated April 22, 1942 the prefect, Mr. Chiariotti, states that Tina Modotti "resides abroad in an unknown place, and she is in contact with her sister Gioconda, who lives in Trieste."[78] Her vicissitudes, especially the political ones, had obviously made Modotti "an uneasy character" to deal with, on both continents. She was rarely mentioned as a photographer until the 1970s, and even then, with rare exceptions,[79] only in a certain context, which practically neglected her ideology. As an Italian immigrant to the U.S. she was totally ignored, although much less significant Italian immigrants were mentioned, as has been noted.[80]

Modotti's photographic legacy lived on. Only two months after her death, in March 1942, on the initiative of Tina's friends an exhibition of 50 of her photographs was held in the Galeria del Arte Moderno in Mexico City.[81] The exhibit, under the direction of Ines Amor, was organized by the Mexican painter María Izquierdo, the writer Egon Erwin Kisch, and the photographers Manuel and Lola Alvarez Bravo.

Over the years, people came to recognize the vacuum Tina had left. Vidali himself admitted that he appreciated her much more after she was gone, when he realized what she really meant to people.[82] And on January 6, 1976 he wrote a few verses in Spanish to honor the thirty-fourth anniversary of her death:

Muy pronto llegará el día que tu soñaste
y los españoles saliran rumbo sus tierras soleadas y valientes
que tu quisiste tanto.
Y se llevaran la lápida que hoy
cubre tu tumba sencilla donde estan esculpidas las
palabras de oro de nuestro Pablo.[83]

Tina Modotti lived an extraordinary life, between art and revolution. Once she fully embraced her political call, she indeed lived more for the people than for herself, fully practicing what Machado had written a few years before: "La única moneda con la cual podemos pagar lo que debemos a nuestro pueblo, es la vida" ("Life is the only form of money with which we can pay what we owe to our people").[84]

Conclusion

"Yo quiero no olvidar todo lo que hoy sé. Que otros hagan la
Historia y cuenten lo que quieran; lo que yo quiero es no
olvidar, y como nuestra capacidad de olvido lo digiere todo, lo
tritura todo, lo que hoy sé quiero sujetarlo en este papel."[1]

Biographers, especially art historians, seem to be in disagreement when it
comes to deciding whether or not Modotti stopped making photographs
once she was totally committed to politics – meaning, more or less from
fall 1930 to her death. Once in a while a photograph attributed to her
emerges and conflicting opinions start up again. Did Modotti's photo-
graphic vein at one point become arid, or is it just that her work became
lost during all her moving about and escaping? Since everything is possi-
ble, I have no reason to believe that I am the sole recipient of the truth,
but I can offer some thoughts on the subject.

Since photography for Modotti was a huge part of her political luggage,
at first it is hard to believe that she had indeed abandoned that part of her
life, because it was indivisible from her political work. This is the theory of
those who seem to be disturbed by the fact that Modotti made a political
choice that excluded photography. Therefore, in order to mitigate her com-
mitment to politics, they claim that there are several photographs taken by
Tina during her political prime, that have been lost. Those who believe in
this theory want to find more photographs, so they can fight more among
themselves.

It is hard to conceive of a completely committed political activist (such
as Modotti became after 1930), who could find the time and the energy,
for example during the Spanish Civil War, to develop photographs while
attending moribund people. Politics had become the center and the
meaning of her life, and photography (even politically committed photo-
graphy) was inevitably considered an aesthetic luxury. There was neither
time nor space for anything else than political work, which took the form
of comforting, healing, listening – anything but contemplating. Indeed, the
time had come to "live other battles in the European inferno."[2] If one
report is accurate, during the Spanish war, when asked why she no longer

photographed, Modotti replied that it was impossible to do "two jobs well."[3] In Moscow in 1932, when the photographer Lotte Jacobi asked her about her "desertion," she replied with the same statement.[4] And yet in 1937 she was named as a photographer in the first journal on photography published in Mexico.[5]

Moreover, one needs motivation to create a picture. It seems that Tina had lost her verve and most of that motivation.[6] It is not uncommon for an artist who has received a powerful shock (such as a war) to lose her creative spirit. If we read the last paragraph of an American artist who participated in the same war only as an outsider, perhaps we can understand Tina's mood better: "I will always remember the eyes of the women and children of Barcelona; the eyes of the prisoners in concentration camps. And this dazed, frantic stare in the eyes of the French. Really, I am beginning to wonder if I will ever paint again . . ."[7]

A contemporary photographer whom I greatly admire, Danny Lyon, at one point in his career chose to stand back from his art, saying that when he was 25 he had "wanted to know what the subjects had to say." Later he had become more interested in what he had to say.[8] Perhaps the same happened to Modotti the photographer and artist. After 1930, politics had taken the upper hand in her life. It is not that in Moscow her photographic voice had become silent or sterile because she was regulated by others. It is not that she had forgotten how to see things and people from the photographer's angle; she was seeing people through another lens. She had passed from a linguistic to a visual/ideological legacy, in order to reach a selfless state. Art – that is, photography – was no longer the most immediate vehicle to revolution. Revolution itself was its own vehicle. In practice this meant a complete and total militancy. But, again, Modotti had not forgotten how to look through the lens. Practically, she did what Henri Cartier Bresson still does, and will do until death: photograph *without* a camera.[9]

Another theory suggests that Tina was an artist "who could not bring herself to compromise her art" and that she was unwilling to "sacrifice the artistic standard her best work upheld."[10] During her years of production, her camera, just like her soul and mind, became impregnated with the richness of the Mexican landscape and people, and she continued to take mental photographs, even when she was no longer photographing. After 1931, her former desire to take photographs was not urgent enough to demand that she express it through a visual medium. However, she still considered photography her profession, as she herself stated in Moscow.[11] But the images, even those not selected to be printed, stayed with her, and

grew by themselves with the years. They kept her company in the moments of loneliness and desperation.

Moreover, all the information points to Modotti's state of mind while taking photographs. She produced her most significant work when she was (or had been, as she was in the case of Mella's story) if not happy, at least sentimentally serene, as in summer 1929. Her scanty photographic body of work – scanty because only a small number of her prints exist – even the most melancholy in terms of subject matter, represents her self so much that it is transparent. I believe that that was her condition of being a committed photographer. From the available documents it appears that after 1930 Tina Modotti was no longer "happy," in the way we commonly use that adjective. Once she left Mexico, she could no longer aspire to happiness. Her doubts about the political system she had embraced were troubling her; the fratricidal war in Spain showed her the fragility and fragmentation of the left; and her relationship with Vidali had always been ambiguous and problematic. The malaise from which Tina was believed to suffer after her return to Mexico in 1939 was probably not imaginary.

Was this the same woman who had once danced naked, free as a bird, on the roof of a Mexican house? Was this the woman described by Weston in his diary? The one who broke the rigid sexual rules and codes of the time? Not at all. She had become Tina the Stalinist comrade, Tina the Comintern member. The price to pay for her transformation was high, and it included sacrificing the art of photography. That is probably the reason why, when she left the Soviet Union for Spain, her pictures and her photographic tools stayed in Moscow. Neruda wrote in his memoirs that Tina, once she became totally involved in her politics, threw her camera into a Moscow river and made a pledge exclusively to the party.[12] However, for the sake of accuracy, I must say that I saw at least two photographs taken during the Spanish Civil War that bear all the hallmarks of Tina Modotti's style. One is on a cover page of a Spanish magazine, published in Valencia; it represents a car crushed on one side.[13] The other depicts a truck that had been bombed, with a hospital in the background.[14]

In a 1992 interview in Paris, the son of a Friulano antifascist exile, Angelo Masutti (who in 1932 had been 17 years old and in Moscow with his family) reconfirmed that, because of his growing interest in photography, Tina had lent him her camera (a Leica) for four years, when she left Moscow.[15] In Vidali's account we are told that Modotti left her camera and her photographs with the Regent family.[16] After the Second World War, in 1947, when Vidali returned to Moscow, he was able to recover both Tina's photographs and equipment.[17] And, thanks to Vidali's then teenage Russian

daughter Bianca, more pictures were recovered when she went to Trieste from Moscow after the war, bringing with her a gray folder tied with a red ribbon full of Tina's photographs.[18]

* * *

Several filmmakers have expressed an interest in making a film on Modotti but nothing so far has materialized. The Italian director Lina Wertmüller had wanted to in the late 1970s.[19] In the 1990s, the European actress who seemed destined to play Modotti was the Italian Francesca Neri.[20] In March 2000, on Women's Day, the actress once again expressed her desire to interpret Modotti, whose story, letters, and films she finds fascinating.[21] In 1996 an American project was rumored to include the American singer Madonna in the role.[22] According to her press agent, Liz Rosenberg, the rock star has "always been a Modotti fan."[23] One can easily see why. Tina Modotti was a glamorous human being, conducive to the creation of a glamorous film script.

In fall 1997 a well-known Italian women's magazine published a photographic fashion essay in black and white, entitled *Pensando a una donna* (Thinking of a woman), inspired by the photographs of and by Modotti.[24] The famous print of the roses is also reproduced on the label of Susie Tompkins, the co-founder of the fashion company Esprit, who paid $165,000 for the print.[25] And the exhibitions of pictures by Tina and on Tina are constantly presented all over the world. Not only that, Modotti inspired a Mexican playwright, Víctor Hugo Rascón, to write a play, *Tina Modotti*,[26] and an Italian composer, Andrea Centazzo, to compose an opera (or a "multimedia work," as it is called), *Tina*.[27] Thus, the interest and the myth continue and grow.

* * *

And that is the story of a human being who was not afraid to live, not afraid to love, and not afraid to die – and she encountered death closely several times. Finally, in that winter of 1942 Tina Modotti was peacefully put to rest, as her companion and comrade Julio Antonio Mella had written, quoting Saint Just: "the revolutionary does not have much rest but in the grave."[28]

Postscript: Letter to Tina Modotti

Dear Tina,

At the close of my project, I feel the need to address a letter to you, since I have been troubled by your persona, your image, your connotations, by the myth created by both men and women around you, and so on.

You have kept me company for several years now – it seems to me that I started working on this project centuries ago! – and you have shown me what real commitment to a cause is – for that, I thank you dearly – while the world of academia failed to do so, devoting excessive time and energy to petty political games, posturing, and hair splitting. I thought of that when I saw a mural by Orozco representing some skeletons in academic garb presiding over the birth of "useless knowledge."

However, I cannot say that I have not hated you for the myth you have become – mainly because of the egos of others. Was it your intention to be mythologized? Absolutely not, I am convinced. You became what others wanted you to be, and they understood you only on their own terms. You, with your belief in communism, have, ironically, become an instrument and an icon for the anticommunists, since they use you for their attacks on Marxism in general, but from an unusual angle, that of a kind of progressive liberalism, which is only a cover. And, by the same token, they appoint themselves the nemeses of justice. Frankly, I have never understood the exaggerated interest generated by your persona among the middle-class petty bourgeois. There is absolutely nothing that you have in common with them.

The last remnants of Stalinism stress your political commitment, and try as much as they can to prove your hard line and your dissociation from any other political faith. Anarchists, in contrast, tend to emphasize your broad political visions and even to hint at your supposed anarchist faith, which, however, they have never proven. Pseudo-feminists, insisting that you cannot be defined by men, stress your independence and your drive to do what was impossible for women in that period. And yet, it seems to me, you relied heavily on men's judgments about your photography, for example, as well as in your political commitment – which is perfectly understandable.

It is tragicomic to read about your generous sharing (typical of your spirit) and yet do just the opposite with the information we glean from history's granary of memoirs, personal accounts, and private interviews and documents. Since individualism and competitiveness were not, to my knowledge, the hallmarks of your soul, perhaps we "Tinologists" should meditate a little on this point, to learn better the art of giving.

When it comes to your personal life, however, Tina, you are a dismally negative model, if we measure it by modern, Californian standards. *Hélas*, Tina, with your turbulent and gypsy life, you could almost serve as a counter-example of puritanical values in manuals on "how to live an unhealthy and perverted life." Thus we must remember *not* to do any of the things you did – smoke, drink, eat high-cholesterol food, have wild sex (one biographer even feels qualified to speak of your "ardent eroticism in lovemaking"). Most of all, we must remember not to become leftists, and not to associate with communists such as Vidali. It is not safe for one's heart.

Tina, Tina, Tina, where am I going to place you in my mind? And where in my heart? It is so difficult to find clear, precise answers to these questions. I do not intend to live with you forever, and – contrary to what one of the participants in a conference on you told me once – I shall go on with my life absolutely *without* you. But parting, like ending a love affair, is not easy. After all, we are told that Bob Dylan was troubled by and fascinated with the question of how to end a songbook, a concert, an interview, an album. And was "therefore fascinated by an unending."[1]

Several people have monopolized and manipulated your persona to serve their own beliefs. Several people have tried to put into your mouth words of justice, because that served their own purpose. Toward the end of your life, you are supposed to have declared that your last companion was a criminal and a murderer. Was that simply an easy way to "clear" your image, and make you more appealing and more human to the world? Perhaps. We shall never know whether or not you made those statements. But it is convenient for some to believe that you did. It makes you more "palatable," and, ultimately, a better icon (a retired senior C.I.A. official even defines you "in the strict sense of the term, a lady."[2] While Weston wrote that you were a woman "who has sold herself to rich men and given herself to poor"[3]). However, putting words in your mouth (besides being an unethical act for an historian) is equivalent to imposing exactly the discursive regime some detest and oppose. Thus, we merely have a "change of guards," not of regimes, which is far more deceptive than the detested Stalinism. Also, what makes us believe we are in the right, choosing one side over the

other? And can we categorically dismiss the historians who are also ideo-
logues, treating them merely as manipulators of truth?[4]

Your words, Tina, in your letters to Edward Weston, are often com-
pelling, passionate, rational, and also reveal a frightened woman – all at the
same time. While the Mexican authorities were expelling you from Mexico,
you had the composure to write to Weston that the accusations were false,
as they were. It seems that you still cared about men's judgments – Weston's
in particular. This dualism of relying on men while being independent from
them is what makes me feel closest to you. At times you were the mistress;
at times you were the comrade; at times you were only a poor, lonely soul
in search of an identity.

You were, for the most part, a caring person from the left. Yet you were
at times despicable, both in your words and in your actions. Was that a
compassionate act, stealing a man from another woman? Was that anti-
semitic slur[5] that you wrote to Weston an indication of a larger problem in
you? Not to mention such statements as "as far as creation is concerned
(outside the creation of species) women are negative – They are too petty
and lack power of concentration . . ."[6] In fact you yourself were the living
proof of the statement's inaccuracy. Or did you consider yourself an excep-
tion? I feel we shall never penetrate that aspect of your personality or char-
acter adequately, at least not until we acquire more precise (and reliable)
information, or until science succeeds in resurrecting you, so I can finally
meet you – and ask how you managed to pack your luggage so quickly and
so many times in your life!

Did I treat you appropriately, with all due respect and honest judgment?
I am sure the critics will find in my work ideological errors, inaccuracies in
the discussion of photography, and will come up with a long list of sug-
gestions and improvements, the first, perhaps, that I gave too much space
to Vidali. Some people live for those moments in which ideas become
objects to be shifted here and there to massage their mandarin egos, as
Hayden White used to say. Since I am an irreverent soul, with a Voltairean
disrespect for institutions, I may even be a bit amused by those negative
comments which, like many attacks, will ultimately say more about the
"attackers" than about the "victim." And since I share the theory of the his-
torian Eric Hobsbawm that, for the most part, Americans tend constantly
to look in history for their own identity, I expect to see more "identities"
appearing on the horizon and on the bookshelves.

The main problem remains: did I do justice to you and your persona?
Or did I read you in the only (bourgeois) way I was able to, projecting the
Tina Modotti that I have pre-constructed in my mind? Only you can

answer that question. Nobody else. Not even the people you met and with whom you interacted in your short life.

But, for the company you have given me, often saving me from a life that at times is rather dull (because of the anti-intellectual shift in our profession), I must profoundly thank you. Also, you have given me the chance to see that it is possible to be committed on various fronts – professionally, artistically, and ideologically – and that one is not incompatible with another. That in itself is a gift, and it is the best example I have drawn from you. I truly hope that, at last, the serious leftists will start paying attention to you as a revolutionary, just as the petty bourgeois world will find another icon to venerate.

I always thought that fate was unfair to you, Tina. You lost your life so young that there had to be a reason for it. Now I know why you, Tina Modotti, lived so intensely: you had little time and much to accomplish!

Un abbraccio forte forte,
Letizia

Notes

Preface

1 Andrew Burstein, "The Problem of Jefferson Biography," *VQR* (*The Virginia Quarterly Review*), vol. 70, no. 3, Summer 1994, p. 411.

2 Corrado Augias, "Adelante Tina la pasionaria," *Televenerdì di Repubblica*, 17–23 March 1995, p. 141.

3 The Friulanos, just like the Sicilians, consider themselves as belonging to a completely different culture from the Italians. They take pride, for example, in showing that the Friulano tongue is not a dialect but a language. In January 1947 the Movimento Popolare Friulano (Popular Friulano Movement) was founded in Udine to "unite, above any political party, all the forces of those who see in the regional autonomies the only guarantee of democratic freedom." The writer and film director Pier Paolo Pasolini (1922–75), whose mother was a schoolteacher from Friuli, was among the promoters. Although originally a native of Emilia, Pasolini always considered himself a Friulano, and fought to have the Friulano language adopted in school. In order to do so, he had to reconcile in his mind federalism and Marxism, despite the Italian Communist Party's (PCI) reluctance to embrace regionalism. Pasolini later abandoned the movement to continue his struggle from inside the party, stating that in an autonomous movement there was "too much tendency to sentimentalism." Roberto Iacovissi, "Pasolini, Tessitori e il futuro dell'autonomismo friulano," *La Panarie: Rivista friulana*, xxv, no. 99, April–December 1993, pp. 27–37. Pier Paolo Pasolini,

"Il Friuli e il Movimento Popolare Friulano," *Il mattino del popolo*, February 28, 1948.

4 Nunzio Pernicone, "Sacco e Vanzetti: The Case That Will Not Die." *La parola del popolo*, LXX, vol. 29, no. 147, November–December 1978, pp. 70–72.

5 The book is Antonio Saborit, *Una mujer sin país: Las cartas de Tina Modotti a Edward Weston 1921–1931* (Mexico City: Cal y Arena, 1992), whose cover shows an Otis Oldfield nude painting of 1933. The issue was also brought up by Amy Conger, who calls this choice "a tasteless attempt to exploit Tina's popularity." Amy Conger, "Tina Modotti: A Methodology, A Proposal and A Lost Love Letter," in Riccardo Toffoletti, ed., *Tina Modotti: Una vita nella storia* (Udine: Arti Grafiche Friulane, 1995), p. 280.

6 Bárbara Mujica, *frida: A Novel* (Woodstock and New York: Overlook Press, 2001), p. 207.

7 Amy Stark, ed., *The Letters from Tina Modotti to Edward Weston*, in *The Archive*, no. 22, January 1986 (Tucson: Center for Creative Photography, 1986), p. 30.

8 Simon Schama, "Clio at the Multiplex," *The New Yorker*, January 19, 1998, p. 39.

9 Ibid., p. 40.

1 Udine

1 To be far from you, Friuli, already means to be unknown. The time of our love seems a sea, shining and dead. "Pier Paolo Pasolini, *Conzeit*, 1952, cited in *Perimmagine* (Udine), Autumn 1994.

2 Arthur James Whyte, *The Evolution of Modern Italy* (Oxford: B. Blackwell, 1950), p. 202.

3 See Gianfranco Ellero, *Tina Modotti in Carinzia e in Friuli* (Pordenone: Cinemazero, 1996), p. 5.

4 *Il secolo*, May 25, 1892, cited in ibid., pp. 7–11.

5 Ibid., p. 131.

6 Ibid., pp. 52–53.

7 Christiane Barckhausen-Canale, *Verdad y leyenda de Tina Modotti* (Havana: Casa de las Américas, 1989), p. 20.

8 Antonio Anastasio Rossi was the Udine archbishop who administered Tina the confirmation on May 22, 1913 in St. Anthony Church. Ellero, *Tina Modotti*, p. 56. A copy of the document is printed in Ellero, p. 92 (it is written in Latin, including the name of Tina's father, which becomes Iosephi, meaning Giuseppe's).

9 Demetrio Canal, *Pensieri socialisti* (Udine, 1892), pp. 4–5.

10 Luigi Pignat (1862–1915) was an excellent portrait photographer, as the many pictures taken by him and kept in the Museo Civico, Udine testify. Giuseppe Bergamini and Cristina Donazzolo Cristante, eds., *1 Pignat fotografi in Udine* (Udine: Arti Grafiche Friulane, 1995). Giuseppe Bergamini, *Lo Studio Pignat* (Udine: Ribis edizioni, 1992).

11 Ellero, *Tina Modotti*, p. 73.

12 In 1897 a bad harvest produced a rapid rise in the price of bread and flour products. The Spanish-American War interfered with normal imports of cereals, doubling the price of bread. At first the Italian government, led by Di Rudinì, reduced grain duties by a third. By the end of April 1898 the government had to suspend all duties on grain, which caused widespread disturbances in Florence, Naples, and especially in Milan, where in May Bava Beccaris used artillery against the rioters. "N'erano assetati," *L'Italia del Popolo*, May 7, 1898. Letizia Argenteri, *Il re borghese: Costume e società nell'Italia di Vittorio Emanuele III* (Milan: Mondadori, 1994), p. 61; Alfassio Grimaldi, *Il re "buono"* (Milan:

Feltrinelli, 1970), pp. 415–18; Salvatore Saladino, *Italy from Unification to 1919* (New York: Crowell, 1970), pp. 85–86, and Denis Mack Smith, *Italy and its Monarchy* (New Haven and London: Yale University Press, 1989), pp. 130–31.

13 "To the excruciating and painful cries of a crowd begging for bread, the fierce monarchic Bava fed the hungry with his bullets." Carlo A. Gennari and Gianfranco De Gregoris, eds., *Canzoniere sociale* (Milan: De Gregoris, 1974), no. 1, p. 26.

14 *La Patria del Friuli*, August 27, 1903, reported in Ellero, *Tina Modotti*, pp. 75–76. On p. 77 see two photographs by Pignat that commemorate the king and queen's visit.

15 It seems that in the Friuli region nicknames, even for last names, were not uncommon from before the eighteenth century. The nickname "Saltarin" may suggest a certain posture or a disposition to walk as if one were jumping, from *saltare*, to jump. Or it could suggest a profession: *saltâr* in Friulano dialect means forest ranger. Ellero, *Tina Modotti*, pp. 26 and 83–84. It is interesting to note that in 1929 when Tina was arrested in Mexico on suspicion of murdering Antonio Mella, she called herself Rose Smith Saltarini.

16 It was in fact the prime minister, Crispi, who encouraged the African adventure. Misfortune and bad judgment led Italy to a humiliating defeat; there were conflicting estimates on the African situation, one from General Antonio Baldissera, the military governor, who warned Crispi of imminent disaster, and the other from the civilian governor, Pietro Antonelli, who trusted Emperor Menelik. Baldissera was replaced for a brief period by General Baratieri, who had to face Menelik's sudden attack on the Makalle fort. Prudence was not one of Baratieri's characteristics: without waiting for Baldissera's reinforcements, Baratieri attacked and lost.

17 Martin Clark, *Modern Italy 1871–1982* (London: Longman, 1984), p. 100.

18 Whyte, *Evolution of Modern Italy*, p. 201.

19 Countess Lara did not die a natural death; she was killed by a jealous lover, Giuseppe Pierantoni, who was tried and condemned to 11 years in prison. He was defended by Salvatore Barzilai, a republican deputy. Lelio Antonioni, *Roma, inizio di secolo: Cronache vissute della Roma umbertina* (Rome: Edizioni Mediterranee, 1970), pp. 70–72.

20 Franco Pedone, *Il Partito Socialista Italiano nei suoi congressi,* vol. i: 1892–1902 (Milan: Edizioni Avanti! 1959), and Clark, *Modern Italy,* p. 111.

21 Giorgio Candeloro, *Storia dell'Italia moderna,* vol. vii (Milan: Feltrinelli, 1974), p. 35.

22 *Neue Freie Presse,* December 20, 1882.

23 Margaret Hooks, *Tina Modotti: Photographer and Revolutionary* (London: Pandora, 1993), p. 27.

25 *L'Altra Italia: Storia fotografica della grande emigrazione italiana delle Americhe (1880–1915)* (Rome: Centro Studi Emigrazione, 1973), pp. 8–9; and "Lamerica: Sogni, sconfitte e . . . rivincite," in Ada Lonni, ed., *Macaronì Vu' Cumprà', Il Calendario del popolo,* no. 579, p. 31.

25 The numbers of the buildings in Pracchiuso Street have been changed, according to an 1842 map of Udine that indicated the number 2885A in Venetian numbering, which corresponded to 113 in 1896. Author's interview with Gianfranco Ellero, July 10, 1994, and Gianfranco Ellero, *The Childhood of Tina Modotti* (Udine: Arti Grafiche Friulane, 1992).

26 *Qui Touring,* June 2001, p. 7.

27 Barckhausen-Canale, *Verdad y leyenda,* pp. 39–40. An example of such bicycles is displayed in the Arms Museum in Ferlach.

28 Ellero, *Tina Modotti,* pp. 16 and 20.

29 Vittorio Vidali, Rafael Alberti, et al., *Tina Modotti: Fotografa e rivoluzionaria* (Milan: Idea editions, 1979), n.p.

30 Ellero, *Tina Modotti,* p. 18.

31 Ellero comments that, since Tina's mother had her children baptized, it is unlikely that she herself would not have gone to Sunday mass and taken the children along. Ibid., p. 18. This conflicts with what he says on p. 51, though: "everybody has their children baptized in Italy, even the socialists, who culturally possessed deep Christian roots. . . . The children who did not receive baptism then (and even now), in Italy were (and are) extremely rare, since that would present a problem later in their life."

32 Ibid., p. 49.

33 These are the birth dates and places of the Modotti family: Giuseppe Saltarini Modotti (Udine, April 16, 1863) and Assunta Mondini (November 25, 1863) married on October 5, 1892. Their seven children were: Mercedes Margherita (Udine, November 4, 1892), Ernesto (Udine, August 29, 1894), Assunta Adelaide Luigia, called Tina (Udine, August 16, 1896), Valentina Maddalena, called Gioconda (Ferlach, January 7, 1899), Jolanda Luisa (St. Ruprecht, July 7, 1901), Pasquale Benvenuto (St. Ruprecht, May 18, 1903), and Giuseppe Pietro Maria (Udine, August 30, 1905). Of all the children, only Gioconda had a child, Tullio, and only Gioconda never emigrated to America. Tina and Mercedes were unable to have children, while Jolanda, according to her nephew, had 11 abortions. None of the Modotti children survives. The last of the family to die was Jolanda, in California in November 1991. There are still some Modottis in the Friuli areas, but none is related to Tina Modotti: for example, Mario Modotti "Tribuno," an antifascist who belonged to the partisan movement in Italy in 1945. *Movimento di Liberazione in Friuli 1900–1950* (Udine: Istituto Friulano per la Storia del Movimento di Liberazione, 1973), pp. 222–23.

34 Saverio Tutino, "Una traccia che rimane," in Antonio De Piero, ed., *L'isola della Quarantina* (Florence: Giunti, 1994), p. 83.

35 Carlo Sgorlon, "L'emigrazione friulana," in *Partono i bastimenti,* ed. by Paolo Cresci and Luciano Guidobaldi (Milan: Mondadori, 1980), p. 99.

36 Leonardo Zannier ("In our places people are born anyway"). "Libers di scugni

là" "In our area there is no work, but people are born anyway. So one grows as a little goat left free around his mother's skirt. And when one starts to understand, one must leave." Leonardo Zannier, *Poesie* (Udine: Tarantola-Tavoschi, 1972).

37 Robert D'Attilio, "Appunti per le future biografie di Tina Modotti: la famiglia Modotti a San Francisco," in Riccardo Toffoletti, ed., *Tina Modotti: Una vita nella storia* (Udine: Arti Grafiche Friulane, 1995), p. 323.

38 Gianfranco Ellero, "Uno studio Modotti a San Francisco nel 1908: Anche il padre di Tina era fotografo," *Il Messaggero Veneto*, November 8, 1992.

39 Answer to the questionnaire of the Organizing Section of the Executive Committee of the Communist International, no. 1796*, February 21, 1932. Document in Russian and English. Comintern Archive, Moscow.

40 Sarah M. Lowe, *Tina Modotti: Photographs* (New York: Abrams, 1995), p. 14.

41 Section "Testimonianze," in Vittorio Vidali, *Ritratto di donna: Tina Modotti* (Milan: Vangelista, 1982), p. 87, by Jolanda Modotti. Also in *Tina Modotti: garibaldina e artista* (Udine: Circolo Culturale Elio Mauro, 1993). The factory is believed to be Domenico Raiser and Sons, founded in 1840 in Udine, located at 8 Treppo Street.

42 Lowe, *Tina Modotti: Photographs*, p. 14. Lowe's reason for objecting to the apparent contradiction is that she finds the role of undereducated, struggling seamstress and immigrant, whose "natural genius" was later discovered by male artists, not always corresponding to reality because "the seeds of her vocations – art and politics – may have been planted during her formative years." Ibid.

43 "whose childhood knew privation and hard work." February 14, 1924. Nancy Newhall, ed., *The Daybooks of Edward Weston*, vol. I (New York: Aperture Foundation, 1981), p. 49. Weston kept a diary from January 1922 to December 1934. The original is lost; all that is left is a transcription.

44 "Mom, oh, my mom, I am tired of being a spinning miller, *cal* and *poc* in the

morning and control twice a day [*cal* and *poc* are elements of control of the work done]. The work of spinning mill is a work for assassins; those women who work there are indeed poor souls!" Gennari and De Gregoris, *Canzoniere sociale*, no. 1, p. 35. For textile work in the Friuli region, see E. Bartolini, *Filande in Friuli* (Udine: Casamassima, 1974).

45 Vidali and Alberti, *Tina Modotti: Fotografa*, n.p.

46 Lowe, *Tina Modotti: Photographs*, p.13.

47 Answer to the questionnaire of the Organization Section, no. 1796* (498/241/40, no. 4).

48 U.S. Department of Immigration Records, Ellis Island Museum of Immigration, New York.

49 The project was part of a conference devoted to Modotti, held in Udine in March 1993. Ivana Bonelli, Valeria Moretti, Rosetta Porracin, and Maria Pia Tamburlini, "Un cappello caduto nell'acqua: Tracce di Tina nella sua terra d'origine," in Toffoletti, ed., *Tina Modotti: Una vita nella storia*, pp. 63–74.

50 One of Pietro Modotti's photographic portraits is reproduced in Italo Zannier, *Fotografia in Friuli 1850–1970* (Udine: Chiandetti, 1979), p. 52. The original print is kept at the Archivio Musei Civici in Udine.

51 *La Gazzetta della fotografia* (Milan, March 1905); *Annuario Santoponte* (Rome, 1905); *Il progresso fotografico* (Milan, September 1904 and April 1905); *Annuario del corriere fotografico* (Turin, 1911), all cited in Zannier, *Fotografia in Friuli*, p. 17, and Zannier, *L'occhio della fotografia: protagonisti, tecniche e stili dell'invenzione meravigliosa* (Rome: La Nuova Italia, 1988), pp. 204–05. See also Gianfranco Ellero, *Pietro Modotti* (Udine: Ribis, 1992), p. 10.

52 *La Patria del Friuli*, September 1, 1903, cited also in Bonelli and Moretti et al., "Un cappello caduto nell'acqua." p. 73.

53 Gianfranco Ellero, "Gli allievi di Pietro Modotti," *Cinemazero*, June 1993, pp. 31–33. In 1916, Spartaco Zampi spent some time in Milan as a professional photographer. He later moved to the railway business, but continued his interest in pho-

tography. In 1925, so during the fascist period, he lost his job in Friuli for political reasons. Ibid., p. 33. By contrast, according to one biographer, Pietro Modotti had been a fascist sympathizer, although no proof supports this statement. Barckhausen-Canale, *Verdad y leyenda*, p. 27.

54 Barckhausen-Canale, *Verdad y leyenda*, p. 26.

55 Gianfranco Ellero, "I disegni di Pietro Modotti fotografo in Udine," *La Panarie: Rivista friulana*, xxv, no. 99, April–December 1993, p. 60. However, after Tina Modotti emigrated to the U.S.A., the contacts between her family and her cousin Cora's family were almost nonexistent, even after Tina's mother returned to Italy in 1930. And in later years, when Tina was discovered as a photographer, Cora did not show much interest in her cousin. Riccardo Toffoletti, ed., "Tina Modotti e la storia della fotografia: Le tappe della riscoperta," in Toffoletti, ed., *Tina Modotti: Una vita nella storia*, pp. 233 and 243, n. 15.

2 America! America!

1 "Mom, oh my mom, give me 100 liras. I want to go to America. I'll give you 100 liras, but to [go to] America, no, no, no!" This was a popular Northern Italian song, associated with immigration to the new world, in the second half of the nineteenth century. Many versions of it exist, all different in text and music. The original version, called *La figlia disobbediente* (The Disobedient Daughter), or *La maledizione della madre* (The Mother's Curse), had nothing to do with immigration. It told of a girl eloping on horseback to marry the man she loved. Struck by the curses of her furious mother, she died. Later versions added references to immigration, such as the ship that sank in the middle of the journey: fish ate the girl's flesh and whales drank her blood. Carlo A. Gennari and Gianfranco De Gregoris, eds., *Canzoniere sociale*, no. 1, (Milan: De Gregoris, 1974), p. 64.

2 Mercedes had arrived in the U.S.A. on April 12, 1911. Conger, "Tina Modotti: A Methodology," p. 302, n. 46.

3 Ellero, *The Childhood of Tina Modotti* (Udine: Arti Grafiche Friulane, 1992), p. 56.

4 U.S. Department of Immigration Records, Ellis Island Museum of Immigration, New York.

5 Once in the U.S., the immigrants constantly had to be wary of false hotel keepers and false porters, and of people who would offer them an advantageous exchange rate. Paolo Cresci and Luciano Guidobaldi, eds., *Partono i bastimenti* (Milan: Mondadori, 1980), p. 41.

6 Marcus L. Hansen, "This History of American Immigration as a Field for Research," *American Historical Review*, vol. 32, no. 3, April 1927, p. 513.

7 For an example of the records left by immigrants, see Emilio Franzina, *Merica! Merica! Emigrazione e colonizzazione nelle lettere dei contadini veneti in America Latina 1876–1902* (Milan: Feltrinelli, 1979). The book cites and comments on letters sent to relatives, friends, and acquaintances by Italian peasants from the Veneto region who emigrated to Brazil in the 19th and the 20th centuries. What stands out in the book is the debate between the so-called oppressed classes and their related primary sources, a debate that was unprecedented. For images and photographs sent by emigrants back to their relatives, see also "Immagine costruite, immagini trasmesse," in Franco Della Peruta, ed., *Il Calendario del popolo* (Milan), September 1997, no. 612, pp. 62–63. This particular issue, edited by Ada Lonni, was devoted to immigrant women.

8 Vittorio Vidali, *Orizzonti di libertà* (Milan: Vangelista, 1980), p. 250.

9 "Sine nomine: Avvertenze per chi emigra in California," *Bollettino dell'emigrazione* (San Francisco), xii, 1913.

10 Pio Vanzi, "L'assistenza legale ai nostri emigranti," *L'Italia*, June 23, 1913, p. 1; "Per chi vuole la cittadinanza americana," ibid.: July 23, 1913; "La voce dei nostri emigranti," ibid., September 3 and 10, 1913.

11 President Woodrow Wilson cited in *Attività italiane in California* (San Francisco), 1929.

12 Felice A. Bonadio, *A. P. Giannini* (Berkeley: University of California Press, 1994).

13 Deanna Paoli Gumina, *The Italians of San Francisco, 1850–1930* (New York: Center for Migration Studies, 1978), p. 167.

14 Carlo Cassola, "Emigranti," in Cresci and Guidobaldi, eds, *Partono i bastimenti*, p. 201.

15 Rosemary Spinoso, "A Man and His Dream," *L'Italo-americano*, January 31, 1985, p. 12. *L'Italo-americano* was edited by Cleto M. Baroni, born the same year as Tina in Fiesole, Tuscany.

16 Rosario Ferré, "Tina y Elena: El Ojo y el Oido de México," *Nexos*, vol. 98, 1983, p. 5. In 1890 a "red passport" cost 2 *lire*; after 1901 it cost 8. *L'altra Italia: Storia fotografica della grande emigrazione italiana nelle Americhe (1880–1915)* (Rome: Centro Studi Emigrazione, n.d.), p. 5.

17 Emilio Franzina, "Il Friuli e l'America: Donne, società, emigrazione fra 800 e 900," in Riccardo Toffoletti, ed., *Tina Modotti: Una vita nella storia* (Udine: Arti Grafiche Friulane, 1995), p. 92.

18 From 1876 to 1976 the number of emigrants to America from other regions are: the Veneto 3,300,000; Campania 2,700,000; Sicily 2,500,000; Lombardy 2,300,000; and Calabria 1,900,000. Emilio Franzina, *Gli italiani al nuovo mondo: L'emigrazione italiana in America 1492–1942* (Milan: Mondadori, 1995), p. 145. For emigrant data, see also Gioacchino Volpe, *L'Italia in cammino* (Rome: Giovanni Volpe, 1973), pp. 78–88; G. Cosattini, *Emigrazione temporanea del Friuli* (Rome: Bertero, 1903); Ercole Sori, *L'emigrazione italiana dall'Unità alla seconda guerra mondiale* (Bologna: Il Mulino, 1979), which is rich in data and strong on theory, a rare combination.

19 *Movimento di Liberazione in Friuli 1900–1950* (Udine: Istituto Friulano per la Storia del Movimento di Liberazione, 1973), p. 21. In 1913 Italian emigration peaked with a total of 900,000 Italians leaving their native country, equaled by no other European country. Gianfranco Rosoli,

"L'azione della chiesa a fianco degli italiani espatriati. L'esemplarità del caso lombardo," in Ambrogio Amati, ed., *Chiesa e migrazioni* (Milan: Fondazione Cariplo, I.S.M.U., 4/1998), p. 29.

20 Antonio De Piero, *L'isola della Quarantina* (Florence: Giunti, 1994), p. 43. With an introduction by Carlo Ginzburg, this book is an interesting memoir of an emigrant, written in 1922 in a mixture of Italian and Friulano dialect, while in transit at Hoffman Island, New York.

21 Paoli Gumina, *Italians of San Francisco*, p. VIII.

22 For the process of migration and assimilation into a new environment, see Leon and Rebeca Grinberg, *Psychoanalytic Perspectives on Migration and Exile* (New Haven and London: Yale University Press, 1989), pp. 87–98.

23 Vincenzo Ancona, "Amerisicula," n.d., *Maledittu la lingua/Damned Language*, ed. Anna L. Chairetakis and Joseph Sciorra, trans. Gaetano Cipolla (New York: Legas, 1990), p. 55. Vincenzo Ancona (1916–2000), born and educated in Castellamare del Golfo, Sicily, emigrated to New York in 1956, where he worked in a broom factory and a jewelry workshop, and continued writing poetry in Sicilian dialect. *The New York Times*, March 5, 2000, Obituaries, p. 28.

24 Cresci and Guidobaldi, *Partono i bastimenti*, p. 133.

25 "And so the crowd of emigrants, sails and disappears in the golden fog, leaving long trails of wishes and hopes." Fanny Vanzi-Mussini, *Emigranti ed altri versi* (San Francisco: Italian Press Co., 1914), p. 7. The Italian Press was located at the core of the Italian colony, at 118 Columbus Street.

26 "The sun is beating down. The photograph is yellow, that young man is you. / My friend I am with you / my friend because / One never gets used to being a foreigner. Never!" Gianni Canova, "L'emigrato e la sua condizione," in Amati, *Chiesa e migrazioni*, p. 76. Some of these feelings were captured in the television program *Come l'America* (Like America), written by Sandro Petraglia and Stefano Rulli, directed by Andrea and

Antonio Frazzi, presented on Italian TV on April 23 and 24, 2001, and in the new multimedia opera, *Ellis Island*, by Giovanni Sollima, composer and violinist.

27 This issue is raised in the context of emigration by Paolo De Simonis, "Rappresentare se stessi," in De Piero, *L'isola della Quarantina*, p. 94.

28 Cresci and Guidobaldi, *Partono i bastimenti*, p. 108. According to some historians, the accounts by some prominent Italian-Americans of the situation of their ancestors in California are distorted by presenting self-aggrandizing and far rosier pictures of the integration of the Italian community than were real. I wish to thank Charles Zappia for this clarification.

29 "I keep California in my heart / It goes to my mind all the time. / There I had the most pleasant time / And I will never, never forget it." Verses by Giovanni De Rosalia, written for the actress Irene Veneroni. *Irene Veneroni's Scrapbook* (no date), in the collection of Guido Gabrielli, an Italian immigrant who was married for a short period to Jolanda Modotti. Italian American Collection, San Francisco Public Library.

30 "This might be called my home town . . ." Tina Modotti, letter to Edward Weston (hereafter TM to EW), January 23, 1926. Edward Weston Archive (EWA) Center for Creative Photography, University of Arizona, Tucson.

31 Doris Marion Wright, "The Making of Cosmopolitan California – Part II: An Analysis of Immigration, 1848–1870," *California Historical Society Quarterly*, vol. 20, no. 1, March 1941, p. 72.

32 Rose Doris Scherini, *The Italian American Community of San Francisco: A Descriptive Study* (New York: Arno Press 1980).

33 In 1918 San Francisco's population was 583,376. Just over ten years later it was 634,394, of which 27,311 were emigrants from Italy (16,333 male and 10,478 female). Patrizia Salvetti, "La comunità italiana di San Francisco tra italianità e americanizzazione negli anni 30 e 40," *Studi emigrazione* (Rome), XIX, no. 65, March 1982, p. 4, and *L'Italia*, March 14, 1918.

34 Paoli Gumina, *Italians of San Francisco*, p. x.

35 *La voce del popolo*, May 12, 1867.

36 Paoli Gumina, *Italians of San Francisco*, p. 103, and Franzina, *Gli italiani al nuovo mondo*, p. 334.

37 Q. David Bowers, *Nickelodeon Theatres and Their Music* (New York: Vestal Press, 1986), p. 10.

38 Alessandro Baccari, Vincenza Scarpaci, and Gabriel Zavattaro, *Saints Peter and Paul Church: The Chronicles of "The Italian Cathedral" of the West, 1884–1984* (San Francisco: A. Baccari, 1985), pp. 1–4. Enriched with wonderful photographs, this was published for the centennial celebration of the church.

39 See also the collection of 44 black and white photographs from the files of *L'eco d'Italia*, 1970.

40 By 1921, Sbrana had moved to the Santa Clara Valley, where he built a studio behind his home.

41 Deanna Paoli Gumina, "Gino Sbrana," *Exhibit*, March–April 1989, n.p. See also the catalogue of Sbrana's exhibition of "mammoth prints," held at the Museo Italo Americano at Fort Mason, San Francisco, March 10–28, 1989.

42 See e.g. *L'Italia*, June 27, 1913.

43 Ibid., July 1, 1913.

44 Victoria Pastry, at 1362 Stockton, referred to itself as "the biggest Italian pastry shop in the US." Ibid., December 13, 1917.

45 Ibid., October 20, 1917.

46 Ibid., November 18, 1921.

47 Ibid., April 9, 1917.

48 Ibid., June 26, 1913.

49 Ibid., July 8 and September 19, 1913.

50 Ibid., July 31, 1913.

51 "L'arrivo del M.o Leoncavallo a San Francisco," ibid., October 22, 1913.

52 "La raccapricciante serie dei disastri negli antri e nelle officine del lavoro negli Stati Uniti," ibid., July 5, 1913.

53 "Matrimoni per fotografia," ibid., February 14, 1921.

54 Ibid., February 9, 1917.

55 Michael Kazin, *Barons of Labor: The San Francisco Building Trades and Union*

Power in the Progressive Era (Urbana: University of Illinois Press, 1987), p. 21. Also cited in Ferdinando Fasce, "Il movimento operaio in California negli anni dieci del Novecento, in Toffoletti, *Tina Modotti: Una vita nella storia*, p. 100. For the anti-Asian attitude of the European immigrants, see Alexander Saxton, *The Indispensable Enemy: Labor and the Anti-Chinese Movement in California* (Berkeley: University of California Press, 1971). My thanks to Jonathan McLeod for pointing out Saxton's book.

56 Kazin, *Barons of Labor*, p. 169.

57 Saxton, *The Indispensable Enemy*, p. 257.

58 Melvyn Dubofsky, *We Shall Be All: A History of the Industrial Workers of the World* (New York: Quadrangle/The New York Times Book Co., 1969), p. 294.

59 Joyce L. Kornbluh, ed., *Rebel Voices: An I.W.W. Anthology* (Ann Arbor: University of Michigan Press, 1964), p. 405.

60 David F. Selvin, *A Place in the Sun: A History of California Labor* (San Francisco: Boyd and Fraser, 1981), pp. 35–36.

61 The I.W.W. movement was founded in Chicago in 1905, in response to the A.F.L. (American Federation of Labor) opposition to industrial unionism. Industrial Workers of the World, *Proceedings of the First Convention of the Industrial Workers of the World: The Founding Convention of the I.W.W.* (New York: Merit, 1969). For more information on the I.W.W., see Philip Sheldon Foner, *History of the Labor Movement in the United States*, vol. IV, *The Industrial Workers of the World, 1905–1917* (New York: International Publishers, 1975); Fred Thompson, "Digging into IWW History: The Schenectady Sit Down," *Industrial Worker*, August 1975; Kornbluh, *Rebel Voices*; and Dubofsky, *We Shall Be All*. I thank Charles Zappia for clarifying the role of the I.W.W. for me.

62 Carleton Hubbell Parker, "California Commission of Immigration and Housing. A report of His Excellency Hiram W. Johnson, governor of California, by the Commission of Immigration and Housing in California on the causes pertaining to the so-called Wheatland Hop Fields' Riot," in *The Casual Laborer and Other Essays* (New York: Harcourt, Brace and Howe, 1920), pp. 171–99.

63 Philip Sheldon Foner, *Women and the American Labor Movement: From Colonial Times to the Eve of World War I* (New York: Free Press, 1979), p. 411.

64 Dubofsky, *We Shall Be All*, p. 294.

65 Michaela Di Leonardo, *The Varieties of Ethnic Experience* (Ithaca: Cornell University Press, 1984), p. 63.

66 Dubofsky, *We Shall Be All*, pp. 297–98.

67 "La popolazione di San Francisco," *L'Italia*, June 24, 1913. The article pointed out an increase of 23,702 people from the previous year.

68 With a second defeat in 1915, McCarthy ended the party's existence. Ira Cross, *A History Of The Labor Movement in California* (Berkeley: University of California Press, 1935), p. 336; Selvin, *A Place in the Sun*, p. 24; and Baccari, Scarpaci, and Zavattaro, *Saints Peter and Paul Church*, p. 62. For a comparison of elections in San Francisco in various years, see Michael Paul Rogin and John L. Shover, *Political Change in California: Critical Elections and Social Movements, 1890–1966* (Westport: Greenwood Publishing, 1970).

69 Giuseppe Novello and Paolo Monelli, *La guerra è bella ma è scomoda* (Milan: Aldo Garzanti, 1951), p. 104.

70 Emilio Franzina, "Il Friuli e l'America," p. 92.

71 R. N. Lynch, "La California e l'emigrante," *Il Monitore California*, October 15, 1913. Patrizi also wrote a piece along the same lines: Ettore Patrizi, "The wonderful achievements of the Italians in California," *The Star of San Francisco*, September 5, 1913.

72 José Clemente Orozco, *Autobiografía* (Mexico City: Era, 1970), pp. 48 and 51. Orozco visited San Francisco in 1917, when Woodrow Wilson also came to promote his League of Nations.

73 José Vasconcelos, *Ulises criollo*. Part II: *La tormenta* (Mexico City: ediciones Botas, 1936), p. 497.

74 Tina Modotti Richey, ed., *The Book of Robo* (Los Angeles, 1923), p. 32.

75 Bertram D. Wolfe, *A Life In Two Centuries: An Autobiography* (New York: Stein and Day, 1981), pp. 254–55. Wolfe was referring to San Francisco in the early 20, though.

76 Pier Giuseppe Bertarelli, letters to his brothers, May 12 and May 15, 1850. *Viaggio e avventure di un milanese in California: Lettere di Pier Giuseppe Bertarelli, 1849–1853* (Milan: 1969), pp. 48–50.

77 A standard American middle-class family spent an average of $348 a year on entertainment and diversions, thus around $7 a week. *L'Italia*, July 20, 1920.

78 Kenneth Rexroth, *An Autobiographical Novel* (Garden City, N.Y.: Doubleday, 1966), pp. 366–67. He was referring to 1927 San Francisco.

79 This aspect is also noticed, although in another context, by Leonardo Gandini, "Hollywood e il mondo culturale californiano," in Toffoletti, ed., *Tina Modotti: Una vita nella storia*, p. 122.

80 René Dubos, *A God Within* (New York: Charles Scribner's Sons, 1972), p. 123.

81 Philip Montesano, "I giornali etnici di San Francisco, 1850–1870," *Il gazzettino*, vol. 2, no. 2, December 1974–January 1975, pp. 6–7.

82 *L'Italia's* offices were destroyed by the 1906 earthquake, but the paper resumed publication three days after the disaster.

83 *L'Italia*, July 14, 1913, p. 1. The article specified that male textile workers in Paterson, New Jersey, were paid $9 per week, while female workers were paid $1.25.

84 Ibid., July 2, 1913.

85 For example, "Ed ora parliamo noi," ibid., October 19, 1918, in which *L'Italia* accuses *La voce del popolo* of sabotaging the war effort, of not having a defined and clear political line, and of misleading its readers. The behavior of *La voce del popolo* (called "the little tyrant") was compared by *L'Italia* with the behavior of the Germans, who were losing the war.

86 Ettore Patrizi, "L'avvenire darà ragione a D'Annunzio," ibid., January 8, 1921.

87 Ettore Patrizi, *Come considero Mussolini: Pensieri di un italiano all'estero* (Rome: S.F.I.E., 1924), p. 10.

88 A.C.S. (State Archive, Rome), Segreteria Particolare del Duce, Carteggio ordinario. See dossier Patrizi, which records the meetings between Patrizi and Mussolini held in 1932, 1935, and 1937.

89 San Francisco Archives, Italian-American Collection, San Francisco Public Library.

90 Later on, Louise Bryant, the companion of the journalist John Reed, contributed to *The Blast* with her own poetry and sketches. Robert A. Rosenstone, *Romantic Revolutionary: A Biography of John Reed* (New York: Vintage Books, 1981), p. 240.

91 Stephen Schwartz, *From West to East: California and the Making of the American Mind* (New York: Free Press, 1998), p. 188.

92 C. M. Furio, "The Cultural Background of the Italian Immigrant Woman and its Impact on her Unionization in the New York City Garment Industry, 1880–1919," in George Pozzetta, ed., *Pane e lavoro: The Italian American Working Class* (Toronto: Multicultural History Society of Ontario, 1980), pp. 91–98.

93 Ellero, *Tina Modotti*, pp. 58 and 131.

94 Di Leonardo, *Varieties of Ethnic Experience*, p. 52. Di Leonardo is trying to alter the conception of the "timeless Italian peasant migrant."

95 Several advertisements for Praeger's, the shop located at Market and Jones Street, appeared in *L'Italia*, 1913–1915.

96 Vidali, Alberti, et al., *Tina Modotti*, n.p.

97 Margaret Hooks, *Tina Modotti: Photographer and Revolutionary* (London: Pandora, 1993), p. 18.

98 *Crocker-Langley Directory* (San Francisco, 1913), also cited in Robert D'Attilio, "Appunti per le future biografie di Tina Modotti: la famiglia Modotti a San Francisco," in Toffoletti, ed., *Tina Modotti: Una vita nella storia*, p. 324. D'Attilio follows the Modotti family saga through the data provided by the telephone directories. He points out ambiguities and questionable

data. D'Attilio is interested in proving that the first Modotti biographers were hasty in their statements, thus presenting Tina Modotti in a distorted light. He is also trying to prove that Tina's social background was not proletarian, because that would put Modotti (and her family) in an entirely different social category from the one usually presented. In D'Attilio's opinion, Modotti's story went through an inevitable "politically correct" revision.

99 Vidali, Alberti, et al., *Tina Modotti*, n.p.

100 "Il tunnel di Twin Peaks e il progresso di San Francisco," *L'Italia*, February 5, 1918.

101 Pamphlet of the North Beach Museum, which defines itself as "an independent entity, though sponsored by Eureka Bank."

102 Cesare Crespi, "La nostra colonia: Il bene e il male. Il dare e l'avere," *Libertas* (farewell number, San Francisco), January 1929, p. 13.

3 Enter Robo

1 José Clemente Orozco, *Autobiografía* (Mexico City: Era, 1970), p. 48.

2 Later, Genthe's photography engaged more in portraits of actors and screen stars – a phase that coincided with Genthe's move to New York in 1911. Helmut and Alison Gernsheim, *A Concise History of Photography* (London: Thames and Hudson, 1965), p. 149.

3 *The Bulletin*, no. 68, May 16, 1906, reproduced in Q. David Bowers, *Nickelodeon Theatres and Their Music* (New York: Vestal Press, 1986), p. 14.

4 Michael Kazin, *Barons of Labor: The San Francisco Building Trades and Union Power in the Progressive Era* (Urbana: University of Illinois Press, 1987), p. 218.

5 Alessandro Baccari, Vincenza Scarpaci, and Gabriel Zavattaro, *Saints Peter and Paul Church: The Chronicles of "The Italian Cathedral" of the West, 1884–1984* (San Francisco: A. Baccari, 1985), p. 60.

6 *L'Italia*, February 21, 1915.

7 Baccari, Scarpaci, and Zavattaro, *Saints Peter and Paul Church*, p. 59.

8 In a previous scene, the two protagonists of *Good Morning, Babylon*, the brothers Andrea and Nicola, meet the Italian crew participating in the Exposition. The two brothers end up in Hollywood working for Griffith on his film *Intolerance*, released in 1916.

9 Patricia Albers, *Shadows, Fire, Snow: The Life of Tina Modotti* (New York: Clarkson Potter, 1999).

10 Ibid., p. 34.

11 Ibid., p. 35.

12 Jolanda Modotti to Mildred Constantine, January 15, 1974. The J. Paul Getty Research Institute, Los Angeles.

13 R. W. Borough, "Art, Love and Death: Widow Must Sell Batiks," *Los Angeles Examiner*, May 9, 1922, n.p., wrongly filed by Edward Weston as May 12.

14 *El Universal Ilustrado*, April 1922.

15 Robert D'Attilio, "Glittering Traces of Tina Modotti," *Views* (Boston), Summer 1985, p. 9.

16 Tina Modotti Richey, ed., *The Book of Robo* (Los Angeles, 1923).

17 Patricia Albers, ed., *Dear Vocio: Photographs by Tina Modotti*, exh. cat. (La Jolla: University Art Gallery, 1997), p. 24.

18 The divorce became final in September 1919. Albers, *Shadows, Fire, Snow*, pp. 34, 42, and 338.

19 Modotti Richey, *Book of Robo*.

20 Ibid., p. 57.

21 This notion is explained in one of Robo's unfinished novels, "Fragments of a Novel," in ibid., *Book of Robo*, p. 53.

22 Sarah M. Lowe, *Tina Modotti: Photographs* (New York: Abrams, 1995), p. 16.

23 Marionne died in 1987 aged 91. Albers, *Dear Vocio*, p. 24.

24 Jules Tygiel, *The Great Los Angeles Swindle* (Oxford and New York: Oxford University Press, 1994), p. 11.

25 Later, they moved to 313 S. Lake Street.

26 Also stated in Vittorio Vidali, *Ritratto di donna: Tina Modotti* (Milan: Vangelista, 1982), p. 11.

27 Amy Conger, *Edward Weston: Photographs from the Collection of the Center for Creative Photography* (Tucson: Center for Creative Photography, 1992) 117/1924, no. 1. Cited in Lowe, *Tina Modotti: Photographs*, p. 146, n. 70. The photograph was reproduced in Prentice Duell, "Textiles and Interior Decoration Department: A Note on Batik," *California Southland*, vol. 23, November 1921, p. 19.

28 R. W. Borough, "Art, Love and Death," n.p.

29 Lowe, *Tina Modotti: Photographs*, p. 17.

30 Sake drinking is mentioned in one of Ricardo Gomez Robelo's letters to Edward Weston, September 19, (?)1922, EWA, Center for Creative Photography, University of Arizona, Tucson; hereafter, EWA, Tucson.

31 Carleton Beals, *Glass Houses, Ten Years of Free Lancing* (Philadelphia: J. B. Lippincott, 1938), p. 242.

32 During the First World War, Hartmann was put under surveillance by American Military Intelligence for his radicalism. D'Attilio, "Glittering Traces of Tina Modotti," pp. 7 and 9.

33 The quote is dated March 17, 1931. Nancy Newhall, ed., *The Daybooks of Edward Weston* (New York: Aperture Foundation, 1981), ii, p. 209. The term "parlor politics" was previously used by Weston in a letter of December 7, 1923 to his wife Flora, sent when he was in Mexico with Tina. He explained the role of the Mexican leftist artists, such as Diego Rivera: "The artists here are closely allied with the communist movement. It is not parlor politics with them." EWA, Tucson.

34 Ben Maddow, *Edward Weston* (New York: Aperture, 1973), p. 46.

35 Antonio Saborit, *Una mujer sin país: Las cartas de Tina Modotti a Edward Weston 1921–1931* (Mexico City: Cal y Arena, 1992), p. 14.

36 Elena Poniatowska, *Tinísima* (Mexico City: Era, 1992), pp. 119–20; and Saborit, *Una mujer sin país*, p. 14. (*Tinísima* suffers in the English translation from the strange deletion of the part on politics.)

37 Antonio Saborit, *Tina Modotti: Vivir y morir en México* (Mexico City: Consejo Nacional para la Cultura y las Artes, 1999), p. 14.

38 Borough, "Art, Love and Death," n.p.

39 "Lo sciopero in una Canneria," *L'Italia*, August 2, 1917; "Lo sciopero di una Canneria," ibid., August 3, 1917, and "Lo sciopero delle Cannerie," ibid., August 6, 1917.

40 Elizabeth Reis, "Cannery R.O.W.: The AFL, the IWW, and Bay Area Italian Cannery Workers," *California Historical Society Quarterly*, vol. 64, no. 3, Summer 1985, p. 176.

41 "Strikers Grant Week in Which to Settle Dispute: Canneries Closed Today" (unsigned), *San Jose Mercury Herald*, vol. 93, no. 28, July 28, 1917, p. 1.

42 Reis, "Cannery R.O.W.," p. 186.

43 In 1918 the question was unsuccessfully reopened. *L'Italia*, August 24, 1918.

44 The letter, unsigned, is in Modotti's handwriting. EWA, Tucson. There is an earlier letter, dated April 25, 1921, copied into an unpublished page of Weston's *Daybooks*, in which Modotti says she was "intoxicated with the memory" of the previous night, and "overwhelmed by the beauty and madness of it." Probably Weston met Modotti through McGehee's contacts with the movie colony. Maddow describes Modotti as "an extraordinary woman who was to shatter and then reconstruct his life." Maddow, *Edward Weston*, p. 46.

45 Mildred Constantine, *Tina Modotti: A Fragile Life* (San Francisco: Chronicle Books, 1983), p. 36.

46 Modotti Richey, *Book of Robo*, introduction by John Cowper Powys.

47 Reported by Weston on March 23, 1924. Newhall, ed., *Daybooks of Edward Weston*, i, 58.

48 The *Rubáiyyát* of Omar Khayyám, rendered into English by Edward FitzGerald (New York: Walter J. Black, 1942), p. 97, stanza 101 (and p. 154, stanza 93). FitzGerald's acquaintance with the Persian language began in 1853. By 1859, he had

finished his first version of the *Rubáiyyát.* Four more versions were published during his life (in 1868, 1872, 1879, and 1889), all anonymously. The line in question belongs to the second, third, fourth, and fifth versions, while in the first version, p. 43, stanza 69, it reads "Have drown'd my Honour in a shallow Cup." The entire stanza reads: "Indeed the Idols I have loved so long/Have done my credit in this World much wrong:/Have drown'd my Glory in a shallow Cup,/And sold my Reputation for a Song." Ibid., p. 154, stanza 93.

49 Vidali, *Ritratto,* p. 15. Valentina Agostinis noticed that the Modotti depicted by Vidali here was more the woman he wanted her to be than the woman she actually was. Vidali's book "does not have less fiction than Hollywood movies in defining the profile of a woman that it intends to portray." Valentina Agostinis, "Tina Modotti: Gli anni luminosi," in Valentina Agostinis, ed., *Tina Modotti: Gli anni luminosi* (Pordenone: Cinemazero and Edizioni Biblioteca dell'Immagine, 1992), p. 18.

50 Rebecca Zurier, *Art for the Masses* (Philadelphia: Temple University Press, 1988), p. 93.

51 Michael Gold, "Notes on Art, Life, Crap-Shooting, etc.," *New Masses,* September 1929, p. 11. Weston was also critical of the *Little Review,* whose content he found trivial and pretentious. Maddow, *Edward Weston,* p. 73. See also Newhall, ed., *Daybooks of Edward Weston,* i, p. 190, where Weston calls the *Little Review* "old fashioned."

52 *L'Italia,* July 20, 1917.

53 Ibid., September 4, 1917.

54 Kenneth Rexroth, *An Autobiographical Novel* (Garden City, N.Y.: Doubleday, 1966), p. 366.

55 Bowers, *Nickelodeon Theatres,* p. 138.

56 Ibid., pp. 68 and 77.

57 Lawrence Estevan, ed., *The Italian Theater in San Francisco.* San Francisco Theater Research Monograph Series, Works Progress Administration, Monograph 21 (San Francisco, 1939), reprinted in Lawrence Estevan, *The Italian Theater in San Francisco*

(San Bernardino: Borgo Press, 1991). See also Robert H. Williams, "Little Italy," *San Francisco Examiner,* November 25, 1923.

58 Alessandro Baccari, "The Stage is Now Empty," in *Columbus: The Publication of the Columbus Celebration – 1977. Historical Issue: Italians in California* (San Francisco: Baccari, 1977), pp. 141–46. Maxine Seller, "Antonietta Pisanelli Alessandro and the Italian Theatre in San Francisco: Entertainment, Education, and Americanization," *Educational Theatre Journal,* vol. 28, no. 2, May 1976, pp. 206–19.

59 Baccari, "The Stage is Now Empty," p. 142.

60 Maxine Seller, *Theater and Community: The Popular Italian Theater of San Francisco: 1905–1925* (Staten Island, N.Y.: American Italian Historical Association, 1976), p. 3. Repr. Emelise Aleandri and Maxine Schwartz Seller, "Italian American Theatre," in Seller, ed., *Ethnic Theatre in the United States* (Westport, Conn.: Greenwood Press, 1983), pp. 237–76.

61 Ibid.

62 Ibid.

63 J. M. Scanland, "An Italian Mosaic," *Overland Monthly,* April 1906, vol. 47, p. 328, and Ernest Peixotto, "Italy in California," *Scribner's,* vol. 48, July 1910, p. 82.

64 The *Chauve-souris,* by Nikita Balieff, had its debut in Paris in 1920, and in the United States (New York) in 1922. Modotti must have liked this type of show because in a letter to Weston (who in November 1922 was leaving for New York) she highly recommended it. Weston found it "a frank, gay artificiality." Newhall, *Daybooks of Edward Weston,* i, pp. 4 and 7. On September 17, 1924 in Mexico, Modotti herself performed in a Mexican production of *Chauve-souris (murciélago).* Ibid., p. 92.

65 Seller, *Theater and Community,* p. 5.

66 Deanna Paoli Gumina, *The Italians of San Francisco, 1850–1930* (New York: Center for Migration Studies, 1978), p. 65.

67 Estevan, *Italian Theater in San Francisco,* p. 22.

68 In modern times, nickelodeon has come to refer to coin-operated musical instruments of various sorts, but in the early part of the century a nickelodeon was strictly a five-cent theater, a nickel being the price of admission. Bowers, *Nickelodeon Theatres*, p. vii.

69 By 1907, there were more than 3,000 nickelodeons in America, Chicago being the city with the largest number. Ibid., p. 43.

70 Seller, *Theater and Community*, p. 8.

71 "Mimì Aguglia in Italian At Cort," *San Francisco Chronicle*, July 14, 1914, p. 4.

72 Rexroth, *Autobiographical Novel*, p. 366. Rexroth is referring here to a later period, probably the late 1920s.

73 From the recollections of the actress (and radio announcer) Argentina Ferrau Brunetti, daughter of the actors Mimì Aguglia and Vincenzo Ferrau. Author's telephone interview with Argentina Brunetti, February 7, 1999.

74 Deanna Paoli Gumina, "Connazionali, Stenterello, and Farfariello: Italian Variety Theatre in San Francisco," *California Historical Quarterly*, Spring 1957, pp. 27–36. Also cited in Paoli Gumina, *Italians of San Francisco*, pp. 67–69.

75 Franzina, *Gli italiani al nuovo mondo: L'emigrazione italiana in America 1492–1942* (Milan: Mondadori, 1995), pp. 332–33. For Migliaccio's acting as Farfariello see "La serata di Farfariello," *L'Italia*, February 21, 1918; "La serata d'onore di Farfariello," ibid., February 25, 1918; and "La grande serata di Farfariello," ibid., February 26, 1918.

76 Cited in Estevan, *Italian Theater in San Francisco*, p. 52.

77 Ibid., pp. 50–55.

78 Seller, *Theater and Community*, p. 9.

79 *L'Italia*, April 15, 1918.

80 Ibid., July 31, 1918.

81 "La guerra ai nomi tedeschi," ibid., August 21, 1918. See also "Ferocia tedesca: I tedeschi torturano i nostri prigionieri," (unsigned), ibid., February 12, 1918.

82 John Higham, *Hanging Together: Unity and Diversity in American Culture*, ed. Carl Guarneri (New Haven and London: Yale University Press, 2001), p. 207.

83 *L'Italia*, January 29, 1917.

84 Ibid., February 8, 1917. The committee was located at 678 Green Street.

85 Ibid., April 9, 1917. The committee was located at 1801 Larkin Street.

86 Ibid., May 2, 1917.

87 Ibid., June 29 and July 3, 1917.

88 Ibid., May 14, 1917. See also ibid., May 19, 1917, where it is written that "bread is the most economic of all the food products"; ibid., May 26, 1917, where bread is linked to longevity; and ibid., May 30, 1917, where "the answer – it is stated – is bread."

89 Ibid., October 23, 1917.

90 Ibid., November 16, 1917. The Ghirardelli Co. offered chocolate to the participants. Another ball was held on November 19 at the Masonic Hall.

91 Ibid., November 22, 1917.

92 Ibid., May 7 and May 15, 1917.

93 Ibid., August 24, 1918.

94 The incidents related to flags abound in *L'Italia*, even before the First World War. Any act considered a profanation of the flag was reported and harshly commented on by the Italian–American press. On July 4, 1913 the Consul General of Paraguay was asked by two patriotic Americans to lower its flag. The Italian reporter stressed that none of the American newspapers reported the incident. "La grassa ignoranza di certi Americani a proposito di bandiere straniere," signed *Il cronista*, ibid., July 7, 1913. In the same issue, *L'Italia* reported that an unidentified, non-American flag, was seen flying on a San Francisco balcony. The act was regarded by "a good American citizen" as an insult. The man succeeded in lowering the unidentified flag, only to find out that the place was a foreign consulate, which was required by law to raise its flag. The article ends with the sentence *Che doccia fredda per gli chauvinisti schiamazzatori!* (What a cold shower for the noisy chauvinists!).

95 Ibid., December 23, 1917. At Christmas 1921 *L'Italia* published a poem by Trilussa, written during the war. *Natale di guerra*, ibid., December 22, 1921.

96 Ibid., December 27, 1921.

97 "Le entusiastiche accoglienze fatte al generale Diaz," ibid., November 2, 1921.

98 "L'omaggio degli italiani di Fresno al general Diaz," ibid., November 28, 1921. In spring the same year *L'Italia* announced the visit of the heir to the throne, Prince Humbert of Savoy. Gastone Bertini, "Se venisse Sua Altezza Reale," ibid., March 31, 1921.

99 "Anita Garibaldi a San Francisco," ibid., October 20, 1920.

100 "La voce di un profugo del Friuli," ibid., December 4, 1917. In the article, Tina is identified as "the beautiful aspiring actress."

101 Tullio, who never met his biological father, was called Modotti at birth. His mother was recorded in her Italian identity card as "prostitute," which was probably what single mothers were called then. When Tullio was a teenager, in order to avoid the humiliations of being identified all his life as illegitimate, he acquired the last name of Cosolo, from Dante Cosolo, his aunt Mercedes' friend. Barckhausen-Canale, *Verdad y leyenda*, pp. 35–36. One of Tullio Cosolo's sons, Bruno, a telecom technician, was murdered in Trieste on April 4, 2000 in a sex-related crime. With the help of a hidden video camera installed by Cosolo, the assassins (three Egyptian sailors) were soon arrested. Roberto Vitale, "Telecamera nascosta filma i killer," *Il gazzettino* (Udine), April 6, 2000, p. 7; (unsigned), "Triestino ucciso in casa," *Messaggero Veneto*, April 5, 2000, p. 1.

102 On another occasion *L'Italia* reported on a corrupt banker from Udine, Domenico Volpi, director of the San Vito Bank, who in summer 1913 fled to Austria with his loot. *L'Italia*, July 9, 1913.

103 On that occasion, Mussolini saluted the city of Udine, remembering the courage of its people during the First World War. *Movimento di Liberazione in Friuli 1900–1950* (Udine: Istituto Friulano per la Storia del Movimento di Liberazione, 1973), p. 115.

104 "Il triste pellegrinaggio dei profughi friulani," *L'Italia*, December 17, 1917.

105 "Il Natale dei bambini dei miseri profughi del Veneto," ibid., February 25, 1918.

106 "Dieci minuti saranno destinati a parlare della nostra guerra," ibid., February 11, 1918.

107 "Per la gran serata al Washington," ibid., February 2, 1918; "Questa sera! Tutti al Teatro Washington," ibid., February 13, 1918; and "Due teatri in uno solo," ibid., February 12, 1918.

108 "Un ricordo all'artista Seragnoli," ibid., February 18, 1918. See also "Chi più ammirare? L'uomo o l'artista?," ibid., February 4, 1918.

109 "Dieci minuti saranno destinati a parlare della nostra guerra," ibid., February 11, 1918.

110 "Un'altra serata d'amore e di patriottismo," ibid., February 14, 1918. The theater was "decorated with Italian and American flags, made by Mr. Giacomo Battestini."

111 "Per il ballo del Comitato di Soccorso," ibid., February 28, 1918. See also "Per il ballo in maschera del Comitato di Soccorso Italiano," ibid., February 16, and "Il ballo in maschera di domenica," ibid., March 2, 1918.

112 See n. 80 above. Ibid., July 31, 1918.

113 "La signorina Pezza contro il Prof. Portanova," ibid., March 1, 1918.

114 "Girl Models for Statue Will Testify," *San Francisco Examiner*, February 27, 1918.

115 *L'Italia*, February 27, 1918.

116 Ibid., February 28, 1918.

117 "Art Models Appear in Court," *San Francisco Examiner*, February 28 and March 6, 1918.

118 Ibid., March 6, 1918.

119 "Il prossimo debutto della C.ia Aratoli al Liberty," *L'Italia*, March 16, 1918, and "Al Teatro Liberty: Questa sera avrà luogo il debutto della Compagnia Città di Firenze," ibid., March 18, 1918.

120 "Al Teatro Liberty," ibid., March 29, 1918.

121 "Al Teatro Liberty: Serata a totale beneficio della Croce Rossa Italiana," ibid., April 4, 1918, and "Lo spettacolo pro Croce Rossa al Liberty," ibid., April 5, 1918.

122 "Il successo dell' 'Acqua cheta' al Liberty," ibid., April 19, 1918.

123 "La gran serata di domani al Washington Theater," ibid., July 10, 1918.

124 "Cronaca teatrale al Teatro Washington," ibid., July 25, 1918.

125 Ibid.

126 "I disonesti al Teatro Washington," ibid., July 31, 1918.

127 "Al Teatro Washington: Molto pubblico va ad assistere alla serata in onor dell'attore Oreste Seragnoli," ibid., August 3, 1918.

128 "Un interessante spettacolo al Teatro Washington," ibid., August 12, 1918.

129 "La serata dell'artista Mattioli," ibid., August 14, 1918, and "Al Teatro Washington," ibid., August 16, 1918.

130 "Tutti al Liberty stasera," ibid., August 23, 1918.

131 "La nemica," and "Tutti al Teatro Washington questa sera," ibid., August 21, 1918; "La nemica, una madre!" ibid., August 23, 1918, and "Un bagno di patriottismo ed una bella serata d'arte," ibid., August 28, 1918.

132 "Serata indimenticabile e memorabile quella di ieri," ibid., August 29, 1918.

133 "Oltre 800 dollari d'incasso," ibid., September 4, 1918.

134 *La voce del popolo*, September 22, 1918. This information was provided by Alessandro Baccari, Jr., whose picture as a boy appears in the article cited, written by him. Author's interviews with Alessandro Baccari, March 10, 1994 and October 19, 1997. Mr. Baccari is the son of Alessandro Baccari, photographer and composer, born in Campania, Italy. Mr. Baccari, Sr. met Modotti in New York and San Francisco. *Attività italiane in California* (San Francisco, 1929), p. 301, photograph of A. Baccari, Sr. See also "La prossima stagione della compagnia di operette La Moderna," ibid., August 17, 1918.

135 "Drammi patriottici al Teatro Washington," ibid., October 10, 1918.

136 "Al Teatro Washington," ibid., October 7, 1918, and "Al Teatro Washington," ibid., October 9, 1918.

137 According to Patricia Albers, who had access to documents and belongings from the Richey family, a legal marriage never took place. Albers, *Dear Vocio*, p. 54, n. 3, and Albers, *Shadows, Fire, Snow*, pp. 48 and 338. The documents are now kept at the San Francisco Museum of Modern Art.

138 Andrew F. Rolle, *California, A History* (New York: Crowell, 1963), and Christopher Rand, *Los Angeles, The Ultimate City* (Oxford and New York: Oxford University Press, 1967).

139 Terry Ramsaye, *A Million and One Night* (New York: Simon and Schuster, 1926); Edwin O. Palmer, *History of Hollywood* (New York: Garland, 1978), and Hortense Powdermaker, *Hollywood: The Dream Factory* (New York: Grosset and Dunlap, 1950).

140 Leonardo Gandini, "Hollywood e il mondo culturale californiano," in Toffoletti, ed., *Tina Modotti: Una vita nella storia* (Udine: Arti Grafiche Friulane, 1995), p. 119.

141 Ibid., p. 120.

142 *Motion Picture News*, July 3, 1920, and *Moving Picture World*, July 3, 1920.

143 *The American Film Institute Catalog of Motion Pictures in the United States* (Berkeley: University of California Press, 1971), vol. 1, p. 933. It is odd that in another source the cast appears as W. Butts, Myles McCarthy, and W. Weed. Tina Modotti is not even mentioned. David Bordwell, Janet Staiger, and Kristin Thompson, *The Classical Hollywood Cinema: Film Style and Mode of Production to 1960* (New York: Columbia University Press), p. 395.

144 Livio Jacob, "Tina Modotti a Hollywood," in Agostinis, *Tina Modotti*, p. 213. E. W. W. Hodkinson Film Archives, University of Southern California, Los Angeles.

145 Albers, *Shadows, Fire, Snow*, p. 59.

146 Lowe, *Tina Modotti: Photographs*, p. 17.

147 Bordwell, Staiger, and Thompson, *Classical Hollywod Cinema*, p. 15.

148 *Moving Picture World*, October 30, 1920.

149 Ibid., November 6, 1920.

150 Ibid., November 20, 1920, cited in Jacob, "Tina Modotti a Hollywood," pp. 214–15.

151 Ibid., p. 215.

152 "Al Teatro Washington: La pellicola 'Tiger's Coat' con la nota attrice Tina Modotti," *L'Italia*, November 1, 1921.

153 Jacob, "Tina Modotti a Hollywood," p. 218.

154 *The American Film Institute Catalog of Motion Pictures*, vol. 2, p. 654.

155 Twentieth Century Fox Archive, Collection 010, folder no. 148.1, Theater Arts Library, University of California at Los Angeles.

156 *Variety*, December 16, 1921.

157 *American Film Institute Catalog of Motion Pictures*, vol. 2, p. 372.

158 *Memories of the Future: The Daybooks of Tina Modotti. Poems by Margaret Gibson* (Baton Rouge and London: Louisiana State University Press, 1986), p. ix, also cited in Jacob, "Tina Modotti a Hollywood," p. 220.

159 Edward Weston, February 22, 1924. EWA, Tucson.

160 Reported by Weston on March 12, 1924. Newhall, ed., *Daybooks of Edward Weston*, i, p. 56. In the words of Vidali, the Hollywood experience was regarded by Modotti as a *divertissement*. Vidali, Alberti, et al., *Tina Modotti*, n.p.

161 Valentina Agostinis, ed., *Tina Modotti: Vita, arte e Rivoluzione. Lettere a Edward Weston 1922–1931* (Milan: Feltrinelli, 1994), p. 19.

4 Mexico!

1 "Mexico lives in my life as a small, lost eagle that goes around in my veins. Only death will fold its wings on my sleeping soldier heart."

2 John A. Britton, *Revolution and Ideology: Images of the Mexican Revolution in the United States* (Lexington: University Press of Kentucky, 1995), p. 43.

3 *Gale's*, March 1919.

4 *Gale's*, October 1918–January/ February 1921; Karl Michael Schmitt, *Communism in Mexico: A Study in Political Frustration* (Austin: University of Texas Press, 1965), p. 4.

5 *Gale's: Journal of Revolutionary Communism*, vol. 3, no. 4, November 1919, pp. 4–5 and 30.

6 Ibid., vol. 3, no. 6, January 1920, pp. 6–7.

7 Ibid., vol. 3, nos. 11–12, June–July 1920, pp. 10–12.

8 Ibid., vol. 4, no. 2, September 1920, p. 8.

9 Emil Lyon, "The Italian 'Lock-in'," ibid., vol. 4, no. 3, October 1920, p. 28.

10 The Social Revolution in Germany," ibid., vol. 3, no. 10, May 1920, pp. 10–12.

11 Dr. O. B. Din, "The Turkish Question," ibid., vol. 4, no. 4, November 1920, p. 2.

12 Lionel Lynx, "Mexico and Australia compared," ibid., vol. 3, no. 10, May 1920, p. 27.

13 John Reed, "Aspects of the Russian Revolution," ibid., vol. 3, no. 4, November 1919, pp. 15–18.

14 Yone Basada, "Russia, Persia, India and Japan," ibid., vol. 4, no. 2, September 1920, p. 19.

15 George D. Coleman, "The Jew as a Revolutionist," ibid., vol. 4, no. 6–7, February 1921, p. 23.

16 George N. Falconer, "With Malatesta in Italy," ibid., vol. 4, no. 4, November 1920, p. 23.

17 Sen Katayama, "Japanese Women," ibid., vol. 3, no. 7, February 1920, pp. 12–13.

18 Ibid., vol. 3, no. 10, May 1920.

19 Cover drawing for ibid., vol. 4, no. 2, September 1920.

20 Victor Alba, *The Mexicans: The Making of a Nation* (New York: Praeger, 1967).

21 Introduction by Carlos Fuentes in *The Diary of Frida Kahlo* (Mexico City: Abrams, 1995), p. 9.

22 Miguel Covarrubias, *Mexico South: The Isthmus of Tehuantepec* (New York: Knopf, 1946), p. xxvi.

23 Kenneth Rexroth, *An Autobiographical Novel* (Garden City, N.Y.: Doubleday, 1966), p. 344. In the late 1920s Jackson Pollock was seduced by Mexico's art revival and thought of Mexico as Parnassus itself, even considering living there. Deborah

Solomon, *Jackson Pollock: A Biography* (New York: Cooper Square Press, 1987), pp. 43 and 259.

24 Britton, *Revolution and Ideology*, p. 37.

25 Robert A. Rosenstone, *Romantic Revolutionary: A Biography of John Reed* (New York: Vintage Books, 1981), p. 167. For the author, the power of *Insurgent Mexico* came from the close identification of Reed with his subject; he says that in composing the book the poet was stronger than the journalist. See also Jim Tuck, *Pancho Villa and John Reed: Two Faces of Romantic Revolution* (Tucson: University of Arizona Press, 1984), esp. pp. 103–20 on *Insurgent Mexico*. Tuck points out the factual errors with which Reed's book apparently abounds and in so doing debunks the myth of John Reed's Mexican assignment as a "drama of redemption."

26 Michael Gold, "John Reed: He Loved the People," in Joseph North, ed., *New Masses: An Anthology of the Rebel Thirties* (New York: International Publishers, 1969), p. 277.

27 John Dos Passos cited in Tuck, *Pancho Villa and John Reed*, p. 120.

28 The journalist and writer Carleton Beals, for example, who believed that when Mexican Indian art mixed with established art it lost its purity and perfection. Carleton Beals, *Mexico: An Interpretation* (New York: B. W. Huebsch, 1923).

29 Antonio Saborit, *Una mujer sin país: Las cartas de Tina Modotti a Edward Weston 1921–1931* (Mexico City: Cal y Arena, 1992), pp. 13–14.

30 Christiane Barckhausen-Canale, *Verdad y leyenda de Tina Modotti* (Havana: Casa de las Américas, 1989), p. 70; Saborit, *Una mujer sin país*, p. 14; and Margaret Hooks, *Tina Modotti: Photographer and Revolutionary* (London: Pandora, 1993), p. 43.

31 Anita Brenner, *The Wind That Swept Mexico* (New York: Harper & Brothers, 1943), p. 48, and photograph by European Picture Service (Paul Thompson), pl. 109. The book was the first published work in English on the history of the Mexican revolution. See also Bertram D. Wolfe, *A Life In Two Centuries: An Autobiography* (New York: Stein and Day, 1981), p. 284.

32 Linda B. Hall, *Alvaro Obregón: Power and Revolution in Mexico, 1911–1920* (College Station: Texas A & M University Press, 1991), pp. 120–39. Siqueiros had also fought on Obregón's side in one of the Red Battalions.

33 Tuck, *Pancho Villa and John Reed*, p. 186.

34 Donald Hodges and Ross Gandy, *Mexico 1910–1982: Reform or Revolution?* (London: Zed Press, 1983), pp. 26–27, and Mary Kay Vaughan, *The State, Education, and Social Class in Mexico, 1880–1928* (DeKalb: Northern Illinois University Press, 1982), passim.

35 Katherine Anne Porter, "The New Man and The New Order," *The Magazine of Mexico*, March 1921, in *Uncollected Early Prose of Katherine Anne Porter*, ed. Ruth M. Alvarez and Thomas F. Walsh (Austin: University of Texas Press, 1993), pp. 51–61.

36 Enrique Krauze, *Biografía del poder: Caudillos de la Revolución mexicana (1910–1940)* (Barcelona: Tusquets, 1997), p. 301. According to Krauze, Vasconcelos did not fully understand the almost religious implication of that line when he created it.

37 Raquel Tibol, *José Clemente Orozco: Una vida para el arte* (Mexico City: Cultura, 1984), p. 58.

38 José Vasconcelos, *Ulises criollo*. Part II: *La tormenta* (Mexico City: ediciones Botas, 1936), p. 555, and Part III: *El desastre* (Mexico City: ediciones Botas, 1951), p. 19. See also Alfonso Taracena, *José Vasconcelos* (Mexico City: Editorial Porrúa, 1982), p. 36. Taracena knew Vasconcelos at first hand and wrote more than one book on him.

39 *Boletín de la Universidad: Organo del Departamento universitario y de Bellas Artes IV Epoca*, tomo i, núm. 1, July 13, 1920, in José Vasconcelos, *Discursos 1920–1950* (Mexico City: ediciones Botas, 1950), p. 33.

40 John W. F. Dulles, *Yesterday in Mexico: A Chronicle of the Revolution, 1919–1936* (Austin: University of Texas Press, 1961), p. 121.

41 The sketch by Toño Salazar, for

example, depicted Vasconcelos sitting in the yoga lotus position. José Joaquín Blanco, *Se llamaba Vasconcelos: Una evocación crítica* (Mexico City: Fondo de cultura económica, 1977), facing p. 112.

42 Mildred Constantine, *Tina Modotti: A Fragile Life* (San Francisco: Chronicle Books, 1983), p. 53, and Pino Cacucci, *Tina* (Milan: Interno Giallo, 1991), p. 29.

43 Andrea Kettenmann, *Frida Kahlo 1907–1954: Pain and Passion* (Cologne: Taschen, 1992), p. 21.

44 Wolfe, *A Life In Two Centuries*, p. 286. In 1924 Vicente Lombardo Toledano criticized Vasconcelos's education policy (without openly mentioning Vasconcelos) for serving a class that was an enemy of the proletariat. Vicente Lombardo Toledano, *El problema del indio* (Mexico City: SepSetentas, 1973), p. 62.

45 Blanco, *Se llamaba Vasconcelos*, pp. 106–08.

46 Breton was actually speaking of Frida Kahlo, whose art he called *un ruban autour d'une bombe* (a ribbon around a bomb). André Breton, *Le Surréalisme et la peinture* (Paris: Gallimard, 1965), p. 144.

47 Robert Evans (?Joseph Freeman), "Painting and Politics: The Case of Diego Rivera," *New Masses*, February 1932.

48 Introduction by Carlos Fuentes in *Diary of Frida Kahlo*, p. 8.

49 Amy Conger, *Edward Weston in Mexico 1923–1926* (Albuquerque: University of New Mexico Press, 1983), p. 21. Weston comments in his diary on Porfirio Díaz's bad taste and adds that he should have been dethroned for aesthetic reasons, not political. Nancy Newhall, ed., *The Daybooks of Edward Weston* (New York: Aperture Foundation, 1981), I, p. 187. For the international image of Mexico in the *Fiestas del Centenario*, see Paul Garner, *Porfirio Díaz: Profiles in Power* (London: Pearson, 2001), pp. 158–59.

50 Diego Rivera lived in Paris for the second time from 1911 to July 1921. In his autobiography, written in English with Gladys March, see the scene in which the painter returns to Mexico and experiences "an esthetic exhilaration." Diego Rivera, *My*

Art, My Life: An Autobiography with Gladys March (New York: Citadel Press, 1960), p. 124. See also Florence Arquin, *Diego Rivera: The Shaping of an Artist, 1889–1921* (Norman: University of Oklahoma Press, 1971). Siqueiros, Alfredo Ramos Martínez, and Orozco returned from France. Orozco, *Autobiografía*, pp. 32 and 67, and Vittorio Vidali, *Spagna lunga battaglia* (Milan: Vangelista, 1975), p. 332.

51 Raymond Barrio, *Mexico's Art and Chicano Artists* (Sunnyvale, Calif.: Ventura Press, 1975), p. 36.

52 Orozco, *Autobiografía*, pp. 56–65. See the first encounter of Edward Weston with these murals in Mexico: Newhall, ed., *Daybooks of Edward Weston*, I, p. 17. See also the speech delivered by Vasconcelos on July 9, 1922 to inaugurate the building of the Ministry of Education. Vasconcelos, *Obra completas*, vol. IV (Mexico City: Libreros Mexicanos Unidos, 1958), pp. 796–803. The local bars or *pulquerías* were often called funny and comic names. For a list of them, see the part of the play "Tina Modotti" in which Modotti and Rivera raise each other on *pulquerías* titles. Víctor Hugo Rascón, *Tina Modotti y otras obras de teatro* (Mexico City: SEP, 1986), pp. 124–25.

53 José Clemente Orozco, *El artista en Nueva York (cartas a Jean Charlot, 1925–1929, y tres textos inéditos)* (Mexico City: Siglo XXI, 1971), p. 160.

54 Anita Brenner, *Idols behind Altars* (New York: Biblo and Tannen, 1929 and 1967), p. 250.

55 Conger, *Edward Weston in Mexico*, p. 20.

56 Arnaldo Córdova, *La revolución y el estado en México* (Mexico City: Era, 1989), p. 145.

57 Laura Mulvey and Peter Wollen, *Frida Kahlo and Tina Modotti*, exh. cat. (London: Whitechapel Art Gallery, 1982), p. 12.

58 Britton, *Revolution and Ideology*, p. 63.

59 Mulvey and Wollen, *Frida Kahlo and Tina Modotti*, p. 20. See also Charlot's testimonial in Jean Charlot, *The Mexican Mural Renaissance, 1920–1925* (New

Haven: Yale University Press, 1967), pp. 28–39.

60 For an explanation of Rivera's murals at the Ministry of Education see *Diego Rivera: Los murales en la Secretería de Educación Pública* (Mexico City: SEP, 1986).

61 Orozco, *Autobiografía*, p. 67.

62 Jean Franco, *The Modern Culture of Latin America: Society and the Artist* (Baltimore: Penguin, 1970), p. 155.

63 Barrio, *Mexico's Art and Chicano Artists*, p. 38, and Orozco, *Autobiografía*, pp. 66–67.

64 Orozco, *Autobiografía*, p. 64. On p. 68 Orozco says that to condemn easel painting as "aristocratic" means to condemn the majority of art at all times.

65 Alicia Azuela, "*El Machete* and *Frente a Frente*," *Art Journal*, vol. 52, no. 1, Spring 1993, p. 85.

66 Diego Rivera, "De pintura y otras cosas que no lo son," *La Falange*, December 1, 1922, pp. 270–71.

67 See a flaming red flyer in which the Syndicate of Painters and Sculptors voiced its protest against the university rector, Ezequiel A. Chávez, and a group of students who had vandalized the murals. *El Machete*, July 1–15, 1924. See also the prologue by Luis Cardona Y Aragón in Orozco, *El artista en Nueva York*, pp. 15–16, and the appendix by Jean Charlot, p. 145.

68 Bertram D. Wolfe, *Diego Rivera: His Life and Times* (New York: Knopf, 1943), p. 223.

69 Newhall, ed., *Daybooks of Edward Weston*, I, p. 158. In May 1926 Weston and Anita Brenner paid a visit to Orozco in Coyoacán.

70 Tamayo's *Mexican Worker with Machete* was printed on the cover of *New Masses*, August 1929, whose function and role are discussed later in this chapter.

71 Xavier Guerrero, *El que ne trabaja no come* (Who does not work does not eat), *New Masses*, September 1926, cover.

72 In contrast, the figure on the far right is María Antonieta Rivas Mercado, the promoter of a theater group called Ulysses. Rivera presents her in a white dress, with a 1920s hairstyle. She is handed a broom, to signify manual work.

73 Brenner, *Idols behind Altars*, p. 256.

74 Tibol, *José Clemente Orozco*, pp. 67–68.

75 Orozco, *Autobiografía*, pp. 66–67. See the chapter on the Syndicate in Brenner, *Idols behind Altars*, pp. 244–59. While Weston was in Mexico, Diego Rivera explained to him the meaning of this union. Newhall, ed., *Daybooks of Edward Weston*, I, p. 33. See also the comment on Siqueiros by Rexroth, who professed his strong likings for the Mexican painter. In a personal (and unique) reading of Siqueiros, Rexroth regarded the painter as "a completely genuine man, uncorrupted by politics." Rexroth, *Autobiographical Novel*, p. 344.

76 Sarah M. Lowe, *Frida Kahlo* (New York: Universe, 1991), p. 21.

77 "Manifiesto del Sindicato de Obreros Técnicos Pintores y Escultores," *El Machete*, no. 7, June 1924. Also cited in Brenner, *Idols behind Altars*, pp. 254–55, and Tibol, *José Clemente Orozco*, p. 70.

78 Orozco, *Autobiografía*, p. 62.

79 Ibid., pp. 68 and 70. It is interesting to note that when Plutarco Elías Calles became president in December 1924, Vasconcelos left his post of minister of education and the syndicate collapsed. The new minister of education, José Manuel Puig Casauranc, cut the funds for muralist art, keeping only Rivera employed in the ministry.

80 For Haya de la Torre's ideology and messianic–prophetic visions, see Frederick B. Pike, "Visions of Rebirth: The Spiritualist Facet of Peru's Haya de la Torre," *The Hispanic American Historical Review*, vol. 63, no. 3, August 1983, pp. 479–516.

81 V. R. Haya de la Torre, *El antimperialismo y el APRA* (Santiago, 1982), and Hodges and Gandy, *Mexico 1910–1982*, p. 2. It is believed that Haya de la Torre greatly influenced the Argentinian dictator Juan Domingo Perón, who studied Haya's argument for Latin American political unity. Ibid., p. 149. See also Jussi Pakkasvirta, *Un continente, una nación? Intelectuales latinoamericanos, comunidad política y las*

*revistas culturales en Costa Rica y en el Perú
(1919–1930)* (Tuusula, Finland: Academia
Scientiarum Fennica, 1997), pp. 93–104.

82 Most of Mella's attacks appeared in
El Machete. Raquel Tibol, *Julio Antonio
Mella en El Machete* (Mexico City: Fondo
de Cultura Popular, 1968), pp. 105–37. See
also Julio Antonio Mella, *Escritos revolu-
cionarios* (Mexico City: Siglo XXI, 1978), pp.
181–207. I wish to thank Christine Hatszky
for her enlightening suggestions on Mella's
criticism of the A.P.R.A. movement.

83 Hayden Herrera, *Frida Kahlo: The
Paintings* (New York and London: Harper-
Collins, 1991), p. 30.

84 Ibid., p. 30. In 1954, when Frida
Kahlo died, Iduarte gave a funeral oration in
her memory. See the photograph on p. 222.

85 These words of Diego Rivera's are
reported in Raquel Tibol, *Frida Kahlo: Una
vida abierta* (Mexico City: Oasis, 1983),
p. 97.

86 Lola Alvarez Bravo saw Kahlo "as
embodying her times." Lola Alvarez Bravo,
The Frida Kahlo Photographs, Introduction
and Interview by Salomon Grimberg,
curator, exh. cat. (Dallas: Society of Friends
of Mexican Culture, 1991), p. II/II. However,
Tibol records another theory, that Frida's
chronological change was made purely out of
vanity, since Kahlo had fallen in love with
Alejandro Gómez Arias, a younger man.
Raquel Tibol, "Algunas razones para juntar a
Frida y Tina en el Munal," *Proceso*, no. 344,
June 6, 1983, p. 50.

87 Herrera, *Frida Kahlo*, p. 6, and
Guadalupe Rivera Marín and Marie-Pierre
Colle Corcuera, *Las fiestas de Frida y Diego:
Recuerdos y recetas* (New York: Clarkson
Potter, 1994), p. 30. Herrera also suggests
that the long ruffled folk skirts, Tehuana
style, could hide the slight limp caused
by her injured right leg. See also Bárbara
Mujica, *frida: A Novel* (Woodstock and New
York: Overlook Press, 2001), pp. 25 and
207.

88 Kettenmann, *Frida Kahlo 1907–
1954*, p. 26.

89 Porfiriato is the common name for
the regime of Porfirio Díaz, the last pre-
revolutionary Mexican president who was in

power from 1876 to 1911, called Mexico's
Age of Iron since Díaz ruled as an absolute
dictator, re-electing himself over and over.
Díaz, who had "the soul of a white man
under his brown skin," was frequently
mocked by Mexican artists, who represented
him in his gala uniform, his chest covered
with heavy medals, as the 1908 caricature by
Miguel Covarrubias shows. Covarrubias,
Mexico South, p. 233.

90 Mulvey and Wollen, *Frida Kahlo
and Tina Modotti*, p. 8.

91 Wolfe, *Diego Rivera*, p. 126.

92 "Mexican Renaissance," in Mulvey
and Wollen, *Frida Kahlo and Tina Modotti*,
p. 8.

93 Sergei Eisenstein and Upton Sin-
clair, *The Making and Unmaking of "Que
Viva Mexico!,"* ed. Harry Geduld and
Ronald Gottesman (Bloomington: Indiana
University Press, 1934).

94 The debate was held at the Hotel
Brevoort, New York. Gladys Oaks, "Radical
Writer and Woman Artist Clash on Propa-
ganda and Its Uses," *New York World*, March
16, 1930. Also cited in Laurie Lisle, *Portrait of
an Artist* (New York: Washington Square
Press, 1987), p. 239. Gold insisted that
writers and artists employ proletarian themes
and advance the inevitable class struggle. In
1930, he published a novel, *Jews without
Money*, dealing with poverty in an urban
setting, specifically New York. James T.
Patterson, *America in the Twentieth Century: A
History* (New York: Harcourt, 1976), p. 217.

95 Robo de Richey, letter to Edward
Weston, December 23, 1921, EWA, Tucson.

96 Tina Modotti Richey, ed., *The Book
of Robo* (Los Angeles, 1923).

97 TM to EW, December 23, 1921,
EWA, Tucson.

98 Patricia Albers, *Shadows, Fire, Snow:
The Life of Tina Modotti* (New York:
Clarkson Potter, 1999), pp. 86–87.

99 Hooks, *Tina Modotti: Photographer
and Revolutionary*, p. 52. See also Borough,
"Art, Love and Death," n.p. See also
Constantine, *Tina Modotti*, p. 47.

100 Tina Modotti to Rose and
Marionne Richey, February 11, 1922, cited
in Albers, *Shadows, Fire, Snow*, p. 88.

101 Part of the letters and photographs sent by Modotti to Rose and Marionne Richey is presented by Patricia Albers in *Dear Vocio: Photographs by Tina Modotti*, exh. cat. (La Jolla: University Art Gallery, 1997).

102 Benvenuto Modotti to Tina Modotti, November 19, 1928. Comitato Tina Modotti, Udine.

103 Mine is the comment; the information is from Albers, *Shadows, Fire, Snow*, p. 46.

104 The photograph was taken by Modotti in 1927. Rose de Richey is standing near her son's tomb.

105 Modotti Richey, *Book of Robo*, Biographical Sketch.

106 Tina Modotti to Roy Rosen, March (19?) 1922, cited in Sarah M. Lowe, *Tina Modotti: Photographs*, p. 20.

107 News of the exhibition appeared in the *Boletín de la Secretária de Educación Pública* (Mexico City), vol. 1, no. 2, 1922, p. 198.

108 EW to Johan Hagemeyer, April 6, 1922, EWA, Tucson, also quoted in Valentina Agostinis, *Tina Modotti: Vita, arte e rivoluzione, lettere a Edward Weston 1922–1931* (Milan: Feltrinelli, 1994), p. 22. See also Newhall, ed., *Daybooks of Edward Weston*, I, p. 21, where the name of one of the buyers is given, de la Peña.

109 *El Universal Ilustrado*, 1922.

110 Obituary for Giuseppe Modotti, *L'Italia*, March 15, 1922. Giuseppe is remembered as an "excellent family man, patriot and father."

111 Guido Gabrielli, *La mia storia* (unpublished material). Italian American Collection, San Francisco Public Library.

112 Hooks, *Tina Modotti: Photographer and Revolutionary*, p. 55.

113 In 1930 Assunta, Mercedes, and Benvenuto, for reasons unknown, moved from San Francisco to Los Angeles and then, again for unknown reasons, returned to Italy. Beppo (Joseph) stayed in San Francisco. Robert D'Attilio, "Appunti per le future biografie di Tina Modotti: la famiglia Modotti a San Francisco," in Riccardo Toffoletti, ed., *Tina Modotti: Una vita nella*

storia (Udine: Arti Grafiche Friulane, 1995), pp. 326–27.

114 Newhall, ed., *Daybooks of Edward Weston*, I, pp. 113 and 43. On the same occasion, Weston called Los Angeles an "impossible village."

115 Puccini's *La fanciulla del west* was first performed in 1910, when the exotic, in this case, California, was popular in Europe.

116 Constantine, *Tina Modotti*, p. 46.

117 Tina Modotti to Hagemeyer, September 17, 1921. EW to JG correspondence, EWA, Tucson.

118 Tina Modotti to Hagemeyer, April 7, 1922. EW to JG correspondence, EWA, Tucson. This letter was signed Tina Modotti de Richey.

119 Enrico Caruso Jr. and Andrew Farkas, *Enrico Caruso: My Father and My Family* (Portland: Amadeus Press, 1990), p. 621. I am indebted to Riva Bacon and Richard Koprowski from the Stanford University Music Library for this information.

120 Ibid., p. 633, n. 174.

121 The song "Nina" was sung both by tenor and soprano voices. See the Decca 1974 recording *Eighteenth Century Arias* on which the soprano Renata Tebaldi sings it, accompanied by the New Philarmonia Orchestra, conducted by Richard Bonynge; and the compact disc *Arie antiche*, recorded on September 25, 1987 at Wyastone Leys, on which it is sung by the tenor Alfredo Kraus accompanied at the piano by José Tordesillas. The former attributes the song to Pergolesi with the full title; the second attributes it to Ciampi with the short title. In other versions, Paisiello himself is mentioned as the composer of the song "Tre giorni son che Nina" (not the opera aria "Nina").

122 Constantine, *Tina Modotti*, p. 46.

123 Richard Lorenz, "Johan Hagemeyer: A Lifetime of Camera Portraits." *The Archive*, no. 16, June 1982, pp. 7–8.

124 Ben Maddow, *Edward Weston* (New York: Aperture Press, 1973), p. 43.

125 EW to JH, July 25, 1920. Weston–Hagemeyer correspondence, EWA, Tucson. For the Weston–Hagemeyer friendship, see Paul Hill and Thomas Cooper, *Dialogue*

with Photography (New York: Farrar, Straus, and Giroux, 1979).

126 The property was eventually sold to Edward Poore, who had the Cottage built. Today this landmark is known as the Forest Lodge. I am grateful to the Forest Lodge and Suites for the information kindly provided.

127 Tina Modotti to Hagemeyer, April 7, 1922. EW to JG correspondence, EWA, Tucson.

5 Edward Weston

1 R. W. Borough, "Art, Love and Death: Widow Must Sell Batiks," *Los Angeles Examiner*, May 9, 1922, n.p.

2 Introduction by John Cowper Powys in Tina Modotti Richey, ed., *The Book of Robo* (Los Angeles, 1923).

3 Ibid., p. 43.

4 TM to EW, January 27, 1922. EWA, Tucson. A letter from April 1921 also gives an indication of their feelings.

5 Amy Stark, ed., *The Letters from Tina Modotti to Edward Weston*, in *The Archive* (Tucson: Center for Creative Photography), no. 22, January 1986, p. 12.

6 Handwritten *curriculum vitae*, EWA, Tucson.

7 Ben Maddow, *Edward Weston: His Life* (New York: Aperture, 1989), p. 57, and author's interview with Kim Weston, April 6, 1996.

8 Handwritten *curriculum vitae*, EWA, Tucson.

9 As of 2002, Cole is the only son alive. He lives in Northern California.

10 Weston, February 1, 1932. Nancy Newhall, ed., *The Daybooks of Edward Weston* (New York: Aperture Foundation, 1981), ii, p. 241.

11 Anthony Anderson, "Of Art and Artists," *Los Angeles Times*, November 12 and 26, 1922.

12 Anita Brenner, *Idols behind Altars* (New York: Biblo and Tannen, 1929 and 1967), p. 237.

13 Frida Kahlo too employed this stylization in her paintings. Andrea Ketten-mann, *Frida Kahlo 1907–1954: Pain and Passion* (Cologne: Taschen, 1992), p. 24.

14 Katherine Anne Porter, *Outline of Mexican Arts and Crafts* (Los Angeles: Young & McCallister, 1922), also cited in *Uncollected Early Prose of Katherine Anne Porter*, ed. Ruth M. Alvarez and Thomas F. Walsh (Austin: University of Texas Press, 1993), pp. 136–87.

15 Sarah M. Lowe, *Tina Modotti: Photographs* (New York: Abrams, 1995), p. 150, n. 196.

16 John A. Britton, *Revolution and Ideology: Images of the Mexican Revolution in the United States* (Lexington: University Press of Kentucky, 1995), p. 58.

17 Mildred Constantine, *Tina Modotti: A Fragile Life* (San Francisco: Chronicle Books, 1983), p. 55, and Maddow, *Edward Weston*, p. 48.

18 Edward Weston to his family, February 22, 1924, EWA, Tucson.

19 Gilles Mora, "Weston in Mexico," in Gilles Mora, ed., *Edward Weston: Forms of Passion* (New York: Abrams, 1995), p. 65.

20 Maddow, *Edward Weston*, p. 50.

21 Ibid. A source who wishes to remain anonymous has stated that it was Weston's wife who encouraged Chandler to accompany his father to Mexico, so the boy could report Weston's life and relationships to her.

22 *El Universal Ilustrado*, September 27, 1923.

23 Edward Weston to Flora C. Weston, October 16, 1923. EWA, Tucson.

24 The blacks who were not destroyed were forced into exile. Michael D'Orso, *Rosewood: Like Judgment Day* (New York: Boulevard, 1996). The incident was the subject of a film, called "Rosewood," directed by John Singleton in 1996.

25 David Vestal, "Tina's Trajectory," *Infinity*, no. 15, February 1966, p. 28.

26 Newhall, ed., *Daybooks of Edward Weston*, i, p. 82. He was referring to a meeting held in July 1924 at the home of Alfons Goldschmidt, a German radical professor living in Mexico. A "new Communist group" was supposedly created then.

27 Ibid., p. 196.

28 Ibid., p. 130.

29 Ibid., pp. 117–18.

30 TM to EW, October 22, 1922, now missing, quoted in Constantine, *Tina Modotti*, p. 55.

31 Newhall, ed., *Daybooks of Edward Weston*, I, pp. 5–6.

32 Tina Modotti de Richey, "Plenipotentiary," *The Dial*, May 1923, p. 474.

33 Francis Birrell, "Marcel Proust: The Prophet of Despair," *The Dial*, May 1923, pp. 463–74.

34 Benedetto Croce, "Walter Scott," *The Dial*, October 1923, pp. 325–31.

35 Luigi Pirandello, "The Man With The Flower In His Mouth," *The Dial*, October 1923, pp. 313–22.

36 *The Dial*, August 1923, pp. 170–72.

37 Bertrand Russell, "Leisure and Mechanism," *The Dial*, August 1923, pp. 105–22.

38 Amy Conger, "Tina Modotti: a Methodology, a Proposal and a Lost Love Letter," in Riccardo Toffoletti, ed., *Tina Modotti: Una vita nella storia* (Udine: Arti Grafiche Friulane, 1995), p. 294.

39 Maddow, *Edward Weston*, p. 50.

40 Newhall, ed., *Daybooks of Edward Weston*, I, p. 23. McGehee was believed to be much in love with Weston, and utterly devoted to him. Their relationship has been described as "delicate and complex." Maddow, *Edward Weston*, pp. 44 and 60–61. According to Mildred Constantine, Weston too "was most certainly bisexual, and in the final analysis loved no one but himself." Letter to Maddow, June 6, 1975. The J. Paul Getty Research Institute, Los Angeles.

41 Patricia Albers, *Shadows, Fire, Snow: The Life of Tina Modotti* (New York: Clarkson Potter, 1999), pp. 111 and 63.

42 Maddow, *Edward Weston*, p. 45.

43 Ibid., p. 50.

44 EWA, Tucson.

45 Newhall, ed., *Daybooks of Edward Weston*, I, p. 13.

46 Ibid., pp. 13, 14, and 22.

47 Ibid., p. 14.

48 Ibid.

49 Ibid.

50 Ibid.

51 Ibid., p. 15.

52 Ibid., pp. 15 and 20.

53 Ibid., p. 71.

54 Ibid., p. 15.

55 Ibid., pp. 18 and 24 (this last part refers to the ride to Xochimilco, an area that Modotti compared to her native Italy). The same comparison was also made by Wolfe, who found resemblances between the ways of life in the early Italian towns and those of modern Mexico City. Bertram D. Wolfe, *Diego Rivera: His Life and Times* (New York: Knopf, 1943), p. 216.

56 Newhall, ed., *Daybooks of Edward Weston*, I, p. 110.

57 Ibid., p. 89.

58 Ibid., p. 81.

59 Ibid., p. 181.

60 Amy Conger, *Edward Weston in Mexico 1923–1926* (Albuquerque: University of New Mexico Press, 1983), p. xix.

61 Newhall, ed., *Daybooks of Edward Weston*, I, p. 15.

62 Ibid., p. 64.

63 Ibid., p. 17.

64 Ibid., p. 21. Weston's comment ends with the exclamation "Viva Mexico!"

65 Ibid., p. 49. In corresponding with Weston, some people referred to Modotti as "the Signora Tina Modotti." Ross Parmenter, *Lawrence in Oaxaca* (Salt Lake City: Gibbs M. Smith, 1984), p. 142.

66 Ibid., p. 25.

67 Conger, *Edward Weston in Mexico*, p. 15.

68 Newhall, ed., *Daybooks of Edward Weston*, I, p. 25.

69 Ibid., pp. 27 and 25.

70 "Weton [*sic*], el Mago del Lente, Nos Abandona," *El Universal Ilustrado*, July 10, 1924.

71 Marius De Zayas, exhibition announcement, EWA, Tucson.

72 Edward Weston to Flora C. Weston, September 1, 1923. EWA, Tucson.

73 Ben Maddow, "Venus Beheaded: Weston and His Women," *The New Yorker*, February 24, 1975, p. 44.

74 Carleton Beals, *The Great Circle* (Philadelphia: J. B. Lippincott, 1940), p. 312.

75 Jesús Hernández, *Yo fuí un ministro de Stalin* (Mexico City: Editorial America, 1953), p. 344.

76 Just like the futurists, the *estridentistas* stressed the power of machines. Since it underlined the aesthetics and presented itself as an innovative art form, *estridentismo* came into conflict with muralism, which used traditional forms but with provocative social connotations. *Estridentista* poetry called itself the "music of ideas," exalting the sounds of words. The *estridentistas*, who were active for about seven years, met at the Café de nadie (Nobody's Café) in avenida Jalisco. In April 1924 Weston exhibited six photographs under their auspices. Newhall, ed., *Daybooks of Edward Weston*, I, p. 63. Manuel Maples Arce, a poet, was considered the ideologue of the movement. In 1923, following the first *manifiesto estridentista*, issued in Puebla on January 1 in response to "lethargic reactionarism" and "sugary sentimentalism," Maples Arce wrote that *estridentismo* was not a school or a tendency but a message of strategy, an expression, and an irruption. Among the followers were the sculptor Germán Cueto, who experimented with stone, bronze, and iron wire; the French writer and artist Jean Charlot; the Guatemalan writers Arqueles Vela, Salvador Gallardo, and the poet Germán List Arzubide, who in 1926 directed the magazine *Horizonte*, where some of Modotti's photographs were published. (See Arzubide's recollection in "Mi Amiga Tina Modotti," *Excelsior*, March 24, 1993, p. 1.) Modotti's photographs were supposed to illustrate Arzubide's book of poems, *El canto de los hombres*, but it was never published. Maricela Gonzáles Cruz Manjarrez, *Tina Modotti y el Muralismo Mexicano* (Mexico City: Universidad Nacional Autónoma de México, 1999), p. 11. Maples Arce edited the magazine *Irradiador* (1924), which published one of Weston's photographs. Luis Mario Schneider, *El estridentismo: una literatura de la estrategia* (Mexico City: Instituto Nacional de Bellas Artes, 1970); Germán List Arzubide, *El Movimiento Estridentista* (Jalapa, Veracruz: Horizonte, 1926/27), where Modotti's photograph of telegraph wires is reproduced on p. 55), and Pino Cacucci, *Tina* (Milan: Interno Giallo, 1991), pp. 34–37. See also Raquel Tibol, "El Estridentismo al Ataque en Casa del Lago," *Proceso*, no. 339, May 2, 1983, pp. 52–54, where Tibol mentions Modotti among the "plastic artists."

77 The letter, dated December 29, 1924, was entitled by Modotti "Morning coffee." EWA, Tucson.

78 Claudia Canales's interviews with Monna Alfau and Felipe Teixidor, Archivo de la Palabra, Instituto Histórico, Mexico City, also cited in Margaret Hooks, *Tina Modotti: Photographer and Revolutionary* (London: Pandora, 1993), p. 88.

79 Newhall, ed., *Daybooks of Edward Weston*, I, p. 20.

80 Ibid., p. 50.

81 Ibid., p. 102.

82 Ibid., p. 114.

83 Ibid., p. 118.

84 For a thorough analysis of these photographs and others mentioned in this book, the works of historians of photography must be consulted.

85 Newhall, ed., *Daybooks of Edward Weston*, I, p. 137.

86 Pete Hamill, *Diego Rivera* (New York: Abrams, 1999), p. 126. Hamill claims that in Rivera's work of the pre-Modotti period, there are virtually no nudes and that it was because of Tina that Rivera became interested in the female form.

87 Apparently, for her personal documents Modotti used primarily Weston's portraits of her: her Italian passport, issued by the Italian authorities in Mexico, the Union foto membership in Berlin, her visa for the Soviet Union. And it was a portrait attributed to Weston that was enlarged and shown at her funeral. Valentina Agostinis, *Tina Modotti: Vita, arte e rivoluzione, lettere a Edward Weston 1922–1931* (Milan: Feltrinelli, 1994), p. 45, n. 12.

88 Mildred Constantine, interview with Carlos Maria Orozco Romero, January 21, 1974. The J. Paul Getty Research Institute, Los Angeles.

89 Newhall, ed., *Daybooks of Edward Weston*, I, p. 22.

90 Baltazar Dromundo, in Christiane Barckhausen-Canale, *Verdad y leyenda de Tina Modotti* (Havana: Casa de las Américas, 1989), p. 86.

91 Pablo Neruda, *Confieso que he vivido* (Barcelona: Argos Vergara, 1974), p. 289; and Teresa Cirillo, *Neruda a Capri Sogno di un'isola* (Naples: La Conchiglia, 2001), p. 85.

92 Mildred Constantine, interview with Fernando Gamboa, January 20, 1974. The J. Paul Getty Research Institute, Los Angeles.

93 Monna Teixidor, in Barckhausen-Canale, *Verdad y leyenda*, p. 89.

94 Wolfe, *Diego Rivera*, p. 213.

95 Paul O' Higgins, reported in Constantine, *Tina Modotti*, p. 70.

96 Ibid., p. 97, citing the photographer Manuel Alvarez Bravo's comments.

97 The poet Juan de la Cabada cited in ibid., p. 176.

98 Lola Alvarez Bravo, *Recuento fotográfico* (Mexico City: editorial Penélope, 1982), p. 97.

99 Caroline Amor de Fournier to Mary Heath, November 29, 1971, in which Amor de Fournier states that in Mexico Modotti lived in the same street where her family lived, but their contacts were superficial despite the fact that Tina photographed Caroline. The J. Paul Getty Research Institute, Los Angeles.

100 Adriana Williams, *Covarrubias*, ed. Doris Ober (Austin: University of Texas Press, 1994), pp. 243 and 303–04. Cuevas added, though, that Covarrubias was the most beautiful of the three.

101 Barckhausen-Canale, *Verdad y leyenda*, pp. 88–89.

102 Vittorio Vidali, *Comandante Carlos* (Rome: Editori Riuniti, 1983), p. 70.

103 Constantine, *Tina Modotti*, p. 64, also reported in Cacucci, *Tina*, p. 178.

104 Constantine, *Tina Modotti*, p. 64, also reported in Cacucci, *Tina*, p. 34. Federico Marín was Lupe's brother.

105 Ione Robinson, *A Wall to Paint On* (New York: E. P. Dutton, 1946), pp. 85–86.

106 Constantine, *Tina Modotti*, p. 176.

107 Barckhausen-Canale, *Verdad y leyenda*, p. 276.

108 Mildred Constatine, "Mexican Encounters: My Contribution to the Rediscovery of Tina Modotti," in Toffoletti, ed., *Tina Modotti: Una vita nella storia*, p. 248. Constantine is one of the few people still alive who met Modotti. Mildred Constantine, correspondence with the author, June 7, 1999, and September, 2, 2002.

109 Barckhausen-Canale, *Verdad y leyenda*, p. 102.

110 Patrick Marnham, *Dreaming with His Eyes Open: A Life of Diego Rivera* (New York: Knopf, 1998), p. 182.

111 In 1910, Dr. Atl and other members of the art circle tried unsuccessfully to paint some murals at the Escuela Nacional Preparatoria (National Preparatory School), a plain, simple, antique building near the Zócalo, in the center of the capital. Before him, Juan Cordero had tried the same. In 1911, Atl (renamed "the Saint John Baptist of Mexican Art") spent some time in France, where he edited the paper *La révolution au Mexique*, together with Luis Quintanilla. He returned to Mexico in 1914, disguised as "an Italian," and soon after edited the paper *La Vanguardia*. MacKinley Helm, *Modern Mexican Painters* (Freeport, N.Y.: Books for Libraries Press, 1941), p. 1; José Clemente Orozco, *Autobiografía* (Mexico City: Era, 1970), p. 40; and Raquel Tibol, *José Clemente Orozco: Una vida para el arte* (Mexico: Cultura, 1984), p. 43. According to Rivera, "Atl's violent individualism took him to the extreme right and ultimately into the role of a fascist agent." Diego Rivera, *My Art, My Life: An Autobiography with Gladys March* (New York: Citadel Press, 1960), p. 48. According to other sources, in the late thirties "he reappeared as a not very successful propagandist for Germany." Bertram Wolfe, *A Life In Two Centuries: An Autobiography* (New York: Stein and Day, 1981), p. 300; Barckhausen-Canale, *Verdad y leyenda*, p. 103, who states that he became a Nazi sympathizer. She probably drew her information from Julián Gorkin, who quoted Trotsky. The Russian said that while living in Mexico he was accused by the Stalinists of having secret meetings with Dr. Atl, in collabora-

tion with the German fascists living in Mexico. Julián Gorkin, *Cómo asesinó Stalin a Trotsky* (Barcelona: Plaza & Janes, 1961), p. 50. See also Antonio Luna Arroyo, *El Dr. Atl: Sinopsis de su vida y su pintura* (Mexico City: Editorial Cultura, 1952); Arturo Casado Navarro, *Gerardo Murillo, el Dr. Atl* (Mexico City: Unam, 1984), and Adriana Malvido, *Nahui Olín, la mujer del sol* (Mexico City: editorial Diana, 1993), p. 112.

112 Carmen Mondragón (Olín), the daughter of the Porfirian general Manuel Mondragón, was a Mexican poet and painter, who had been married to the painter Manuel Rodríguez Lozano; she separated from him, alleging he was homosexual. In her past there was also an infant baby girl, who died in rather mysterious circumstances. Rumors said that perhaps she had choked the new born baby, although Carmen's family always denied that. Malvido, *Nahui Olín*, pp. 26–27. Olín made an interesting little painting of Weston, ed., currently kept at the Museo Estudio Diego Rivera, Mexico City.

113 The quote refers to a party in which Lupe was dressed in red and gold. Newhall, *Daybooks of Edward Weston*, I, p. 41.

114 Barckhausen-Canale, *Verdad y leyenda*, p. 76.

115 Carlos Monsivais, Foreword to Susannah Joel Glusker, *Anita Brenner: A Mind of Her Own* (Austin: University of Texas Press, 1998), p. xi.

116 Newhall, ed., *Daybooks of Edward Weston*, I, p. 17.

117 Britton, *Revolution and Ideology*, p. 51. The same phenomenon occurred in the United States during the 1960s when, among certain radicals, China was believed to be the place which better articulated a revolution, in practical as well as theoretical terms.

118 Newhall, ed., *Daybooks of Edward Weston*, I, p. 65.

119 Ibid., p. 70.

120 Ibid.

121 Ibid., p. 73.

122 The *Chauve-Souris* is mentioned as *The Theatre of the Bat* by D. H. Lawrence,

who spent the winter of 1924/25 in Mexico. Ross Parmenter, *Lawrence in Oaxaca* (Salt Lake City: Gibbs M. Smith, 1984), p. 8.

123 Newhall, ed., *Daybooks of Edward Weston*, I, p. 92.

124 Ibid., p. 100. The prints appeared in the November 15, 1924 issue of *La Antorcha*, a journal of "Letras, Arte, Ciencia y Industria."

125 Newhall, ed., *Daybooks of Edward Weston*, I, p. 104.

126 EWA, Tucson.

127 Carlos Garcés, "Tina Modotti en la leyenda y la verdad, con Christiane Barckhausen-Canale," *Casa de las Américas* (Havana), November 1988, p. 113.

128 Newhall, ed., *Daybooks of Edward Weston*, I, p. 75.

129 Ibid., p. 77.

130 Ibid., p. 75. The incident took place in front of the Hotel Princess in Mexico City, and was narrated by Weston to his son Brett in a letter of May 29, 1924.

131 Ibid., p. 166.

132 Ibid., p. 160.

133 Ibid., p. 147.

134 Ibid., p. 155.

135 Ibid., pp. 132–33. Weston's photograph of the toilet, entitled *Excusado*, has been regarded as a surrealist masterpiece by historians of photography.

136 Ibid., p. 147.

137 Ibid., p. 88.

138 José Vasconcelos, *Memorias*, II: *El desastre: El Proconsulado* (Mexico City: Fondo de Cultura económica, 1982), pp. 64–65. See also Wolfe, *Diego Rivera*, pp. 213–14. (Words like these reveal the writer more than the target.) Others have described Modotti as "voluptuous," "model, student, paramour," Britton, *Revolution and Ideology*, p. 53; and "high-class courtesan, Mata Hari for the Comintern," Kenneth Rexroth, *An Autobiographical Novel* (Garden City, N.Y.: Doubleday, 1966), p. 344.

139 When he was no longer minister of education, in 1924, Vasconcelos denounced even Rivera's work, although he had recalled the painter from Europe for a project for which he as minister took full credit. According to Wolfe, Rivera was becoming

more and more revolutionary in his work and Vasconcelos more and more reactionary. Wolfe, *Diego Rivera*, p. 232. Rivera's response to Vasconcelos was again a witty mural *Los sabios* (The Learned) for the Ministry of Education, in which the former minister is depicted sitting on a white Indian elephant, holding a poet's pen and turning his back on the true culture of Mexico. Rivera shows how impractical Vasconcelos was as an educator and how detached from the country's reality. The elephant, as Rivera explained to an American, was supposed to be "a fancy toilet," piled high on each side with books by Aristotle and Plato – two authors translated by Vasconcelos. Robinson, *A Wall to Paint On*, p. 84. Others have interpreted the white elephant as the fancy the minister took to Eastern philosophies. Rivera called Vasconcelos "a mystical nut." Ibid. For Vasconcelos's orientalism, see José C. Maríategui, "Indología por José Vasconcelos," in Julio Antonio Mella, José C. Maríategui, Juan Marinello, and Aníbal Ponce, *Marxistas de America* (Managua: editorial Nueva Nicaragua, 1985). Vasconcelos disliked animals in general (he used to call Rivera "frog"), so the offense was even worse. José Joaquín Blanco, *Se llamaba Vasconcelos: Una evocación crítica* (Mexico City: Fondo de cultura económica, 1977), p. 194. (By an odd coincidence, Rivera's Vasconcelos bears a strong resemblance in posture and shape of ears to the former prime minister of Italy, Giulio Andreotti, whose Catholic beliefs did not prevent him from supposedly becoming entangled in a mafia affair and in the murder of a journalist, for which he was tried and twice acquitted in 1999, but found guilty in fall 2002.) In 1940 Vasconcelos founded the magazine *Timón*, which was openly in favor of Mussolini and Hitler. Blanco, *Se llamaba Vasconcelos*, p. 171. It has always been a mystery how somebody with so much vision, who as minister of education supported and funded women's anthologies (one prepared by the Chilean poet Gabriela Mistral), could later turn against women and away from the women's question. According to one theory, Vasconcelos always remained an *hombre de frontera*

(border man) trapped between two worlds; he was mainly a conservative, with sporadic progressive moments in his youth, and overall took a paternalistic view of Mexican Indians.

140 Modotti too photographed a bullfight in Oaxaca, concentrating on the audience.

141 From December 7, 1923 to March 1924 there was a rebellion that coincided with the new presidency of Plutarco Elías Calles, a schoolteacher from Guaymas, Sonora. The dissidents supported Adolfo de la Huerta, who had been interim president from June to November 1920. Among the leftists murdered by the dissidents was Felipe Carrillo Puerta, a socialist governor of Yucatán, who in 1916 had created a leftist government. He was killed with members of his family. In March 1924 the government crushed the rebels. De la Huerta escaped to Los Angeles, where he earned his living as a singing teacher. He later returned to Mexico under the Cárdenas government. Anita Brenner, *The Wind That Swept Mexico* (New York: Harper, 1943), p. 72.

142 Mildred Constantine, interview with Carlos María Orozco, January 21, 1974. The J. Paul Getty Research Institute, Los Angeles.

143 Their stormy relationship was the subject of a short novel, "The Lovely Legend," by Katherine Anne Porter, in *Uncollected Early Prose of Katherine Anne Porter*, ed. Ruth M. Alvarez and Thomas F. Walsh (Austin: University of Texas Press, 1993), pp. 204–17.

144 Newhall, ed., *Daybooks of Edward Weston*, i, p. 136.

145 For prices of daily items, see Carleton Beals, *Mexico: An Interpretation* (New York: B. W. Huebsch, 1923), pp. 118–19.

146 Although illiterate, Elisa was quick, intelligent, hardworking, and appreciative. Newhall, ed., *Daybooks of Edward Weston*, i, pp. 33 and 74. After Weston returned to California, Ortíz emigrated there with her sister to work for him. Ibid., ii, p. 26.

147 Britton, *Revolution and Ideology*, p. 53. Britton points out that the parallel with

Greenwich Village is, however, imprecise, because the Mexico City group was more widely dispersed throughout the city and in rural areas.

148 Newhall, ed., *Daybooks of Edward Weston*, II, p. 55.

149 This party occurred during Weston's second trip to Mexico, in 1925 (he mentioned that his son Brett was there, dressed "as a California Bathing Beauty"). Ibid., p. 127. Chandler had returned to California to stay.

150 Ibid., pp. 87–88.

151 Ibid., p. 81.

152 José Domingo Cabús, "El asesinado de Julio Antonio Mella," *Trinchera*, October 20, 1963, p. 22.

153 Raymond Barrio, *Mexico's Art and Chicano Artists* (Sunnyvale: Ventura Press, 1975), p. 41.

154 Arnoldo Martínez Verdugo, ed., *Historia del comunismo en México* (Mexico City: colección enlace 1983), p. 58.

155 Robert J. Alexander, *Trotskyism in Latin America* (Stanford: Hoover Institution Press, 1973), p. 194.

156 Wolfe, *Diego Rivera*, p. 248. Bertram D. Wolfe, *The Fabulous Life of Diego Rivera* (New York: Knopf, 1963), pp. 226–28. I should like to underline that I am quoting from both books by Wolfe, written twenty years apart. But whenever possible I use his first version of 1943, not only because some information is given only in that edition, but especially because Wolfe was then still an idealist and less cynical about politics and human nature in general. At any rate, Rivera himself was not pleased with the first edition, which he said was "not very Marxist at all." Letter from Rivera to Wolfe, March 19, 1939. Bertram Wolfe Collection, box # 12, folder no. 54, Hoover Institution, Stanford.

157 Wolfe, *Diego Rivera*, pp. 204–05. Another comment on the impracticality of Rivera can be found in van Heijenoort: Rivera "was the least gifted person in the world to serve as secretary of anything whatsoever." Jean van Heijenoort, *With Trotsky in Exile: From Prinkipo to Coyoacán* (Cam-

bridge, Mass.: Harvard University Press, 1978), p. 136.

158 Bertram D. Wolfe, "Art and Revolution," *Nation*, 1924, pp. 207–08.

159 The comment was made in January 1924. Newhall, ed., *Daybooks of Edward Weston*, I, p. 45.

6 The Party Calls

1 "A Call to Action," poem by Ch'iu Chin from *The Orchid Boat: Women Poets of China*, trans. and ed. Kenneth Rexroth and Ling Chung (New York: Seabury Press, 1972), p. 80. Ch'iu Chin (?1879–1907), a Chinese poet, was trained in Japan in 1904–06 where she joined Sun Yat-Sen's revolutionary party and soon rose to leadership. In 1906 she returned to China to teach in school and founded a newspaper for women in Shanghai. In 1907 she joined the staff of a school that served as the secret headquarters and arsenal for the revolutionary army. In June 1907 she was arrested by the Manchu government. At her trial her poems were used as evidence of treason. She was beheaded on July 15, 1907, less than five years before the overthrow of the Manchu Dynasty.

2 Jim Seymour's *Sacco and Vanzetti* was first printed in *Industrial Pioneer* in December 1921. Joyce L. Kornbluh ed., *Rebel Voices: An I. W. W. Anthology* (Ann Arbor: University of Michigan Press, 1964), p. 358.

3 Kenneth Rexroth, *An Autobiographical Novel* (Garden City, N.Y.: Doubleday, 1966), p. 367. He continues, "The world in which . . . I had grown up came forever to the end."

4 *New Masses*, September 1928.

5 Vittorio Vidali, "Per questo ci uccideranno," *Rinascita*, August 6, 1971, p. 15, n. 32. The text of a letter from Vanzetti to Vidali, as Sormenti, appears in ibid., p. 16. Katherine Anne Porter, "The Never-Ending Wrong," *The Atlantic Monthly*, vol. 239, no. 6, June 1977, p. 56; Francis Russell, "The Never-Ending Wrong," *National Review*, August 17, 1973, p. 887. Philip V. Cannistraro, "Mussolini, Sacco–Vanzetti,

and the Anarchists: The Transatlantic Context," *The Journal of Modern History*, vol. 68, no. 1, March 1996, pp. 31–62. *L'Italia* tried to interest the Italian community of California in the case. "Pro Sacco e Vanzetti: L'appello del Comitato di Difesa ai Lavoratori Italiani," October 15, 1921; "Pro Sacco e Vanzetti: L'interessante articolo di un giornale americano," October 13, 1921; and "Pro Sacco e Vanzetti: La grande serata del 6 novembre al Crescent Theatre," October 27, 1921.

6 Arnoldo Martínez Verdugo, ed., *Historia del comunismo en México* (Mexico City: colección enlace 1983), p. 414. Even after 1927 the Sacco–Vanzetti case, especially the execution, remained in people's minds. *El Machete* celebrated the anniversaries of their deaths: "23 [22] de Agosto: Sacco y Vanzetti," July 1930; "El Aniversario de Sacco Vanzetti es un día de lucha por nuestros presos," August 1930; "La Jornada Sacco Vanzetti," August 30, 1931; and "La Jornada Sacco y Vanzetti," September 10, 1932.

7 For Vidali's youth, see his *Orizzonti di libertà* (Milan: Vangelista, 1980), a sort of spiritual testimony and by far the best of his books.

8 Ibid., p. 221.

9 Enea Sormenti (alias Vittorio Vidali) to Nino Capraro, September 10, 1927, from Riga, Latvia. Capraro Papers, box 3, folder Enea Sormenti, Immigration History Research Center, Minneapolis. I thank Rudolph Vecoli for giving me access to this document.

10 Vittorio Vidali, *Missione a Berlino* (Milan: Vangelista, 1978), p. 67. Guttuso's cover design depicts Vidali in the middle of a storm, holding a red flag. "Carlos" in the dedication was one of Vidali's aliases.

11 Among the ship's passengers there was another activist, Maya Kowski. Concepción Ruiz-Funes, interview with Vittorio Vidali, April 28–May 1, 1979. Courtesy of the Vidali family.

12 Isaac Don Levine, *The Mind of an Assassin* (New York: Farrar, Straus, and Cudahy, 1959), p. 70.

13 Andreu Castells, *Las Brigadas Inter-*

nacionales de la guerra de España (Barcelona: Ariel, 1974), p. 40, n. 55.

14 In commenting on the attempt, the socialists wrote: "When all freedoms are suppressed, only acts can talk." Filippo Turati, "De Rosa," *L'Italia*, November 1, 1929. By fatal coincidence, De Rosa died on September 15, 1936, the day of Humbert of Savoy's birthday, while fighting with the republicans in the Spanish Civil War. Pietro Nenni, "Italiani che onorano il popolo d'Italia: Fernando De Rosa," in *Garibaldini in Ispagna* (Madrid: Diana, 1937), pp. 31–33. See also Giorgio Candeloro, *Storia dell'Italia moderna*, vol. ix: *Il fascismo e le sue guerre* (Milan: Feltrinelli, 1986), p. 407.

15 Theodore Draper, *American Communism and Soviet Russia* (New York: Viking, 1960), p. 179.

16 *El Universal*, December 18, 1924.

17 Nancy Newhall, ed., *The Daybooks of Edward Weston* (New York: Aperture Foundation, 1981), i, p. 125.

18 Ibid., p. 127, and *El Sol*, August 31, 1925. For Weston's second period in Mexico, see Amy Conger, *Edward Weston in Mexico 1923–1926* (Albuquerque: University of New Mexico Press, 1983), pp. 41–69.

19 J. M. H., "Mañana se clausurá la magnifica exposición de Weston y Modotti," *El Sol*, iii, no. 641, September 5, 1925, also in Newhall, ed., *Daybooks of Edward Weston*, i ,
p. 128.

20 S. Echeverria, (no title indicated), September 5, 1925, from a newspaper clipping in EWA, Tucson.

21 David Alfaro Siqueiros, "Una trascendental labor fotográfica: La Exposición de Weston–Modotti," *El Informador* (Guadalajara), September 4, 1925, p. 6. Also cited in Newhall, ed., *Daybooks of Edward Weston*, i, p. 129.

22 José M. Peña, "La Bella y Genial Artista Italiana Tina Modotti, y su Excelso Arte Fotográfico," *El Sol*, iii, no. 635, August 29, 1925.

23 Newhall, ed., *Daybooks of Edward Weston*, i, p. 129.

24 Carleton Beals, *Glass Houses: Ten Years of Free Lancing* (Philadelphia: J. B. Lippincott, 1938), p. 243.

25 Ibid., p. 181.

26 Carleton Beals, *The Great Circle* (Philadelphia: J. B. Lippincott, 1940).

27 Newhall, ed., *Daybooks of Edward Weston*, I, p. 152.

28 Octavio Paz, "Frida y Tina: vidas no paralelas," *Vuelta*, vol. 7, no. 82, September 1983, p. 48. This claim was questioned by Andrea Noble, who observes that if Modotti belongs to the history of passion it is "because critics like Paz choose to consign her to that place." Andrea Noble, *Tina Modotti: Image, Texture, Photography* (Albuquerque: University of New Mexico Press, 2000), p. 40.

29 Carleton Beals, "Tina Modotti," *Creative Art*, February 1929, vol. 4, no. 2, p. xlvii, repr. Laura Mulvey and Peter Wollen, *Frida Kahlo and Tina Modotti*, exh. cat. (London: Whitechapel Art Gallery, 1982), p. 30.

30 *El Universal Ilustrado*, September 27, 1923.

31 TM to EW, January 23, 1926, EWA, Tucson.

32 Anita Brenner, *The Wind That Swept Mexico* (New York: Harper & Brothers, 1943), p. 292. Brenner refers to a photograph of Emiliano Zapata, taken by an unidentified photographer. Modotti produced the print out of a battered negative.

33 Diego Rivera, "Edward Weston and Tina Modotti," *Mexican Folkways*, 2, April–May 1926, p. 6.

34 Amy Stark, ed., *The Letters from Tina Modotti to Edward Weston*, in *The Archive*, no. 22, January 1986 (Tucson: Center for Creative Photography, 1986), p. 33.

35 TM to EW, February 9, 1926. EWA, Tucson.

36 For the details of the project, see Conger, *Edward Weston in Mexico*, pp. 47–60. For analysis and identification of the photo-graphs, see Patricia Albers, *Dear Vocio: Photographs by Tina Modotti*, exh. cat. (La Jolla: University Art Gallery, 1997), pp. 31–41.

37 For background and the gestation of Brenner's *Idols behind Altars*, see Susannah Joel Glusker, *Anita Brenner: A Mind of Her Own* (Austin: University of Texas Press, 1998), pp. 97–110 (a revision of Glusker's 1995 Ph.D. diss. of the same title at Union Institute, Los Angeles, Calif.

38 Newhall, ed., *Daybooks of Edward Weston*, I, p. 156. According to Brenner's journal, though, negotiations started the previous year.

39 Ben Maddow, *Edward Weston* (New York: Aperture, 1973), p. 73.

40 Marie Brenner, *The Great Dames* (New York: Crown, 2000) p. 230. I am grateful to Leslie Ann Coles for pointing out this book to me.

41 Newhall, ed., *Daybooks of Edward Weston*, I, p. 133.

42 Glusker, *Anita Brenner*, p. 68. I am grateful to Susannah Joel Glusker for precious information on her mother. Author's correspondence with Ms. Glusker, 1995–96.

43 Ibid., p. 69.

44 Ibid., p. 68.

45 Mildred Constantine, interview with Anita Brenner, n.d. The J. Paul Getty Research Institute, Los Angeles.

46 Glusker, *Anita Brenner*, p. 68. The comments are dated February 17, 1927. According to Brenner, Francisco Goitia (1882–1960) was among the best artists of the time, but he is rarely mentioned because he was a hermit-like loner and did not truly belong to the Rivera group. Ibid., p. 60. However, Weston mentions him briefly in his diary: Newhall, ed., *Daybooks of Edward Weston*, I, p. 197; II, p. 143.

47 Glusker, "Anita Brenner: A Mind of Her Own," Ph.D. diss., Union Institute, Los Angeles, 1995, p. 157. When Glusker converted her dissertation into a book, Brenner's comment about "unethical comrades" was deleted. Glusker, *Anita Brenner*, p. 107. Apparently, there were others too – Orozco complained to Charlot about Francis Toor reproducing one of his drawings without the author's permission. José Clemente Orozco, *The Artist in New York: Letters to Jean Charlot and Unpublished Writings, 1925–1929* (Austin: University of Texas Press, 1974), p. 25.

48 Anita Brenner, *Idols behind Altars*

(New York: Biblo and Tannen, 1929), acknowledgment.

49 Modotti to Brenner, October 9, 1929. Glusker, *Anita Brenner*, p. 109.

50 Ernestine Evans, untitled, *Creative Art*, February 1930.

51 Glusker, *Anita Brenner*, p. 98.

52 The attack, which came from an American Stalinist, Joseph Freeman, was based on somewhat simplistic categories and definitions. While accusing Brenner of limited vision, he did not realize that his vision was at least equally limited, though in a different direction. Joseph Freeman, "The Well-Paid Art of Lying," *New Masses*, no. 7, October 1931, p. 1011.

53 Antonieta Rivas Mercado, *87 Cartas de amor y otros papeles*, ed. Isaac Rojas Rosillo (Veracruz: Universidad Veracruzana, 1981), p. 77. The irony of all this is that Rivas Mercado herself claimed to be of Jewish origins.

54 Ibid., p. 82. Part of the bitterness felt by Rivas Mercado came from the fact that Brenner did not mention Manuel Rodríguez Lozano, with whom Rivas Mercado was then in love.

55 Carleton Beals, "Goat's Head on a Martyr," *The Saturday Review of Literature*, vol. 6, no. 20, December 7, 1929, p. 505. Beals points out that Brenner's treatment of Diego Rivera, though good, "seems inadequate."

56 See "The Dark Madonna," in Brenner, *Idols behind Altars*, pp. 127–56.

57 John A. Britton, *Revolution and Ideology: Images of the Mexican Revolution in the United States* (Lexington: University Press of Kentucky, 1995), p. 100.

58 Conger, *Edward Weston in Mexico*, p. 51.

59 Tim Golden, "Mexican Myth and Master of Photographic Images," *The New York Times*, December 16, 1993, p. B4.

60 *S. M. Eisenstein: Dibujos mexicanos ineditos* (Mexico City: Dirección de Cinematografía de la Dirección General de Radio, Televisión y Cine, 1978). See also C. M. Arconada, "Eisenstein–Upton Sinclair," *Octubre* (Madrid), no. 3, August–September 1933, pp. 24 and 31; and Sergei Eisenstein and Upton Sinclair,

The Making and Unmaking of Que Viva Mexico!, ed. Harry M. Gedul and Ronald Gottesman (Bloomington: Indiana University Press, 1970).

61 Newhall, ed., *Daybooks of Edward Weston*, i, p. 175. By this time Modotti had overcome what Albers calls her "initial suspicion of lower class Mexicans," judging by her letter of February 4, 1922 to Rose Richey, in which she expresses her anxiety for the faces around her. Albers, *Dear Vocio*, p. 25.

62 Newhall, ed., *Daybooks of Edward Weston*, i, pp. 178 and 182. Galván is recorded by Weston as a music lover who would play the guitar and sing at their parties. Weston took an interesting photograph of him.

63 This is the main accusation against the Catholic Church in Mexico by Ernest Gruening in *Mexico and its Heritage* (New York: Century, 1928).

64 Víctor Ceja Reyes, *Los Cristeros: Crónica de los que perdieron* (Mexico City: Grijalbo, 1981), p. 22. See also David C. Bailey, *Viva Cristo Rey: The Cristero Rebellion and the Church–State Conflict in Mexico* (Austin: University of Texas Press, 1974).

65 Reyes, *Los Cristeros*, p. 30. The author, a journalist who had a first-hand account of the event, claims that it was the ecclesiastical authorities who decided not to intervene in July 1926, to avoid further violence. Ibid., p. 51. Modotti wrote the same to Weston, June 6, [1928], EWA, Tucson. See also Jean Meyer, *La Cristiada: El conflicto entre la iglesia y el estado 1926–1929* (Mexico City: Siglo XXI, 1973).

66 Brenner, *The Wind That Swept Mexico*, p. 78. See also John Dos Passos, "Relief Map of Mexico," *New Masses*, April 1927, p. 24.

67 Brenner, *The Wind That Swept Mexico*, p. 78.

68 For perceptions of the church–state conflict in the U.S.A., see Britton, *Revolution and Ideology*, pp. 96–99.

69 Albers, *Dear Vocio*, fig. 22 and p. 46.

70 John W. F. Dulles, *Yesterday in Mexico: A Chronicle of the Revolution, 1919–1936* (Austin: University of Texas Press, 1961), pp. 312–15.

71 Kim (Julio Antonio Mella), "Fanatismo," *El Machete*, IV, no. 136, August 11, 1928, also cited in Raquel Tibol, *Julio Antonio Mella en El Machete: Antologia parcial de un luchador y su momento histórico* (Mexico City: Fondo de Cultura Popular, 1968), pp. 292–93. In the same issue of *El Machete*, see "En Nueva York y Roma se tramó el asesinato de Obregón" (unsigned).

72 Beals, *Great Circle*, p. 206.

73 Brenner, *The Wind That Swept Mexico*, p. 79. Pl. 139 reproduces the photograph taken five minutes before Obregón's assassination.

74 Dulles, *Yesterday in Mexico*, p. 399.

75 At the Islas María penitentiary, Mother Conchita married one of her disciples, also imprisoned. Beals, *Great Circle*, p. 208.

76 Manuel Plana, "Il Messico degli anni venti," in Riccardo Toffoletti, ed., *Tina Modotti: Una vita nella storia* (Udine: Arti Grafiche Friulane, 1995), p. 146.

77 Dulles estimated the number as between 800 and 1,000. Dulles, *Yesterday in Mexico*, p. 463.

78 He promised an amnesty for the rebels and the return of religious rituals. Church bells rang again on Sunday, June 30, 1929.

79 Edward Weston, "Photography," *Mexican Life*, vol. 2, no. 4, June 1926, pp. 16–17, repr. in *Edward Weston on Photography*, ed. Peter C. Bunnell (Salt Lake City: Gibbs M. Smith, 1983), p. 45. Many thanks to Amy Conger for pointing out this article to me.

80 Adriana Williams, *Covarrubias*, ed. Doris Ober (Austin: University of Texas Press, 1994), p. 46.

81 Ibid., p. 46. Strangely enough, though, Weston, who was usually accurate and precise in his diary, mentioned no teaching of photography to Rosa Covarrubias in this period or any other. And none of Modotti's biographers mentions it. However, many of the photographs in one of Miguel Covarrubias's books are by Rosa. Miguel Covarrubias, *Mexico South: The Isthmus of Tehuantepec* (New York: Knopf, 1946).

82 Newhall, ed., *Daybooks of Edward Weston*, I, p. 202.

83 Ibid.

84 Letter, March 22, 1927, EWA, Tucson.

85 Letter, June 4, 1927, EWA, Tucson.

86 Gary Higgins, *Truth, Myth, and Erasure: Tina Modotti and Edward Weston*. History of Photography Monograph Series, 28 (Tempe: Arizona State University Press, 1991), n.p.

87 TM to EW, January 23, 1926 (handwritten). EWA, Tucson.

88 Cacucci, *Tina*, p. 41.

89 Claudio Natoli, "Tra solidarietà e rivoluzione: Il Soccorso Rosso Internazionale," in Toffoletti, ed., *Tina Modotti: Una vita nella storia*, p. 194.

90 Mildred Constantine, interview with Carlos María Orozco, January 21, 1974. The J. Paul Getty Research Institute, Los Angeles.

91 Lola Alvarez Bravo, *Recuento fotográfico* (Mexico City: editorial Penelope, 1982), p. 97.

92 Robinson, *A Wall to Paint On*, p. 86.

93 In 1929 Modotti gave a party to celebrate Siqueiros's release from an Argentinian prison. Ibid., p. 98.

94 Mildred Constantine, interview with Manuel Alvarez Bravo, January 21 and April 11, 1974. The J. Paul Getty Research Institute, Los Angeles.

95 Ibid.

96 Conversazione con Vittorio Vidali," ed. Riccardo Toffoletti, *Perimmagine*, July–September 1993, n.p.

97 On May 15, 1927 Brenner wrote in her journal that Modotti was in the company of this German doctor at Lola Cueto's home. Glusker, "Anita Brenner," p. 100. Lola and Gérman Cueto, both artists, had created a collective art workshop, and were renting several houses to the artists involved in the project.

98 *El Machete*, no. 51, September 30, 1926, p. 4, with a photograph.

99 Kollontai's last and most famous

diplomatic appointment came in 1930, when she became Soviet ambassador to Sweden, the first woman in modern history to hold full ambassadorial rank. Vidali met her in Stockholm in 1935. Vidali, *Comandante Carlos*, p. 82. In 1946, because of her peacemaking efforts, Kollontai received the Nobel Prize for Peace. Richard Stites, "Alexandra Kollontai and the Russian Revolution," in *European Women on the Left: Socialism, Feminism, and the Problems Faced by Political Women, 1880 to the Present*, ed. Jane Slaughter and Robert Kern (Westport: Greenwood Press, 1981), pp. 118–19; Marie Marmo Mullaney, *Revolutionary Women: Gender and the Socialist Revolutionary Role* (New York: Praeger, 1983), p. 91; Rosario Ferré, "En defensa del pájaro blanco," in *Sitio & Eros: Trece Ensayos Literarios* (Mexico City: J. Mortiz, 1980), pp. 85–96; and Elizabeth A. Wood, *The Baba and the Comrade: Gender and Politics in Revolutionary Russia* (Bloomington: Indiana University Press, 1997).

100 Harry Thayer Mahoney and Marjorie Locke Mahoney, *Espionage in Mexico: The 20th Century* (San Francisco: Austin & Winfield, 1997), p. 172.

101 Alix Holt, ed. and trans., *Alexandra Kollontai: Selected Writings* (New York: Norton, 1977), p. 21.

102 Vittorio Vidali, *Ritratto di donna: Tina Modotti* (Milan: Vangelista, 1982), p. 40. Modotti even gave Kollontai her famous photograph *Calla Lily*, recently sold to an American collector for $200,000, the highest known price paid for a Modotti photograph. Amy Page, "Flower Power," in *Art and Antiques*, November 2002, p. 101.

103 Beals, *Glass Houses*, p. 354, and Daniela Spenser Grollová, "El tiempo de Ella Wolfe," *Nexos*, no. 34, April 1991, pp. 10–11.

104 Margaret Hooks, *Tina Modotti: Photographer and Revolutionary* (London: Pandora, 1993), p. 136. Mahoney and Mahoney, *Espionage in Mexico*, p. 172. According to the Mahoneys, the real reason for the raid was the recent discovery, by Scotland Yard in London, of the list of Russian spies operating in Mexico.

105 Rivera always claimed that this was his doctor's statement. Diego Rivera, *My Art, My Life: An Autobiography with Gladys March* (New York: Citadel Press, 1960), p. 242 (I use the original English, as in other notes). All the women associated in whatever way with Rivera were accused of having an affair with him – one such story came to light recently: Carl Nagin, "A Life Discovered," *Art and Antiques*, January 1999, pp. 76–81.

106 Sarah M. Lowe, *Tina Modotti: Photographs* (New York: Abrams, 1995), p. 149, n. 169.

107 Maricela Gonzáles Cruz Manjarrez, *Tina Modotti y el Muralismo Mexicano* (Mexico City: Universidad Nacional Autónoma de México, 1999), p. 17.

108 Pete Hamill, *Diego Rivera* (New York: Abrams, 1999), p. 126.

109 Letters dated April 1, June 4, and July 4, 1927, EWA, Tucson. For the collection of photographs of murals by Modotti, see Gonzáles Cruz Manjarrez, *Tina Modotti*.

110 May 23, 1927. Glusker, "Anita Brenner," p. 93.

111 Lupe Marín quoted in Rivera, *My Art, My Life*, p. 298.

112 Carleton Beals, *House in Mexico* (New York: Hastings House, 1958), p. 100.

113 Apparently both Nahui Olín and Anita Brenner received nasty notes from Lupe. Glusker, *Anita Brenner*, p. 63.

114 Rivera and Siqueiros traveled via Berlin where, according to Siqueiros, they visited a cabaret full of women, only to be told that those were not women but men. David Alfaro Siqueiros, *Me llamaban el coronelazo (Memorias)* (Mexico City: Biografías Gandesa, editorial Grijalbo, 1977), p. 237.

115 José Guadalupe Rodríguez was arrested and assassinated in May 1929 by the regular army, under orders of the Durango governor, Terrones Benítez.

116 Bertram Wolfe, *Diego Rivera: His Life and Times* (New York: Knopf, 1943), p. 237.

117 *Krasnaya Niva*, no. 12, March 17, 1928.

118 Wolfe, *Diego Rivera*, p. 242.

119 The poem starts with the words

"Father and maestro and comrade" and later continues "Eternity opens its arms and writes a name in the silence . . . ," cited in Marcello Flores, *L'immagine dell'URSS: L'Occidente e la Russia di Stalin (1927–1956)* (Milan: Il Saggiatore, 1991), p. 379. See also *Il mito dell'URSS*, ed. Marcello Flores and Francesca Gori (Milan: Franco Angeli, 1991).

120 Robert J. Alexander, *Trotskyism in Latin America* (Stanford: Hoover Institution Press, 1973), p. 194.

121 According to Rivera, his first scandal occurred when he was 4 years old, in church. Rivera, List of Scandals, Anita Brenner Archive. Unclassified, cited in Glusker, "Anita Brenner," p. 327.

122 Wolfe, *Diego Rivera*, p. 272. Apparently, after the publication of Rivera's biography by Wolfe, Lupe Marín sued Wolfe for damage to her reputation. The trial, which was held in New York, found in Wolfe's favor. Bertram D. Wolfe, *A Life In Two Centuries: An Autobiography* (New York: Stein and Day, 1981), pp. 686–95.

123 Victor Hugo Rascón, *Tina Modotti y otras obras de teatro* (Mexico City: SEP, 1986), p. 126.

124 Constantine, *Tina Modotti*, p. 96.

125 Wolfe, *Diego Rivera*, p. 172. Guerrero was reported to be "reserved, mute, and undecipherable." Vidali, *Ritratto*, p. 7.

126 Vidali, *Ritratto*, p. 8.

127 Martínez Verdugo, *Historia del comunismo*, p. 81. Also, see the commemoration of Moreno's fifth death anniversary in *El Machete*, September 1930, p. 2, in which Julio Mella is also mentioned.

128 Beals, "Tina Modotti," p. xlviii. When making this comment, Beals was not referring to this photograph in particular.

129 Hooks, *Tina Modotti: Photographer and Revolutionary*, p. 133.

130 Albers, *Dear Vocio*, fig. 17; see also pp. 41–43.

131 Hooks, *Tina Modotti: Photographer and Revolutionary*, p. 133.

132 Williams, *Covarrubias*, p. 276, n. 7.

133 Xavier Guerrero, "A Mexican Painter," *New Masses*, May 1927, p. 18.

134 See e.g. the beautiful and powerful drawing "Aztec Festival," *New Masses*, December 1929.

135 Dos Passos also relied on Carleton Beals as a guide. In Mexico, Dos Passos met Gladwin Bland, an American former I.W.W. member, on whom he based the character of Fenin "Mac" McCreary in *The 42nd Parallel*. Britton, *Revolution and Ideology*, p. 55.

136 John Dos Passos, "Paint the Revolution!," *New Masses*, March 1927, p. 15. The following month, Dos Passos wrote another article on Mexico, mentioned earlier.

137 The original letter has been lost, but Weston copied it in his diary. Newhall, ed., *Daybooks of Edward Weston*, II, p. 5.

138 Vidali, *Ritratto*, p. 9. Vidali's statement is relative and he may have been thinking of his own political activity – he perceived "active intervention in party life" differently from other members.

139 Letter from Guerrero to Modotti, June 24, 1928, written from the Soviet Union.

140 TM to EW, April 2, 1925, EWA, Tucson. Only at the end of her letter can it be assumed that the shop might be a bookstore: her closing words mischievously refer to the items sold in the store, "book, books to you." The name of the shop's owner is quite funny in Italian: it means "he who damages things."

141 James Martin Ryle, "International Red Aid and Comintern Strategy 1922–1926," *International Review of Social History*, vol. 15, 1970, pp. 44–45, a revised version of his thesis, "International Red Aid: A Case Study of a Communist Front Organization," MA thesis, Emory University, 1962, p. 2. "Situazione e compiti attuali del Soccorso Rosso" (unsigned), *Soccorso Rosso*, serie II, III, no. 5, September 1933, pp. 1 and 5; "Alcuni esempi di lavoro del Soccorso Rosso" (unsigned), ibid., IV, no. 3, April 1934.

142 For the first years of existence and its composition, see Natoli, "Tra solidarietà e rivoluzione" in Toffoletti, ed., *Tina*

Modotti: Una vita nella storia, pp. 193–211. The same name, Soccorso rosso (Red Aid) was used years later for an organization created by the Nobel laureate Dario Fo and his wife Franca Rame in order to guarantee legal assistance for political prisoners.

143 See, for example, the letter from an Italian Communist Party official to Ercoli (Palmiro Togliatti), November 24, 1926 (that is, during the fascist period): "Please, look into the MOPR matter. There are cases which are truly miserable: workers banned, together with their families, exiled, in terrible situations, jailed and so on." To which, on December 6, Togliatti replied: "I am taking care of MOPR." Chiara Daniele and Giuseppe Vacca, eds., *Gramsci a Roma, Togliatti a Mosca: Il carteggio del 1926* (Turin: Einaudi, 1999), pp. 459 and 471.

144 *Socorro rojo P.O.U.M.*, Barcelona, March 15, 1937.

145 *Organizzazione e funzionamento dei gruppi del Soccorso Rosso*, notes, n. p., Istituto Nazionale per la Storia del Movimento di Liberazione in Italia, Milan, and *Direttive per i Comitati di Base Patronati Fiduciari a Attivisti* (Rome: Soccorso Rosso Internazionale, Sezione Italiana, 1933), pp. 18–19.

146 Natoli, "Tra solidarietà e rivoluzione," in Toffoletti, *Tina Modotti: Una vita nella storia*, p. 195. For Münzenberg's activities, see Willi Münzenberg, *Solidarität: Zehn Jahre Internationale Arbeiterhilfe 1921–1931* (Berlin: Neuer Deutscher Verlag, 1931), and Ryle, "International Red Aid," p. 88.

147 Robert Conquest, *The Great Terror: A Reassessment* (Oxford and New York: Oxford University Press, 1990), p. 402.

148 G. Verdi, *I patronati all'opera* (Italian section of Red Aid, 1933), n. 16.

149 "Il Soccorso rosso internazionale," in Elena D. Stasova, *Compagno Absoljut*, ed. Vittorio Vidali (Rome: Editori Riuniti, 1973), p. 234. However, in March 1935, following various campaigns all over Europe, and a conference held in Paris, Red Aid merged with the Matteotti Foundation to form the Committee for the Aid of Victims of Fascism and War. Ibid., pp. 237–38.

150 *Organizzazione e funzionamento dei gruppi del Soccorso Rosso: Campagna per la preparazione del Congresso mondiale del S.R.I.* (Rome: Soccorso Rosso Internazionale, 1932), p. 2, and Natoli, "Tra solidarietà e rivoluzione," in Toffoletti, *Tina Modotti: Una vita nella storia*, p. 200. See also Israel Amter, "First World Conference in the International Red Relief," *Inprecor*, July 31, 1925, p. 557.

151 Mario Passi, *Vittorio Vidali* (Pordenone: Studio Tesi, 1991), pp. 16–17.

152 Bernardo Claraval, *Cuando fui comunista* (Mexico City: ediciones Polis, 1944), p. 85. Claraval refers to Vidali as Sormenti.

153 Letter addressed to *cara compagna*, signed "Jorge Contreras," December 7, 1928 from Mexico. Vidali (alias Contreras) wrote that in Mexico he had to start everything from new, since upon his arrival there was not even a central committee of the Red Aid section. Moreover they had to devote time and energy to a campaign to free a comrade condemned to death. I am grateful to this letter's source, who wishes to remain anonymous.

154 Vidali, *Ritratto*, p. 11. Hooks, *Tina Modotti: Photographer and Revolutionary*, pp. 154–55.

155 Lowe, *Tina Modotti: Photographs*, p. 29.

156 *Direttive per i Comitati*, p. 6. For a complete picture of Red Aid's work until 1927, see *Fünf Jahre Internationale Rote Hilfe* (Berlin, 1928). Between 1929 and 1931, International Red Aid became involved in 94 political campaigns at the international level. One of these was the campaign to liberate Antonio Gramsci, the founder of the P. C. I. (Italian Communist Party), who was imprisoned by Italian fascists in November 1926 for his opposition to the government. The campaign to liberate him started in France among the antifascists. Giovanni Germanetto, "Salviamo Gramsci," *Soccorso Rosso, organo della sezione italiana del S. R. I.*, serie II,

III, no. 4, June 1933, p. 1; ibid., IV, no. 1, January 1934 (p. 4 showed a photograph of Sandro Petrini, later president of Italy). Romain Rolland, "In difesa di Antonio Gramsci," ibid., no. 6, October 1934, p. 1.

157 See, for example, *El Machete*, IV, no. 131, September 15, 1928, p. 2; *El Machete*, IV, no. 132, September 22, 1928, p. 2; and *El Machete*, IV, no. 136, October 20, 1928, p. 2;

158 Jean Charlot to Edward Weston, August 15, 1927. EWA, Tucson.

159 Patricia Albers, *Shadows, Fire, Snow: The Life of Tina Modotti* (New York: Clarkson Potter, 1991), p. 176.

160 Notes by Vittorio Vidali, *Archivo de la Palabra*, Mexico City, f. 119.

161 The caption of the photograph says *Esta bandera fue avanzada al la 47 CIA II Rgto del cuerpo de marinos de los Estados Unidos en el combate de El Zapote, el 14 de mayo de 1928. El Machete*, no. 136, cover page.

162 Socrates Sandino (carpenter), "My brother, gen. Sandino," *New Masses*, July 1928, p. 6. The photograph accompanying the article shows Jerry Campbell, an American miner, and his family on strike.

163 Olga Cabrera, "La tercera Internacional y su influencia en Cuba (1919–1935), *Sociedad-Estado* (Guadalajara), no. 2, 1989, p. 55.

164 Frances Toor, *A Treasury of Mexican Folkways* (New York: Crown, 1947), illustrated by Carlos Merida's drawings. Toor aroused comment by dressing in khaki paints and going around on a donkey.

165 Frances Toor, "Editor's Foreword," *Mexican Folkways*, 1, June–July 1925, pp. 3–4. See also Toor to Brenner, March 15, 1925, and Toor to Beals, March 15, 1925, both in the Brenner Collection, Mexico City.

166 Glusker, "Anita Brenner," p. 95.

167 José Clemente Orozco, *The Artist in New York: Letters to Jean Charlot and Unpublished Writings, 1925–1929* (Austin: University of Texas Press, 1974), p. 73.

168 Ibid., p. 79.

169 Letter from Paca Toor to Joseph Freeman, June 7, 1930. Freeman Collection, box 38, folder 45, Hoover Institution for War, Revolution, and Peace, Stanford, Calif.; hereafter, Hoover Institution, Stanford. Ione Robinson, then Freeman's wife, wrote of Toor: "God help that woman!" Ione Robinson to Joseph Freeman, October 24, 1929. Ibid., box 34, folder 18.

170 Newhall, ed., *Daybooks of Edward Weston*, I, p. 160.

171 In *Mexican Folkways* Modotti was listed as a contributing editor and advertised at first with Weston; later she advertised alone.

172 Tina Modotti to Albert Bender, November 17 (no year, presumably 1927). Albert Bender Collection, Special Collections, Mills College, Oakland. I am grateful to Janice Braun for her cooperation in obtaining this document.

173 TM to EW, September 18, 1928, Modotti went on to compare Orozco's and Rivera's ways of painting, clearly stating that she preferred Orozco's. The letter closes with "I am always conscious of the fineness of your being and your life." EWA, Tucson.

174 Orozco, *The Artist in New York*, p. 73.

175 Ibid., p. 18. The comment is not present in the original Spanish version: José Clemente Orozco, *El artista en Nueva York (cartas a Jean Charlot, 1925–1929, y tres textos inéditos)* (Mexico City: Siglo XXI, 1971). For Orozco's visit to New York, see Orozco, *Autobiografía* (Mexico City: Era, 1970), p. 85.

176 Williams, *Covarrubias*, p. 53.

177 Hooks, *Tina Modotti: Photographer and Revolutionary*, p. 132.

178 John Mraz, "En el camino hacia la realidad," *La Jornada Semanal*, July 30, 1989, p. 22.

179 As noted by Weston in a letter to his wife, March 29, 1924, EWA, Tucson.

180 The Portes Gil government closed *El Machete*'s office, as well as the headquarters of the party, in June 1929, but the paper appeared legally until August 1929.

181 Gómez Lorenzo was deported from Mexico to the Islas Marías in summer 1932.

El Machete, August 30 and September 10, 1932. He returned and in spring 1933 was expelled from the party, mainly for mishandling funds. "R. Gómez Lorenzo, expulsado del P.C.," *El Machete*, March 30 and April 10, 1933.

182 For a definition of *corridos*, see Katherine Anne Porter, "Corridos," in *Uncollected Early Prose of Katherine Anne Porter*, ed. Ruth M. Alvarez and Thomas F. Walsh (Austin: University of Texas Press, 1993), pp. 194–200.

183 Brenner, *Idols behind Altars*, p. 249.

184 Siqueiros, *Me llamaban el coronelazo*, p. 193, and Verdugo, *Historia del comunismo en México*, p. 75. Some versions replace *humillar* with *abatir* (to defeat).

185 Raquel Tibol, *David Alfaro Siqueiros* (Mexico City: Empresas editoriales, 1969), photographic section, n.p.

186 *El Machete*, May 15, 1924, cover page.

187 Siqueiros, *Me llamaban el coronelazo*, pp. 76 and 414. The date is also given as April on p. 414 and May on p. 76. For the birth of *El Machete*, see also pp. 216–20.

188 Ibid., p. 219.

189 Tibol, *José Clemente Orozco*, pp. 71–75.

190 Wolfe, *Diego Rivera*, pp. 169–70.

191 "Salud al embajador del pueblo ruso," *El Machete*, 9–16 October, 1924 (unsigned).

192 Beals, "Tina Modotti," p. xlviii–xlix.

193 Mario Rigoni Stern, *Le stagioni di Giacomo* (Turin: Einaudi, 1995), p. 111.

194 *Direttive per i Comitati*, p. 7, and M. Ridolfi, "La campagna Gastone Sozzi: Ruolo e attività del Soccorso Rosso," in *Alle origini del PCI: Atti del Convegno su Gastone Sozzi* (Cesena, 1980), pp. 189–221.

195 Francesco Leone, "La centuria 'Gastone Sozzi,'" in *Garibaldini in Ispagna* (Madrid: Diana, 1937), pp. 59–83. Sozzi is also mentioned in the magazine of the Italian Red Aid *Soccorso rosso*, January–February 1932, serie II, II, no. 1, because his father, Amedeo, a socialist, died

in 1932, followed by the death of Gastone's mother and brother Sigfrido.

196 "Los Horrores del Fascismo en Italia," *El Machete*, IV, no. 131, September 15, 1928 (unsigned).

197 "Manifestaciones Antifascistas en Italia,"*El Machete*, IV, no. 134, October 6, 1928 (unsigned).

198 *El Machete*, May 12, 1928.

199 Letizia Argenteri, *Il re borghese: Costume e società nell'Italia di Vittorio Emanuele III* (Milan: Mondadori, 1994), pp. 170–71.

200 *El Machete*, May 19, 1928, published in the column "Ayuda Roja."

201 Folder no. 015319: Mexico: subversive movement, July 3, 1928. Ministry of Foreign Affairs. Comitato Tina Modotti, Udine.

202 Letters from Benvenuto Modotti to Tina Modotti, October 18 and November 3, 1928. Comitato Tina Modotti, Udine.

203 "La ruptura de relaciones con el gobierno de Mussolini: Fue Pedido en el Mitin de la Liga Internacional Antifascista," *El Machete*, no. 138, November 7, 1928, p. 8.

204 The most famous among them is Michael Ledeen, *The First Duce* (Baltimore: Johns Hopkins University Press, 1977).

205 "Un Aspecto de la Obra Civilizadora de Mussolini en Abisinia," *El Machete*, May 17, 1936.

206 "La nave Italia mensajera de Mussolini, arribará en breve a Veracruz," *El Machete*, July 15–30, 1924. The article was signed by the National Executive Committee of the Mexican Communist Party. See also, "Como y porqué nació y ha conquistado el Poder; Sus Resultados," *El Machete*, August 21–28, 1924, (unsigned); and "Viva la Rusia de los Soviets! La nave Italia, arsenal de fascistas," ibid.

207 "Se fue la nave Italia!" *El Machete*, 4–11 September, 1924.

208 "Llega a México la maffia [*sic*] de los camisas prietas", *El Machete*, August 28–September 4, 1924, p. 1.

209 Ludovico Incisa di Camerana, "La grande traversata di un Vittoriale galleggiante," in *Sartorio 1924: Crociera della*

Regia Nave Italia nell'America Latina, exh. cat. (Rome: De Luca, 1999), p. 1.

210 Bruno Mantura, "Sartorio poco prima e poco dopo il viaggio in America Latina," in ibid., p. xiii.

211 Ibid., p. xiv.

212 See the chapter devoted to the Matteotti murder in Argenteri, *Il re borghese,* pp. 154–63, and "El Fascismo Italiano a Punto de Derrumbarse," *El Machete,* August 21–28, 1924 (unsigned).

213 When Matteotti was murdered, the *Italia* was in Punta Arena, Argentina, heading for Baia Fortescue. For the *Italia's* itinerary, see *Sartorio 1924.*

214 *Diario de la Marina* (Havana), September 3, 1924.

215 Erasmo Dumpierre, *J. A. Mella, biografía* (Havana: editorial de ciencias sociales, 1977), pp. 36–37.

216 Much the same happens with other phenomena, such as feminism. Current western European-style feminism, for example, is linked to politics, while American-style feminism can exist independently, can be merely issue-oriented, and can afford to be apolitical, or at least give the illusion of being so.

217 Dos Passos, "Relief Map of Mexico," p. 24.

218 Wolfe, *A Life In Two Centuries,* p. 281.

219 For a recent example see Ferdinando Scianna, "Henri Cartier Bresson l'occhio del secolo: Intervista al grande fotografo," *La Repubblica,* September 17, 1998. Cartier Bresson states that for him "communism is a by-product of Christianity."

220 Vidali, *Ritratto,* pp. 26 and 57. In the same paragraph on p. 57, Vidali states that Modotti "did not possess the vocation to participate in the political life of the party." This is extremely odd, first of all because, with regard to her participation, the facts speak for themselves; secondly, because it hides a good dose of paternalism, with a strong need to stand out, typical of a man like Vidali. The same point was brought up by a journalist in 1980, when Vidali was still alive, who claimed that Vidali's systematic diminishing of Modotti's political stature could be detected in phrases such as "a modest contributor to the International" and that in his books Vidali had given a distorted impression of Modotti as not only politically irrelevant but in some way morally unpalatable. Elio Bartolini, "Per Tina Modotti," *Il Piccolo* (Trieste), March 5, 1980. Vidali met Bartolini on March 23 and then in his unpublished diary (in a private archive) vented his anger at him, comparing him to Super Topo Gigio (Super Gigio Mouse, a much-loved Italian children's character).

221 I am referring to Octavio Paz's comment on Tina Modotti (and Frida Kahlo), who Paz claims never had her own original and political thought but merely "derived" them from others, that is, men. Paz, "Frida y Tina," p. 48.

222 *New Masses,* October and December 1928. On October 18 and November 3, 1928, Benvenuto Modotti congratulated and thanked his sister for the magazine. *New Masses* (1926–48), which cost 15c. a copy and $2 for an annual subscription, had superseded the magazine *The Liberator* (April 1918–24), affiliated with the American Communist Party, which in 1924 had merged with *Workers Monthly. The Liberator,* which upheld the prewar Wilsonian program and called for a negotiated peace (having one foot in bohemia, the other in the revolution), in its turn had superseded *Masses* (1911–18), a monthly journal devoted to the interests of the working people. *Masses* was created by two idealists, Piet Vlag, a Dutchman, and Rufus Weeks, an American. Among other founders were John Reed, Floyd Dell, and Max Eastman. The contributors to *New Masses* included Theodore Dreiser, Katherine Anne Porter, Joseph Freeman, Ernest Hemingway, Egmont Arens, and John Dos Passos. One of the founders was Carleton Beals. The executive board includeed Helen Black, Robert Dunn, John Dos Passos, William Gropper, Paxton Hibben, Freda Kirchwey, Robert Leslie, Louis Lozowick, and Rex Stout (the last as business manager). Many of the original *Masses* contributors and

editors (such as Max Eastman) found *New Masses'* policy of following the Stalinist line uncongenial and resigned, despite the frequent articles devoted to Trotsky and by Trotsky that appeared in the journal. See the chapter devoted to *New Masses* in Joseph Freeman, *An American Testament: A Narrative of Rebels and Romantics* (New York: Farrar & Rinehart, 1936), pp. 365–86; Daniel Aron, *Writers on the Left: Episodes in American Literary Communism* (New York: Harcourt, Brace, and World, 1961), pp. 96–102 and 199–205; and Rebecca Zurier, *Art for The Masses* (Philadelphia: Temple University Press, 1988), pp. 26, 29, and 66–67.

223 Lowe, *Tina Modotti: Photographs*, p. 34.

224 The uncredited photographs that could be by Modotti are in *El Machete*, IV, no. 121, June 30, 1928, p. 2 (interior of a house in the Bolsa colony), captioned "Donde no ha llegado la Revolución;" IV, no. 122, July 7, 1928 (woman with child), "Los pobres no consiguen más que miseria, degradación y hambre;" IV, no. 129, September 1, 1928, p. 2 (El Reinado del orden); IV, no. 132, September 22, 1928, p. 4 (funeral of comrade Julio V. Cruz, killed in Jalapa); V, no. 161, April 1929, p. 1.

Besides the photograph of Mella dead (which I will describe later), those that are credited to Tina Modotti in *El Machete* appeared in IV, no. 120, September 8, 1928, p. 2; and IV, no. 120, June 23, 1928, cover page. This last is a montage with the famous picture of the children in the Bolsa colony at the bottom while at the top is a bourgeois woman pushing a pram with two children on each side. The May 1, 1929 issue (V, no. 162) reproduced for the first time the Modotti photograph of the guitar and sickle. The picture forms the advertisement for a tape of revolutionary songs with words and music by Concha Michel, which sold for 20 cents.

225 For the identification of Emiliano Zapata (social bandit or social revolutionary?) see Samuel Brunk, "The Sad Situation of Civilians and Soldiers: The Banditry of Zapatismo in the Mexican Revolution,"

The American Historical Review, vol. 101, no. 2, April 1996, pp. 331–53.

226 Pablo González Casanova, *La clase obrera en la historia de México: En el primer gobierno constitucional (1917–1920)*, vol. VI (Mexico City: Siglo XXI, 1980), p. 153.

227 Barry Carr, "Marxism and Anarchism in the Formation of the Mexican Communist Party, 1910–19," *The Hispanic American Historical Review*, vol. 63, no. 2, May 1983, p. 281.

228 Ibid., p. 291.

229 Beals, *Glass Houses*, p. 50.

230 Carr, "Marxism and Anarchism," p. 303.

231 Ibid., p. 299.

232 Linn A. E. Gale, "Editorials," *Gale's: Journal of Revolutionary Communism*, vol. 3, no. 6, January 1920, p. 1.

233 Robert J. Alexander, *Communism in Latin America* (New Brunswick: Rutgers, 1957), pp. 320–21. The book reflects the political atmosphere of the time: see, for example, the title of chapter XVII: "Coffee, Bananas, and Communism in Central America." (Even an industrialized and advanced country such as the U.S.A. could not escape being labeled as a banana republic by some in the European press who mocked Americans for the chaos that resulted from the presidential election in November 2000.

234 Katayama, the son of a Japanese Buddhist priest, converted to Christianity and went to study in California, Tennessee, and Iowa, before returning to Japan and then again to San Francisco in the 1890s to study the American Federation of Labor. In 1904 he toured the Japanese community of the West Coast, denouncing the Russo-Japanese war. He later took refuge in the Soviet Union, where he became a Comintern official. Stephen Schwartz, *From West to East: California and the Making of the American Mind* (New York: Free Press, 1998), pp. 136–37, 149, and 197.

235 Katayama later returned to the Soviet Union, where he died in 1933. "Murió senator Katayama," *El Machete*, December 10, 1933.

236 Arnoldo Martínez Verdugo, ed.,

Historia del comunismo en México (Mexico City: colección enlace 1983), pp. 411 and 431.

237 Ibid., pp. 54–57.

238 Ibid., p. 57.

239 Benjamín Maldonado Alvarado, *La Utopia de Ricardo Flores Magón: Revolución, Anarquía y Comunalidad India* (Oaxaca: Universidad autonoma Benito Juarez de Oaxaca, 1994), p. 59.

240 José Muñoz Cota, *Ricardo Flores Magón: El águila ciega* (Mexico City: Instituto Oaxaqueño de La Culturas, 1973), p. 93.

241 Martínez Verdugo, *Historia del comunismo en México*, p. 59.

242 Ella Wolfe, interview with the author, February 18, 1998. For Ella Wolfe's long life (she died at 103 in 2000), see Daniela Spenser Grollová, "El tiempo de Ella Wolfe," *Nexos*, no. 34, April 1991, pp. 5–11, and Jeanene Harlick, "Life of the Party," *Stanford*, January/February 2002, pp. 50–55.

243 For the political situation when Modotti arrived in Mexico, see Manuel Plana, "Il Messico degli anni venti," in Toffoletti, *Tina Modotti: Una vita nella storia*, pp. 131–51.

244 Marcela de Neymet, *Cronología del Partido Comunista Mexicano: Primera parte, 1919–1939* (Mexico City: ediciones de cultura popular, 1981), p. 31.

245 Verdugo, *Historia del comunismo en México*, p. 35.

246 Manuel Márquez Fuentes and Octavio Rodríguez Araujo, *El Partido Comunista Mexicano (en el periodo de la Internacional Comunista: 1919–1943)* (Mexico City: "El Caballito", 1973), p. 105. In 1932, Rafael Carrillo was sentenced to eight months in prison and fined 100 *pesos* for his political activities. The International Red Aid lawyers appealed to the Tribunal del Primer Circuito. "La represión en México," *El Machete*, May 1, 1932.

247 *El Machete*, no. 11, August 28–September 4, 1924.

248 Bert to Ella Wolfe, July 13, 1924.

Wolfe Collection, box 16, folder 24, Hoover Institution, Stanford.

249 Carrillo to Ella Wolfe, July 20, 1924. Wolfe Collection, box 4, folder 11, Hoover Institution, Stanford. The party secretary briefs the Wolfes on the political situation in Mexico. All of the letters from Carrillo to the Wolfes written in this period (1925–27, also from Moscow), show the tortuous development of the party. They also reveal the great trust placed by the Mexican communists in the Wolfes.

250 B. Wolfe, " Mahatwa Gandhi y la resistencia pasiva en la India," *El Machete*, March 1–15, 1924, and "La Rusia de Hoy," Report on the V Congress of the Communist International, *El Machete*, September 25–October 2, 1924.

251 Wolfe, *A Life in Two Centuries*, p. 345. See also news of *El Libertador* in *El Machete*, March 19 and 26, 1925.

252 Wolfe, *A Life in Two Centuries*, pp. 355–59 and 366–67. In 1925, the Wolfes officially represented the Communist Party of Mexico at the American Communist Party Conference, and the Anti-Imperialist League of America. See authorization and credentials dated August 10, 1925, signed by Rafael Carrillo and Xavier Guerrero. Wolfe Collection, box 4, folder 11, Hoover Institution, Stanford. The Wolfes continued their political work in New York for a number of years, before abandoning the communist cause altogether and moving to the West Coast.

253 Bertram Wolfe, "Back to Mexico," April 16, 1936, Wolfe Collection, Hoover Institution, Stanford. Wolfe's strong attacks on Cárdenas as a petty dictator helped by the army and by Washington provoked the anger of the Mexican president, who answered with a letter addressed to William Cameron Townsend. Britton, *Revolution and Ideology*, p. 138.

254 The verses, part of the poem "Odio la máscara," are from José Martí, *Versos sencillos*, no. 60, in *Los cien mejores poemas de José Martí*, ed. Antonio Castro Leál (Mexico City: Aguilar, 1974), p. 167.

255 *El Machete*, IV, no. 152, February 16, 1929.

256 Patrick Marnham, *Dreaming with His Eyes Open: A Life of Diego Rivera* (New York: Knopf, 1998), p. 207.

257 Raquel Tíbol, *Episodios fotográficos* (Mexico City: Proceso, 1989), p. 136.

258 Ibid., p. 137.

7 *Persona Indesiderata*

1 "Love, that releases no beloved from loving, took hold of me so strongly through his beauty that, as you see, it has not left me yet." *Inferno*, Dante Alighieri, *The Divine Comedy*, trans. Allen Mandelbaum (New York: Bantam: 1980), p. 45.

2 "La ruptura de relaciones con el gobierno de Mussolini," *El Machete*, no. 138, November 7, 1928, p. 8; mentioned also in Erasmo Dumpierre, *Mella, esbozo biográfico* (Havana: Instituto de la Historia, 1965), p. 40. See also Alfonso Taracena, *La verdadera revolución mexicana: Decimacuarta etapa (1928–1929)* (Mexico City: Juan Pablos, 1964), p. 243.

3 Carleton Beals, *The Crime of Cuba* (Philadelphia: J. B. Lippincott, 1933), pp. 241–42.

4 Gabriel García Márquez, "Hemingway, el nuestro," in Norberto Fuentes, *Hemingway en Cuba* (Managua: Nueva Nicaragua, 1984), p. 11.

5 Olga Cabrera and Carmen Almodóbar, eds., *La luchas estudiantiles universitarias 1923–1934* (Havana: Editorial de Ciencias Sociales, 1975), p. 15. Years later, in March 1952, it was the F.E.U. which instigated the struggle against the Cuban dictator Batista. K. S. Karol, *Les guérrileros au pouvoir* (Paris: Robert Laffont, 1970), p. 462.

6 Jaime Suchlicki, *University Students and Revolution in Cuba, 1920–1968* (Coral Gables: University of Miami Press, 1969), p. 21, and Olga Cabrera, *Guiteras, la época, el hombre* (Havana: Editorial de Arte y Literatura, 1974), p. 81.

7 Cabrera, *Guiteras, la época, el hombre*, p. 117, and Olga Cabrera, *Julio Antonio Mella: Reforma estudiantil y antimperialismo* (Havana: Editorial de Ciencias Sociales, 1977), pp. 15–26.

8 José Domingo Cabús, "El asesinado de Julio Antonio Mella," *Trinchera*, October 20, 1963, p. 23; and *Julio Antonio Mella: documentos para una vida. Primer Congreso Nacional de Estudiantes* (Havana: Comisión Nacional Cubana de la UNESCO, 1964).

9 Cabrera, *Guiteras, la época, el hombre*, p. 83.

10 Karol, *Les guérrileros au pouvoir*, p. 72.

11 In other sources, the Party Secretary General is listed as José Miguel Pérez, a Spaniard from the Canary Islands. *Hoy*, August 15, 1965, pp. 2–6. See also Karol, *Les guérrileros au pouvoir*, p. 72.

12 Efrén Córdova, *Clase trabajadora y movimiento sindical en Cuba*, vol. I 1819–1959 (Miami: ediciones universal, 1995), p. 130.

13 For Mella's youth and background see Angel Augier, "Cómo era Julio Antonio Mella," *Bohemia* (Havana), January 30, 1949, p. 93; Alfonso Bernal del Riesgo, "Mella, líder rápido y multiforme," *Bohemia*, August 9, 1963, p. 30; Sarah Pascual, "La fructifera juventud de Julio Antonio Mella," *Bohemia*, August 16, 1963, p. 21; "En memoria de Mella," *Konsomólskaia Pravda* (Moscow), January 16, 1929, p. 1; Juan Marinello, "Dos temas sobre Mella," *Bohemia*, May 20, 1964, p. 6; and Pedro Serviat, "Mella, la clase obrera y los intelectuales," *Revista de la universidad de La Habana*, May–June 1966, pp. 102–3. For his character and personality, see Bernardo Claraval, *Cuando fuí comunista* (Mexico City: ediciones Polis, 1944), where Mella is identified as "an exception in the communist movement," p. 31. Claraval, who makes no secret of his disapproval of Modotti, presents the Cuban revolutionary as an idealist and a believer in God and the supernatural. The whole approach appears to be more Claraval's wishful thinking, than an attempt to represent the truth.

14 Olga Cabrera, "La tercera Internacional y su influencia en Cuba (1919–1935)," *Sociedad–Estado* (Universidad de Guadalajara), no. 2, 1989, p. 53.

15 Claudio Natoli, "Tra solidarietà e rivoluzione: Il Soccorso Rosso Internazionale," in Riccardo Toffoletti, ed., *Tina Modotti: Una vita nella storia* (Udine: Arti Grafiche Friulane, 1995), p. 198.

16 *El Machete*, no. 44, December 19, 1925, p. 1, and Natoli, "Tra solidarietà e rivoluzione," p. 198.

17 Cabús, "El asesinado de Julio Antonio Mella," p. 24.

18 Alejandro Gálvez Cancino, "L'auto-absolution de Vidali et la mort de Mella," *Cahiers Leon Trotsky*, June 26, 1986, p. 48. Gálvez Calcino reports the research by K. S. Karol. See also Cabrera, "La tercera Internacional," p. 53.

19 Carrillo to the Wolfes, October 8, 1926; Carrillo told them that Mella was about to leave Mexico for a conference in Brussels, after going through a hunger strike that had left him debilitated. Apparently, in spring 1927 Mella was also in the U.S.A., since Carrillo in a letter of May 19, 1927 expressed the hope that Mella would come back to Mexico, in order to avoid any problem related to the visit of Machado in the U.S.A. Wolfe Collection, box 4, folder 11, Hoover Institution, Stanford.

20 Erasmo Dumpierre, "Mella en México: Diálogo con Rosendo Gómez Lorenzo," *El Mundo* (Havana), December 3, 1967.

21 Arnoldo Martínez Verdugo, ed., *Historia del comunismo en México* (Mexico City: colección enlace, 1983), p. 416.

22 Mella to Rafael Carrillo, signed "Julio," n.d. (1927?). Wolfe Collection, box 10, folder 39, Hoover Institution, Stanford.

23 *Excelsior*, January 16, 1929. Natacha's picture appeared in *Excelsior*, January 14, 1929.

24 *The San Francisco Examiner*, February 16, 1961, reported that "the widow of Julio Antonio Mella, founder of the Cuban Communist Party, has been fired as Consul General in Denmark for refusing to return to Havana, when called by the Foreign Ministry." The article is entitled "Cuba Fires Balky Widow of Red." Zaldívar became a political refugee and, like many Cubans who opposed Castro's regime, she settled in Florida. According to Barckhausen-Canale, her daughter Natacha followed the same path, after having studied in Nazi Germany. Christiane Barckhausen-Canale, *Verdad y leyenda de Tina Modotti* (Havana: Casa de las Américas, 1989), p. 129.

25 Mildred Constantine, interview with Rosendo Gómez Lorenzo, January 25, 1974. The J. Paul Getty Research Institute, Los Angeles. See also María Luisa Laffita quoted in Adys Cupull, *Tina Modotti: Semilla profunda* (Havana: Pablo de la Torriente, 1996), p. 72.

26 Claraval, *Cuando fui comunista*, p. 55.

27 In fact, the letter was published in *Excelsior*, January 16, 1929, but only to discredit Modotti.

28 Cupull, *Tina Modotti*, pp. 40–43.

29 It is uncanny that in a letter of June 24, 1928 to Modotti, Guerrero signed with the name of Julio, not knowing that there was (or was going to be) a real Julio in Tina's life.

30 Carrillo decided against giving Tina the letter. Margaret Hooks, *Tina Modotti: Photographer and Revolutionary* (London: Pandora, 1993), p. 160.

31 The Hotel Lux housed many international communists and inspired Ruth von Mayenburg's *Hotel Lux: Mit Dimitroff, Ernst Fischer, Ho Tschi Minh, Pieck, Rakosi, Slansky, Dr. Sorge, Tito, Togliatti, Tsou En-lai. Ulbricht und Wehner im Moskauer Quartier der Kommunistischen Internationale* (Munich: Bertelsmann, 1978). See also Vittorio Vidali, *Ritratto di donna: Tina Modotti* (Milan: Vangelista, 1982), p. 10.

32 Carrillo to the Wolfes, January 14, 1926, Wolfe Collection, box 4, folder 11, Hoover Institution, Stanford, cited in Daniela Spenser Grollová, "El tiempo de Ella Wolfe," *Nexos*, no. 34, April 1991, p. 7. After the Spanish Civil War, the Lux became

the gathering place of many communists, and the chief residence of several Spanish refugees. Paolo Spriano, *Storia del Partito communista italiano*, vol. VI (Turin: Einaudi, 1973), p. 117, and Andrés Carabantes and Eusebio Cimorra, *Un mito llamado Pasionaria* (Barcelona: Planeta, 1982), pp. 230–31.

33 Mildred Constantine, *Tina Modotti: A Fragile Life* (San Francisco: Chronicle Books, 1983), p. 137.

34 Vidali, *Ritratto*, p. 23.

35 Victor Haya de la Torre, *El antimperialismo y el APRA* (Lima: Amauta, 1982), p. XVI.

36 According to the account of a medical student, Francisco de la Cavada, Mella was later very disappointed by Díaz Mirón's political changes. "En otra ocasión se habia intendado asesinar a Julio Antonio Mella," *Excelsior*, January 16, 1929.

37 Adys Cupull, *Julio Antonio Mella en los mexicanos* (Mexico City: Ediciones el Caballito, 1983).

38 Some of Fidel Castro's love letters written between 1953 and 1955 to his mistress Naty (or Natty) Revuelta convey the same impression. They have been published in Spain and in the U.S.A. by Alina Fernández Revuelta, the daughter of Revuelta and Castro, born in Cuba on March 19, 1956. "Viva la Revolución! Oh, and Viva la Diferencia!" *The New York Times*, March 16, 1997. They are also mentioned in Alina Fenández, *Alina: Memorias de la hija rebelde de Fidel Castro* (Barcelona: Plaza & Janés Editores, 1997), p. 21. See also Wendy Gimbel, *Havana Dreams: A Story of Cuba* (New York: Knopf, 1998), pp. 130–39.

39 Mella's letter was published in *Excelsior*. "El movil de asesinato de Mella no fue pasional, segun quedo descubierto ayer," *Excelsior*, January 15, 1929.

40 See the photograph of Mella while talking to the students, after being released from prison. Cabrera, *Guiteras, la época, el hombre*, n.p.

41 Ibid., p. 91. After Mella's death, a student manifesto in Cuba referred to Machado as *asno con garras*. Cabrera and Almodóbar, *La luchas estudiantiles*, p. 50.

42 Hooks, *Tina Modotti: Photographer and Revolutionary*, p. 156.

43 Sarah M. Lowe, *Tina Modotti: Photographs* (New York: Abrams, 1995), p. 40.

44 *Excelsior*, January 15, 1929.

45 *Perifonemas* (Mexico City), January 8, 1942.

46 Claraval, *Cuando fuí comunista*, p. 36.

47 *Perifonemas*, January 8, 1942.

48 Suchlicki, *University Students and Revolution in Cuba*, p. 21. However, when Mella applied to the university in Mexico he still used the name Nicanor MacPartland.

49 Claraval, *Cuando fuí comunista*, p. 36.

50 Víctor Alba, *Esquema Histórico del Comunismo en Iberoamérica* (Mexico City: Ediciones Occidentales, 1960), p. 96.

51 Raquel Tibol, *Julio Antonio Mella en El Machete: Antologia parcial de un luchador y su momento histórico* (Mexico City: Fondo de Cultura Popular, 1968).

52 Ibid., pp. 85–86. Cuauhtémoc Zapata, "El arte de los campesinos," *El Machete*, June 1927.

53 Tibol, *Julio Antonio Mella en El Machete*, p. 141–51. Various articles published in *El Machete*, January 15–22, 1925.

54 Tibol, *Julio Antonio Mella en El Machete*, pp. 267–74. C. Z., "La libertad sindical en México de Vicente Lombardo Toledano," *El Machete*, June 25, 1927. Cuauhtémoc Zapata, "Aquí nadie pasa hambre," *El Machete*, August 27, 1927.

55 Tibol, *Julio Antonio Mella en El Machete*, pp. 291–92. "Los juegos olimpicos," *El Machete*, August 4, 1928 (unsigned). See also Mella's writings in a collection by four revolutionaries, Julio Antonio Mella, José C. Mariátegui, Juan Marinello, and Aníbal Ponce, *Marxistas de America* (Managua: editorial Nueva Nicaragua, 1985), pp. 14–85.

56 *Ahora que la política es sinónimo de revolución es el momento oportuno para que las masas comprendan lo que es para nosotros comunistas, la política*. Mella to Bertram Wolfe, addressed to "my dear comrade," 1927, sent from New York and signed

"Gerardo" (pseudonym for Mella). Wolfe Collection, box 10, folder 39, Hoover Institution, Stanford.

57 Cupull, *Julio Antonio Mella en los Mexicanos*, p. 13.

58 George Novack, Dave Frankel, and Fred Feldman, "The Evolution of the Comintern," in *The First Three Internationals: Their History and Lessons* (New York: Pathfinder Press, 1974), p. 90.

59 Alfonso L. Fors to Machado, June 5, 1928; Fors said that Mella had insulted the head of the state and the Cuban authorities. Olga Cabrera, "Un crimen político que cobra actualidad," *Nueva Antropología*, vol. 7, no. 27, 1985, p. 56.

60 Claraval, *Cuando fui comunista*, pp. 56–57.

61 Jorge García Montes and Antonio Alonso Ávila, *Historia del Partido Comunista de Cuba* (Miami: Ediciones Universal, 1970), p. 91. The event is recounted slightly differently in this book.

62 "I have no country, and neither do I want one, not a king, nor God, nor a flag, I am a citizen of the world and I reject any frontiers." Ibid.

63 *Islas* (Revista de la Universidad de Las Villas), no. 38, January–April 1971, p. 45, cited in Gerardo Peláez, *Partido Comunista Mexicano: 60 años de historia (Cronología 1919–1968)* (Culiacán: Universidad Autónoma de Sinaloa, 1980), p. 32.

64 "Julio A. Mella habla desde la tumba," *Excelsior*, January 13 and January 16, 1929.

65 Hooks, *Tina Modotti: Photographer and Revolutionary*, p. 4.

66 "Tina Modotti tiene la verdadera clave sobre el asesinato," *Excelsior*, January 14, 1929. In another source the name is reported as Leonardo Fernández Sánchez. Cabrera, "Un crimen político," p. 59.

67 *El Universal*, January 11, 1929, pp. 1 and 9.

68 Ibid., January 20, 1929, pp. 1 and 8.

69 Carleton Beals, *The Great Circle* (Philadelphia: J. B. Lippincott, 1940), p. 215.

70 "El periodista cubano Antonio Mella fue herido a noche de suma gravedad," *Excelsior*, January 11, 1929, pp. 1 and 6.

71 *El Machete*, January 19, 1929, IV, no. 148. The whole issue is devoted to Mella's murder: "Castigo a los Asesinos de J. A. Mella! Ruptura de Relaciones con Machado," "Julio Antonio Mella Asesinados por Agentes del Presidente Machado," "El entierro del camarada," and "Corrido de la Muerte de J. A. Mellá" (this last in the section "People's Songs"). See also "Se quiere echar tierra sobre el asesinado de Julio Antonio Mella?," *El Machete*, IV, no. 151, p. 1 and 4. Immediately after the murder, *El Machete* published a special issue on Mella, wherein the Mexican government is also held responsible as an accomplice to the crime. "Julio Antonio Mella Cayó Bajo el Plomo de los Esbirros de Machado y del Criminal Imperialismo Yanqui," *El Machete*, January 11, 1929, IV, special edition.

72 Felix Ibarra is the mask's keeper. Pino Cacucci, *I fuochi le ombre il silenzio: La fragil "vida" di Tina Modotti negli anni delle certezze assolute* (Bologna: Agalev, 1988), p. 136.

73 José Clemente Orozco, *The Artist in New York: Letters to Jean Charlot and Unpublished Writings, 1925–1929* (Austin: University of Texas Press, 1974), p. 19. Siqueiros also mentioned this funeral, quoted in Cupull, *Tina Modotti*, p. 49.

74 "Candentes discursos pronunciaron los comunistas," *Excelsior*, January 13, 1929.

75 Cabrera, "Un crimen político," p. 58.

76 *El Universal*, January 14, 1929, p. 11.

77 Beals, *Great Circle*, p. 217.

78 "Portes Gil Organizó el Asesinato de Mella," *El Machete*, October, 1930.

79 Cabrera and Almodóbar, *La luchas estudiantiles*, p. 25; see also manifesto no. 2, dated November 27, 1929, issued by university students, pp. 249–51.

80 Eduardo Chibás, e.g., during his anticorruption campaigns in 1924–25 and 1938, mentioned Mella continuously. Elena Alavez Martín, *Eduardo Chibás en la hora de la ortodoxia* (Havana: Editorial de Ciencias Sociales, 1994), pp. 11, 15, and 36. Cabrera, "Un crimen político," p. 64.

81 "Julio Mella," *New Masses*, February 1929.

82 "When Julio Mella fell, he said with his hand on his heart: "My death is beautiful. It is for the Revolution." These are the first lines of the *Corrido de la Muerte de Julio Antonio Mella*, published anonymously in *El Machete*, no. 148, January 1929. According to Rosendo Gómez Lorenzo, the ballad was written by Marco M. Montero. Tibol, *Julio Antonio Mella en El Machete*, p. 413. See also *El trabajador latinoamericano*, I, no. 9, January 15, 1929, p. 4, cited in Peláez, *Partido Comunista Mexicano*, p. 32.

83 Ione Robinson, *A Wall to Paint On* (New York: E. P. Dutton, 1946), p. 92.

84 "Una protesta desde Cuba por el Asesinato de J. A. Mella," *El Machete*, v, no. 156, March 16, 1929, p. 4, signed "El secretariato, el Presidente;" "Como en el Régimen de Mussolini," and "Donde Está la Justicia en el Caso Mella?" *El Machete*, v, no. 159, April 6, 1929; "Mella," *El Machete*, v, no. 166, May 23, 1929, p. 2; "Julio Antonio Mella," *El Machete*, November, 1930; "La Jornada Mella," *El Machete*, no. 190, February 15–28, 1931, pp. 1 and 4; "No Permitimos que se Eche Tierra al Asesinato de Mella," *El Machete*, November 10 and 20, 1931; "Las Jornadas de Enero: Lenin, Liebknecht y Rosa Luxemburgo, Mella y Rio Blanco," *El Machete*, December 20 and 30, 1931; "La Comemoración del Asesinato de Mella," *El Machete*, January 10 and 20, 1932; "Castigo para Lopez Valiñas, Asesino de Julio Antonio Mella!," *El Machete*, May 30, 1933; "Honremos la Memoria de Mella!," *El Machete*, January 10, 1934; and "50 Aniversario del Asesinato de Mella," *El Machete*, January 20, 1934.

85 "Pepe Magriñat se halla tranquilo," *Excelsior*, January 17, 1929, pp. 2–3.

86 On August 12, 1933 Mella's death was revenged by command of the young organization Pro Ley y Justicia (For Law and Justice). "Cayo Machado: Abajo Cespedes! Viva la revolución popular de Cuba!" *El Machete*, August 20, 1933. Magriñat was thrown from a balcony and dragged around the streets of Havana. Claraval, *Cuando fuí comunista*, p. 64, n. 1.

According to Vidali's report, Pedro Vizcaino was the command leader. Vidali, *Ritratto*, p. 32. See also *Perifonemas*, January 8, 1942. Machado died years later under surgery. Ibid.

87 Claraval, *Cuando fuí comunista*, p. 64, n. 1.

88 Martínez Verdugo, *Historia del comunismo en México*, pp. 105–7. See also Paca Toor to Joseph Freeman, November 12, 1931. Freeman Collection, box 38, folder 45, Hoover Institution, Stanford.

89 "Los asesinos de Mella," *El Machete*, October 30, 1931.

90 "Castigo para Lopez Valiñas, asesino de Julio Antonio Mella," *El Machete*, May 30, 1933. The involvement of the Cuban ambassador to Mexico was assumed by many communists. Elena Poniatowska, taped interview with Vittorio Vidali, September 19, 1981. Courtesy of Elena Poniatowska and George Esenwein.

91 "Lo que declaraba el embajador de Cuba," *Excelsior*, January 12, 1929. The *Excelsior* article appears to believe Mascaró's illness.

92 *Excelsior*, January 14, 1929. The statement by Portes Gil appeared in a telegram addressed to the Mexican Communist Party.

93 Beals, *Great Circle*, pp. 215–16, and David Vestal, "Tina's Trajectory," *Infinity*, no. 16, February 1966, p. 16.

94 "Declaración sobre la Actitud de la Autoridades en el caso Mella: La complicidad de Valente Quintana," *El Machete*, March 2, 1929, IV, no. 154, p. 1. Quintana, "a thin little worm-like man," who had risen from a private detective agency of "not too savory antecedents," spent time in Cuba, where he met Machado. Beals, *Great Circle*, pp. 215–16. When Modotti died, Quintana declared that he worked on the case only 18 hours. On May 30, 1940 Quintana wrote to an attorney, Vidriera, justifying his doings. Vidriera, "Cosmópolis," *Excelsior*, January 7, 1942.

95 Claraval, *Cuando fuí comunista*, p. 60.

96 A telegram sent to Diego Rivera by Carlos F. Galán in January 1929 with precise information on the political nature of the

crime did not reach Rivera until much later. The police had intercepted it and kept it secret. Private archive of Aida Hernández, widow of Leonardo Fernández Sánchez. Olga Cabrera, "Un crimen político," *Nueva Antropología*, pp. 60–61.

97 Harry Thayer Mahoney and Marjorie Locke Mahoney, *The Saga of Leon Trotsky: His Clandestine Operations and His Assassination* (San Francisco, London, Bethesda: Austin & Winfield, 1998), p. 489, n. 323.

98 Karol, *Les guérrileros au pouvoir*, p. 113.

99 *San Francisco Examiner*, May 15, 1932, p. 6.

100 Carleton Beals, "The Crime of Cuba," *Common Sense*, no. 1, December 29, 1932, pp. 10–11 and 29–32; and Carleton Beals, *The Crime of Cuba* (Philadelphia: J. B. Lippincott, 1933). Beals was in contact with Octavio Seigle, a Cuban exile living in the U.S.A. and a member of the Cuban Patriotic League, an anti-Machado organization. John A. Britton, *Carleton Beals: A Radical Journalist in Latin America* (Albuquerque: University of New Mexico Press, 1987), p. 106.

101 "En otra ocasión se habia intendado asesinar a Julio Antonio Mella," *Excelsior*, January 16, 1929, and Claraval, *Cuando fui comunista*, pp. 39–40.

102 See the photograph of Juan Marinello while bringing back Mella's ashes to Cuba. Cabrera, *Guiteras, la época, el hombre*, n.p. "Los restos de Mella, a Cuba," *El Machete*, August 30, 1933; "Gran Mitin Pro-Mella," *El Machete*, September 20, 1933, and "Las cenizas de Mella estan en Cuba!," *El Machete*, September 30, 1933. See also Julio Antonio Mella, *Escritos revolucionarios* (Mexico City: Siglo xxi, 1978), p. 30. Grobart in the prologue never mentions Tina Modotti, not even as a comrade, although on p. 25 he mentions Rivera, Siqueiros, Isidro Fabela, and "other prominent communists." Women are often ghosts, even among so-called progressive people.

103 In September 1936 Marinello went from Cuba to Spain to attend a meeting of the prorepublican faction in Madrid. According to one source, this was only the pretext to escort 63 Soviet agents for the operation "Caribe Ibérica." To make the trip more credible, the agents were mixed among a group of Cuban intellectuals – the writer Felix Pita Rodriguez and the poets Nicolas Guillén and Manuel Navarro Luna among them. Juan Vivès, *Les maîtres de Cuba* (Paris: Robert Laffont, 1981), p. 70.

104 Karol, *Les guérrileros au pouvoir*, p. 84.

105 Raúl Roa, *Retorno a la alborada* (Santa Clara: Universidad de Las Villas, 1964).

106 Grobart in Mella, *Escritos revolucionarios*, p. 30.

107 "Un fresco ramo de novia," in Cupull, *Julio Antonio Mella en los mexicanos*, p. 99. See also Carlos Garcés, "Tina Modotti en la leyenda y la verdad, con Christiane Barckhausen-Canale," *Casa de las Américas*, November 1988, p. 114.

108 Claraval, *Cuando fui comunista*, pp. 63–64, n. 1.

109 Riccardo Toffoletti, "Tina Modotti e la storia della fotografia. Le tappe della riscoperta," *Tina Modotti: Una vita nella storia*, pp. 240–41. The same photograph of Mella was reproduced on the cover of the German journal A.I.Z., xi, n. 3, 1932.

110 The sculptor was Alberto Lezcay. Cupull, *Tina Modotti*, pp. 12 and 16.

111 Lola Alvarez Bravo, *Recuento fotográfico* (Mexico City: editorial Penélope, 1982), p. 97.

112 "Tina Modotti tiene la verdadera clave sobre el asesinato," *Excelsior*, January 14, 1929.

113 Elena Poniatowska, taped interview with Vittorio Vidali, September 19, 1981. Courtesy of Elena Poniatowska and George Esenwein.

114 "Tina Modotti tiene la verdadera clave sobre el asesinato," *Excelsior*, January 14, 1929.

115 Jack Starr Hunt, "Love linked to murder," *The Times*, n.d. but probably January 13, 1929. The clipping of the article,

kept in the Johan Hagemeyer collection, is reproduced in Amy Stark, ed., *The Letters from Tina Modotti to Edward Weston*, in *The Archive*, no. 22, January 1986 (Tucson: Center for Creative Photography, 1986), p. 61.

116 "Cuban rebel is killed in Mexico City," reported in Stark, *Letters from Tina Modotti*, p. 61.

117 Nancy Newhall, ed., *The Daybooks of Edward Weston* (New York: Aperture Foundation, 1981), II, p. 108.

118 TM to EW, "a daily here refered to me as to a woman of striking beauty," and again, "evidently women here are measured by a motion picture standard." Sent from the U.S. Immigration Station in New Orleans, Louisiana, March 9, 1930, EWA, Tucson.

119 "Mussolini, figura mondiale," *L'Italia*, January 10, 1929, and "Una conferenza su Mussolini," *L'Italia*, January 19, 1929. The talks, whose tickets cost from $1.50 to $4, were given in the Oakland Auditorium Theater, and in the San Francisco Scottish Rite Hall.

120 "La traición de Tina Modotti," *El Universal Ilustrado*, February 3, 1934.

121 Enea Sormenti, "Contra una Canallesca Mentira: Tina Modotti es una Luchadora," *El Machete*, January 19, 1929, IV, no. 148.

122 "Tina Modotti fue detenida por la policia reservada," *La Prensa*, January 13, 1929, p. 3. The newspaper reprinted the photograph of the exact location of the "vile" (*cobarde*) murder.

123 The information, from Gabriel Fernández Ledesma, is reported by Elena Poniatowska in "Algunas Fotógrafas de México," *Compañeras de México: Women Photograph Women*, essays by Amy Conger and Elena Poniatowska (Riverside: University of California Press, 1990), p. 46.

124 Elena Poniatowska, *Tinísima* (Mexico City: Era), p. 98, and Hooks, *Tina Modotti: Photographer and Revolutionary*, p. 172.

125 "El movil de asesinato de Mella no

fue pasional, segun quedo descubierto ayer," *Excelsior*, January 15, 1929.

126 Pablo Neruda, *Confieso que he vivido* (Barcelona: Argos Vergara, 1974), p. 181.

127 Bertram Wolfe, *A Life In Two Centuries: An Autobiography* (New York: Stein and Day, 1981), p. 355. Upon his return to the U.S.A., Gale was arrested as a draft-dodger. While in jail, in September 1921 he recanted his leftist ideas through his lawyer, Samuel Castleton.

128 "La traición de Tina Modotti," *El Universal Ilustrado*, February 3, 1934.

129 "Se Calumnia a Tina Modotti: Se Prepara la Libertad de López Valiñas," *El Machete*, February 20, 1934.

130 Cube Bonifants, "Asesinaron al hombre . . ." *El Universal Ilustrado*, January 20, 1929.

131 *Excelsior*, January 14, 1929.

132 Things have not improved much for women in the case of rape trials, when the victims (that is, the women) are often degraded and told that they "unconsciously desired to be raped."

133 The comment is dated January 28, 1929. In the same paragraph, Brenner remarked: "Poor Mella was no great danger: a student . . ." and that "Tina behaved with great poise and dignity." Susannah Joel Glusker, *Anita Brenner: A Mind of Her Own* (Austin: University of Texas Press, 1998), p. 69.

134 Verdugo, *Historia del comunismo en México*, pp. 107–8.

135 Philippe Cheron, "Tina Stalinísima," *Vuelta*, vol. 7, no. 82, September 1983, pp. 46–47. The same issue is brought up in an interview with Barckhausen-Canale. Garcés, "Tina Modotti en la leyenda y la verdad," p. 111.

136 Julián Gorkin, *Cómo asesinó Stalin a Trotsky* (Barcelona: Plaza y Janés Editores, 1961), pp. 204–5.

137 Octavio Paz, "Frida y Tina: vidas no paralelas," *Vuelta*, vol. 7, no. 82, September 1983, p. 48. According to Pino Cacucci, Paz explained that he intended to break away from a mythology typical of

the Stalinist tradition. As he told Cacucci, the choice of the title of the article, "Tina Stalinísima," was deliberately provocative, in order to stimulate topics that had become stagnantly hagiographic. Cacucci, *I fuochi le ombre il silenzio*, pp. 83 and 85.

138 *El Machete*, cited in Cabús, "El asesinado de Julio Antonio Mella," p. 25.

139 *El tren blindado*, no. 1, September, 1928.

140 Julio Antonio Mella, "Un comentario a la zafra de Agustín Acosta," *Escritos revolucionarios*, p. 256.

141 Michael Gold, "America Needs a Critic," *New Masses*, October 1926, p. 7.

142 Claraval, *Cuando fui comunista*, pp. 48–49.

143 Wolfe Collection, box 4, folder 11, Hoover Institution, Stanford. The letter, sent to the Wolfes in *Gringolandia*, is wrongly dated "92" (probably meaning '29), but by December 1929 Mella was already dead. In the letter, Carrillo acknowledges some problems between Mella and the party, mainly due to the Central Committee's request that the Cuban communists in Mexico act less independently.

144 Oscar Enrique Ornelas, "Sólo los que no conocen la historia se aficionan a los modelos puros: Arriola Woog," *El Financiero*, February 20, 1995, p. 100.

145 Vidali, *Ritratto*, p. 10.

146 Ibid. In this very passage, Vidali confesses that it was he who was purged from the Mexican Communist Party, of which he was not even an official member.

147 Alba, *Esquema Histórico*, p. 97. Claraval, *Cuando fui comunista*, pp. 50–51. See also *Claridad: Boletín de la Oposición Comunista de Izquierda* (Mexico City), no. 5, March 5, 1931.

148 Russell Blackwell, "Julio A. Mella," *The Militant*, January 15, 1931. In 1928 Modotti photographed Blackwell among a group of seven Communist Youth Association members. See also *Claridad proletaria* (New York), no. 5, March 1931, and *Lucha obrera*, January 20, 1941.

149 Blackwell, "Julio A. Mella."

150 Ibid.

151 Robert J. Alexander, *Communism in Latin America* (New Brunswick: Rutgers University Press, 1957), p. 271.

152 Robert J. Alexander, *Trotskyism in Latin America* (Stanford: Hoover Institution Press, 1973). p. 218.

153 Ibid.

154 Gorkin, *Cómo asesinó Stalin a Trotski*, p. 204, quoted in Alexander, *Trotskyism in Latin America*, p. 218.

155 Cabús, "El asesinado de Julio Antonio Mella," p. 25.

156 Montes and Ávila, *Historia del Partido Comunista de Cuba*, p. 95.

157 Víctor Alba, *Historia del Comunismo en América Latina* (Mexico City: Ediciones Occidentales, 1954), quoted in Alexander, *Communism in Latin America*, p. 271, and Alba, *Esquema Histórico*, p. 97. Alba named the communist as Enea Sormenti, alias Vittorio Vidali, "one of the most sinister characters of Latin American communism." Ibid., pp. 97–98.

158 Vivès, *Les maîtres de Cuba*, pp. 54–63.

159 Córdova, *Clase trabajadora*, i, p. 129.

160 Suchlicki, *University Students and Revolution in Cuba*, p. 22 and nn. p. 140. Let us not forget that when Suchlicki interviewed Mella's widow in Miami in 1967, Ms. Zaldívar was a political refugee from Cuba. The theory of Vidali as Mella's assassin is repeated in Patrick Marnham, *Dreaming with His Eyes Open: A Life of Diego Rivera* (New York: Alfred A. Knopf, 1998), p. 212.

161 Hector Hernandez Pardo, "La muerte truncó en Mella una figura de alcance imprevisible para el movimiento revolucionario," *Gramma* (Havana), May 16, 1976.

162 *Gli 80 anni di Vittorio Vidali* (Trieste: Federazione Autonoma Triestina del P.C.I.), September 27, 1980, p. 46.

163 The letter was published in *El Avance Criollo*, March 24, 1961, p. 31. See Montes and Ávila, *Historia del Partido Comunista de Cuba*, p. 95. Natacha Mella's letter poses serious questions of credibility, since it was published only a month after her

mother (and perhaps Natacha herself) had defected from Castro's regime. A disassociation from communism was at that juncture politically advisable.

164 Leon Trotsky, *Literature and Revolution* (Ann Arbor: University of Michigan Press, 1968), p. 253. The Spanish version is *Literatura y revolución* (Madrid: M. A. Aguilar, 1924), p. 257. I thank very much Wilfred Dubois for his unpublished essay, "Zu Modotti-Foto von Mellas Schreibmaschine und Trotzki-Zitat."

165 Vidali, *Ritratto*, p. 26.

166 Wolfgang Lubitz, ed., *Trotsky Bibliography* (Munich: K. G. Saur, 1982), p. 14.

167 I thank very much the historian Barry Carr for helping me clarify this position, and for many other suggestions that he made most generously and unpretentiously. The same point – any accusation of Trotskyism leveled at Mella in fact masked the real content of his opposition, without being specifically Trotskyism – is also brought up by Gary Tennant in his excellent article "Julio Antonio Mella and the Roots of Dissension in the Partido Comunista de Cuba," *Revolutionary History*, vol. 7, no. 3, p. 41. In his book on the Italian communists who in the 1930s became victims of Stalinism, Guelfo Zaccaria made the same point. There was indeed much ideological confusion in Moscow in the 1930s, and the word "Trotskyism" became synonymous with any unpardonable crime. Guelfo Zaccaria, *A Mosca senza ritorno: Duecento comunisti italiani fra le vittime dello stalinismo* (Milan: Sugar, 1983), p. 30.

168 Franz Borkenau, *The Spanish Cockpit* (Ann Arbor: University of Michigan Press, 1963), p. 240.

169 Vittorio Vidali, letter addressed to "Dear Germanetto," on Mexican Communist Party stationery, February 14, 1928, signed Enea Sormenti. Archivio Istituto Gramsci, Rome. Giovanni Germanetto was an active member of the Italian Communist Party since its founding in 1921, and a member of the Italian delegation to the Fourth Congress of the Communist International. In 1922 he was sent to Moscow by the party. As a correspondent for the news-

paper *L'Unità*, he took the pseudonym of Copper Beard. On his return in 1924 he was subjected to fascist persecution. In the same year, he returned to the Soviet Union, where he engaged in active propaganda to save Sacco and Vanzetti, and he kept an intense correspondence with Bartolomeo Vanzetti. Germanetto's memoirs, although written originally in Italian, first appeared in Russian in 1930. Giovanni Germanetto, *Memoirs of a Barber* (New York: International Publishers, 1931).

170 Grigorij Pjatakov, a Bolshevik hero from 1910, was among the accused. Paolo Spriano, *Storia del Partito comunista italiano*, vol. 5 (Turin: Einaudi, 1970), p. 159.

171 In a twenty-minute trial, Babel was sentenced to death. The sentence was carried out on January 27, 1940. A. N. Pirozhkova, *At His Side: The Last Years of Isaac Babel* (South Royalton, Vt: Steerforth Press, 1996), p. xxix.

172 Alan M. Wald, *The Rise and Decline of the Anti-Stalinist Left from the 1930s to the 1980s* (Chapel Hill: University of North Carolina Press, 1987), p. 91.

173 Mella, *Escritos revolucionarios*; Julio Antonio Mella, "La agitación universitaria de 1923," *Juventud* (Havana), March 1925, p. 28; Mella, "Todo tiempo futuro tiene que ser mejor," ibid., November–December 1923; Mella, "Los nuevos libertadores," ibid., November–December 1924; Mella, *La Correspondencia Suramericana*, no. 25, 1927, pp. 16–17; and Mella, "Declaraciones al periódico *El Sol*" (Mexico City), June 20, 1928.

174 *Creo que seré útil al partido y a la revolución. Quien ha aceptado y sufrido la "disciplina del más inquisidor" de los partidos de la Internacional no va a rebelarse en México.* Mella to Bertram Wolfe, n.d. (believed to be 1927), signed Julio. Wolfe Collection, box 10, folder 39, Hoover Institution, Stanford.

175 *Y si al final ya no sirvo haganme como ahora se le ha hecho a Trotzky.* Ibid.

176 Cabrera, "La tercera Internacional, p. 57.

177 Carrillo to the Wolfes, December 1928. Wolfe Collection, box 4, folder 11, Hoover Institution, Stanford.

178 Haya de la Torre, *El antimperialismo*, p. xvi.

179 Gálvez Cancino, "L'autoabsolution de Vidali," *Cahiers Leon Trotsky*, June 26, 1986, p. 48. However, it is not clear whether the meeting between Mella and Nín actually took place in Moscow, during the Profintern's Fourth Congress, because by spring 1928, when the congress took place, Mella was no longer in the Soviet Union. Tennant, "Julio Antonio Mella and the Roots of Dissension," *Revolutionary History*, vol. 7, no. 3, p. 45, n. 22.

180 Other names under which Nín was earlier referred to are Roig, Fatarella, L. Tarquín, and Roberto. Olivia Gall, *Trotsky en México y la vida política en el periodo de Cárdenas, 1937–1940* (Mexico City: Era, 1991), p. 357, n. 5.

181 According to one theory, such changes were the result of new leadership. Vidali, Gómez Lorenzo, and Julio Ramínez were responsible for the gradual party intolerance. Antonio Saborit, "Politica e scandalo: Tina Modotti e il delitto di via Abraham González," in Toffoletti, ed., *Tina Modotti: Una vita nella storia*, p. 340. Also, government repression had become severe.

182 Concha Michel to Joseph Freeman, January 20, 1935. Freeman Collection, box 30, folder 29, Hoover Institution, Stanford. Evidently, Michel was expelled from the party, since she writes of her desire to request readmission.

183 "Trotzky, Agitador Contrarrevolucionario," *El Machete*, May 20, 1932; "Trotzky agitador imperialista," *El Machete*, August 20, 1932; "Una criminal provocación de los Trotzkistas," *El Machete*, November 20, 1933; "Los Trotzkistas Contra la URSS y Contra La Internacional Comunista," *El Machete*, November 20, 1933; "Guerra al Trotzkismo," *El Machete*, December 10, 1933; "Los Trotzkistas: Calumniadores, Provocadores, Divisionistas, Contrarrevolucionarios," *El Machete*, March 20, 1934; and "Contra el Trotzkismo Contrarrevolucionario," *El Machete*, May 30, 1934.

184 In a publication printed in the 1970s in the Soviet Union and translated into English (n.d.), it is stated that "present day Trotskyism is essentially a falsification of communism in the spirit of identification with the 'European' models of pseudo-Marxism." And, again, "Trotkyism has always been unprincipled and unscrupulous in its means. In the Trotskyite arsenal the enemies of the Party and socialism found slander, lies, deceit, hypocrisy, double-dealing, and political adventurism." *The Bolshevik Party's Struggle Against Trotskyism in the Post-October Period* (Moscow: Progress Publishers, n.d.), pp. 9 and 170.

185 "Malatesta ha muerto," *El Machete*, December 10, 1932.

186 Disagreements and conflicts within the left are frequently seized upon by conservative and right-wing historians who tend to enlarge them so they can attack the left in general. Unfortunately, some leftist political groups do much the same, that is, they prefer to channel their energies into frequent petty power struggles. Inevitably they lose the overall picture and consequently lose sight of the real target. The result is the same, for neither position helps the progressive cause.

187 Verdugo, *Historia del comunismo en México*, p. 92.

188 *El Machete*, February 9, 1929, IV, no. 151, p. 4.

189 Modotti's speech was reported in *El Machete*, February 16, 1929, IV, no. 152.

190 Robinson, *A Wall to Paint On*, p. 110. Besides political matters, Freeman had a personal grudge against Rivera, involving possible advances made by the painter to his fiancé, Ione, nicknamed Dot. Freeman was obviously forgetting his own statements on jealousy – a negative emotion that "should not fit a revolutionist." Ibid., p. 124. In October 1930, before leaving Mexico, Freeman wrote a sarcastic five-page letter to Rivera, which he never sent. It begins *My estimado maestro*. Freeman Collection, box 34, folder 13, Hoover Institution, Stanford. Bárbara Mujica, talking about Rivera's interest in Frida Kahlo's child, writes that Diego was "too busy screwing his American assistant, Ione Robinson, to pay

much attention." Bárbara Mujica, *frida: A Novel* (Woodstock and New York: Overlook Press, 2001), p. 205.

191 Vidali (as J. Contreras) to Joseph Freeman, June 1, 1932. Freeman Collection, box 16, folder 43, Hoover Institution, Stanford.

192 Robinson, *A Wall to Paint On*, p. 107. When she arrived in Mexico in 1929, after a period of work and study first in New York and then in Europe, Robinson had no understanding whatsoever of communism. And from her memoirs it is clear that she was ideologically detached from it, despite her engagement to Freeman. Therefore, her spontaneous comments on Rivera's faith and on his worldview appear all the more insightful and unprejudiced.

193 Robert Evans (Joseph Freeman) "Painting and Politics: The Case of Diego Rivera," *New Masses*, February 1932, and Robinson, *A Wall to Paint On*, p. 116.

194 Vittorio Vidali, *Comandante Carlos* (Rome: Editori Riuniti, 1983), p. 66.

195 Evans (Freeman), "Painting and Politics." About 30 years later, while Wolfe was revising his biography on Rivera, Freeman wrote to him, explaining and justifying the words and tone of his 1932 article. The first draft of this letter to Wolfe is dated October 25, 1962. Two other drafts are dated January 11 and January 13, 1963. Freeman Collection, box 42, folder 13, Hoover Institution, Stanford. The 1932 article by Freeman produced a strong reaction in defense of Rivera, voiced in an unsigned article, "Shameless Fraud," *Workers' Age*, June 15, 1933. There it was pointed out that Freeman's lies about Rivera's mural changes were meant to slander the painter, and that Freeman's comments about an alleged decline in Rivera's painting technique were totally gratuitous and out of place.

196 Donald L. Herman, *The Comintern in Mexico* (Washington, D.C.: Public Affairs Press, 1974), p. 97.

197 TM to EW, "September 17," 1929. EWA, Tucson. All evidence shows that the letter is wrongly dated: it should be September 27. Modotti also wrote to Anita

Brenner, October 9, 1929. Anita Brenner Archive, cited in Susannah Joel Glusker, "Anita Brenner, a Mind of Her Own." Ph.D diss., Union Institute, Los Angeles, 1995, p. 160. See also Robinson, *A Wall to Paint On*, p. 106, and an open letter by Diego Rivera in response to his denunciation by Terrones Benitez, governor of Durango, *El Universal*, August 10, 1929. Rivera's political excommunication more or less coincided with his official marriage to Frida Kahlo, on August 30, 1929, as Tina wrote in the same letter to Weston, adding in capital letters "A VER QUE SALE!" (let us see what comes out of it!). Apparently, at the end of August, the relationship between Modotti and Rivera was still amicable, since Tina lent him her rooftop studio for his wedding party, as indicated by Rivera's own daughter, Guadalupe, who moved the wedding date to August 21 (elsewhere to August 26), and wrote that Tina Modotti was the *madrina de la boda* (maid of honor of the wedding), as is shown in the 2002 film *Frida* by Julie Taymor, where Tina is played by Ashley Judd. Guadalupe Rivera Marín and Marie-Pierre Colle Corcuera, *Las fiestas de Frida y Diego: Recuerdos y Recetas* (New York: Clarkson Potter, 1994), pp. 12 and 29; Hooks, *Tina Modotti: Photographer and Revolutionary*, p. 189. Another source mentions that the party was held in Roberto Montenegro's home. Cupull, *Tina Modotti*, p. 52.

198 TM to EW, September 17, 1929. EWA, Tucson.

199 Vidali, *Ritratto*, p. 10. Vidali is referring to Mella's conflicts within the party and to his own conflicts.

200 Isaac Deutscher, *The Prophet Outcast: Trotsky, 1929–1940* (Oxford: Oxford University Press, 1963), p. 444.

201 Diego Rivera, *My Art, My Life: An Autobiography with Gladys March* (New York: Citadel Press, 1960), p. 164.

202 Herman, *Comintern in Mexico*, p. 97.

203 Other members were Luis G. Monzón, Enrique Flores Magón, Roberto Reyes Pérez, Federico Bach, and Luis Vargas Rea. Verdugo, *Historia del comunismo en México*, p. 418.

204 David Alfaro Siqueiros, *Me llama-ban el coronelazo (Memorias)* (Mexico City: Biografías Gandesa, Editorial Grijalbo, 1977), pp. 243–44. See also Siqueiros's article "Rivera's Counter-Revolutionary Roads," *New Masses*, May 29, 1934, where, as Bertram Wolfe puts it, "pompous self-laudation alternates with unscrupulous invention of slander and scandal." Bertram Wolfe, "Diego Rivera on Trial," *The Modern Monthly*, July, 1934, p. 338. Wolfe Collection, box 25, folder 6, Hoover Institution, Stanford. Siqueiros's article is full of inaccuracies, the most striking being that "Rivera never painted Julio Antonio Mella." Nevertheless, the article was highly praised by Joseph Freeman (who always showed a strong antipathy for Rivera) in a note to Siqueiros of May 23, 1934. Freeman Collection, box 37, folder 10, Hoover Institution, Stanford.

205 This fact provoked Rivera and Trotsky's alienation and, eventually, their falling out. Deutscher, *The Prophet Outcast*, p. 444. See also Guadalupe Pacheco Méndez, Arturo Anguiano Orozco, and Rogelio Vizcaíno, *Cárdenas y la izquierda mexicana* (Mexico City: Juan Pablos, 1975), p. 155.

206 Bertram D. Wolfe, *Diego Rivera: His Life and Times* (New York: Knopf, 1943), p. 256.

207 Robinson, *A Wall to Paint On*, p. 88.

208 Von Mayenburg, *Hotel Lux*, p. 189.

209 Alexander, *Trotskyism in Latin America*, p. 180. According to Freeman, Rivera's Trotskyist tendencies were merely a pose, characteristic of a certain type of intellectuals, since "to flaunt Trotskyist colors enabled him to pose as a communist without being one." Evans (Freeman), "Painting and Politics." From 1937 to 1938, Rivera and Trotsky were extremely close to each other, since Trotsky liked Rivera in a personal way. Jean van Heijenoort, *With Trotsky in Exile: From Prinkipo to Coyoacán* (Cambridge, Mass.: Harvard University Press, 1978), pp. 134–36.

210 Alexander, *Trotskyism in Latin America*, p. 185.

211 Glusker, *Anita Brenner*, p. 161. It is usually written that it was through Frida Kahlo, by 1937 Rivera's wife, a strong Trotskyist, that the Trotskys were allowed into Mexico. However, this conflicts with Rivera's own account in his autobiography: "Frida detested Trotsky's politics." But she went ahead with the plan to host the Trotskys in January 1937 to please her husband. Diego Rivera, *My Art, My Life*, pp. 229–30. Trotsky lived in the Riveras' house until spring 1939.

212 Rivera quoted by Alice Bunin to J. Freeman, October 25, 1929. Freeman Collection, box 16, folder 10, Hoover Institution, Stanford.

213 Siqueiros questioned Rivera's motives, which, in his opinion, rather than coming from sincere feelings reflected more a pose of "futurist" opportunism. Siqueiros, *Me llamaban el coronelazo*, p. 236.

214 Deutscher, *The Prophet Outcast*, p. 359, n. 1.

215 Pierre Broué, *Trotsky* (Paris: Fayard, 1988), p. 846.

216 The letter is reproduced on pp. 205–6 of Gall, *Trotsky en México*.

217 Alexander, *Trotskyism in Latin America*, pp. 181–82.

218 "La ruptura de relaciones con el gobierno de Mussolini," *El Machete*, no. 138, November 7, 1928, p. 8, and Elena Poniatowska, "Añil y carne humana," in *Diego Rivera y los escritores mexicanos: Antología tributaria* (Universidad Nacional Autónoma de México, 1986), p. 171.

219 Letter to B. Wolfe, March 19, 1939, Bertram Wolfe Collection, box 12, folder 54, Hoover Institution, Stanford.

220 The personal conflict occurred when Kahlo had an affair with Trotsky. Isabel Alcántara and Sandra Egnolff, *Frida Kahlo and Diego Rivera* (Munich: Prestel, 1999), p. 54.

221 *El Machete*, October 10, 1934.

222 "Diego Rivera, la Inmundicia Mayor del Trotzkismo," *El Machete*, June 10, 1934; "El Trotzkista Diego Rivera Ayuda a Engañar a los Repatriados," *El Machete*, July 10, 1934; "Los Trotzkistas provocadores pistoleros," *El Machete*, July 20, 1934;

"Trotzki, Téorico del P.N.R." *El Machete*, August 20, 1934.

223 "La ruptura de relaciones con el gobierno de Mussolini: Fue Pedido en el Mitin de la Liga Internacional Antifascista," *El Machete*, no. 138, November 7, 1928, p. 8.

224 Anita Brenner, *Idols behind Altars* (New York: Biblo and Tannen, 1929), p. 277.

225 Ibid., p. 279.

226 Robinson, *A Wall to Paint On*, p. 99.

227 Mauricio Magdaleno, "El sentido social del arte de Diego Rivera," in *Diego Rivera y los escritores mexicanos*, p. 124.

228 Wolfe, *A Life In Two Centuries*, p. 640. When writing his memoirs, Wolfe had already left the communist cause out of disenchantment and probably associated communism only with Stalinism. Therefore, nothing made him happier than denouncing these incoherences on the part of communists. However, a genuine feeling for Mexico and its people remained in his heart.

229 If Wolfe's account in this matter is accurate, it was Rafael Carrillo who admitted that to Wolfe. Bertram Wolfe, *The Fabulous Life of Diego Rivera* (New York: Stein and Day, 1963), p. 237. Despite his intransigence, which reflected the new, hard line of the party, Siqueiros suffered Rivera's fate; he was expelled from the party, for much more complicated reasons (including personal ones) on March 27, 1930. "David A. Siqueiros Expulsado del Partido Comunista," *El Machete*, no. 180, April, 1930. See also Siqueiros, *Me llamaban el coronelazo*, p. 279.

230 Harry Thayer Mahoney and Marjorie Locke Mahoney, *Espionage in Mexico: The Twentieth Century* (San Francisco: Austin & Winfield, 1997), p. 213, n. 13.

231 Alcántara and Egnolff, *Frida Kahlo and Diego Rivera*, p. 114. According to Wolfe, the party decided to take the painter back not because he had become "manageable" but because they decided that he was useful. In 1957, when Rivera died, the party "said its say" at his cremation. Wolfe, *Fabulous Life of Diego Rivera*, pp. 424 and 413.

232 Diego Rivera, "The Question of Art in Mexico," *Indice*, 1953, cited in Desmond Rochfort, *Mexican Muralists* (New York: Universe, 1994), p. 227, n. 14. Rivera associates a certain degeneration in the standard of his art with his support for Trotsky.

233 Siqueiros, *Me llamaban el coronelazo*, p. 212. Rivera's love and admiration for Zapata had no limits. In one of his murals, at the School of Agriculture in Chapingo, he honored the Mexican hero with these words: "Here one is taught to exploit the soil, not men."

234 *Gli 80 anni di Vittorio Vidali*, p. 42. Since there is no distinction in Italian between "Trotskyist" and "Trotskyite," I have translated using the negative term, because that was Vidali's intention.

235 Rivera, *My Art, My Life*, p. 162.

236 "Tina Modotti la compañera del estudiante Julio Antonio Mella, y su acerrimo defensor el pintor comunista Diego Rivera," *Excelsior*, January 18, 1929, p. 1.

237 The letter, dated January 16, 1929, is reproduced in Constantine, *Tina Modotti*, pp. 137–38, and cited in Adriana Williams, *Covarrubias*, ed. Doris Ober (Austin: University of Texas Press, 1994), p. 56.

238 She commented on that possibility later in a letter to Weston of September 1929. EWA, Tucson.

239 Classified document no. 03114, August 7, 1929, by the prefect of Udine to the Italian Ministry of the Interior. Tina was mistaken for her sister Gioconda, who was an unmarried mother. Comitato Tina Modotti, Udine.

240 Karol, *Les guérrileros au pouvoir*, p. 73.

241 TM to EW, April 5, 1929, EWA, Tucson.

242 Robinson, *A Wall to Paint On*, p. 85.

243 Ibid., p. 86

244 Ibid.

245 Ibid.

246 Two photographs confirm Benvenuto's participation in the demonstration, held in Tizayuca on April 7, 1929, and in the first informal Latin American Red Aid

meeting, held in Mexico City on April 13, 1929. Comintern Archive, Moscow, and Comitato Tina Modotti, Udine.

247 Benvenuto to Tina Modotti, December 29, 1928, written from Pasadena, California. Comitato Tina Modotti, Udine. Benvenuto thanked Tina for the $15 she sent her family.

248 Benvenuto to Tina Modotti, December 10, 1928. Comitato Tina Modotti, Udine.

249 Telegram no. 5612, February 2, 1929–fascist year VII. See also a previous letter, dated June 15, 1928—fascist year VI, by the Italian Consulate in San Francisco to the Ministry of Foreign Affairs, and a classified document of June 12, 1928 from the Ministry of the Interior, in which two other Italians living in San Francisco were watched closely as "subversive antifascists," F. Traversa and D. Pagliari. Comitato Tina Modotti, Udine.

250 "Benvenuto is here, and sends saludos to Eduardito; He is such a fine and wholesome boy, and such a precious camarada!" TM to EW, April 5, 1929, EWA, Tucson.

251 "Tina was telling me that he will be a great company to her and great help to her now." Monna Sala to EW, March 2, 1929, EWA, Tucson.

252 Benvenuto to Tina Modotti, October 18, 1928. Comitato Tina Modotti, Udine. In spite of his communist beliefs, Benvenuto was considered an anarchist by the Italian fascist police, who apparently did not know the difference. Note no. 59280, August 7, 1929, by the prefect of Udine to the Ministry of the Interior.

8 Camera as Comrade

1 Felicia R. Lee, "Revisiting a Watershed Era," *The New York Times,* January 18, 1999, p. B3.

2 The year 1935 coincides with the beginning of her development as an independent photographer, no longer linked to her former husband, Manuel Alvarez Bravo, either personally or professionally. Elizabeth

Ferrer, "Lola Alvarez Bravo: A Modernist in Mexican Photography," *History of Photography,* vol. 18, no. 3, Autumn 1994, pp. 211–18.

3 Sarah M. Lowe, "The Immutable Still Lifes of Tina Modotti: Fixing Form," *History of Photography,* vol. 18, no. 3, Autumn 1994, p. 208.

4 Mildred Constantine, *Tina Modotti: A Fragile Life* (San Francisco: Chronicle Books, 1983), p. 93.

5 Gisèle Freund, statement to the author, J. Paul Getty Center, Santa Monica, 1989. Freund died in March 2000.

6 Marius De Zayas, "Photography and Artistic Photography," in Alan Trachtenberg, ed., *Classic Essays in Photography* (New Haven: Leete's Island Books, 1980), pp. 125–32, cited in Graham Clarke, *The Photograph* (Oxford: Oxford University Press, 1997), pp. 167 and 225.

7 EWA, Tucson.

8 For De Zayas's explanation, see Clarke, *The Photograph,* p. 167. Clarke explains that since De Zayas was writing in 1913 for *Camera Work,* a leading photographic journal, founded and published by Alfred Stieglitz, the question of whether or not photography was an art was moot, for the journal "extolled photography as an art form in its own right."

9 Martí Casanovas, "Las fotos de Tina Modotti: Anécdotas revolucionarias," *Revista 30–30* (Mexico City), vol. 10, 1929.

10 Pasquale Verdicchio, "Tina Modotti: The Ink of Resistance," preface to Tina Modotti, *5,000,000 Widows 10,000,000 Orphans: Women! Do You Want That Again?* (La Jolla: Parenthesis, 1996), p. i. The piece was originally published in 1932 in German. For the subject of "photographic pauperism," see also Riccardo Toffoletti, "note su fotografia e dintorni," *Perimmagine* (Udine), Fall 2000, p. 3.

11 Mildred Constantine, interview with Fernando Gamboa, January 20, 1974. The J. Paul Getty Research Institute, Los Angeles.

12 Riccardo Toffoletti, " Tina Modotti e la storia della fotografia: Le tappe della riscoperta," in Toffoletti, ed., *Tina Modotti:*

Una vita nella storia (Udine: Arti Grafiche Friulane, 1995), p. 236.

13 Armando Castellanos, "Frida Kahlo Tina Modotti," *Munal* (Tacuba), no. 8, June–August 1983. This point, though from another angle, was brought up by John Mraz, who rightly states that Modotti's images are crucial in understanding the transformation of her views as resulting from living inside one of the great revolutionary experiences of modern times. This transformation could be defined as "filling the form with a content." John Mraz, "En el camino hacia la realidad," *La Jornada Semanal*, July 30, 1989, p. 23.

14 Concepción Ruiz-Funes, interview with Vittorio Vidali, April 28–May 1, 1979. Courtesy of the Vidali family. A transcript of this interview is kept at the Archivo de la Palabra, Mexico City.

15 Gary Higgins, "Truth, Myth, and Erasure: Tina Modotti and Edward Weston," *The History of Photography Monograph Series*, no. 28, Spring 1991, n.p.

16 Omitting the photographs of the murals, Amy Conger believes that there are only 160 photographs attributable to Modotti; Rosa Casanova believes there are 196, while Sarah Lowe believes there are between 225 and 230 that can be attributed to Modotti.

17 Margaret Hooks, *Tina Modotti: Photographer and Revolutionary* (London: Pandora, 1993), pp. 120–21. See also Andrea Noble, *Tina Modotti: Image, Texture, Photography* (Albuquerque: University of New Mexico Press, 2000), pp. 87–107.

18 The four journals that printed the photograph were *New Masses* (1928), presented as *May Day in Mexico*; *Creative Art* (1929): *A Peasants' Manifestation*; *transition* (1929): *Strike Scene*; and *BIFUR* (1930): *Mexique*. Sarah M. Lowe, *Tina Modotti: Photographs* (New York: Abrams, 1995), p. 149, n. 189.

19 This aspect is brought up by Eli Bartra, in relation to the photographs by Tina Modotti, Lola Alvarez Bravo, and Graciela Iturbide. Eli Bartra, "Women and Portraiture in Mexico," *History of Photography*, vol. 20, no. 3, Autumn 1996, p. 220.

20 This picture appeared in e.g. *L'antifascista*, xxx, February 2, 1983, p. 11.

21 Rosario Ferré, "Tina y Elena: El Ojo y el Oido de México," *Nexos*, vol. 98, 1983, p. 8.

22 Benvenuto to Tina Modotti, October 18, 1928. Comitato Tina Modotti, Udine.

23 Lola Alvarez Bravo, *Recuento fotográfico* (Mexico City: editorial Penelope, 1982), p. 98.

24 Mariana Figarella Mota, "Edward Weston y Tina Modotti en México: Su inserción dentro de las estrategias estéticas del arte post-revolucionario," Tesis de Maestria, Historia del Arte, Universidad Nacional Autónoma de México, 1995, p. 145, cited in Bartra, "Women and Portraiture in Mexico," pp. 220 and 225, n. 4. See also Riccardo Toffoletti, "La tesi di Mariana," in *Tina Modotti: Arte Vita Libertà* (Trieste: Il Ramo d'Oro, 2001), p. 206, where Toffoletti clarifies a few misconceptions about this picture, mainly about the color of the woman's flag: Toffoletti argues that it is undoubtedly red, not black.

25 Bartra, "Women and Portraiture in Mexico," p. 220. However, Bartra also states that, although Iturbide focused on individuals in her photography, hers are not portraits, even when people's names are included in the title.

26 David Vestal, *The Craft of Photography* (New York: Harper & Row, 1972), p. 56.

27 This point is brought up by Clarke in another context, not in comparison with Modotti's photography. Clarke, *The Photograph*, p. 173.

28 Elena Poniatowska, "Algunas Fotógrafas de México," in *Compañeras de México: Women Photograph Women*, essays by Amy Conger and Elena Poniatowska (Riverside: University of California Press, 1990), p. 55.

29 The statement is by the photographer Eva Rubinstein in Douglas O. Morgan, David Vestal, and William L. Broecker, eds., *Leica Manual: The Complete Book of 35mm Photography* (New York: Morgan & Morgan, 1973), p. 335.

30 Poniatowska, "Algunas Fotógrafas de México," p. 44 .

31 Lowe, "The Immutable Still Lifes of Tina Modotti," p. 205.

32 Paul O'Higgins quoted in *Tina Modotti garibaldina e artista* (Udine: Circolo Culturale "Elio Mauro", 1973), p. 26. On the cover of this book, Tina is immortalized in a drawing by Renato Guttuso.

33 Mildred Constantine, interview with Anita Brenner, n. d. The J. Paul Getty Research Institute, Los Angeles.

34 Patricia Albers, *Shadows, Fire, Snow: The Life of Tina Modotti* (New York: Clarkson Potter, 1991), p. 271.

35 Riccardo Toffoletti, "Tina Modotti e la storia della fotografia," p. 235.

36 Ibid., p. 236.

37 Eli Bartra, *Mujer, ideología y arte* (Capellades: la Sal, 1987), p. 35.

38 This picture appeared in e.g. *L'antifascista*, February 2, 1983, p. 1.

39 Octavio Paz, "Frida y Tina: vidas no paralelas," *Vuelta*, n. 82, vol. 7, September 1983, p. 48.

40 Weston to Hagemeyer, February 28, 1924, cited in Amy Stark, ed., *Letters from Tina Modotti to Edward Weston*, in *The Archive*, no. 22, January 1986 (Tucson: Center for Creative Photography, 1986), pp. 18 and 23, n. 8. See also Nancy Newhall, ed., *The Daybooks of Edward Weston* (New York: Aperture Foundation, 1981), i, pp. 69 and 101. In his diary, Weston was referring to the print of the tower of Tepotzotlán, where Modotti "accentuated the ambiguity of the space by using the platinum printing process, which registers an exceptionally broad range of gray tones." *The Art Institute of Chicago: The Essential Guide*, selected by James N. Wood and Teri J. Edelstein. With entries compiled by Sally Ruth May (Art Institute of Chicago, 1993), p. 177.

41 *El Machete*, iv, no. 120, June 23, 1928, cover page. See also a note by Toffoletti in *Perimmagine,* July–September, 1993, n.p.

42 As late as 1983 the photograph appeared in e.g. *L'antifascista*, xxx, February 2, 1983, p. 7.

43 See the photograph in Stéphane Place, ed., *Tina Modotti: The Mexican Renaissance* (Paris: Jean-Michel Place, 2000).

44 TM to EW, July 4, 1927 (with ciga-

rette hole in the letter); it ends "Tenderly as always." EWA, Tucson. This is the source for her visit to the de la Bolsa colony.

45 Carleton Beals, "Tina Modotti," *Creative Art*, February 1929, vol. 4, no. 2, p. i; Laura Mulvey and Peter Wollen, *Frida Kahlo and Tina Modotti*, exh. cat. (London: Whitechapel Art Gallery, 1982), p. 30.

46 Rosa Casanova, "Tina Modotti nella tradizione fotografica messicana," in Toffoletti, *Tina Modotti: Una vita nella storia*, p. 265.

47 Ibid., p. 264. This picture also appeared in *L'antifascista*, xxx, February 2, 1983, p. 5. Clarke distinguishes between an image and a portrait in *The Photograph*, p. 114.

48 Andrea Noble brings up an interesting point about hands in painting, mentioning Giovanni Morelli's studies of hands. Noble, *Tina Modotti*, pp. 68–69.

49 Lola Alvarez Bravo, *Recuento fotográfico*, p. 97.

50 Vicki Goldberg, "A Rarefied Belgian Who Specialized in Mournful Beauty," *The New York Times*, January 17, 1999, p. 39.

51 One example was the famous photograph, *Carolina Cotton Mill*, dated 1908. Helmut and Alison Gernsheim, *A Concise History of Photography* (London: Thames and Hudson, 1965), p. 149. To gain entrance to the southern textile mills, Hine would sometimes claim to be a fire inspector or an insurance salesman. Vicki Goldberg, *The Power of Photography: How Photographs Changed Our Lives* (New York: Abbeville, 1991), p. 173.

52 The Corcoran Gallery of Art, Washington, D.C., September 30–November 26, 1978; El Museo del Barrio, New York City, December 8, 1978–February 25, 1979; in Rebecca Zurier, ed., *Photographs of Mexico: Modotti/Strand/Weston*, exh. cat. The cover reproduced Modotti's *Woman Carrying Pot.*

53 That is the way Poniatowska represented the Tehuantepec women who came in contact with Modotti in summer 1929 in her *Tinísima*. The same issue of women represented in the guise of "spiritual mediators" is raised by Leigh Binford in commenting

on the photographs of women by Graciela Iturbide. Leigh Binford, "Graciela Iturbide: Normalizing Juchitán," *History of Photography*, vol. 20, no. 3, Autumn 1996, p. 244.

54 Concepción Ruiz-Funes, interview with Vittorio Vidali, April 28–May 1, 1979. Courtesy of the Vidali family. See also Vittorio Vidali, *Ritratto di donna: Tina Modotti* (Milan: Vangelista, 1982), p. 17.

55 Susannah Joel Glusker, "Anita Brenner: A Mind of Her Own," Ph.D. diss., Union Institute, Los Angeles, 1995, p. 81.

56 Casanova, "Tina Modotti nella tradizione fotografica messicana," p. 269, n. 35.

57 "How to flirt in Tehuantepec," in Carleton Beals, *House in Mexico* (New York: Hastings House, 1958), p. 181. A more recent (and serious) description on the same theme can be found in Elena Poniatowska, "El Hombre con el Pito Dulce," in *Juchitán de las Mujeres*, with photographs by Graciela Iturbide (Mexico City: Ediciones Toledo, 1989). The book features the dominant women of the village of Juchitán, in the state of Oaxaca, whose inhabitants – around 150,000 – belong to the Zapotec community, famous for the strength and independence of its women.

58 Charles Étienne Brasseur de Bourbourg, *Voyage sur l'isthme de Tehuantepec, dans l'état de Chiapas e la république de Guatemala* (Paris: A. Bertrand, 1861).

59 Miguel Covarrubias, *Mexico South: The Isthmus of Tehuantepec* (New York: Knopf, 1946), p. xxii.

60 Graham Clarke, "Public Faces, Private Lives: August Sander and the Social Typology of the Portrait Photograph," in Graham Clarke, ed., *The Portrait in Photography* (London: Reaktion Books, 1992), p. 80. Clarke believes that to look at Sander's portraits is to view a social order, "a public world of individuals defined through their public role." Ibid., p. 71.

61 Eric Homberger, "J. P. Morgan's Nose: Photographer and Subject in American Portrait Photography," in ibid., p. 123. Homberger recorded a photographic session by Weston on Modotti in 1924, of which two

versions exist, one far more explicit and cited by Ben Maddow, and the other cited by Nancy Newhall. Ibid., p. 214, n. 15.

62 Remo Bufano, "The Marionette in the Theater," *The Little Review*, Winter 1926, p. 42.

63 Thomas Mann's short story deals with Mario, a waiter at an Italian lake resort, Torre di Venere, who is about to succumb to a seedy illusionist, who symbolizes the character of fascism, until he reacts and strikes back. In 1929, Thomas Mann had been the recipient of the Nobel Prize for Literature, although his best work was still to come.

64 Toffoletti, "Tina Modotti e la storia della fotografia," p. 236.

65 Susannah Joel Glusker, *Anita Brenner: A Mind of Her Own* (Austin: University of Texas Press, 1998), p. 69.

66 Joseph Freeman to Ione Robinson, August 2, 1931. Freeman Collection, box 34, folder 20, Hoover Institution, Stanford.

67 Robinson to Freeman, October 29, 1929. Freeman Collection, box 34, folder 18, Hoover Institution, Stanford.

68 "Reizvoll aber schwierig: Photographien," *Kunst & Antiquitäten*, no. 95, April 24, 1991, p. 1. $165,000 was the highest sum paid for a photograph at auction at that time. Margaret Hooks, "Assignment, Mexico: The Mystery of the Missing Modottis," *Afterimage*, vol. 19, no. 4, November 1991, p. 10.

69 Lowe, "The Immutable Still Life of Tina Modotti," p. 207.

70 Noble, *Tina Modotti*, pp. 56–57.

71 Bárbara Mujica, *frida: A Novel* (Woodstock and New York: Overlook Press, 2001), p. 207.

72 Mraz, "En el camino hacia la realidad," p. 23. Mraz is thinking specifically of the pictures with objects such as the guitar, hammer and sickle, etc.

73 Crispolti saw this photograph for the first time in 1962, at the Museum of Modern Art in New York, thanks to Edward Steichen, and immediately fell in love with the image. Riccardo Toffoletti, ed., *Tina Modotti: Perchè non muore il fuoco* (Udine: Arti Grafiche Friulane, 1992), pp. 62–63.

74 Mraz, "En el camino hacia la realidad," p. 23.

75 Lowe, *Tina Modotti: Photographs*, p. 40.

76 Beals, "Tina Modotti," pp. xliv–li, Mulvey and Wollen, *Frida Kahlo and Tina Modotti*, pp. 30–31.

77 Ibid., p. xlix, and ibid., p. 31.

9 Expulsion

1 For an assessment of the Mexican political situation by a Trotskyist, see Max Shachtman, "The Civil War in Mexico," *The Militant*, March 15, 1929, p. 3. In January 1937 Schachtman, one of the founders of the Trotskyist movement in the U.S.A., was among those who greeted Trotsky when he arrived in Mexico. Victor Serge and Natalia Sedova Trotsky, *The Life and Death of Leon Trotsky* (New York: Basic Books, 1975), p. 210. In 1958 Schachtman detached himself from Trotskyism to join the American Socialist Party.

2 Arnaldo Córdova, *La clase obrera en la historia de México: En una época de crisis (1928–1934)*, ed. Pablo González Casanova, vol. 9 (Mexico City: Siglo xxi, 1980), p. 83.

3 Letter to Weston, September 17, 1929, EWA, Tucson.

4 Letters to Modotti from Albert Jourdan, from the Pacific International Salon of Photographic Art in Portland, Oregon, May 6, 1929; P. G. Van Hecke, from the French magazine *Variétés*, May 7, 1929, and George Brown, editor of the *British Journal of Photography*, July 1, 1929. The J. Paul Getty Research Institute, Los Angeles.

5 Carlos Mérida to Tina Modotti, November 5, 1929. The J. Paul Getty Research Institute, Los Angeles.

6 *El Universal*, December 3, 1929. See also Raquel Tibol, "Algunas razones para juntar a Frida y Tina en el Munal," *Proceso*, no. 344, June 6, 1983, p. 51.

7 *New Masses*, June 1929. There the photograph is titled "Mexican miner's wife picketing before a mine in Jalisco." In the Mexican *El Nacional*, December 4, 1929, p. 1, the photograph is called "Mujer con bandera (negra) anarcosindacalista."

8 *New Masses*, September 1929, pp. 1 and 12. Carlo Tresca, "A Day in the Life of an Agitator."

9 This picture of Modotti surrounded by her works is on the cover of a recent bilingual catalogue devoted to this exhibition. Jesús Nieto Sotelo and Elisa Lozano Alvarez, eds., *Tina Modotti: Una nueva mirada, 1929* (Universidad Autónoma del Estado de Morelos: CNCA/Centro de la Imagen, 2000). See p. 25 for the list of the identified works exhibited.

10 Modotti immortalized Michel and her inseparable guitar in a print probably taken the year before. Two examples of songs by Michel are on pp. 18–19 of ibid.

11 Archivo General de la Nación, Fondo Presidentes: Emilio Portes Gil, no. 5/302/217.

12 "Tina Modotti exhibit," *New Masses*, December 1929.

13 Carleton Beals, "Tina Modotti," *Creative Art*, February 1929, vol 4, no. 2, pp. xliv–li.

14 Frances Toor, "Exposición de fotografías de Tina Modotti," *Mexican Folkways*, October–December 1929.

15 "Conversazione con Vittorio Vidali," ed. Riccardo Toffoletti, *Perimmagine*, July–September 1993, n.p.

16 In his speech, entitled "The First Revolutionary Photographic Exhibit in Mexico," Siqueiros took the opportunity to criticize Rivera, calling him "an opportunist and a collaborationist." Ione Robinson, *A Wall to Paint On* (New York: E. P. Dutton, 1946), p. 125. Dromundo's speech was reported in *El Universal*, December 15, 1929. Modotti's letter to Dromundo Cherne was dated December 20, 1929.

17 Modotti to Dromundo Cherne, reported in Adys Cupull, *Julio Antonio Mella en los mexicanos* (Mexico City: Ediciones el Caballito, 1983), p. 39.

18 Margaret Hooks, *Tina Modotti: Photographer and Revolutionary* (London: Pandora, 1993), p. 192.

19 John W. F. Dulles, *Yesterday in Mexico: A Chronicle of the Revolution, 1919–1936* (Austin: University of Texas Press, 1961), p. 476; also in José Joaquín

Blanco, *Se llamaba Vasconcelos: Una evocación crítica* (Mexico City: Fondo de Cultura Económica, 1977), p. 164.

20 "19 slain as Mexico elects Ortiz Rubio president; losers call poll a fraud" (unsigned), *The New York Times*, November 18, 1929, and "Losers in Mexico quit after defeat" (unsigned), *The New York Times*, November 19, 1929.

21 Dulles, *Yesterday in Mexico*, p. 476; also in Blanco, *Se llamaba Vasconcelos*, p. 164.

22 "Vasconcelos, nuevo Mesías," *El Machete*, March 16, 1929, v, no. 156, p. 2.

23 Blanco, *Se llamaba Vasconcelos*, p. 164.

24 Antonio Saborit, "Politica e scandalo: Tina Modotti e il delitto di via Abraham Gonzáles," in Riccardo Toffoletti, ed., *Tina Modotti: Una vita nella storia* (Udine: Arti Grafiche Friulane, 1995), p. 339. See also Antonio Saborit, *Una mujer sin país: Las cartas de Tina Modotti a Edward Weston 1921–1931* (Mexico City: Cal y Arena, 1992), p. 43.

25 "Ortiz Rubio lauded for aid to schools" (unsigned), *The New York Times*, December 29, 1929. From Washington, D.C., Ortiz Rubio went on to Buffalo, Niagara, and Detroit. Dulles, *Yesterday in Mexico*, p. 479.

26 Richard Philips, "José Vasconcelos and the Mexican Revolution of 1910," Ph.D. thesis, Stanford University, 1953, p. 235.

27 "Le que Significa el Gobierno de Ortiz Rubio: Manifiesto del Partido Comunista de México," (unsigned), *El Machete*, no. 179, March 1930, pp. 7–8, cited in Gerardo Peláez, *Partido Comunista Mexicano: 60 años de historia (Cronología 1919–1968)* (Culiacán: Universidad Autónoma de Sinaloa, 1980), p. 36.

28 Carleton Beals, *The Great Circle* (Philadelphia: J. B. Lippincott, 1940), p. 224.

29 Alice Bunin to Joseph Freeman, November 4, 1929. Freeman Collection, box 16, folder 10, Hoover Institution, Stanford.

30 Juan De Torres, "The Mexican Reaction," *New Masses*, September 1929,

p. 13. See also Carl Ramburg, "Mexico in Revolution," *New Masses*, April 1929, p. 11.

31 "Chicago has arrested more communists in one day than all of Mexico in a month." Joseph Freeman to Alice Bunin, November 4, 1929. Freeman Collection, box 16, folder 10, Hoover Institution, Stanford.

32 Olga Cabrera, *Guiteras, la época, el hombre* (Havana: Editorial de Arte y Literatura, 1974), p. 82.

33 Manuel Márquez Fuentes and Octavio Rodríguez Araujo, *El Partido Comunista Mexicano (en el periodo de la Internacional Comunista: 1919–1943)* (Mexico City: El Caballito, 1973), p. 159.

34 "Corrido de la clausura de El Machete," *El Machete*, v, no. 170, June 22, 1929, p. 2 (signed M.A.M.).

35 Robert Evans (Joseph Freeman), "Painting and Politics: The Case of Diego Rivera," *New Masses*, February 1932.

36 "*El Machete* necessita dinero urgentemente," *El Machete*, October 30, 1931; "Salvemos al Machete! Paguemos las deudas atrasadas! No desarmemos a los obreros, campesinos y soldados!," *El Machete*, July 30, 1932, and "Es Preciso Salvar El Machete!," *El Machete*, July 10, 1933.

37 A book by Lenin cost $1.80, a book by Malraux (*Los Soviets en China*), $1.50, and the complete edition of Marx's *Das Kapital* cost $18. *El Machete*, May 20, 1932.

38 *El Machete*, December 10, 1933.

39 Peláez, *Partido Comunista Mexicano*, p. 33. The book is dedicated explicitly to José Guadalupe Rodríguez. See also Marcela de Neymet, *Cronología del Partido Comunista Mexicano: Primera parte, 1919–1939* (Mexico City: Ediciones de Cultura Popular, 1981), p. 67.

40 Vittorio Vidali, *Ritratto di donna: Tina Modotti* (Milan: Vangelista, 1982), p. 12.

41 Vittorio Vidali, *Comandante Carlos* (Rome: Editori Riuniti, 1983), p. 65. Vidali remembers that Rodríguez used to brand his horses with the hammer and sickle sign – a mistake, since the enemy could recognize them.

42 Manuel Márquez Fuentes and Octavio Rodríguez Araujo, *El Partido Comunista Mexicano*, p. 159.

43 Carleton Beals, *Glass Houses: Ten Years of Free Lancing* (Philadelphia: J. B. Lippincott, 1938), p. 355.

44 Beals, *Great Circle*, p. 225.

45 "Le que Significa el Gobierno de Ortiz Rubio," pp. 7–8. The article explains that the Mexican Communist Party had no interest whatsoever in eliminating a president who would be immediately followed by another much the same, or even worse. It also mentions Diego Rivera in negative terms once again.

46 Express mail no. 211559, April 1, 1931–fascist year IX, issued by the Ministry of Foreign Affairs, Rome. Comitato Tina Modotti, Udine.

47 Classified document no. 509/66, identified as "strictly confidential," February 22, 1930–fascist year VIII, addressed to the Ministry of Foreign Affairs, Rome. Comitato Tina Modotti, Udine.

48 ... *trabar mejor la quijada para impedir la mordida*. Blanco, *Se llamaba Vasconcelos*, p. 165.

49 Alfonso Taracena, *Los Vasconcelistos sacrificados en Topilejo* (Mexico City: Clasica Selecta Editora, 1958), p. 18.

50 Ibid., p. 22.

51 Beals, *Great Circle*, p. 226.

52 Vasconcelos (who heard about the attempt on Ortiz Rubio's life while in Los Angeles) never forgave the government for the Topilejo massacre, and left word that he refused to be buried in the Pantheon of Illustrious Men. Alfonso Taracena, *José Vasconcelos* (Mexico City: Editorial Porrúa, 1982), p. 148; Taracena, *Los Vasconcelistos sacrificados*, pp. 13 and 31, and Colin M. MacLachlan and William H. Beezley, *El Gran Pueblo* (Upper Saddle River: Prentice Hall, 1999), p. 315.

53 Classified document, March 29, 1930, filed on April 9, 1930. Italian Ministry of the Interior. Comitato Tina Modotti, Udine.

54 Paca Toor to Joseph Freeman, June 7, 1930. Freeman Collection, box 38, folder 45, Hoover Institution, Stanford.

55 State Archive, Archivo General de la Nación, Presidentes, Grupo Documental Pascual Ortiz Rubio, Exp. Comunistas/Atentado Presidente, no. 1930, f. 168A. The letter is also reproduced in Saborit, *Una mujer sin país*, pp. 151–52.

56 Saborit, "Politica e scandalo," p. 341.

57 José Manuel Puig Casauranc, *Galatea rebelde a varios pigmaliones* (Mexico City: Impresores unidos, 1938), p. 366. Apparently, Quintana was notorious for using unorthodox methods. In May 1929, during the university student strike in Mexico City, a student commission presented a petition to President Portes Gil requesting Quintana's dismissal. The petition was rejected but, thanks to Puig Casauranc, at that time minister of education, the university became autonomous. Dulles, *Yesterday in Mexico*, p. 465. In summer 1930 Puig Casauranc resigned as head of the federal district and left for Europe.

58 Dulles, *Yesterday in Mexico*, pp. 486 and 495.

59 She had been thinking of leaving Mexico in around January 1930. Modotti to Joseph Freeman, November 4, 1929. Freeman Collection, box 30, folder 36, Hoover Institution, Stanford. See also Lou Bunin to Joseph Freeman, November 4, 1929. Freeman Collection, box 16, folder 10, Hoover Institution, Stanford. To mock the efficiency of the Mexican government, Bunin ironically warns his friend that, according to a rumor, he (Freeman) may soon be expelled from Mexico, through Article 33, while in reality he was already out of Mexico and settled in New York. See also the letters from Modotti to Weston, in which she wrote: "Things are very insecure for 'pernicious foreigners' – I am prepared for the worst." April 5, 1929. And "it is so disagreeable not to know how much longer one is allowed to remain." And "I begin to feel restless." September 17, 1929. EWA, Tucson.

60 Vidali, *Ritratto*, p. 13.

61 Modotti to Anita Brenner, October 9, 1929. Modotti thanked Brenner for a copy of *Idols behind Altars*, and gave some

information on her life, expressing "the need to move on," and to test herself anew. Modotti also briefed Brenner on Rivera's expulsion from the party. Susannah Joel Glusker, *Anita Brenner: A Mind of Her Own* (Austin: University of Texas Press, 1998), p. 108.

62 Paca Toor to Joseph Freeman, December 29, 1929. Freeman Collection, box 38, folder 45, Hoover Institution, Stanford.

63 Mildred Constantine, interview with Fernando Gamboa, January 20, 1974. The J. Paul Getty Research Institute, Los Angeles.

64 Lola Alvarez Bravo, *Recuento fotográfico* (Mexico City: Editorial Penélope, 1982), p. 97, and Tim Golden, "Mexican Myth and Master of Photographic Images," *The New York Times*, December 16, 1993, p. B4. According to Manual Alvarez Bravo, he actually met Tina in 1927 when he had just returned from Guaxata. Mildred Constantine, interviews with Manuel Alvarez Bravo, January 21 and April 11, 1974. The J. Paul Getty Research Institute, Los Angeles.

65 Elena Poniatowska, *Tinísima* (Mexico City: Era, 1992), pp. 286–88. According to Alvarez Bravo's testimony, he sat on the train with Tina until her departure to Veracruz. Mildred Constantine, interviews with Manuel Alvarez Bravo, January 21 and April 11, 1974. The J. Paul Getty Research Institute, Los Angeles. Both Manuel and Lola Alvarez Bravo became outstanding photographers. Among other things, Manuel made a wonderful print of Trotsky in Coyoacán in 1939. Lola took a series of photographs of Frida Kahlo; see Lola Alvarez Bravo, *The Frida Kahlo Photographs*, introduction and interview by Salomon Grimberg, exh. cat. (Dallas: Society of the Friends of Mexican Culture, 1991).

66 "She left Veracruz for the sea by force, ship without a passenger, captured sea-gull . . . And she goes far, leaves the land fog swallows her up, without a single complaint." Victor Hugo Rascón, *Tina Modotti y otras obras de teatro* (Mexico City: SEP, 1986), p. 168.

67 Nancy Newhall, ed., *The Daybooks of Edward Weston* (New York: Aperture Foundation, 1981), ii, p. 143.

68 Mario Passi, *Vittorio Vidali* (Pordenone: Studio Tesi, 1991), p. 53.

69 Telegram no. 304822/1159, February 26, 1930, by the Italian Ministry of Foreign Affairs, and classified information no. 441/04320, March 17, 1930, by the Italian Ministry of the Interior, to Casellario Politico Centrale, Rome. Comitato Tina Modotti, Udine. The information on Julio Ramírez Gómez's death is cited in Christiane Barckhausen-Canale, *Verdad y leyenda de Tina Modotti* (Havana: Casa de las Américas, 1989), p. 246.

70 TM to EW from the U.S. Immigration Station in New Orleans, Louisiana, March 9, 1930, EWA, Tucson.

71 Ibid.

72 Benvenuto to Tina Modotti, November 3, 1928. Comitato Tina Modotti, Udine.

73 *San Francisco Examiner*, July 28, 1929. The activist Anita Whitney was also arrested during the "Red Riot" in Chinatown. I am grateful to Andrew Canepa for this information.

74 TM to EW, February 25, 1930. EWA, Tucson.

75 Ibid.

76 The exact quote is from Nietzsche: "What does not destroy you, makes you stronger," and was later used by Hitler Youth training centers.

77 Telegram no. 304822/1159, February 26, 1930. Comitato Tina Modotti, Udine.

78 Letter to the Italian police, signed "F.to Sirks," by the Rotterdam Chief of Police Bureau, following a request by telephone. The letter also mentions the communists Johann Windisch and Icek Rosenblum. Comitato Tina Modotti, Udine.

79 Vidali, *Comandante Carlos*, pp. 66–67.

80 Germán List Arzubide, "Mi Amiga Tina Modotti," *Excelsior*, March 24, 1993, LXXVII, no. 11, p. 2.

81 Paca Toor to Joseph Freeman, June

7, 1930. Freeman Collection, box 38, folder 45, Hoover Institution, Stanford.

82 John A. Britton, *Carleton Beals: A Radical Journalist in Latin America* (Albuquerque: University of New Mexico Press, 1987), pp. 94–99.

83 "El Saqueo a las Oficinas del Socorro Rojo y la Captura de sus Funcionarios," *El Machete*, September 1930.

84 Vidali, *Comandante Carlos*, p. 66. The situation remained conservatively stable until the inauguration of Lázaro Cárdenas in December 1934, whose administration radically changed the whole picture of politics. In November 1935 *El Machete* became a weekly. On May 23, 1938 it became a daily newspaper. On September 15 of the same year the title was changed to *La voz de México* (The Voice of Mexico). Peláez, *Partido Comunista Mexicana*, p. 60.

85 The song is mentioned in another context in Adys Cupull, *Tina Modotti: Semilla profunda* (Havana: Pablo de la Torriente, 1996), p. 20.

86 Modotti to Joseph Freeman, November 4, 1929. Freeman Collection, box 30, folder 36, Hoover Institution, Stanford.

10 Vittorio Vidali

1 "Trieste has a rough grace. If one likes it, it is like a sour and greedy youngster, with blue eyes and hands much too big to make the gift of a flower." Umberto Saba (1883–1957), Italian poet, was born and raised in Trieste, where he spent most of his life with the exception of a brief period during the Second World War, because of the antisemitic laws.

2 TM to EW, April 14, 1930. EWA, Tucson.

3 Ibid.

4 Elias Canetti, *Die Fackel im Ohr Lebensgeschichte 1921–1931* (Munich: Carl Hanser Verlag, 1980); Eng. ed: *The Torch in My Ear* (New York: Farrar, Straus and Giroux, 1982), p. 269. For Berlin during the Weimar republic, see also Annemarie Lange, *Berlin in der Weimarer Republik* (Berlin: Dietz Verlag, 1987).

5 Canetti, *The Torch*, pp. 273–6.

6 Ibid., pp. 286–94, and Elias Canetti, "Isaak Babel," in *Berliner Begegnungen: Ausländische Künstler in Berlin 1918 bis 1933*, ed. Klaus Kändler, Helga Kardewski and Ilse Siebert (Berlin: Dietz Verlag, 1987), pp. 89–97.

7 Canetti, *The Torch*, p. 304.

8 Ibid., pp. 267–8.

9 Ibid., pp. 299–306.

10 Paca Toor to Joseph Freeman, June 7, 1930. Freeman Collection, box 38, folder 45, Hoover Institution, Stanford.

11 Document no. 310086/3342, June 30, 1930, Ministry of Foreign Affairs, Rome, and police document from the Udine Police, October 30, 1930, Comitato Tina Modotti, Udine.

12 Classified document no. 3308, issued by the Italian Embassy in Germany, October 1, 1931–fascist year IX, addressed to the Italian Ministry of the Interior, and express mail no. 0847, March 3, 1932–fascist year X, issued by the Italian Embassy in Germany, addressed to the Italian Ministry of the Interior. Tina is there identified as a "short, 39-year-old lady (who looks younger), with black hair, brown eyes, who speaks German well." Comitato Tina Modotti, Udine.

13 TM to EW, April 14, 1930. EWA, Tucson.

14 Ibid., Modotti pitied Herr Goldschmidt for "accepting matrimony very philosophically as an inevitable evil." The second wife of Alfons Goldschmidt, Leni Kroul, was apparently a very different person. She also met Modotti in Mexico, on May Day 1939. Kroul to Christiane Barckhausen-Canale, October 14, 1985. Comitato Tina Modotti, Udine.

15 TM to EW, April 14, 1930. EWA, Tucson.

16 According to what she told Constantine, Brenner met Modotti in Hamburg, not Berlin, and described her as a "dedicated communist member." Mildred Constantine, interview with Anita Brenner, n.d. The J. Paul Getty Research Institute, Los Angeles. See also Susannah Joel Glusker, "Anita Brenner, a Mind of Her Own," Ph.D

diss., Union Institute, Los Angeles, 1995, p. 95, and Susannah Joel Glusker, *Anita Brenner: A Mind of Her Own* (Austin: University of Texas Press, 1998), pp. 245–46 n. 7.

17 Classified document no. 033586, November 13, 1936–fascist year IV. Prefettura di Trieste to the Italian Embassy in Berlin. Comitato Tina Modotti, Udine.

18 Ella Winter to Weston, August 8, 1930, EWA, Tucson.

19 TM to EW, April 14, 1930. EWA, Tucson.

20 Paca Toor to Joseph Freeman, June 21, 1930. Freeman Collection, box 38, folder 45, Hoover Institution, Stanford.

21 Amy Stark, ed., *Letters from Tina Modotti to Edward Weston*, in *The Archive*, no. 22, January 1986 (Tucson: Center for Creative Photography, 1986), p. 63. See also Christiane Barckhausen-Canale, "Tina Modotti: Entscheidung in Berlin," in Kändler *et al.*, *Berliner Begegnungen*, p. 423. The Italian police was aware of the Jacobi connection, thanks to the Italian Embassy in Berlin. Classified document no. 3308, issued by the Italian Embassy in Germany, October 1, 1931–fascist year IX, addressed to the Italian Ministry of the Interior. Comitato Tina Modotti, Udine.

22 TM to EW, May 23, 1930. EWA, Tucson.

23 Isaac Deutscher, *Stalin: A Political Biography* (Oxford and New York: Oxford University Press, 1949), p. 366.

24 Ibid.

25 Tina Modotti to Rose and Marionne Richey, December 24, 1935. Patricia Albers, *Shadows, Fire, Snow: The Life of Tina Modotti* (New York: Clarkson Potter, 1999), p. 279.

26 Sheila Fitzpatrick, *Everyday Stalinism: Ordinary Life in Extraordinary Times: Soviet Russia in the 1930s* (Oxford and New York: Oxford University Press, 1999). See also the chapter on the Soviet era in James H. Billington, *The Icon and the Axe* (New York: Knopf, 1967), pp. 519–49.

27 Fitzpatrick, *Everyday Stalinism*, p. 3.

28 Apparently, the stupidity and inefficiency of Soviet bureaucrats was the main target of the Soviet humorous journal *Krokodil.* Ibid., p. 29. For an account of mass culture in the Soviet Union, see James von Geldern and Richard Stites, eds., *Mass Culture in Soviet Russia: Tales, Poems, Songs, Movies, Plays, and Folklore 1917–1953* (Bloomington: Indiana University Press, 1995). For the perception of the Soviet Union in the West, see Marcello Flores and Francesca Gori, eds., *Il Mito dell'URSS: La cultura occidentale e l'Unione Sovietica* (Milan: Franco Angeli, 1990).

29 Mario Passi, *Vittorio Vidali* (Pordenone: Studio Tesi, 1991).

30 Archivio Centrale dello Stato, Rome, Ministero dell'Interno. Direzione Generale di Pubblica Sicurezza, Divisione Affari Generali e Riservati, Casellario Politico Centrale "Vittorio Vidali," b.n. 5403, f.

31 Vittorio Vidali, *Orizzonti di libertà* (Milan: Vangelista, 1980). During the celebration for Vidali's 80th birthday, the book was mentioned and praised again, with good reasons. Aldo Natoli, "Le avventure di un picaro rosso," *La Repubblica*, September 3, 1980.

32 Max Shachtman, "Enea Sormenti," *The Labor Defender*, January 1927, p. 2.

33 Vidali, *Orizzonti di libertà*, p. 33. For revenge, Vidali used to call his sister "Schultze," the name of the executioner in a book they had read together.

34 Anonymous source.

35 TM to EW, January 12, 1931, EWA, Tucson. It seems that she indeed bought herself a Leica. Silvano Castano, "Mosca 1932: Tina e Angelo," *Cinemazero*, supplement to no. 1a, XI, no. 11, December 1992, p. 23.

36 Unpublished notes. Fondo Vittorio Vidali, Istituto Gramsci, Rome.

37 Vittorio Vidali, *Comandante Carlos* (Rome: Editori Riuniti, 1983), p. 70.

38 The Col. A. officer was Harry Mahoney. Harry Thayer Mahoney and Marjorie Locke Mahoney, *The Saga of Leon Trotsky: His Clandestine Operations and His Assassination* (San Francisco, London, Bethesda: Austin & Winfield, 1998), p. 244.

39 Giorgio Pressburger, "Tina Modotti e Vittorio Vidali: L'amore al tempo della

rivoluzione," *Corriere della sera,* August 24, 2000, p. 31. I thank Cristina Argenteri for pointing out this article to me.

40 Vittorio Vidali, *Ritratto di donna* : *Tina Modotti* (Milan: Vangelista, 1982), p. 30.

41 Bianca Vidali, interview with the author, June 30, 1998.

42 Concepción Ruiz-Funes, interview with Vittorio Vidali, April 28–May 1, 1979. Courtesy of the Vidali family.

43 Passi, *Vittorio Vidali,* p. vii.

44 Answer to the questionaire (*sic*) of the Organizing Section of the Executive Committee of the Communist International, no. 1796* (498/241/40, p. 4), in Russian and English, filled out by Modotti in Moscow, January 27, 1932. Comintern Archive, Moscow. In the document, Modotti concealed the name of Julio Antonio Mella and her story with him, including the murder case and consequent trial.

45 Vidali, *Ritratto,* p. 28.

46 For a description of Stasova, see Vidali, *Orizzonti di libertà,* p. 269.

47 Vidali, *Ritratto,* pp. 23–24, and Vidali, *Comandante Carlos,* p. 67. See also Passi, *Vittorio Vidali,* p. 18.

48 Paca Toor to Joseph Freeman, November 12, 1931. Freeman Collection, box 38, folder 45, Hoover Institution, Stanford.

49 Enea Sormenti (alias Vittorio Vidali) to Nino Capraro, from Riga, U.S.S.R., September 10, 1927. Capraro Papers, box 3, folder "Enea Sormenti." Immigration History Research Center, Minneapolis.

50 Vidali, *Ritratto,* p. 26. Ivano Regent, a Yugoslavian from Trieste, who had been one of the founders of the Italian Communist Party in 1921, is also mentioned in Guelfo Zaccaria, *A Mosca senza ritorno: Duecento comunisti italiani fra le vittime dello stalinismo* (Milan: Sugar, 1983), pp. 86–87.

51 Zaccaria, *A Mosca senza ritorno,* pp. 75–76.

52 Author's correspondence with Rafael Alberti, 1996–97. Alberti was unclear about meeting Tina in Moscow. The two surely

met during the Spanish Civil War, when Alberti worked as a photographer in the propaganda section of the Madrid Junta Delegada de Defensa. Document stating the photographer's affiliation, April 15, 1937. Comitato Tina Modotti, Udine.

53 Felicita Ferrero, *Un nocciolo di verità,* ed. Rachele Farina (Milan: La Pietra, 1978), p. 111.

54 Ibid., pp. 112–13, and Zaccaria, *A Mosca senza ritorno,* pp. 33–34. "Pera" ended his days in a Siberian camp; Bertoni went back to Italy to work for the Ministry of the Interior before returning to Moscow, while of Capanni nobody knows the end.

55 Vidali, *Comandante Carlos,* p. 82.

56 Ferrero, *Un nocciolo di verità,* p. 113.

57 Ibid., p. 115.

58 Ibid.

59 Zaccaria, *A Mosca senza ritorno,* pp. 54–55.

60 This occurred during the launch of Vidali's book, *Diario del xx Congresso.* Umberto Tommasini, *L'anarchico triestino,* ed. Claudio Venza (Milan: Antistato, 1984), p. 50, n. 67, 105–06, 310, and 467–8.

61 Pierre Broué and Émile Témime, *La Révolution et la Guerre d'Espagne* (Paris: Les Éditions de Minuit, 1961), p. 209.

62 See Elena Stasova, *MOPR's Banners Abroad: Report to the Third MOPR Congress for the Soviet Union* (Moscow, 1931); *Soccorso Rosso,* series 2, III, no. 6, October 1933, and Barbara Evans Clements, *Bolshevik Women* (Cambridge: Cambridge University Press, 1997), p. 288.

63 Vidali to Elena Stasova, December 8, 1935. Fondo Vittorio Vidali, Istituto Gramsci, Rome.

64 Vidali, *Ritratto,* p. 24, also in Vittorio Vidali, Rafael Alberti, et al., *Tina Modotti: Fotografa e rivoluzionara* (Florence: Idea editions, 1979), n.p. In an interview conducted by Attilio Colombo, Vidali stated that it was actually a mistake to quit photography at that juncture. *I Grandi Fotografi: Tina Modotti* (Milan: Fabbri, 1983), p. 7. Constantine reads Modotti's refusal as a way to "be part of the new reality," in which there was no room for photography. Mildred Constantine, *Tina Modotti: A Fragile Life* (San

Francisco: Chronicle Books, 1983), p. 172.

65 Christiane Barckhausen-Canale, "Lettera da Berlino," *Perimmagine*, July–September 1993, n.p.

66 Alma Guillermoprieto, Review of Elena Poniatowska *Tinísima*, *The Washington Post*, 1997.

67 Vittorio Vidali, *Missione a Berlino* (Milan: Vangelista, 1978), p. 72.

68 Serge Schmemann, "Soviet Archives Offering a Partly Open, Clouded Window Onto the Past," *The New York Times*, April 26, 1995, p. A10.

69 Vidali, *Missione a Berlino*, pp. 100–01, and Vidali, *Comandante Carlos*, pp. 91–92.

70 The biographer in question, Christiane Barckhausen-Canale, was a self-declared communist party member from the former East Germany.

71 Elena Poniatowska, *Tinísima* (Mexico City: Era, 1992), p. 355.

72 M. H. Mahoney, *Women in Espionage: A Biographical Dictionary* (Santa Barbara: ABC-Clio, 1993), pp. 157–58.

73 Poniatowska, *Tinísima*, p. 346.

74 Luis Quintanilla dedicated his book, *Estación KT* (published in 1934) to his brother's memory. Antonio Saborit, *Una mujer sin país: Las cartas de Tina Modotti a Edward Weston 1921–1931* (Mexico City: Cal y Arena, 1992), p. 68, n. 12.

75 Antonieta Rivas Mercado (alias Valeria), considered one of the most modern women of her time, belonged to a wealthy and prestigious Mexican family. With her father's inheritance, she became the patron of several cultural activities, such as the publication of various literary journals and the founding of the Ulises Theater, on Mesones Street, together with María Luisa Cabrera, nicknamed Malú. Rivas Mercado was married to an American engineer, Alberto E. Blair, when she became Vasconcelos's lover, following him in his peregrinations in the U.S. and in Europe. She killed herself in Notre Dame with the gun that Vasconcelos had bought for protection during his political campaign. José Joaquín Blanco, *Se llamaba Vasconcelos: Una evocación crítica* (Mexico City: Fondo de Cultura

Económica, 1977), pp. 165–68. The 1982 film *Antonieta* was directed by Carlos Saura and interpreted by the German actress Hanna Schygulla. See "Antonieta, tragico destino" (unsigned article), *Proceso*, no. 335, April 4, 1983, pp. 62–63, which prints Rivas Mercado's photograph by Tina Modotti, taken in 1929. For Rivas Mercado's feminism, see Antonieta Rivas Mercado, *La cultura en México*, no. 741, April 20, 1976. The text was originally written in English and translated into Spanish by Elena Urrutia.

76 Her exact words are "he has a series of photographs: two of them are as good as if they were by Tina." The letter, whose date is indicated only as "Thursday 11," was probably written on November 11, 1929. Antonieta Rivas Mercado, *87 Cartas de amor y otros papeles*, ed. Isaac Rojas Rosillo (Veracruz: Universidad Veracruzana, 1981), p. 75.

77 Vidali, *Comandante Carlos*, pp. 75–76.

78 Report by Tina Modotti, indicated as "strictly confidential," May 31, 1933. Comitato Tina Modotti, Udine.

79 Vidali, *Ritratto*, p. 29. However, in 1939 she was disturbed by the pact that Stalin made with Hitler, which the party supported.

80 Claudio Natoli, "Tina Modotti: una vita tra avanguardia artistica, impegno politico e 'nuova umanità'," in Ruggero Giacomini, ed., *Tina Modotti: La vicenda artistica politica e umana* (Ancona: Centro culturale "La Città futura," 1999), p. 31.

81 Vidali, *Comandante Carlos*, p. 78.

82 Roy A. Medvedev, *Let History Judge: The Origins and Consequences of Stalinism* (New York: Vintage Books, 1971), pp. 158–59. This book is fairly important because, when it was published in the U.S. it represented an attempt by a Soviet Marxist "to begin the discussion of Stalinism at home," as the introduction by David Joravsky indicates.

83 Fitzpatrick, *Everyday Stalinism*, p. 170.

84 Pier Luigi Contessi, ed., *I processi di Mosca (1936–1938): Le requisitorie di*

Vyscinskij, le accuse del "breve Corso" e la denuncia di Krushcev (Bologna: Il Mulino, 1970), p. 129.

85 Vidali, *Comandante Carlos*, p. 82.

86 Ibid., p. 81.

87 "I love Russia, I love its heroic and generous people, I love its revolutionary tradition and I believe in its progressive mission for the world proletariat." And "One leaves Russia more prone on fighting." Enea Sormenti (alias Vittorio Vidali) to Nino Capraro, from Riga, U.S.S.R., September 10, 1927. Capraro Papers, box 3, folder "Enea Sormenti." Immigration History Research Center, Minneapolis.

88 Vidali, *Missione a Berlino*, p. 152, and Vidali, *Comandante Carlos*, p. 84.

89 Pablo Neruda, *Confieso que he vivido* (Barcelona: Argos Vergara, 1974), pp. 138–39.

11 María

1 "I had dreamt about you, / Between my hands, / a rose, a lily and a captured bird. / I was among wild grasses, / jack-rabbits, owls, / seagulls and sparrows. / I began to walk . . . / I saw you with your olive green uniform and the jacket / you wore when I met you, militia woman." John Taylor, "Miliciana," *A Nation of Poets: Writings from the Poetry Workshops of Nicaragua*, trans. with an introduction by Kent Johnson (Los Angeles: West End Press, 1985), pp. 82–83.

2 Vidali takes much credit for the victory of the Popular Front, without ever acknowledging Modotti in these actions. In fact, he constantly uses the singular "I," never "we." Vittorio Vidali, *Comandante Carlos* (Rome: Editori Riuniti, 1983), pp. 81–82. In his lucid essay, Natoli gave a different interpretation, seeing Vidali and Modotti as a united, compact bloc. Claudio Natoli, "Tra solidarietà e rivoluzione: Il Soccorso Rosso Internazionale," in Riccardo Toffoletti, ed., *Tina Modotti: Una vita nella storia* (Udine: Arti Grafiche Friulane, 1995), p. 206.

3 Jacinto Benavente, *News of Spain*, New York: Spanish Information Bureau,

August 1938. Benavente won the Nobel Prize for Theater and Literature.

4 Sheila Fitzpatrick, *Everyday Stalinism: Ordinary Life in Extraordinary Times: Soviet Russia in the 1930s* (Oxford and New York: Oxford University Press, 1999), p. 171.

5 Guy Hermet, "La tragédie espagnole," *L'Histoire*, no. 200, June 1996, p. 23.

6 David T. Cattell, *Communism and the Spanish Civil War* (Berkeley: University of California Press, 1955), p. 72.

7 The telegram was dated October 15, 1937. Paolo Spriano, *Storia del Partito comunista italiano*, vol. v (Turin: Einaudi, 1970), p. 130. This bond between the Spanish left and the Soviet Union started much earlier, during the 1930s, when even certain bourgeois such as the poets Antonio Machado and Federico García Lorca, strongly favored the communist country. Antonio Elorza, "Ces agents venus de Moscou," *L'Histoire*, no. 200, June 1996, p. 42.

8 Marcello Flores, *L'immagine dell'URSS: L'Occidente e la Russia di Stalin (1927–1956)* (Milan: Il Saggiatore, 1990), p. 258.

9 John Cowper Powys, "The Real and the Ideal," *Spain and the World*, supplement, vol. 2, no. 34, May 1938, p. 3.

10 Susannah Joel Glusker, *Anita Brenner: A Mind of Her Own* (Austin: University of Texas Press, 1998), p. 173.

11 Anita Brenner, "Class War in Republican Spain," *Modern Monthly*, vol. 10, no. 8, September 1937, pp. 4–17. Carlo Tresca was a contributor of the journal.

12 Courtesy of Margarita Ponce, who during the Spanish Civil War was a teenager in Mexico.

13 Paul Preston, *The Coming of the Spanish Civil War: Reform, Reaction and Revolution in the Second Republic* (London: Methuen, 1983); Paul Preston, *The Spanish Civil War 1936–1939* (London: Weidenfeld & Nicolson, 1990); and Burnett Bolloten, *The Spanish Civil War: Revolution and Counterrevolution* (Chapel Hill: University of North Carolina Press, 1991). For a general history of the war, see Ubaldo Bardi, *La guerra civile di Spagna: Saggio per una bibliografia italiana* (Urbino: Argalìa, 1974).

After more than 20 years, Bardi's book is still an excellent bibliographical start. For the formation of the Franchist movement, see Stanley G. Payne, *Falange: A History of Spanish Fascism* (Stanford: Stanford University Press, 1961), and his review article "Recent Historiography on the Spanish Republic and Civil War," "*Journal of Modern History*, vol. 60, no. 3, September 1988, pp. 540–56. For a less academic audience, see Angelo Del Boca, *L'Altra Spagna* (Milan: Bompiani, 1961), where the author vividly shows the astute form of the dialectics of Franco's movement and consequent regime.

14 Langston Hughes, "Moonlight in Valencia: Civil War," in Langston Hughes, *Poems* (New York: Knopf, 1994), p. 121.

15 Stephen Spender, *World Within World* (New York: Harcourt, Brace, 1948), pp. 196f.

16 Ione Robinson, *A Wall to Paint On* (New York: E. P. Dutton, 1946), p. 341.

17 Carl Geiser, *Prisoners of the Good Fight: The Spanish Civil War, 1936–1939* (Westport: Lawrence Hill, 1986). For the International Brigades in general, see also Nick Gillain, *Le mercenaire* (Paris: Arthème Fayard, 1938), whose last words are: *Le brouillard se leva et toutes choses se troublèrent, s'effacèrent à ma vue* (Fog arose and everything grew dim and blurred and vanished in front of me). The International Brigades, created at the end of September 1936 under the auspices of the Komintern or Third International, were composed of almost 30,000 foreigners, of whom 15,000 were French; 5,000 German and Austrian; 3,350 Italians; 2,800 Americans, and 2,000 British.

18 Giovanni De Luna, *La passione e la ragione* (Milan: La Nuova Italia, 2001), p. 167. See also Gabriele Ranzato, ed., *Guerre fratricide: Le guerre civili in età contemporanea* (Turin: Bollati Boringhieri, 1994).

19 Vidali, *Comandante Carlos*, p. 103. At the end of the war, Acevedo escaped to the Soviet Union, where he died.

20 Concepción Ruiz-Funes, interview with Vittorio Vidali, April 28–May 1, 1979. Courtesy of the Vidali family. See also Vittorio Vidali, *Ritratto di donna: Tina*

Modotti (Milan: Vangelista, 1982), p. 33.

21 Christiane Barckhausen-Canale, *Verdad y leyenda de Tina Modotti* (Havana: Casa de las Américas, 1989), p. 267.

22 Antonio Elorza, "Ces agents venus de Moscou," *L' historie*, n. 200, June 1996, p. 42.

23 For example, Shirley Mangini, *Memories of Resistance: Women's Voices from the Spanish Civil War* (New Haven and London: Yale University Press, 1995), and Mary Nash, *Defying Male Civilization: Women in the Spanish Civil War* (Denver: Arden Press, 1996). In a couple of Italian publications, Modotti is practically the only woman mentioned in long lists of men. Paolo Robotti and Giovanni Germanetto, *Trent'anni di lotte dei comunisti italiani 1921–1951* (Rome: Edizioni di Cultura Sociale, 1952), p. 160, and Bruno Steffé, ed., *Antifascisti di Trieste, dell'Istria, dell'Isontino e del Friuli in Spagna*, (Trieste: Associazione Italiana Combattenti Volontari Antifascisti in Spagna, 1974), p. 138.

24 Gusti Jirku, *We Fight Death: The Work of the Medical Service of the International Brigades in Spain* (Madrid: Rivadeneyra, [1937]), pp. 56–58.

25 Claud Cockburn was referring to the Mangada Column. "With Men and Women Fighters in Front Line," *Daily Worker*, August 13, 1936, repr. in James Pettifer, ed., *Cockburn in Spain* (London: Lawrence and Wishart, 1986), p. 52.

26 Riccardo Toffoletti, ed., "Conversazione con Vittorio Vidali" *Perimmagine*, July–September 1993, n.p. On women during the war see n. 23 above, and for a publication issued during the war see "Les femmes dans la guerre d'Espagne," *L'Espagne d'aujourd'hui* (Paris: Jean Fouquet), May 15, 1938, pp. 1–12. As an indication of the international nature of Red Aid, see the drawing of the Chinese revolutionary woman Tin-Ling, *Soccorso Rosso*, serie I, v, no. 1, January 1935, p. 4. In 1933 she had been arrested, with seven other women, tortured, and raped by the nationalist Kuomintang. Her mutilated body was found later.

27 This aspect was brought up by

Giorgio Bocca in relation to the Italian situation, "Quattro no a De Felice," *La Repubblica*, September 5, 1995, p. 33.

28 I would like to thank Paul Preston for the information. His articles and books on the Spanish Civil War are widely regarded as authoritative.

29 The three books are: *Il Quinto Reggimento: Documenti e testimonianze* (Milan: La Pietra, 1973); *Spagna lunga battaglia* (Milan: Vangelista, 1975); and *Comandante Carlos*. The last acquired special meaning, not only because it was published five months before Vidali's death, but also because it reproduces on the cover a portrait of Vidali made in 1938 by José Giorla, a militia fighter on the Madrid front. For Vidali's participation in the Spanish Civil War, see Estella (Teresa Noce), "Il comandante Carlos (Vittorio Vidali)," in *Garibaldini in Ispagna* (Madrid: Diana, 1937), pp. 113–17.

30 Paolo Spriano, *Storia del Partito comunista italiano: I fronti popolari, Stalin, la guerra* (Turin: Einaudi, 1970), vol. v, p. 86. Vidali is also mentioned in Giorgio Candeloro, *Storia dell'Italia moderna: Il fascismo e le sue guerre*, vol. IX (Milan: Feltrinelli, 1986), p. 407.

31 My comment is just that, a comment, and does not imply that Ibárruri hated Vidali. *Memorias de Dolores Ibárruri (Pasionaria): La lucha y la vida* (Barcelona: Planeta, 1985), pp. 292–94, 348, and 505. Jealousy of the Spanish communists toward their foreign comrades (such as Vidali, Palmiro Togliatti, Jacques Duclos), partly explains that; their activity in the party tended to obscure the Spaniards. Alberto Rovighi and Filippo Stefani, *La partecipazione italiana alla guerra civile spagnola (1936–1939)*, vol. L (Rome: Ufficio Storico SME, 1992), p. 73. However, Ibárruri devotes quite a few pages to Togliatti in her book, pp. 499–508.

In my research I found that when it comes to Vidali the world is divided into two distinct camps: the people who venerated him (even excessively), and the people who hated him (which again is not to suggest that Ibárruri hated him). This attitude is ob-

viously reflected in the literature, which is strictly laudatory or denigratory. The laudatory faction, located mainly in Italy and Spain, claims (in my opinion, not totally satisfactorily) that Vidali did not commit all the murders attributed to him, but that he let himself be accused because silence was imposed by the party. The denigratory group, located mainly in the U.S., is far more numerous. In fact, apart from his family members, in the U.S. I have not found a single soul who praised, liked, or respected the revolutionary from Trieste. This is not surprising when one realizes that the American books that mention Vidali are usually written either by anarchists (or anarchy sympathizers) who blame him for the deaths of Trotsky, Nín, Carlo Tresca, Sandalio Junco, and others, or by former communists, who have turned into combative right-wing zealots, ready and willing to do what they claim Vidali was doing in his books: rewrite history on his own terms. A third current faction of the anti-Vidali camp is represented by some feminists, located mainly in the U.S., who I am afraid do not always fully understand the maneuvers of European politics, and therefore tend to make a few generalizations about Stalinism, Trotskyism, and politics in general (always pertinent to their immediate reality), quoting phrases out of context, etc. It is a shame that some Modotti biographers fall into this category. Their inability to understand the subtleties of the Italian language precludes them, for example, from having a first-hand account of Vidali's books, thus from understanding the depth of his thought, regardless of their ideologies.

The surprising fact is that, when it comes to Vidali, the Trotskyists (to whom goes all my respect since they once seduced even the former French prime minister Lionel Jospin) often do not hesitate to ally themselves with right-wing elements. Ultimately, although I agree that Stalinism was a degenerated and totally negative form of communism, the anti-Vidali campaign in the U.S.A. should be seen in the context of the hate nurtured by Americans in general for Marxism. Despite the few token scholars that quietly

identify themselves as marxists, the general public (even the educated part) is still very unwilling even to understand Marxism, let alone communism. And, all of his life, Vidali was extremely vocal about his communist credo.

32 M. H. Mahoney, *Women in Espionage: A Biographical Dictionary* (Santa Barbara: ABC-Clio, 1993), pp. 157–58. "Mura" (Agueda Serna Morales) seems to have been the actual inspiration for Hemingway's character of María. Barckhausen-Canale, *Verdad y leyenda*, p. 285. In 1943 *For Whom the Bell Tolls* was made into a Paramount film, in which María was played by Ingrid Bergman. In 1959, Columbia Broadcasting transformed the novel in a television movie, where María was played by Maria Schell.

33 Ernest Hemingway, *For Whom the Bell Tolls* (New York: Scribner, 1995), p. 26.

34 José Castillo-Puche, *Hemingway in Spain* (Garden City: Doubleday, 1974), p. 50.

35 Constancia de la Mora, *In Place of Splendor: The Autobiography of a Spanish Woman* (New York: Harcourt, Brace, 1939), p. 260.

36 Spriano, *Storia del Partito comunista italiano*, pp. 86–87, and Vidali, *Comandante Carlos*, p. 88. For a description of the milieu in which the Fifth Regiment was formed, see Giovanni Pesce, *Un garibaldino in Spagna* (Rome: Edizioni di cultura sociale, 1955), pp. 32–34. See also André Marty's report of October 17, 1936 to comrade Voroshilov about the Fifth Regiment, cited in Ronald Radosh, Mary R. Habeck, and Grigory Sevostianov, eds., *Spain Betrayed: The Soviet Union in the Spanish Civil War* (New Haven and London: Yale University Press, 2001), p. 51.

37 *Mundo Obrero*, July 22, 1936, later reported in a manifesto of the central committee of the party, August 18, 1936. Dolores Ibárruri, *Guerra y revolución en España 1936–1939* (Moscow: Progreso, 1966), vol. i, p. 307.

38 Radosh *et al.*, *Spain Betrayed*, p. 273.

39 R. Dan Richardson, *Comintern Army: The International Brigades and the Spanish Civil War* (Lexington: University Press of Kentucky, 1982), p. 22.

40 Claud Cockburn, e.g., a special correspondent for the *Daily Worker*, joined the Fifth Regiment as a private. Pettifer, ed., *Cockburn in Spain*, p. 14.

41 *Milicia popular*, ii, no. 151, January 5, 1937.

42 *Milicia popular*, i, no. 5, July 31, 1936.

43 Antonio Machado, *Prosas completas*, Edición crítica de Oreste Macrì con la colaboración de Gaetano Chiappini, vol. ii (Madrid: Espasa-Calpe, 1989), pp. 2261–65.

44 Vidali, *Ritratto*, p. 31.

45 Even the Italian writer Camilla Ravera was subjected to an unsuccessful food poisoning by the nationalists. "Suor Patrizia e il direttore poliziotto hanno tentato di avvelenare Camilla Ravera . . ." (unsigned), *Soccorso Rosso*, serie ii, iv, no. 2, March 1934, p. 4.

46 My appreciation to Riccardo Toffoletti and Mari Domini for the information on Ms. Lafita, whom they met personally in May 1998 in Cuba.

47 Vittorio Vidali, *Missione a Berlino* (Milan: Vangelista, 1978), p. 106, and Vidali, *Ritratto*, p. 32.

48 For example, a letter dated September 20, 1938 written from Albacete to the Committee members, asking for a few data.

49 Marcello Flores, *L'immagine dell'URSS: L'Occidente e la Russia di Stalin (1927–1956)* (Milan: Il Saggiatore, 1990), p. 258.

50 The first congress was held in Paris in summer 1935. The writers Isaac Babel and Boris Pasternak were among them, sent by the Soviet government. A. N. Pirozhkova, *At His Side: The Last Years of Isaac Babel* (South Royalton, Vt: Steerforth Press, 1996), pp. 50–51.

51 Febus, "La gran obra de solidaridad del S.R.I.," *Nuestra Bandera* (S.E.I.C.), i, no. 59, September 14, 1937, p. 4.

52 Stephen Spender, *World Within World* (New York: Harcourt, Brace, 1948),

p. 226. A subtle theme constantly discussed in the congress was Stalinists versus André Gide, following his famous *Retour de l'U.R.S.S.*, a critical account of his impressions of a tour in the Soviet Union. Ibid., p. 219.

53 Spriano, *Storia del Partito comunista italiano*, p. 223, and Vidali, *Ritratto*, p. 42.

54 Rosario Ferré, "Tina y Elena: El Ojo y el Oido de México," *Nexos*, vol. 98, 1983, p. 7.

55 Flores, *L'immagine dell'URSS*, p. 258.

56 Spender, *World Within World*, p. 217.

57 Roderick Stewart, *The Mind of Norman Bethune* (Toronto: Fitzhenry & Whiteside, 1977), p. 49.

58 After Spain, Bethune worked in China, where he died on November 12, 1939 from septicemia, the result of the surgeon operating without rubber gloves and of having no sulphur drugs for treatment. He is buried in Chu Ch'eng, a remote rural area in T'ang Hsien, southwest of Peking. Ted Allan and Sydney Gordon, *The Scalpel, the Sword: The Story of Dr. Norman Bethune* (Toronto: McClelland and Stewart, 1952), pp. xi and 316.

59 Allan and Gordon, *The Scalpel, the Sword*, p. 122. See also Fredericka Martin notes and papers, now at the New York University.

60 Bethune to the Reverend Benjamin Spence, from Madrid, December 17, 1936. Stewart, *Mind of Norman Bethune*, p. 52.

61 *Nuestra España, Sanidad* (special issue), December 29, 1937, pp. 13 and 15.

62 See also the contribution of the blood bank of the International Brigades, where the future Nobel prizewinner Hermann Joe Muller worked. Matt Ridley, *Genome: The Autobiography of a Species in 23 Chapters* (New York: Perennial, 2000), p. 48.

63 Allan and Gordon, *The Scalpel, the Sword*, p. 136.

64 Stewart, *Mind of Norman Bethune*, p. 56.

65 Allan and Gordon, *The Scalpel, the Sword*, p. 120.

66 De la Mora, *In Place of Splendor*, p. 328.

67 Tara's remains were sent to Paris after being displayed in the mortuary room at the Association of Intellectuals in Valencia. Andreu Castells, *Las Brigadas Internacionales de la guerra de España* (Barcelona: Ariel, 1974), pp. 250–51. See the wonderful recollection of her by de la Mora, *In Place of Splendor*, pp. 327–28.

68 For the battle of Brunete, see Nick Gillain, *Le Mercenaire* (Paris: Arthème Fayard, 1938), p. 131.

69 An example is *Vértice*, a pro-Franco publication, in which the photograph of Mussolini appears several times. The March 1939 issue is devoted to the new pope, Pious XII, and to Gabriele D'Annunzio.

70 Salobreña, "Barbarie sacrílega de los rojos: Sin comentarios . . . ," *Amanecer*, no. 32, May 15, 1939, p. 28. The reality was different in some small villages in Andalusia where the anarchists protected the priest, whose church had been forcibly occupied by the insurgents. In another case, a militiaman of the Fifth Regiment received a letter of gratitude and admiration from a nun, Sister Veronica La Gasca, for respecting the art treasures and objects of value in the chapels of the Capuchin convent in Madrid. Arthur Koestler, *Spanish Testament* (London: Victor Gollancz, 1937), p. 109.

71 Castillo-Puche, *Hemingway in Spain*, p. 95.

72 Claud Cockburn, "Fascists No Christians," *Daily Worker*, August 27, 1936, repr. in Pettifer, *Cockburn in Spain*, p. 58.

73 *Gli 80 anni di Vittorio Vidali* (Trieste: Federazione Autonoma Triestina del P.C.I.) September 27, 1980, p. 42. Some nuns denied the atrocities claimed by the Franchists. "Nuns deny atrocities," *News of Spain*, August 3, 1938, p. 5.

74 Juan de Córdoba, "Reflexiones," *Amanecer*, no. 32, May 15, 1939, p. 20.

75 Franz Borkenau, *The Spanish Cockpit* (Ann Arbor: University of Michigan Press, 1963), p. 121. Borkenau was reporting on a speech by La Pasionaria in Valencia in August 1936, attended by 50,000 enthusiastic people.

76 Carmelo Cottone, "Pagine di storia nostra," in *Il libro della quinta classe*

elementare: Religione–Grammatica–Storia (Rome: La Libreria dello Stato, 1942), p. 188.

77 Luigi Rinaldi, ed., Il libro della quinta classe: Letture (Rome: La Libreria dello Stato, 1941), p. 154. The cover shows young fascists marching.

78 Vidali, Ritratto, p. 32.

79 Vidali mentions the case of one woman in particular, Adele, from Granada province, who was working as a cleaner in Vidali's illegal bureau. Gradually Adele acquired a political consciousness; she enrolled in the Batallón de Mujeres and learned how to use a gun. "Una donna di Spagna," unpublished writings. Fondo Vidali, Istituto Gramsci, Rome.

80 Jirku, We Fight Death, p. 42.

81 Reported by Simone Téry and cited in Mildred Constantine, Tina Modotti: A Fragile Life (San Francisco: Chronicle Books, 1983), p. 175.

82 Elena Poniatowska, "Algunas Fotógrafas de México," in Amy Conger and Elena Poniatowska, Compañeras de México: Women Photograph Women (Riverside: University of California, 1990), p. 44.

83 Albert Camus, Les Justes in Oeuvres complètes d'Albert Camus (Paris: Gallimard, 1983), p. 421.

84 Vidali, Ritratto, p. 34.

85 Vidali, Comandante Carlos, p. 91.

86 In the letter Tina indicated that she was unable to send money regularly to her family. Letter dated November 1936 [November 30?] to Assunta Modotti, located at Guardiella Scoglietto 210 in Trieste. Comitato Tina Modotti, Udine.

87 Benvenuto to Tina Modotti, November 3, 1928. Comitato Tina Modotti, Udine.

88 Ibid.

89 Vittorio Vidali, Giornale di bordo (Milan: Vangelista, 1977), p. 38.

90 Ministero dell'Interno, Direzione Generale della P.S., Rome, no. 63737, October 4, 1935–fascist year XIII. Jolanda Modotti was indicated as "the sister of well-known communists, Margherita, Tina and Benvenuto Modotti."

91 Benvenuto to Mercedes Modotti, November 23, 1936. Benvenuto indicated that he continued to send his sister articles from The New York Times, hoping that she learned "the art of reading between the lines."

92 Mercedes to Tina Modotti, June 2, 1939, from Trieste, c/o François Le Bihan, 8 Rue Louis Ganne, Paris. Mercedes told her sister that she brought a large bouquet of daisies to her mother's grave. Comitato Tina Modotti, Udine.

93 Marie Marmo Mullaney, Revolutionary Women: Gender and the Socialist Revolutionary Role (New York: Praeger, 1983), p. 198.

94 Barckhausen-Canale, Verdad y leyenda, p. 271.

95 Document no. 18853, June 16, 1937–fascist year XV, signed by the notorious head of police, Carmine Senise. Ministry of the Interior. Comitato Tina Modotti, Udine.

96 Newsletter by Red Aid, Archive de Secours Populaire, Paris, 1938, cited in Barckhausen-Canale, Verdad y leyenda, p. 286.

97 I am grateful to Mr. Victor Berch of the Abraham Lincoln Brigades Archives for the information. All the papers and notes gathered by Ms. Martin formerly at Brandeis University have now been transferred to New York University. Courtesy of Gail Malmgreen.

98 Andreu Castells, Las Brigadas Internacionales de la guerra de España (Barcelona: Ariel, 1974), pp. 255 and 459. This aspect proves that the echo of Mella's murder followed Modotti everywhere and at any time. It is strange that in the book Castells never mentions Modotti in the list of translators, despite her knowledge of several languages, p. 482.

99 The letter, dated May 9, 1938, is written to comandante Carlos and addressed to Carlos Contreras. Machado, Prosas completas, p. 2252.

100 Richardson, Comintern Army, p. 21.

101 Castells, Las Brigadas Internacionales, p. 152.

102 The information was provided by Dr. Oscar Telge in Jirku, We Fight Death, p. 8.

103 Castells, *Las Brigadas Internacionales*, p. 153.

104 Isabel de Palencia, *I Must Have Liberty* (New York: Longmans, Green and Co., 1940), p. 363.

105 Jirku, *We Fight Death*, p. 11.

106 Natoli, "Tra solidarietà e rivoluzione," p. 206.

107 Laura del Castillo, "Mi salida de España en 1939," in *Nuevas raíces: Testimonios de mujeres españolas en el exilio* (Mexico City: Joaquín Mortiz, 1993), p. 262.

108 Vidali, *Comandante Carlos*, p. 76.

109 See the difference between "class enemy," used in the period that preceded the great purges, and "enemy of the people." Fitzpatrick, *Everyday Stalinism*, pp. 191–92.

110 G. Lombardi (Giuseppe Faravelli), "Note ai processi di Mosca," *Il nuovo Avanti*, February 13, 1937.

111 Vidali, *Diario del XX Congresso*, p. 25, and Barbara Evans Clements, *Bolshevik Women* (Cambridge: Cambridge University Press, 1997), p. 290.

112 Vittorio Vidali, *Missione a Berlino* (Milan: Vangelista, 1978), p. 153.

113 Enea Sormenti (alias Vittorio Vidali) to Nino Capraro, September 10, 1927 from Riga, U.S.S.R. Capraro Papers, box 3, folder "Enea Sormenti." Immigration History Research Center, Minneapolis.

114 Vidali, *Comandante Carlos*, p. 56.

115 Sormenti to Nino Capraro, September 10, 1927 from Riga, U.S.S.R. Capraro Papers, box 3, folder "Enea Sormenti." Immigration History Research Center, Minneapolis. Vidali urged Capraro to sacrifice his point of view for the party. The last lines of an unpublished 1923 poem by Vidali convey the tragedy: "Ho visto compagni cadere/con una scarica/nel petto/E con un grido in gola." (I have seen comrades falling down with a shot in the breast and with a cry in the throat.) Private archive.

116 This different approach to violence for a nazi and for a communist was raised by Sergio Minerbi at a recent conference on the political usage of history. Simonetta Fiori, "Usi e abusi della storia," *La Repubblica*, May 31, 2001, p. 39.

117 Herbert L. Matthews, *Half of Spain Died: A Reappraisal of the Spanish Civil War* (New York: Scribner's, 1973), pp. 120–21.

118 Ibid.

119 "The Fifth Column at Work," *The War on Spain*, London, no. 56, April 27, 1940, p. 1.

120 Machado, *Prosas completas*, p. 2265.

121 Castillo-Puche, *Hemingway in Spain*, p. 51.

122 Matthews, *Half of Spain Died*, pp. 120–21. Actually, Vidali lost the thumb of his right hand in fighting during the war. See also an interview with Vidali done in 1950. Seymour Freidin, "Is Tito His Next Target?" *New York Herald Tribune, This Week Magazine*, February 5, 1950, p. 20. In the speech for his 80th birthday Vidali said that in the 1940s a novel was published in the U.S. titled *The Four-Finger Man*. The protagonist, called Carlos Contreras, was a mixture of Landru, Al Capone, and Jack the Ripper. *Gli 80 anni di Vittorio Vidali*, p. 42.

123 Matthews, *Half of Spain Died*, p. 96.

124 Hugh Thomas, *The Spanish Civil War* (New York: Harper & Row, 1961), p. 242.

125 Norberto Fuentes, *Hemingway en Cuba* (Managua: Nueva Nicaragua, 1984), p. 264.

126 Ibid.

127 Ibid. The information is referred to by D'Attilio but it has clearly been misunderstood and inaccurately cited. Robert D'Attilio, "Glittering Traces of Tina Modotti," *Views*, Summer 1985, p. 9, n. 12.

128 Norberto Fuentes, *Hemingway en Cuba* (Managua: Nueva Nicaragua, 1984), p. 293.

129 Hemingway, *For Whom the Bell Tolls* (New York: Scribner, 1940), pp. 100–03. See also Fuentes, *Hemingway en Cuba*, p. 294, and Peter L. Hays, *Ernest Hemingway* (New York: The Continuum, 1990), p. 92. The republican military leader Enrique Lister, from Galicia, did not find any redeeming qualities in Hemingway's novel, which he called a *burda caricatura de nuestra guerra* (coarse caricature of our war), although he recognized Hemingway's

support for the republican cause during the war. Ibid., p. 284.

130 It appears now that women were particularly penalized by the Franco regime up to 1975, the year of Franco's death. Between 1944 and 1948, for example, the prisons of Madrid, Córdoba, Valencia, Málaga, and Segovia were full of women of all ages. Officially it was said that Matilde Landa, Modotti's friend, committed suicide in prison, jumping from a window. Fernanda Romeu Alfaro, *El silencio roto: mujeres contra el franquismo* (Madrid: Romeu Alfaro, 1994), pp. 44 and 329. (Romeu Alfaro concentrates her research mainly on one particular prison in Madrid, Ventas.) But Vidali always believed that Landa (whose original death penalty was later commuted to life imprisonment) was actually killed during torture in the prison of Calle de Salas 46, in Palma de Mallorca. An epileptic attack was simulated to justify the official version of suicide. Her husband, Paco Ganivet, committed suicide in Madrid. The information on Matilde Landa and her family was given to Vidali by Flor Cernuda, who visited Vidali in Italy in 1980. Vidali, *Ritratto*, p. 45, and Vittorio Vidali, "Unpublished notes on Matilde Landa's death," n.d. Fondo Vidali, Istituto Gramsci, Rome. Landa's daughter Carmen spent some time during the civil war in the Soviet Union, from where she wrote to her mother. Part of her letter is reproduced in Barckhausen-Canale, *Verdad y leyenda.* I found no later trace of Carmen Landa Ganivet.

131 Javier Tusell, *Los hijos de la sangre: La España de 1936 desde 1986* (Madrid: Espasa-Calpe, 1986). See also Mino Vignolo, "Franco, il mediocre che piegò la Spagna," *Corriere della Sera*, November 14, 2000, p. 33.

132 Luis Cernuda, "Notas sobre los poetas y para los poetas en los días actuales," *Hora de España*, tomo 2, no. 6, June–October 1937, p. 66.

133 See the commemoration of Lorca by Pablo Neruda, *Confieso que he vivido* (Barcelona: Argos Vergara, 1974), pp. 139–42; and Cernuda, "Notas," p. 66. Octavio Paz contributed to *Hora de España*.

134 Glusker, *Anita Brenner*, pp. 171–72.

135 Pietro Nenni, *Spagna* (Milano: Sugar, 1976), pp. 52–53. See also Pietro Nenni, "Stringiamoci attorno alla Spagna, al suo esercito, al suo governo," *La voce degli italiani* (Paris), I, August 5, 1937; and Filippo Gaja, "Vidali parla di Trotski," *Settimo Giorno*, October 1962, p. 18, in which Vidali claims that anarchists and socialists were far less discipline-oriented than communists. For this point, see also the video *Cara y Cruz de la Revolución* directed by David Hart (Granada UK), Barcelona: S.A.V., 1983, in which the difference in interpreting the war for anarchists and communists is evident. According to Federica Montseny, an anarchist, the war was lost when the spontaneous spirit of the people was "militarized," thus altered.

136 Carlo Rosselli, "Guerra e politica in Spagna," *Giustizia e libertà*, May 7, 1937. In 1980 the anarchist Umberto Tommasini refused to join the association of former fighters in the Spanish Civil War, led by Vidali, on the grounds that it was monopolized by communists who were responsible for his comrades' murders. Umberto Tommasini, *L'anarchico triestino*, ed. Claudio Venza (Milan: Antistato, 1984), p. 116 and n. 169. See also Claudio Venza, "Le falsità continuano," *Volontà*, XXXIII, no. 6, November/December 1978, pp. 403–07.

137 My statement does not share at all the recent historical view, labeled as "revisionist," that perceives the Spanish Civil War mainly in terms of fascism and communism, rather than fascism and antifascism. In Italy, a former diplomat, Sergio Romano, is the most notable example of such a view. Renzo Di Rienzo, "Revisione mon amour," *L'Espresso*, May 28, 1998, pp. 77–78; and Arrigo Petacco, "Guerra di Spagna, orrori su due fronti," *Il giorno*, July 5, 1998, p. 15. Romano has also been at the center of a debate over the Jewish Holocaust.

138 Margarita Nelken was invited by the Association of Soviet Writers. Robert Kern, "Margarita Nelken: Women and the Crisis of Spanish Politics," in Jane Slaughter and Robert Kern, eds., *European Women on*

the Left: Socialism, Feminism, and the Problems Faced by Political Women, 1880 to the Present (Westport: Greenwood Press, 1981), p. 156, and Mangini, Memories of Resistance, p. 30.

139 Brenner, "Class War in Republican Spain," p. 4.

140 Augustin Souchy, "The Tragic End of an Anarchist Fighter," Spain and the World, June 11, 1937, p. 3, and vol. 2, no. 35, May 20, 1938, p. 3. Spain and the World, a publication in English, also covered Sacco and Vanzetti, the conductor Toscanini, and Emma Goldman. Camillo Berneri, an anarchist, was born in Lodi, Italy, on May 20, 1897. As an antifascist, he refused to pledge loyalty to the fascist regime so had to escape to France as a political exile. From there, he went to Spain to fight for the republican cause. A few days before being murdered by the Stalinists, Berneri announced on Radio Barcelona the death of Antonio Gramsci, the founder of the Italian Communist Party. Domenico Tarizzo, L'anarchia: Storia dei movimenti libertari nel mondo (Milan: Mondadori, 1976), p. 260. For Berneri's philosophy, see Camillo Berneri, Pietrogrado 1917–Barcelona 1937: Scritti scelti (Milan: Sugar, 1964); and Guelfo Zaccaria, A Mosca senza ritorno: Duecento comunisti italiani fra le vittime dello stalinismo (Milan: Sugar, 1983), p. 126. See also Guido Rampoldi, "Anarchia, come morí un sogno," La Repubblica, June 27, 1996, p. 31. Berneri was in contact with other leftists such as Angelo Tasca from the early 1930s, but he was not politically close to them. Alexander J. De Grand, In Stalin's Shadows: Angelo Tasca and the Crisis of the Left in Italy and France, 1910–1945 (DeKalb: Northern Illinois University Press, 1986), p. 206, n. 19. Vidali explained Berneri's death as a "casualty of war" and that Berneri, like many others, was a victim of circumstance. Vittorio Vidali, La caduta della reppublica (Milan: Vangelista, 1979), p. 59.

141 The mastermind of such a plan was the Soviet Stanislav Alexeyevich Vaupshasov, "probably the most profusely decorated intelligence hero," who as recently as 1990 was honored by a Russian commemorative stamp. Christopher Andrew and Vasili Mitrokhin, The Mitrokhin Archive: The KGB in Europe and the West (London: Penguin, 1999), p. 97.

142 Ernest Hemingway to Ivan Kashkin, March 23, 1939, cited in Fuentes, Hemingway en Cuba, p. 267.

143 From a letter to Vidali's two-year-old son, Carlos, May 8, 1945, when nazism had been defeated. Mario Passi, Vittorio Vidali (Pordenone: Studio Tesi, 1991), p. 52.

144 Even when the Franco regime was no longer in power in Spain, Vidali always felt uncomfortable about returning there: the Civil Guard still existed, and the places were no longer as he had seen and loved them. Toffoletti, "Conversazione con Vittorio Vidali," n.p., and Passi, Vittorio Vidali, p. 89. My own personal interpretation is that it was more a psychological than a political block that prevented him from returning to a country in which he had fought bravely. Seeing the battlefields where he had killed, and hearing the voices of the dead (friends and enemies alike) in a time of peace might have disturbed and haunted him for the last years of his life (he died in 1983 in Trieste at the age of 83).

145 The issue is raised by Galli, but not in the context of Vidali. Giorgio Galli, In difesa del comunismo nella storia del XX secolo (Milan: Kaos, 1998), p. 55.

146 This phrase was used by Nenni in a general context, not in reference to Modotti. Nenni, Spagna, p. 72.

147 "Dear comrades, The communication cited below was sent by the Brazilian Communist Party to our comrades in Paris who have requested me to transmit it to you, so you may take the necessary measures: 'Lieutenant Alberto Bezouchet is currently in Spain. Since his departure from Brazil we have found that Bezouchet had passed over to Trotskyism. He left a proof which is a true provocation against the national liberation and it is imperative to notify all the comrades, so he cannot be allowed to use the name of the Communist Party of Brazil.' This communication was sent to me in Paris on January 20, the date of my return here.

Let me advise you of the importance of sending a copy of this message to the Political Commissar Office of the International Brigades. With communist greetings María (of International Red Aid–calle Montornes, 1.)"

148 Sheila Fitzpatrick, "Signals from Below: Soviet Letters of Denunciation of the 1930s," *The Journal of Modern History*, vol. 68, no. 4, December 1996, pp. 831–66.

149 Peter Holquist, "Information Is the Alpha and Omega of Our Work: Bolshevik Surveillance in Its Pan-European Context," *The Journal of Modern History*, vol. 69, no. 3, September 1997, pp. 415–50.

150 Julián Gorkin, *Canibales políticos: Hitler y Stalin en España* (Mexico City: Quetzal, 1941), p. 82. See also Bernardo Claraval, *Cuando fui comunista* (Mexico City: Ediciones Polis, 1944), pp. 140–41.

151 All this information has generously been made available to me in the original by Dr. Dainis Karepovs, to whom I am very grateful.

152 The year was 1997. Laura Costantini, "Lo zingaro del rosario si è accampato in Paradiso," *Oggi*, May 14, 1997, pp. 94–97.

153 E. H. Cookridge, *The Net That Covers the World* (New York: Henry Holt, 1955), p. 203, and Pierre Broué and Émile Témine, *The Revolution and the Civil War in Spain* (Cambridge, Mass.: MIT Press, 1970), p. 305.

154 André Marty quoted in Castells, *Las Brigadas Internacionales de la guerra de España*, p. 256.

155 Pierre Broué and Émile Témime, *La Révolution et la Guerre d'Espagne* (Paris: Les Éditions de Minuit, 1961), pp. 55 and 208. In Spain alone, by 1939 party members numbered 300,000. Elorza, "Ces agents venus de Moscou," p. 42.

156 Broué and Témime, *Révolution et la Guerre d'Espagne*, p. 209.

157 Brenner, "Class War in Republican Spain," p. 8.

158 Gorkin, *Canibales políticos*, pp. 89–90.

159 Spriano, *Storia del Partito comunista italiano*, p. 159.

160 For the formation of the Spanish Communist Party, see Paul Preston, "The Origins of the Socialist Schism in Spain, 1917–1931," *Journal of Contemporary History*, no. 12, 1977, pp. 101–32.

161 Broué and Témime, *Révolution et la Guerre d'Espagne*, p. 277, no. 7; and Castells, *Las Brigadas Internacionales*, p. 221. "L'assassinat d'Andreu Nín: Ses causes, ses auteurs," *Spartacus*, no. 19, Paris, June 1939, pp. 22–23. The names of the agents who arrested Nín were never disclosed. Ibid., p. 18.

162 "L'assassinat d'Andreu Nín," p. 19.

163 Broué and Témine, *Revolution and the Civil War in Spain*, pp. 71–72.

164 For example, *La rivoluzione spagnola*, a byweekly publication in Italian, printed in Barcelona. This edition already manifests a certain independence of Poumistas from both Moscow and Trotsky.

165 One indication can be found in the article that defines the role of women in the anti-Franco struggle and encourages them to fight more. Libertad Paz, "La ayuda de la mujer al Socorro Rojo del P.O.U.M.," *Socorro Rojo P.O.U.M.*, Barcelona, March 15, 1937. See also the articles written by Andrade in *La Batalla*, and gathered in J. Andrade, *La revolución española día a día (1936–1937)*, (Barcelona: Nueva Era, 1979).

166 Ronald Fraser, *Blood of Spain: An Oral History of the Spanish Civil War* (New York: Pantheon Books, 1979), p. 335.

167 I am referring to the report of Juan Andrade, P.O.U.M. leader. Ibid., p. 387. Vidali explains the POUM ideology as "of Trotskyite orientation." Vidali, *Comandante Carlos*, p. 95.

168 Several communist reports classify P.O.U.M. as made up of Trotskyite agents "who set in motion provocative attacks . . ." This particular report, dated February 22, 1937, was issued by Marchenko, Soviet plenipotentiary in Spain to Maxim Litvinov. Radosh *et al.*, *Spain Betrayed*, pp. 139–40.

169 Broué and Témine, *Revolution and the Civil War in Spain*, p. 72.

170 Leon Trotsky, "Lesson d'Espagne," in *Ecrits*, vol. III, Paris, 1959, pp. 543–44 (Eng. ed., *The Lessons of Spain: The Last*

Warning (London: Workers' International Press, n.d., written on December 17, 1937), p. 23. See also Leon Trotsky, *La Bataille*, February 1, 1917; Broué and Témime, *Révolution et la Guerre d'Espagne*, pp. 57–58; and Franz Borkenau, *World Communism: A History of the Communist International* (Ann Arbor: University of Michigan Press, 1962), p. 409.

171 Wolfe Collection, box 25, folder 22, Hoover Institution, Stanford.

172 Galli, *In difesa del comunismo*, p. 56.

173 *La rivoluzione spagnola*, I, no. 4, May, 1937; Thomas, *The Spanish Civil War*, p. 453, and Andrade, *La revolución española día a día*, p. 10. Since 1936, the Russian newspaper *Pravda* had already condemned P.O.U.M. and launched an attack against the "Trotskyite elements." *Pravda*, December 17, 1936, while *Frente rojo*, a Stalinist publication issued in Catalan, devoted its front page to "the crimes of the Trotkyite provocateurs." *Frente rojo*, Valencia, I, no. 6, January 27, 1937. *Frente rojo* was especially keen on presenting the famous Pasionaria.

174 "L'assassinat d'Andreu Nín," p. 12.

175 Spriano, *Storia del Partito comunista italiano*, p. 149.

176 Guy Hermet, "La tragédie espagnole," *L'Histoire*, no. 200, June 1996, p. 25.

177 Sheelagh M. Ellwood, *The Spanish Civil War* (Cambridge: Blackwell, 1991), pp. 76–78. See also Gabriel Jackson, *A Concise History of the Spanish Civil War* (London: Thames and Hudson, 1974).

178 Borkenau, *The Spanish Cockpit*, p. 276.

179 Víctor Alba, *El Marxisme a Catalunya (1919–1939)*, vol. III: *Andreu Nín* (Barcelona: Editorial Pòrtic, 1974), p. 245.

180 Antony Beevor, *The Spanish Civil War* (London: Orbis, 1982), pp. 193–94.

181 *Pravda*, October 7, 1936, cited by Pelai Pagès, in Andrade, *La revolución española día a día*, p. 9.

182 Borkenau, *World Communism*, p. 410.

183 Beevor, *Spanish Civil War*, p. 194.

184 Hemingway, *For Whom the Bell Tolls*, p. 247.

185 George Orwell, *Homage to Catalonia* (New York: Harcourt, Brace & World, 1952), p. 174. Orwell devotes some pages to the defense of P.O.U.M. from the ridiculous Communist Party accusations that it was a fascist organization. For Nín's death, see also "L'assassinat d'Andreu Nín," pp. 1–31.

186 Brenner, "Class War in Republican Spain," pp. 15–16.

187 Max Rieger, *Espionaje en España*, trans. Lucienne and Arturo Perucho, preface José Bergamin (Barcelona: Unidad, 1938), pp. 59–60.

188 Jesús Hernández, *Yo fuí un ministro de Stalin* (Mexico City: Editorial América, 1953), pp. 119–28. Vidali (whom Hernández called Arturo Sormenti) is mentioned on p. 126. On p. 120, Hernández as a party member takes full responsibility for Nín's murder. In his book on Trotsky Broué too raises some doubts about Vidali, with respect to the murder of the Italian anarchist Carlo Tresca, on January 11, 1943, in New York. Pierre Broué, *Trotsky* (Paris: Fayard, 1988), p. 1093. The same issue was brought up by Seymour Freidin during an interview with Vidali. Seymour Freidin, "Is Tito His Next Target?" *New York Herald Tribune. This Week Magazine*, February 5, 1950, pp. 5 and 20. For accusations against Vidali, see also Stephen Schwartz, *From West to East: California and the Making of the American Mind* (New York: Free Press, 1998), pp. 361–62. Although Schwartz blames the gangster Carmine "Lilo" Galante for Tresca's murder, indirectly he blames Vidali, because at the time of his death Tresca had just turned over to his typesetter a new edition of his weekly anarchist paper *Il Martello* (The Hammer), with an editorial that aimed to expose the hypocrisy and violence of the Stalinists. So, although Vidali may not have been Tresca's actual assassin, and he may very well have been somewhere else in the world at the time of the murder, he could still be the person who ordered the killing. Dorothy

Gallagher, *All the Right Enemies: The Life and Murder of Carlo Tresca* (New Brunswick: Rutgers University Press, 1988), p. 247.

189 Rieger, *Espionaje en España*, pp. 56–58.

190 The Stalinist witch-hunting policy represents one of the darkest moment of the Spanish Civil War. It is a fact that the Soviet Union intervened "beyond the necessary." However, as Rosselli commented, "without the Soviet Union could Spain still be republican?" Carlo Rosselli, "Crisi in Spagna," *Giustizia e libertà*, May 21, 1937. By the same author, see also "Guerra e politica in Spagna," *Giustizia e libertà*, May 7, 1937.

191 Philip Stein, *Siqueiros: His Life and Works* (New York: International Publishers, 1994), p. 116. Speaking on Trotsky residing in Mexico, Stein goes as far as saying that "Trotsky was considered the mastermind behind the anarchists' activities." Ibid., p. 116.

192 Castells, *Las Brigadas Internacionales*, p. 460.

193 For Orlov's background, see Pavel and Anatoli Sudoplatov, *Special Tasks: The Memoirs of an Unwanted Witness – A Soviet Spymaster* (Boston: Little, Brown, 1994), pp. 43–46. In 1938, Orlov defected to the U.S.A., fearing that he too was on a Stalinist purge list. Andrew and Mitrokhin, *Mitrokhin Archive*, p. 96. The evolution of the Soviet security and intelligence service, originally called CEKA (December 1917), is as follows: in February 1922 it was incorporated in NKVD (as GPU); in 1923 it was called OGPU until 1934, when it was reincorporated in NKVD (as GUGB); in 1941 it became NKGB and was reincorporated in NKVD (as GUGB); from 1943 to 1946 it was NKGB and then it was called MGB. From 1947 to 1951, foreign intelligence was transferred to KI. In 1953 it was combined with MVD to form enlarged MVD, and from 1954 until 1991 it was the KGB. The KGB adopted the CEKA symbols of the sword and the shield: the shield to defend the revolution, and the sword to smite its foes. Andrew and Mitrokhin, *Mitrokhin Archive*, pp. ix and 30.

194 Julián Gorkin, *El proceso de Moscú en Barcelona: El sacrificio de Andrés Nín* (Barcelona: Imprenta Juvenil, 1974), p. 173. The entire story is told on pp. 168–76. In a previous book, published in 1941, Gorkin did not mention Vidali as Nín's executioner. He referred instead to Santiago Garcés, Tomás Rebosa, Leopoldo Mejorada, and Elías Díaz Franco, who were all chosen by the police chief Francisco Ordóñez. Juan Vidarte was also originally chosen, but at the last moment he refused. So he was executed after Nín. Gorkin, *Canibales políticos*, pp. 247–48.

195 "L'assassinat d'Andreu Nín," pp. 29–30.

196 Vidali calls Hernández's story "a sensational invention." Vidali, *Comandante Carlos*, pp. 90 and 97; and Vidali, *La caduta*, pp. 64–71. See also Bocca, who interviewed Vidali about the case and reported that Vidali actually respected Hernández, despite his post-1940 betrayal. Giorgio Bocca, *Palmiro Togliatti* (Bari: Laterza, 1973), pp. 301 and 708, n. 55. A few articles and eulogies written on the occasion of Vidali's death in 1983 mention his involvement in the Nín affair. See, for example, "Professionista della rivoluzione" (signed p.g.), *La Stampa*, November 10, 1983; Leo Valiani, "É morto Vidali, il discusso comandante Carlos," *Corriere della Sera*, November 10, 1983; and Paolo Ojetti, "Un protagonista della storia, rivoluzionario di professione," *Il Tirreno*, November 10, 1983.

197 Andrew and Mitrokhin, *Mitrokhin Archive*, p. 391.

198 Christiane Barckhausen-Canale points her finger toward Grigulevich in her short article, "lettera da berlino," *Perimmagine*, July–September 1993, n.p., claiming to have seen a document in this regard. Anonymous sources also mentioned to me the existence of a film, now kept in Spain, which absolves Vidali from the crime.

199 It is no secret that at Vidali's death in 1983 his archival papers, which according to his will were destined for the Istituto Gramsci, once they arrived in Rome, were

promptly seized by two Italian Communist Party officers and severely scrutinized, perhaps to expunge controversial material. Anonymous source.

200 Section, "In Memoriam," *Modern Monthly*, vol. 10, no. 8, September 1937, p. 3.

201 "Franco announces Vatican has recognized his regime," *New York Herald Tribune*, August 4, 1937, p. 1.

202 Rinaldi, ed., *Il Libro della Quinta Classe: Letture*, p. 154.

203 Luis Suarez Fernández, *Francisco Franco y su tiempo* (Madrid: Fundación Francisco Franco, 1984), vol. 2, p. 345, n. 35. This bulletin was the only one that Franco signed personally. Two versions of it exist, one a bit longer, which Franco promptly shortened, according to his habit of synthesizing and going straight to the point.

204 "Everybody was looking for 'something' in a feverish way: how? where to find a way out from there? But there was such a despair that one's only way out, one's only true escape was death." Juana Doña, *Desde la noche y la niebla: Mujeres en la cárceles franquistas* (Madrid: Ediciones de la Torre, 1978), p. 58.

205 From 1939 until Franco's death on November 21, 1975, Spain was kept politically and culturally isolated from the rest of Europe – an historical irony, when one thinks that for at least three years Spain had been the battlefield of contending ideologies that had attracted worldwide interest. Barcelona was the headquarters of resistance to Franco's dictatorial rule. The Catalan city, traditionally the European center of Spanish-language publishing, was able to play the role of the avant-garde. This role has now been returned to Madrid, which after Franco reacquired its position of capital and cultural center.

206 Robert G. Colodny, *Spain: The Glory and Tragedy* (New York: Humanities Press, 1970), p. 59. The image of Spain as one large prison was taken from La Pasionaria.

207 From a poem by Vidali in 1975. Passi, *Vidali*, p. 97. Rafael is the poet Alberti.

208 Thomas, *Spanish Civil War*, p. 631.

209 Ibid., p. 606.

210 In Ramón Salas Larrazábal, *Pérdidas de la guerra* (Barcelona: Planeta, 1977), the combined total is stated as 270,000. See also the chart cited in Hermet, "La tragédie espagnole," p. 28, with the estimated numbers reported by another historian, Gabriel Jackson. Emilio Silva, a Spanish journalist, is the founder of the Asociación para la recuperación de la memoria histórica, whose aim is the identification of Franco's dead victims. Silva's grandfather, a businessman, was among those victims. Gian Antonio Orighi, "Sottoterra, migliaia di vittime," *Panorama*, April 4, 2002, XL, no. 14, p. 145.

12 Return of the Mexican *hija*

1 Isabel de Palencia, *I Must Have Liberty* (New York: Longmans, Green and Co., 1940), pp. 466–67. See also Alessandra Minerbi, "L'emigrazione antifascista: italiani e tedeschi in Messico, 1939–1945," in Riccardo Toffoletti, ed., *Tina Modotti: Una vita nella storia* (Udine: Arti Grafiche Friulane, 1995), pp. 213–29.

2 Vittorio Vidali, *Ritratto di donna: Tina Modotti* (Milan: Vangelista, 1982), p. 32.

3 Mildred Constantine, interview with Fernando Gamboa, January 20, 1974. The J. Paul Getty Research Institute, Los Angeles.

4 Classified document, no. 18853, June 8, 1939, Prefettura di Trieste. See also Vidali, *Ritratto*, p. 48.

5 "I think of Spain all sold out / from one river to the other, from one mountain to the other, from one sea to the other." Antonio Machado, Sonnet LXVI, *Meditación del día*, written in Valencia in February 1937.

6 The photograph of Tina has been removed from the original passport, kept at the J. Paul Getty Research Institute (Special Collections) and at the Comitato Tina Modotti, Udine. I wish to thank Tracey Schuster and Ted Walbye for assisting me with this document. The information on

Modotti's legal documents is also cited in Vittorio Vidali, *Comandante Carlos* (Rome: Editori Riuniti, 1983), p. 112.

7 Ibid.

8 Patricia W. Fagen, *Exiles and Citizens: Spanish Republicans in Mexico* (Austin: University of Texas Press, 1973), p. 33.

9 Ibid., p. 38. See also Leon and Rebeca Grinberg, *Psychoanalytic Perspectives on Migration and Exile* (New Haven and London: Yale University Press, 1989), pp. 156–65.

10 M. Kenny, V. García, C. Icazuriaga, C. Suarez, and G. Artís, *Inmigrantes y refugiados españoles en México* (Mexico City: Ediciones de la Casa Chata, 1979), p. 300.

11 In relation to this, see the story of a Spanish couple who, due to the formal Mexican way of speaking, confused the roles of guests and hosts. Paloma Ulacia Altolaguirre and Concha Méndez, *Memorias habladas, memorias armadas* (Madrid: Mondadori España, 1990), p. 118.

12 For the experience of the Spanish communists in exile, see David Wingeate Pike, *In the Service of Stalin: The Spanish Communists in Exile, 1939–1945* (Oxford: Clarendon Press, 1993).

13 Luigi Longo received the Order of the Red Flag many years later. André Marty was never given the Order of Lenin, for which he was originally selected. Vidali was never granted any honor, for unknown reasons. Vidali, *Comandante Carlos*, pp. 106–07.

14 Emile Témime and Geneviève Dreyfus-Armand, "Adieu à l'Espagne," *L'Histoire*, no. 200, June 1996, p. 45.

15 D. Abad de Santillan, *Por qué perdimos la guerra: Una contribución a la historia de la tragedia española* (Madrid: Del Toro, 1975), p. 13.

16 Anthony Beevor, *The Spanish Civil War* (London: Orbis, 1982), p. 268.

17 Vidali, *Ritratto*, p. 46. Vidali does not identify the man.

18 For example, Victoria Kent, who brings up this point in her book, *Cuatro años en Paris (1940–1944)*, (Buenos Aires: Sur, 1947).

19 María Magda Sans, "Vicencias del ayer," in Blanca Bravo *et al.*, eds., *Nuevas raíces: Testimonios de mujeres españolas en el exilio* (Mexico City: Joaquín Mortiz, 1993), p. 258. Some of these accounts are from refugees who arrived in Mexico after the Second World War, but the status of refugee and all its connotations were the same as in 1939 because most of them participated in the Spanish Civil War.

20 Milagros Latorre Piquer, "De niña española a mujer en la URSS," in *Nuevas raíces*, p. 113.

21 In order to reinforce this point in their minds, some refugees did not "settle down" in Mexico, meaning in practice that for years they did not buy any property, not even furniture. Altolaguirre and Méndez, *Memorias habladas, memorias armadas*, p. 116.

22 Clara E. Lida, *La Casa de España en México* (Mexico City: Jornadas 113: El Colegio de México, 1988), p. 10, and Clara Lida, *El Colegio de México: Una Hazaña Cultural 1940–1962* (Mexico City: Jornadas 117: El Colegio de México, 1990), p. 54. Also cited in Shirley Mangini, *Memories of Resistance: Women's Voices from The Spanish Civil War* (New Haven and London: Yale University Press, 1995), pp. 153–54.

23 Pere Foix, *Cárdenas* (Mexico City: Trillas, 1990), p. 233.

24 Miguel Covarrubias, *Mexico South: The Isthmus of Tehuantepec* (New York: Knopf, 1946), p. 240, and Arturo Anguiano, *El Estado y la política obrera del cardenismo* (Mexico City: Era, 1975), p. 47. For Cárdenas's relationship with the left, see Guadalupe Pacheco Méndez, Arturo Anguiano Orozco, and Rogelio Vizcaíno, *Cárdenas y la izquierda mexicana* (Mexico City: Juan Pablos, 1975).

25 The saying was chosen as the title for a regional study on the application of Cardenismo in Sonora. Adrian A. Bantjes, *As If Jesus Walked on Earth: Cardenismo, Sonora, and the Mexican Revolution* (Wilmington, Del: SR Books, 1998).

26 Shirley Mangini, "Spanish Republican exiles in Mexico," *The Volunteer: Journal of the Veterans of the Abraham Lincoln*

Brigade, Winter 1997/98, p. 17. The resemblance between Mexico and Spain in terms of land tenure was also pointed out by Anita Brenner in her articles on the Spanish Civil War. Susannah Joel Glusker, *Anita Brenner: A Mind of Her Own* (Austin: University of Texas Press, 1998), p. 169.

27 John W. F. Dulles, *Yesterday in Mexico: A Chronicle of the Revolution, 1919–1936* (Austin: University of Texas Press, 1961), p. 521.

28 Vidali, *Ritratto*, p. 49.

29 Fagen, *Exiles and Citizens*, p. 59, and Notes by Vittorio Vidali, Archivo de la Palabra, Mexico City, ff. 71–72 and 101–05.

30 Manuel Plana, "Un'esperienza atipica: riforme e politica di massa in Messico durante il governo di Lázaro Cárdenas (1934–1940)," in Aldo Agosti, ed., *La stagione dei fronti popolari* (Bologna: Cappelli, 1989), p. 442.

31 Anguiano, *El Estado*, p. 134.

32 Margo Glantz, "Mi infancia durante la época del general Lázaro Cárdenas," *Cuadernos de marcha*, IV, no. 19, May–June 1982, pp. 49–51.

33 Fagen, *Exiles and Citizens*, pp. 43–45.

34 Carmen Romero, "Cómo y cuando llegué a México," in *Nuevas raíces*, pp. 136–37. The part where Romero discovers the Mexican street market, rich in colors, in San Juan, is particularly charming. Ibid., p. 138. As Neruda noticed when he visited the country, Mexico's soul rests in its markets. Pablo Neruda, *Confieso que he vivido* (Barcelona: Argos Vergara, 1974), p. 174.

35 Milagros Latorre Piquer, " De niña española a mujer en la URSS," in *Nuevas raíces*, p. 111.

36 Bernardo Claraval, *Cuando fuí comunista* (Mexico City: Ediciones Polis, 1944), p. 183.

37 Christiane Barckhausen-Canale, *Verdad y leyenda de Tina Modotti* (Havana: Casa de las Américas, 1989), p. 300.

38 Blanca Bravo, "Recuerdos de mi exilio," in *Nuevas raíces*, pp. 33–34.

39 "Night comes: you still leave us, / oh dear images of the earth, trees, / animals, poor people wrapped / in the soldiers' coats, mothers / whose wombs have become arid from tears." *Neve* by Salvatore Quasimodo.

40 Barckhausen-Canale, *Verdad y leyenda*, p. 309.

41 Héctor Rivera, "Como asumió su cuerpo y su libertad, Tina Modotti asumió su pasión política: Retes," *Proceso*, no. 335, April 4, 1983, p. 51.

42 The comment is part of a letter, whose signature is illegible, written to Vidali on March 18, 1982 from Buenos Aires. From the context, it is clear that the author of the letter knew Modotti in Mexico. Fondo Vittorio Vidali, Istituto Gramsci, Rome.

43 Leni Kroul to Christiane Barckhausen-Canale, October 14, 1985. Comitato Tina Modotti, Udine. The letter, translated into Spanish, is cited in Barckhausen-Canale, *Verdad y leyenda*, pp. 304–06. After her husband's death, Leni Kroul left Mexico for good in April 1940 and settled in New York.

44 Claraval, *Cuando fuí comunista*, pp. 182–83.

45 Bertram Wolfe to Martin Temple, April 5, 1940, Wolfe Collection, box 14, folder 45, Hoover Institution, Stanford.

46 Pierre Broué, *Trotsky* (Paris: Fayard, 1988), p. 926.

47 Although in his note Gorkin does not mention any names. Julián Gorkin, *El proceso de Moscú en Barcelona: El sacrificio de Andrés Nín* (Barcelona: Imprenta Juvenil, 1974), p. 216, n. 2.

48 Julián Gorkin, *Canibales políticos: Hitler y Stalin en España* (Mexico City: Ediciones Quetzal, 1941), p. 82. See also Claraval, *Cuando fuí comunista*, pp. 140–41.

49 See the list of Andreu's nationalities and identities in Juan Vivés, *Les maîtres de Cuba* (Paris: Robert Laffont, 1981), p. 71. Andreu's real nationality was Cuban. Since he was married to a famous soprano, Zoila Galvez, and posed as her impresario, Andreu could easily travel and accomplish his secret missions, ordered by his "boss," Fabio Grobart. Ibid., p. 58.

50 Glusker, *Anita Brenner*, p. 173. Brenner also wrote that the friends from Spain, who were in Mexico in 1940, were aware of the activities of many Stalinists who arrived in Mexico as refugees from the Spanish Civil War. Ibid., p. 208.

51 E. H. Cookridge, *The Net That Covers the World* (New York: Henry Holt, 1955), p. 209.

52 It has been claimed that in August 1946 Vidali, a "high profile communist," recruited Fidel Castro as an underground agent. Vivés, *Les maîtres de Cuba*, p. 85. Vidali profoundly respected Tresca, calling him courageous but also a "mixture of ideological contradictions." Unpublished notes, private archive.

53 Stephen Schwartz, *From West to East: California and the Making of the American Mind* (New York: Free Press, 1998), p. 361.

54 "Lombardo Prepara En México El Segundo Acto de La Gran Tragedia Habida en España" (unsigned), *Excelsior*, XXIII, no. 5, September 14, 1939, pp. 1 and 13. It is possible that by "Rosenberg" Rivera meant Marcel Rosenberg, the Soviet ambassador in Spain during the Spanish Civil War, but that is unlikely, because Rosenberg died at the very end of the war. Claraval, *Cuando fui comunista*, pp. 182–83.

55 I refer to Olivia Gall's book on Trotsky, in which it is stated that, upon her return to Mexico, "Tina was immediately attacked by Diego Rivera, who, having broken with Trotsky, accused her of having committed serious political crimes in Spain." Olivia Gall, *Trotsky en México y la vida política en el periodo de Cárdenas, 1937–1940* (Mexico City: Era, 1991), p. 52. To substantiate her statement, on p. 360, n. 33, Gall mentions Paz's article, which she apparently misinterpreted, since Paz wrote that Rivera accused Vidali, not Modotti. Octavio Paz, "Frida y Tina: vidas no paralelas," *Vuelta*, vol. 7, no. 82, September 1983, p. 48.

56 Vidali, *Ritratto*, p. 51.

57 "Tina," *Hoy*, January 17, 1942, and Vidali, *Ritratto*, pp. 52–53.

58 Vittorio Vidali, *Giornale di bordo* (Milan: Vangelista, 1977), p. 97, and unpublished notes by Vidali, dated 1975. Private archive.

59 Vidali, *Ritratto*, p. 53.

60 At Tina's death, Kitty disappeared, while a pregnant Suzi was given away by Vidali. Ibid., p. 54.

61 Testimonial by Claudia Porset, cited in *Tina Modotti garibaldina e artista*, (Udine: Circolo culturale Elio Mauro, 1973), p. 22.

62 Leni Kroul to Christiane Barckhausen-Canale, October 14, 1985. Comitato Tina Modotti, Udine.

63 Vidali, *Ritratto*, p. 55.

64 Claraval, *Cuando fui comunista*, p. 64. The comment was made with a certain glee by one of Mella's Mexican friends, who regarded Modotti as nothing more than a cheap and vulgar adventuress.

65 Mildred Constantine, interview with Rosendo Gómez Lorenzo, January 25, 1974. The J. Paul Getty Research Institute, Los Angeles.

66 Vidali, *Giornale di bordo*, p. 97.

67 The letter is dated January 27, 1940. Comitato Tina Modotti, Udine. Part of the letter (in a slightly different version) is cited in Barckhausen-Canale, *Verdad y leyenda*, p. 303.

68 Barckhausen-Canale, *Verdad y leyenda*, p. 303.

69 Unpublished writings by Vittorio Vidali. Fondo Vidali, Istituto Gramsci, Rome.

70 He was denounced during the Twentieth Party Congress, in front of 1,500 delegates, who sat "transfixed in total silence, interrupting only occasionally with cries of outraged indignation." Dimitri Volkogonov, *Stalin: Triumph and Tragedy* (London: Weidenfeld and Nicolson, 1991), p. 577. The text of Khruschchev's anti-Stalinist report was more than 50 pages. "Khrushchev Talk Cited Stalin Plot Against Molotov: US Has The Text," *The New York Times*, June 4, 1956, p. 1. See also Pier Luigi Contessi, ed., *I processi di Mosca (1936–1938): Le requisitorie di Vyscinskij, le accuse del "breve Corso" e la denuncia di Krushcev* (Bologna: Il Mulino, 1970), pp. 449–514. The response of Western European communist parties (mainly Italian and French) to the news

was different, and understandably so. While the French Communist Party was tied to Moscow, the Italian Communist Party always tried to be independent from Moscow and to act accordingly. This also partly explains the reproachful tone used by the French Trotskyists in general when dealing with the French Communist Party.

71 Daniela Spenser Grollová, "El tiempo de Ella Wolfe," *Nexos*, no. 34, April 1991, p. 6.

72 TM to EW, January 12, 1931, EWA, Tucson.

73 The issue of the inevitability or not of the Stalinist purges, as a tragic consequence of the world struggle against fascism, is also brought up by Rosario Ferré, "Tina y Elena: El Ojo y el Oido de México," *Nexos*, vol. 98, 1983, p. 7.

74 Vidali, *Ritratto*, p. 52. The pact remained ideologically obscure to many people, not only leftists, mainly because an anti-Comintern pact (thus contrary to the Communist International) was already in existence. However, from the strictly practical point of view, the pact had its conveniences for both sides, and was accepted by socialists such as Pietro Nenni, while Angelo Tasca was against it. Alexander J. De Grand, *In Stalin's Shadows: Angelo Tasca and the Crisis of the Left in Italy and France, 1910–1945* (Dekalb: Northern Illinois University Press, 1986), pp. 151–52.

75 Vidali, *Comandante Carlos*, p. 55.

76 Paolo Spriano, *Intervista sulla storia del PCI*, ed. Simona Colarizi (Bari: Laterza, 1979), p. 212.

77 George Orwell, *Homage to Catalonia* (New York: Harcourt, Brace, and World, 1952), p. 6.

78 Dolores Ibárruri (La Pasionaria), "El Pueblo Espanõl No Ha Sido Vencido" (Paris: Ediciones Populares, 1939); the speech was given in Madrid on February 11, 1939.

79 "At the foot of the fallen tree, / dove, tell her, / another tree will grow, and its bark / is dressed in green." Nicolás Guillén, "Pasionaria" in *Pasionaria: Memoria Gráfica* (Madrid: Ediciones PCE), 1985, p. 81.

80 Palencia, *I Must Have Liberty*, p. 469.

81 Altolaguirre and Méndez, *Memorias habladas, memorias armadas*, pp. 15–16, cited in Mangini, *Memories of Resistance*, p. 158.

82 Riccardo Toffoletti, ed., "Conversazione con Vittorio Vidali," *Perimmagine*, July–September 1993, n.p.

83 "Tina," *Hoy*, January 17, 1942.

84 Palencia, *I Must Have Liberty*, p. 472.

85 This explanation of Stalinism comes from the French historian François Furet, who used to notice how many former Soviet citizens today miss that assurance. François Furet, *Le passé d'une illusion: essai sur l'idée communiste au XXe siècle* (Paris: Laffont, 1995). See also Stéphane Courtois *et al.*, eds., *The Black Book of Communism: Crimes, Terror, Repression* (Cambridge, Mass.: Harvard University Press, 1999).

86 The photographer Manuel Alvarez Bravo, who at that time had a studio in the calles de Ayuntamiento, more than once invited Modotti to reconsider her decision to resume photography. Mildred Constantine, interviews with Manuel Alvarez Bravo, January 21 and April 11, 1974. The J. Paul Getty Research Institute, Los Angeles.

87 Constancia de la Mora, *In Place of Splendor: The Autobiography of a Spanish Woman* (New York: Harcourt, Brace and Co., 1939).

88 Margaret Hooks, "Assignment, Mexico: The Mystery of the Missing Modottis," *Afterimage*, vol. 19, no. 4, November 1991, pp. 10–11.

89 Christopher Andrew and Vasili Mitrokhin, *The Mitrokhin Archive: The KGB in Europe and the West* (London: Penguin, 1999), p. 113.

90 Raquel Tibol, "Algunas razones para juntar a Frida y Tina en el Munal," *Proceso*, no. 344, June 6, 1983, p. 50. After the first attempt on Trotsky's life, Rivera panicked and decided to accept a mural commission in San Francisco, where he stayed for six months. Frida Kahlo joined him in September 1940 for a few days only, before moving to New York. Pete Hamill, *Diego Rivera* (New York: Abrams, 1999), pp. 194–95.

91 Pavel and Anatoli Sudoplatov, *Special Tasks: The Memoirs of an Unwanted*

Witness – A Soviet Spymaster (Boston: Little, Brown, 1994), pp. 69, 74, and 81.

92 Hugo Denwar, *Assassins at Large* (London: Wingate, 1951), pp. 118 and 123–24. For the list of the 13 identified accomplices, see Harry Thayer Mahoney and Marjorie Locke Mahoney, *The Saga of Leon Trotsky: His Clandestine Operations and His Assassination* (San Francisco, London, Bethesda: Austin & Winfield, 1998), p. 513.

93 Isaac Don Levine, *The Mind of an Assassin* (New York: Farrar, Straus, and Cudahy, 1959), pp. 79 and 70–71. See also Leandro A. Sánchez Salazar and Julián Gorkin, *Murder in Mexico* (London: Secker & Warburg, 1950), pp. 324–26; Julián Gorkin, *Cómo asesinó Stalin a Trotsky* (Barcelona: Plaza & Janés Editore, 1961), pp. 206–07. The French edition made some changes: Julián Gorkin, *L'assassinat de Trotsky* (Paris: Juilliard, 1970), pp. 275–77. See also Theodore Draper, *American Communism and Soviet Russia* (New York: Viking Press, 1960), p. 179, and Harry Thayer Mahoney and Marjorie Locke Mahoney, *Espionage in Mexico: The Twentieth Century* (San Francisco: Austin & Winfield, 1997), pp. 178 (where Vidali is called "a notorious Comintern executioner and brutal enforcer") and 215, n. 29, and 217–18 n. 47 (Vidali is "a sadistic, amoral executioner and the personification of a dedicated automaton Comintern agent" and "crafty, intelligent, dissembling and dangerously dedicated to communism".) While Draper is more cautious in accusing Vidali – his words are: "he was allegedly implicated in the assassination of Leon Trotsky" – the Mahoneys have no doubt about it, and they continue along the same line in their *Saga of Leon Trotsky.* A Trotsky biographer, Pierre Broué, also raises strong doubts about Vidali. Broué, *Trotsky*, p. 1093. Cacucci leaves no doubt that, if Siqueiros were the killer, Vidali was the orchestrator of the Trotsky crime. Pino Cacucci, *Tina* (Milan: Interno Giallo, 1991), pp. 178–79.

94 Robert Conquest, *The Great Terror: A Reassessment* (Oxford and New York: Oxford University Press, 1990), p. 416.

95 Dorothy Gallagher, *All the Right Enemies: The Life and Murder of Carlo Tresca* (New Brunswick: Rutgers University Press, 1988), p. 169.

96 Jesús Hernández, *Yo fuí un ministro de Stalin* (Mexico City: Editorial America, 1953). I suspect that this is once more an interpretation that precedes the facts, instead of the other way around.

97 Giorgio Bocca, *Palmiro Togliatti* (Bari: Laterza, 1973), and Giorgio Bocca, interview with the author, July 1, 1997. According to Bocca, Togliatti was never soft on Vidali, and criticized him on several occasions. For example, during the 1955 schism in Trieste, Togliatti was heard to say that Vidali "is good for shooting, but not so much for thinking," according to Bruno Corbi. Ibid., pp. 600 and 728, n. 8. Another expert on Togliatti, Giuseppe Vacca, does not mention this incident about Vidali.

98 Robert D'Attilio, "Glittering Traces of Tina Modotti," *Views*, Summer 1985, p. 8.

99 At that time, Hernández was allied with Tito and possibly funded by the Yugoslavs. Thus, anything he said or wrote should be seen in the light of his ideology and should be treated with great caution. I would like to thank Reiner Tosstorff for clarifying this point, and for helping me in understanding some of the political subtleties of the communist movements in general.

100 Roy A. Medvedev, *Let History Judge: The Origins and Consequences of Stalinism* (New York: Vintage Books, 1971), p. xxxiv.

101 Vidali, *Comandante Carlos*, pp. 91 and 114. See also *Gli 80 anni di Vittorio Vidali* (Trieste: Federazione Autonoma Triestina del P.C.I., September 27, 1980), p. 42, where Vidali mentions his "other crimes," besides that against Trotsky, against Nín (1937) and Tresca (1943). See also *Convegno Internazionale per il Quarantesimo anniversario della morte di Leon Trotsky*, Fellonica, October 7–11, 1980, p. 7; and Filippo Gaja, "Vidali parla di Trotski," *Settimo Giorno*, October 1962, pp. 16–18.

102 Vidali, *Comandante Carlos*, pp.

112–13. Years later, in a moment of self-criticism Vidali wrote that he regretted not having understood Trotsky's honesty, and added that the Russian revolutionary was persecuted by men and destiny. Mario Passi, *Vittorio Vidali* (Pordenone: Studio Tesi, 1991), p. 101, and Vidali, unpublished diary, Istituto Gramsci, Rome.

103 Courtesy of Bianca Vidali. However, I have not read the article myself. Joseph Grigulevich (later codenamed Padre and Artur), arrived in Mexico in 1940 after living in Argentina, where his father owned a large drugstore. He managed to meet one of Trotsky's bodyguards, Sheldon Harte (codenamed Amur), through whom he let the Siqueiros group in, on May 24, 1940. After the second, successful attempt on Trotsky's life, Grigulevich escaped from Mexico to the U.S., first to California and then New Mexico, with his Mexican wife, Laura Araujo Aguilar (codenamed Luisa). He later acquired Costarican citizenship, posing as Teodoro Castro, and became chargé d'affaires from Costa Rica to both the Vatican and Yugoslavia. In February 1953 at a meeting in Vienna he volunteered for the role of assassin of Tito, a plan that never materialized. In May 1953, after Stalin's death, the multilingual Grigulevich was recalled to Moscow. In 1958, he became a senior scientific researcher at the Ethnographic Institute of the Soviet Academy of Sciences and made a new life for himself as a writer and academic authority on Latin America. Sudoplatov, *Special Tasks*, pp. 74, 78, 193, 250, 355. Andrew and Mitrokhin, *Mitrokhin Archive*, pp. 465–66.

104 Conquest, *Great Terror*, p. 416.

105 Eitingon is sometimes wrongly confused for another person called Eitingen. Medvedev, *Let History Judge*, p. 179.

106 Vladimir Bukowskij (or Bukowsky), *Gli archivi segreti di Mosca* (Milan: Spirali, 1999), p. 62. See also Mario Raffaele Conti, "A Mosca comanda ancora chi ci ha torturato nel gulag," *Oggi*, April 7, 1999, pp. 105–09. Bukowsky, a Russian dissident, is now a British citizen.

107 David Alfaro Siqueiros, *Me*

llamaban el coronelazo (Memorias), (Mexico City: Biografías Gandesa, Editorial Grijalbo, 1977), p. 363.

108 Andrés Carabantes and Eusebio Cimorra, *Un mito llamado Pasionaria* (Barcelona: Planeta, 1982), p. 151.

109 Siqueiros, *Me llamaban el coronelazo*, pp. 355–56. The painter fails to give a date for the Valencia incident. Dates are not his strongest point, for in the photographic section of the book he indicates Mella's death as 1924 instead of 1929, and a meeting with Diego Rivera as 1967, when Rivera had been dead for ten years. See also Vidali, *Comandante Carlos*, p. 91. For criticism by the communist party of Cárdenas, see Manuel Márquez Fuente and Octavio Rodríguez Araujo, *El partido comunista mexicano (en el periodo de la internacional comunista mexicano 1919–1943)*, (Mexico City: El Caballito, 1973), p. 208.

110 Siqueiros to Cárdenas, February 25, 1938, Archivo de los Presidentes, Mexico City, cited in Marcela de Neymet, *Cronología del Partido Comunista Mexicano: Primera parte, 1919–1939*, (Mexico City: Ediciones de Cultura Popular, 1981), p. 182.

111 The breakdown of the figures was: 28 million rounds of ammunition, 22,000 rifles, 2 batteries of 80-caliber artillery pieces, 4 75's, 1 Vickers' gun, and 65 machine guns. "Mexican Sale of Arms To Spain at 1,500,000," *The New York Times*, January 2, 1937, p. 2.

112 David T. Cattell, *Communism and the Spanish Civil War* (Berkeley: University of California Press, 1955), pp. 80 and 229, n. 33. By August 1937 the nationalists had captured 3,852 Mexican rifles. Pierre Hericourt, *Pourquoi mentir? L'aide franco-soviétique à l'Espagne rouge* (Paris: Baudinière, 1937), cited in Cattell, ibid., p. 78.

113 Andrew and Mitrokhin, *Mitrokhin Archive*, pp. 99–100.

114 *El Machete*, January 12, 1937.

115 "El traidor Trotsky," *La voz de México*, May 19, 1940, p. 1. Vicente Lombardo Toledano (who is probably not the article's author since he is mentioned there

in the third person) called for the dispatch of "the enemy of the socialist revolution from all four corners of the country." It is interesting to notice that such a statement was freely put in the workers' mouths; the Mexican workers had other priorities than condemning a political refugee who for the most part did not become involved in their local politics. See also Alain Dugrand, *Trotsky in Mexico 1937–1940* (Manchester: Carcanet, 1992).

116 Dimitri Volkogonov, *Trotsky: The Eternal Revolutionary* (New York: Free Press, 1996), p. 450.

117 Siqueiros was extremely defensive about the whole business, and mostly blamed Cárdenas for having granted Trotsky political asylum. Siqueiros, *Me llamaban el coronelazo*, pp. 355–77. According to one theory, though, the worst enemies Trotsky had in Mexico were neither the communist party members (linked to Stalin) nor the right, although anticommunist and anti-semitic. It was the Confederación de Trabajadores de México (Confederation of Mexican Workers), headed by Lombardo Toledano, on whose support Cárdenas depended. Isaac Deutscher, *The Prophet Outcast: Trotsky, 1929–1940* (Oxford: Oxford University Press, 1963), p. 357, and Broué, *Trotsky*, pp. 850–51. For the controversy between Lombardo Toledano and Trotsky, see the articles in *Cahiers Léon Trotsky*, no. 11, June 1982. See also Pierre Broué, "Le Mexique au temps de Cárdenas: Trois thèses," *Cahiers Léon Trotsky*, no. 26, June 1986, p. 31, where he unambiguously describes Lombardo Toledano as a notorious liar "in the service of Moscow's foreign politics for its main target, Trotsky."

118 Lola Alvarez Bravo, *Recuento fotográfico* (Mexico City: Editorial Penélope, 1982), p. 101.

119 Vidali, *Comandante Carlos*, p. 114.

120 *La voz de México*, June 23, 1940, and *Excelsior*, September 20, 1953, p. 2, cited in Philip Stein, *Siqueiros: His Life and Works* (New York: International Publishers, 1994), pp. 120 and 363. Trotsky had written that "some members were expelled in order to remove beforehand from the party any

responsibilities for their participation in the assault that was being prepared." *Stalin Seeks My Death* (Fourth International, August 1941), pp. 206–07. In March 1940, in fact, the leaders of the party were ousted and "new henchmen were brought in who had no scruples against the extermination of Trotsky." An honorary presidium, i.e., a group of international communist notables, was appointed. Vidali among them. Levine, *Mind of an Assassin*, p. 79.

121 "El Partido Rojo Refutó Ayer a la Viuda de Trotsky," *Excelsior*, April 23, 1947, pp. 1 and 10. Natalia Sedova Trotsky's open letter to *Excelsior*, April 20, 1947, was itself a reaction to the publication of Louis Francis Budenz, *This is My Story* (New York: McGraw-Hill, 1947). Budenz, for many years the director of *The Daily Worker*, the American Communist Party organ, went through a religious conversion in the last part of his life. The book is pervaded by religious feelings, whereas only a few years earlier his writings reflected a greatly different mood. See, for example, Louis Budenz, *May Day, 1940* (New York: Workers Library Publishers, 1940), pp. 3–15. Budenz has been accused by Trotkyists of becoming an F.B.I. informant. *The Gelfand Case: A Legal History of the Exposure of U.S. Government Agents in the Leadership of the Socialist Labor Workers Party* (Detroit: Labor Publications, 1985), vol. I, pp. x and 58.

122 Rene Tirado Fuentes, "El Trotskismo Está Vivo, Segun Siqueiros," *Excelsior*, April 23, 1947, pp. 1 and 8. At the end of the article, Tirado Fuentes mentions Trotsky's assassin, Mercader, whose behavior in prison was somewhat abulic: he would not read anything and refused to talk to any member of the press.

123 *Ahora*, October 9, 1972, quoted in Mahoney, *Saga of Leon Trotsky*, pp. 391 and 518, n. 620.

124 Hugo Denwar, *Assassins at Large* (London: Wingate, 1951), p. 118.

125 Deutscher, *Prophet Outcast*, pp. 486–87.

126 Carlos Contreras [Vidali], "David Alfaro Siqueiros en la guerra española," *El Popular*, February 18, 1941; Hugi Baduei,

"Vittorio Vidali habla del gran pintor revolucionario: Así recuerdo a Siqueiros," *Unità*, January 8, 1974, and Vidali, *Ritratto*, p. 36.

127 In October 1940 Siqueiros was arrested by the Mexican police, when Trotsky had been dead for two months. In April 1941 the painter was released on a 10,000 *pesos* bail; thanks to the new Mexican president, Ávila Camacho, and to the Chilean consul, Pablo Neruda, he left for Chile via Cuba, where he arrived in June 1941. Altogether Siqueiros spent 2 years in Chile, 8 months in Cuba, and 3 years in Argentina. Neruda did not consult the Chilean ambassador in Mexico, Manuel Hidalgo y Plaza. Sánchez Salazar and Gorkin, *Murder in Mexico*, pp. 211–12. As a result, Neruda's diplomatic functions were suspended for two months. Neruda, *Confieso que he vivido*, pp. 179–80. In December 1941 Neruda was attacked by a group of nazis in Cuernavaca, Mexico.

128 It is a mystery to me how Siqueiros, a man who could produce marvelous paintings such as *Humbled, but not defeated* (1939) or could write sentences that are poetic, could become involved in such a grossly bizarre incident as that in May 1940 when a child was hurt. I am referring to words such as: *regalar flores sin cortarlas – vivas – es uno de los mayores dones del arte de la pintura* (to present flowers as a gift without cutting them – flowers still alive – is one the best gifts of the art of painting). Siqueiros, *Me llamaban el coronelazo*, p. 601. See also the scene in which Siqueiros is arrested, and things appear with great clarity, as if for the last time: *Todas las cosas de mi vida las veía yo resplendicientes. Los sonidos. Los colores. Las formas. Las texturas. Las obras de arte* (I was seeing all things of my life as shining. Sounds. Colors. Forms. Textures. Works of art). Ibid., p. 374.

129 Glusker, *Anita Brenner*, p. 53.

130 *Utka* means "duck." Sudoplatov, *Special Tasks*, p. 69.

131 Dimitri Volkogonov, *Stalin: Triumph and Tragedy*, ed. Harold Shukman (London: Weidenfeld and Nicolson, 1991), p. 378.

132 For Ramon Mercader's fate after 1961, after 20 years' imprisonment in Mexico, see Sudoplatov, *Special Tasks*, pp. 77–81, and Andrew and Mitrokhin, *Mitrokhin Archive*, pp. 115–16. Pavel Sudoplatov met Mercader in Moscow in 1969 at the Union of Writers club. In the mid-1970s Mercader went to Cuba where he acted as an adviser to Fidel Castro. He died of cancer in Cuba in October 1978, and his body was secretly returned to Moscow, where he is buried in the Kuntsevo Cemetery under the name of Ramon Ivanovich Lopez, "hero of the Soviet Union."

133 The cast of the movie includes Richard Burton (the protagonist), Romy Schneider (Sylvia Angeloff), Valentina Cortese (Natalya Trotsky), Luigi Vannucchi (David Alfaro Siqueiros), and Giorgio Albertazzi (the head of the police).

134 The photograph appears in Volkogonov, *Trotsky*, n.p., and is part of the David King Collection, London.

135 Megi Pepeu carried Vidali's materials from Trieste to Rome in 1986 (Vidali had been dead for just over two years).

136 "Trostky assassinated lay dying / within a few hours (between night and day) / since vengeance sooner or later was premeditated. / This fatal tragedy, which moved the country / and all the capital, / occurred on a Tuesday afternoon." / Gorkin, *Cómo asesinó Stalin a Trotsky*, p. 120, and Sánchez Salazar and Gorkin, *Murder in Mexico*, pp. 110–11.

13 The End

1 Hsiung Hung, born in 1940 in Taiwan, is the pen name of Hu Mei-tzu. She received a degree in Fine Arts from Taiwan National University.

2 José M. Peña, "La Bella y Genial Artista Italiana Tina Modotti, y su Excelso Arte Fotográfico," *El Sol*, August 1925.

3 Notes by Vittorio Vidali, Archivo de la Palabra, Mexico City, f. 139.

4 The death certificate of Tina Modotti Mondini (no. 156273, Registro Civil, Mexico City) was mentioned in *El Nacional*, January 7, 1942.

5 Mildred Constantine, *Tina Modotti:*

A Fragile Life (San Francisco: Chronicle Books, 1983), p. 189.

6 Note dated 1975, Vidali's unpublished diary. Fondo Vittorio Vidali, Istituto Gramsci, Rome.

7 "Olvidada y enviejecida ha fallecido Tina Modotti," *Excelsior*, January 7, 1942, p. 1. The title translates as "A forgotten and aged Tina Modotti has died."

8 Margarita Nelken, "Contra Unas Calumnias," *El Popular*, January 13, 1942.

9 Vittorio Vidali, *Comandante Carlos* (Rome: Editori Riuniti, 1983), p. 119.

10 Constantine, *Tina Modotti*, p. 11.

11 Notes by Vittorio Vidali, Archivo de la Palabra, Mexico City, f. 134.

12 Unpublished writings by Vittorio Vidali. Fondo Vittorio Vidali, Istituto Gramsci, Rome.

13 Carlos Vidali, interview with the author November 20, 1996.

14 The Museum of Modern Art, New York, to Isabel Carbajal Bolandi, October 14, 1975, The J. Paul Getty Research Institute (Special Collections), Los Angeles.

15 To understand a little the charm that Vidali exercised on women (even independent women) one has only to watch the film made in Italy around 1980 in which Vidali recalls his role in the Spanish Civil War as Comandante Carlos. He was with a small group of friends, among whom at his side was his last companion, Laura Weiss, a Jewish doctor who stayed with him until his death, and who after 1983 accomplished the laudable task of organizing and transcribing his papers. In the film Weiss appears from her rapturous look to be totally captivated by him. Film courtesy of Riccardo Toffoletti. Comitato Tina Modotti, Udine.

16 Vittorio Vidali, *Ritratto di donna: Tina Modotti* (Milan: Vangelista, 1982), p. 55.

17 Vidali, *Comandante Carlos*, p. 70.

18 For example, Bertram Wolfe, who was well equipped to write on Tina, chose not to for lack of time. Bertram Wolfe to Donald Ackland, New York Graphic Society, July 16, 1975. Courtesy of Ella Wolfe.

19 Vidali, *Comandante Carlos*, pp. 97–98.

20 Vittorio Vidali, *Diario del XX Congresso* (Milan: Vangelista, 1982). Apparently, the English edition convinced the historian Barbara Evans Clements, who has stated that Vidali "was not the docile and admiring foreign communist that the Soviet party wanted in attendance at its meeting." Barbara Evans Clements, *Bolshevik Women* (Cambridge: Cambridge University Press, 1997), p. 307.

21 Giuseppina Re, interviews with the author, January 10, 1998 and August 2, 2002. Vidali's *Ritratto* was reprinted on the occasion of an exhibition devoted to Modotti in Trieste, as *Tina Modotti Ritratto di donna* (Tavagnacco, Udine: Arti Grafiche Friulane, 2002), preface by Riccardo Toffoletti.

22 Margherita Hack to Vidali, March 1, 1982. Fondo Vidali, Istituto Gramsci, Rome.

23 Manolo y Flores to Vidali, March 13, 1982. Fondo Vidali, Istituto Gramsci, Rome.

24 Jolanda Modotti to Vidali, March 13, 1982, from Los Angeles. Fondo Vidali, Istituto Gramsci, Rome. Jolanda thanks Vidali for paying homage to Tina.

25 Giulio Andreotti to Vidali, April 14, 1982. Fondo Vidali, Istituto Gramsci, Rome.

26 Angelo Emiliani to Vidali, April 21, 1982. Fondo Vidali, Istituto Gramsci, Rome.

27 Laura Diaz and Sergio Scarpa to Vidali, April 26, 1982. Fondo Vidali, Istituto Gramsci, Rome.

28 Luigi Nono to Vidali, n.d., addressed to "Dearest Carlos." Nono states: "What a spirit Tina must have been!" Fondo Vidali, Istituto Gramsci, Rome.

29 Mildred Constantine to Vidali, May 19, 1982. Fondo Vidali, Istituto Gramsci, Rome.

30 Pino Cacucci, *I fuochi le ombre il silenzio: La fragil "vida" di Tina Modotti negli anni delle certezze assolute* (Bologna: Agalev, 1988), pp. 107–08.

31 Fondo Vidali, Istituto Gramsci, Rome.

32 In his letter of May 20, 1973, maestro Gavazzeni added that he wished to thank Vidali personally, if his work brought him to Trieste to conduct at the Verdi

Theater. Fondo Vidali, Istituto Gramsci, Rome.

33 Vidali, *Ritratto*, p. 55.

34 Margaret Hooks, *Tina Modotti: Photographer and Revolutionary* (London: Pandora, 1993), p. 247.

35 Mildred Constantine, interview with Anita Brenner, n.d. The J. Paul Getty Research Institute, Los Angeles.

36 Germán List Arzubide, "Mi Amiga Tina Modotti," *Excelsior*, March 24, 1993, p. 1.

37 Silvano Castano, "Mosca 1932: Tina e Angelo," *Cinemazero*, supplement to no. 1a, XI, no. 11, December 1992, p. 24.

38 Vidali, *Comandante Carlos*, p. 113.

39 The realization and awareness of having fought a losing battle came only later: during the war Modotti always believed in the invincibility of her side, while other republicans knew that they were losing – but they never regretted it. Cinzia Sasso, "Spagna 1937, spari e libertà: 'Noi, sul fronte dell'Ebbro'," *La Repubblica*, November 11, 2000, p. vii.

40 Jesús Hernández, *Yo fuí un ministro de Stalin* (Mexico City: Editorial América, 1953), p. 254.

41 It was different for Vidali, who all of his life was a Stalinist, although on his 80th birthday he confessed that he "had to fight the Stalinism" that was still in him. But he added that he had started "to understand and to correct." *Gli 80 anni di Vittorio Vidali* (Trieste: Federazione Autonoma Triestina del P.C.I., September 27, 1980), p. 43.

42 This element of conflict was raised by many communists, especially after Stalin's purges became known. Felicita Ferrero, *Un nocciolo di verità*, ed. Rachele Farina (Milan: La Pietra, 1978), pp. 105 and 189.

43 David Vestal to Bertram Wolfe, August 28, 1965. Courtesy of Ella Wolfe.

44 Rafael Cardona, "Un retrato de Tina Modotti," *Excelsior*, January 16, 1929.

45 This statement was reported by Mildred Constantine to Ben Maddow, letter of October 22, 1974. The J. Paul Getty Research Institute, Los Angeles.

46 Philippe Cheron, "Tina Staliníssima," *Vuelta*, vol. 7, no. 82, September 1983, pp. 46–47. As stated before, Cheron based his allegations on Gorkin's words. However, Cheron also says that "Gorkin's sole testimonial is not sufficient to state what was said before and a full investigation would be required in order to reach more solid conclusions."

47 Julián Gorkin, *Cómo asesinó Stalin a Trotski* (Barcelona: Plaza & Janés Editore, 1961), p. 205.

48 Julián Gorkin, *L'assassinat de Trotsky* (Paris: Juilliard, 1970), p. 272.

49 Gorkin, *Cómo asesinó Stalin a Trotski*, p. 205. Margaret Hooks also conveys the same feeling of obligation on Tina's part as "being married to him," interview with Leni Kroul. Hooks, *Tina Modotti*, pp. 247 and 264, note.

50 Gorkin, *L'assassinat de Trotsky*, p. 272.

51 On April 1, 1943, i.e. a couple of months after Tresca's murder, a group of anti-Stalinist leftists of various nationalities led a memorial meeting in Mexico City for Tresca and other two assassinated comrades, Victor Alter and Heinrich Erlich. But the meeting was disrupted by 100 Mexican communists, who attacked the participants. Gorkin, who was among the wounded, accused Vidali of the attack but "comrade Contreras" was promptly defended by Mario Montagnana, who denounced Gorkin as a liar. Dorothy Gallagher, *All the Right Enemies: The Life and Murder of Carlo Tresca* (New Brunswick: Rutgers University Press, 1988), p. 243.

52 L. F. Bustamante, "El enigma de Tina Modotti," *Jueves de Excelsior*, January 15, 1942. Gonzáles himself declared that the team to assassinate Trotsky in August 1940 was assigned to Contreras (Vidali), to whom they had brought secret instructions from Moscow for handling the assassination. Isaac Don Levine, *The Mind of an Assassin* (New York: Farrar, Straus, and Cudahy, 1959), p. 71.

53 Pablo Neruda, *Confieso que he vivido* (Barcelona: Argos Vergara, 1974), p. 290;

and Teresa Cirillo, *Neruda a Capri: Sogno di un'isola* (Naples: La Conchiglia, 2001), p. 85. Neruda obviously opposed this theory.

54 Concepción Ruiz-Funes, interview with Vittorio Vidali, April 28–May 1, 1979. Courtesy of the Vidali family. See also Pino Cacucci, *Tina* (Milan: Interno Giallo, 1991), p. 179. On p. 312 of *Dreaming with His Eyes Open* (London: Bloomsbury, 1998), Patrick Marnham states that Rivera too suggested that Tina was murdered by Vidali. It is interesting to note that in 1940 the number of active communist party members in Mexico had declined to 2,000, while only a year before at the VII Mexican Communist Party Congress held in February 1939 the members were 30,125. Manuel Márquez Fuente and Octavio Rodríguez Araujo, *El partido comunista mexicano (en el periodo de la internacional comunista mexicano 1919–1943)*, (Mexico City: El Ediciones Caballito, 1973), p. 297; and Manuel Plana, "Un'esperienza atipica: riforme e politica di massa in Messico durante il governo di Lázaro Cárdenas (1934–1940)," in Aldo Agosti, ed., *La stagione dei fronti popolari* (Bologna: Cappelli, 1989), p. 443. Plana attributes the weakness of the party to the politics of the Third International, whose official line was to support the Cárdenas government as an expression of the alliance with the anti-imperialist bourgeoisie.

55 Cacucci, *Tina*, p. 198.

56 Handwritten note, October 5, 1977 (wrongly dated, since Wolfe died on February 21, 1977). Wolfe Collection, box 107, folder 8, Hoover Institution, Stanford. The folder also contains three copies of a review of the first book on Modotti, which Wolfe marked with the words "Spies," "Art," and "Rivera." The theory of poison is insistently repeated by others, for example Schwartz, who has written that Modotti was "very probably poisoned, in Mexico City in 1942, after reportedly breaking with Vidali." Stephen Schwartz, *From West to East: California and the Making of the American Mind* (New York: Free Press, 1998), p. 362.

57 I must repeat here what I said in Chapter 7, n. 228. Because of Wolfe's experience and disenchantment with the form of communism he saw in action – Stalinism – he became an active enemy of communism in general, seeing spies at every corner. Unfortunately, his obsessions, which are evident in his correspondence, put him in much the same category as the people he opposed. Moreover – this again, is evident in his papers at the Hoover Institution – Wolfe spent a good portion of his life (from his rejection of communism until his death) rewriting his own history in the light of his latest beliefs.

58 Vicente Lombardo Toledano, "Como actuan los nazis en México," a speech delivered on October 17, 1941 (Mexico City: Universidad Obrera, 1941).

59 On July 1, 1941 Wilbur Joseph Cash, a Southern U.S. writer, at age 41 was found dead in the La Reforma hotel in Mexico City, where he had gone to write a novel. The death strongly appears to have been a suicide and has been treated as such by all Cash's biographers. Bruce Clayton, *W. J. Cash, a Life* (Baton Rouge: Louisiana State University Press, 1991), p. 187.

60 *The Gelfand Case* (Detroit: Labor Publications, 1985), vol. I, pp. x and xxxiv, and pp. 58–59, cited in Dimitri Volkogonov, *Trotsky: The Eternal Revolutionary* (New York: Free Press, 1996), p. 453. Alan Gelfand's case arose from his expulsion from the ranks of the Socialist Workers Party in 1979 for his repeated attempts to raise questions about the F.B.I.'s possible infiltration of the party. Since Gelfand contended that the party defendants were government agents of the F.B.I., C.I.A., and National Security Agency, he claimed that their actions in expelling him were on behalf of the government. Thus he intended to expose what he called "the combined agencies of imperialism and Stalinism." Ibid., vol. II, pp. 445–46.

61 Notes by Vittorio Vidali, Archivo de la Palabra, Mexico City, f. 139. According to one version, the Italian anarchist Carlo Tresca repeatedly denounced Vidali of the murder "of his own mistress, Tina Modotti." David Wingeate Pike, *In the Service of*

Stalin: The Spanish Communists in Exile, 1939–1945 (Oxford: Clarendon Press, 1993), p. 53.

62 "Tito & the Executioner," *Time*, September 6, 1948, p. 22.

63 Vittorio Vidali, "Il record delle bugie," *L'Unità del popolo*, October 30, 1948, p. 1. The bilingual weekly was published each Saturday by the Italian-American Peoples Publications at 13 Astor Place, New York. One issue cost 5 cents. Its orientation was clearly leftist, and the political target was frequently Alcide De Gasperi, the Italian prime minister of the postwar period, who was a Christian Democrat. See, for example, the cartoon of De Gasperi in Swiss papal guard uniform, holding an American flag. "Ventriloquismo," ibid., March 13, 1948, p. 1. See also another cartoon mocking De Gasperi of September 18, 1948, p. 4, and October 9, 1948, p. 3, which printed a photograph of De Gasperi meeting the former Shah of Iran. De Gasperi introduces himself to the Shah as "the lackey of America." *L'Unità del popolo*, July 17, 1948, p. 5, published a short story by Italo Calvino, whose title was "Si dorme come cani."

64 Benvenuto Modotti, "Come morì Tina Modotti," *L'Unità del popolo*, November 13, 1948, p. 1. Albers has written that on this occasion Benvenuto "acted at the request of Vidali," but we have no proof of that. Patricia Albers, *Shadows, Fire, Snow: The Life of Tina Modotti* (New York: Clarkson Potter, 1999), p. 332.

65 Mercedes Modotti would answer the telephone with "the Vidali residence." Libera Sorini, interview with the author, July 5, 1997, and Giuseppina Re, interviews with the author, January 10, 1998 and August 2, 2002.

66 "My last wishes," handwritten in Italian by Saltarini Modotti Margherita (Mercedes), on January 9, 1965. Mercedes requested no funeral and no wreaths; that her hands should not be crossed but left along her body, with flowers all over. She also requested that all her photographs and belongings should be stored in boxes and given to her sister and her son, Tullio Cosolo, except for a silver vase, a souvenir from Tina, which was to be given to Laura Weiss (the last companion of Vidali). The J. Paul Getty Research Institute (Special Collections), Los Angeles.

67 Mercedes Modotti to Edward Weston, March 16, 1946, written on the stationery of the Ristorante Cavallino, Via Ginnastica, 20, Trieste. EWA, Tucson.

68 "Del sepello de Tina Modotti," *El Popular*, January 8, 1942.

69 *Tina Modotti* (Mexico City, 1942).

70 Margarita Nelken, "Con orgullo: nuestra Tina Modotti," *Magazine de Hoy* (Havana), January 25, 1942.

71 *Tina Modotti* (Mexico City, 1942), p. 20.

72 *La voz de México*, January 7, 1942. In his diary Weston remembered Tina with great affection, speaking in 1944 of her death as "especially poignant to me." Nancy Newhall, ed., *The Daybooks of Edward Weston* (New York: Aperture Foundation, 1981), II, p. 287.

73 *A Fragile Life; Semilla profunda, Perchè non muore il fuoco*; and *Shadow, Fire, Snow*, cited in full in the Bibliography.

74 Germán List Arzubide, "Mi amiga Tina Modotti," *Excelsior*, March 24, 1993, p. 2.

75 Raquel Tibol, "Algunas razones para juntar a Frida y Tina en el munal," *Proceso*, no. 344, June 6, 1983, p. 50.

76 At an indeterminate date, Paco Bolea wrote to Vidali that Tina's tomb needed to be restored and the cost would be around $230. Note of May 10, 1979 in Vidali's unpublished diary. Fondo Vidali, Istituto Gramsci, Rome.

77 "Il Messico rompe le relazioni con gli Stati Balcanici," *L'Italia*, January 10, 1942.

78 Document no. 08976, April 22, 1942–fascist year XX. Udine Police Headquarters. Comitato Tina Modotti, Udine.

79 María Teresa León, "Tina Modotti: Ricordo ed elogio," *Rinascita*, no. 34, August 27, 1971.

80 Toffoletti, "Tina Modotti e la storia della fotografia," Le tappe della riscoperta,"

in Riccardo Toffoletti, ed., *Tina Modotti: Una vita nella storia* (Udine: Arti Grafiche Friulane, 1995), pp. 233 and 243, n. 8.

81 The exhibition lasted from March 19 to March 28. María Izquierdo, *Hoy*, April 11, 1942.

82 Words by Vittorio Vidali, in the brochure of introduction to the exhibition, *Tina Modotti, fotografa e rivoluzionaria*, Palazzo Gambalunga, Rimini, December 1979–January 1980.

83 "Very soon will come the day that you dreamed of / and the Spanish people will go toward their sunny and brave lands / that you loved so much. / And they will take with them the tombstone that today / covers the simple tomb where are engraved the golden words by our Pablo." Private archive.

84 Machado wrote this in Valencia in November 1936. Antonio Machado, *Poesías completas*, edición crítica de Oreste Macrì con la colaboración de Gaetano Chiappini (Madrid: Espasa-Calpe, 1989), p. 44.

Conclusion

1 "I wish not to forget all I know today. Let others write History and tell whatever they like; what I want is not to forget, and since our capacity to forget digests and grinds everything up, what I know today I want to put on paper." Victoria Kent, *Cuatro años en París (1940–1944)*, (Buenos Aires: Sur, 1947), p. 159.

2 Riccardo Toffoletti, *Tina Modotti: Arte Vita Libertà* (Trieste: Il Ramo d'Oro, 2001), p. 199.

3 Vittorio Vidali, *Ritratto di donna: Tina Modotti* (Milan: Vangelista, 1982), p. 34.

4 Mildred Constantine, *Tina Modotti: A Fragile Life* (San Francisco: Chronicle Books, 1983), p. 172.

5 *Boletín Mexicano de Fotografía*, Mexico City, December 1937.

6 Although the situation was completely different, the filmmaker Federico Fellini once spoke in an interview of a mental block, an *impasse*, he had to overcome in his career. He stated that he had lost

the motivation to create and he feared that it was permanent.

7 Ione Robinson, *A Wall to Paint On* (New York: E. P. Dutton, 1946), p. 435.

8 The quote appears on p. 160 of the excellent essay on Danny Lyon's photographic book, *Merci Gonaïves* (dealing with the Haitian revolution), which signaled "Lyon's return to political subject matter." Daniel Wolff, "As News Spreads: Danny Lyon's Photographs," in Wendy Lesser, ed., *Hiding in Plain Sight: Essays in Criticism and Autobiography* (San Francisco: Mercury House, 1993), pp. 159–63.

9 Ferdinando Scianna, "Henri Cartier Bresson l'occhio del secolo: Intervista al grande fotografo," *La Repubblica*, September 17, 1998.

10 Hilton Kramer, "Tina Modotti's Brief but Remarkable Career," *The New York Times*, January 23, 1977, p. 25.

11 Answer to the questionaire (*sic*) of the Organizing Section of the Executive Committee of the Communist International, no. 1796* (498/241/40, p. 4), in Russian and English filled out by Modotti in Moscow, January 27, 1932. Comintern Archive, Moscow. Paca Toor wrote to Joseph Freeman, November 12, 1931, that Tina had given up photography for the present. Freeman Collection, box 38, folder 45, Hoover Institution, Stanford.

12 Pablo Neruda, *Confieso que he vivido* (Barcelona: Argos Vergara, 1974), p. 289.

13 *La voz de la sanidad del exercito de Maniobra*, March 10, 1938.

14 This picture belongs to the private archive of a collector who wishes to remain anonymous.

15 Valentina Agostinis, "Il piccolo, grande gesto," *Cinemazero*, supplement to no. 1a, xi, no. 11, December 1992, p. 23; and Silvano Castano, "Mosca 1932: Tina e Angelo," ibid., pp. 22–25.

16 Vidali, *Ritratto*, p. 30.

17 In the 1970s Vidali donated those photographs to Mexico. Vidali, *Missione a Berlino* (Milan: Vangelista, 1978), p. 152, and "Fulgor de Tina Modotti," *Proceso*, no. 149, October 9, 1979, p. 52. The pho-

tographs are now housed in the Fototeca Instituto Nacional de Antropología e Historia, Pachuca.

18 Bianca Vidali interview with the author, June 30, 1998.

19 Wertmüller contacted Mildred Constantine for a film on Modotti, and Constantine was suggested by her friends to "keep clear on De Laurentis." Mildred Constantine to Ben Maddow, July 9, 1975 and June 10, 1976. The J. Paul Getty Research Institute, Los Angeles.

20 Andreina De Tomassi, "La passione di Tina," *Il Venerdì di Repubblica*, September 4, 1992, pp. 84–86.

21 In the article, Francesca Neri calls Modotti "one of the first feminists in the true sense of the term." Laura Laurenzi, "Ma quale emozione é un giorno come tanti," *La Repubblica*, March 8, 2000, p. 34.

22 Alessandro Oppes, "Il paese 'machista' la incoronò regina," *La Repubblica*, December 12, 1996, p. 39, in which Madonna restated her hope of interpreting Modotti in a film. See also Marsha Kay Seff, "Revolutionary Role," *The San Diego Union-Tribune*, February 24, 1997.

23 Carol Vogel, "Inside Art," *The New York Times*, May 19, 1995, p. C26. mainly commenting on the financial support Madonna gave to the exhibition on Modotti at the Philadelphia Museum of Art in 1995.

24 "Pensando a una donna," reportage by Rachele Bagnato, in *D. La Repubblica delle Donne*, II, no. 69, September 30–October 6, 1997, pp. D178–87, with photographs by Christophe Kutner and clothes by Marni, Krizia, Fendi, Giorgio Armani, Yohji Yamamoto, Moschino, Les Copains, Dolce & Gabbana, and Lawrence Steele. I thank Stéphane Allart and Christophe Kutner for their help and cooperation.

25 David Bonetti, "Illuminating the Work of Tina Modotti," *San Francisco Examiner*, March 28, 1996, pp. C-1 and 7.

26 In Victor Hugo Rascón, *Tina Modotti y otras obras de teatro* (Mexico City: SEP, 1986).

27 Lewis Segal, "A 'Tina' Taken Out of Time and Context," *Los Angeles Times*, June 8, 1998, p. F3.

28 *El revolucionario no tiene más descanse que la tumba.* Letter to Rafael Carrillo, n.d. (probably 1927), signed "Julio." Wolfe Collection, box 10, folder 39, Hoover Institution, Stanford. The same sentence is reported by Claraval, reporting on Mella's leit-motif. Bernardo Claraval, *Cuando fuí comunista* (Mexico City: Ediciones Polis, 1944), p. 42.

Letter

1 Christopher Ricks, "Bob Dylan," in Wendy Lesser, ed., *Hiding in Plain Sight: Essays in Criticism and Autobiography* (San Francisco: Mercury House, 1993), pp. 145–58.

2 Harry Thayer Mahoney and Majorie Locke Mahoney, *The Saga of Leon Trotsky: His Clandestine Operations and His Assassination* (San Francisco, London, Bethesda: Austin & Winfield, 1998), p. 247.

3 Nancy Newhall, ed., *The Daybooks of Edward Weston* (New York: Aperture Foundation, 1981), I, p. 49.

4 This aspect was raised in another context by the historian Claudio Pavone in commenting on the approach used by Ernesto Galli della Loggia and Giovanni Belardelli, editors of *Miti e storia dell'Italia unita* (Bologna: Il Mulino, 1999), a compendium of new revisionist historiography. Simonetta Fiori, "La bibbia dei revisionisti," *La Repubblica*, October 22, 1999, pp. 46–47.

5 "Frances has been very active and even made money here – which fact made me wish I was a Jew." TM to EW, January 23, 1926. EWA, Tucson.

6 TM to EW, July 7, 1925. EWA, Tucson. However, the next sentences of the letter read: "Is this too rough a statement? Perhaps it is, if so I humbly beg women's pardon." (P. S. I forgive you and even absolve you, dear Tina!)

Selected Bibliography

Books

Agostinis, Valentina, ed. *Tina Modotti: Gli anni luminosi*. Pordenone: Cinemazero and Edizioni Biblioteca dell'Immagine, 1992.

—. *Tina Modotti: Vita, arte e rivoluzione. Lettere a Edward Weston 1922–1931*. Milan: Feltrinelli, 1994.

Albers, Patricia. *Shadows, Fire, Snow: The Life of Tina Modotti*. New York: Clarkson Potter, 1999.

—, ed. *Dear Vocio: Photographs by Tina Modotti*. Exh. cat. La Jolla, Calif.: University Art Gallery. 1997.

Altolaguirre, Paloma Ulacia, and Concha Méndez. *Memorias habladas, memorias armadas*. Madrid: Mondadori España, 1990.

Ballanti, Paola, ed. "Terra e libertà," presented at the exhibition "Tina Modotti, arte vita libertà." Ancona, April 23–May 31, 1998.

Barckhausen, Christiane. *Auf den Spuren von Tina Modotti*. Kiel: Agimos Verlag, 1996.

—. [Barckhausen-Canale] *Verdad y leyenda de Tina Modotti*. Havana: Casa de las Américas, 1989.

Beals, Carleton. *Mexico: An Interpretation*. New York: B. W. Huebsch, 1923.

"Bella Exposición, de arte en centro Museo del Estado hermosas fotografías." *Acción Social*, September 4, 1925, vol. 2, no. 184.

Brenner, Anita. *Idols behind Altars*. New York: Biblo and Tannen, (1929) 1967.

Britton, John A. *Revolution and Ideology: Images of the Mexican Revolution in the United States*. Lexington: University Press of Kentucky, 1995.

Cacucci, Pino. *I fuochi, le ombre, il silenzio: La fragil "vida" di Tina Modotti negli anni delle certezze assolute*. Bologna: Agalev, 1988.

—. *Tina*. Milan: Interno Giallo, 1991.

Conger, Amy, and Elena Poniatowska. *Compañeras de México: Women Photograph Women*. Riverside, Calif.: University Art Gallery, 1990.

Constantine, Mildred. *Tina Modotti: A Fragile Life*. San Francisco: Chronicle Books, 1983.

Cupull Reyes, Adys. *Tina Modotti: Semilla profunda*. Havana: Pablo de la Torriente, 1996.

Dillo, Richard. *North Beach: The Italian Heart of San Francisco.* Novato, Calif.: Presidio Press, 1985.

Ellero, Gianfranco. *The Childhood of Tina Modotti.* Udine: Arti Grafiche Friulane, 1992.

—. *Pietro Modotti.* Udine: Ribis, 1992.

—. *Tina Modotti in Carinzia e in Friuli.* Pordenone: Cinemazero, 1996.

Ewald, Donna, and Peter Clute. *San Francisco Invites the World.* San Francisco: Chronicle Books, 1991.

Facondo, Gabriella. *Socialismo italiano esule negli USA (1930–1942).* Foggia: Bastogi, 1993.

Ferré, Rosario. "El privilegio de una pasion," in *Sitio a Eros: Trece ensayos literarios.* Mexico City: J. Mortiz, 1980, pp. 79–84.

Figarella Mota, Mariana. "Edward Weston y Tina Modotti en México: Su inserción dentro de las estrategias estéticas del arte post-revolucionario." Tesis de maestria, Historia del Arte, Universidad Nacional Autónoma de México, 1995.

Garibaldini in Ispagna. Milan: G. Thierry, 1937. Repr. Milan: Feltrinelli, 1966.

Giacomini, Ruggero, ed. *Tina Modotti: La vicenda artistica politica e umana.* Ancona: Centro Culturale "La Città futura," 1999.

Gibson, Margaret. *Memories of the Future: The Daybooks of Tina Modotti.* With poems by Margaret Gibson. Baton Rouge: Louisiana State University Press, 1986.

Glusker, Susannah Joel. *Anita Brenner: A Mind of Her Own.* Austin: University of Texas Press, 1998.

Gonzáles Cruz Manjarrez, Maricela. *Tina Modotti y el Muralismo Mexicano.* Mexico City: Universidad Nacional Autónoma de México, 1999.

Herrera, Hayden. *Frida: A Biography of Frida Kahlo.* New York: Harper and Row, 1985.

Higgins, Gary. *Truth, Myth, and Erasure: Tina Modotti and Edward Weston.* History of Photography Monograph Series, 28. Tempe: Arizona State University Press, 1991.

Hooks, Margaret. *Tina Modotti: Photographer and Revolutionary.* London: Pandora, 1993. Repr., New York: Da Capo Press, 2000.

—. *Tina Modotti.* Aperture Masters of Photography. Cologne: Könemann, 1999.

J. M. H. "Mañana se clausurará la magnífica exposición de Weston y de Modotti." *El Sol,* September 5, 1925, III, no. 641.

Kettenmann, Andrea. *Frida Kahlo 1907–1954: Pain and Passion.* Cologne: Taschen, 1992.

Krause, Barbara. *Der Verbrannte Schmetterling: Tina Modotti.* Berlin: Neues Leben Verlag, 1993.

Lowe, Sarah M. *Tina Modotti: Photographs.* New York: Abrams, 1995.

—. *Tina Modotti: Photographs 1923–1929.* New York: Throckmorton Fine Art, 1996.

"Mañana se inaugura la exposición de la bella artista Tina Modotti." *El Sol,* August 31, 1925.

Martinez, Romeo, and Bryn Campbell. *I Grandi fotografi: Tina Modotti.* Milan: Fabbri, 1983.

México de las mujeres. Galería Arvil en su XXV aniversario presenta fotografías de Lola Alvarez Bravo, Kati Horna, Graciela Iturbide, Tina Modotti y Mariana Yampolsky. Mexico City: Galería Arvil, 1994.

Modotti Richey, Tina, ed. *The Book of Robo.* Los Angeles, 1923.

—. *5,000,000 Widows. 10,000,000 Orphans. Women! Do You Want That Again?* San Diego: Parentheses, 1996.

Mora, Gilles, ed. *Edward Weston: Forms of Passion.* New York: Abrams, 1995.

Mulligin, Therese. *Modotti y Weston: Mexicanidad.* Coruña: Fundación Pedro Barrié de la Maza, 1999.

Mulvey, Laura, and Peter Wollen. *Frida Kahlo and Tina Modotti.* Exh. cat. London, Whitechapel Art Gallery, 1982.

Natoli, Claudio, "Tina Modotti: Una vita tra avanguardia artistica impegno politico e 'nuova umanità.'" In Ruggero Giacomini, ed., *Tina Modotti: La vicenda artistica politica e umana.* Ancona: Centro Culturale "La Città futura," 1999, pp. 11–39.

Newhall, Nancy, ed. *The Daybooks of Edward Weston.* I: Mexico. II: California. New York: Aperture Foundation, 1981.

Noble, Andrea. *Tina Modotti: Image, Texture, Photography.* Albuquerque: University of New Mexico Press, 2000.

Orozco, José Clemente. *Autobiografía.* Mexico City: Era, 1945.

Paoli Gumina, Deanna. *The Italians of San Francisco, 1850–1930.* New York: Center for Migration Studies, 1978.

Photographs of Mexico: Modotti/Strand/Weston. Text by Rebecca Zurier. Corcoran Gallery of Art, Washington, D.C. September 30 – November 26, 1978; Museo del Barrio, New York City, December 8, 1978 – February 25, 1979.

Place, Stéphane. *Tina Modotti: The Mexican Renaissance.* Paris: Jean-Michel Place, 2000.

Poniatowska, Elena. *Tinísima.* Mexico City: Era, 1992.

Rascón, Víctor Hugo. *Tina Modotti y otras obras de teatro.* Mexico City: SEP, 1986.

Rivera, Diego. *My Art, My Life: An Autobiography with Gladys March.* New York: Citadel Press, 1960.

Rodríguez, José Antonio, ed. *Tina Modotti, vanguardia y razón.* Mexico City: Sistema Nacional de Fototecas, 1998.

Saborit, Antonio. *Una mujer sin país: Las cartas de Tina Modotti a Edward Weston 1921–1931*. Mexico City: Cal y Arena, 1992.

—. *Tina Modotti: Vivir y morir en México*. Mexico City: Consejo Nacional para la Cultura y las Artes, 1999.

Schultz, Reinhard. *Tina Modotti: Photographien und Dokutiente*. Berlin: Sozialarchivs, 1989.

Sotelo, Jesús Nieto, and Elisa Lozano Alvarez, ed. *Tina Modotti: Una nueva mirada, 1929*. Universidad Autónoma del Estado de Morelos: CNCA/Centro de la Imagen, 2000.

Stark, Amy, ed. *The Letters from Tina Modotti to Edward Weston*, in *The Archive*. Tucson: Center for Creative Photography, 1986.

Tina Modotti & Edward Weston: Mexican Years. Introduction by Malin Barth. New York: Throckmorton Fine Arts, 1999.

Tina Modotti: garibaldina e artista. Udine: Circulo Culturale Elio Mauro, 1993.

Toffoletti, Riccardo, ed. *Tina Modotti*, portfolio. Florence: Alinari, 1992.

—. *Tina Modotti: Arte Vita Libertà*. Trieste: Il ramo d'oro, 2001.

—, ed. *Tina Modotti: Perchè non muore il fuoco*. Udine: Edizione Arti Grafiche Friulane, 1992.

—, ed. *Tina Modotti: Una vita nella storia. Atti del Convegno Internazionale di Studi*. Udine: Comitato Tina Modotti. Arti Grafiche Friulane, 1995.

Vidali, Vittorio. *Comandante Carlos*. Rome: Editore Riuniti, 1983.

—. *La caduta della repubblica*. Milan: Vangelista, 1979.

—. *Diario del XX congresso*. Milan: Vangelista, 1974.

—. *Orizzonti di libertà*. Milan: Vangelista, 1980.

—. *Il Quinto Reggimento*. Milan: La Pietra, 1976.

—, ed. *Ritratto di donna: Tina Modotti*. Milan: Vangelista, 1982. Repr. *Tina Modotti: Ritratto di donna*. Tavagnacco, Udine: Arti Grafiche Friulane, 2002.

—, Rafael Alberti, *et al.*, *Tina Modotti: Fotografa e rivoluzionaria*. Milan: Idea editions, 1979.

Edward Weston 1886–1958, ed. Manfred Heiting. With an essay by Terence Pitts and a personal portrait by Ansel Adams. Cologne: Taschen, 1999.

Wolfe, Bertram D. *A Life in Two Centuries: An Autobiography*. New York: Stein and Day, 1981.

Articles

Ariel Lopez, José. "Tina Modotti." *Propositos*, no. 496, May 17, 1973.

The Art Institute of Chicago. *The Essential Guide*. Selected by James N. Wood and Teri J. Edelstein. With entries written and compiled by Sally Ruth May. Chicago, 1993, pp. 177–78.

Arzubide, Germán List. "Mi amiga Tina Modotti," *Excelsior*, March 24, 1993, LXXVII, n. 11, pp. 1–2.

Augias, Corrado. "Adelante Tina la pasionaria." *Televenerdì di repubblica*, March 17–23, 1995, p. 141.

Baccari, Alessandro, and Andrew M. Canepa. "The Italians of San Francisco in 1865: G. B. Cerruti's Report to the Ministry of Foreign Affairs." *California Historical Society Quarterly*, Winter 1981/82, vol. 9, no. 4, pp. 350–69.

Barckhausen-Canale, Christiane. "Tina Modotti: Entscheidung in Berlin," in *Berliner Begegnungen: Ausländische Künstler in Berlin 1918 bis 1933*. Berlin: Dietz Verlag, 1987, pp. 421–27.

Barta, Eli. "Women and Portraiture in Mexico," *History of Photography*, vol. 20, n. 3, Autumn 1996, pp. 220–25.

Bartolini, Elio. "Per Tina Modotti." *Il piccolo*, Trieste, March 5, 1980.

—. "Tina Modotti, forse per infarto." *Corriere del Friuli*, July 1980.

Bastianelli, Marco. "Tina Modotti." *Reflex*, XIII, no. 146, May 1992.

Bauret, Gabriel. "Edward Weston et Tina Modotti." *Photographies Magazine*, no. 34, Spring 1992, pp. 42–45.

Beals, Carleton. "Goat's Head on a Martyr." *The Saturday Review of Literature*, December 7, 1929, p. 505.

—. "Tina Modotti," *Creative Arts*. February 1929, vol. 4, no. 2, pp. xlvi–li, repr. Mulvey and Wollen, *Frida Kahlo and Tina Modotti*, pp. 30–31.

Beltrame, Alessandra. "É morta Jolanda, memoria di Tina." *Il messaggero veneto*, March 20, 1992.

Bertossi, Silvano. "Tina grande con il clic." *Messaggero Veneto*, October 3, 1992.

Bethel, Denise. "Modotti and Weston in Mexico." *Sotheby's Preview*, October 1991.

Bignardi, Irene. "Que viva Tina!" *La Repubblica*, May 1, 1990, p. 31.

Bonetti, David. "Illuminating the work of Tina Modotti." *San Francisco Examiner*, March 28, 1996, pp. C1–C7.

Cabrera, Olga. "Un crimen político que cobra actualidad." *Nueva Antropología*, July 27, 1985.

Cacucci, Pino. "Una giornata con Tina." *Cinemazero*, XI, no. 11, December 1992, pp. 26–27.

Canepa, M. Andrew, "Fonti sull'Emigrazione in California." Paper presented at the *IV Colloquio sulle fonti per la storia dell'emigrazione: l'emigrazione italiana in America del Nord 1870–1970*. Rome, October 1993, pp. 1–12.

Cantarutti, Ludovica. "Tina deliziosa stanca ma anche introversa." *Pordenone*, July 20, 1992.

Caputo, Iaia. "Una, due, tante Tine." *L'indipendente*, December 15/16, 1991.

Cardona, Rafael. "Un retrato de Tina Modotti," *Excelsior*, January 16, 1929, pp. 1 and 12.

Carnelli, María Luisa. "Retrato de Tina Modotti." *Así Es*, no. 17, May 28/June 3, 1982, p. 15.

Caronia, Maria. "Lo stile della passione." *L'illustrazione italiana*, no. 82, Spring 1992, pp. 57–63.

Casella, Alessandra. "Tina e Frida: due destini che s'incrociano." *Oggi*, October 1997, p. 132.

Castano, Silvano. "Mosca 1932: Tina e Angelo." *Cinemazero*, supplement to no. 1a, xi, no. 11, December 1992, pp. 22–25.

Castellanos, Armando, Julia Soto, and Alma Lilia Roura. "Frida Kahlo Tina Modotti." Museo Nacional de Arte *MUNAL* – Tacuba, no. 8, June–August 1983.

Celadin, Anna. "Tina Modotti a Milano." *Il ponte della Lombardia*, no. 4, May/June 1997, pp. 43–44.

"Centenario de Tina." *Raíces*. August–September 1996.

Cerroni Cadoresi, Domenico. "Ritratto di Tina Modotti." *Il punto*, no. 10, June 15, 1982, p. 76.

Cheron, Philippe. "Tina, Stalinísima," *Vuelta*, vol. 7, n. 82, September 1983, pp. 46–47.

Ciriello, Mario. "Tina Modotti? Uccisa per ordine di Mosca." *La stampa*, February 27, 1992.

Colin, Gianluigi. "Tina: Identificazione di una donna." *Corriere della sera*, December 10, 1993.

—. "Tina, le passioni d'una pasionaria." *Corriere della sera*, May 19, 1994, p. 31.

—. "Voluttuosa Tina, pasionaria della foto." *Corriere della sera*, August 21, 1992.

Colombo, Attilio. "Fotografa nella rivoluzione" in *I Grandi Fotografi*. Milan: Fabbri, 1983, pp. 58–61.

—. "Tina Modotti raccontata da Vidali." in *I Grandi Fotografi*. Milan: Fabbri, 1983, pp. 1–57.

Conger, Amy. "Facts and Figures." *Afterimage*, September/October 1996, p. 2.

—. "Tina Modotti and Edward Weston: A Re-evaluation of their Photography." In Peter C. Bunnell and David Featherstone, eds. *Edward Weston 100: Centennial Essays in Honor of Edward Weston*. California: Friends of Photography, 1986, p. 63.

Constantine, Mildred. "Tina Modotti en Méjico." *La Gaceta*, viii, no. 93, September 1978, pp. 2–6.

Crocco, Raffaele. "Tina, la vita, il clic." *Trieste oggi*, February 21, 1992.

Cupull, Adys. "Tina Modotti, una mujer extraordinaria." *Bohemia*, 1986, p. 38.

Curti, Denis. "Tina, la rosa del Messico." *Corriere della sera*, November 23, 2000, p. 59.

D'Attilio, Robert. "Glittering Traces of Tina Modotti." *Views* (Boston), Summer 1985, pp. 6–9.

De Ita, Fernando. "No hay una Tina Modotti, sino que son muchas, afirma el dramaturgo Rascón." *Uno más uno*, May 5, 1981.

De la Torriente, Lolo. "Gracia y estilo en Tina Modotti." *Bohemia*, February 15, 1974.

De Sanctis, Lina. "¡Que viva Tina!" *Il Venerdì di repubblica*, no. 364, February 17, 1995, pp. 98–100.

De Stefano, Cristina. "Occhi d'amore." *Elle*, December 1991.

De Tomassi, Andreina. "La passione di Tina." *Il Venerdì di repubblica*, September 4, 1992, pp. 84–86.

Di Giammarco, Rodolfo. "Tina, un mondo di storie," *La Repubblica*, October 11, 1996, p. 42.

Dromundo, Baltasar. "De Baltasar Dromundo a Raquel Tibol sobre Tina Modotti." *Proceso*, no. 345, June 13, 1983, p. 52.

Ellero, Gianfranco. "Acceso dibattito su Tina Modotti." *Corriere del Friuli*, April 1980, p. 2.

—. "Gli allievi di Pietro Modotti." *Cinemazero*, no. 6, June 1993, pp. 31–33.

—. "Ancora un libro su Tina Modotti." *Corriere del Friuli*, March–April 1982, p. 3.

—. "Chi ha paura di Tina Modotti?" *Corriere del Friuli*, June 1980, p. 2.

—. "Die Fotografin Tina Modotti." *Die Brücke*, no. 3, 1996, pp. 13–16.

—. "I disegni di Pietro Modotti fotografo in Udine." *La Panarie: Rivista friulana*, no. 99, April–December 1993, pp. 57–60.

—. "In borgo Pracchiuso con Tina Modotti." *Sot la nape*, no. 4, December 1992, pp. 41–46.

—. "L'infanzia di Tina Modotti." *Corriere del Friuli*, October 1979, pp. 3–4.

—. "Tina Modotti a Villa Varda: una mostra esemplare e diversa dalle altre." *Il messaggero veneto*, September 28, 1992.

—. "Tina Modotti, dall'oblio al mito." *La Panarie*, October 1992, pp. 23–28.

—. "Tina Modotti e Giuliano Borghesan francobolli." *Il gazzettino* (Udine), February 11, 1999.

—. "Tina Modotti, fotografa e rivoluzionaria." *La vita cattolica*, May 12, 1979, p. 10.

—. "Stilemi nativi nella fotografia di Tina Modotti." *Quaderni della Face*, no. 81 July–December 1992, pp. 19–30.

—. "Su Tina verità made in USA." *Il Friuli*, July 30, 1999, p. 25.

—. "Uno studio Modotti a San Francisco nel 1908: Anche il padre di Tina era fotografo." *Il messaggero veneto*, November 8, 1992.

Ellero, Roberto. "Bruciante avventura: Hollywood, Weston, la leggenda di Stalin." *Il messaggero veneto*, April 2, 1992.

—. "Weston e Modotti: Ghiaccio e fervore." *Il messaggero veneto*, August 21, 1992.

Falces, Manuel. "Modotti y los Certificados de Izquierda." *El País*, October 17, 1998.

Fernandez, Montserrat. "Una exposició a la caixa repassa la vida i l'obra de Tina Modotti." *El 9 nov.*, May 9, 1994.

Ferrara, Marcella. "Dalla parte di Tina." *Rinascita*, no. 10, March 12, 1982, p. 32.

Ferré, Rosario. "Tina y Elena: El Ojo y el Oido de México." *Nexos*, vol. 98, 1983, pp. 5–8.

Ferrer, Elizabeth. "Lola Alvanez Bravo: A Modernist in Mexican Photography," *History of Photography*, vol. 18, no. 3, Autumn 1994, pp. 211–18.

Fini, Marco. "Que viva Tina." *Panorama*, May 29, 1979.

Fischer, Jack. "Exposures: The Risky Lives of Tina Modotti." *San Jose Mercury News*, April 30, 1994.

"La fotografia pictórica." *Agfa* (Mexico), ii, no. 20, August 1929.

Gagliano, Ernesto. "Diva del nudo, fotografa, spia è la la Mata Hari del Cominterm." *La stampa*, December 9, 1991.

—. "Foto di una rivoluzionaria." *La stampa*, February 24, 1992.

Gaja, Filippo. "Vidali parle di Trotsky," *Settimo giorno*, October 1962, pp. 16–18.

Garcés, Carlos. "Tina Modotti en la leyenda y la verdad, con Christiane Barckhausen-Canale." *Casa de las Américas*, Havana, November 1988, pp. 109–15.

Gilbert, Sari. "Tina la 'pasionaria'." *Il giornale nuovo*, Milan, February 21, 1978.

Golin, Valeria. "Così ho trovato nella biblioteca di Mosca quel testo di Tina dedicato ai peones." *Il messaggero veneto*, September 10, 1992.

Gruber Benco, Aurelia. "Un fiore femminile." *Corriere della sera*, July 5, 1973, p. 3.

Hansen, Marcus L. "The History of American Immigration as a Field for Research." *American Historical Review*, vol. 32, no. 3, April 1927, pp. 500–18.

Harlick, Jeanene. "Life of the party." *Stanford*, January/February 2002, pp. 50–55.

Hellman, Roberta, and Marvin Hoshino. "Tina Modotti." *Arts Magazine*, vol. 51, no. 8, April 1977, p. 2.

Herrera, Hayden. "Self Portrait of Frida Kahlo as a Tehuana." *Heresies* (New York), no. 4, 1978–79.

Higgins, Gary. "Tina and Edward." *Creative Camera*, no. 314, February/March 1992, pp. 20–23.

—. "Truth, Myth, and Erasure: Tina Modotti and Edward Weston." *The History of Photography Monograph Series*, no. 28, Spring 1991, n.p.

Higonnet, Anne. "Women, Images, and Representations." In Françoise Thébaud, ed. *A History of Women: Toward a Cultural Identity in the Twentieth Century.* Cambridge, Mass.: Harvard University Press, 1996.

Hooks, Margaret. "Assignment, Mexico: The Mystery of the Missing Modottis." *Afterimage*, vol. 19, no. 4, November 1991, pp. 10–11.

—. "De-Mythologizing Modotti." *Afterimage*, vol. 21, no. 4, November 1991.

—. "Separating Art From Life." *Afterimage*, January–February 1996, p. 19.

—. "Tina Modotti: fotógrafa o revolucionaria?" (trans. James Valender), *El Nacional Dominical*, July 28, 1991.

Hulick, Diana. "Edward Weston: The Mexican Photographs." *Latin American Art*, vol. 3, Autumn 1991, pp. 65–67.

Kimmelman, Michael. "A Legacy That Mingles Myth With Politics." *The New York Times*, October 8, 1995, p. H39.

Kramer, Hilton. "Tina Modotti's Brief but Remarkable Career." *The New York Times*, January 23, 1977, p. 25.

—. "Turning the Legend of Tina Modotti into a Soap Opera." *The New York Times*, June 8, 1975, p. 31.

Lajolo, Davide. "Tina Modotti, grande fotografa, di professione rivoluzionaria." *Corriere della sera*, September 18, 1982.

Lavell, Stephen. "Frida Kahlo and Tina Modotti." *Arts Review*, April 9, 1982, p. 182.

Léon, Maria Teresa. "Tina Modotti: Ricordo ed elogio." *Rinascita*, no. 34, August 27, 1971.

Lippincott, Robin. "Through a Lens, Radically." *The New York Times Book Review*, April 17, 1994, p. 18.

Loke, Margaret. "Inside Photography." *The New York Times*, March 14, 1997, pp. 33–34.

Loos, Ted. "La comradessa." *New York Times Book Review*, May 2, 1999, p. 24.

Lorenz, Richard, John P. Schaefer, and Terence R. Pitts. "Johan Hagemeyer." *The Archive* (Tucson, Arizona: Center for Creative Photography), no. 16, June 1982.

Lowe, Sarah M. "The Immutable Still Lifes of Tina Modotti: Fixing Form." *History of Photography*, vol. 18, no. 3, Autumn 1994, pp. 205–10.

—. "Tina Modotti: l'ingombro di una biografia." *Lapis*, no. 27, September 1995, pp. 34–37.

Lusa, P. "Tina Modotti: Un mondo marcia verso il luogo dove tu andavi, sorella." *Il Lavoratore*, March 5, 1982.

Madeccia, Bianca. "Tina, con la vita negli occhi." *Donne*, September 2, 1992, pp. 56–60.

Maniacco, Tito. "Tina Modotti emigrante anomala." *Tutto Udine*, November 1991.

Maranzana, Silvio. "Tina, una miniera alla luce del sole." *Il piccolo*, March 31, 1982.

Marcoaldi, Franco. "Tina, la pasionaria." *La Repubblica*, February 20, 1992.

Melinkoff, Ellen. "Who Was Tina Modotti?" *Art & Antiques*, vol. 9, no. 7, September 1992, pp. 58–63.

Meloni, Michele. "Tina Modotti nata libera per due mondi." *Il messaggero veneto*, July 7, 1991.

Merlin, Tina. "In due continenti la vita e le lotte di Tina Modotti." *L'unità*, June 4, 1973.

Micucci, Dana. "The Blue House." *Art & Antiques*, October 1994, pp. 64–69.

Molderings, Herbert, "Tina Modotti: Fotografin und Agentin der GPU," *Kunst Forum International* (FRD), November 9, 1982, p. 92.

Molinari, Paolo. "Ancora un libro su Tina Modotti." *Corriere del Friuli*, March–April 1982.

Monda, Antonio. "Gli occhi delle donne," *Tó donna*, September 24, 1996, p. 32.

Montagnana, Mario. "Tina Modotti: donna, artista e combattente." *Il lavoratore*, v, no. 13, December 1971, p. 18.

Morales, Sonia. "Tina Modotti: el arte fotográfico al servicio de las ideas." *Proceso*, no. 335, April 4, 1983, pp. 50–51.

John Mraz. "En el camino hacia la realidad." *La Jornada Semanal*, no. 7, July 30, 1989, pp. 21–23.

Mutti, Roberto. "La leggenda di Tina tutti gli scatti di una vita." *La Repubblica*, March 23, 1997, p. vii.

Natoli, Aldo. "Le avventure di un picaro rosso." *La Repubblica*, September 3, 1980.

—. "É morto Vittorio Vidali il comandante Carlos in Spagna." *La Repubblica*, November 10, 1983, p. 5.

—. "La rivoluzione come mestiere, lo stalinismo come 'istinto'." *La Repubblica*, November 10, 1983, p. 5.

Nelken, Margarita. "Con orgullo: nuestra Tina Modotti," *Magazine de Hoy*, January 25, 1942.

Page, Amy. "Flower Power," *Art Antiques*, November 2002, p. 101.

Pausic, Rudi. "Modottijev Pogled Skovi Fotografijo." *Primorski Dnevnik*, February 29, 1992.

Paz, Octavio. "Frida y Tina: vidas no paralelas." *Vuelta*, vol. 7, no. 82, September 1983, p. 48.

Pellegrino, Alberto. "Tina Modotti, reporter sociale." *Nickelodeon*, no. 42, April 1992.

Pellizzari, Gianmatteo. "Quella mostra distorce la vita e l'opera di Tina." *Il gazzettino*, September 25, 1992.

Peralta, Braulio. "T. M. nunca estuvo a la derecha de Stalin." *La Jornada*, September 28, 1986.

Perazzi, Mario. "Tina Modotti: Gli scatti di una pasionaria." *Io donna*, no. 48, November 25, 2000.

Peresani, Rita. "Sulle tracce di Tina." *Nickelodeon*, no. 42, April 1992.

Pisu, Renata. "Fotografa di popolo: La vita inimitabile di Tina Modotti." *Linus*, March 1978, pp. 108–09.

Plagens, Peter. "What a Life She Red." *Newsweek*, October 2, 1995, p. 88.

Poniatowska, Elena. "La muerte de Mella." *Cuadernos de marcha*, IV, no. 20, July–August 1982, pp. 3–21.

—. "¿Que se hace a la hora de morir, Tina Modotti?" *El Semanario*, July 3, 1983, II, vol. 2, no. 63, pp. 1–2.

—. "Tinísima: Fragmento de novela." *México en el arte*, Summer 1983, pp. 31–40.

Pressburger, Giorgio. "Tina Modotti e Vittorio Vidali: L'amore al tempo della rivoluzione." *Corriere della sera*, August 24, 2000, p. 31.

Reis, Elizabeth. "Cannery R.O.W." *California Historical Society Quarterly*, Summer 1985, vol. 64, no. 3, pp. 174–91.

Rigutto, Liana. "A Tina, do dome un recuart." *La patrie dal Friuli*, March 1992, pp. 20–21.

Rivera, Diego. "Edward Weston and Tina Modotti." *Mexican Folkways*, no. 2, April–May 1926, pp. 16–17; in Spanish, pp. 27–8. Repr. in Mulvey and Wollen, *Frida Kahlo and Tina Modotti*, pp. 6–9.

Rivera, Héctor. "Como asumió su cuerpo y su libertad, Tina Modotti asumió su pasión politica: Retes." *Proceso*, n. 335, April 4, 1983, pp. 50–53.

—. "Polemica por Tina: Retes impugna a sus críticos; Rascón añora su texto original." *Proceso*, no. 342, May 23, 1983, pp. 60–61.

Robilant, Andrea. "La fragile vita di Tina Modotti." *Il progresso*, September 9, 1981.

Rubin, Sabrina. "Lucky Star." *Philadelphia*, September 1995, p. 75.

Salvetti, Patrizia. "La comunità italiana di San Francisco tra italianità e americanizzazione negli anni '30 e '40." *Studi emigrazione* (Rome), XIX, no. 65, March 1982, pp. 3–39.

Sapia, Vincenzo. "Donna, fotografa e rivoluzionaria." *Quotidiano di Lecce*, May 11, 1982.

Scaraffia, Giuseppe. "Gli scatti della pasionaria." *Il messaggero*, December 16, 1991.

Scherini, Rose Doris. "Executive Order 9066 and Italian Americans: The San Francisco Story." *California Historical Society Quarterly*, Winter 1991/92, vol. 70, no. 4, pp. 367–77.

Schwartz Hartley, Christine. "An Unstill Life." *The New York Times Book Review*, January 7, 1996, p. 21.

Scimè, Giuliana. "Lampi dal Messico: la leggenda di Tina Modotti." *Corriere della sera*, February 23, 1992.

Segal, Lewis. "A 'Tina' Taken Out of Time and Context." *Los Angeles Times*, June 8, 1998, p. F3.

Settimelli, Wladimiro. "Visita guidata al mito di Tina Modotti." *L'unità*, March 13, 1992.

Shachtman, Max, "Enea Sormenti," *Labor Defender*, January 1927, vol. ii, n. 1, p. 2.

Siqueiros, David Alfaro. "Una Trascendental Labor Fotográfica: La Exposición Weston-Modotti." *El Informador* (Guadalajara), September 5, 1925, p. 6.

Smith, Joan. "Tina Modotti's Revolutionary Journey," *San Francisco Examiner Image*, November 14, 1993, pp. 20–25.

Smith, Patricia. "Tina Modotti: Photographer of Culture." *San Diego Decor & Style*, vol. 11, no. 11, November 1996, pp. 50–51.

Stajano, Corrado. "Quel sogno friulano rato in America." *Corriere della sera*, September 27, 1994, p. 3.

Tamburlini, Maria Pia. "Tina, promossa a pieni voti." *Il messaggero veneto*, September 25, 1992.

Tennant, Gary. "Julio Antonio Mella and the Roots of Dissension in the Partido Comunista de Cuba." *The Hidden Pearl of the Caribbean: Trotskyism in Cuba. Revolutionary History*, vol. 7, no. 3, pp. 40–54.

Tibol, Raquel. "Algunas razones para juntar a Frida y Tina en el Munal." *Proceso*, no. 344, June 6, 1983, pp. 50–55.

—. "Bocetos y sucedidos, Tina Modotti." *Episodios fotográficos* (Mexico City: Libros de Proceso), 1989, pp. 122–38.

—. "Correción de la corrección de Dromundo." *Proceso*, no. 345, June 13, 1983, pp. 52–53.

—. "Tina Modotti precursora de la fotografiá mexicana de hoy." *Excelsior*, July 8, 1973, p. 5.

"Tina Modotti. Some Photographs." *The Massachusetts Review*, 1972, pp. 112–24.

"Tina Modotti a Villa Varda: la parola agli organizzatori dopo la polemica." *Il messaggero veneto*, October 4, 1992.

Toffoletti, Riccardo. "Per Tina." *Tutto Udine*, no. 1991.

—. "Tina Modotti." *Perimmagine*, December 1980, n.p.

—. "Tina Modotti: Una vita di passioni." *Nuova Emigrazione*, xxiv, no. 3, March 1992, pp. 73–75.

Tosoni, Mario. "Tina, rivive un mito." *Il gazzettino*, January 4, 1992.

Trevisani, Rosalba. "Le lettere: dalla grafologia uno spiraglio sulla personalità di Tina Modotti." *Perimmagine*, July–September 1993, n.p.

Vallarino, Roberto. "Tina Modotti: Una vida frágil." *Uno más uno*, September 5, 1979.

Valentinetti, Claudio M. "Le passioni di Tina." *Grazia*, December 22, 1991.

Vestal, David. "Tina's Trajectory." *Infinity*, no. 15, February 1966, p. 6.

Viñas, David. "Tina desnuda e invicta." *Uno más uno*," January 6, 1982, p. 17.

Vitone, Samuel, "The Italian-Americans of San Francisco and Public Education." In *Columbus. The publication of the Columbus Celebration – 1977. Historical Issue: Italians in California.* San Francisco: Baccari, 1977, pp. 115–18.

Vogel, Carol. "Inside Art." *The New York Times*, May 19, 1995, p. 31.

Volli, Ugo. "Tina Modotti, la pasionaria," *La Repubblica*, November 11, 1996, p. 28.

Wolfe, Bertram. "Rise of another Rivera." *Vogue*, November 1, 1938.

Wright, Doris Marion. "The Making of Cosmopolitan California – Part II: An Analysis of Immigration, 1848–1870." *California Historical Society Quarterly*, vol. 22, no. 1, March 1941, pp. 65–79.

Yáñez, Richard. "Fue donado el archivo fotográfico de Tina Modotti al pueblo mexicano." *Uno más uno*, 27 August 1979.

Zaniboni, Maria. "Tina Modotti." *Historia*, May 1989, p. 29.

Zannier, Italo. "Chi ha ucciso Tina Modotti?" *Fotologia*, Spring–Summer, 1991.

—. "Tina Modotti." *Fotografia Italiana* (Milan), no. 186, October 1973, and *Corriere del Friuli*, November 15, 1973.

—. "Tina Modotti." *Il Fotografo* (Milan), March 1982.

Films available on Tina Modotti and with Modotti as protagonist

Bardischewski, Marie, and Ursula Jeshel. *Tina Modotti: Fotografin und Revolutionärin.* Spartafilm: West Berlin, 1982.

Glintenkamp, Pamela. *Tina Modotti: Putting Art into Life.* Sandpail Productions: Studio City, California, 2003.

Islas, Alejandra. *Tina Modotti.* Mexico City, 1996.

Longfellow, Brenda. *Tina in Mexico*, documentary. Toronto: Gerda Film Productions, 2002.

Mulvey, Laura, and Peter Wollen. *Frida Kahlo and Tina Modotti.* London, 1983.

The Tiger's Coat. Dial Film Co: Los Angeles, 1921.

Index